ANDRES SERRANO
AMERICA
and other work

TASCHEN

KÖLN LONDON LOS ANGELES MADRID PARIS TOKYO

ACKNOWLEDGEMENTS

Terese Andren, Julie Ault, Barnabas Bencsik, Blake Boyd, Thomas Buda, Michael Coulter, Tai Dang, Barry Frier, Enrique Guzman, Scott Griffin, John Hartnett, Cliff Hawkins, Karolina Henke, Ellis Henican, Tiffany Hunold, Nathan Jude, Krishna Kaur, Cynthia Karalla, Jellike Oeberius-Kaptijn, Jeung Kim, Monica Kroepil, Anne Lambert, Danielle St. Laurent, Elizabeth Laser Magic, J.R. Martin, Victor Matthews, Jill Matula, Esteban Mauchi, Miranda McGuire, Barbel Miebach, Irina Movmyga, Alexander Nasarewsky, Beatrice Neumann, Anna Nyri, Moni Ogzilik, Tamako Okamura, Aaron Olshan, Anne Pasternak, Sibylle De Saint Phalle, Tamar Press, Helga Eszter Rajz, Ruth Rosenberg, Peter Stern, Stefan Stux, Richard Sudden, Tracy Sue Thompson, Alan Twine, Hope Urban, Jose Vargas, Willie Vera, Mark Wilson, and Akira Yoshizaki.

Special thanks to
Paula Cooper and Yvon Lambert.

© 2004 TASCHEN GmbH
Hohenzollernring 53, D-50672 Köln
www.taschen.com

© 2004 Andres Serrano; photographs
Courtesy of The Paula Cooper Gallery
All rights reserved.

Editor: Dian Hanson
Coverdesign by Sense/Net,
Andy Disl and Birgit Reber, Cologne /
Design by Tamako Okamura, New York
German translation by Thomas Kinne, Nauheim /
French translation by Lien, Amsterdam

To stay informed about upcoming
TASCHEN titles, please request our magazine
at www.taschen.com or write to TASCHEN,
Hohenzollernring 53, D-50672 Cologne, Germany,
Fax: +49-221-254919. We will be happy to send
you a free copy of our magazine which is filled with
information about all of our books.

Printed in Italy
ISBN 3-8228-3504-8

For my friends,
Michael Coulter, Snuky Tate and Solomon Avital.
May they rest in peace.

NOTES ON AMERICA

A few days after the 11th, I told a friend, "I want to enlist in the war effort as an artist." What I meant by that was that I wanted to make a statement about what America is, and who.

At first, I thought I would do thirty or forty portraits. Later, the idea expanded to sixty, and eventually to over one hundred portraits of people from all walks of life. Rich, poor. Black, White. They are one hundred people I think embody America. There could have been another hundred or thousand people, but these are the ones I chose to represent America.
My America. Without apology or prejudice. One flag, over all.

Andres Serrano

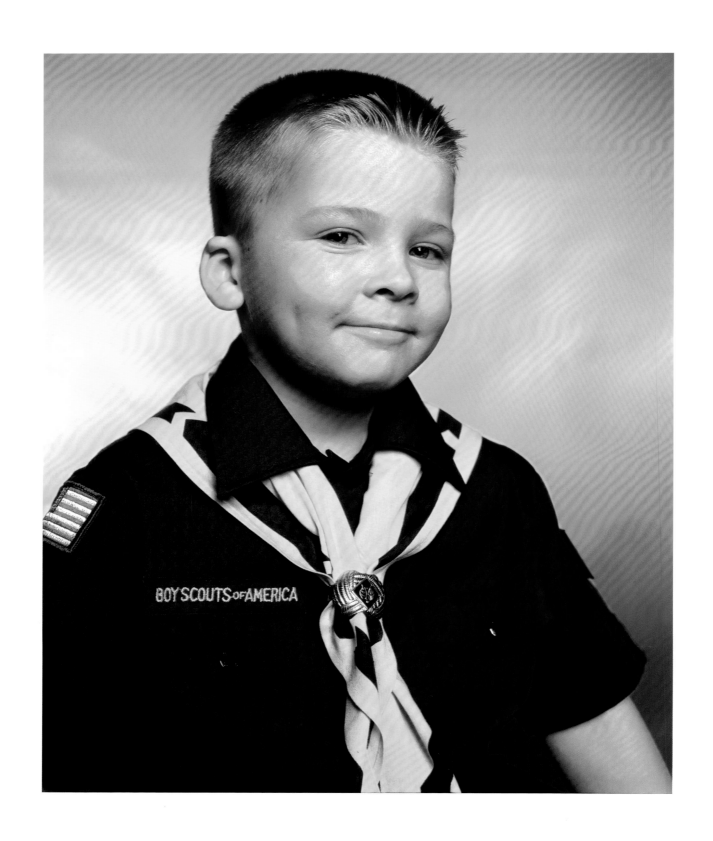

CONTENTS

LOOKING FOR AMERICA

By Eleanor Heartney

In the turbulent days following Sept. 11, 2001, people across the United States were shocked into introspection about their country and its role in the world. Andres Serrano found himself haunted by questions about the targets of the terrorists. Who, he wondered, did they imagine they were attacking when they declared war on America? Did they have any conception of the heterogeneity of the people who make up the United States? Would they have been surprised to discover how many different races, ethnicities, social classes and backgrounds were represented by the victims of their rage?

The ultimate result of these thoughts is *America*, a series of over a hundred photographic portraits of Americans – famous and infamous, rich and poor, celebrated and unknown. Shot against luminous painted backdrops devoid of any other imagery, each figure is presented alone and calmly posed in his or her own characteristic clothing. The photographs are devoid of overt editorial comment because Serrano intends for them to tell the story of America by themselves.

There are precedents for this kind of monumental effort, but other such photographic projects differ in significant ways. Serrano's *America* is not a celebration of American diversity or a paean to the unity within its diversity in the manner of Edward Steichen's 1955 photo essay *The Family of Man*. Neither is it a dispassionate compendium of types in the manner of August Sander's effort to document the German people. Instead, Serrano approaches his subject from a very personal perspective. Throughout his career, he has been drawn to the surreal, the visually striking, the eccentric. His picture of America reflects these preferences. But at the same time, *America* radiates respect and empathy. Whether he is depicting a captain of industry or a sex worker, Serrano accords each the full measure of their humanity.

In choosing portraiture as his medium for a picture of America, Serrano consciously incorporates elements of the most familiar versions of that genre. In some of these photographs we see the tropes of official portraiture. Costumes, accessories, even point of view, place the individual in a role – endowing him or her with the accoutrements of power, wealth or glamour.

Opposing this tradition is the convention of the democratic portrait. Here the individual is presented as the embodiment of everyman. Such images are often served up with a populist agenda, and are designed to demonstrate the essential goodness of the regular guy (or gal).

In Serrano's *America*, one can see something of both approaches. However, he deliberately mixes their signals – the homeless man is imbued with the heroic aura of a charismatic politician, while the power broker made the equal of the welfare mother. We sense at times a touch of the homespun nobility that has made Grant Wood's painting *American Gothic* an enduring icon. In other *America* photographs, we glimpse a touch of sardonic subversion, recalling the way that grand robes can't quite cloak the glimmer of venality and imbecility in the royal portraits of Francisco Goya.

But in the end, Serrano is after something more complicated than either star worship or egalitarian leveling. His picture of America is a deliberately fractured view.

America begins with a fresh-faced Boy Scout. That initial image of wholesome principle and unsullied honor gives way within this series to a cast of characters that includes entrepreneurs, showgirls, con artists, heroin addicts, firemen, migrant workers, pimps, educators and

socialites. America, Serrano suggests, is a country that makes room for Trinidadian street vendors, Chinese cooks, Amish grandmothers and Muslim religious leaders. It is also a place where celebrity status is accorded to figures with such dubious accomplishments as Lizzie Grubman and Jayson Blair. Serrano has included individuals who represent our best impulses and those who have succumbed to our worst ones. There are criminals and heroes, victims and perpetrators, entertainers and public servants. This is a complex country, he argues, and simple delinations of us versus them or good versus evil will not suffice.

In these photographs, Serrano plays on the conflict between type and individual, a tension inherent in every portrait. In one sense *America* presents Americans in their uniforms - the nurse appears in her whites, firefighters with their hats and hoses, the investment banker in a sober business suit. Even the street hustler garbed in decoratively tattered rags is wearing a uniform, Serrano discovered, which he discards when he goes home for the day. But while the costumes engage us, what ultimately compels are the faces, the eyes, the expressions. Even when hidden or masked, as in his portrait of a gas masked emergency worker or a street denizen whose face is lost beneath the shadows of his hood, – we search for clues to inner life.

The complexity of vision apparent in *America* is evident in all Serrano's work. His work embraces duality and often turns on the interplay between surface and interior. On occasion, this complexity has gotten him into trouble. Critics and commentators sometimes forget that he is an artist, not a journalist – and as such is at ease with symbols, metaphors and multiple readings. His works are never simply provocations or one-line sound bites.

A survey of Serrano's work makes this strikingly evident. Over the years he has embraced a variety of artistic strategies. Like *America*, some series involve real people representing themselves. In such photographs the subject's authenticity is key to the meaning of the work. The grizzled and eccentrically garbed individuals in the *Nomads* photographs are indeed homeless people whom Serrano discovered on the street. The shaded eyes peering from the holes of peaked hoods in *The Klan* do belong to members of the Ku Klux Klan. The robed figures in *The Church* are representatives of the Catholic religious hierarchy. The sensitive representations of bruised and decaying flesh in *The Morgue* document real cadavers.

Within this category of literal truth, one could also include *Immersions* and the *Bodily Fluids* photographs, one of which, *Piss Christ* sparked Serrano's early notoriety. These works employ physical substances both for their beautiful visual effects and for their cultural, historic and religious meanings. To substitute some other material would have undermined their aesthetic and conceptual power.

In other series, meaning resides in the imaginative truth conveyed by tableaux, which have been staged or otherwise visually constructed. The earliest works here, which date from 1983, reveal the young artist struggling with the contradictions of his Catholic heritage. While embracing Catholicism's lush visual tradition and its almost hallucinatory imagery, Serrano was troubled by the social and political inequities embedded in the policies of the contemporary Church. In works like *Heaven and Hell*, people close to him dressed up (or undressed) to represent players in complex religious dramas of sin, sacrifice and responsibility. In the 1996 series *A History of Sex*, he returned to the

geht es Serrano um etwas, das komplizierter ist als Promikult oder Gleichmacherei. Sein Bild von Amerika ist absichtlich ein gebrochenes, bruchstückhaftes.

America beginnt mit dem Gesicht eines Pfadfinders. Diese Darstellung gesunder Grundsätze und unbeflecter Ehre weicht innerhalb der Porträtreihe einem Reigen aus Unternehmern, Revuetänzerinnen, Betrügern, Heroinsüchtigen, Feuerwehrleuten, Wanderarbeitern, Zuhältern, Pädagogen und Vertretern der „oberen Zehntausend". Amerika, scheint Serrano sagen zu wollen, ist ein Land, in dem Platz ist für Straßenhändler aus Trinidad und Köche aus China, für eine alte Dame der Amish People und moslemische Religionsführer. Es ist auch ein Land, in dem Figuren wie Lizzie Grubman und Jayson Blair mit ihren recht fragwürdigen Leistungen Prominentenstatus erlangen. Serrano hat Individuen aufgenommen, die unsere besten Impulse repräsentieren, und solche, die unseren schlimmsten erlegen sind. Es gibt Verbrecher und Helden, Opfer und Täter, Entertainer und Beamte. Dies ist ein vielschichtiges Land, zeigt er, und einfache Abgrenzungen wie „wir" gegen „die" oder „gut" gegen „böse" werden ihm nicht gerecht.

In diesen Fotografien spielt Serrano mit dem Konflikt zwischen Typ und Individuum, eine Spannung, die in jedem einzelnen Porträt steckt. Auf gewisse Weise präsentiert *America* die Amerikaner in ihren Uniformen – die Krankenschwester in Weiß, die Feuerwehrleute mit Helmen und Schläuchen, der Investitionsbankier im nüchternen Geschäftsanzug. Selbst der Straßengauner in dekorativ zerfetzten Lumpen trägt eine Uniform, die er ablegt, wenn er Feierabend macht und nach Hause geht. Während die Kostüme unsere Aufmerksamkeit wecken, sind es Gesichter, Augen und Mienenspiel, die uns letztlich faszinieren. Selbst wenn sie verborgen oder maskiert sind – wie in seinem Porträt eines Rettungshelfers mit Gasmaske oder eines Obdachlosen, dessen Gesicht sich im Schatten seiner Kapuze verliert – suchen wir nach Hinweisen auf das Seelenleben.

Die in *America* offenbare Komplexität des Sehens ist in allen Werken Serranos zu erkennen. Sein Schaffen ist von Dualität geprägt und handelt oft von der Wechselwirkung zwischen Oberfläche und Innenleben. Gelegentlich hat ihm diese Komplexität Ärger gebracht. Kritiker und Kommentatoren vergessen gelegentlich, dass er Künstler ist und nicht Journalist – und sich als solcher leicht tut mit Symbolen, Metaphern und Doppeldeutigkeiten. Seine Arbeiten sind nie schlichte Provokationen oder dahingeworfene Sprüche.

Das sticht sofort ins Auge, wenn man Serranos Gesamtwerk betrachtet. Im Laufe der Jahre hat er sich eine Vielzahl künstlerischer Strategien zu eigen gemacht. Wie *America* geht es in einigen der Reihen um echte Personen, die sich selbst darstellen. In solchen Fotografien ist die Echtheit des Objekts der Schlüssel zur Bedeutung des Werkes. Die angegrauten und ausgefallen gewandeten Individuen in den Fotografien von *Nomads* („Nomaden") sind tatsächlich Obdachlose, die Serrano auf der Straße entdeckte. Die abgedunkelten Augen, die in *The Klan* („Der Klan") aus Löchern in spitzen Kapuzen herauslugen, gehören wirklich Mitgliedern des Ku-Klux-Klans. Die Figuren in den Gewändern, die in *The Church* („Die Kirche") zu sehen sind, vertreten tatsächlich die Hierarchie der katholischen Kirche. Die feinfühligen Darstellungen verletzten oder verwesenden Fleisches in *The Morgue* („Die Leichenhalle") dokumentieren echte Kadaver.

In diese Kategorie der trockenen Wahrheit könnte

souteneurs, des éducateurs et des mondaines. L'Amérique, comme le suggère Serrano, est un pays où les vendeurs de rue de Trinidad côtoient les cuisiniers chinois, les grand-mères Amish et les chefs religieux musulmans. C'est aussi un pays où des individus au talent douteux comme Lizzie Grubman et Jayson Blair sont devenus des stars. Serrano a rassemblé des personnages qui illustrent le meilleur et le pire de nous-mêmes. Il y a des criminels et des héros, des victimes et des assassins, des artistes et des fonctionnaires. C'est une nation complexe, dit-il, et les dichotomies simplistes comme nous/eux ou le bien/le mal ne suffisent pas.

Dans ces photographies, Serrano joue sur le conflit entre la catégorie et l'individu, une tension que l'on retrouve dans tous ses portraits. Dans un sens, *America* montre les Américains en uniforme – l'infirmière en blanc, les pompiers avec leurs casques et tuyaux, le banquier dans son complet strict. Même le mendiant dans la rue en haillons savamment déchirés porte un uniforme, qu'il retire à la fin de la journée pour rentrer chez lui, comme l'a découvert Serrano. Mais si les costumes nous enchantent, ce sont finalement les visages, les yeux, les expressions qui nous touchent le plus. Même lorsqu'ils sont cachés ou masqués, comme dans ce portrait d'un secouriste portant un masque à gaz, ou ce sans-abri dont la face est à demi-enfouie dans l'ombre de son capuchon – nous sommes à la recherche de signes d'une vie intérieure.

La vision complexe caractéristique dans *America*, est présente dans toute l'œuvre de Serrano. Son travail épouse la dualité et souvent joue sur l'interaction entre la surface et l'intérieur. A plusieurs occasions, cette complexité lui a causé des problèmes. Les critiques et les commentateurs oublient parfois que Serrano est un artiste et non pas un journaliste – et qu'en cette qualité il utilise des symboles, des métaphores et de multiples interprétations. Ses photos ne sont jamais de simples provocations ni des clichés faciles.

Une étude de l'œuvre de Serrano le prouve sans conteste. Au cours des années, il s'est essayé à diverses approches artistiques. Dans certaines séries semblables à *America* on retrouve des personnages réels qui ne représentent qu'eux-mêmes. Sur ces photographies, l'authenticité du sujet est la clé de la compréhension de l'œuvre. Les personnages mornes et bizarrement habillés de *Nomads* sont réellement des sans-abris que Serrano a rencontrés dans la rue. Les yeux dans l'ombre qui regardent par les trous des capuches dans *The Klan* appartiennent bien à des membres du Ku-Klux-Klan. Les personnages en soutanes dans *The Church* sont bien des représentants de la hiérarchie de l'Eglise catholique. Les troublantes représentations de chair meurtrie en décomposition dans *The Morgue* sont bien celles de rééls cadavres.

Dans cette catégorie de vérité réaliste, s'inscrivent aussi les photographies *Immersions* et de *Bodily Fluids*; l'une d'entre elles, *Piss Christ*, a d'ailleurs fait connaître Serrano à ses débuts. Ces travaux emploient des substances corporelles à la fois pour leurs magnifiques effets visuels et pour leurs significations culturelle, historique et religieuse. Un autre matériau aurait dénaturé leur signification artistique et conceptuelle.

Dans d'autres séries, la signification réside dans la vérité que l'on devine, évoquée par des tableaux mis en scène ou travaillé sur le plan visuel. Les travaux les plus anciens ici, de 1983, révèlent le jeune artiste aux prises avec les contradictions de son héritage catholique. Bien qu'il reprenait la tradition d'exubérance visuelle du catholicisme et son imagerie presque hallucinatoire, Serrano se sentait

staged image, this time to explore the complexities of desire. Unusual pairings – an old woman and young man, for instance, or a female dwarf and a normal-sized man – break taboos while reminding us that lust is not always confined to socially acceptable objects.

In a similar fashion, Serrano's *The Interpretation of Dreams* takes off from Freud's text of the same name, and proceeds by opening up and subverting cultural icons like Santa Claus, Cowboys and Indians, Elvis Presley and Aunt Jemima. Unusual twists – Santa Claus is black and the Indian is triumphing over the Cowboy – force us to contemplate the involuntary and sometimes unsavory contents of our own unconscious.

In the *America* photographs, truth exists on both these levels. On the one hand, Serrano has been scrupulously careful to ensure that each figure is accurately described and represented. Like the individuals portrayed in the *Nomads* and *The Klan*, they are who they say they are.

But from another perspective, *America* contains a strong element of theater and creative interpretation. There is nothing random or arbitrary about the cast of characters assembled here. Serrano has carefully considered his selection of portrait subjects. Thus, though all the actors play themselves, the hundred plus portraits also stand in for the manifold nature of the American dream and its underside, the American nightmare. Taken together, they can be seen as Serrano's ultimate staged tableau, a carefully constructed approximation of that slippery entity we know as the United States. In this series, America itself becomes a metaphor, standing in for the rolling mix of desire, hope, compassion, greed, lust and fear that makes us human.

man auch *Immersions* („Eintauchen") und die Fotografien von *Bodily Fluids* („Körperflüssigkeiten") einordnen, von denen eines, *Piss Christ* („Pisse-Christus"), den Anlass gab zu Serranos frühem schlechten Ruf. Diese Werke verwenden Körpersubstanzen sowohl wegen ihrer wunderschönen optischen Wirkung als auch wegen ihrer kulturellen, historischen und religiösen Bedeutung. Sie durch ein anderes Material zu ersetzen, hätte ihre ästhetische und begriffliche Kraft unterminiert.

In anderen Reihen liegt die Bedeutung in der erfundenen Wahrheit, die von Bildern vermittelt wird, die gestellt oder auf andere Weise visuell konstruiert sind. Die frühesten Werke in dieser Kategorie, die bis ins Jahr 1983 zurückreichen, offenbaren den jungen Künstler, der mit den Widersprüchen seiner katholischen Erziehung hadert. Während er an der üppigen visuellen Tradition des Katholizismus und seiner nahezu halluzinatorischen Bildersprache durchaus Gefallen fand, war Serrano über die in den Grundsätzen der Gegenwartskirche verankerten sozialen und politischen Ungerechtigkeiten beunruhigt. In Werken wie *Heaven and Hell* („Himmel und Hölle") ver- (oder ent-)kleideten sich Menschen, die ihm nahestanden als Darsteller in komplexen religiösen Dramen, die von Sünde, Opfer und Verantwortung handeln. In der Fotoreihe *A History of Sex* („Eine Geschichte des Sex") von 1996 kehrte er wieder zum gestellten Bild zurück – diesmal, um die Vielschichtigkeit des Begehrens auszuloten. Ungewöhnliche Paarungen – zum Beispiel eine alte Frau und ein junger Mann oder eine Zwergin mit einem normalgroßen Mann – brechen mit Tabus und erinnern uns gleichzeitig daran, dass sich Lust nicht immer auf salonfähige Objekte beschränkt.

In ähnlicher Weise geht Serranos Reihe *The Interpretation of Dreams* („Traumdeutung") von Freuds Abhandlung gleichen Titels aus und fährt dann fort, indem sie Kulturikonen wie den Weihnachtsmann, Cowboys und Indianer, Elvis Presley und Aunt Jemima der Kritik öffnet und dann vom Sockel stürzt. Ungewöhnliche Wendungen – der Weihnachtsmann ist schwarz, und der Indianer triumphiert über den Cowboy – zwingen uns, über den unfreiwilligen und bisweilen unappetitlichen Inhalt unseres eigenen Unbewussten nachzudenken.

In den Fotografien der Reihe *America* existierte die Wahrheit auf beiden Ebenen. Einerseits war Serrano peinlich genau darauf bedacht, dass jede Person wahrheitsgemäß beschrieben und dargestellt wurde. Aus einem anderen Blickwinkel betrachtet enthält *America* jedoch starke theatralische Elemente und Augenblicke schöpferischer Interpretation. Nichts an der hier versammelten Riege von Charakteren ist zufällig oder willkürlich. Serrano hat die Auswahl seiner Objekte sorgsam überdacht. Auch wenn alle Darsteller sich selbst spielen, stehen die über hundert Porträts auch für das mannigfaltige Wesen des amerikanischen Traums und seiner Kehrseite, des amerikanischen Alptraums. Zusammengenommen können sie als Serranos endgültiges Bild betrachtet werden, eine sorgfältig konstruierte Annäherung an jenes schwer fassbare Wesen, das wir als die Vereinigten Staaten kennen. In dieser Reihe wird Amerika selbst zur Metapher für die bunte Mischung aus Wünschen, Hoffnungen, Mitleid, Gier, Lust und Angst, die uns so menschlich macht.

interpellé par les injustices sociales et politiques au sein de l'Eglise contemporaine. Dans *Heaven and Hell*, des personnes proches de lui s'habillaient (ou se déshabillaient) pour représenter les acteurs de drames religieux complexes sur le péché, le sacrifice et la responsabilité. Dans *A History of Sex*, publié en 1996, il revient à la mise en scène de l'image, cette fois pour explorer les arcanes du désir. Des couples inhabituels – une vieille femme et un jeune homme, par exemple, ou une naine et un homme de taille normale – brisent les tabous en nous rappelant que le désir ne se borne pas aux conventions sociales.

De la même façon, *The Interpretation of Dreams* part du texte de Freud du même nom pour faire éclater et dénoncer les icônes culturelles comme le Père Noël, les cow-boys et les indiens, Elvis Presley et Tante Jemima. Des scénarios inhabituels – le Père Noël est noir et l'indien triomphe du cow-boy – nous obligent à examiner les éléments involontaires et pas toujours avouables de notre inconscient.

Dans les photographies d'*America*, la vérité existe sur ces deux plans. D'un côté Serrano a pris soin de décrire et de présenter fidèlement chaque personnage. Comme les personnes photographiées dans *Nomads* et *The Klan*, ils sont authentiques.

Mais *America*, vue sous une autre perspective, puise dans les techniques du théâtre et de l'interprétation créative. Rien n'est laissé au hasard ou à l'arbitraire dans le choix des personnages. Aussi, bien que tous les acteurs jouent leur propre rôle, la centaine de portraits représente les multiples facettes du rêve américain et sa face cachée, le cauchemar américain. Pris ensemble, on peut les voir comme l'ultime tableau mis en scène par Serrano, une approximation soigneusement reconstituée de l'entité fugace de ce que l'on appelle les Etats-Unis. Dans cette série, l'Amérique elle-même devient une métaphore pour ce tourbillon de désir, d'espoir, de compassion, de convoitise, de passion et de peur qui nous rend humains.

AN INTERVIEW
WITH ANDRES SERRANO

By Julie Ault

Julie Ault: In your work from the 1980s, you constructed and photographed scenes and environments first conjured up in your imagination and subsequently realized with the help of props and particular visual strategies (i.e. cropping) such as you used in making *Bodily Fluids* and *Immersions* series. Those methods rendered spectacular results. Subsequent bodies of work including *The Morgue*, *The Klan*, *Nomads* and many others, up to *America*, are less dependent on internal fantasy but rather focus on externally locating your interest in the theatrical, for instance in social groupings such as in *The Klan* or *The Church*. In many series you have specifically focused on surface, whether on the surface of the bodies found in the morgue, or on uniforms, clothing, costume and various iconography employed and embodied by individuals. A couple questions emerge. What are you looking for, and what do you want to show or reveal with this attention to surfaces?

Andres Serrano: I am looking to express my unconscious. My constructions have become more refined, and in *America*, the props and uniforms are real. Nevertheless, they still feel like figments of my imagination, like they were twenty years ago. I have always photographed, to some extent, the pictures in my head. Even when dealing with reality, I try to make it look like fantasy or theater. That's what makes it art for me. My desire is to see what ideas look like. Sometimes my choice of models or subjects is a statement in itself. I champion the underdog and unheralded as much as I applaud the normal or original. My curiosity and interests are constantly expanding, yet they remain the same. I am particularly drawn to the strange and unusual. Surfaces are important because that's what the camera sees and that's what the audience responds to. When I first started shooting *The Morgue*, I was at a distance of several feet from my subjects. The more I shot, the closer I got. By the end, I was doing close-ups and focusing on details. It's the same with *America*. Toward the end, the portraits got bigger. As you mature as an artist, you realize that what you leave out of a picture is as important as what you put in.

JA: Would you talk about this shift of the location of the theatrical from the total construction of an image driven by your internal vision to this new method of selecting subjects and subjecting them to your art direction and photographic point of view?

AS: My shift has been from the subjective to the objective, while still remaining true to my roots as a tableaux artist. I chronicle and document the real in an unreal environment: the studio. Even when I shoot outdoors, I make it look like a backdrop in a studio. When I began *America*, I was photographing singular portraits as is always my custom. Halfway through the series, I realized that these portraits would be shown facing each other. Therefore, the portraits needed to work together, either by size or disposition. Certain portraits immediately fell into place, while others just cried out for each other. In the end, *America* turned out to be a story that told itself, with a beginning, a middle and an end, and I felt like a movie director with a cast of actors who wrote their own scripts. Had it been entirely up to me, I might have written a different script, but this is the hand that I was dealt and the story just kind of wrote itself. I often don't have a point of view, and if I do, I keep it to myself. I explore with an open mind and let the work take its own course. I don't have an agenda except to create. I remember when I did *The Klan* a Klansman asked me, "Do you know much about the

Julie Ault: In Ihren Arbeiten aus den achtziger Jahren konstruierten und fotografierten Sie Szenen und Milieus, die Sie sich erst ausgedacht haben und dann mit Hilfe von Requisiten und bestimmten visuellen Techniken, die Sie auch in Ihren Reihen *Bodily Fluids* und *Immersions* angewandt hatten, in die Tat umsetzten. Diese Methoden führten zu spektakulären Ergebnissen. In nachfolgenden Arbeiten, darunter *The Morgue*, *The Klan*, *Nomads* und viele andere, bis zu *America*, bringen Sie weniger Ihre innere Phantasie zum Ausdruck und konzentrieren sich eher auf Ihr äußerliches Interesse am Theaterhaften, beispielsweise in gesellschaftlichen Gruppen wie *The Klan* oder *The Church*. In vielen Reihen haben Sie sich speziell auf die Oberfläche konzentriert, sei es auf die Oberfläche der Leichen in der Leichenhalle, seien es Uniformen, Kleider, Kostüme und die unterschiedliche Bildersprache, die von Individuen angewandt oder verkörpert wird. Daraus ergeben sich einige Fragen: Wonach suchen Sie, und was versuchen Sie zu zeigen oder aufzudecken, wenn Sie sich derart auf Oberflächen konzentrieren?

Andres Serrano: Ich versuche, mein Unbewusstes auszudrücken. Meine Konstruktionen sind raffinierter geworden, und in *America* sind die Requisiten und Uniformen echt. Dennoch wirken sie noch immer wie meine Phantasiegebilde, wie vor zwanzig Jahren. In gewissem Maße habe ich eigentlich immer die Bilder in meinem Kopf fotografiert. Selbst wenn ich es mit der Realität zu tun hatte, versuchte ich, es wie Phantasie oder Theater aussehen zu lassen. Darin liegt für mich die Kunst. Manchmal ist bereits meine Wahl der Modelle oder Motive eine Aussage für sich. Ich stehe genauso auf der Seite der sozial Benachteiligten und derer, die nicht im Rampenlicht stehen, wie ich das Normale oder Originelle begrüße. Meine Neugier und meine Interessen erweitern sich ständig und bleiben doch die gleichen. Besonders fühle ich mich vom Seltsamen und Ungewöhnlichen angezogen. Oberflächen sind wichtig, denn sie sind ja das, was die Kamera erfasst, und worauf das Publikum reagiert. Als ich mit den Fotografien zu *The Morgue* begann, hielt ich immer einen guten Meter Abstand zu den Motiven, aber je mehr ich fotografierte, desto näher kam ich ihnen. Am Ende machte ich Nahaufnahmen und konzentrierte mich auf Details. Bei *America* war es das Gleiche: Zum Ende hin wurden die Porträts größer. Während man als Künstler heranreift, wird einem klar: Was man auslässt, ist ebenso wichtig wie das, was man in ein Bild hineinpackt.

JA: Möchten Sie etwas zu dieser Verschiebung des Anwendungsbereichs des Theatralischen sagen, von der totalen Konstruktion eines Bildes, die von ihrer inneren Vision getrieben wurde, hin zu dieser neuen Methode, sich Objekte zu suchen und sie Ihrer künstlerischen Leitung und Ihrer fotografischen Sicht zu unterwerfen?

AS: Diese Verschiebung spielte sich bei mir vom Subjektiven zum Objektiven ab, während ich meinen Wurzeln als Künstler der anschaulichen Darstellung dabei stets treu blieb. Ich dokumentiere und zeichne das Reale in einer irrealen Umgebung auf: dem Studio. Selbst wenn ich im Freien arbeite, dann lasse ich es so aussehen wie ein Studiohintergrund. Als ich mit *America* begann, fotografierte ich einzelne Porträts, wie es bei mir immer üblich gewesen war. Etwa auf halber Strecke wurde mir klar, dass diese Porträts ja auf gegenüberliegenden Seiten abgebildet würden. Deshalb mussten sie irgendwie zueinander passen, entweder in der Größe oder in der Art. Am Ende geriet *America* zu einer Geschichte, die sich selbst erzählt,

Julie Ault: Dans vos œuvres des années 80, vous avez d'abord imaginé les scènes et les ambiances que vous alliez composer et photographier, et vous les avez réalisées en vous servant d'accessoires et de techniques visuelles (par ex. le recadrage), comme vous l'avez fait pour les séries *Bodily Fluids* et *Immersions*. Ces méthodes ont donné des résultats spectaculaires. Les séries suivantes, *The Morgue*, *The Klan*, *Nomads* et plusieurs autres y compris *America*, sont moins le fruit de votre imagination que celui de votre regard sur le monde extérieur et sur son côté théâtral, comme par exemple les photographies de communautés telles que *The Klan* ou *The Church*. Dans plusieurs séries vous vous êtes plus particulièrement intéressé aux surfaces, que ce soit la surface des corps à la morgue ou les uniformes, les vêtements, les costumes et les divers symboles sociaux arborés et personnifiés par les individus. Deux questions s'imposent. Que cherchez-vous et que voulez-vous montrer ou révéler avec votre travail sur les surfaces ?

Andres Serrano: Je cherche à exprimer mon inconscient. Mes compositions sont devenues plus sophistiquées et, dans *America*, les accessoires et les uniformes sont authentiques. Néanmoins, elles ont toujours l'air d'être le fruit de mon imagination, comme elles l'étaient déjà il y a vingt ans. J'ai toujours photographié, dans une certaine mesure, les images dans ma tête. Même lorsque je photographie la réalité, je la transforme toujours en quelque chose d'imaginaire ou de théâtral. Pour moi, c'est ce qui en fait de l'art. Je cherche à donner une forme à mes idées. Quelquefois, le choix des modèles ou des sujets est déjà une forme d'expression. Je suis du côté de l'opprimé et du héro méconnu autant que j'applaudis le normal ou l'original. Le champ de ma curiosité et de mes intérêts s'élargit en permanence, bien qu'il demeure le même. Je suis particulièrement attiré par l'étrange et l'inhabituel. Les surfaces sont importantes parce que c'est ce que voit l'objectif et ce qui touche le public. Au début, pour les photos de *The Morgue*, je me tenais assez loin de mes sujets. Plus je photographiais, plus je me rapprochais. J'ai fini par faire des gros plans en isolant les détails. C'est ce que j'ai fait pour *America*. Vers la fin, les portraits sont plus grands. A mesure que votre art arrive à maturité, vous réalisez que ce que vous ne montrez pas est aussi important que ce que vous montrez.

JA: Pouvez-vous nous parler de ce déplacement du théâtral dans la composition intégrale d'une image à partir de votre vision intérieure vers cette nouvelle méthode où vous choisissez vos sujets et où vous les mettez en scène selon votre sens de la photographie ?

AS: Je suis passé de l'objectif au subjectif, tout en restant fidèle à mes origines, la composition de tableaux. C'est un documentaire et une recherche sur le réel dans un environnement irréel : le studio. Même lorsque je fais des photos à l'extérieur, je lui donne une apparence de toile de fond de studio. Quand j'ai commencé *America*, j'ai réalisé des portraits insolites, comme j'ai l'habitude de le faire. A peu près à la moitié de la série, j'ai réalisé que ces portraits seraient placés l'un à côté de l'autre, ce qui impliquait que les portraits devaient avoir un rapport entre eux, soit par leur taille soit par leur caractère. Certains portraits s'harmonisaient immédiatement pendant que d'autres étaient en complète dissonance. Finalement, *America* est devenue une histoire qui se raconte elle-même, avec un début, un milieu et une fin et j'avais l'impression d'être le réalisateur d'un film où les acteurs écrivaient leur propre scénario. Si cela n'avait tenu qu'à moi, le scénario aurait pu être différent,

Klan?" When I went to the morgue I was asked, "Have you ever seen dead people before?" The answer to both questions was "No." I'm an outsider, just like the audience.

JA: What are the stimuli and criteria you have when identifying a subject?

AS: I usually start with an idea or title, such as *The Interpretation of Dreams* or *A History of Sex*. In both cases I felt the titles were umbrellas I could fit almost anything under. I start with one or two pictures, and then the work takes off in its own direction. In *A History of Sex*, I investigated and fabricated sexual scenarios. *The Interpretation of Dreams* allowed me to give full rein to my imagination. In the case of *America*, it was easy to come up with a cast of characters, starting with some of the more obvious ones. At first it was a Boy Scout or airline pilot, but later, some of the people I sought became the embodiment of issues and ideas that represent different aspects of America. There could have been others, but these are the ones I got.

JA: Can you talk about your relation to, and interest in, fame and infamy, which seems to be very American.

AS: America loves a hero and an anti-hero. We are just as fascinated by the bad guys as we are by the good guys. Everyone likes to hear about everyone else's downfall. That's why the news is so full of gossip and hearsay. We are a nation that thrives on other people's misfortunes, as well as successes. In my own case, there still seems to be a question in some people's minds as to whether I'm a good guy or a bad guy.

JA: You almost invariably use a straight-on, direct point of view compositionally. You also seem to be a purist when it comes to wanting only what you see through the camera to construct the image. You don't use digital enhancement, special effects, and as far as I know, you don't even crop when printing – all cropping takes place through the lens. Do these rules or habits speak of a photographic philosophy you adhere to?

AS: Even though I consider myself a conceptual artist, I am a traditionalist when it comes to photography. I like to use film and shoot straight. No technical gimmicks or special effects. What you see is what I saw when I looked though the camera. If I've dazzled you with lights and colors, it's because I've dazzled you with lights and colors. Ideas are more important than effects. And effects are always better when they're real. In *Lori And Dori*, for instance, the conjoined sisters are dressed like fairy tale princesses evoking a dreamy and surreal landscape of the mind. But they're real. Other times I have to make things look real, even if they're not. In *White Nigger*, a man is made Black through make-up, while a child is "hung" with a harness. Ezra Pound once said, "Make it new." I do. And make it real, too.

The trick is not so much coming up with ideas, as how to make them work. When I first tried to photograph my ejaculations, for instance, I kept shooting and missing. After about eight times of getting back black film I realized that I needed a motor drive on my camera. I would start shooting film before I felt myself coming, and was able to shoot a roll of film in seconds. Invariably, there would be one shot, and one shot only, of my ejaculate. In *Vagina Dentata* (Vagina with Teeth) the teeth – they were shark's teeth – kept falling out. I had to keep pushing them in to keep them from coming out. After a while, they stayed in place. When the shoot was over, I tried to get them out, but they

mit einem Anfang, einer Mitte und einem Schluss, und ich kam mir vor wie ein Filmregisseur mit einer Truppe von Schauspielern, die alle ihr eigenes Drehbuch schrieben. Wenn ich es ganz allein zu bestimmen gehabt hätte, wäre vielleicht ein anderes Drehbuch dabei herausgekommen, aber so schrieb sich die Geschichte sozusagen von alleine. Oft habe ich keinen bestimmten Standpunkt, und, wenn, dann behalte ich ihn für mich. Ich gehe völlig offen auf Entdeckungsreise und lasse der Arbeit ihren freien Lauf. Ich erinnere mich, als ich *The Klan* fotografierte, da fragte mich eines der KKK-Mitglieder: „Wissen Sie viel über den Klan?" Und als ich ins Leichenschauhaus ging, fragte man mich: „Haben Sie schon jemals zuvor einen Toten gesehen?" In beiden Fällen war meine Antwort: „Nein." Ich bin ein Außenstehender, genau wie das Publikum.

JA: Welchen Anreiz oder welche Kriterien haben Sie, wenn Sie sich ein Motiv aussuchen?

AS: Normalerweise fange ich mit einer Idee oder einem Titel an, wie etwa *The Interpretation of Dreams* oder *A History of Sex*. In beiden Fällen hatte ich das Gefühl, dass die Titel ein Dach bildeten, unter das ich nahezu alles stellen konnte. Ich fange mit ein oder zwei Bildern an, und dann nimmt die Arbeit ihren Lauf. In *A History of Sex* habe ich sexuelle Szenarien erforscht und erfunden. *The Interpretation of Dreams* erlaubte mir, meiner Phantasie freien Lauf zu lassen. Im Falle von *America* war es einfach, die Charaktere zu finden. Am Anfang war da ein Pfadfinder oder ein Pilot, aber später wurden einige der Leute, die ich mir aussuchte, zur Verkörperung von Anliegen und Ideen, die verschiedene Aspekte Amerikas repräsentieren. Möglicherweise hätten es auch noch mehr sein können, aber das waren die, die ich bekommen konnte.

JA: Können Sie sich über Ihre Beziehung zu Ruhm und Verrufenheit äußern, die typisch amerikanisch zu sein scheinen?

AS: Amerika liebt seine Helden und Antihelden. Wir sind von den bösen Jungs genauso fasziniert wie von den guten. Jeder hört gern vom Unglück des anderen. Deshalb sind die Nachrichten so voll von Klatsch und Tratsch. Wir sind eine Nation, die auf dem Unglück anderer Leute gedeiht, genauso auf deren Erfolgen. In meinem eigenen Fall scheint es bei einigen Leuten immer noch Zweifel zu geben, ob ich zu den Guten oder den Bösen gehöre.

JA: In einer Komposition nehmen Sie immer einen direkten Blickwinkel ein. Sie scheinen auch ein Purist zu sein, wenn es darum geht, nur das ins Bild zu bringen, was Sie durch die Kamera sehen. Sie verwenden keine digitale Verstärkung oder Spezialeffekte und, soweit ich weiß, schneiden Sie Ihre Bilder nicht einmal zu, wenn Sie Abzüge machen: Ihr Zuschnitt geschieht sozusagen schon in der Kamera. Sprechen diese Regeln oder Gewohnheiten für eine fotografische Philosophie, an die Sie sich halten?

AS: Auch wenn ich mich selbst für einen Konzeptkünstler halte, bin ich Traditionalist, wenn es um die Fotografie geht. Ich verwende gerne Film und fotografiere geradeheraus, ohne technischen Schnickschnack oder Spezialeffekte. Was Sie sehen, ist das, was ich sah, als ich durch die Kamera blickte. Ideen sind wichtiger als Effekte. Und Effekte sind immer besser, wenn sie echt sind. In *Lori and Dori*, zum Beispiel, sind die beiden verbundenen [„siamesischen"] Zwillinge wie Märchenprinzessinnen gekleidet und beschwören auf diese Art eine traumhafte

mais telle était la situation et l'histoire s'est écrite pour ainsi dire d'elle-même. Souvent, je n'ai pas d'opinion et si j'en ai une, je la garde pour moi. J'explore avec l'esprit ouvert et je laisse l'œuvre se construire d'elle-même. Je ne sais jamais à l'avance ce que je vais faire, je sais seulement que ce sera une création. Je me souviens, en faisant *The Klan*, qu'un membre du Ku Klux Klan m'avait demandé « Vous connaissez le Klan ? » Quand je suis allé à la morgue, on m'a demandé « Vous avez déjà vu des morts ? » J'ai répondu « Non » aux deux questions. Je suis un spectateur, comme mon public.

JA: Qu'est-ce qui vous inspire et quels sont vos critères pour choisir un sujet ?

AS: Je commence habituellement par une idée ou un titre, comme je l'ai fait pour *The Interpretation of Dreams* ou *A History of Sex*. Dans les deux cas, j'ai pensé que ces titres étaient des fourre-tout dans lesquels je pouvais caser presque tout ce que je voulais. Je commence avec une ou deux photos, puis le travail part où il veut. Dans *A History of Sex*, j'ai analysé et créé des scénarios de sexe. *The Interprétation of Dreams* m'a permis de donner libre cours à mon imagination. Pour *America*, il a été facile de trouver les personnages, à commencer par les plus évidents. D'abord, j'ai photographié un scout, un pilote de ligne, mais plus tard mes personnages personnifiaient les différentes facettes de l'Amérique. Cela aurait pu être d'autres personnes, mais c'était celles que j'avais.

JA: Pouvez-vous nous parler de votre rapport et de votre intérêt pour la gloire et l'infamie, qui semblent être des nations typiquement américaines ?

AS: L'Amérique adore les héros et les anti-héros. Nous sommes autant fascinés par le type honnête que par le salaud. Tout le monde se repaît du malheur des autres. C'est pour ça que les nouvelles ne font que répéter les rumeurs et les ragots. Nous sommes un pays qui prospère sur les échecs des autres autant que sur leurs succès. Dans mon cas, il semble qu'il y ait encore un doute, dans l'esprit de certaines personnes, si je suis un type honnête ou un salaud.

JA: Vous utilisez presque invariablement une approche franche et directe dans vos compositions. Vous semblez aussi être un puriste, vous ne voulez que ce que vous voyez dans votre objectif pour composer une photo. Vous n'utilisez pas de procédés numériques, d'effets spéciaux et, pour autant que je sache, vous ne faites pas les recadrages au tirage – vous les faites directement avec votre appareil. Est-ce que ces principes ou habitudes font partie d'une philosophie de la photographie dans laquelle vous vous inscrivez ?

AS: Bien que personnellement je me considère comme un artiste conceptuel, je suis un traditionnaliste en ce qui concerne la photographie. J'aime utiliser la pellicule et photographier directement. Sans artifices techniques ou effets spéciaux. Ce que vous voyez c'est ce que j'ai vu à travers mon objectif. Et si vous avez été ébloui par les lumières et les couleurs, c'est que je voulais vous éblouir par les lumières et les couleurs. Les idées sont plus importantes que les effets. Et les effets sont toujours meilleurs lorsqu'ils sont réels. Dans *Lori And Dori*, par exemple, les deux sœurs siamoises sont habillées comme des princesses de contes de fées, évoquant un paysage mental de rêve surréaliste. Mais elles sont bien réelles. A d'autres moments, je dois faire en sorte que les choses paraissent réelles, même

were stuck. I then realized that the glue that kept them in place was dried menstrual blood.

JA: I'm also interested in whether or not you identify with any photographic traditions, such as documentary, street photography, etc.

AS: In *America*, I felt I was reporting the news. I was documenting what I saw, starting with September 11th. I was reading the news and watching TV like everyone else. Of course, not everyone sees the same thing, even when they think they do. But I attempted to chronicle a moment in time that stretched into three years. And of course, I did it my way. Without ever really knowing who I would get, or what it would mean. Ultimately, *America* became a puzzle that fell into place, in very unexpected ways.

I started as a street photographer. I would approach people on the street and take their pictures. One time, I saw a middle-aged man in a dark green coat and cap standing in a doorway. As I approached him, I asked him if I could take his picture. "Wait," he said, as he reached down and picked something up from a small chair behind him. He then looked in the camera and held up a white card with the words, "You are a criminal asshole," across his face as I took his picture. I was always amazed that I found that man there, as if he were waiting for me.

JA: In *America* the individuals photographed are diverse in many ways, while your use of painted backdrops and uniform distance has a leveling tendency, putting them all on an equal ground. Would you talk about your thinking in doing these portraits in this way?

AS: Isn't that what America is all about? Being on equal ground? Every backdrop was painted especially for one individual. And every individual became part of one picture: *America*. What you have to remember about my work is that I have always used portraiture as a way of expressing myself. This has been especially true in the case of *America*. Someone once asked me, "Why don't you do a self-portrait?" And I replied, "What do you think this is? This is a self-portrait."

– July 2004

und surreale Landschaft im Kopf herauf. Aber sie sind echt. Ein anderes Mal muss ich Dinge echt aussehen lassen, auch wenn sie es nicht sind. In *White Nigger* wird ein Mann schwarz geschminkt, während ein Kind mit einem Geschirr „aufgehängt" wird. Ezra Pound sagte einmal: „Mach's neu." Das tu ich. Und ich mach es auch echt. Der Trick ist nicht so sehr, Einfälle zu haben, sondern sie zum Funktionieren zu bringen. Als ich beispielsweise anfänglich versuchte, meine Ejakulationen zu fotografieren, knipste ich und verpasste sie. Nachdem ich ungefähr achtmal schwarzen Film zurückbekam, war mir klar, dass ich einen Motor für die Kamera benötigte. Ich drückte dann den Auslöser schon bevor ich merkte, dass ich kam und verknipste in Sekunden eine ganze Filmrolle. Unweigerlich war aber eine Aufnahme dabei – und zwar nur eine einzige – von meinem Ejakulat. In *Vagina Dentata* [Vagina mit Zähnen] fielen die Zähne – es waren Haifischzähne – immer wieder raus. Ich musste sie jedesmal wieder reinschieben, damit sie nicht rausfielen. Nach einer Weile blieben sie sitzen. Als die Aufnahmen vorbei waren, versuchte ich, sie rauszuholen, aber sie steckten fest. Dann wurde mir klar, dass der Klebstoff, der sie festhielt, getrocknetes Menstruationsblut war.

JA: Mich würde auch interessieren, ob Sie sich mit irgendeiner fotografischen Tradition identifizieren, zum Beispiel mit Dokumentation, Straßenfotografie usw.

AS: In *America* fühlte ich mich wie ein Nachrichtenreporter. Ich dokumentierte, was ich sah, angefangen mit dem 11. September. Ich las die Nachrichten und sah fern, wie jeder andere auch. Natürlich sieht nicht jeder das gleiche, auch wenn man glaubt, das sei so. Aber ich versuchte, einen Augenblick zu dokumentieren, der sich über drei Jahre erstreckte. Letztendlich wurde *America* zu einem Puzzle, das sich einfach zusammenfügte, auf sehr unerwartete Weise. Ich fing als Straßenfotograf an. Ich ging auf die Leute auf der Straße zu und fotografierte sie. Einmal sah ich einen Mann mittleren Alters, der in dunkelgrünem Mantel und Mütze in einem Türeingang stand. Als ich auf ihn zuging, fragte ich ihn, ob ich ihn fotografieren dürfte. „Moment!" sagte er und griff hinter sich, um etwas von einem kleinen Stuhl aufzuheben, der hinter ihm stand. Dann schaute er in die Kamera und hielt sich eine weiße Karte vor das Gesicht, auf der stand: „Du bist ein kriminelles Arschloch", und so fotografierte ich ihn. Es hat mich immer verblüfft, dass ich diesen Mann dort fand, als ob er auf mich gewartet hätte.

JA: In *America* sind die fotografierten Individuen auf vielerlei Art sehr unterschiedlich, während der Gebrauch gemalter Hintergründe sie einander anzugleichen scheint, sie alle auf die gleiche Grundlage stellt. Möchten Sie etwas darüber sagen, was Sie dachten, als Sie diese Porträts auf diese Art aufnahmen?

AS: Ist das nicht der Sinn und Zweck Amerikas – auf gleicher Grundlage zu stehen? Jeder Hintergrund wurde speziell für eine Person gemalt, und jedes Individuum wurde Teil eines Gesamtbildes: *America*. Was Sie bei meinem Werk nicht vergessen dürfen, ist, dass ich die Porträtfotografie stets dazu benutzt habe, mich selbst auszudrücken. Das trifft besonders im Falle von *America* zu. Mich fragte mal jemand: „Warum machen Sie kein Selbstporträt?" Und ich antwortete: „Was glauben Sie denn, was das ist? Das ist ein Selbstporträt."

– Juli 2004

si elles ne le sont pas. Dans *White Nigger*, un homme est maquillé en nègre et un enfant est « suspendu » dans un harnais. C'est Ezra Pound qui avait dit « Faites du neuf. » C'est ce que je fais. Et en plus, je lui donne l'apparence du réel.

Le problème n'est pas tant de trouver les idées que de les réaliser. Quand j'ai voulu photographier mes éjaculations, par exemple, je n'y suis pas arrivé du premier coup. Après avoir essayé huit fois et raté toutes les photos, j'ai compris qu'il fallait mettre un moteur sur l'appareil. Je commençais à photographier avant de sentir monter l'orgasme et j'utilisais toute la pellicule en quelques secondes. Invariablement, il y avait une photo et une seule de mon éjaculation. Dans *Vagina Dentata* (Vagin avec dents) les dents – c'était des dents de requins – n'arrêtaient pas de tomber. Il fallait que je les remette en place à chaque fois. Au bout d'un moment, elles ont tenu. Quand la séance a été terminée, j'ai voulu les enlever, mais elles étaient collées. C'est là que je me suis aperçu que la « colle » était en réalité du sang menstruel séché.

JA : Je voudrais aussi savoir si vous vous identifiez ou non avec des styles de photographie traditionnels comme le documentaire, la photo de rue, etc.

AS: Avec *America*, j'ai eu l'impression de faire un reportage sur l'actualité. Je photographiais ce que je voyais, en commençant par le 11 septembre. Je lisais les journaux et je regardais la télévision comme tout le monde. Bien sûr, personne ne voit la même chose même si l'on croit le contraire. Mais j'ai essayé de faire un reportage sur un moment dans le temps qui a duré trois ans. Et bien sûr, je l'ai fait à ma manière. Sans jamais vraiment savoir qui j'allais photographier et pourquoi. Finalement, le puzzle d'*America* s'est mis en place de façon complétement inattendue.

J'ai commencé comme photographe de rue. J'abordais les gens et je les prenais en photo. Une fois, j'ai vu un homme entre deux âges habillé d'un manteau vert et d'une casquette dans l'embrasure d'une porte. Je me suis approché et je lui ai demandé si je pouvais le prendre en photo. Il m'a dit « Attends » et il s'est retourné pour prendre quelque chose sur une petite chaise derrière lui. Puis il a pris la pose en tenant une petite carte devant son visage sur laquelle on pouvait lire « Tu es un salaud d'enfoiré » et j'ai fait la photo. Ça m'a toujours étonné d'avoir trouvé ce type à cet endroit, comme s'il m'attendait.

JA: Dans *America* les portraits sont très différents les uns des autres, bien que votre utilisation de toiles de fond peintes et vos prises à la même distance donnent un effet d'uniformité, les plaçant tous sur le même plan. Pouvez-vous nous parler de votre démarche intellectuelle pour réaliser ces portraits ?

AS: Est-ce que ce n'est pas l'idée même de l'Amérique ? Etre sur le même plan ? Chaque toile de fond a été spécialement peinte pour chaque personnage. Et chaque personnage n'est qu'une partie de l'image *America*. Vous ne devez pas oublier que dans mon travail j'ai toujours utilisé le portrait comme une façon de m'exprimer. C'est particulièrement vrai pour *America*. Un jour quelqu'un m'a demandé « Pourquoi ne faites-vous pas un autoportrait ? » Et j'ai répondu « Qu'est-ce que vous croyez que c'est ? C'est mon autoportrait. »

– Juillet 2004

Dear Mr. Serrano,

I'm indeed honored you would think of me in connection with your America — I have never before seen a series of photos in such astonishing color; as for the subjects, they cover just about everything, as you intend — But that's a problem for me because I can see no way of linking the subjects into a single "America" or even Istanbul — If I could I would gladly come up with something but our weird country and your eclectic images defy encapsulation — Anyway, congratulations for having got this terrible new century off to such a cascade of fireworks —

Sincerely,
Gore Vidal

AMERICA

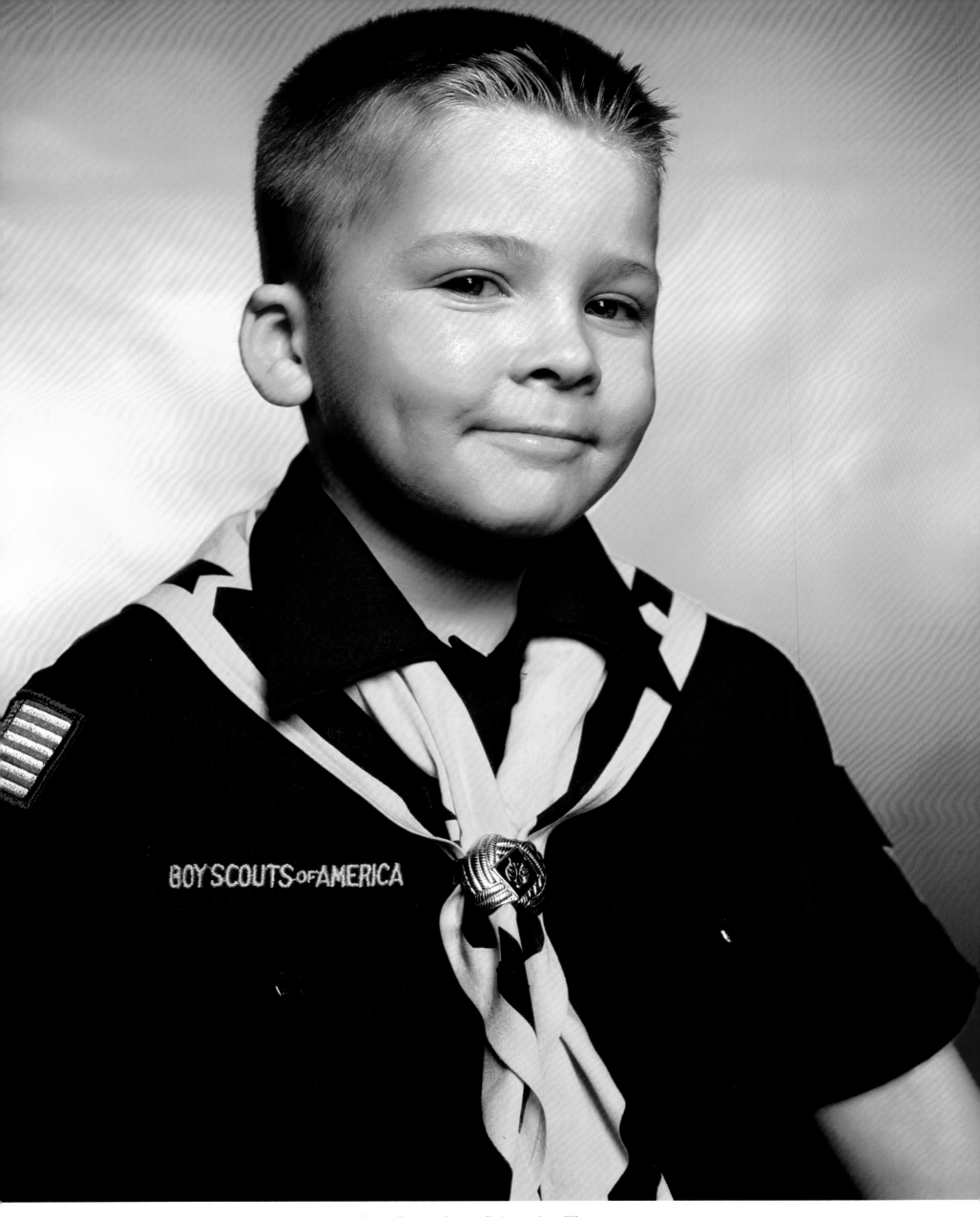

Boy Scout John Schneider, Troop 422

2002

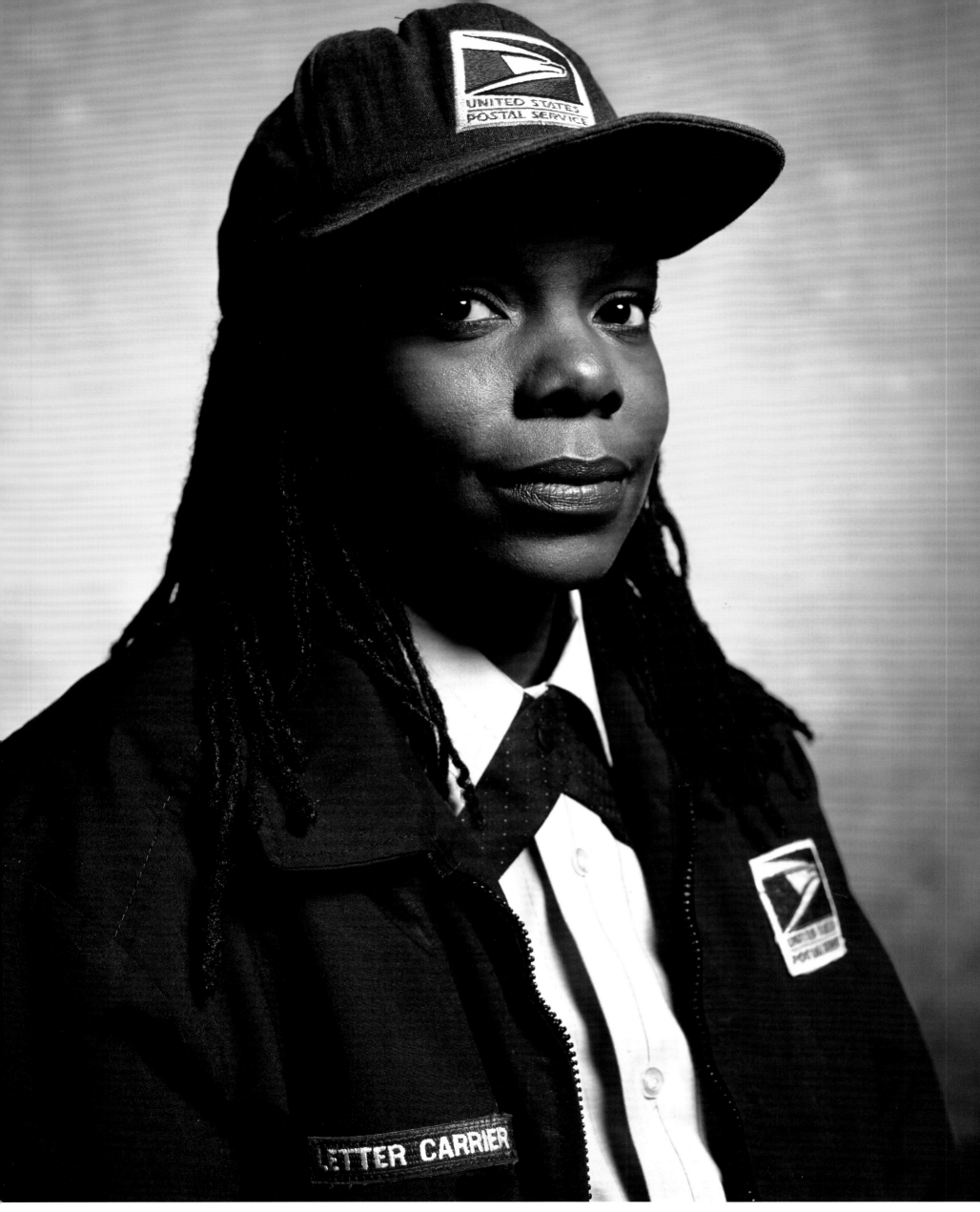

Beverly Pabon, U.S. Postal Carrier

2002

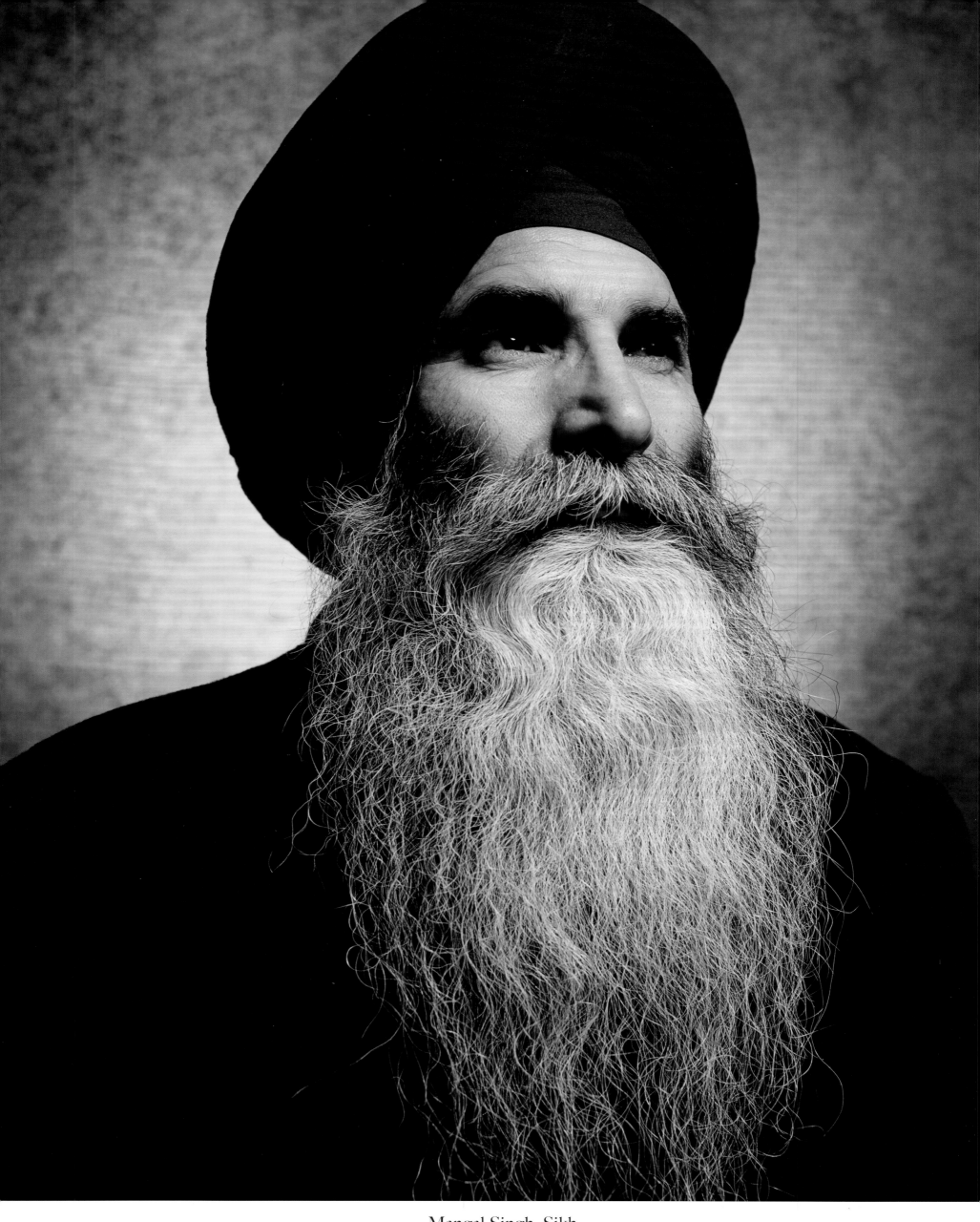

Mangal Singh, Sikh
2002

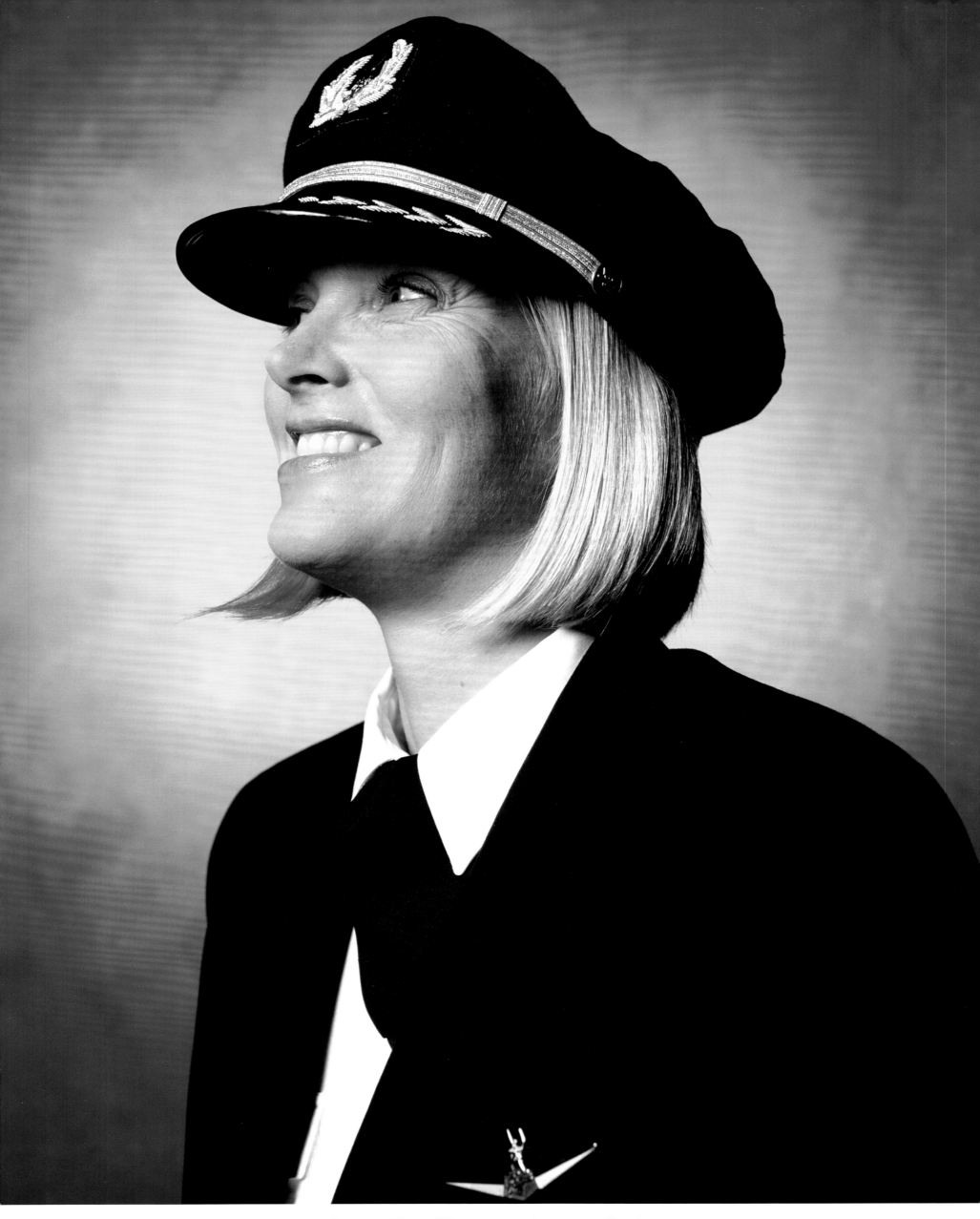

Captain Tracy Thompson, American Eagle
2002

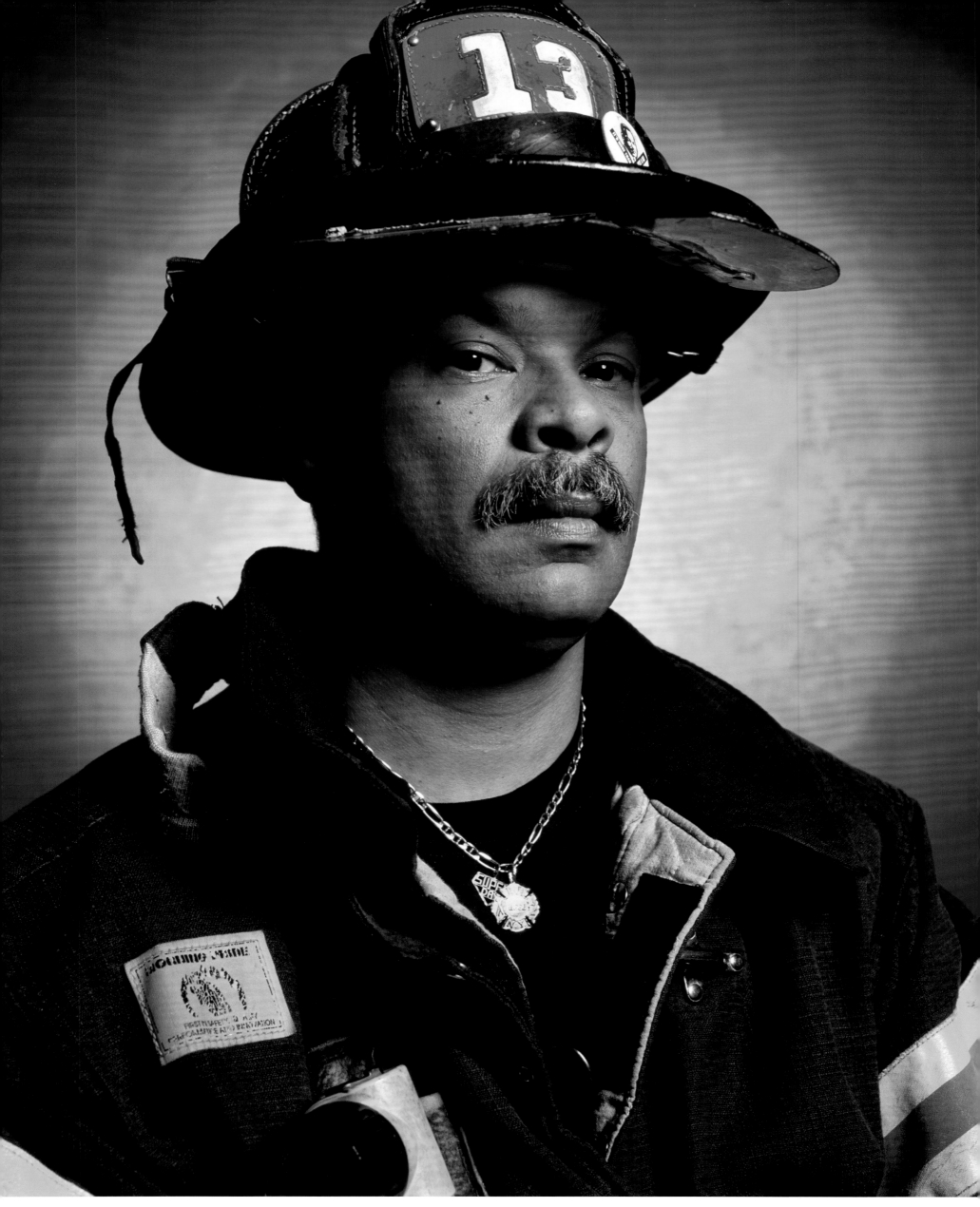

Firefighter Darrell Dunbar

2002

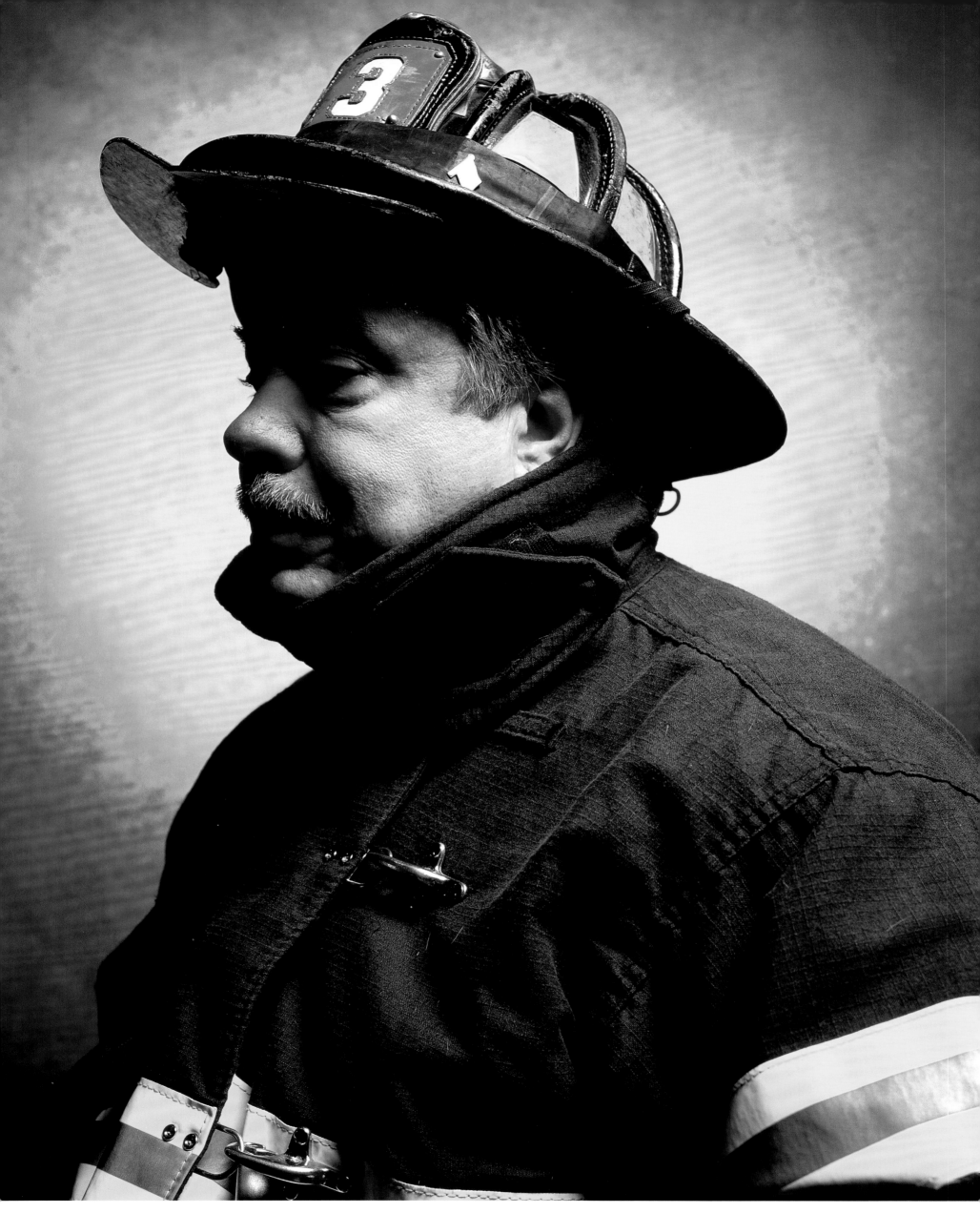

Firefighter John L. Thomasian
2002

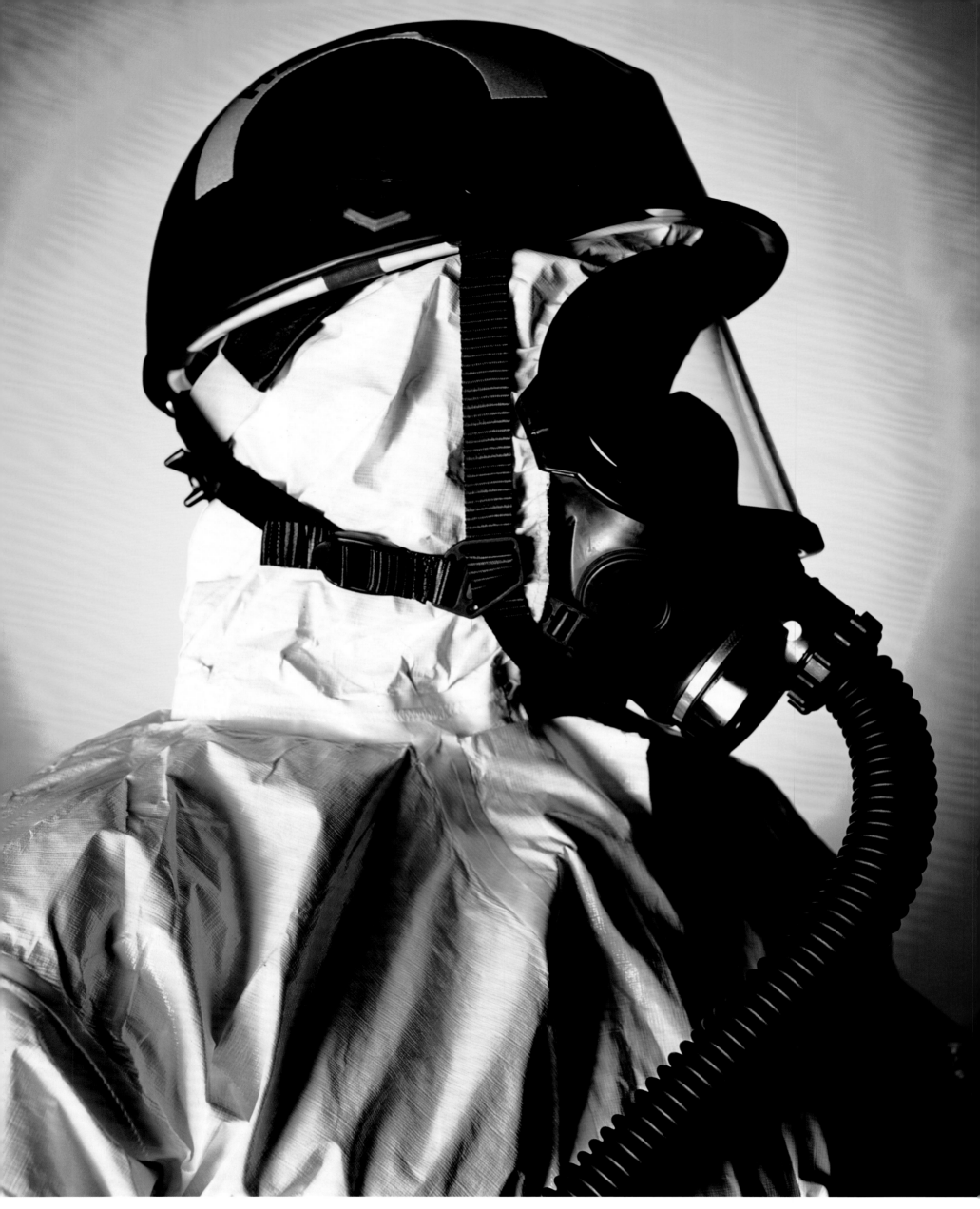

Thomas Buda, Hazmat Chemical Biological Weapons Response Team
2002

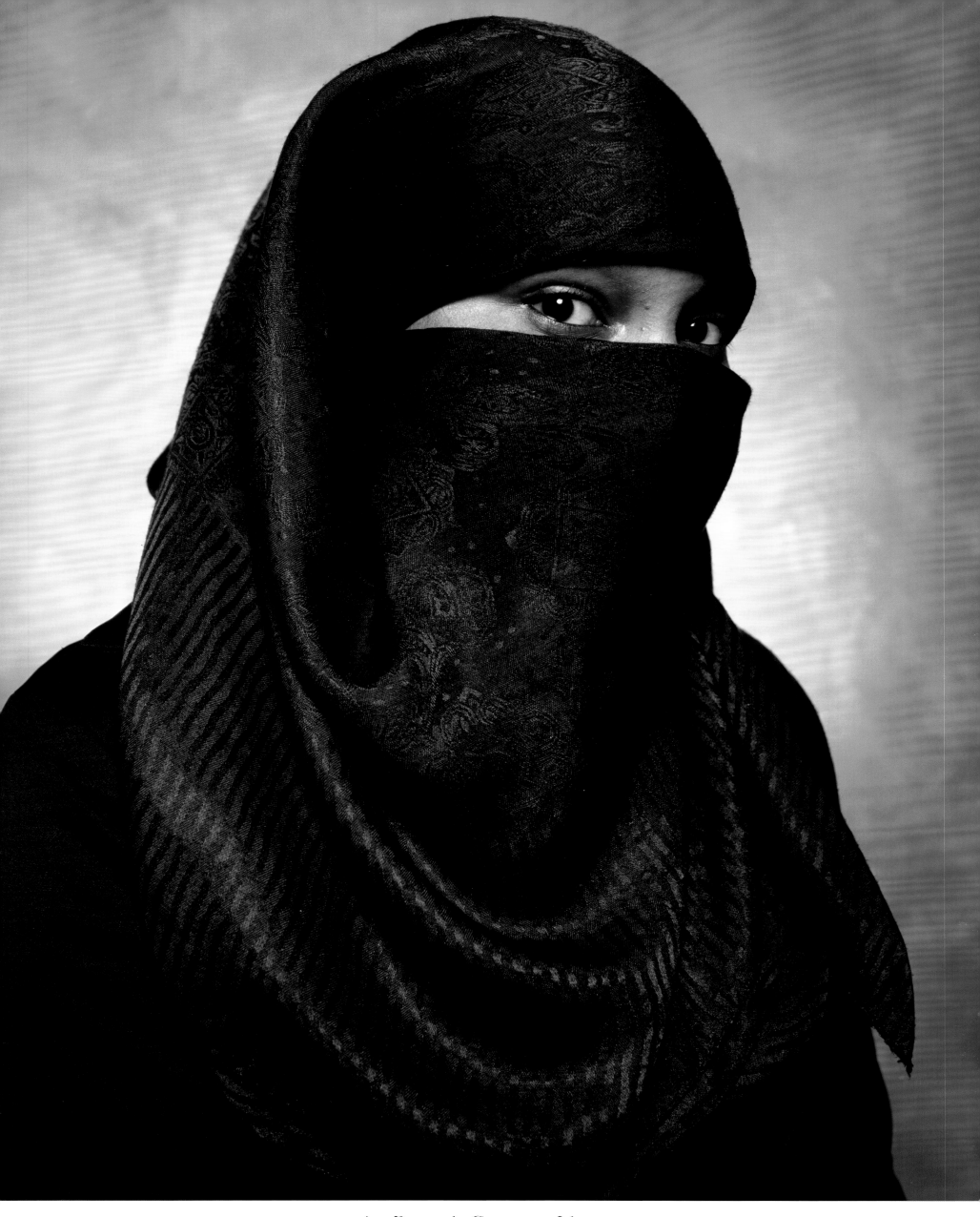

Aya Basemah, Convert to Islam

2002

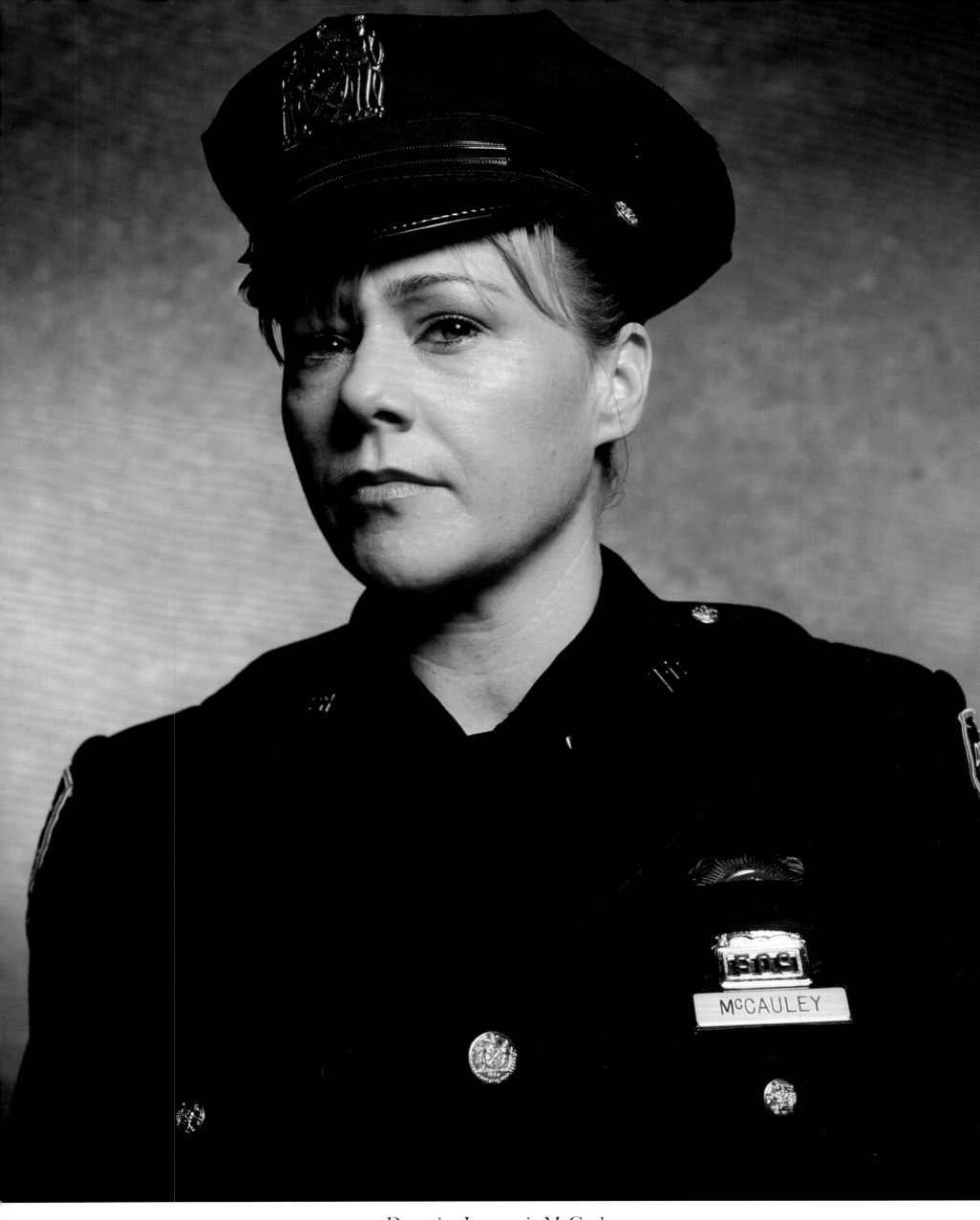

Detective Joanmarie McCauley

2002

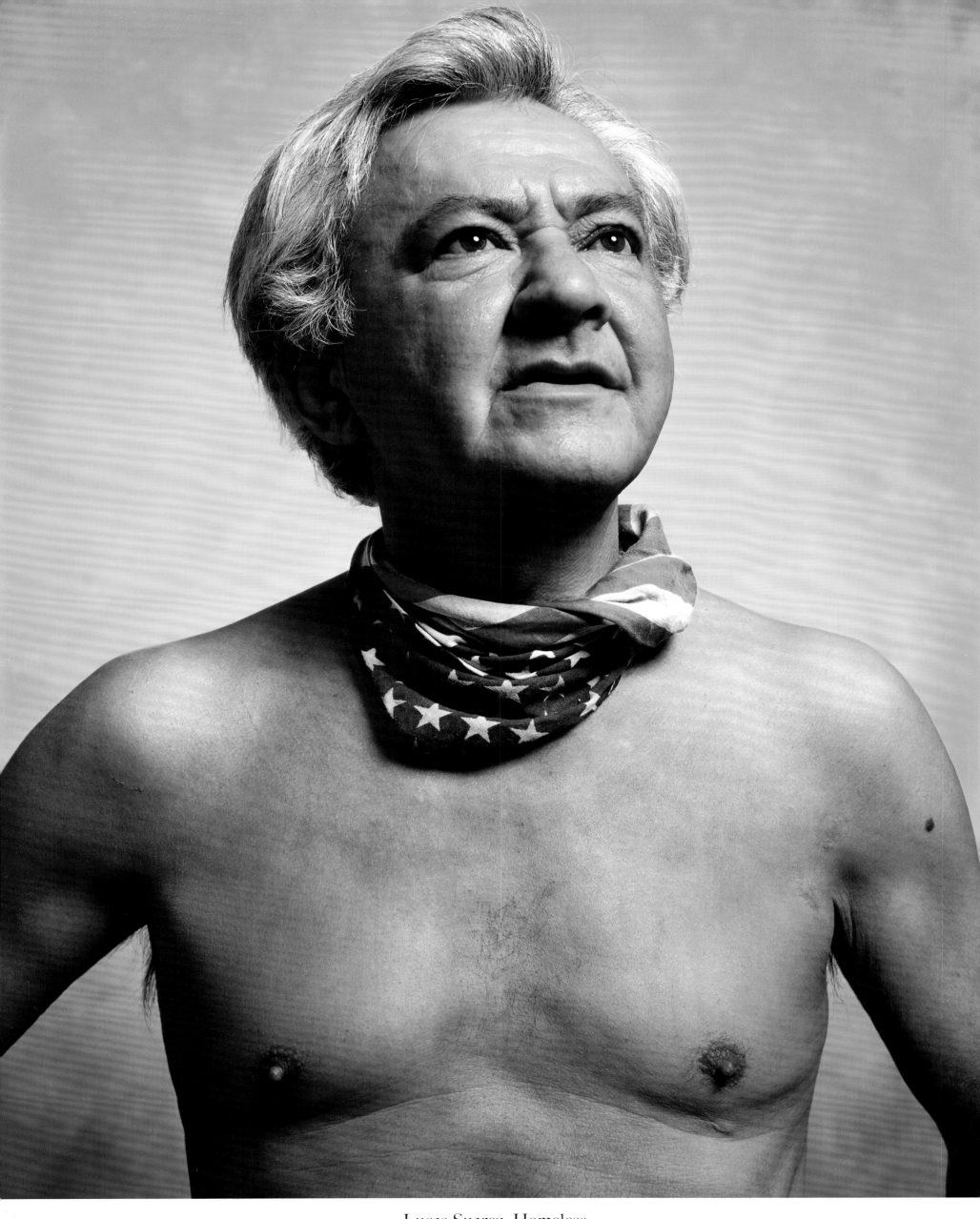

Lucas Suarez, Homeless

2002

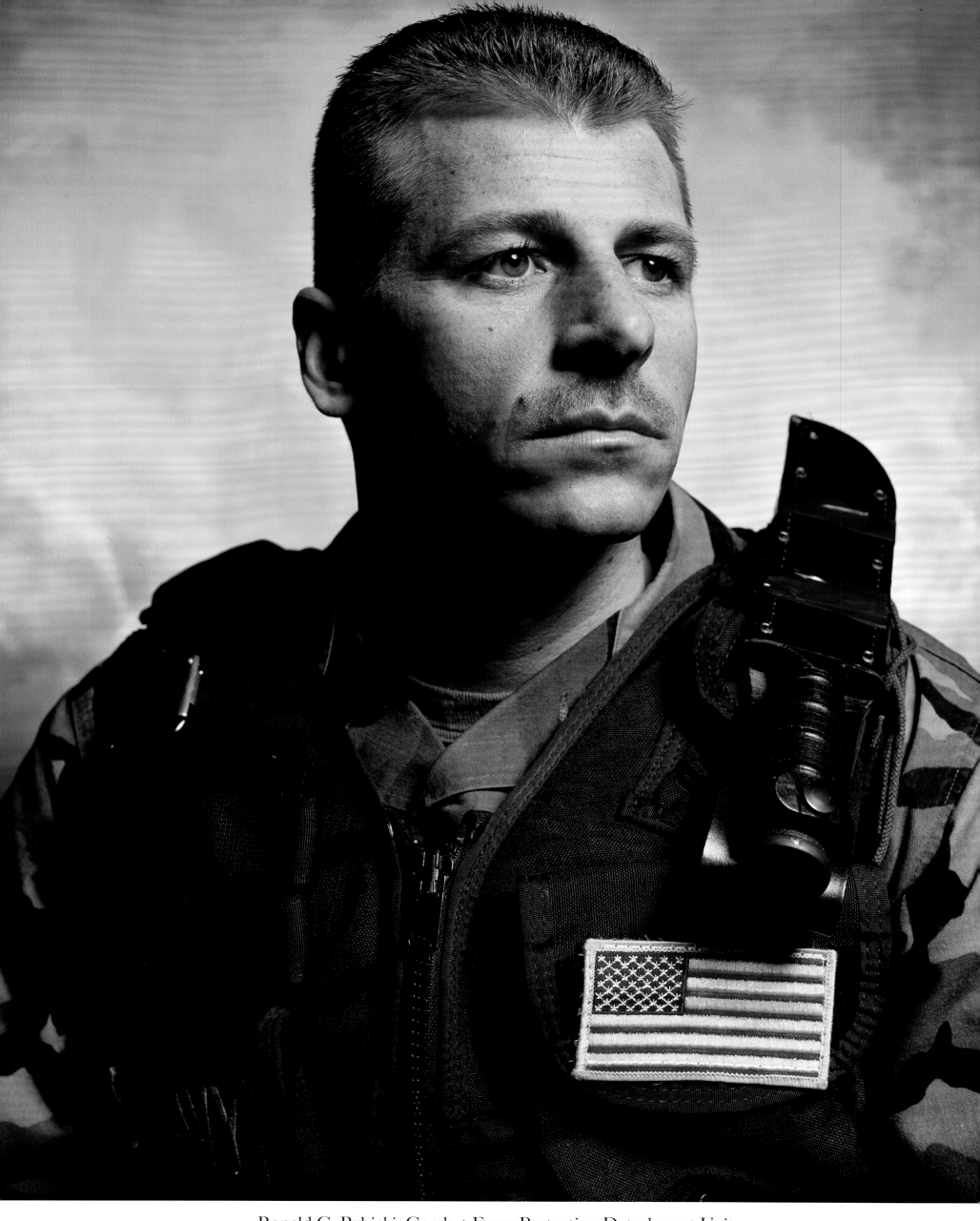

Ronald C. Rybicki, Combat Force Protection Detachment Unit
2002

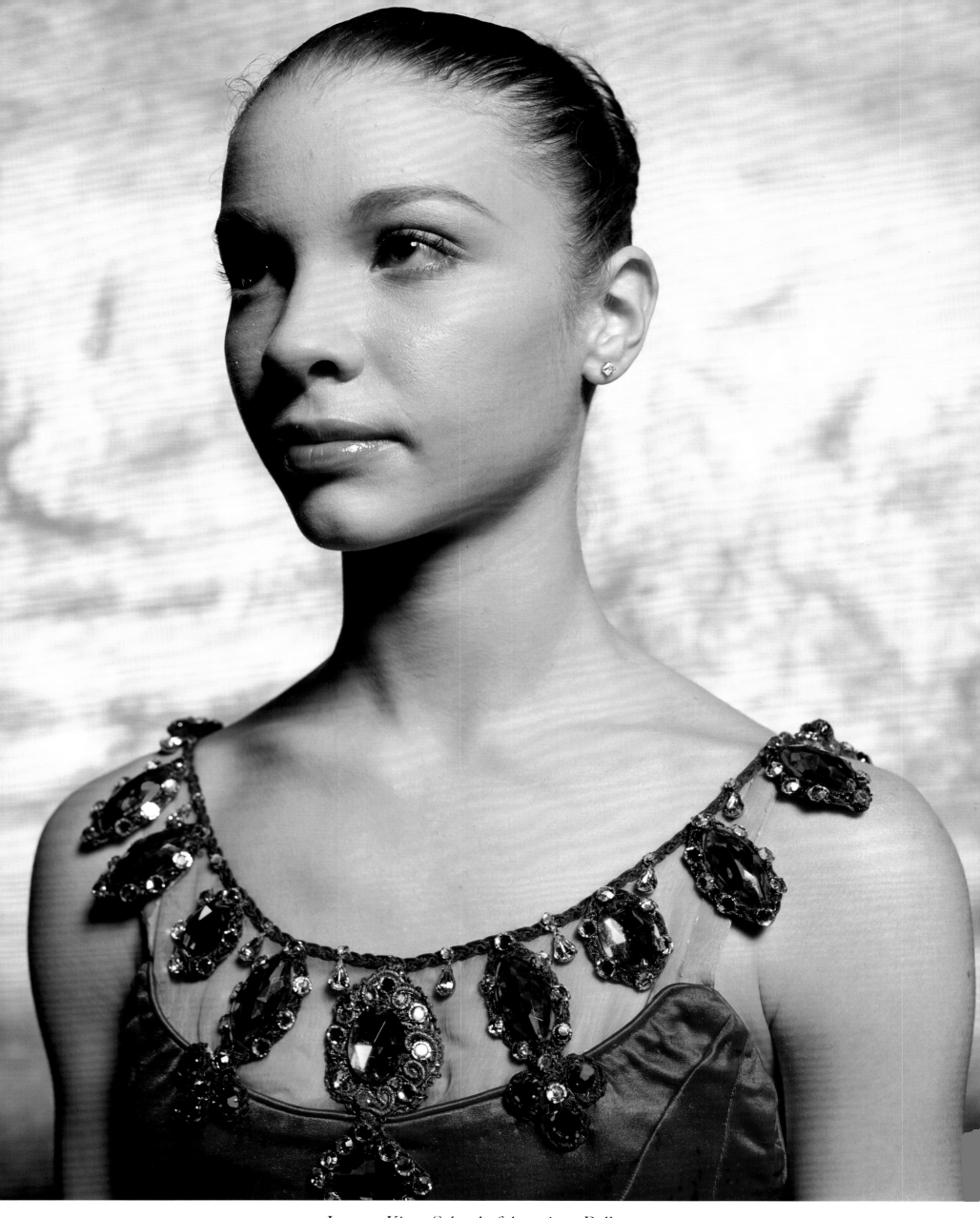

Lauren King, School of American Ballet

2002

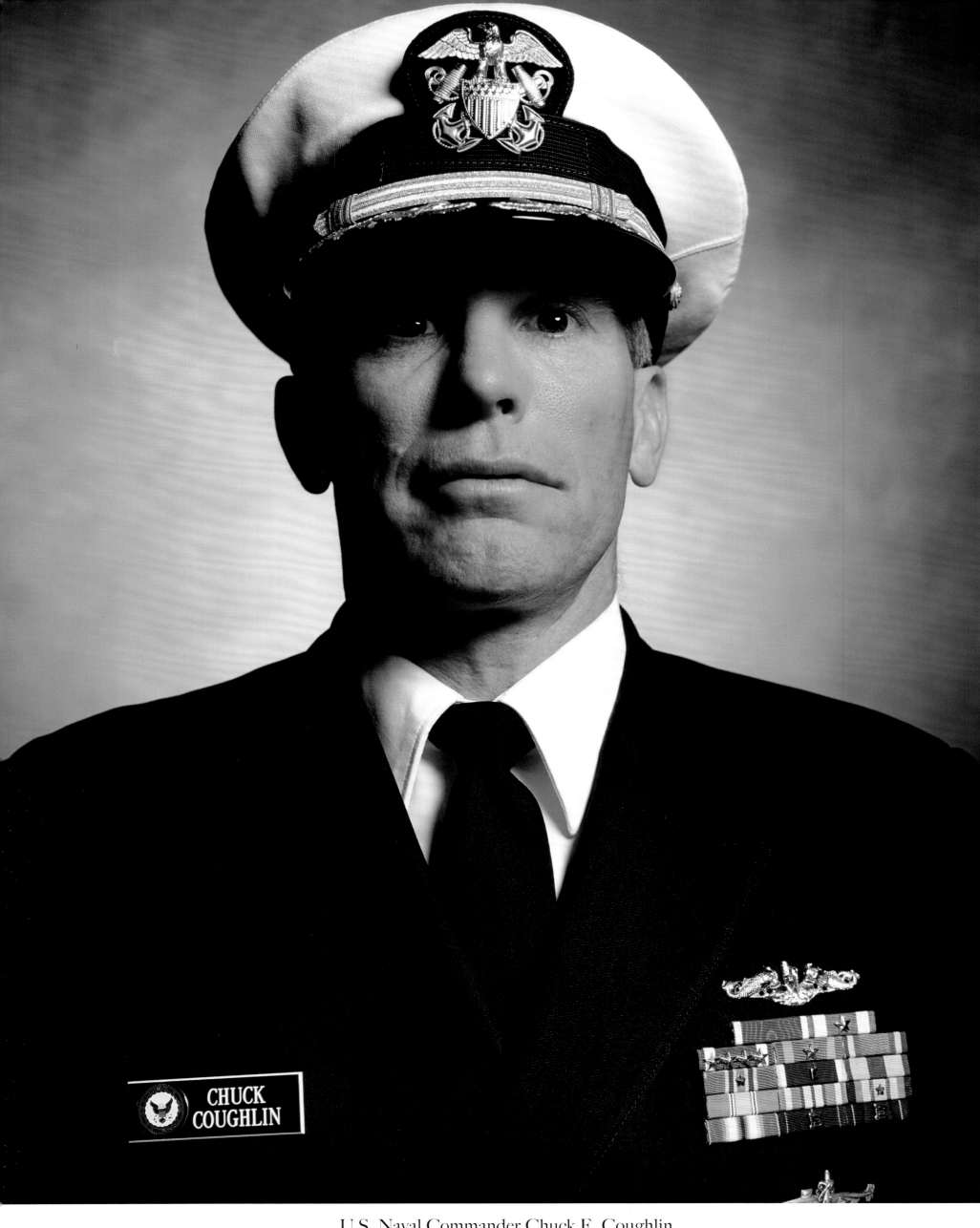

U.S. Naval Commander Chuck E. Coughlin

2002

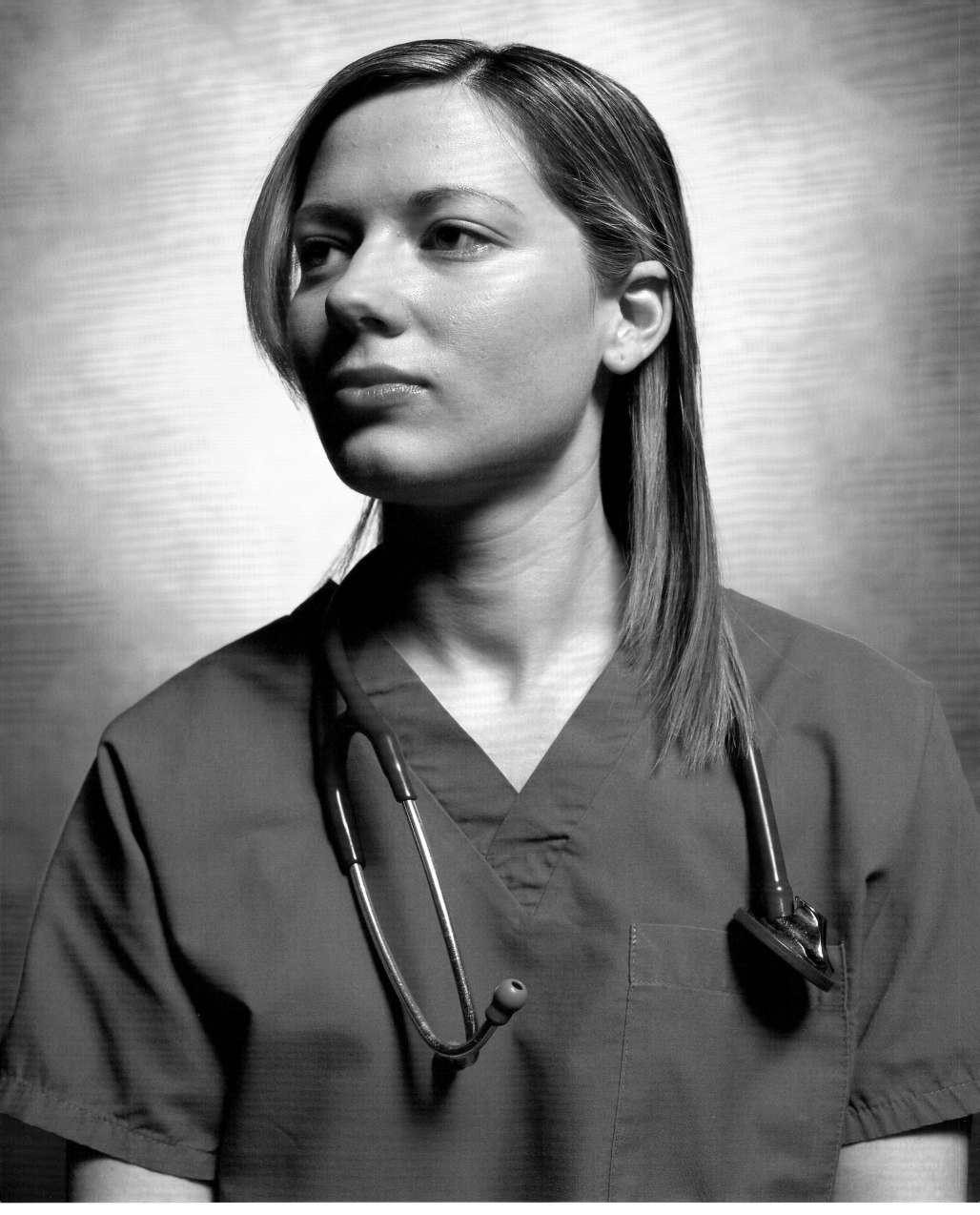

Nurse Yulia Fileva

2003

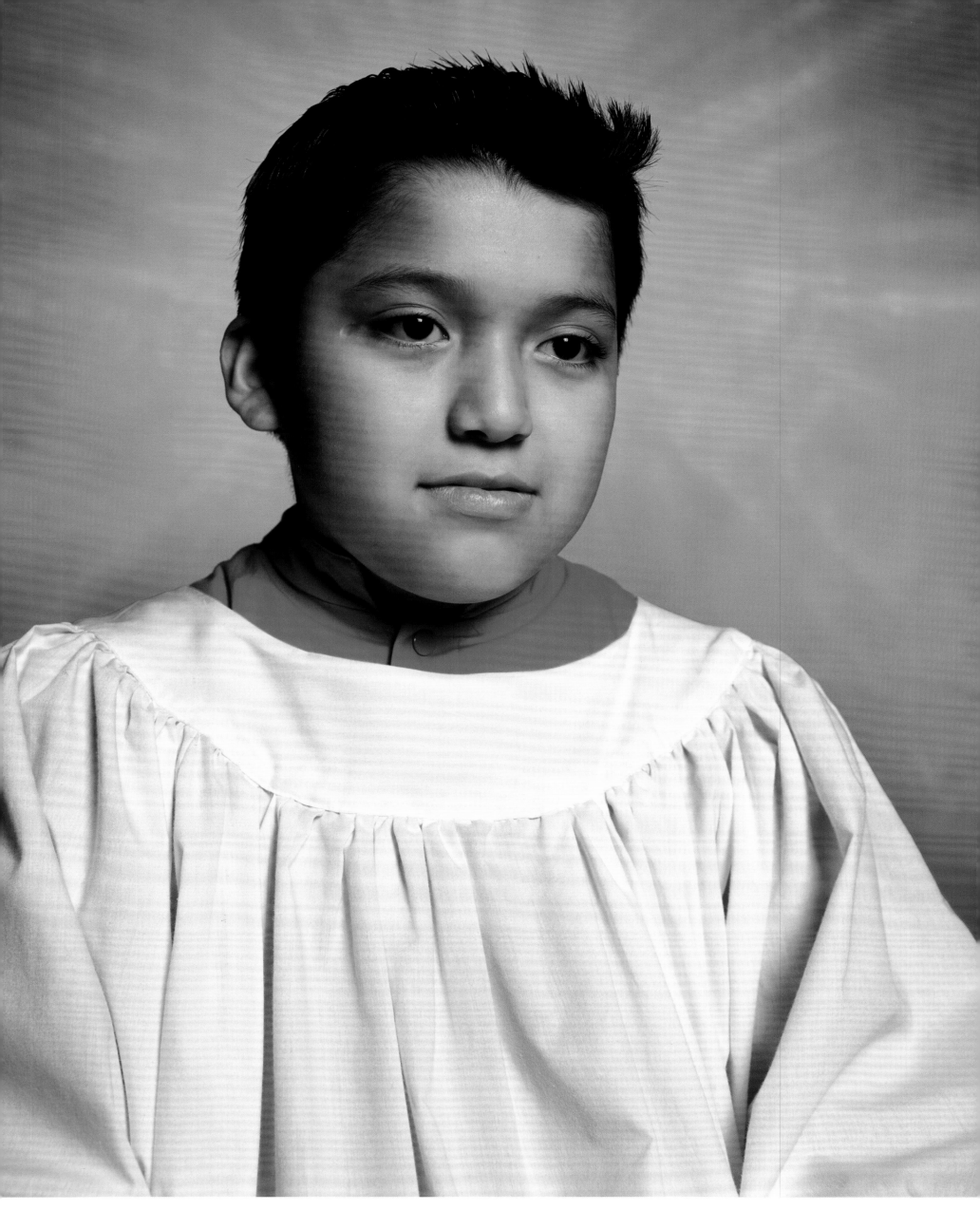

Charlie Uruchima, The Sacred Heart of Jesus School

2002

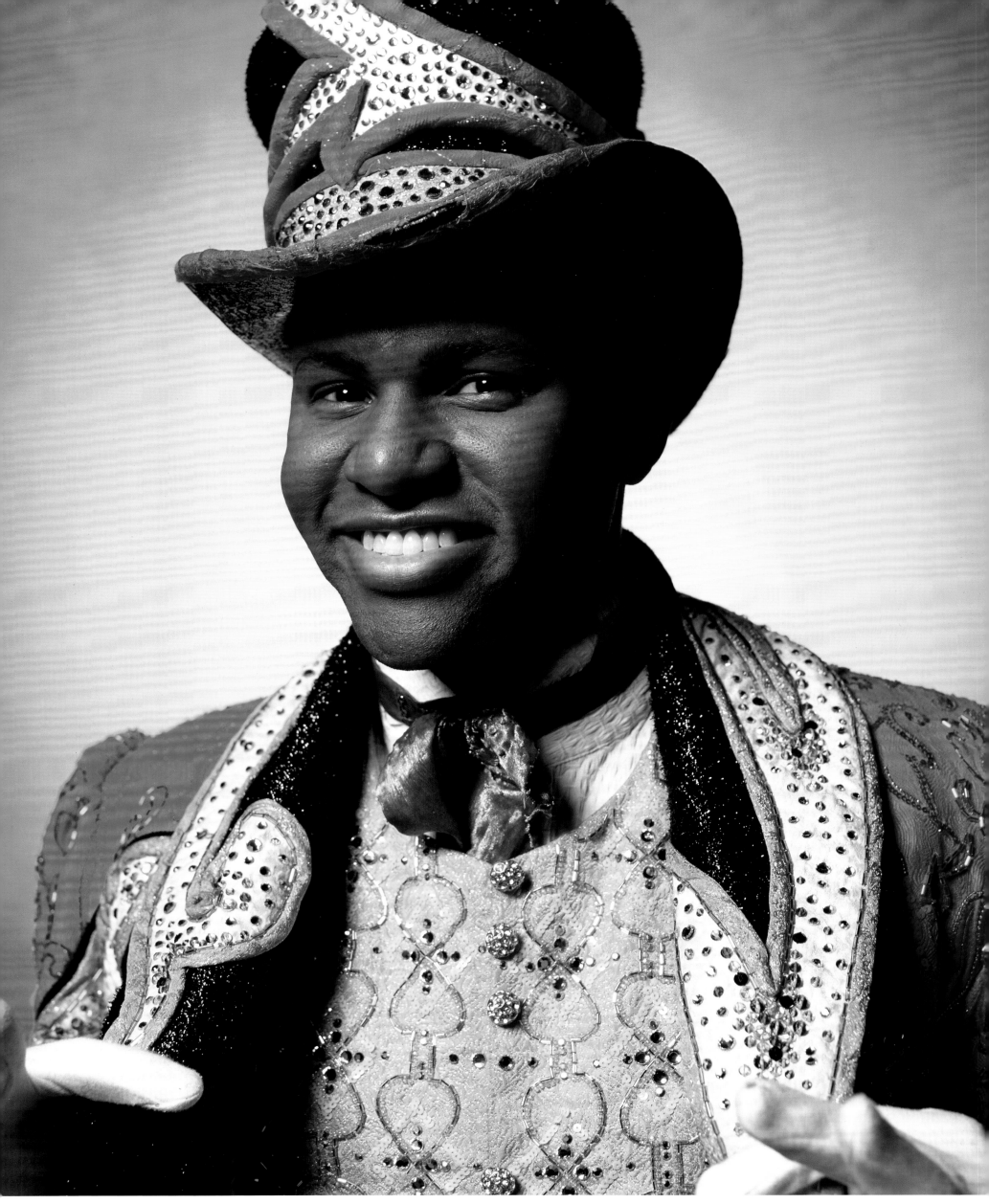

Ringmaster Johnathan Lee Iverson, Ringling Bros. and Barnum & Bailey Circus
2003

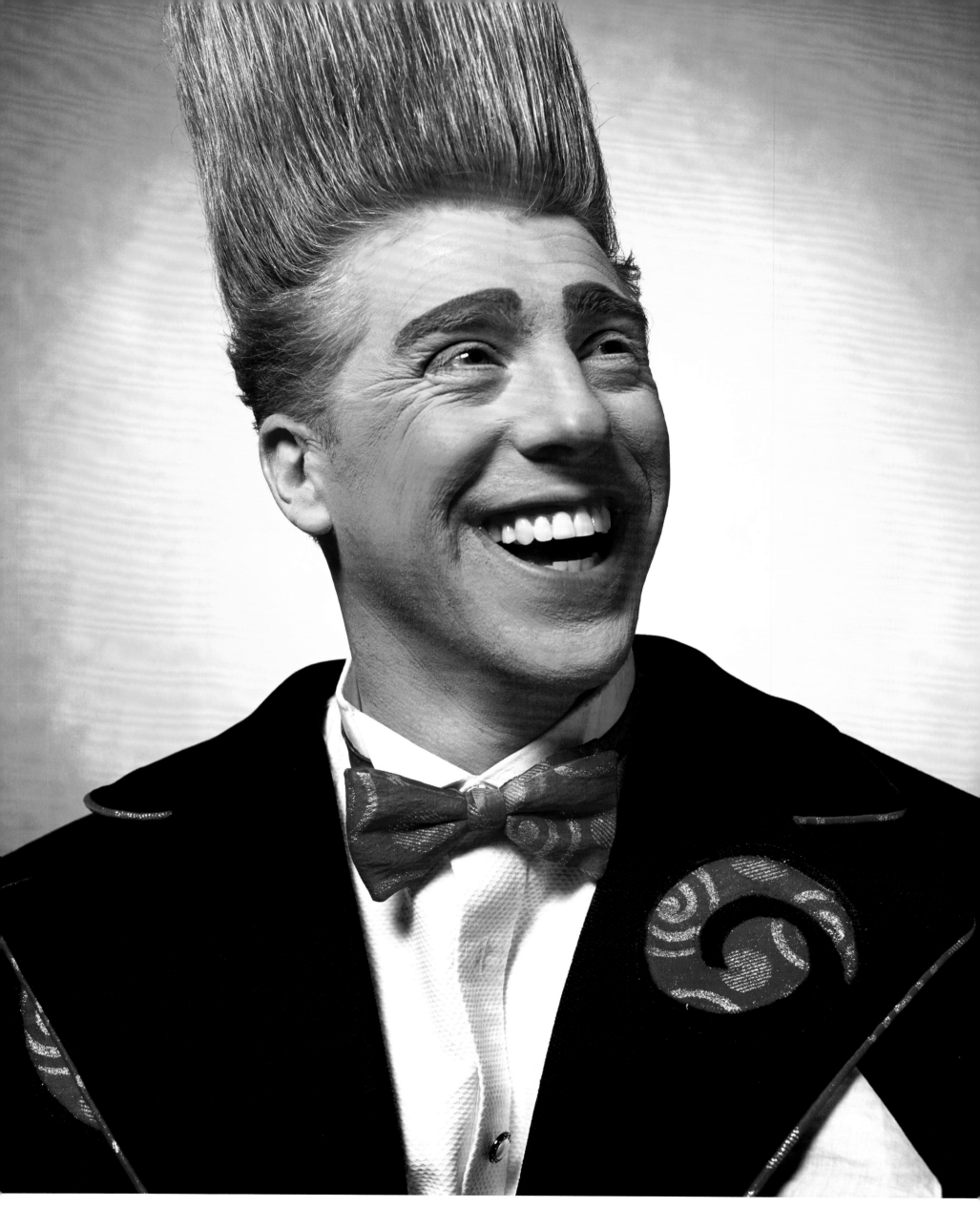

Bello Nock, 'America's Best Clown'. Ringling Bros. and Barnum & Bailey Circus
2003

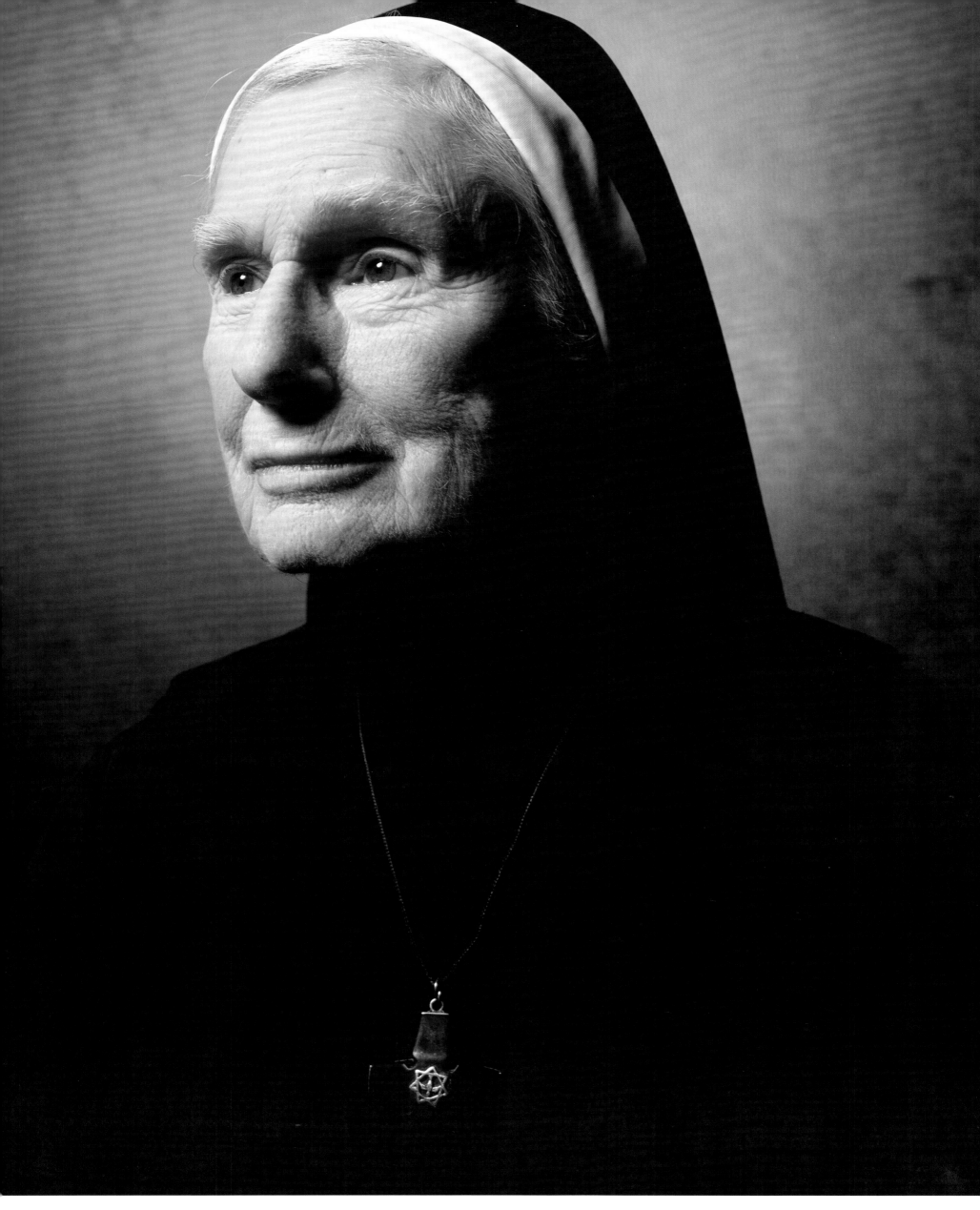

Sister Mary Christabel, Community of The Holy Spirit
2002

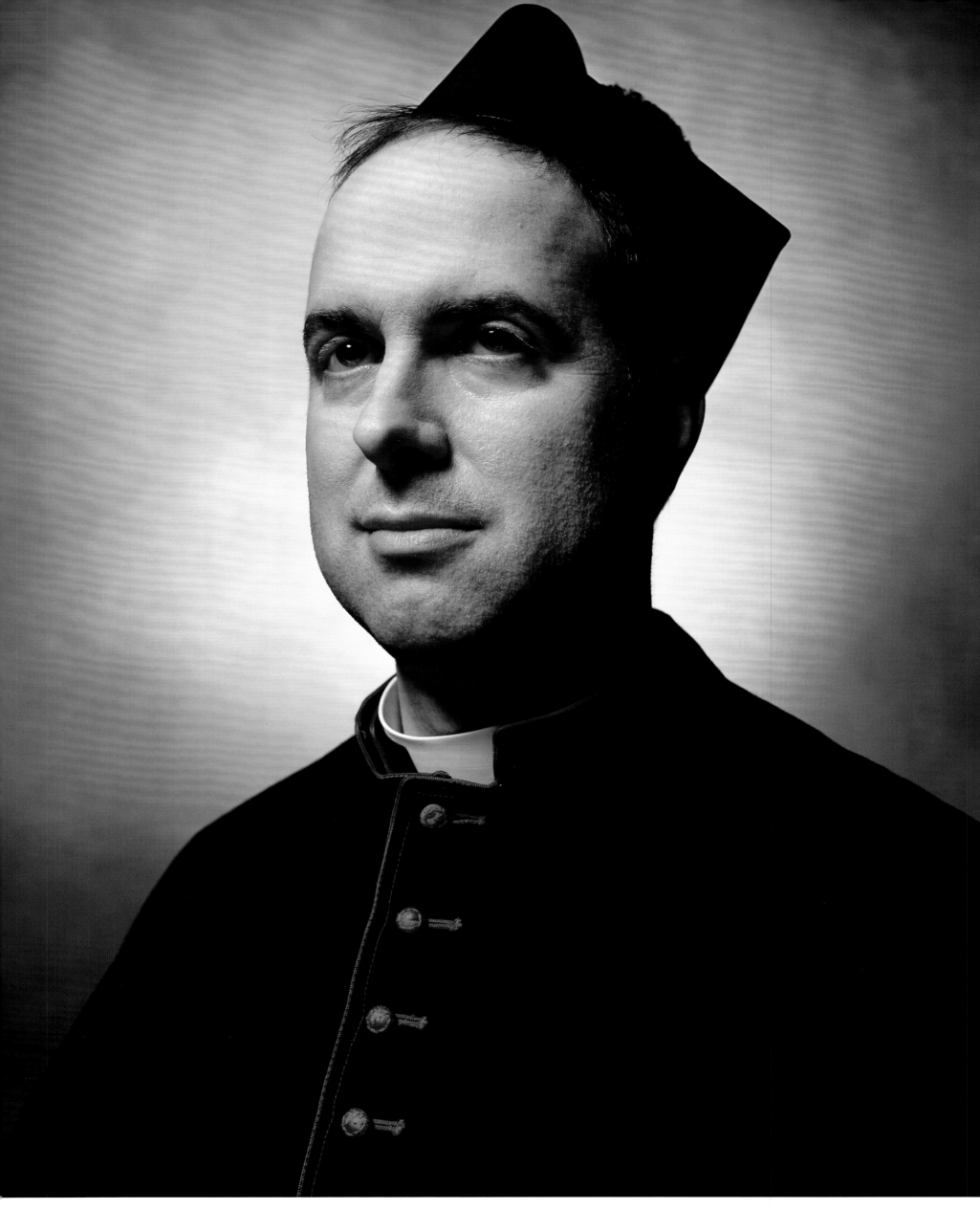

The Rev. Canon Jay Wegman, The Cathedral Church of St. John the Divine

2002

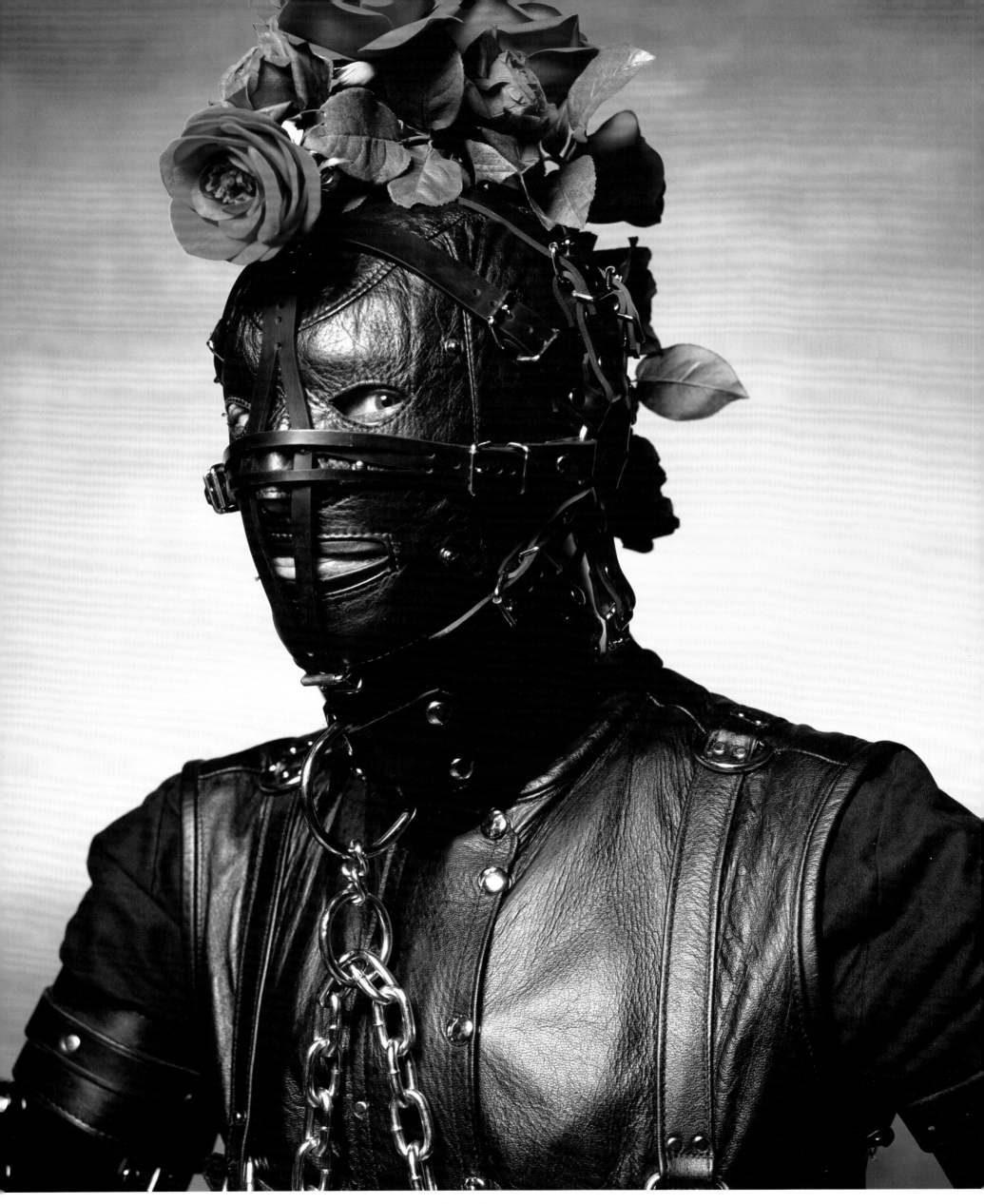

Ken Cox, Set Designer

2002

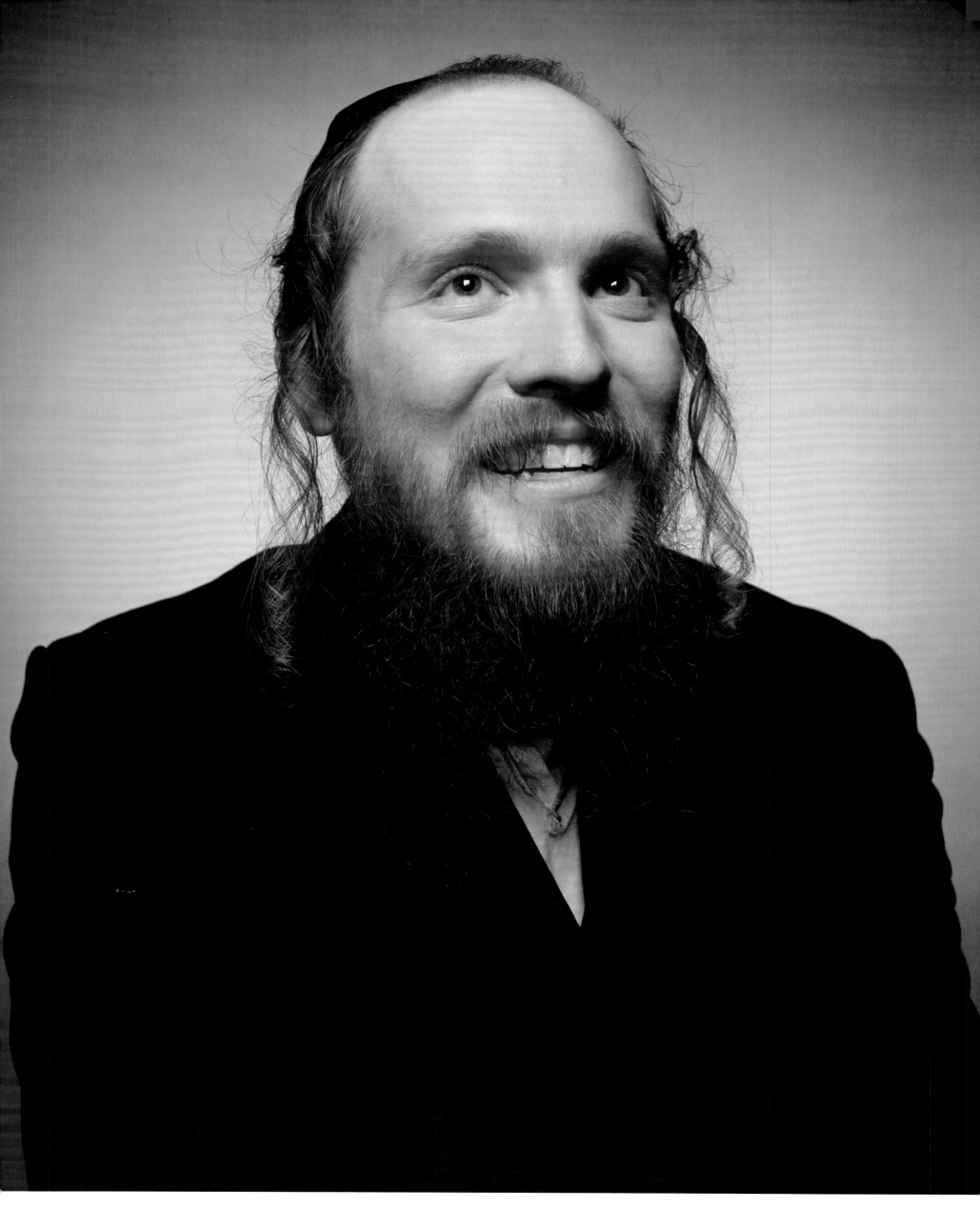

Abraham Schnitzer

2001

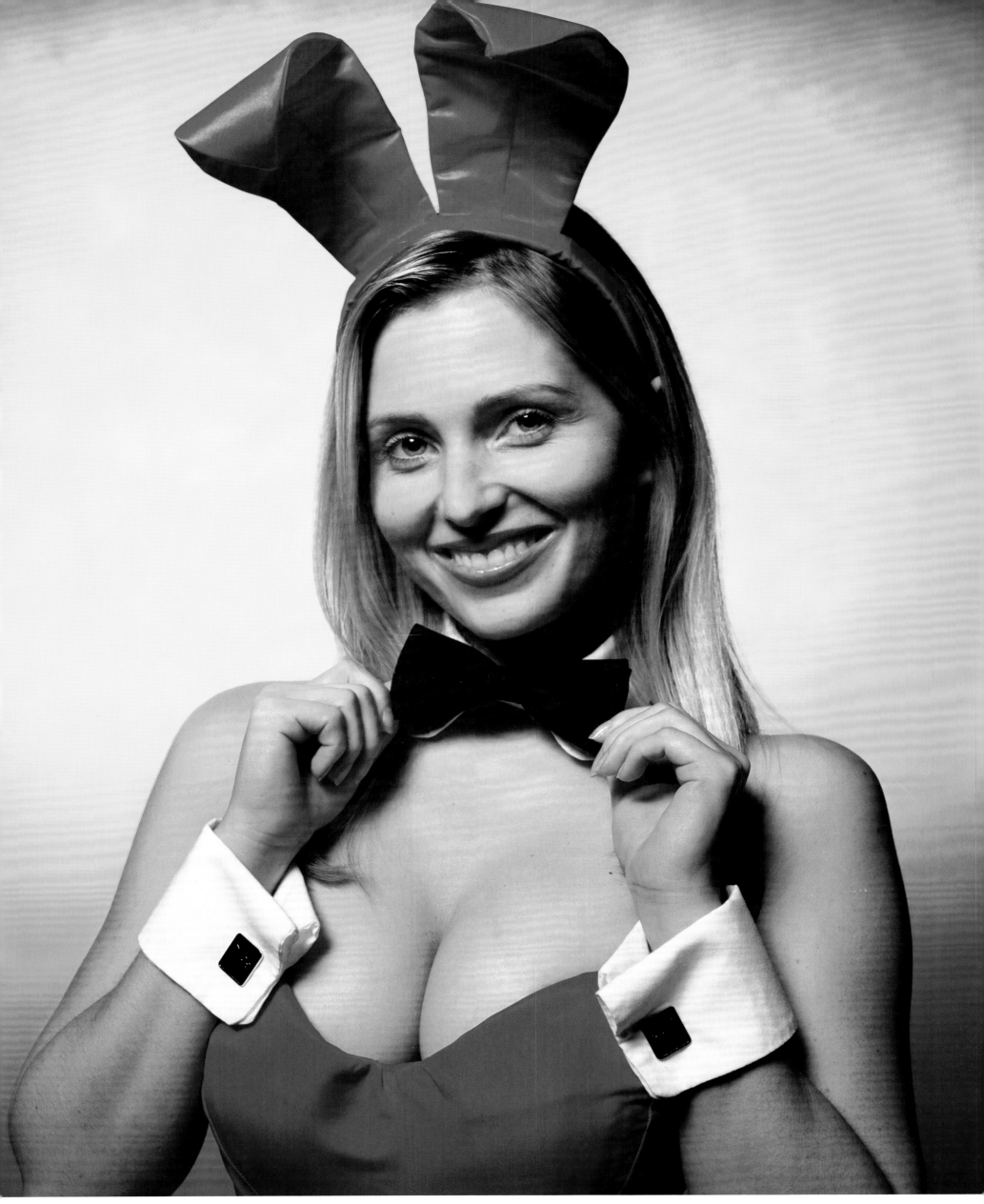

Playboy Bunny Deanna Brooks

2002

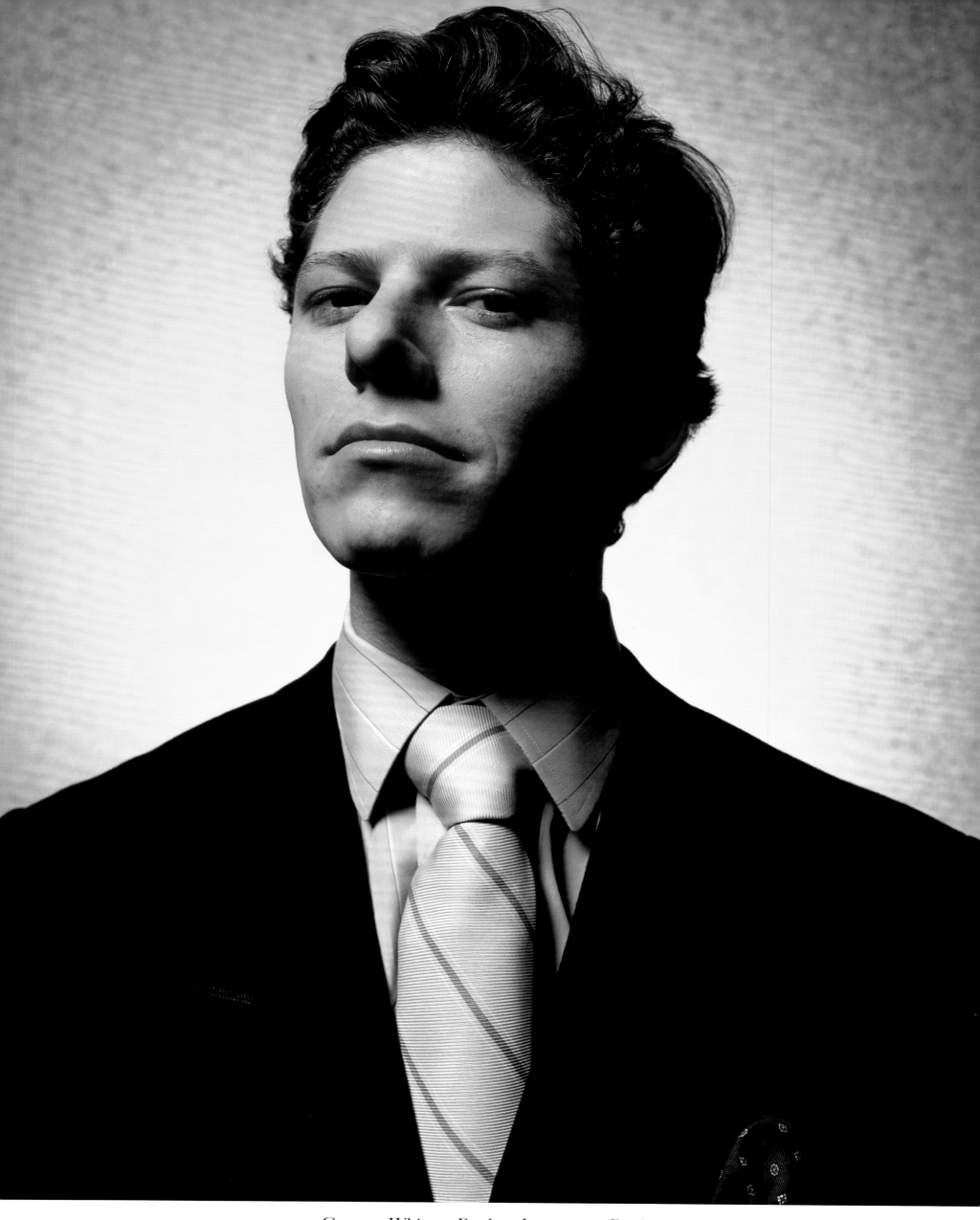

Gregory Whitney Perdon, Investment Banker

2002

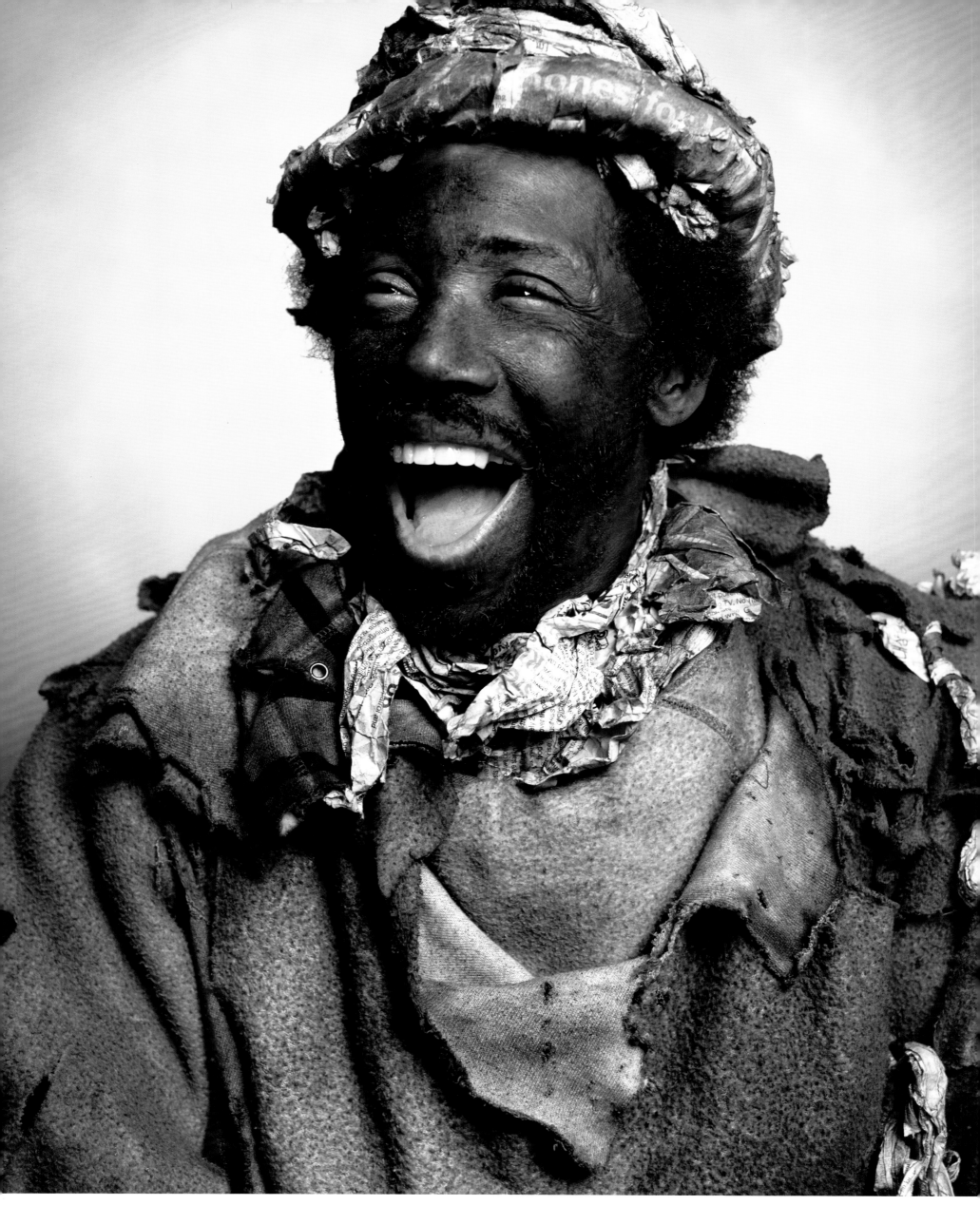

Gary Lewis, Street Hustler

2002

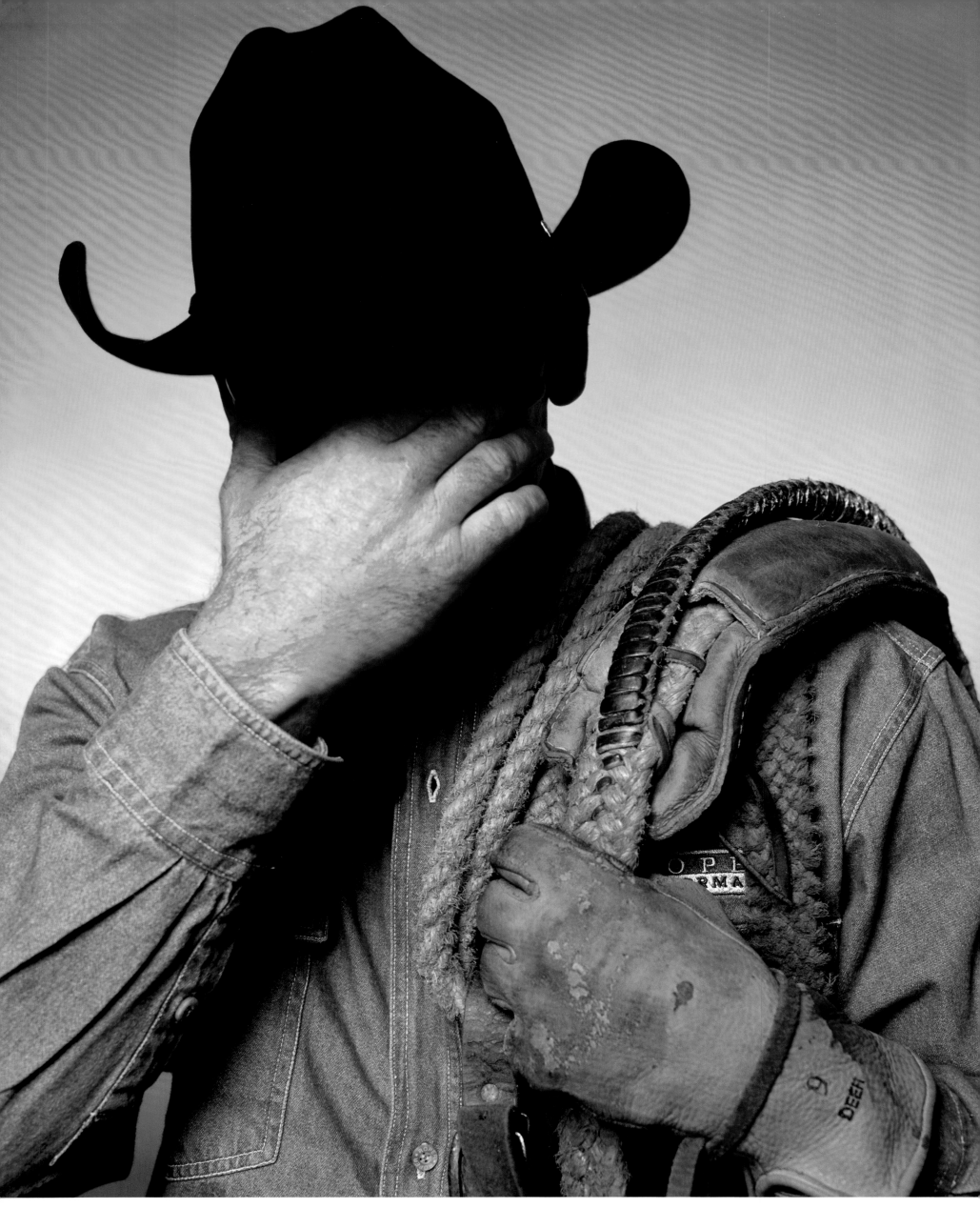

Cowboy Randy

2002

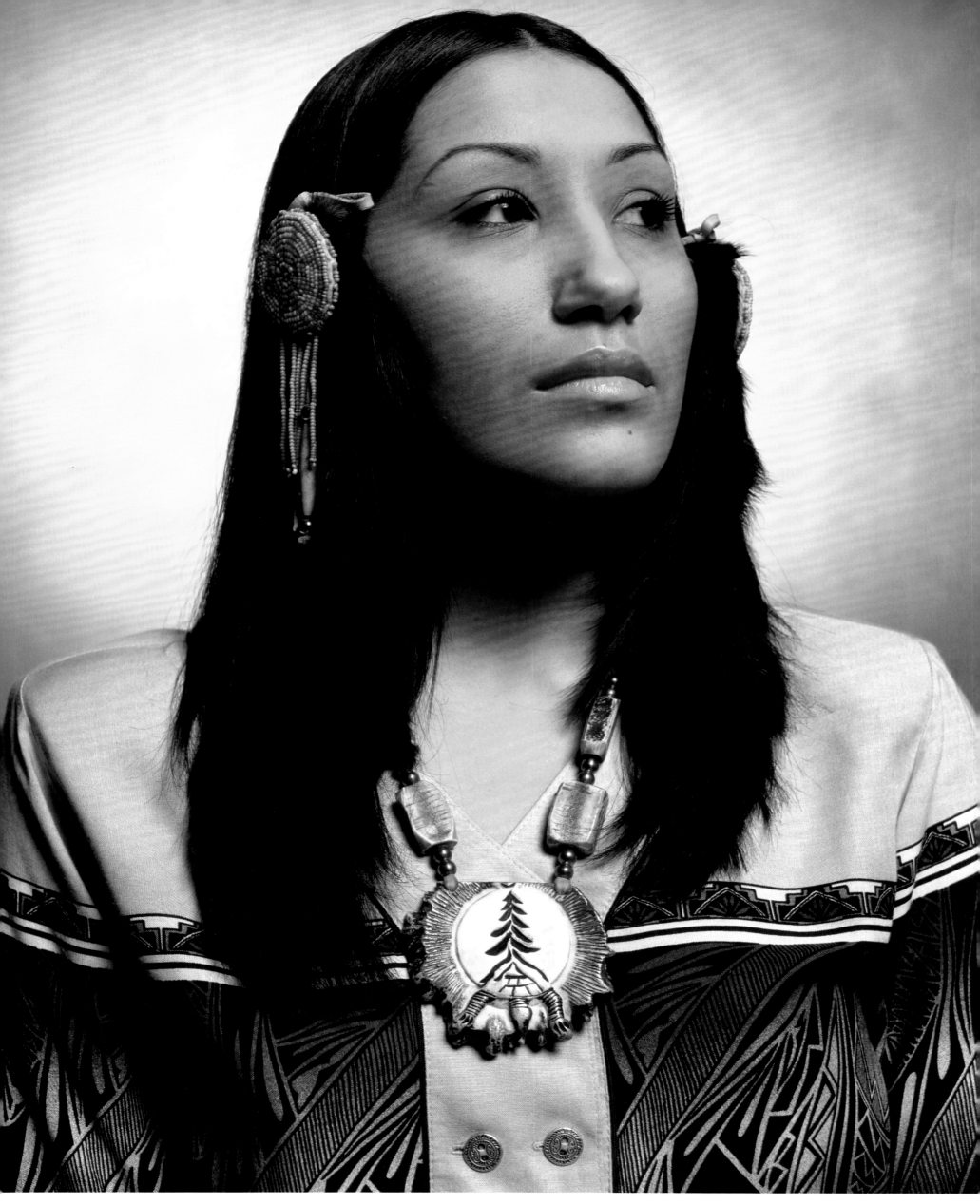

Jill Hardy, Powhatan Renape Nation
2002

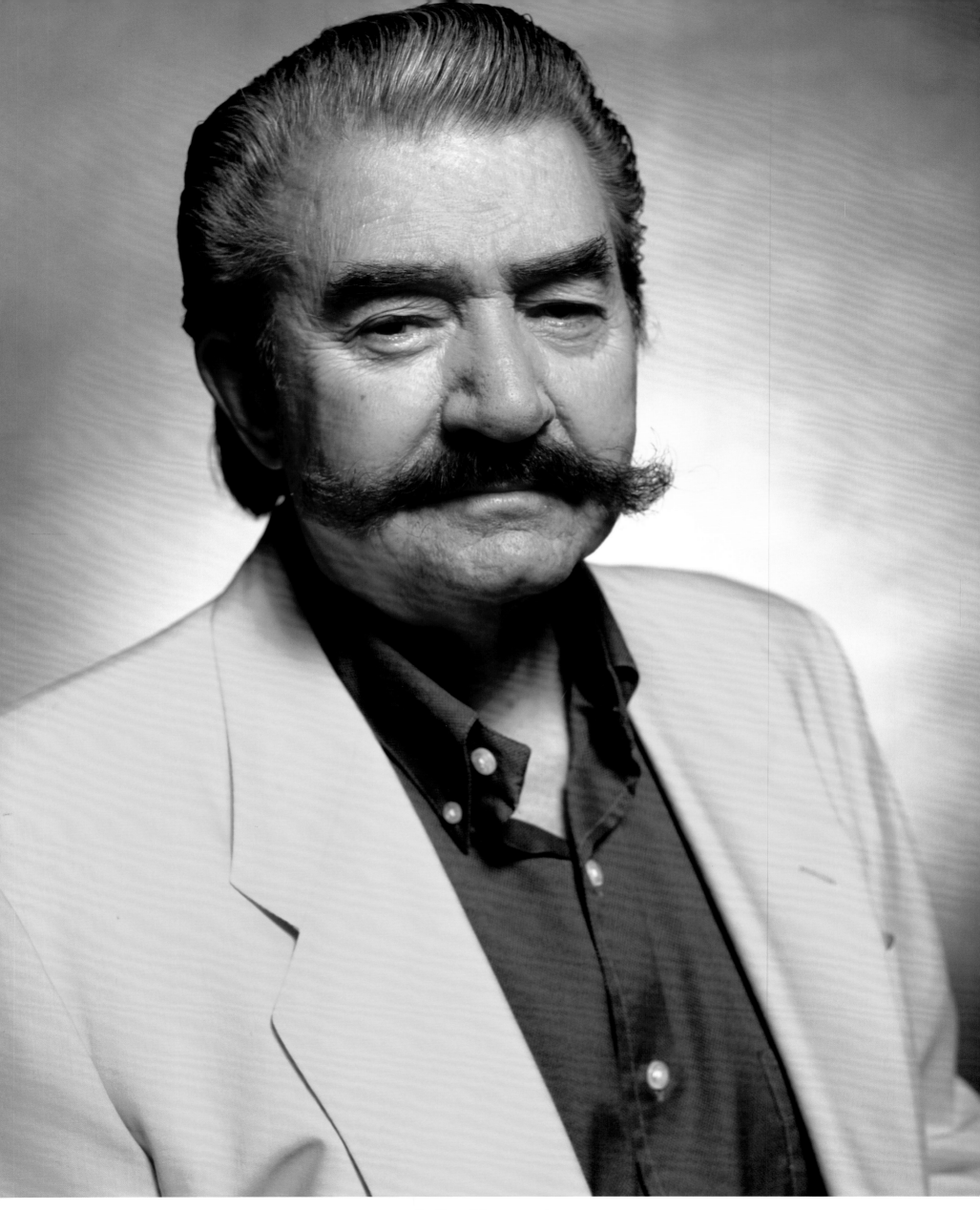

LeRoy Neiman, Artist

2002

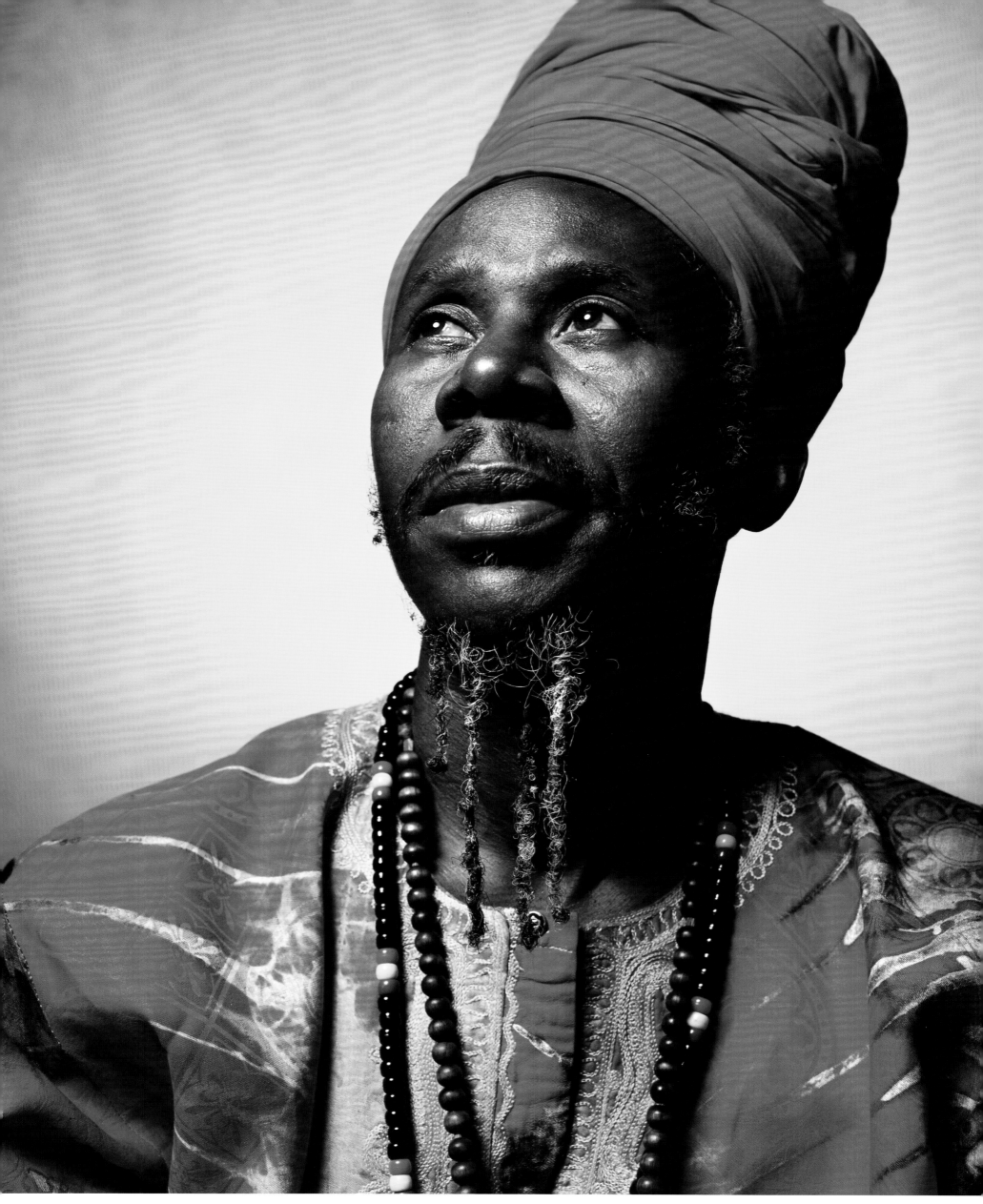

Shaka Zulu, Trinidadian Street Vendor
2002

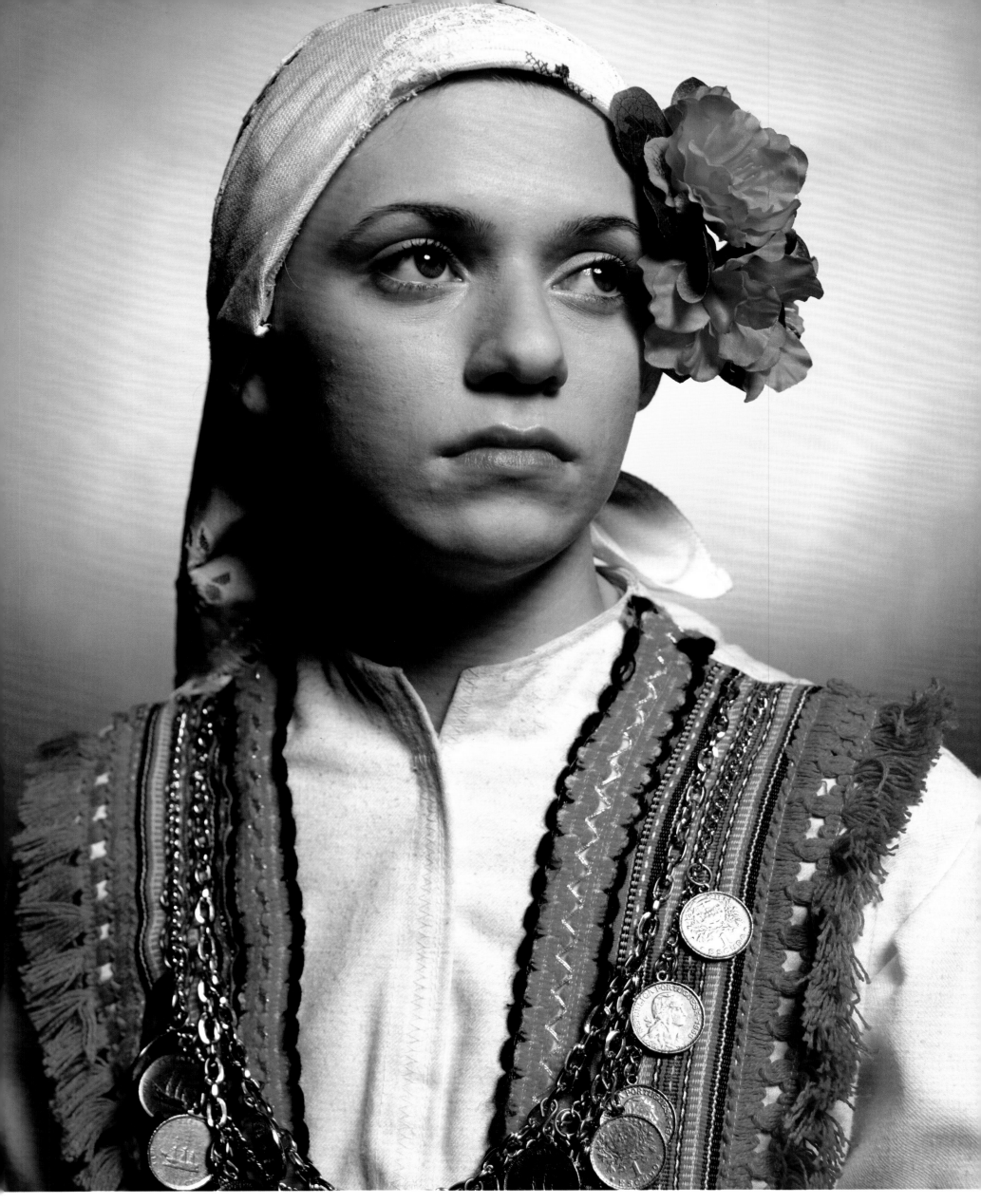

Anita Ilkovski, Macedonian Troupe Dancer

2002

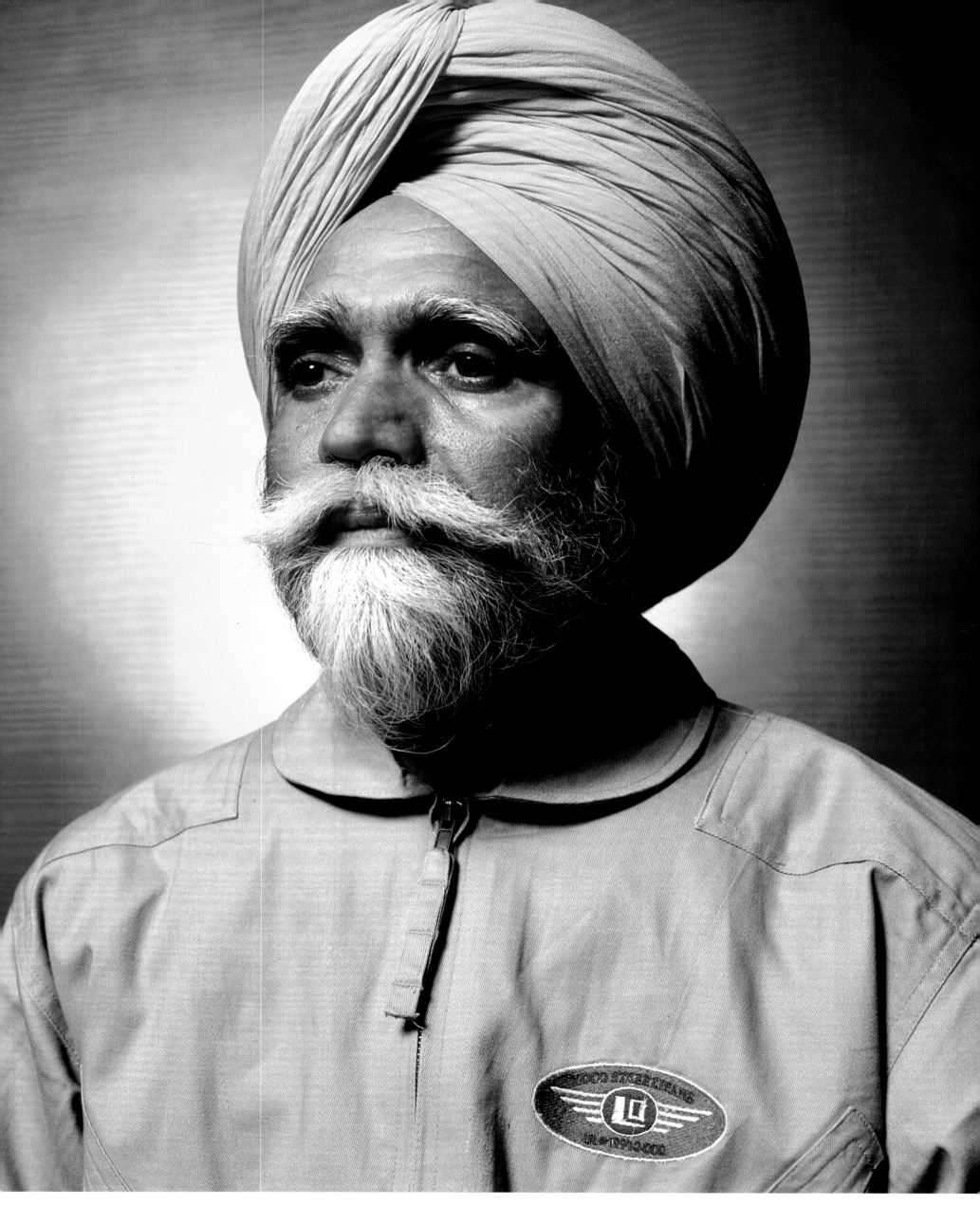

K.S. Flora, Bricklayer

2002

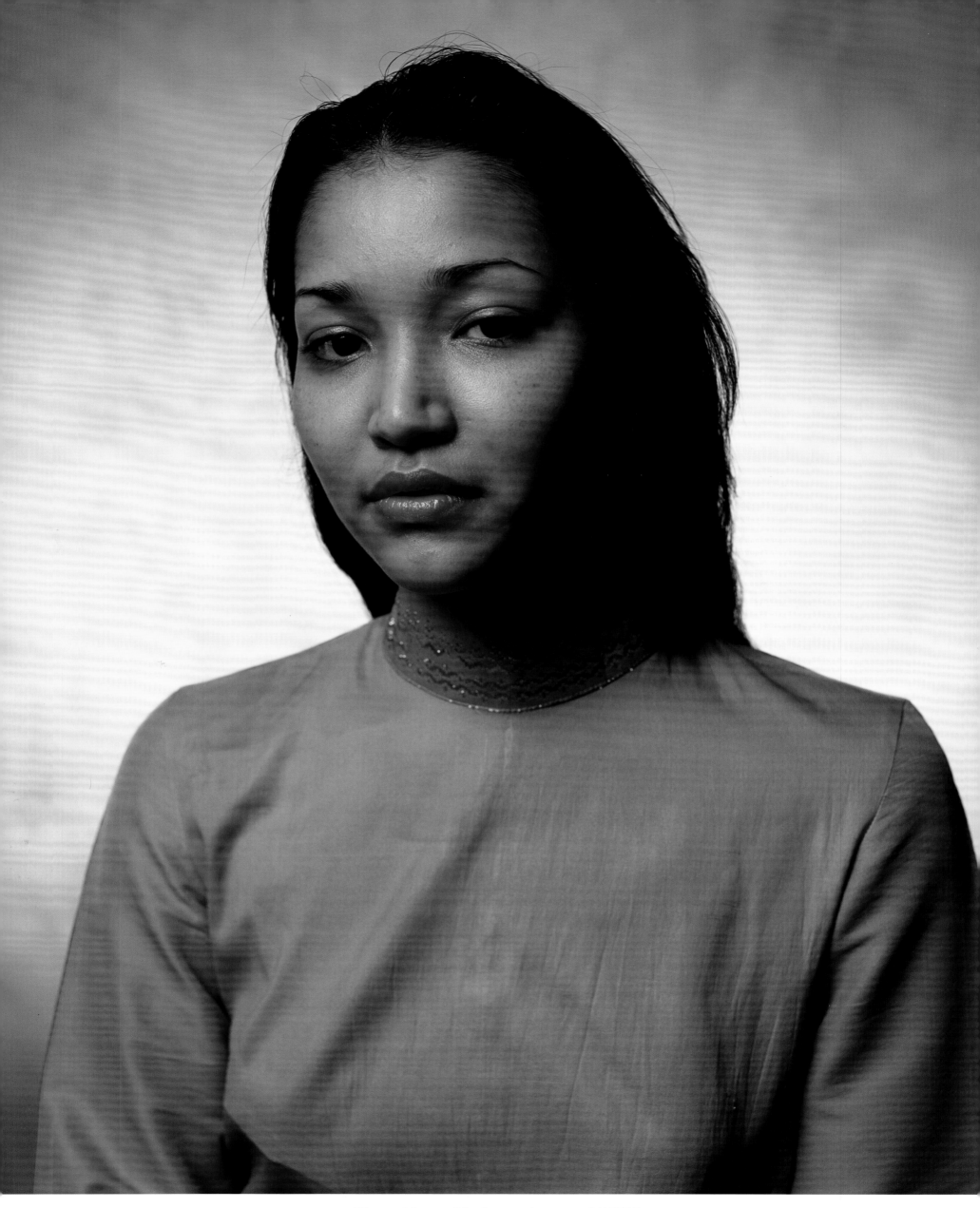

Kaori Niina, Undergraduate at N.Y.U.

2001

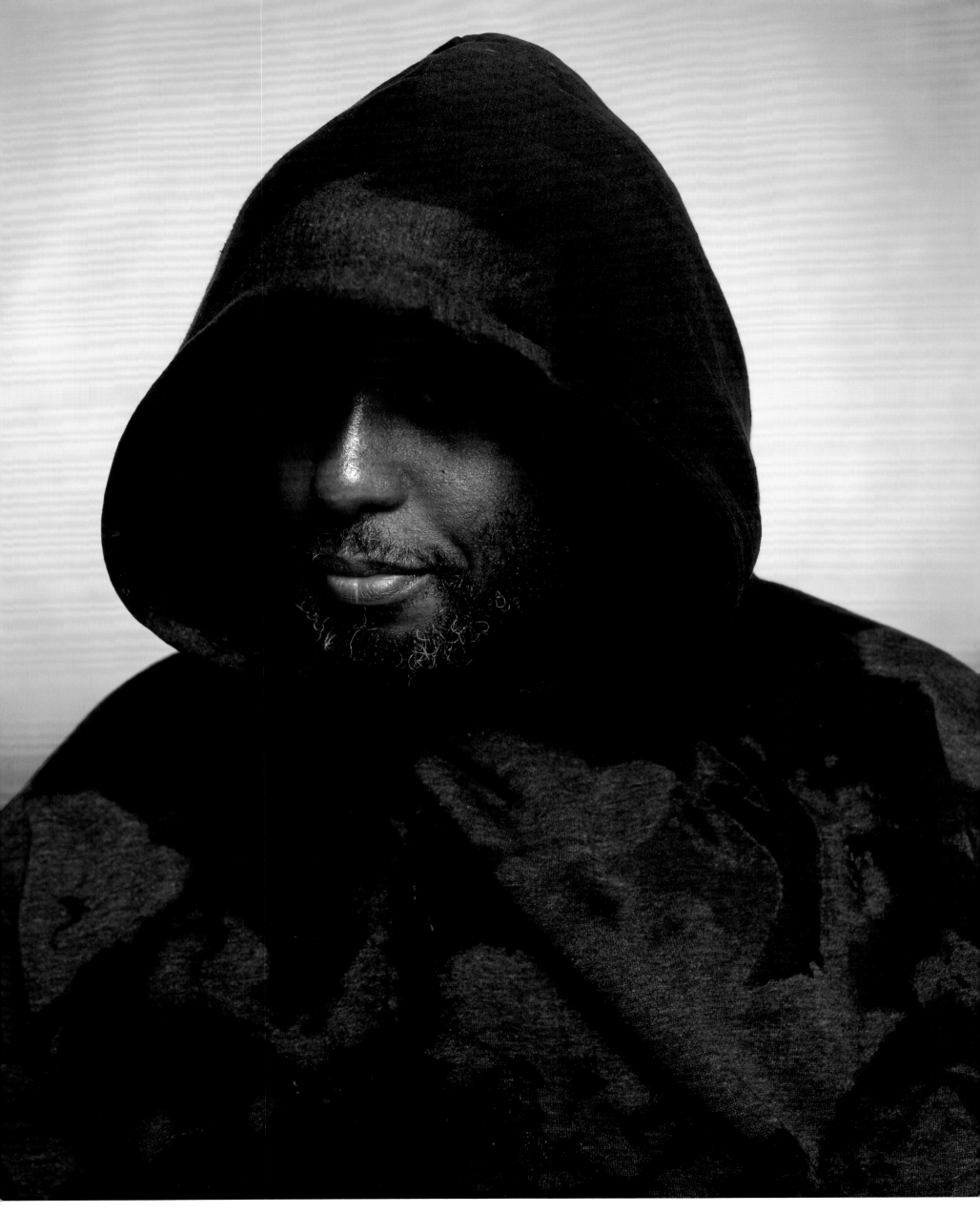

Leonard Young

2002

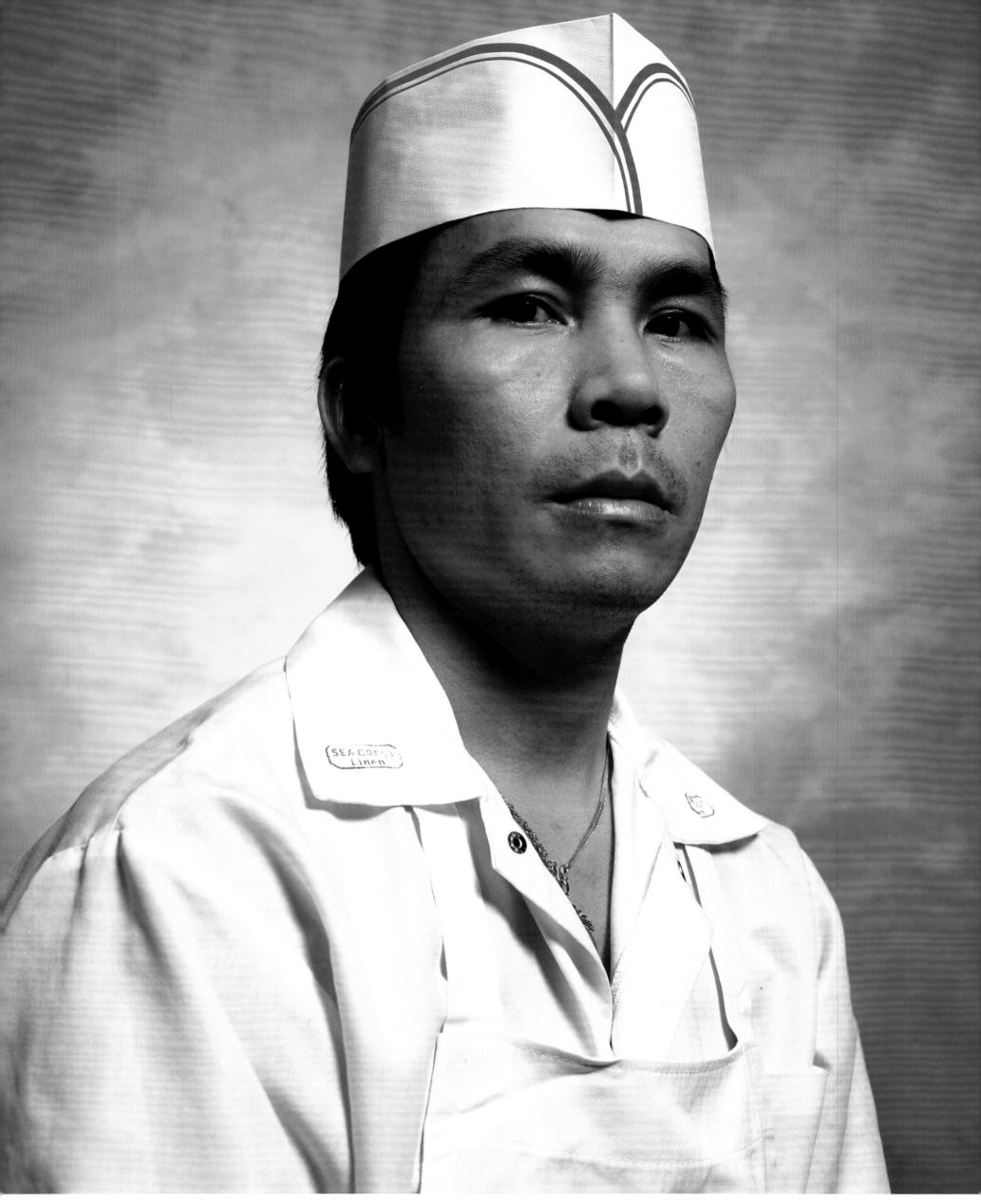

Yao Zhao, Chinese Cook

2002

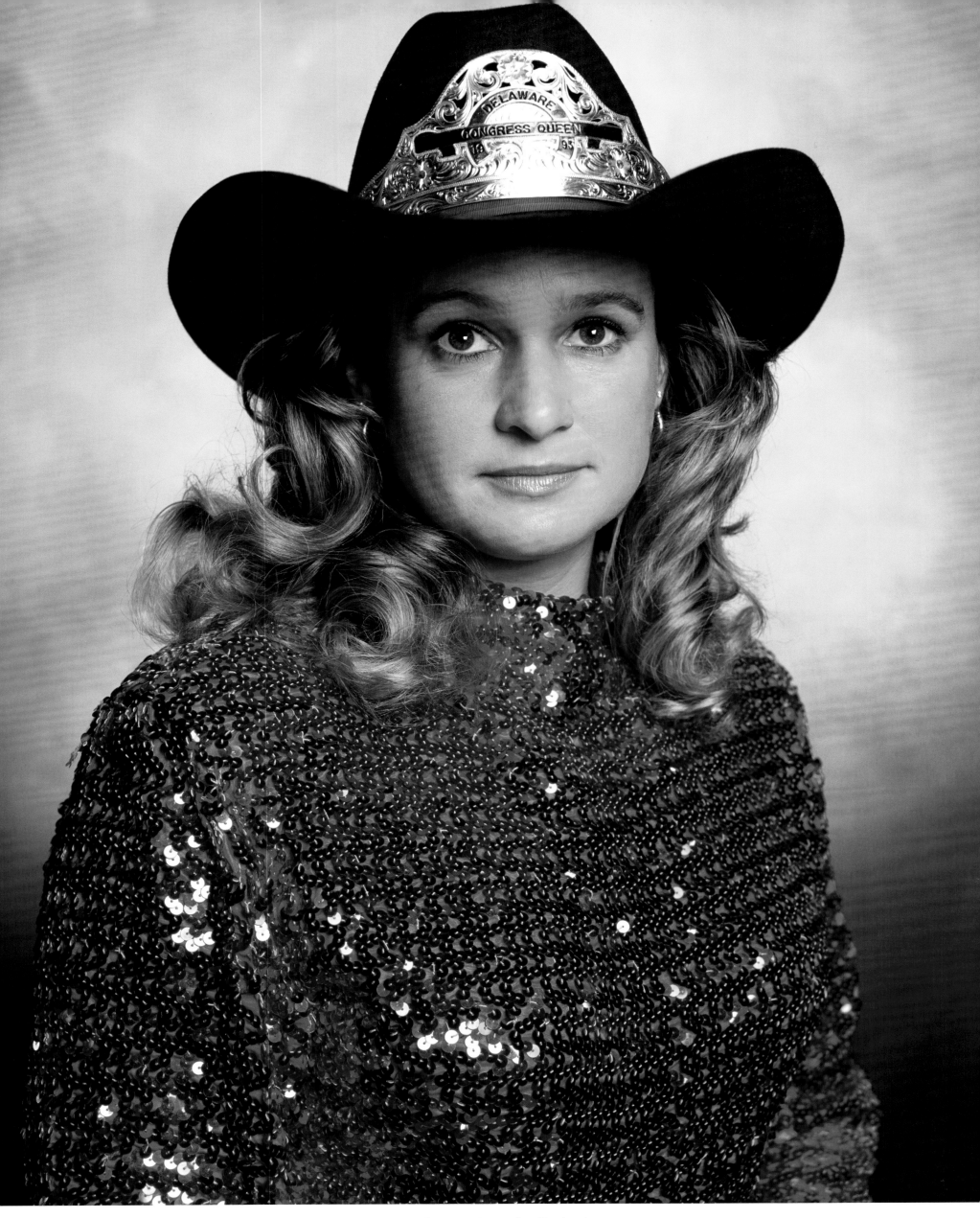

Rodeo Queen Jennifer Ridgely

2002

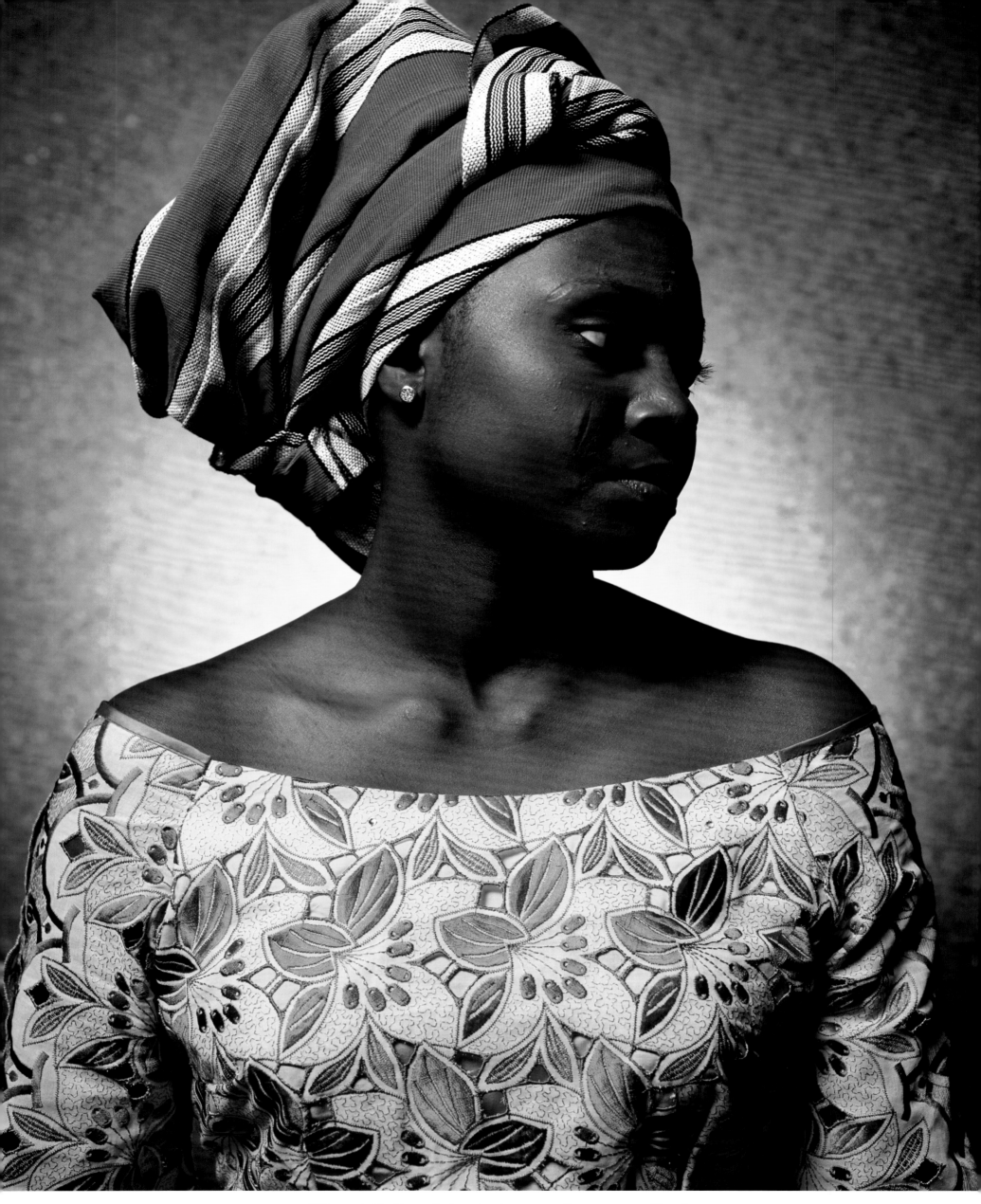

Wunmi Fadipe, Sales Assistant at Investment Bank
2002

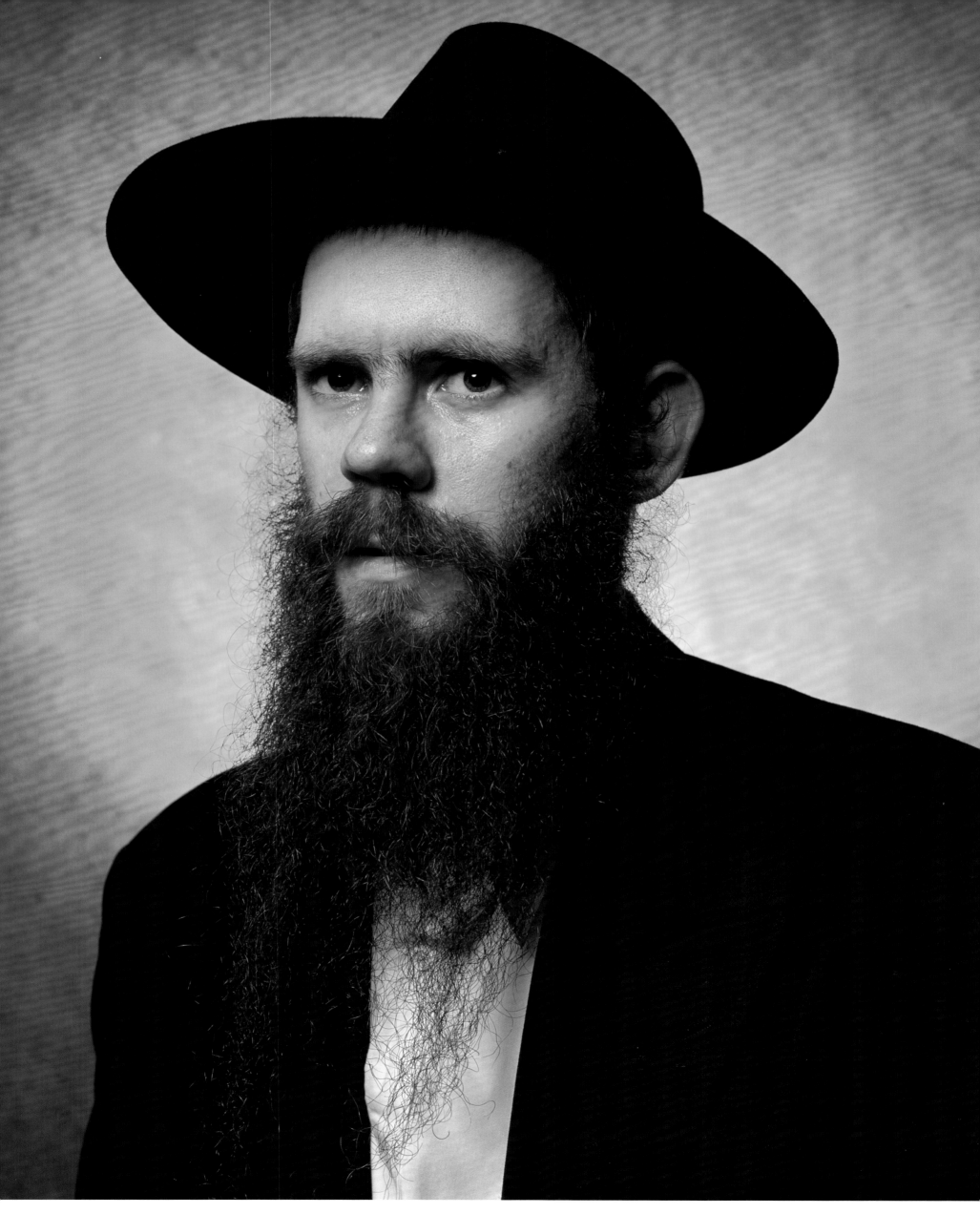

Leib Kats, Lubavitch Hassid

2002

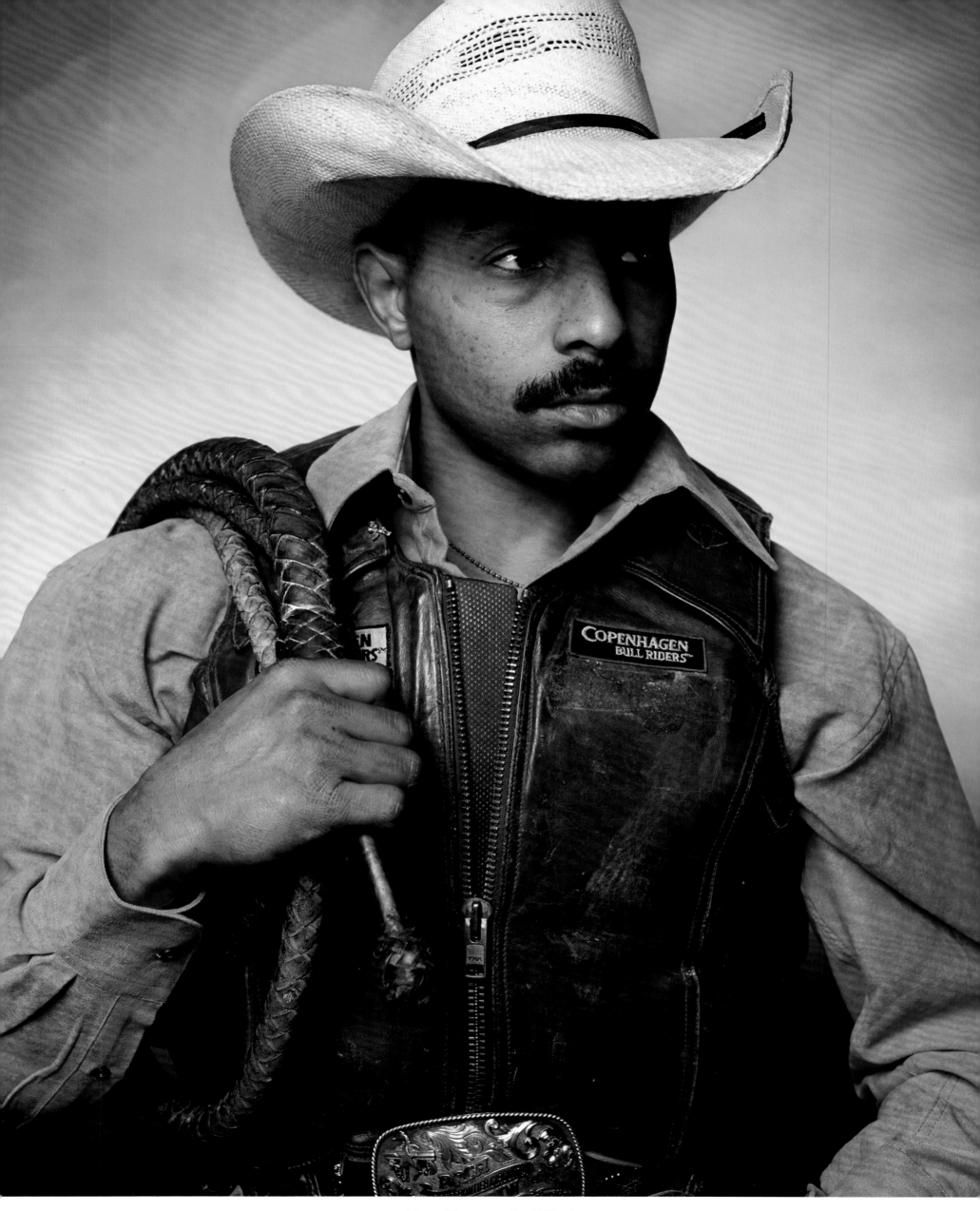

Troy Rowen, Bull Rider

2002

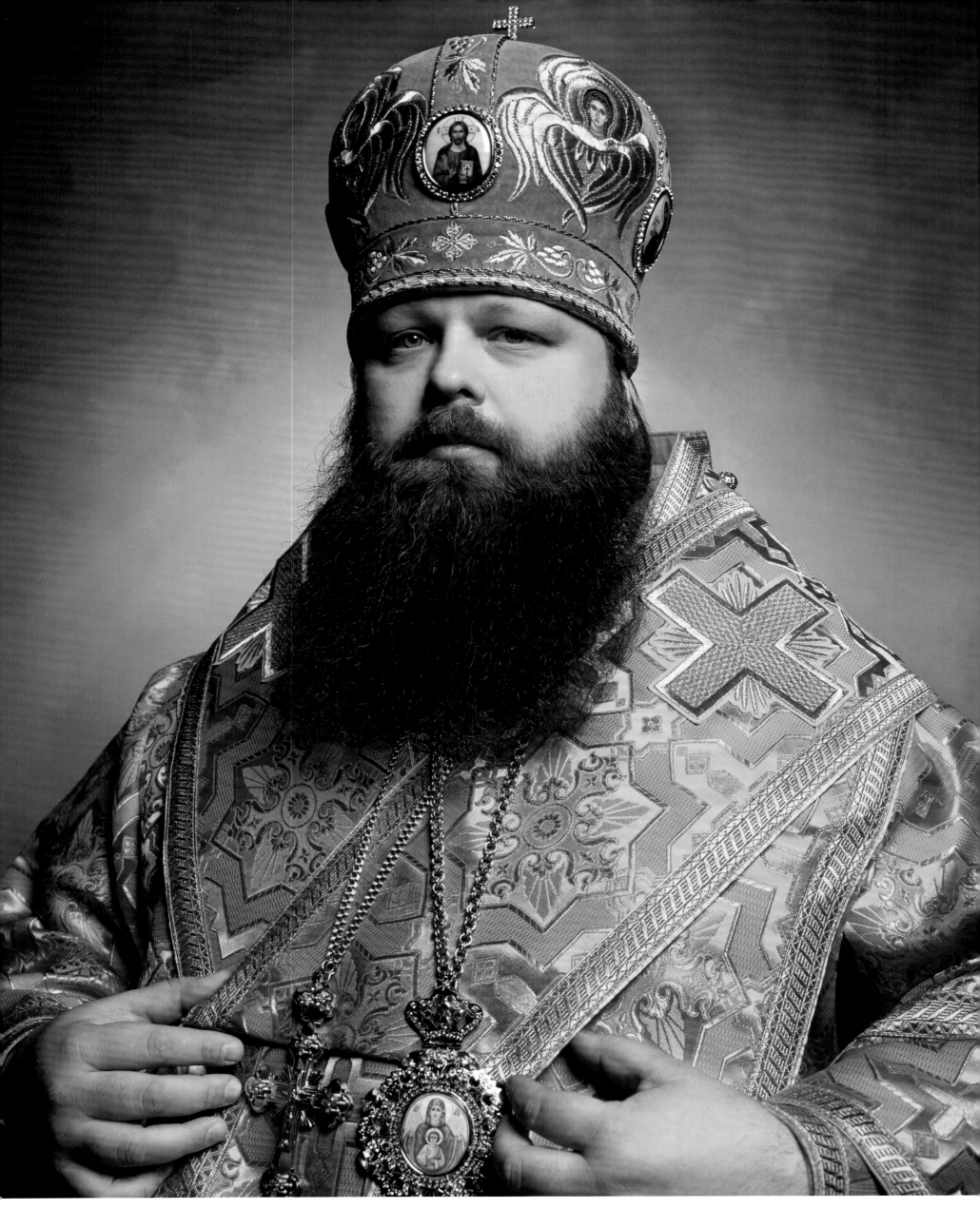

Bishop Mercurius of The Russian Orthodox Church in N.Y.

2002

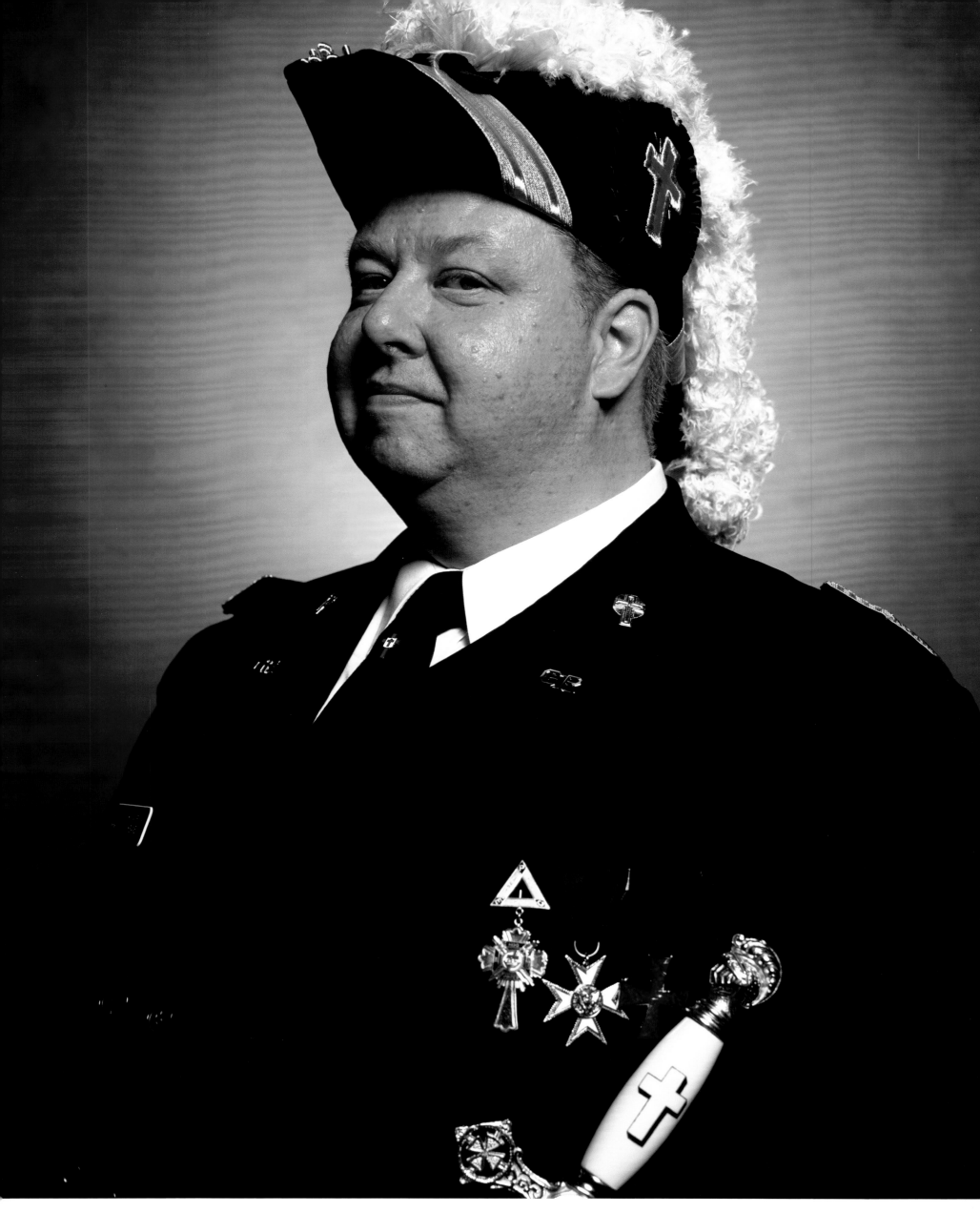

Sir Knight James M. Keane, Knights Templar/ Freemason

2002

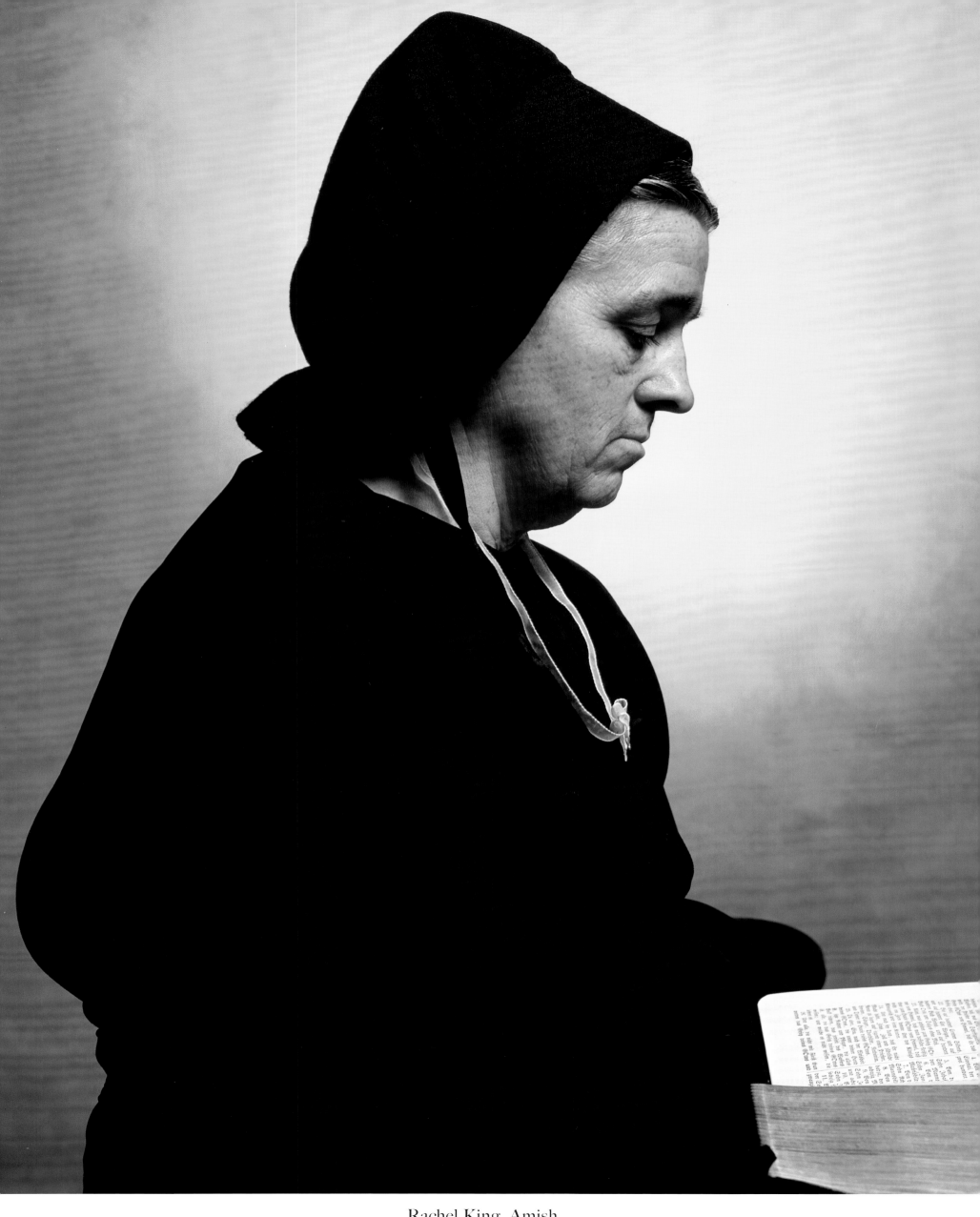

Rachel King, Amish

2002

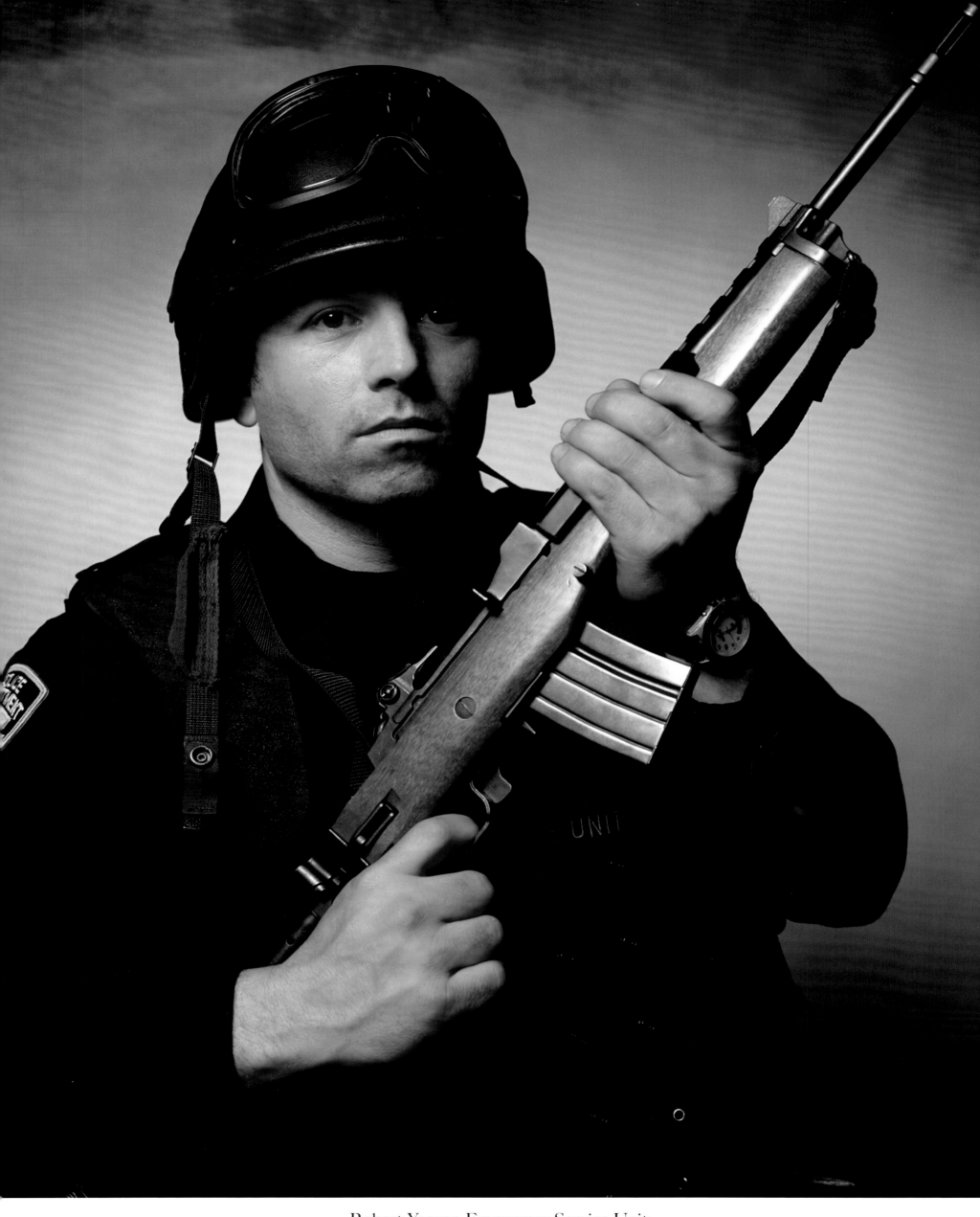

Robert Yaeger, Emergency Service Unit
2001

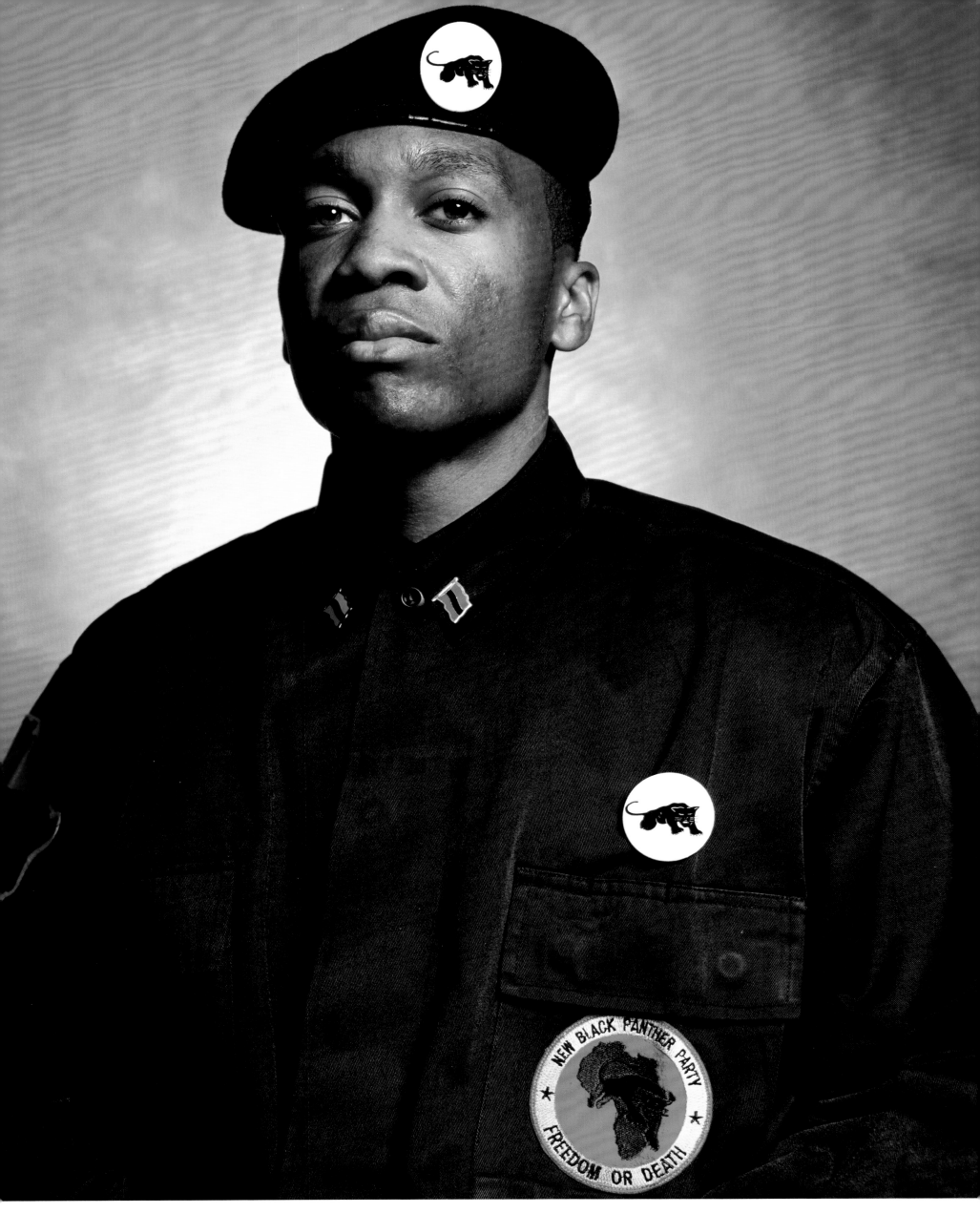

Brother Divine Allah, N.J. Chairman of The New Black Panther Party

2002

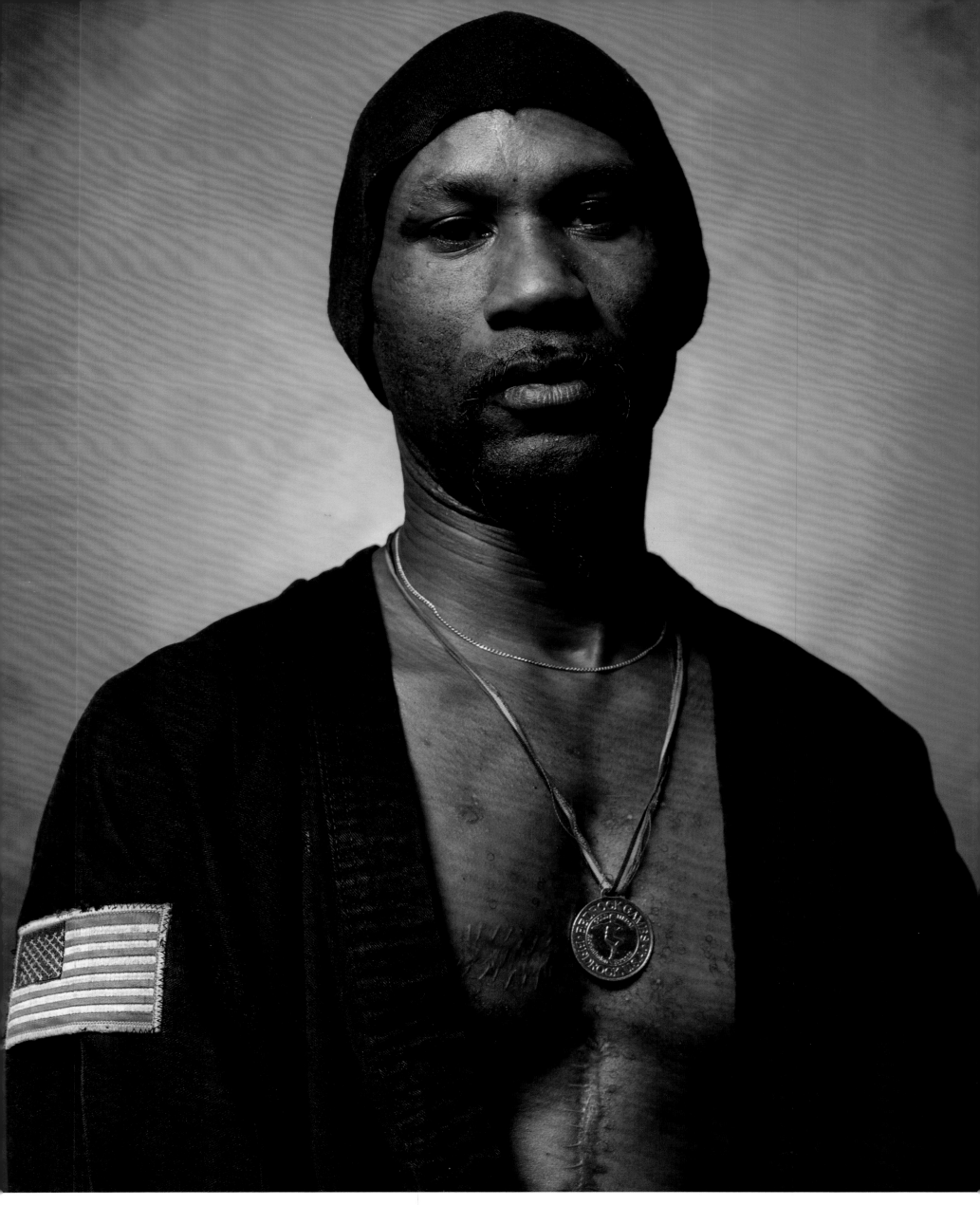

Derrick Ezell, Resident of The Sunshine Hotel on the Bowery
2002

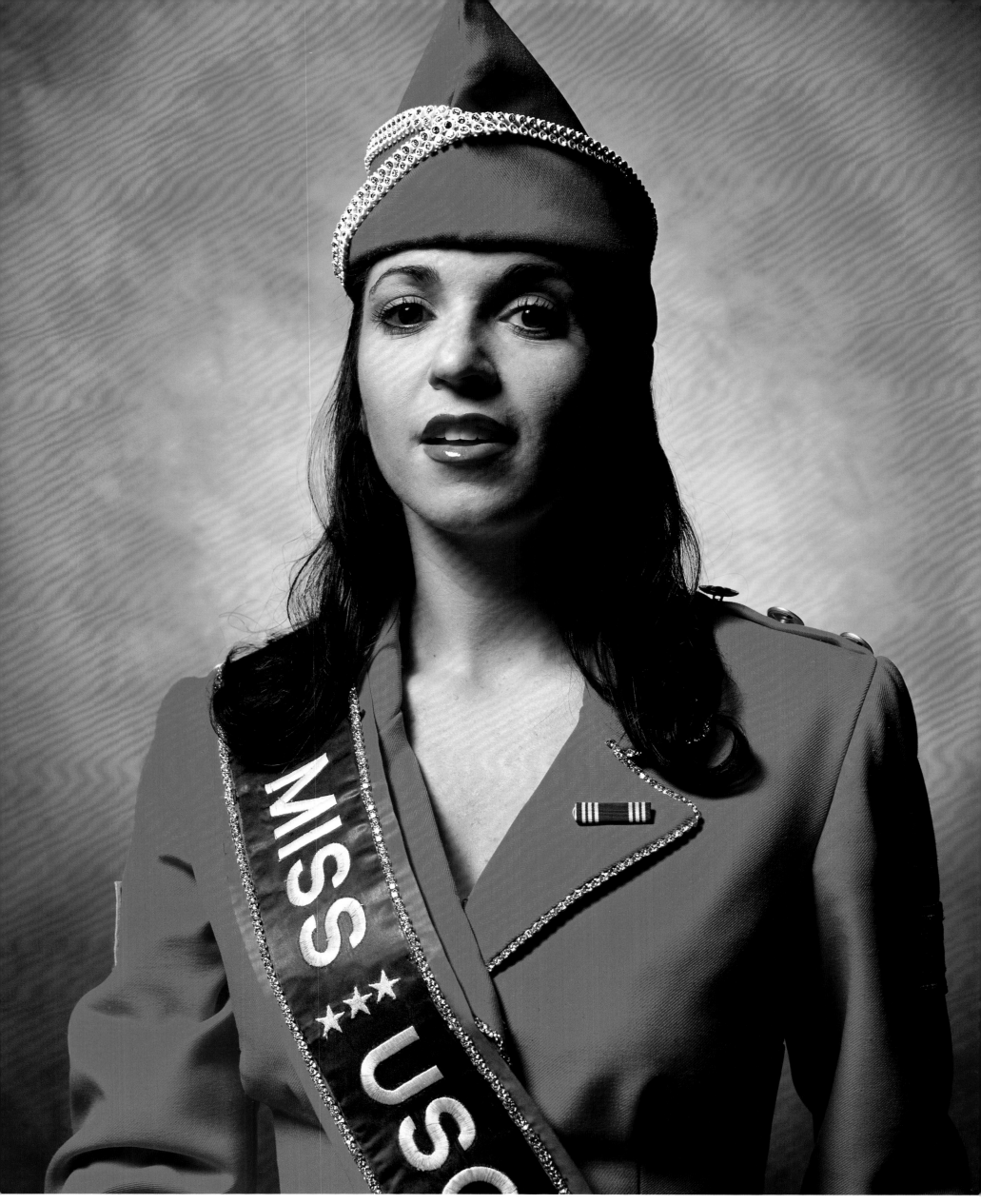

Laurie Ferdman, Miss USO

2002

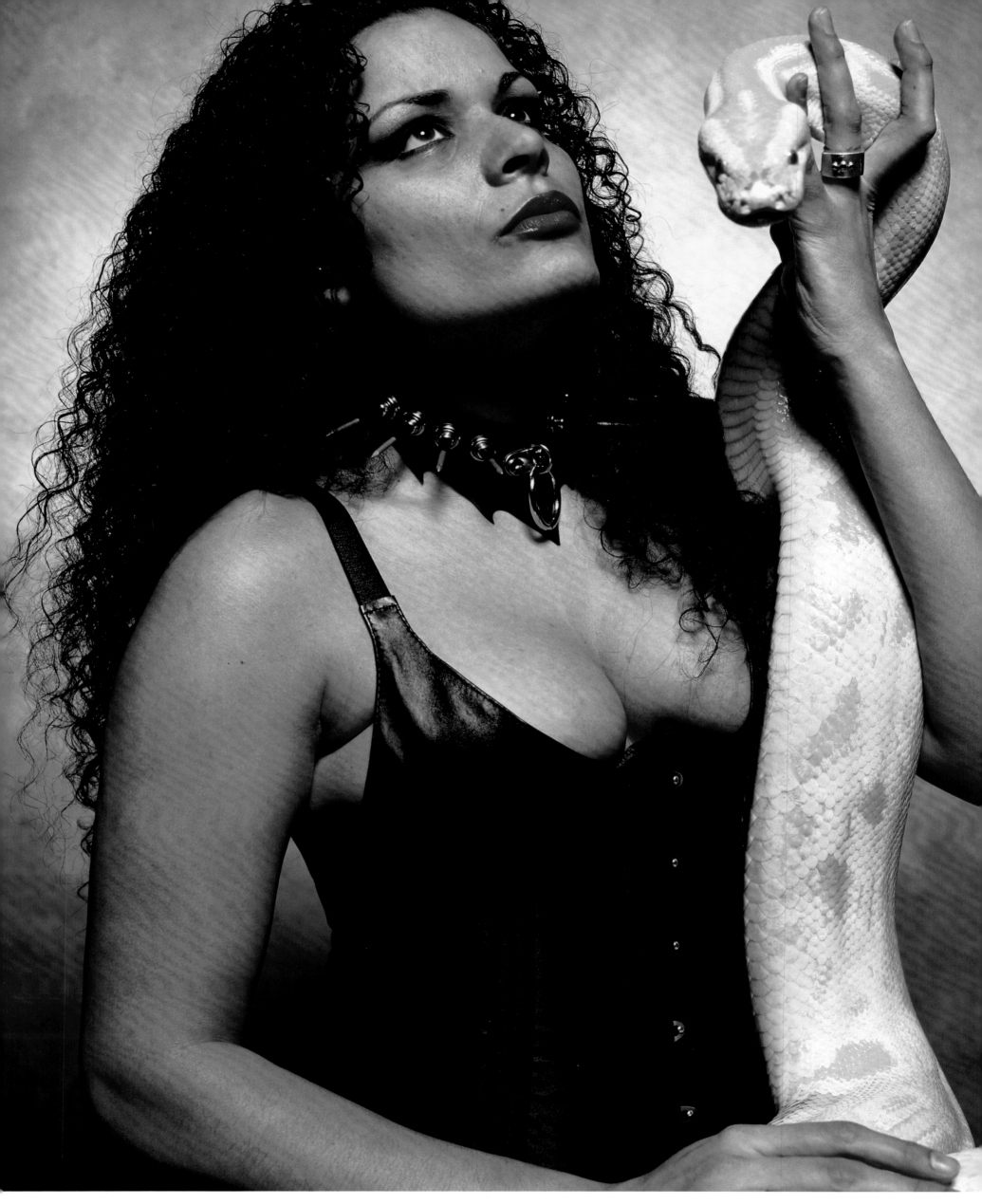

Serpentina, The Coney Island Circus and Sideshow
2003

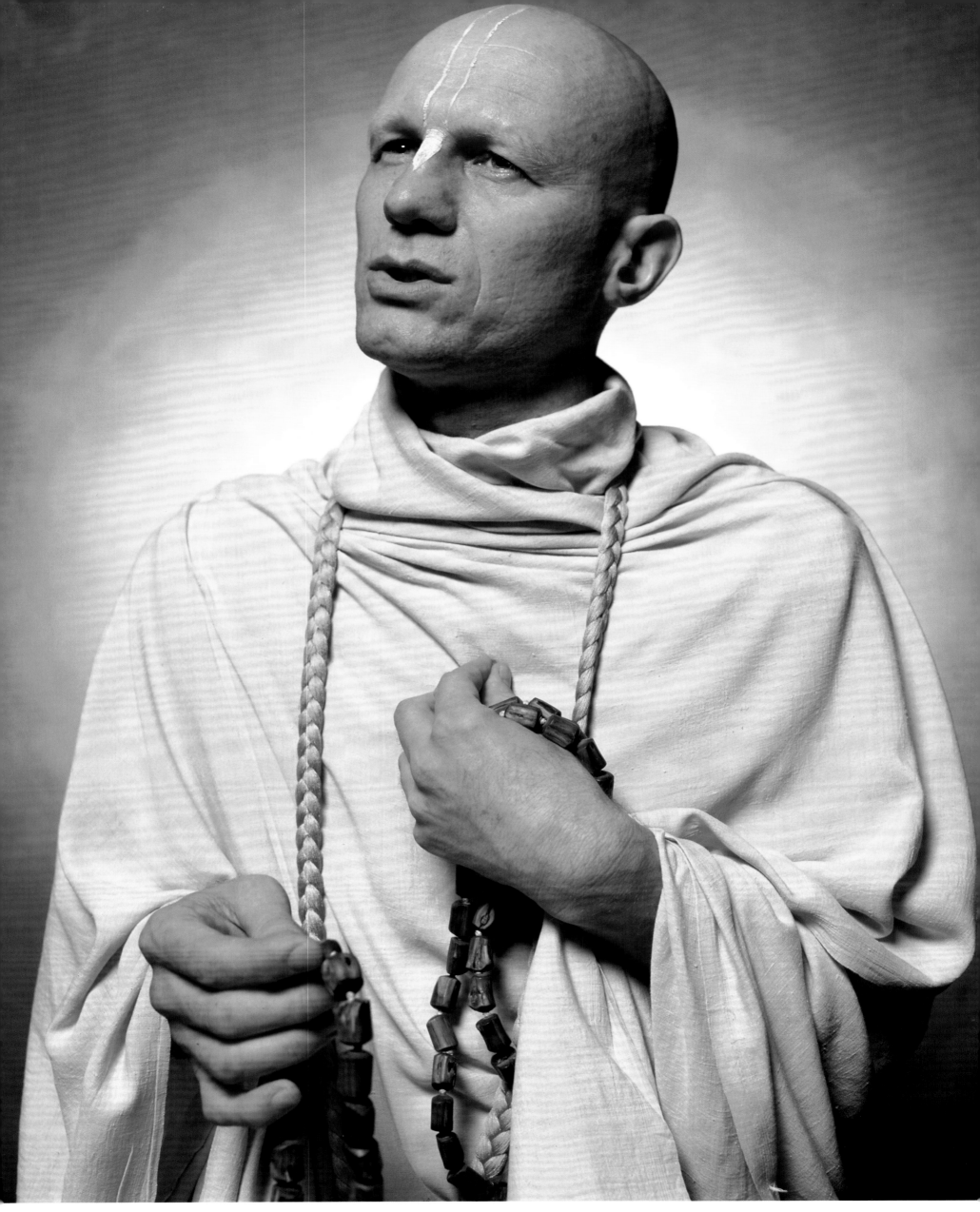

Yajna Purusha Dasa, Hare-Krishna Devotee
2003

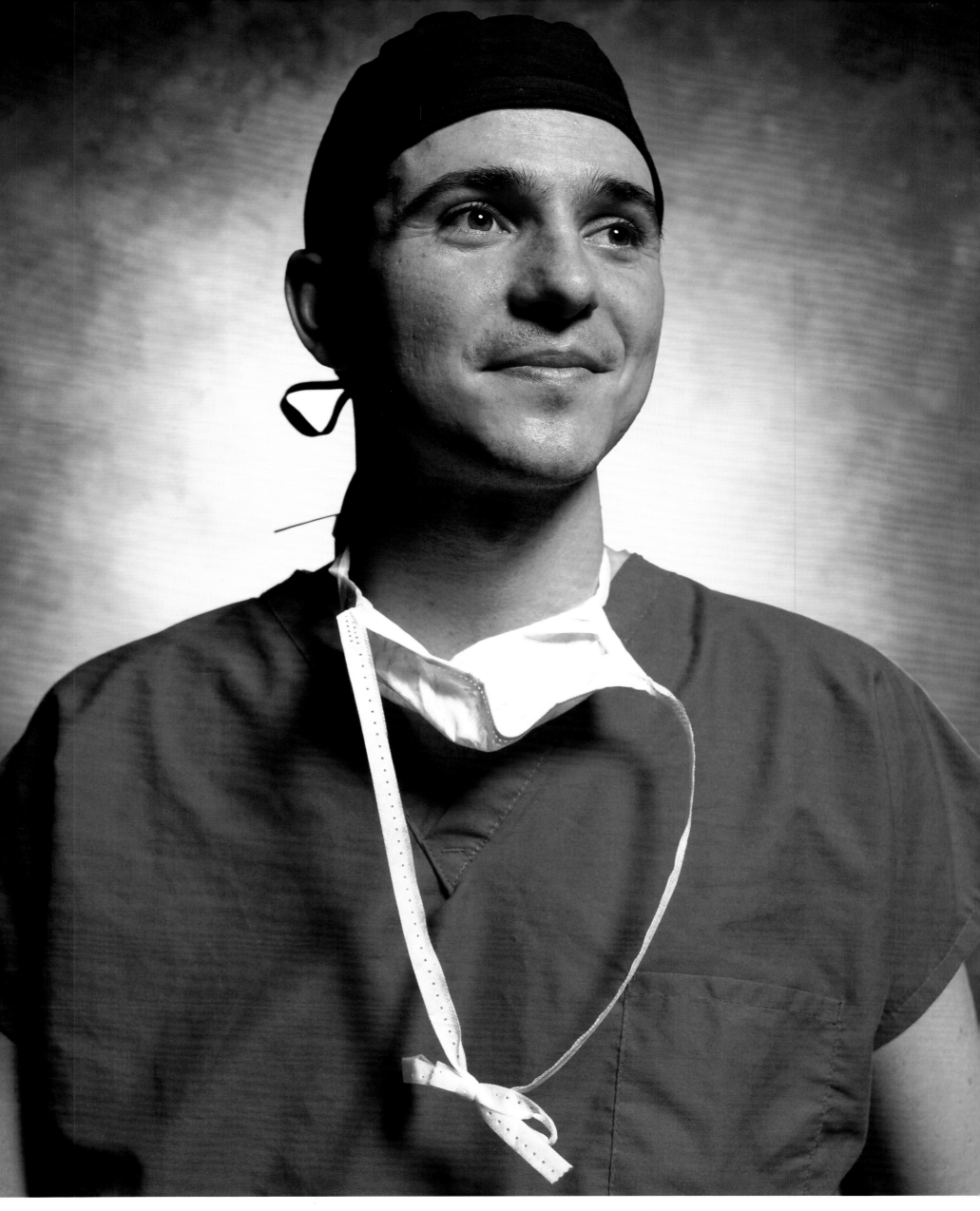

Dr. Francisco G. Bravo, Reconstructive Plastic Surgeon
2003

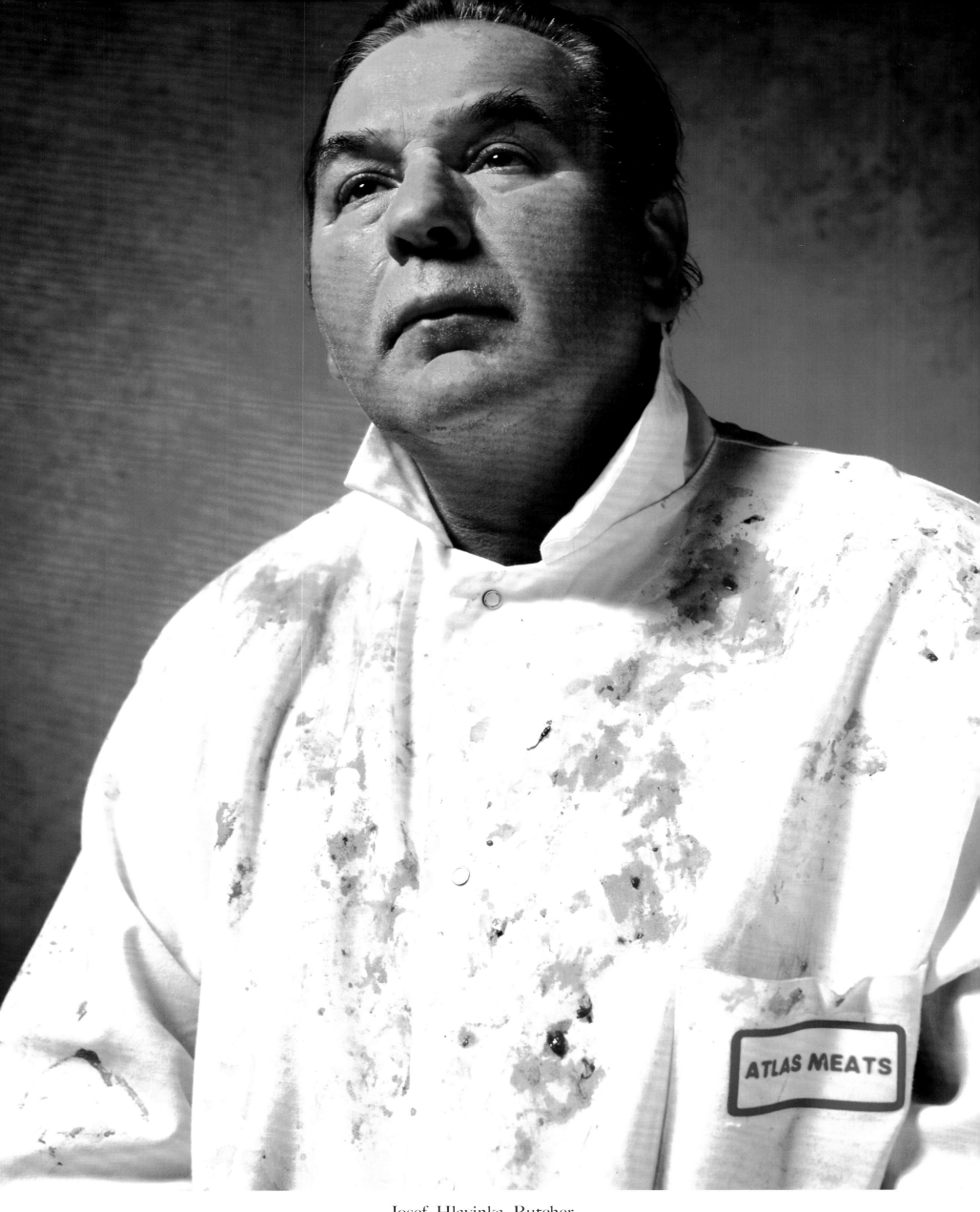

Josef Hlavinka, Butcher
2003

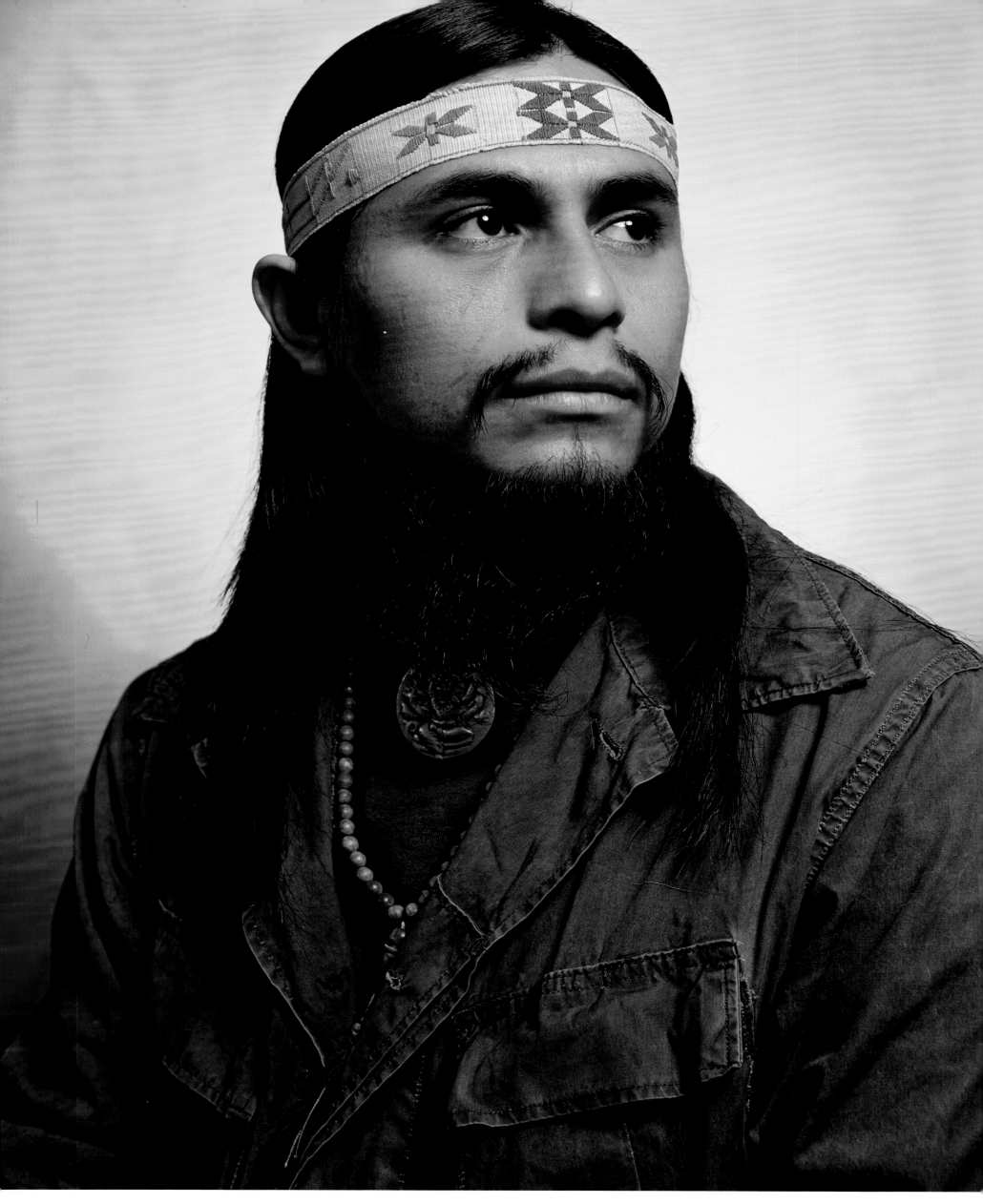

Cheneke Nanaoxi, Mexican Migrant Worker
2002

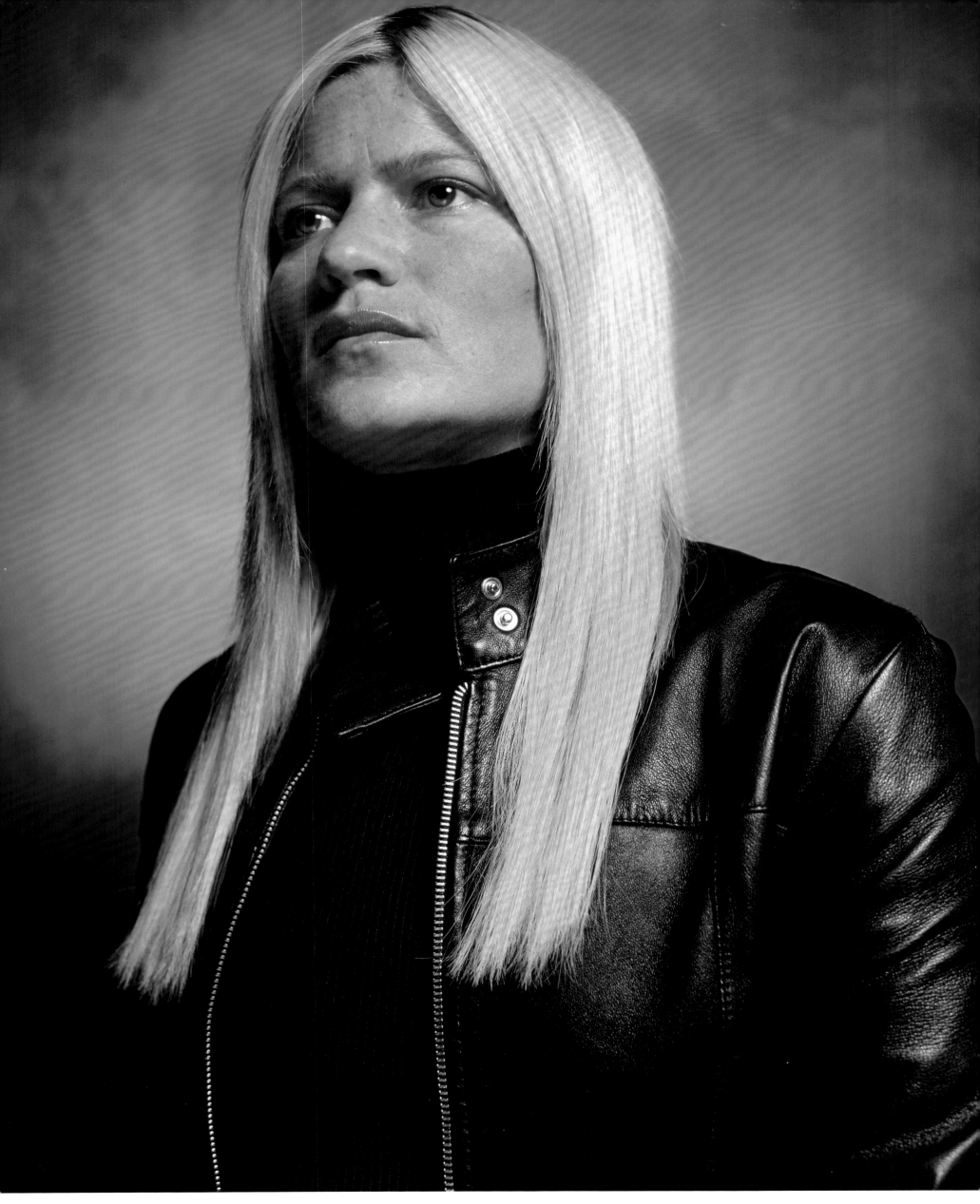

Lizzie Grubman, Public Relations
2003

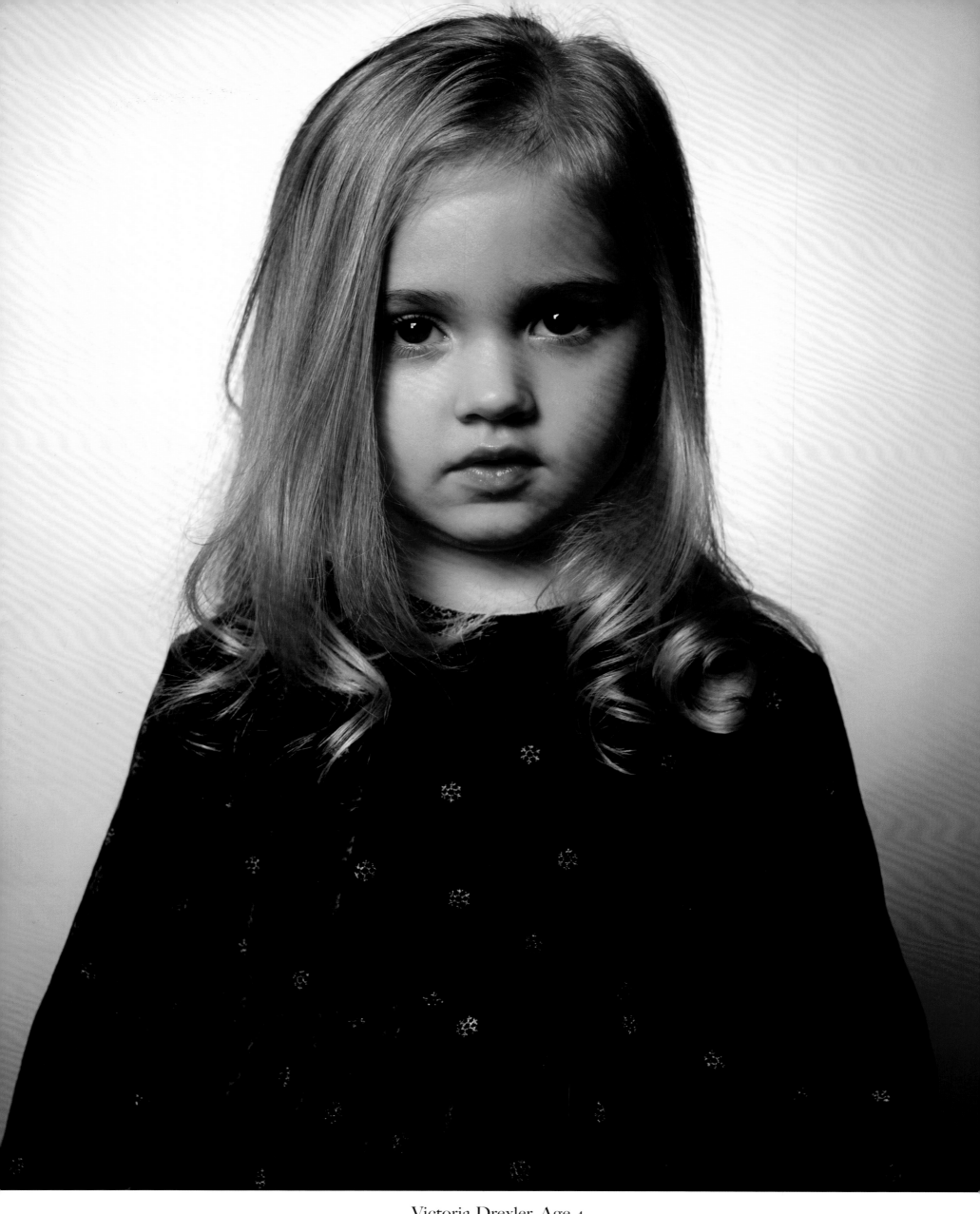

Victoria Drexler, Age 4

2002

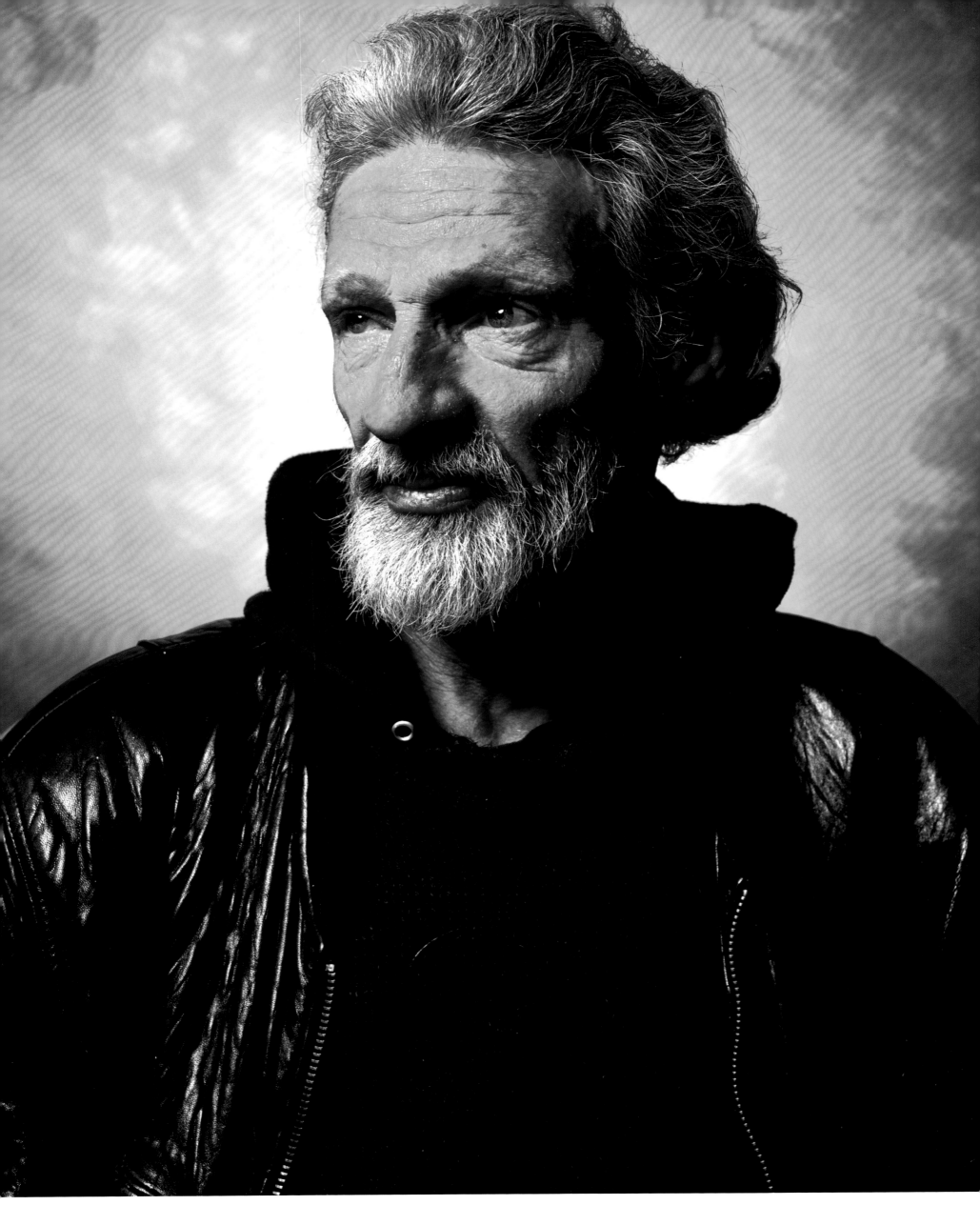

William Nelson, Heroin Addict

2002

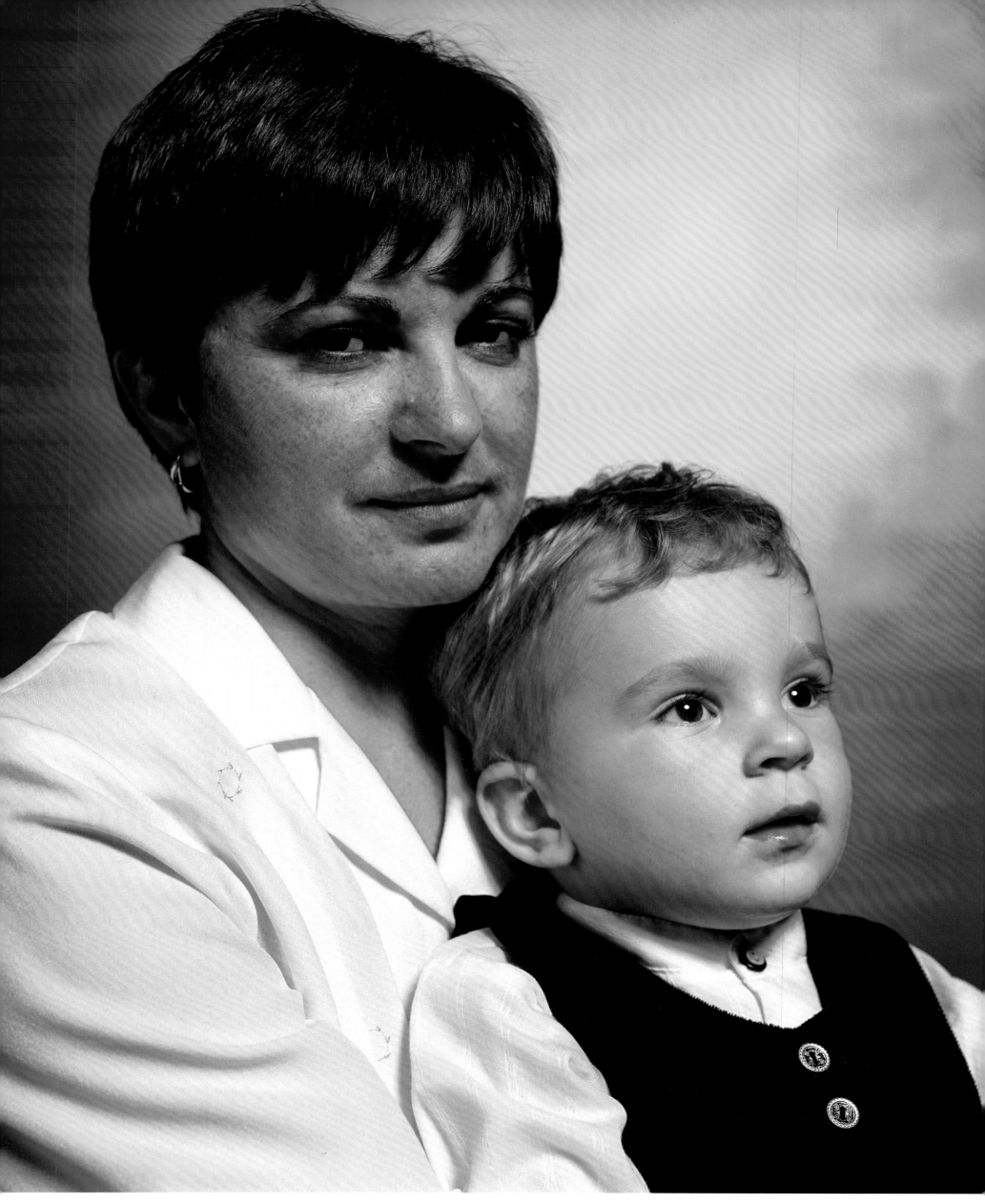

Ulyana and Artur, Mother And Child On Welfare
2003

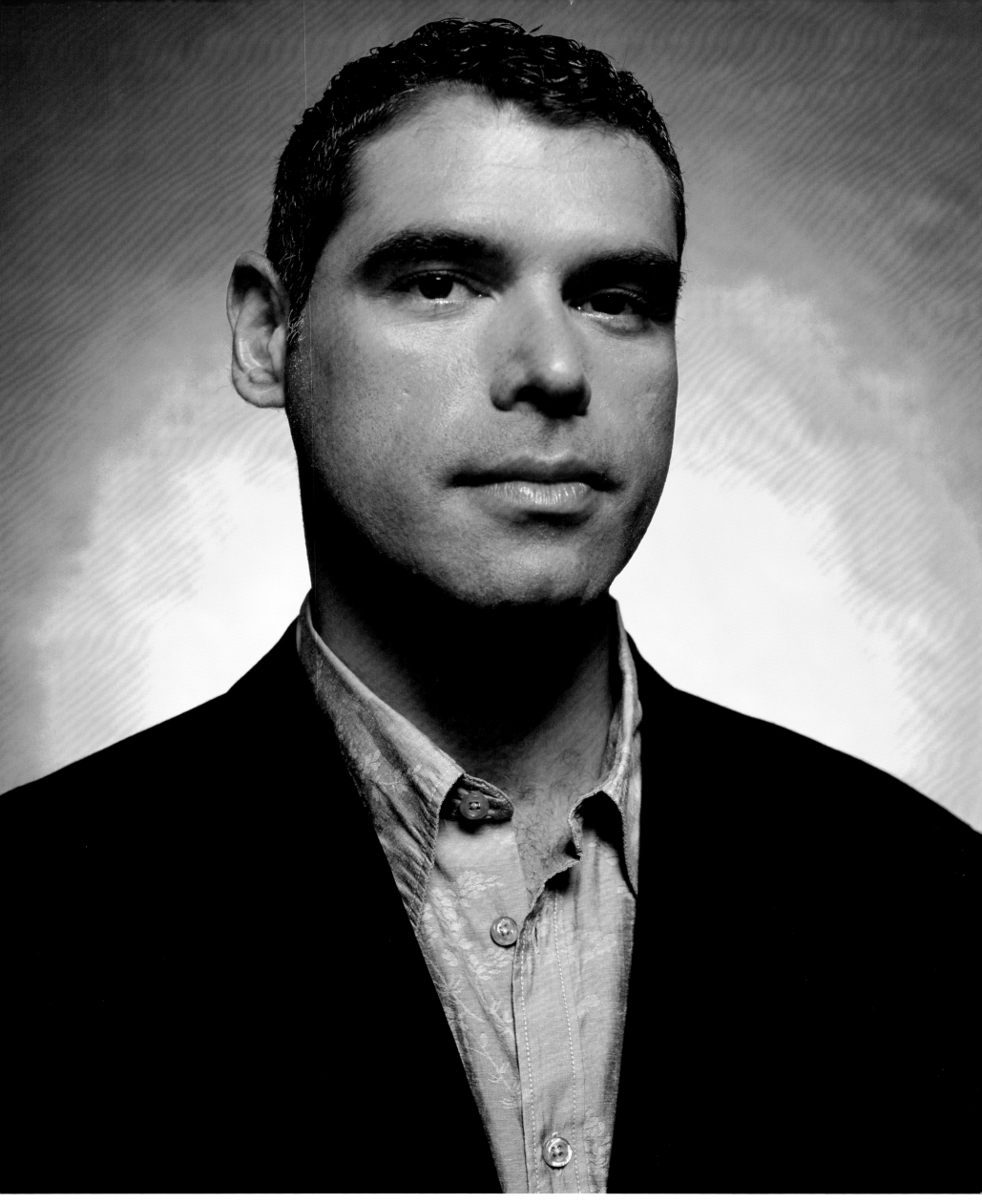

Jorge Masdeu, HIV Positive
2003

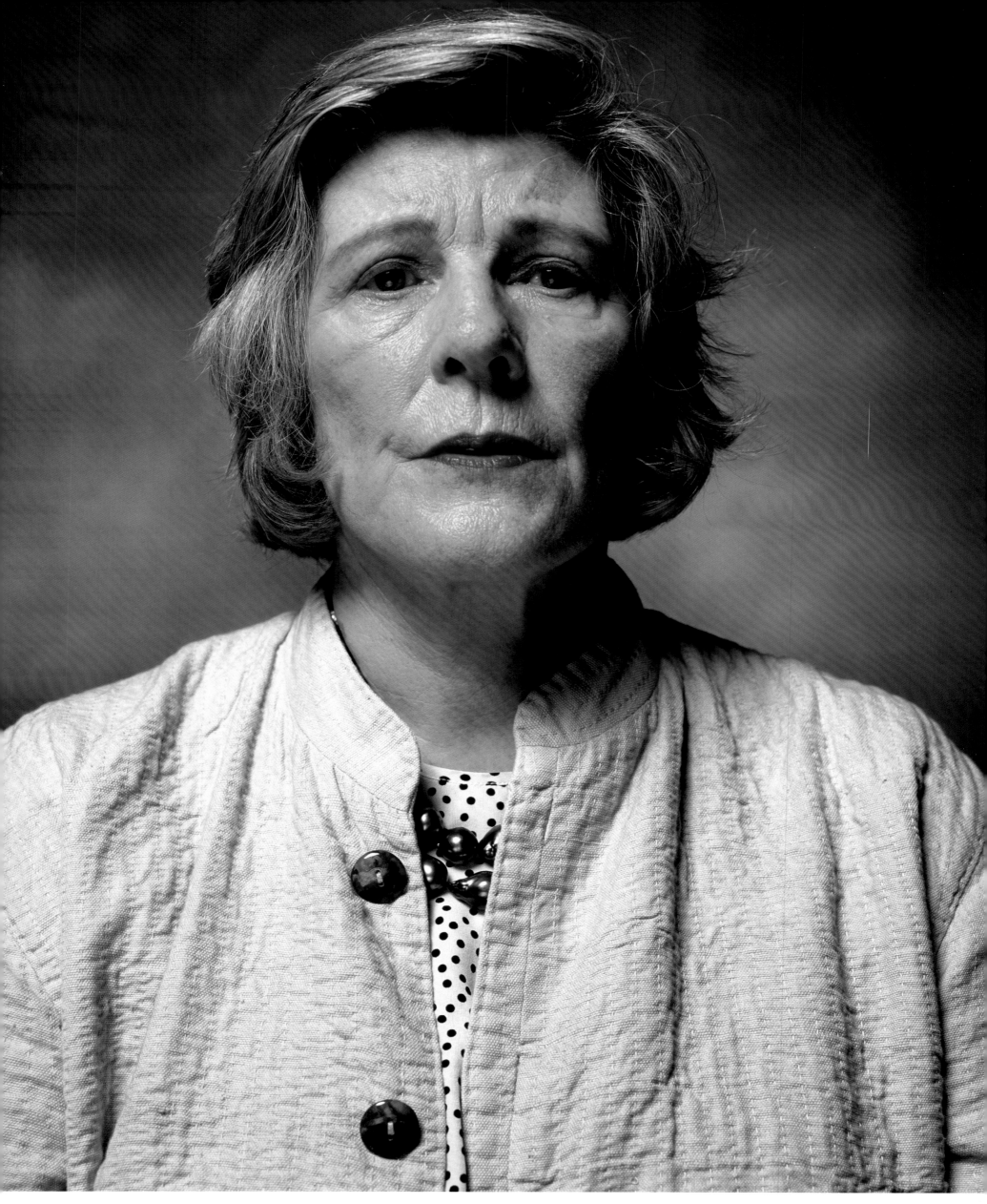

Agnes Gund, Philanthropist
2004

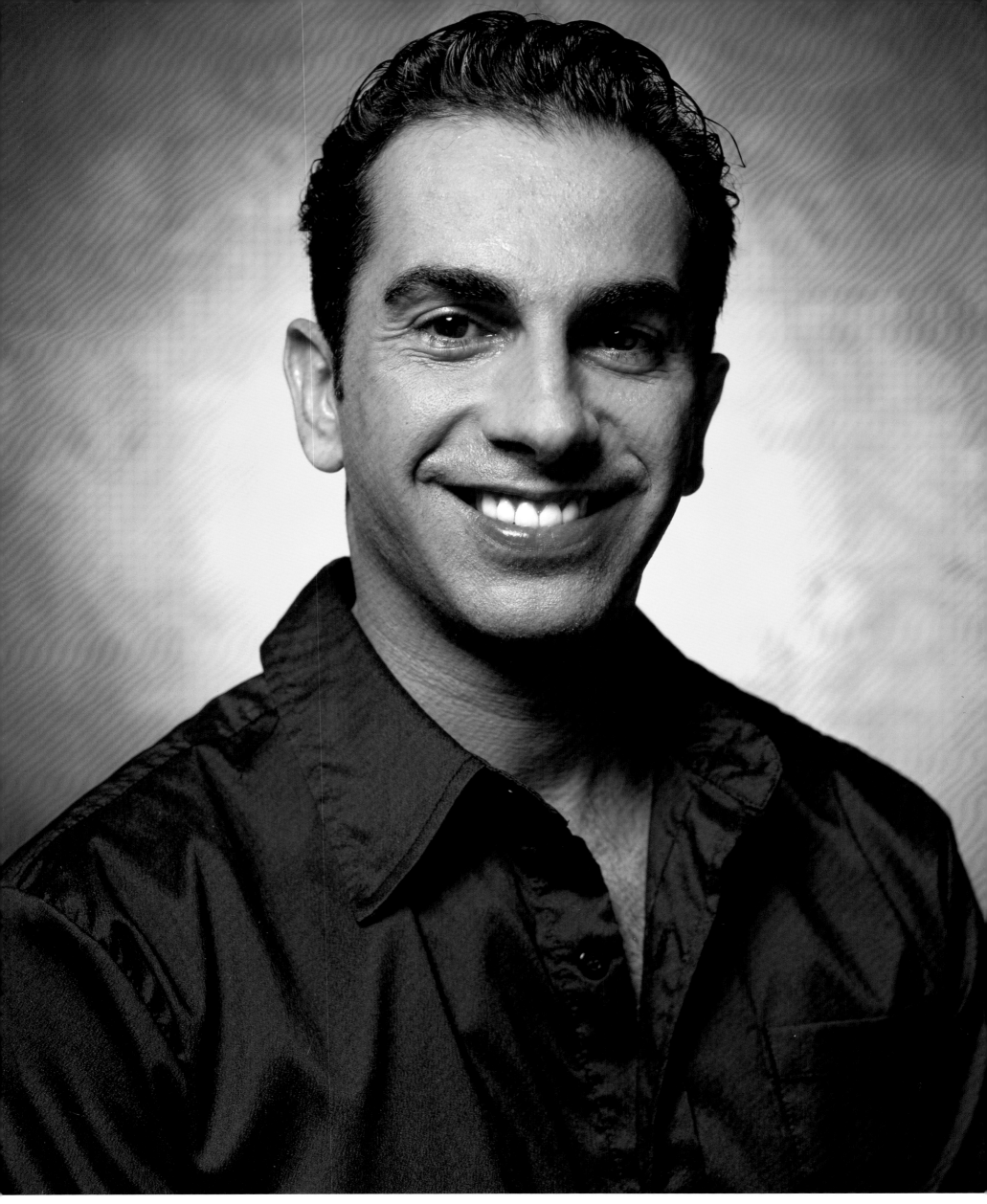

Henry Menendez, Person With Aids

2003

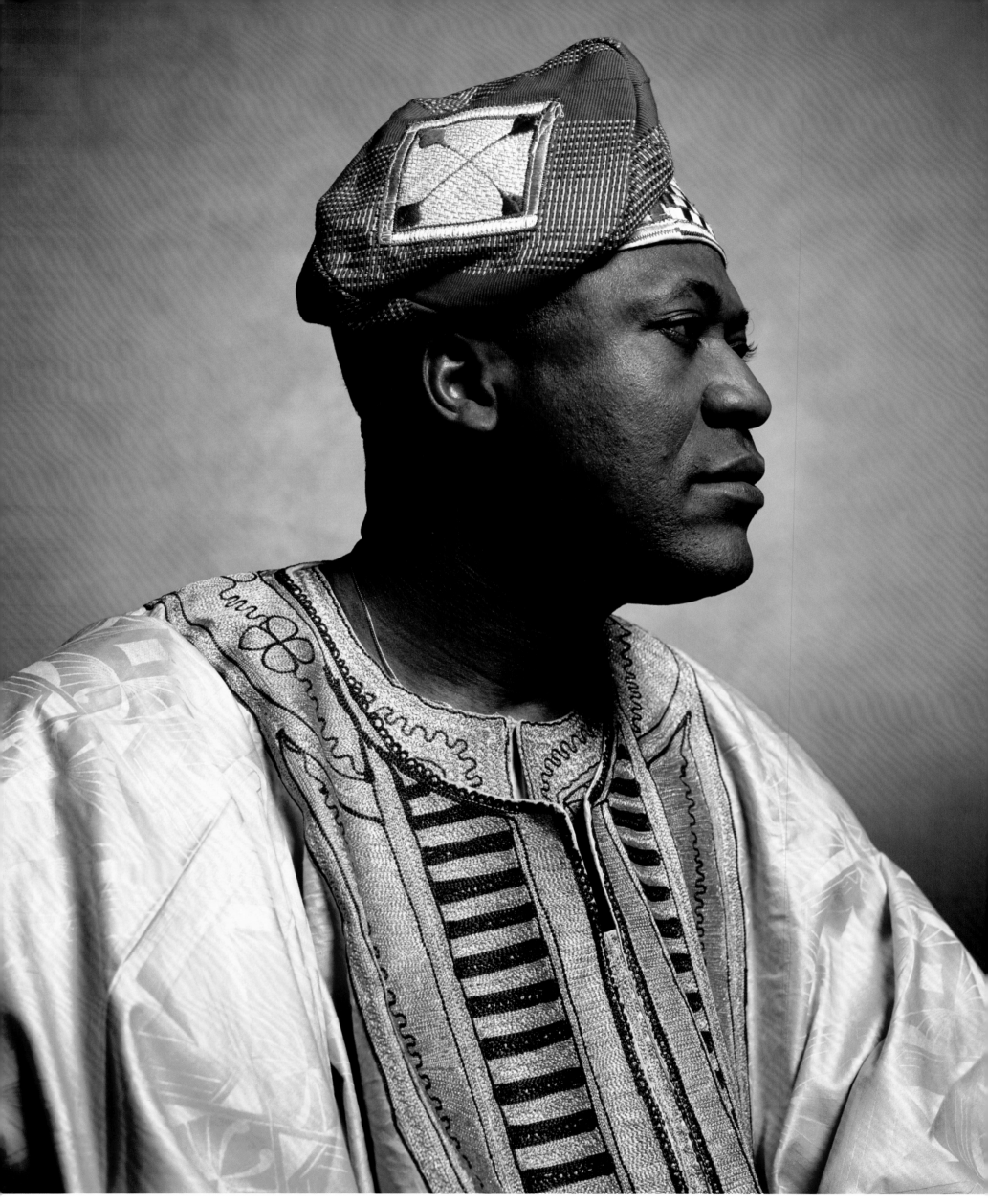

Emmanuel Obadina, Procurement Analyst

2002

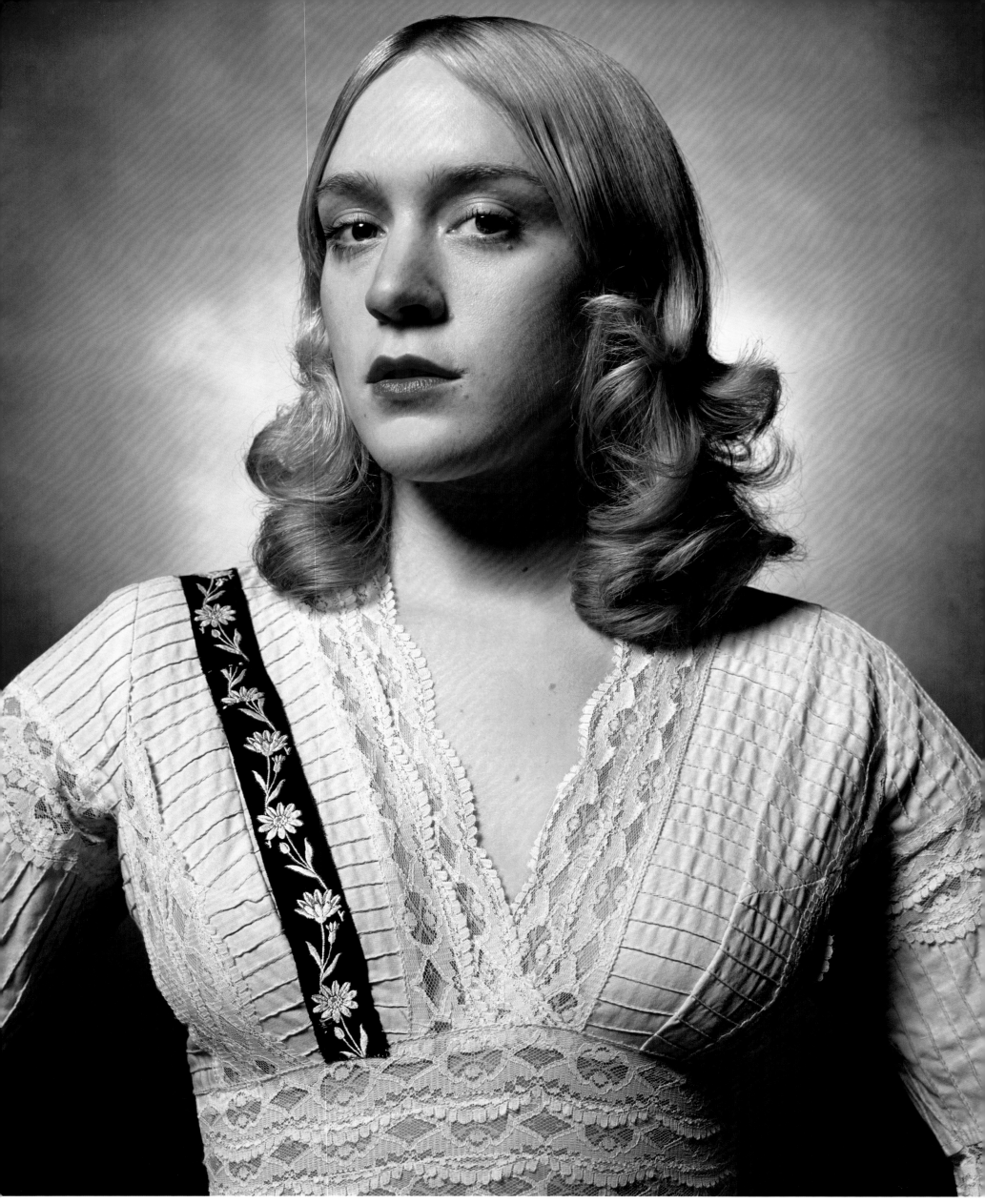

Chloë Sevigny

2002

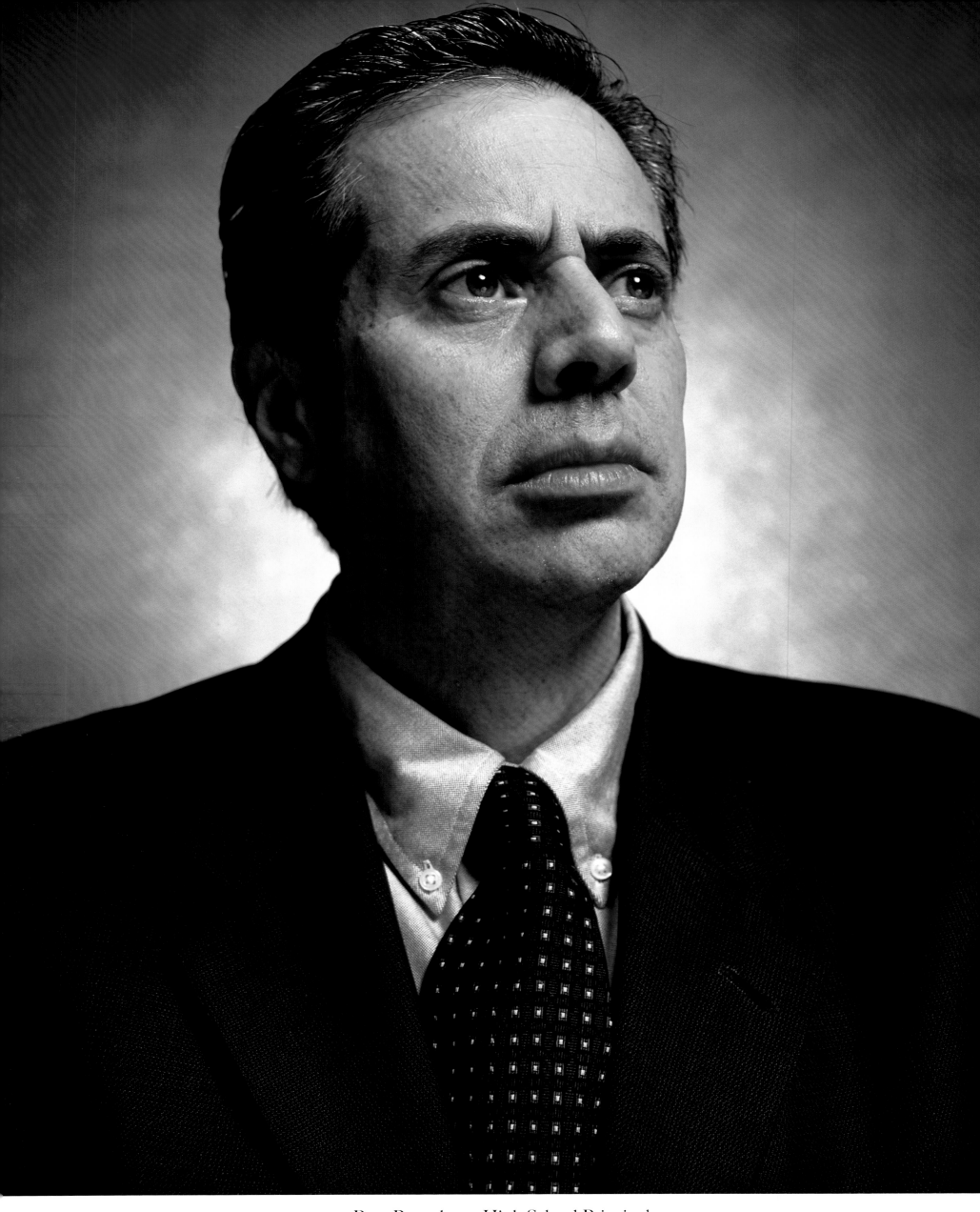

Burt Rosenberg, High School Principal
2003

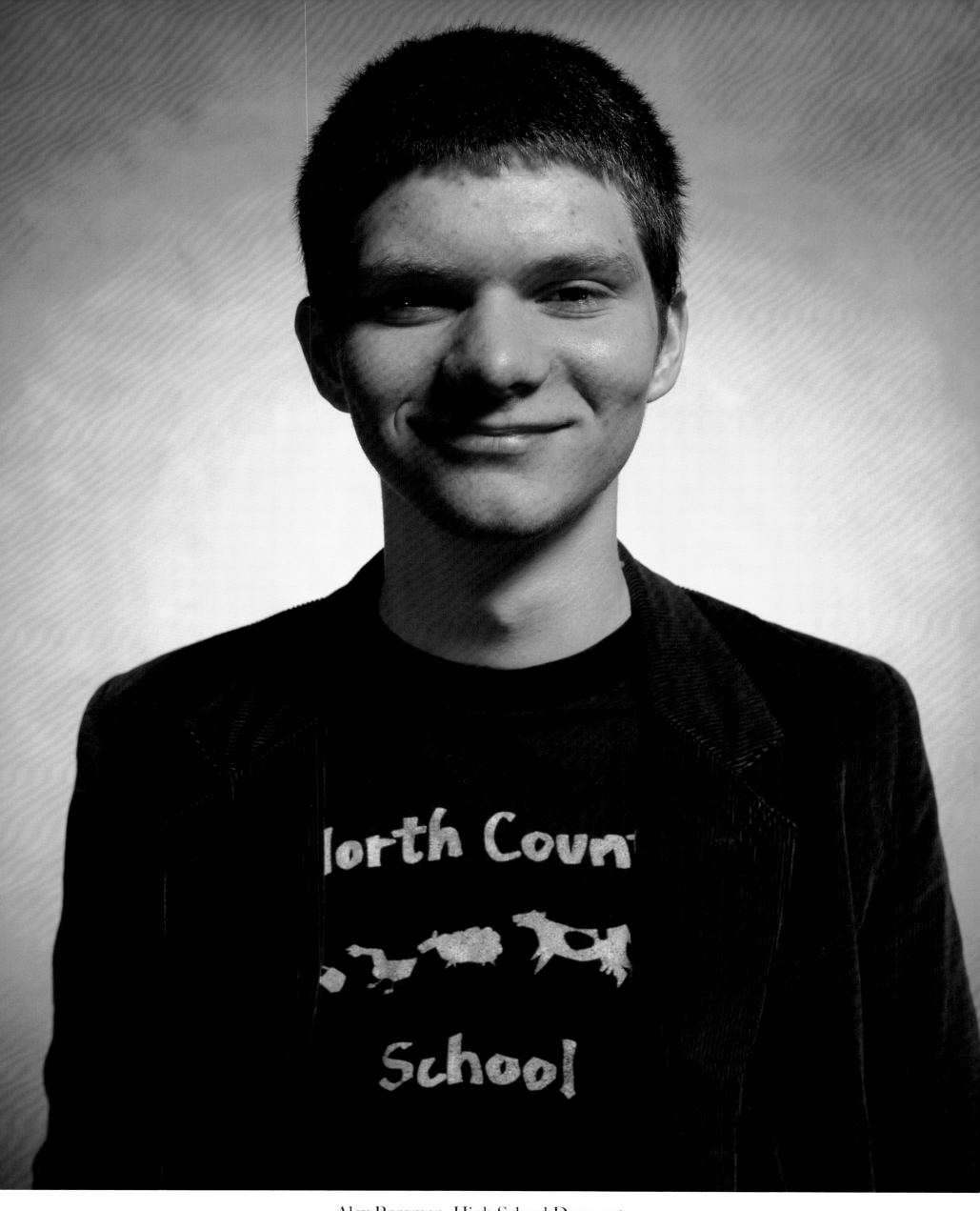

Alex Bergman, High School Drop-out
2003

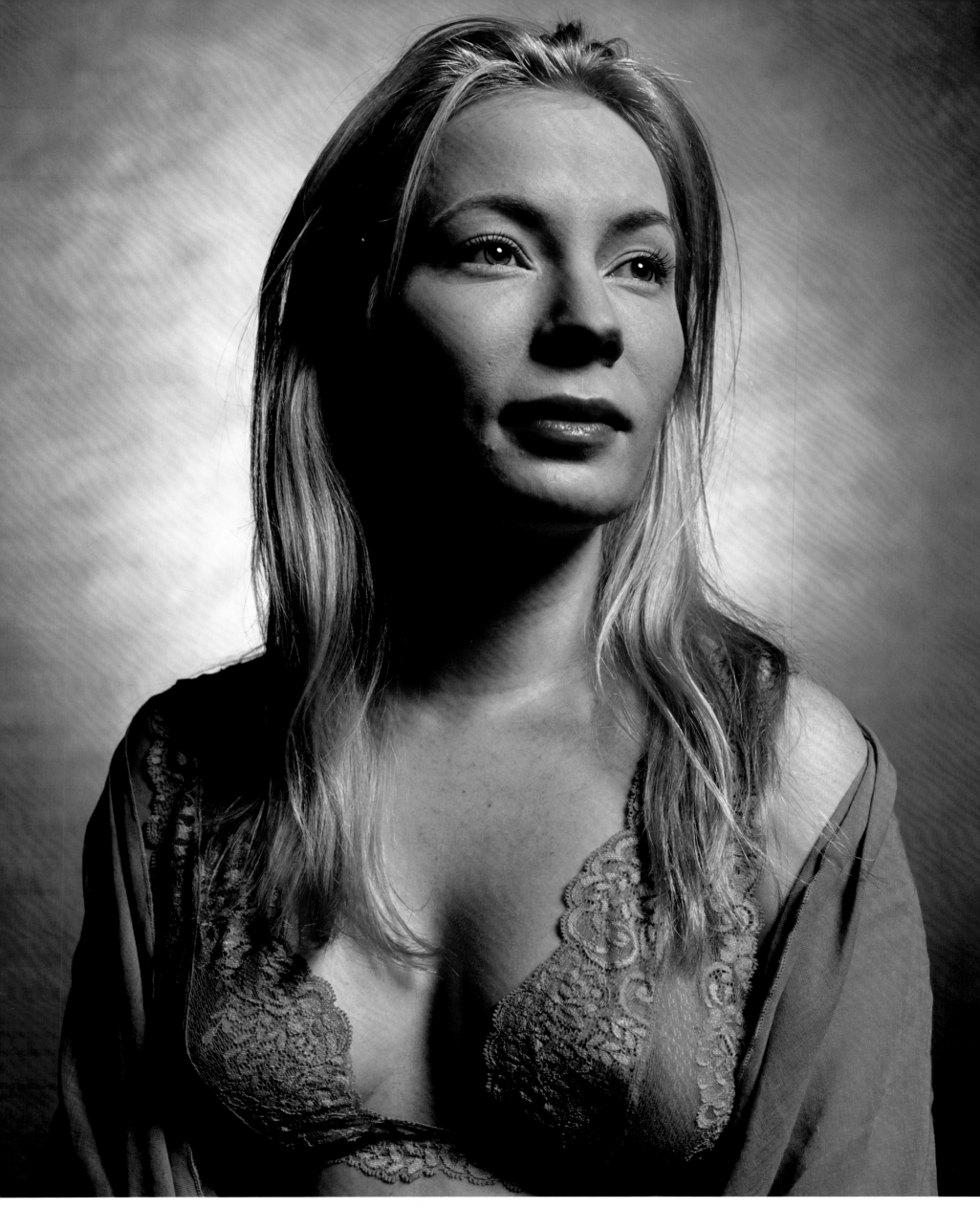

Rebecca Kaye, Escort

2002

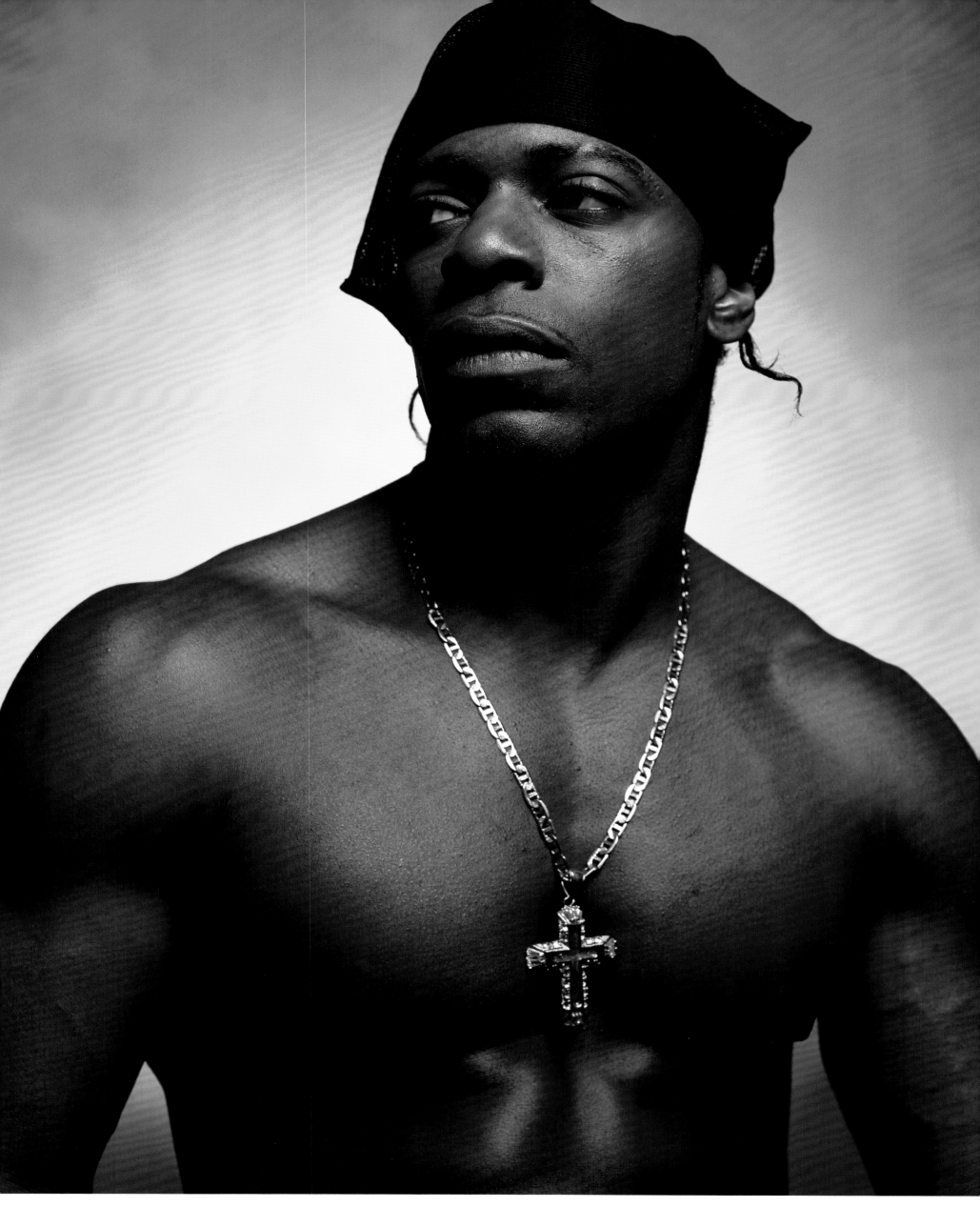

Lawrence Artis, Performer

2002

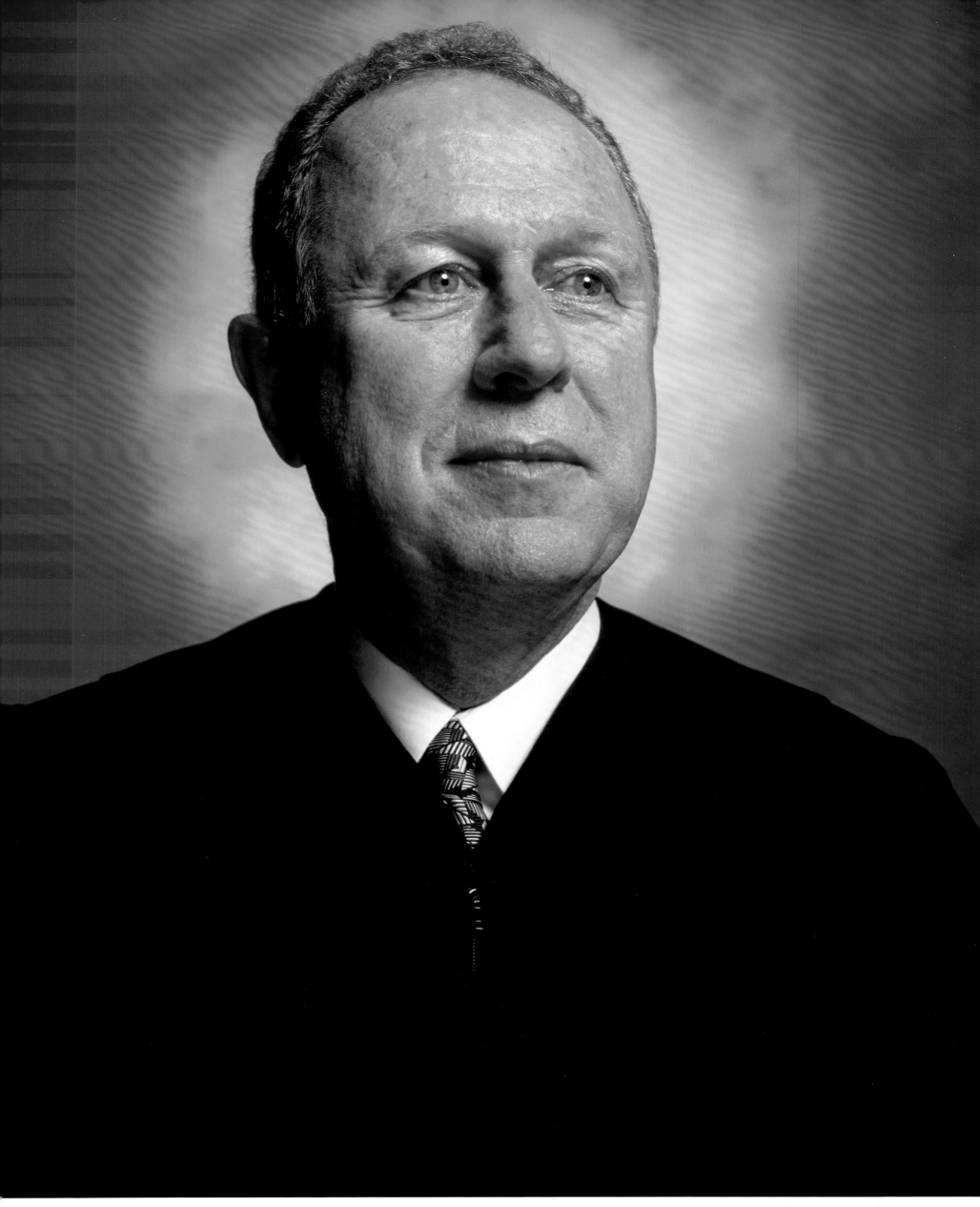

Federal Judge William Royal Furgeson

2003

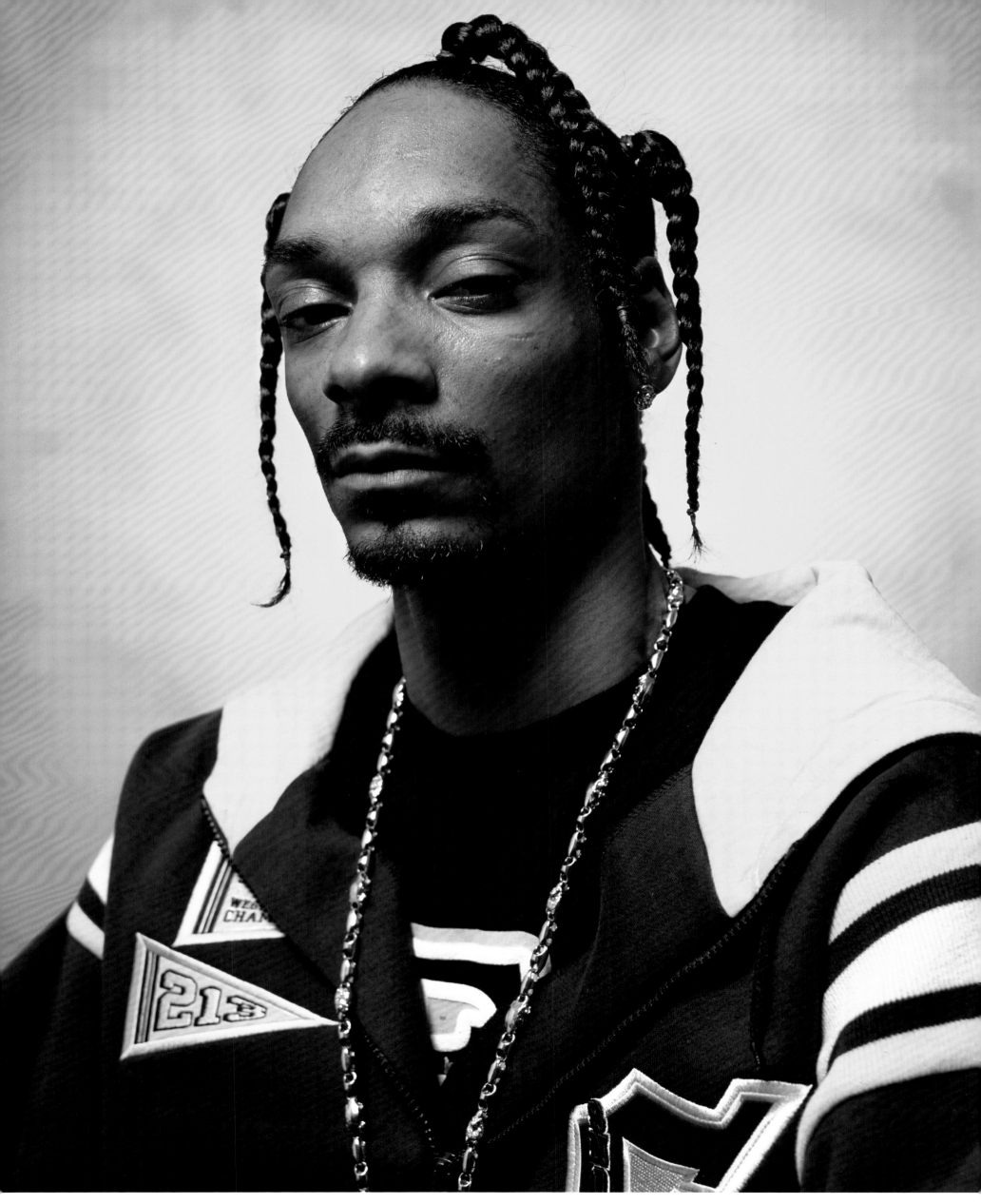

Snoop Dogg
2002

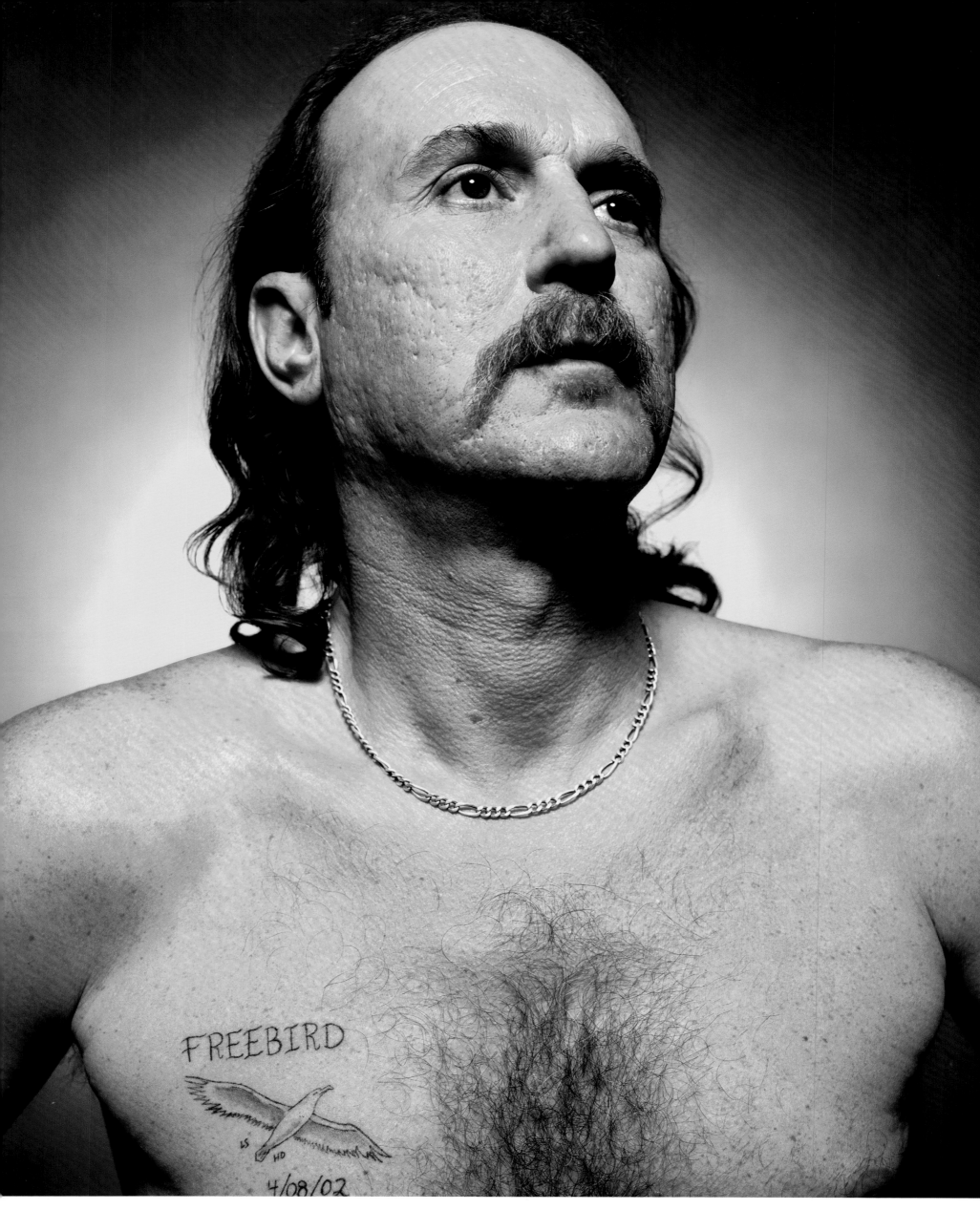

Ray Krone, Released from Death Row
2003

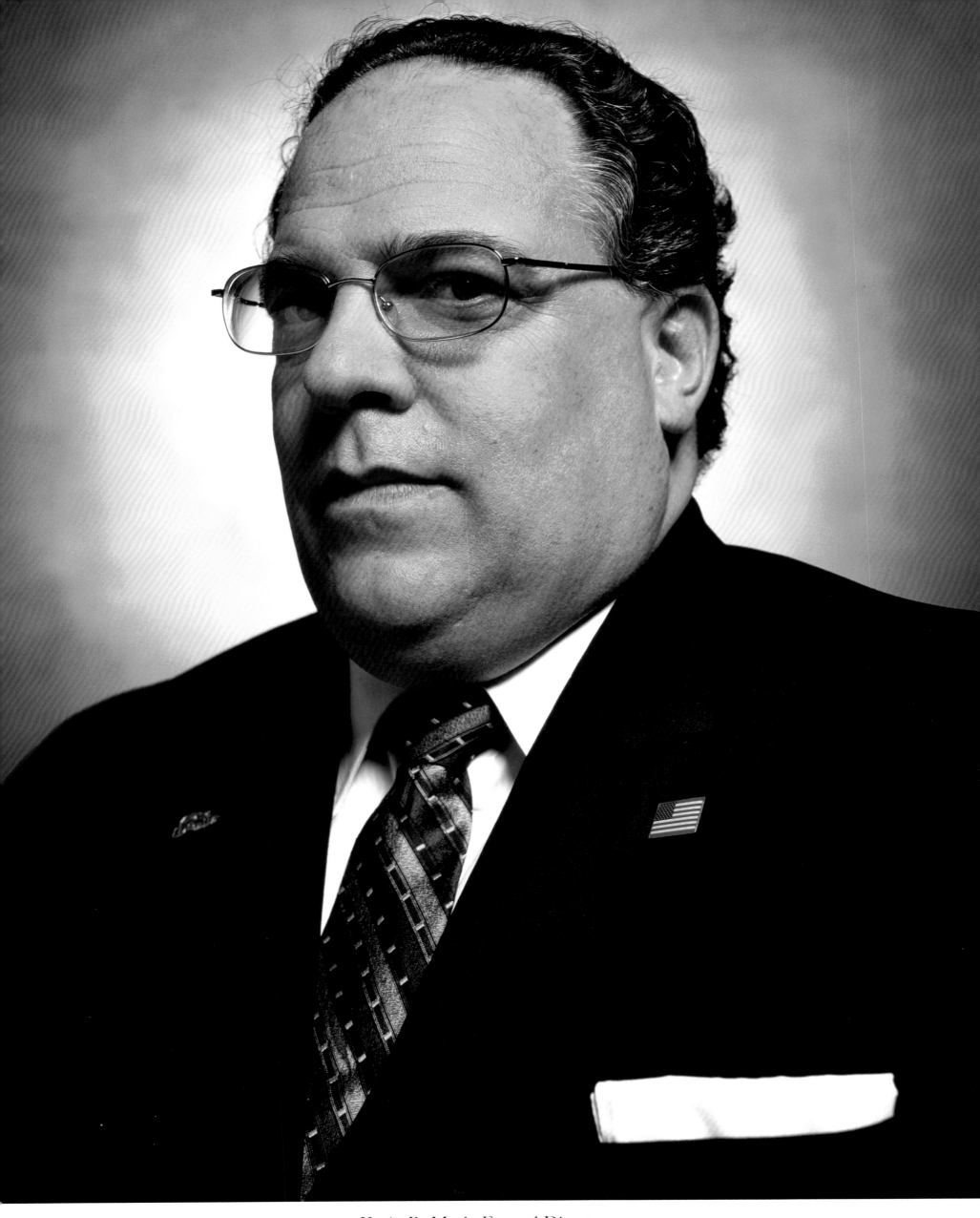

Kevin R. Mack, Funeral Director

2003

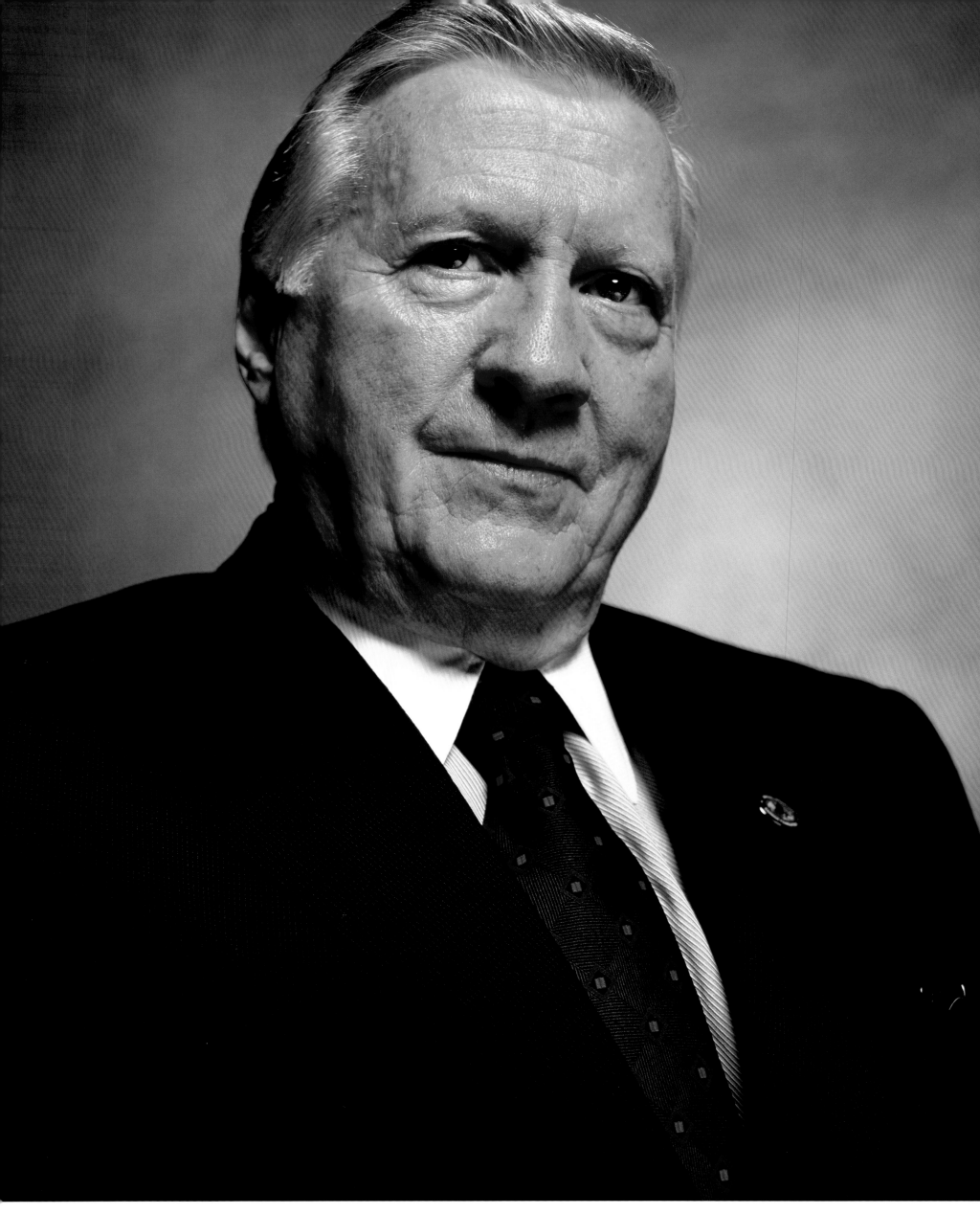

George Steinbrenner, Owner of The New York Yankees
2003

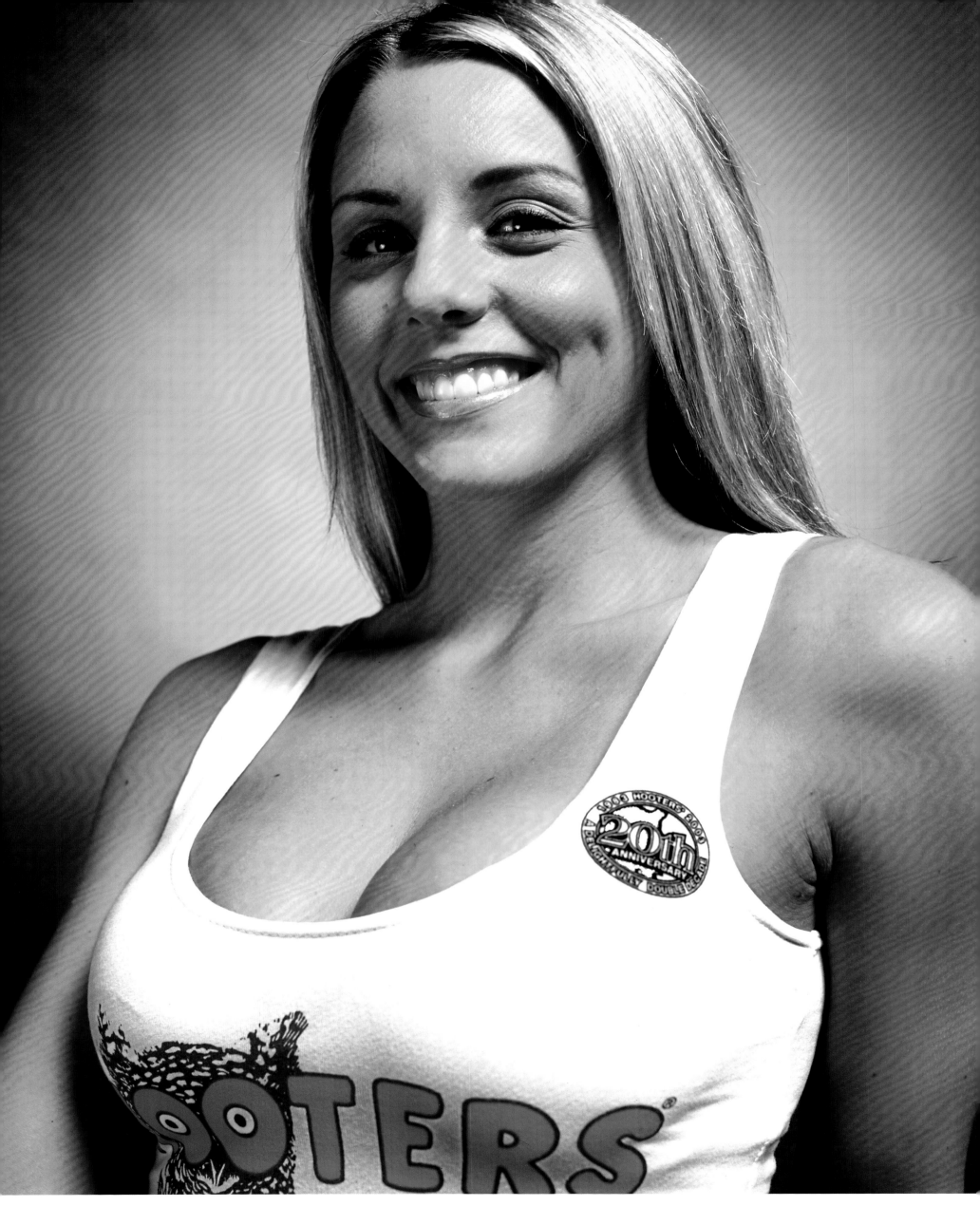

Miss Hooters, Erica Burgess
2003

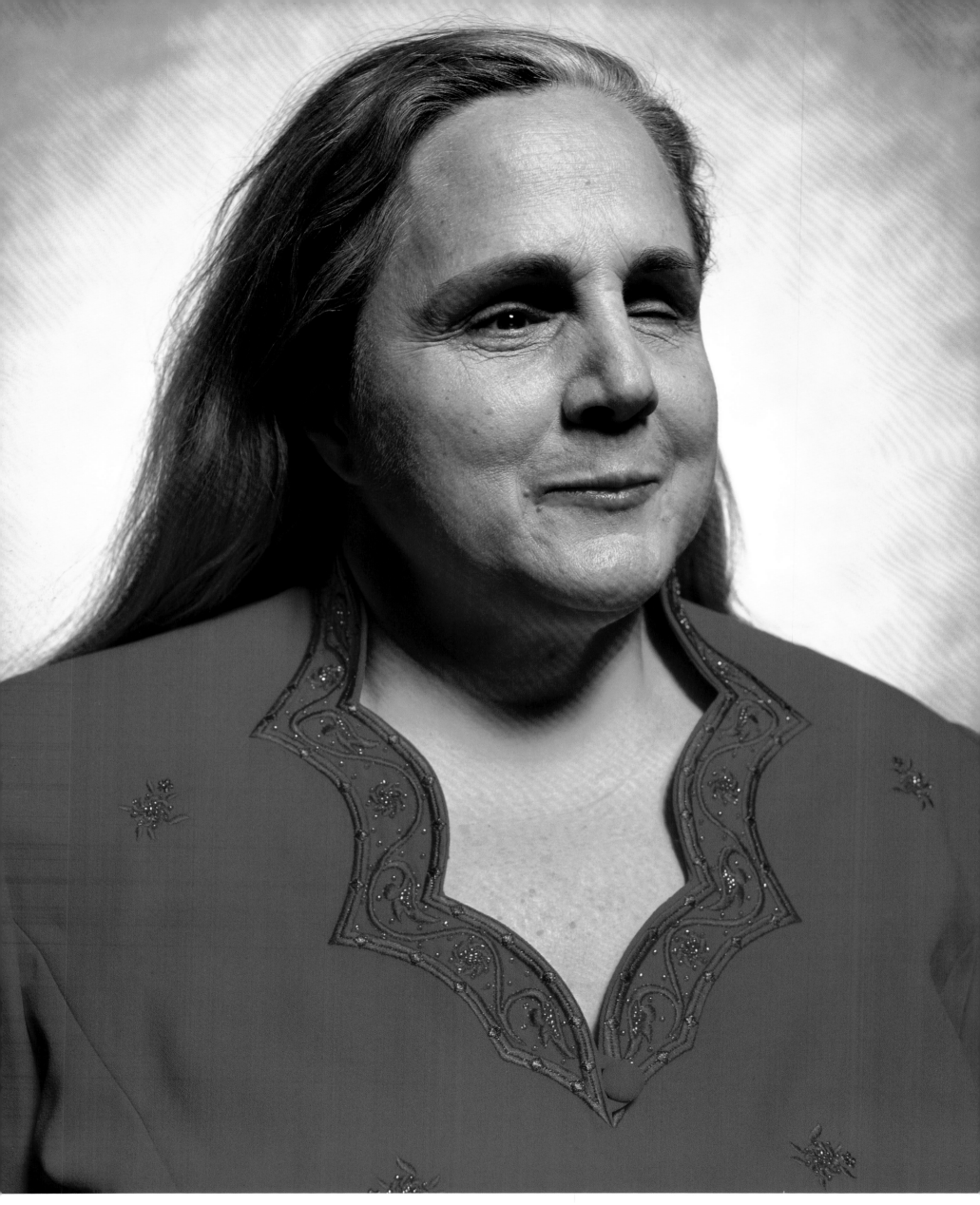

Lucia Marett, Blind

2003

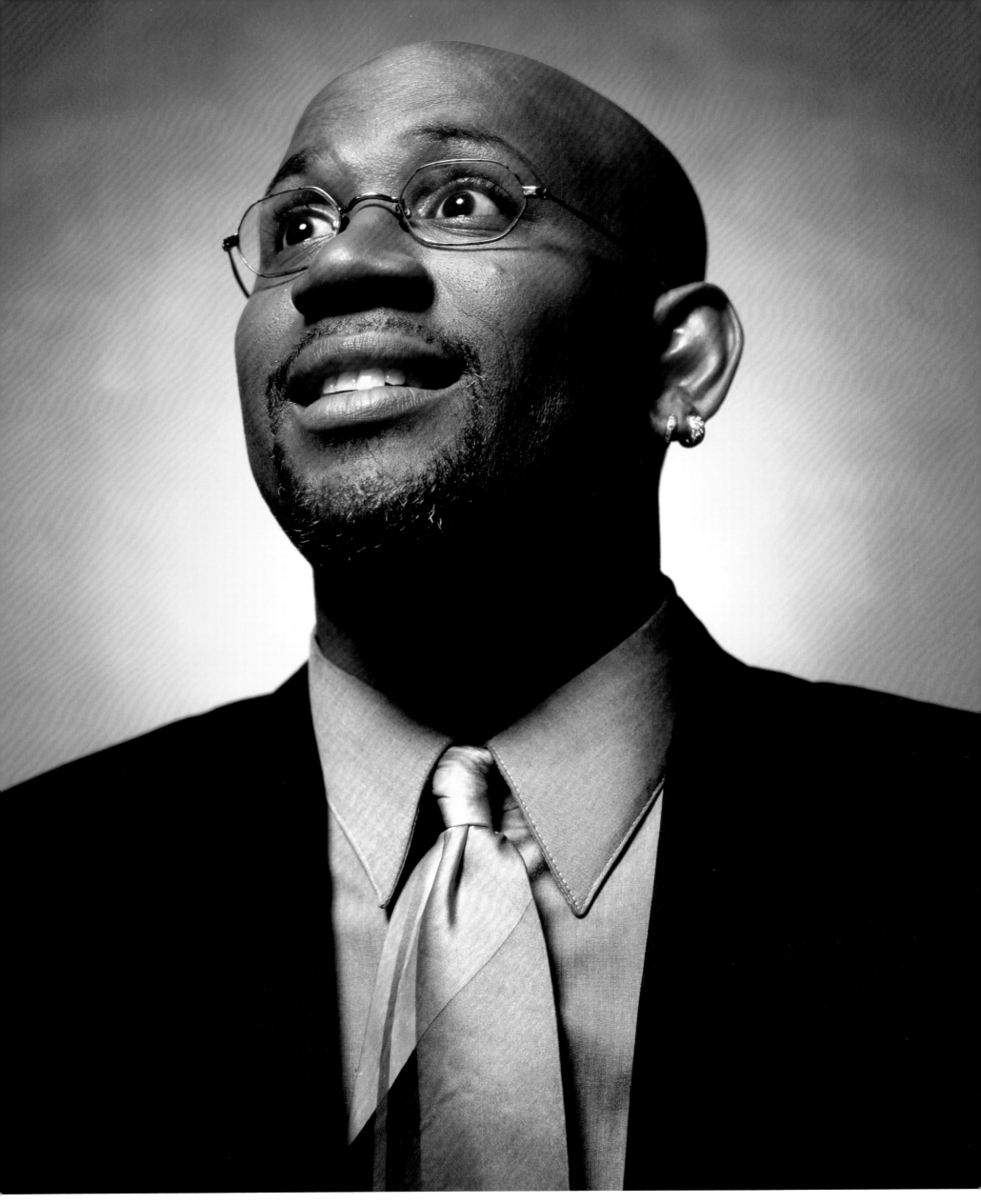

Paul F. Mitchell, Deaf

2003

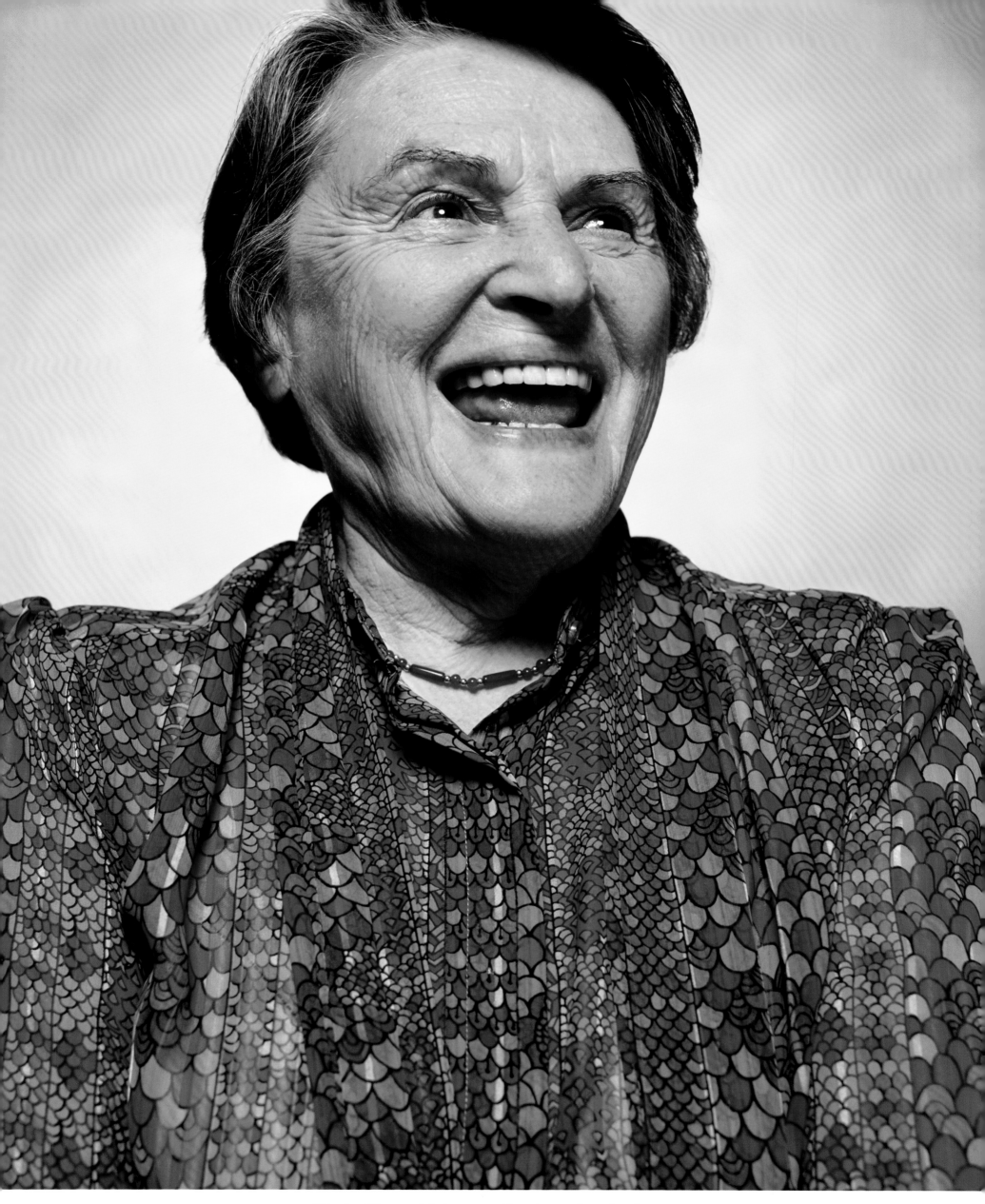

Gisela Glaser, Holocaust Survivor: Auschwitz 1945
2003

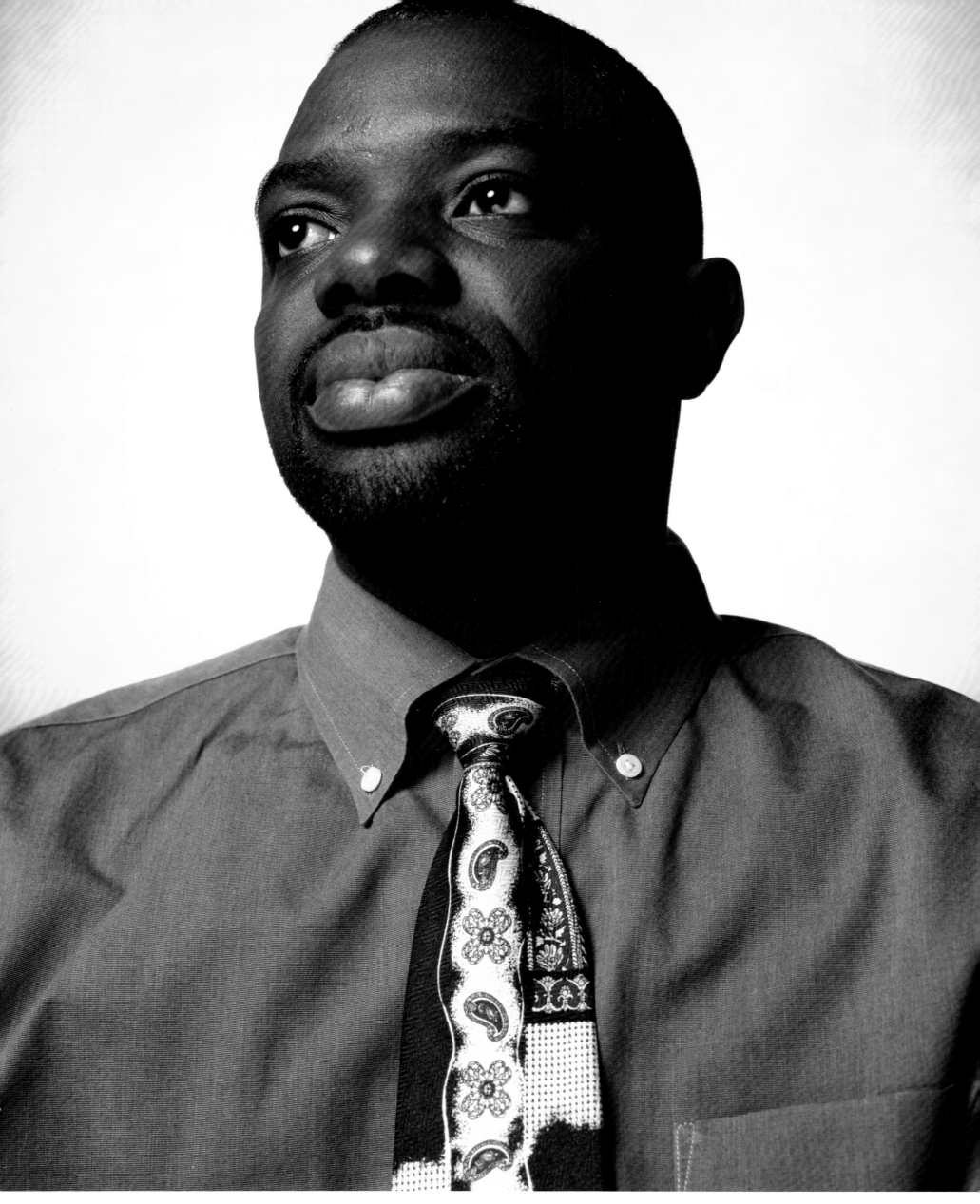

Abner Louima
2003

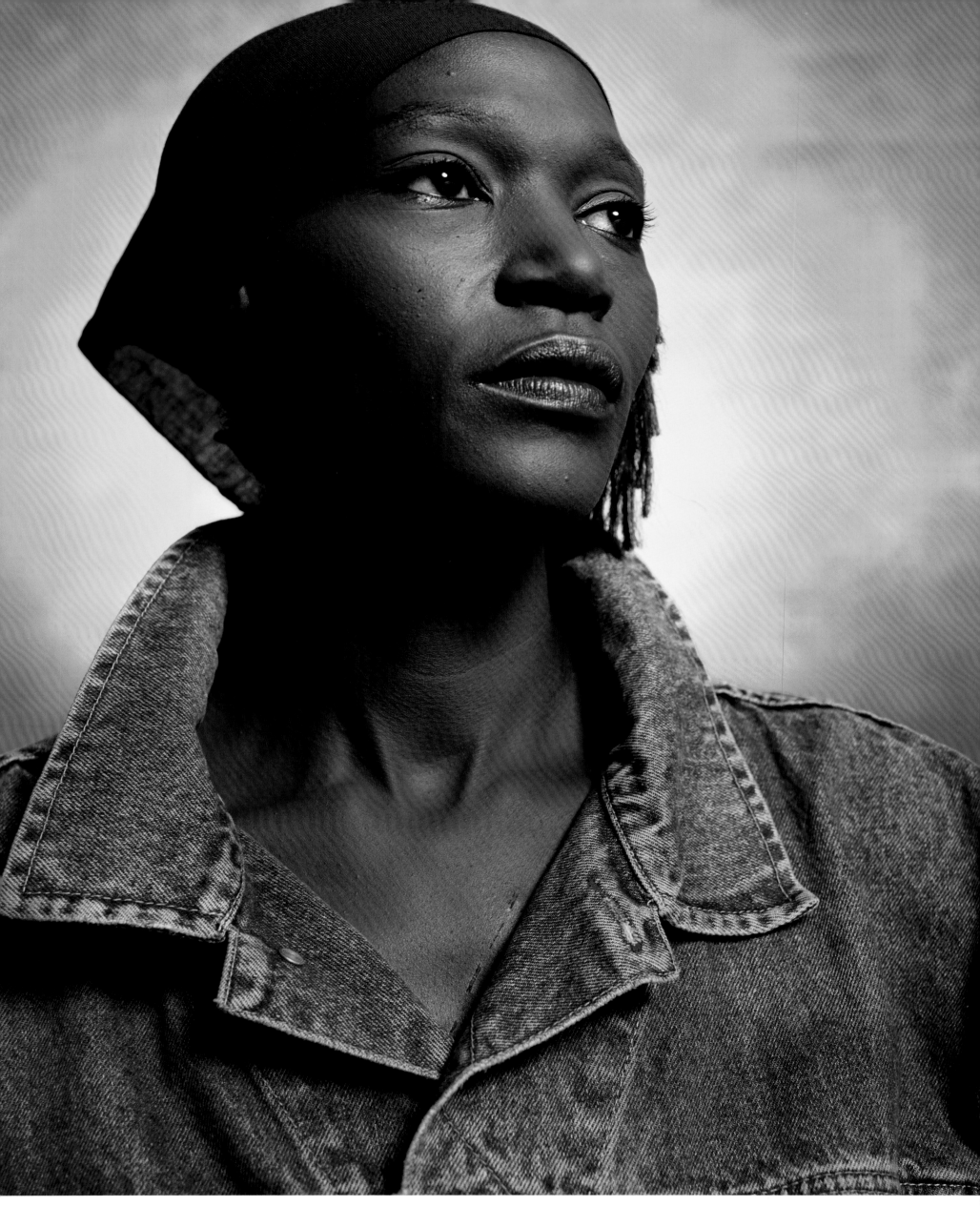

Denise Smith, Ex-Model and Crackhead
2003

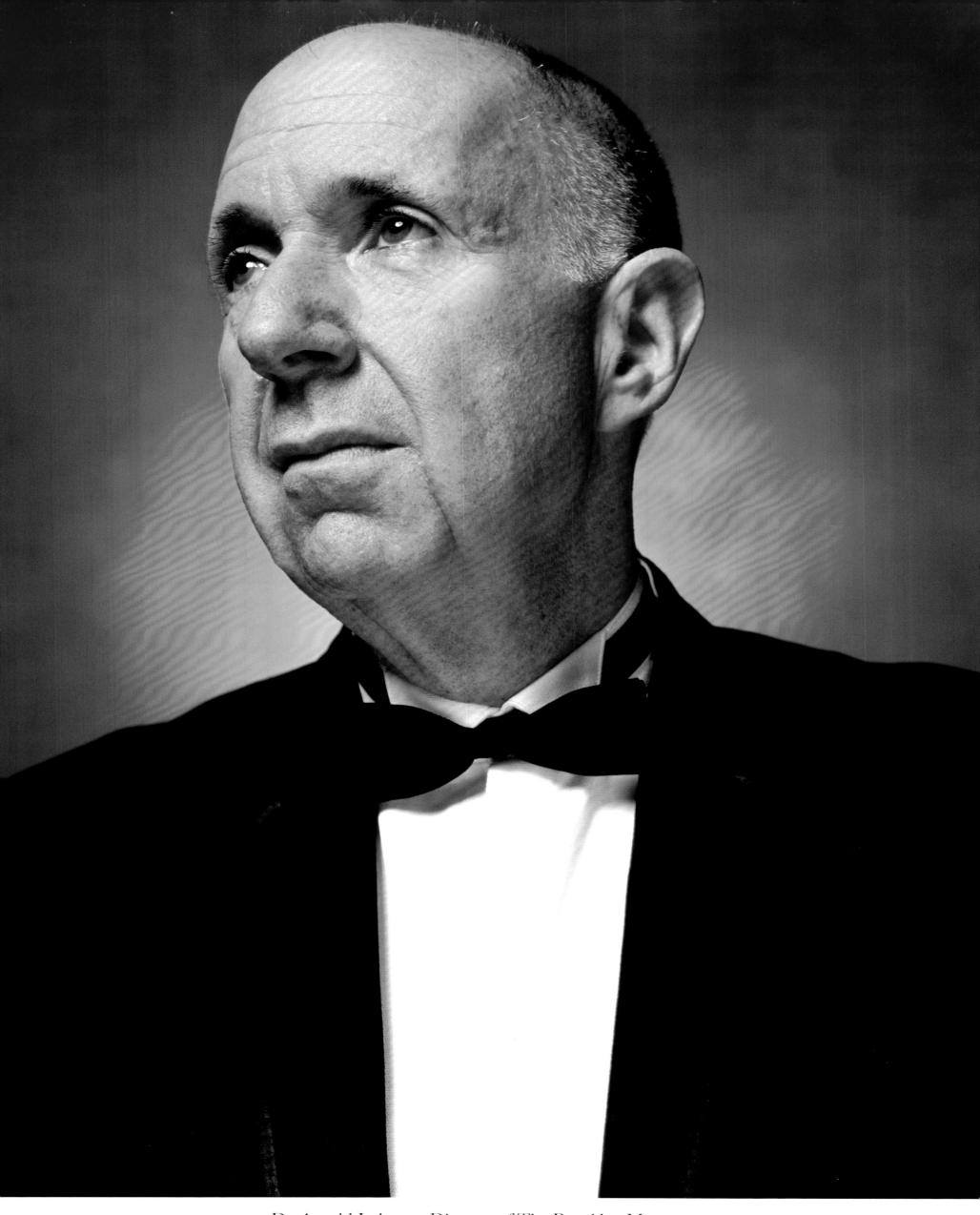

Dr. Arnold Lehman, Director of The Brooklyn Museum
2004

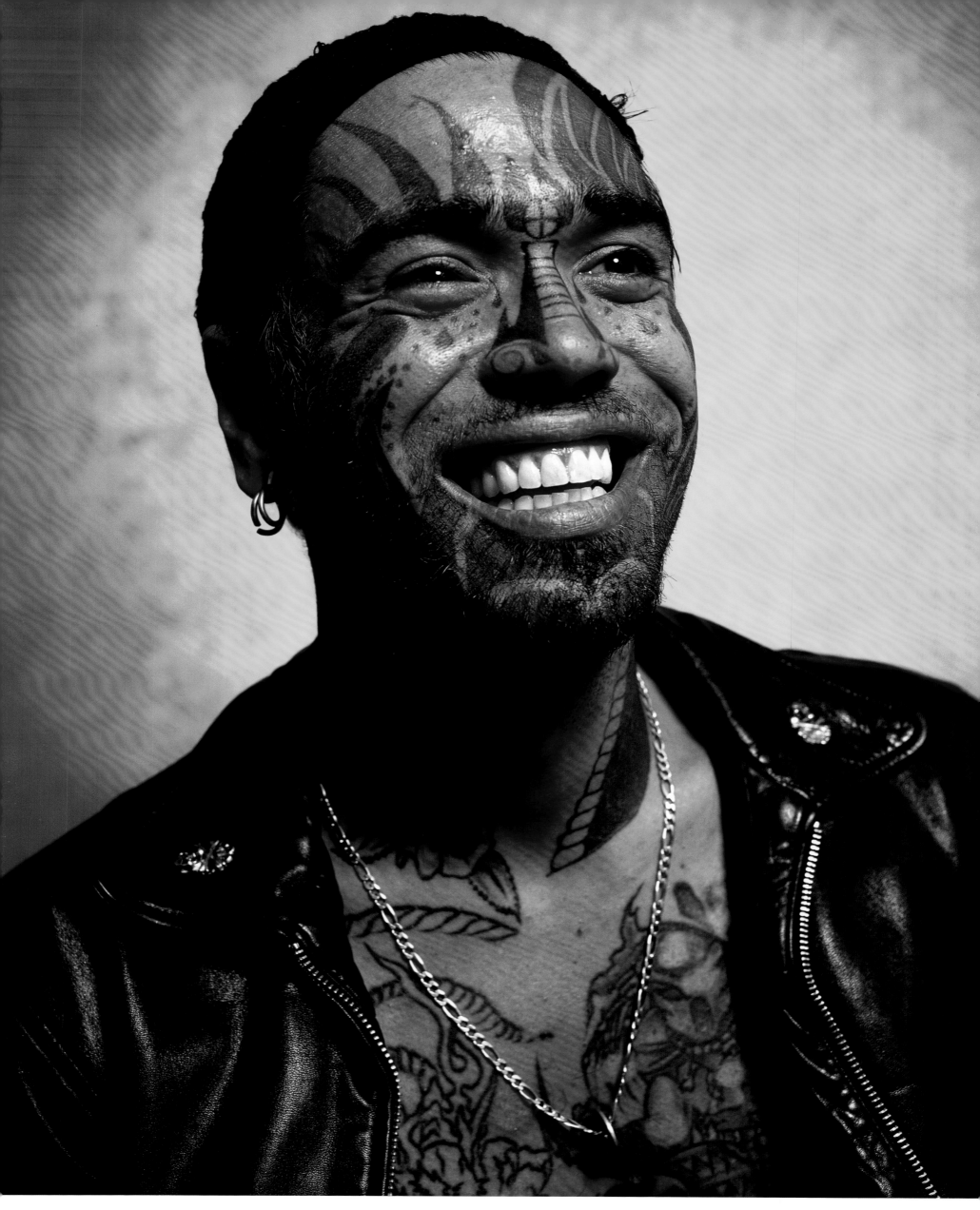

Johny Hawaii

2003

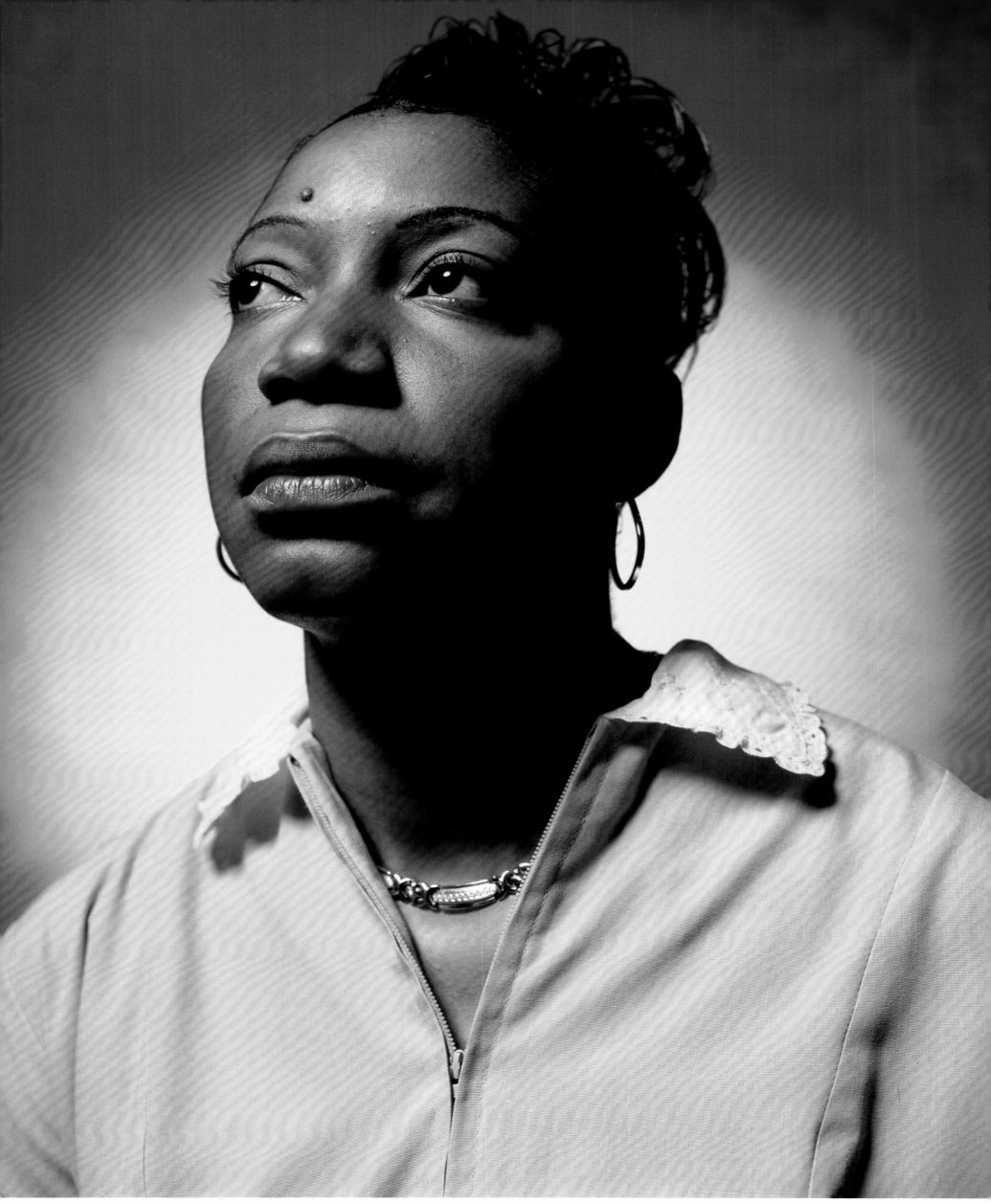

Bernetta Samuda, Housekeeper
2003

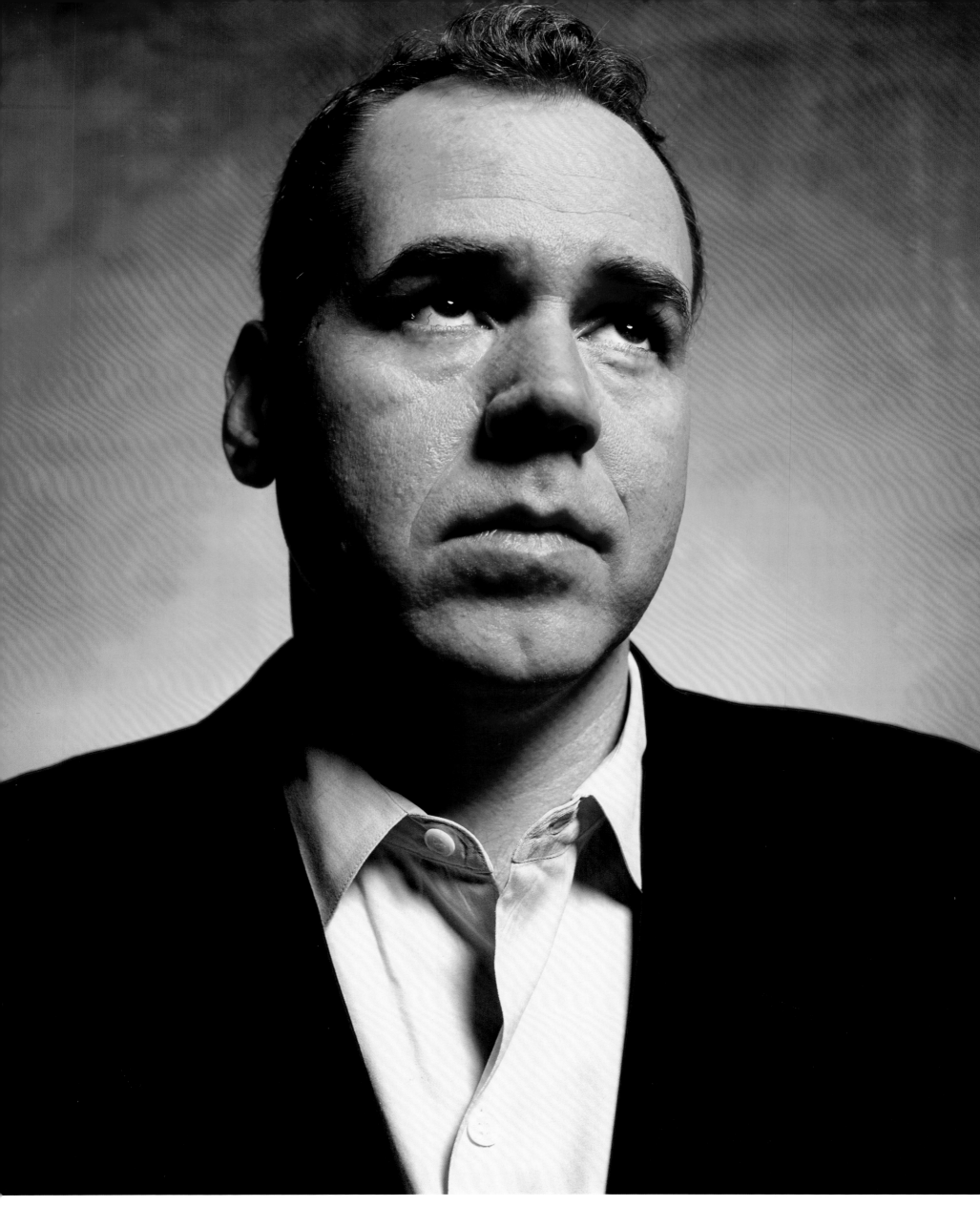

Bret Easton Ellis, Author of 'American Psycho'
2003

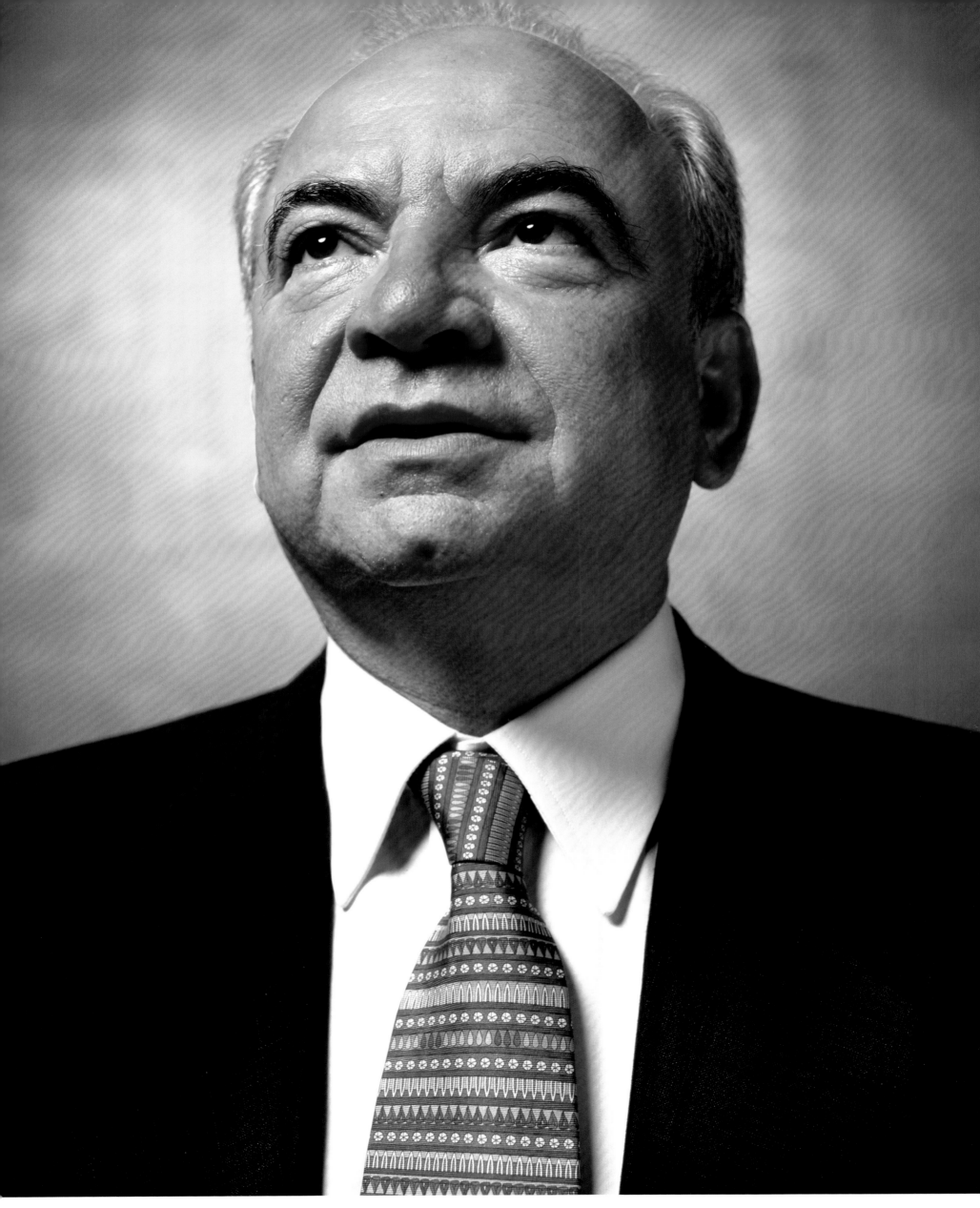

Dr. Manuel Trujillo, Director of Psychiatry at Bellevue

2003

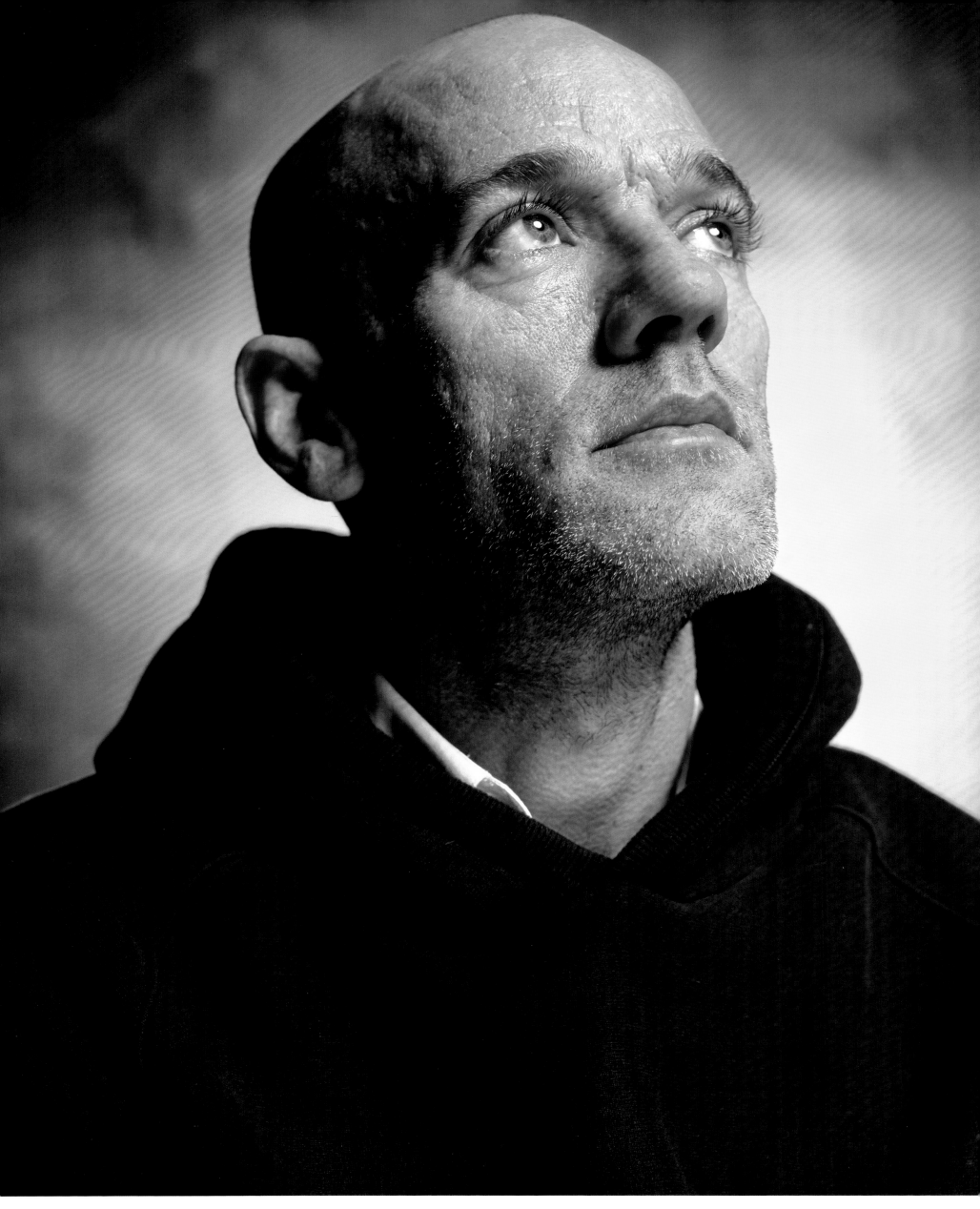

Michael Stipe
2003

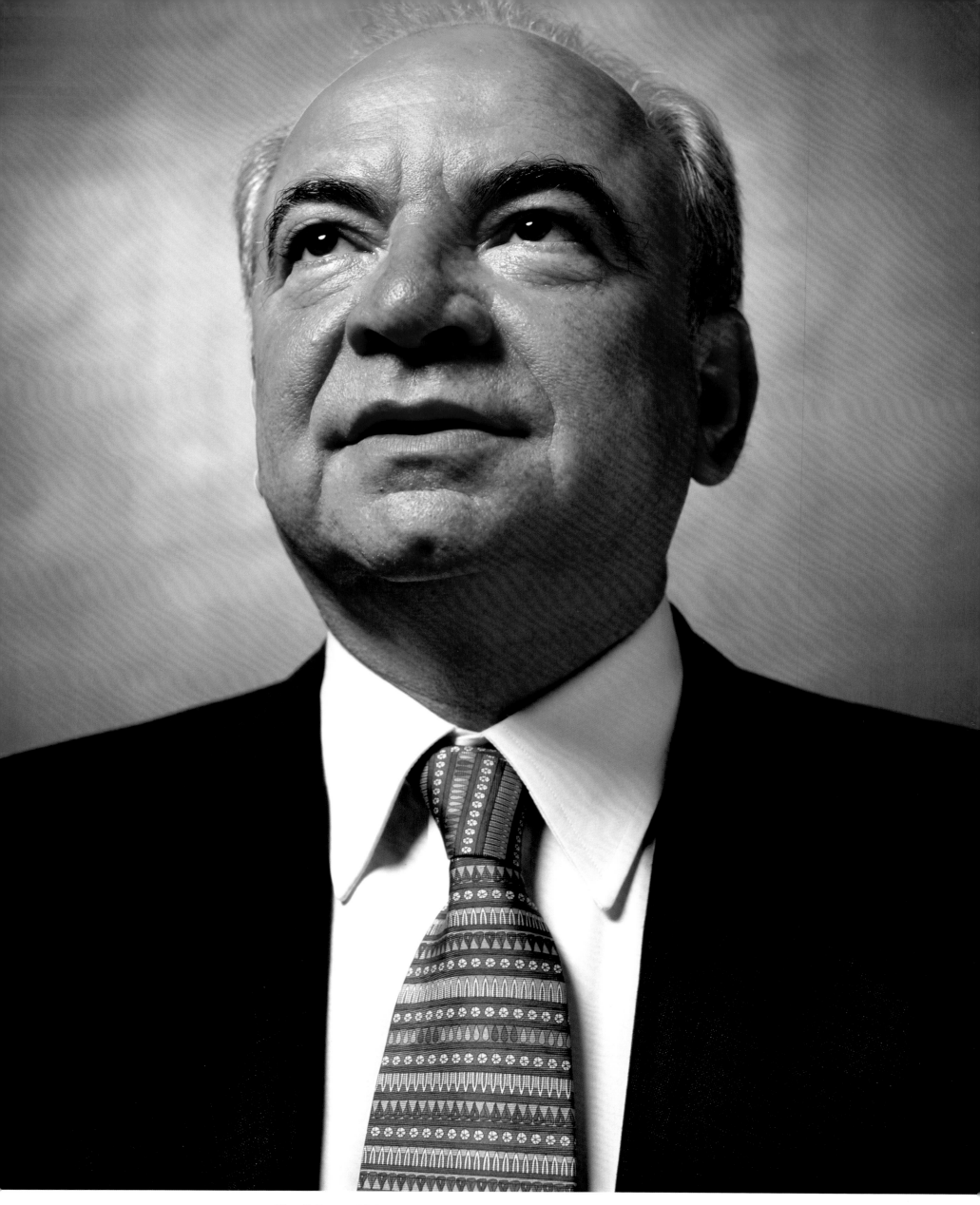

Dr. Manuel Trujillo, Director of Psychiatry at Bellevue
2003

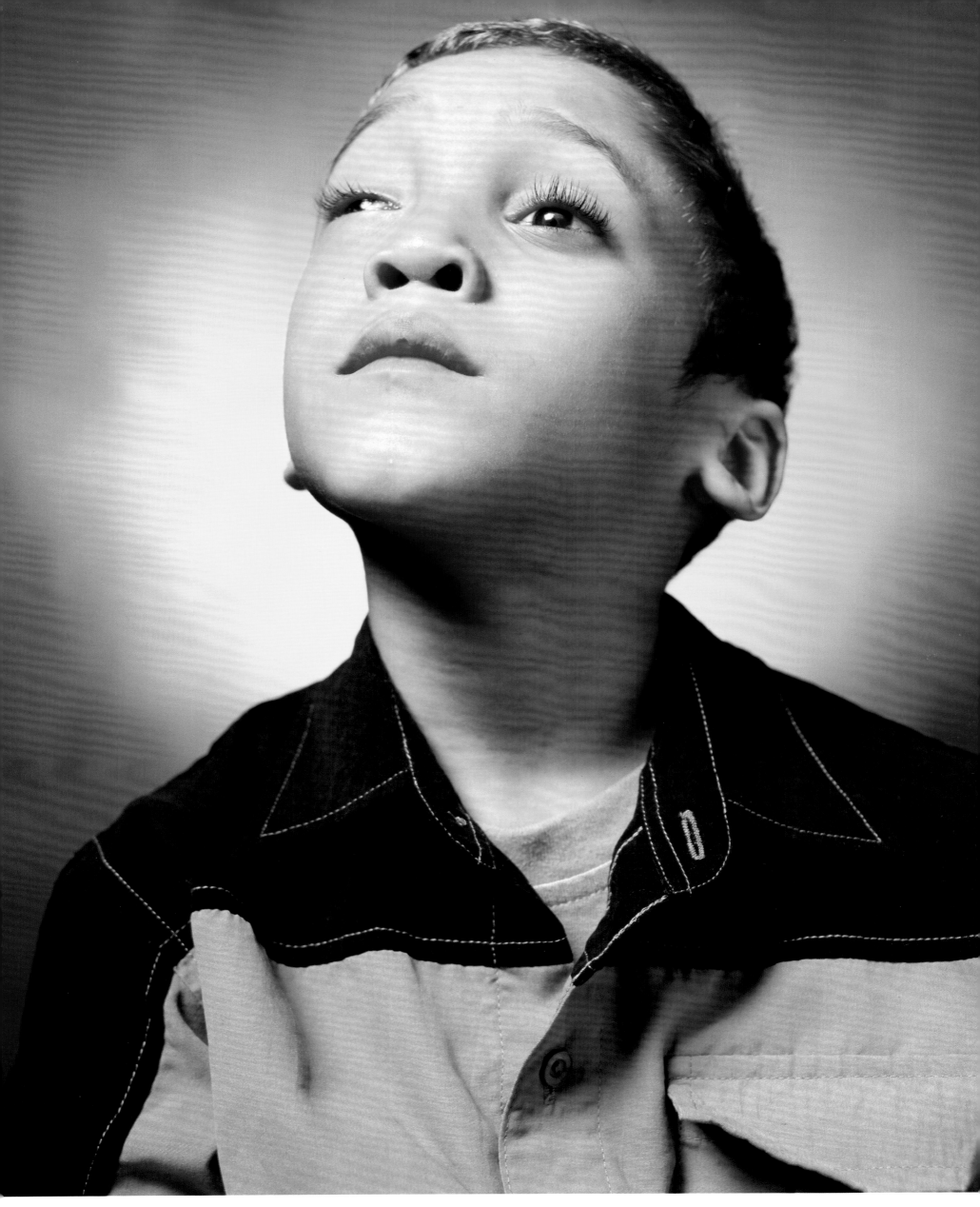

Kato Rivera, Special Needs Child
2004

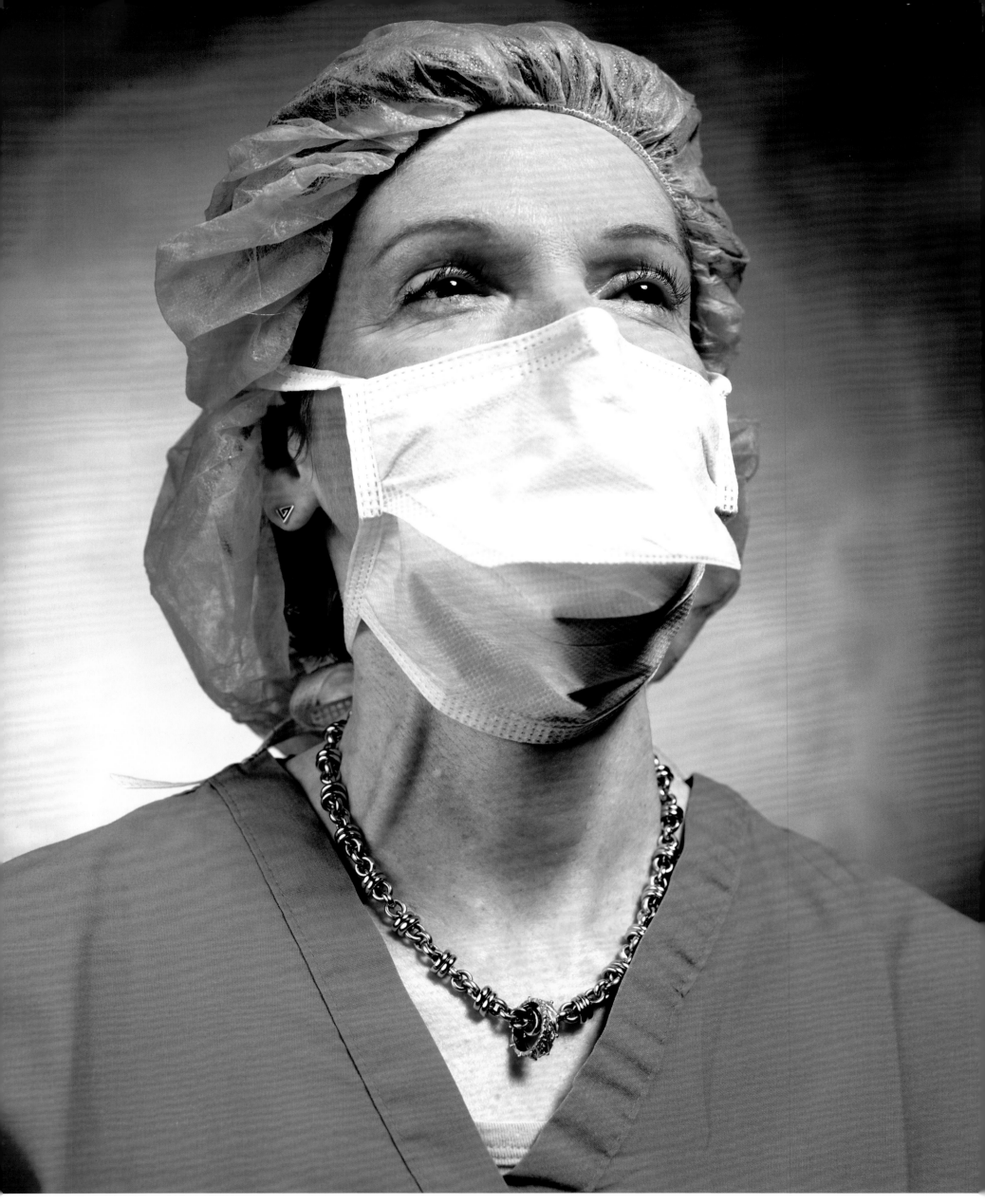

Anne T. Carlon, M.D. Obstetrician-Gynecologist
2003

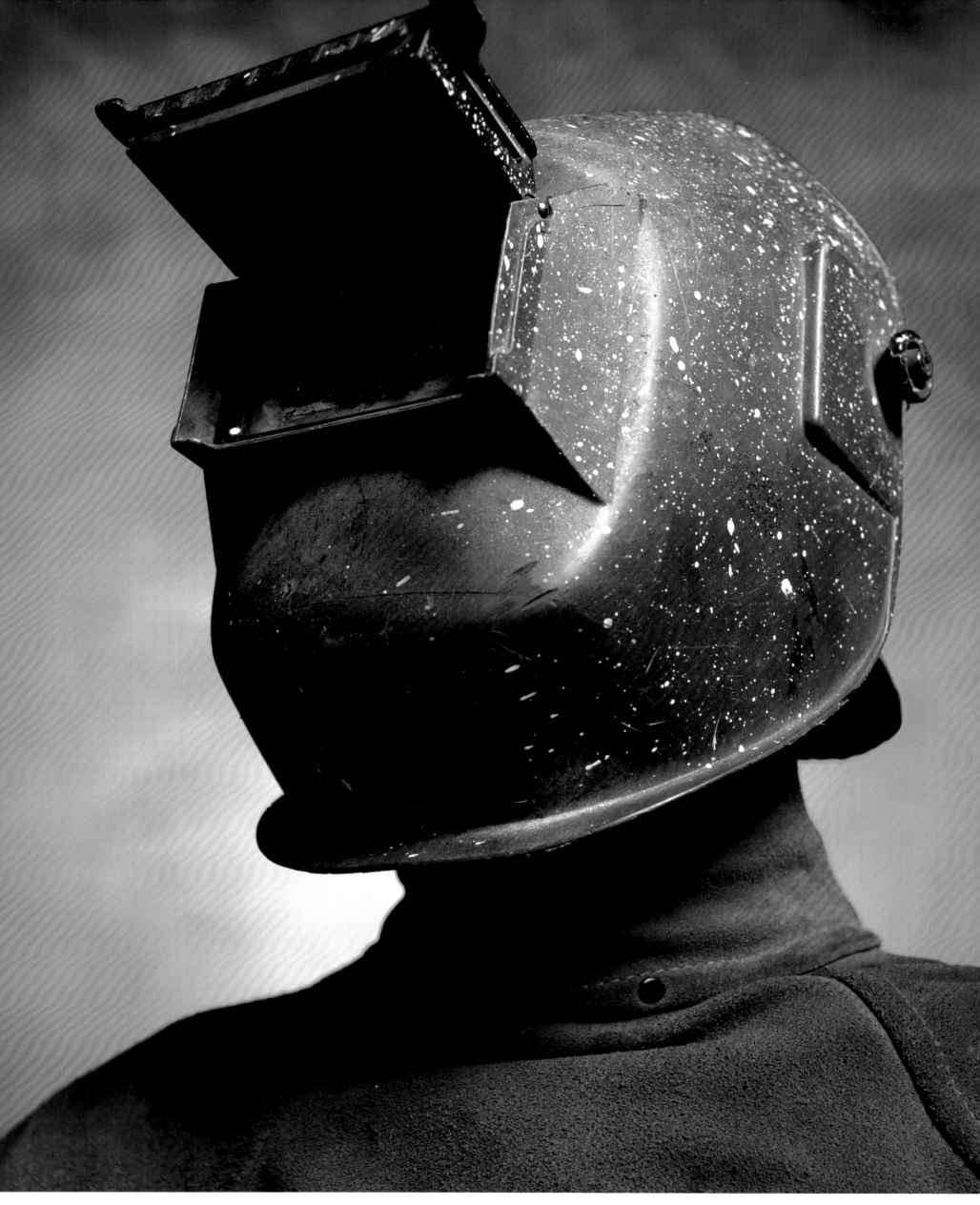

Harold Bisagni, Iron Worker
2004

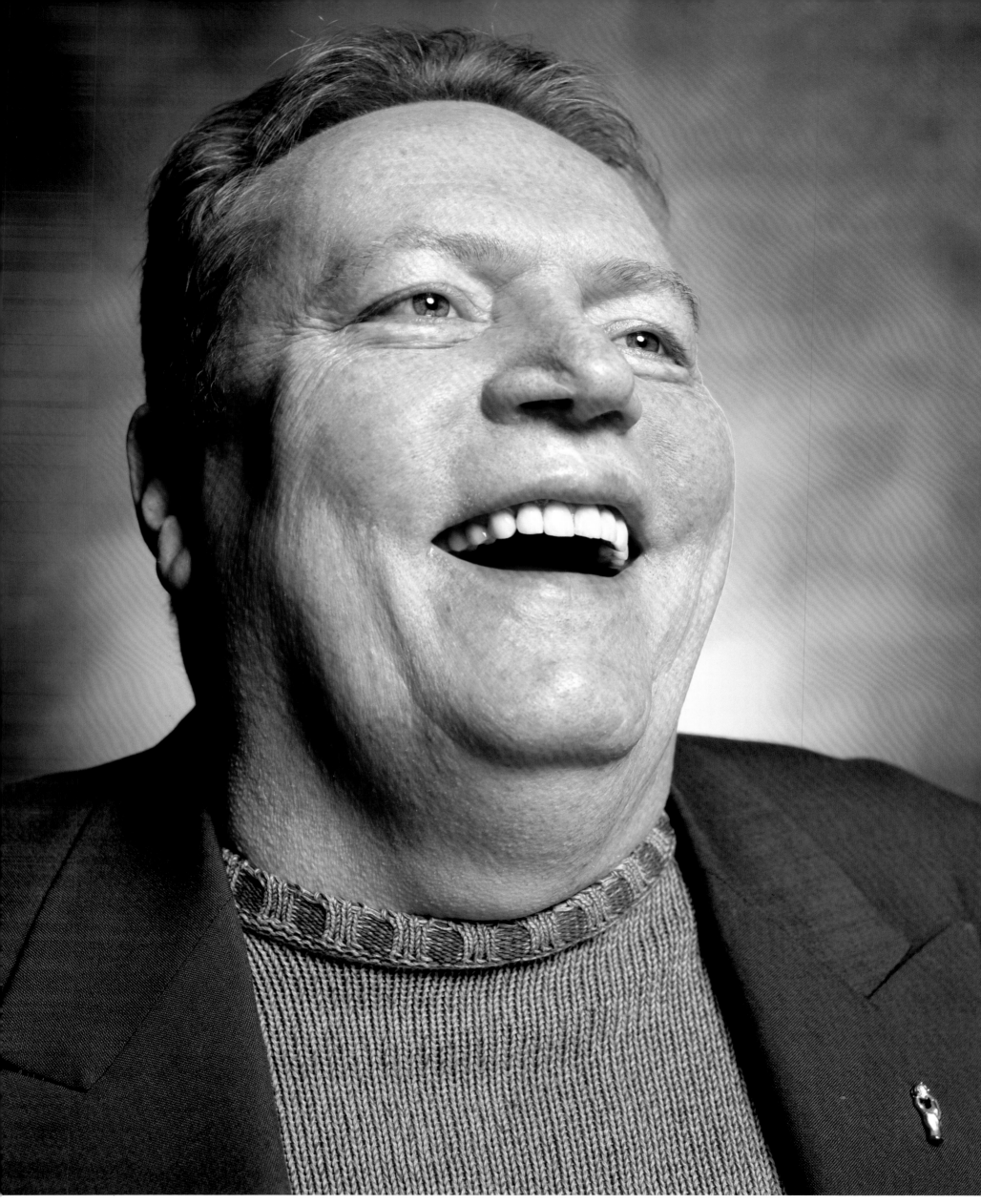

Larry Flynt
2004

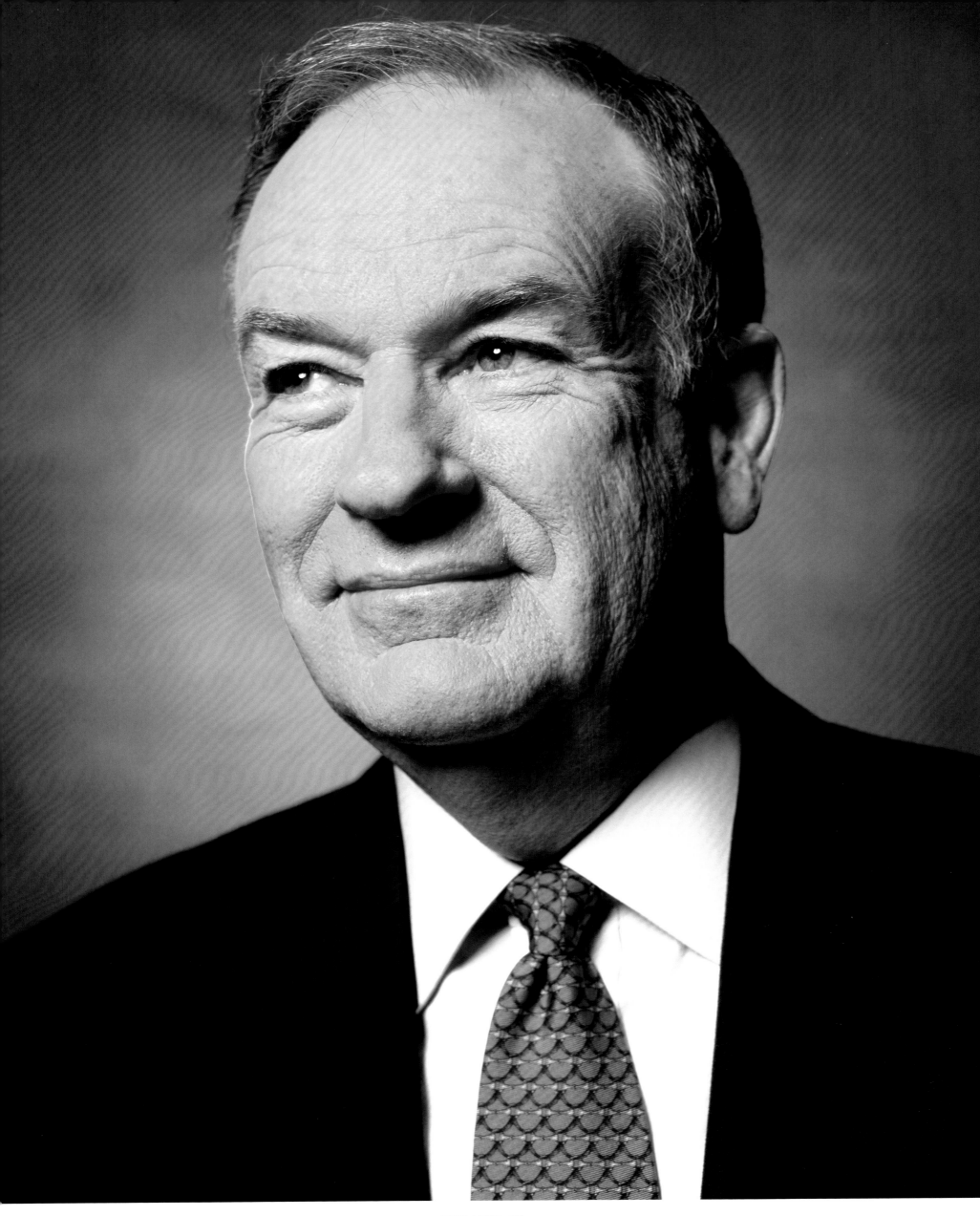

Bill O'Reilly
2004

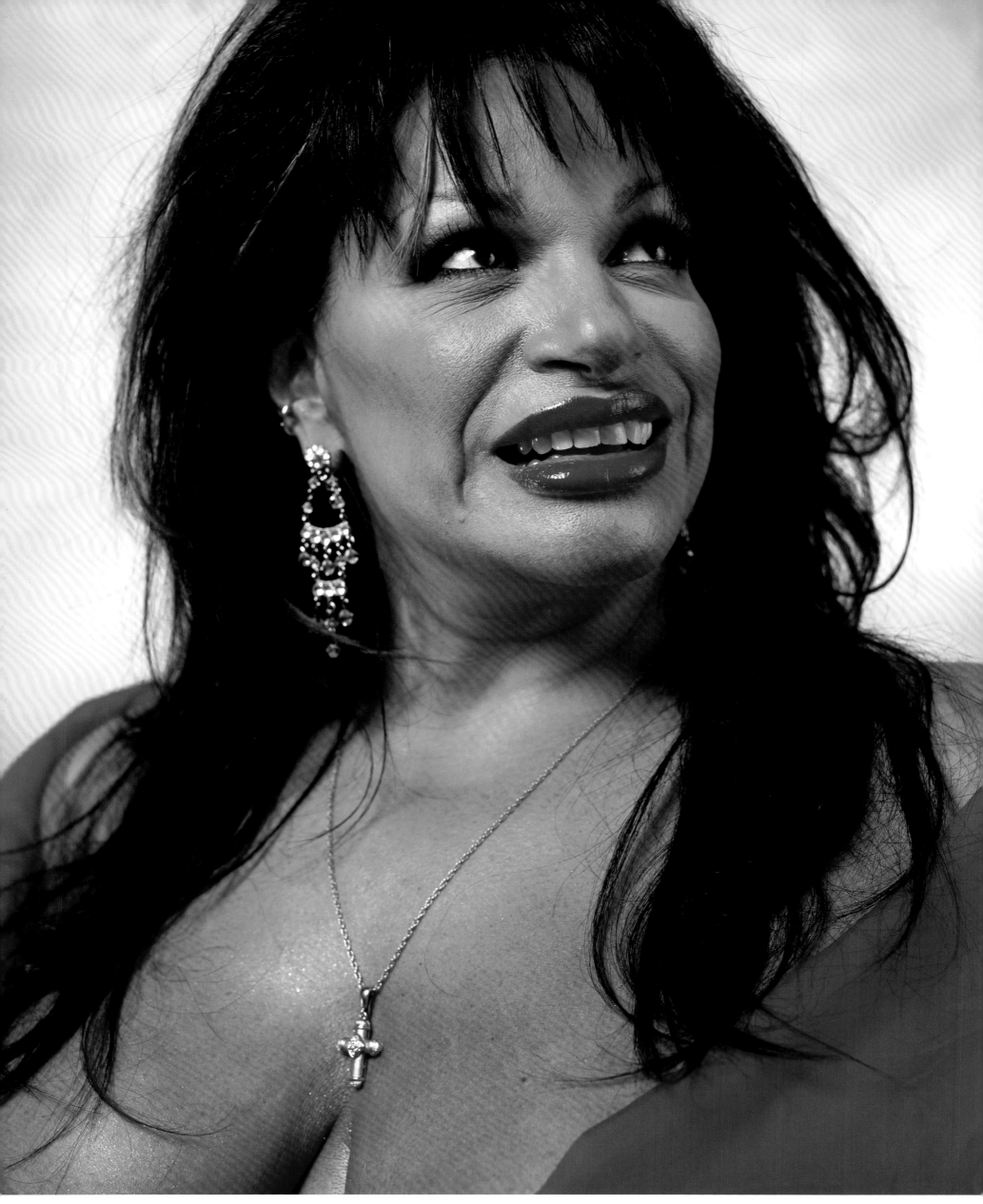

Vanessa del Rio, Porn Star
2003

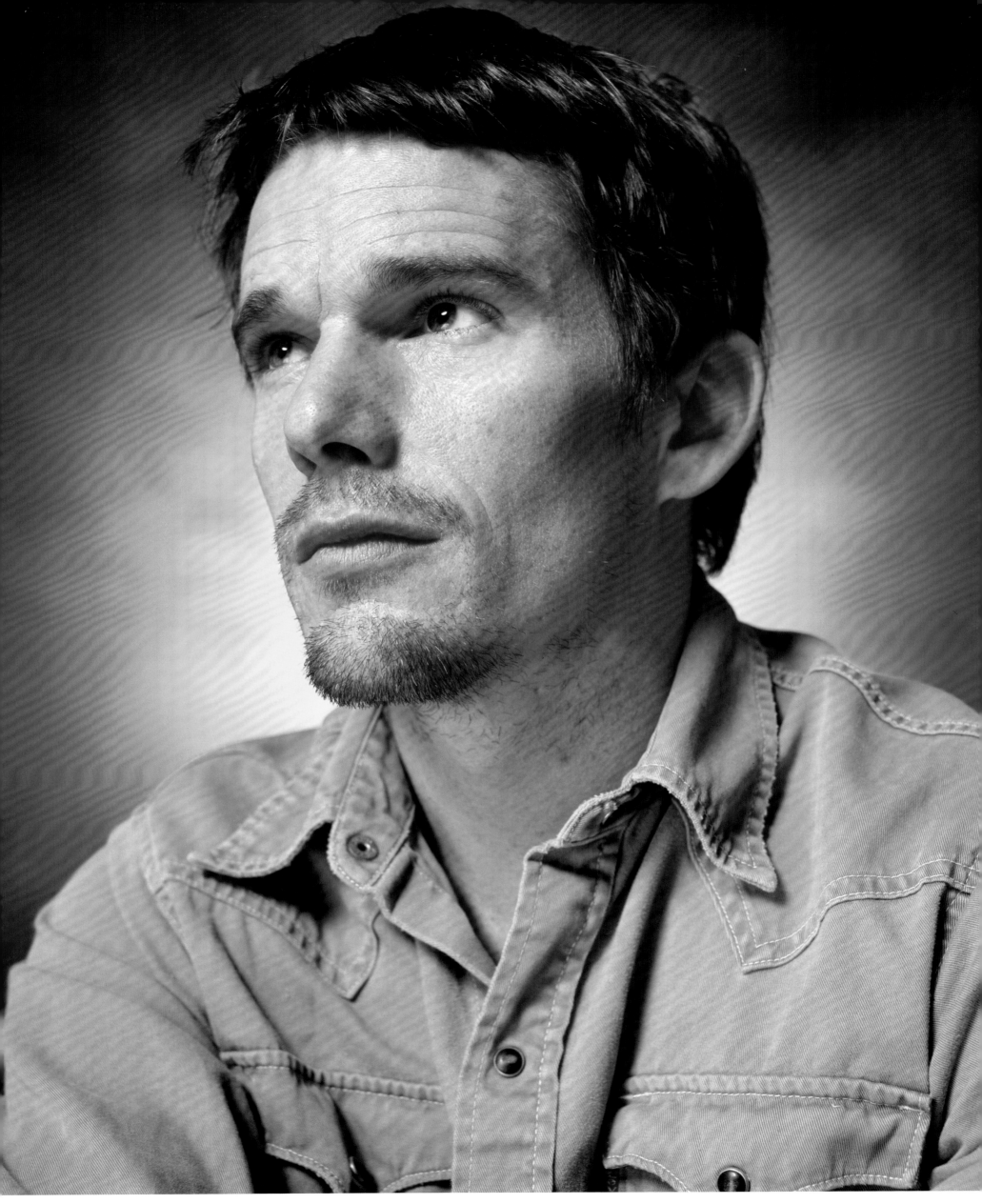

Ethan Hawke
2004

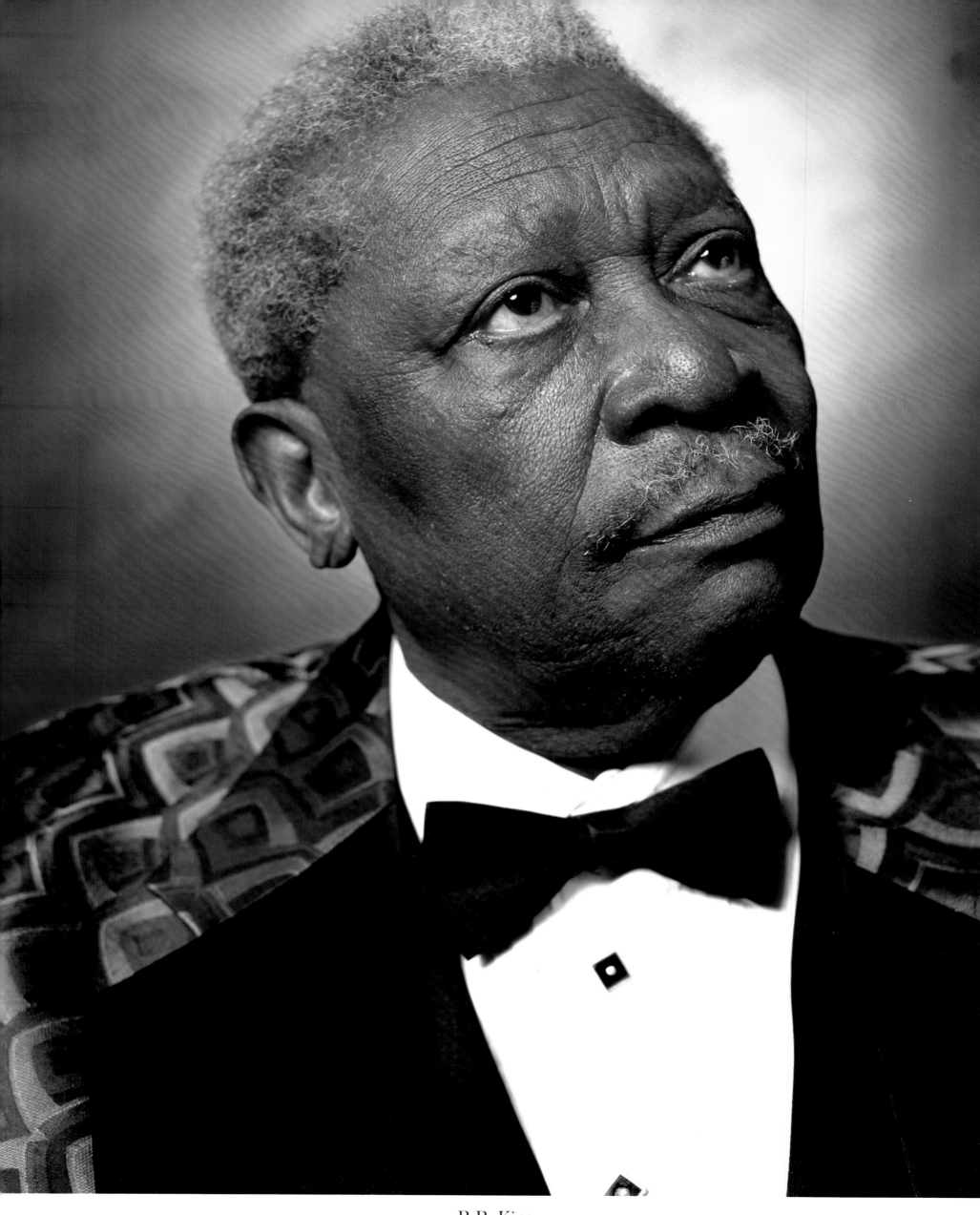

B.B. King
2004

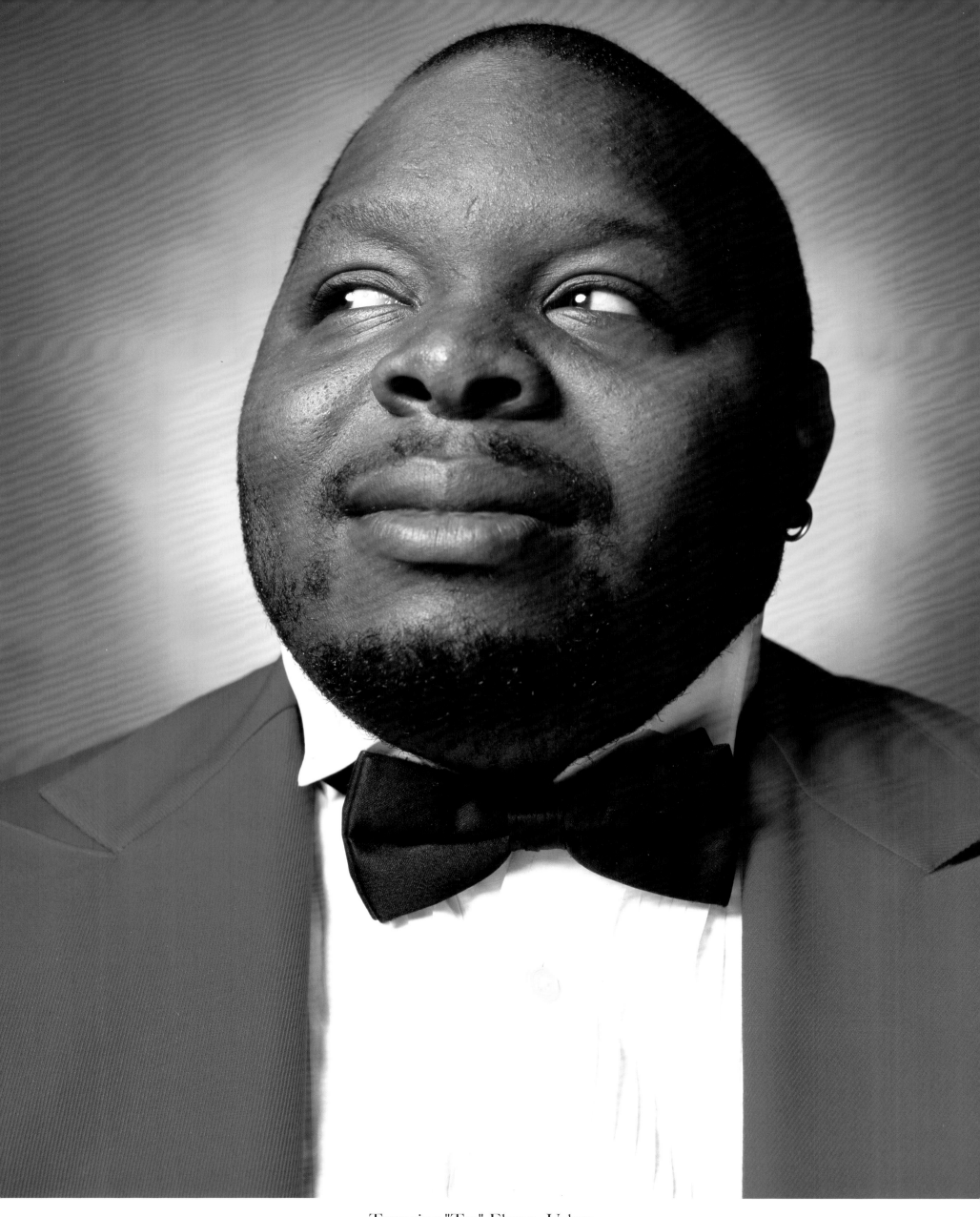

Tramaine "Tee" Ebron, Usher

2004

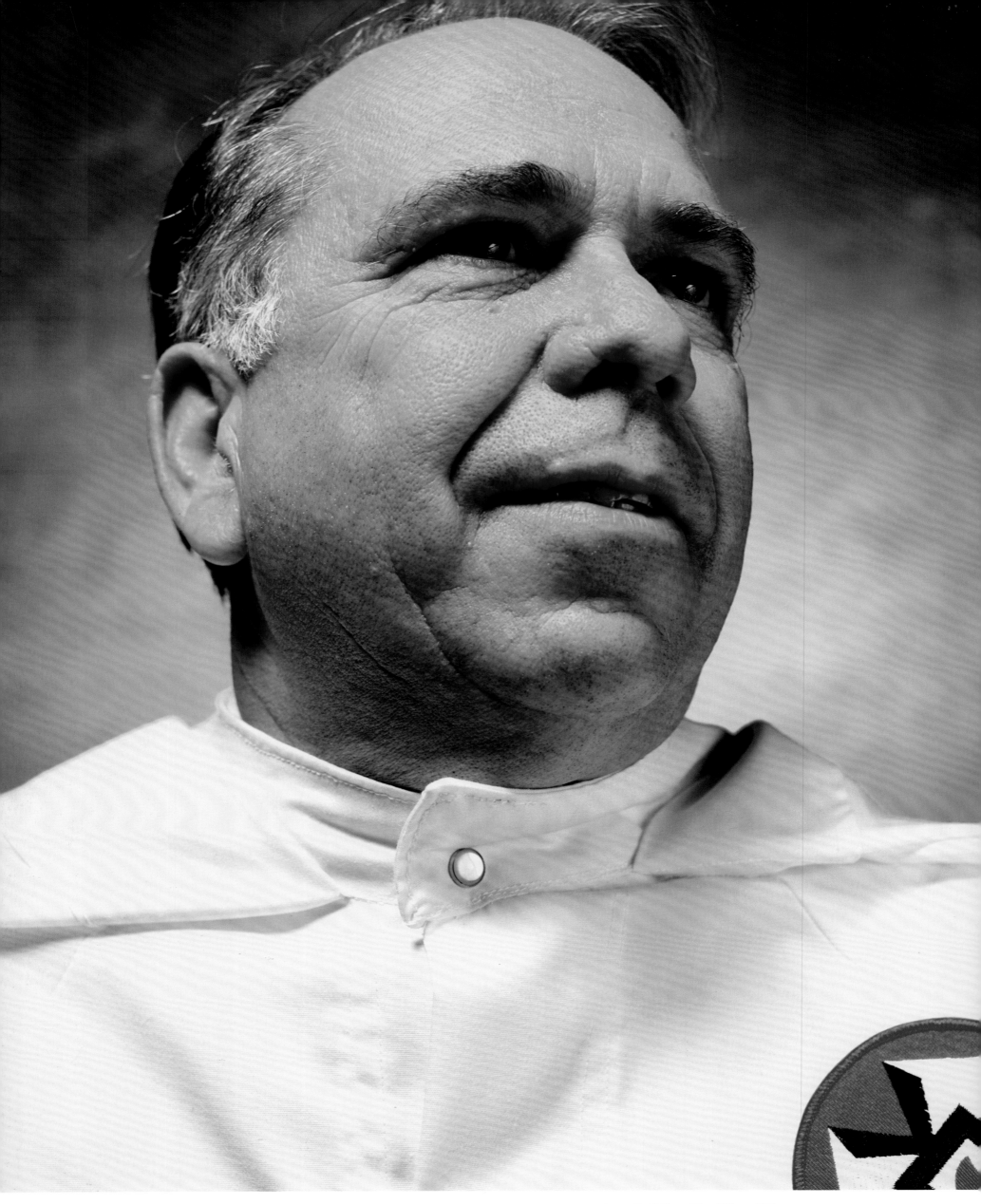

Pastor Thomas Robb, National Director of The Knights Of The Ku Klux Klan
2004

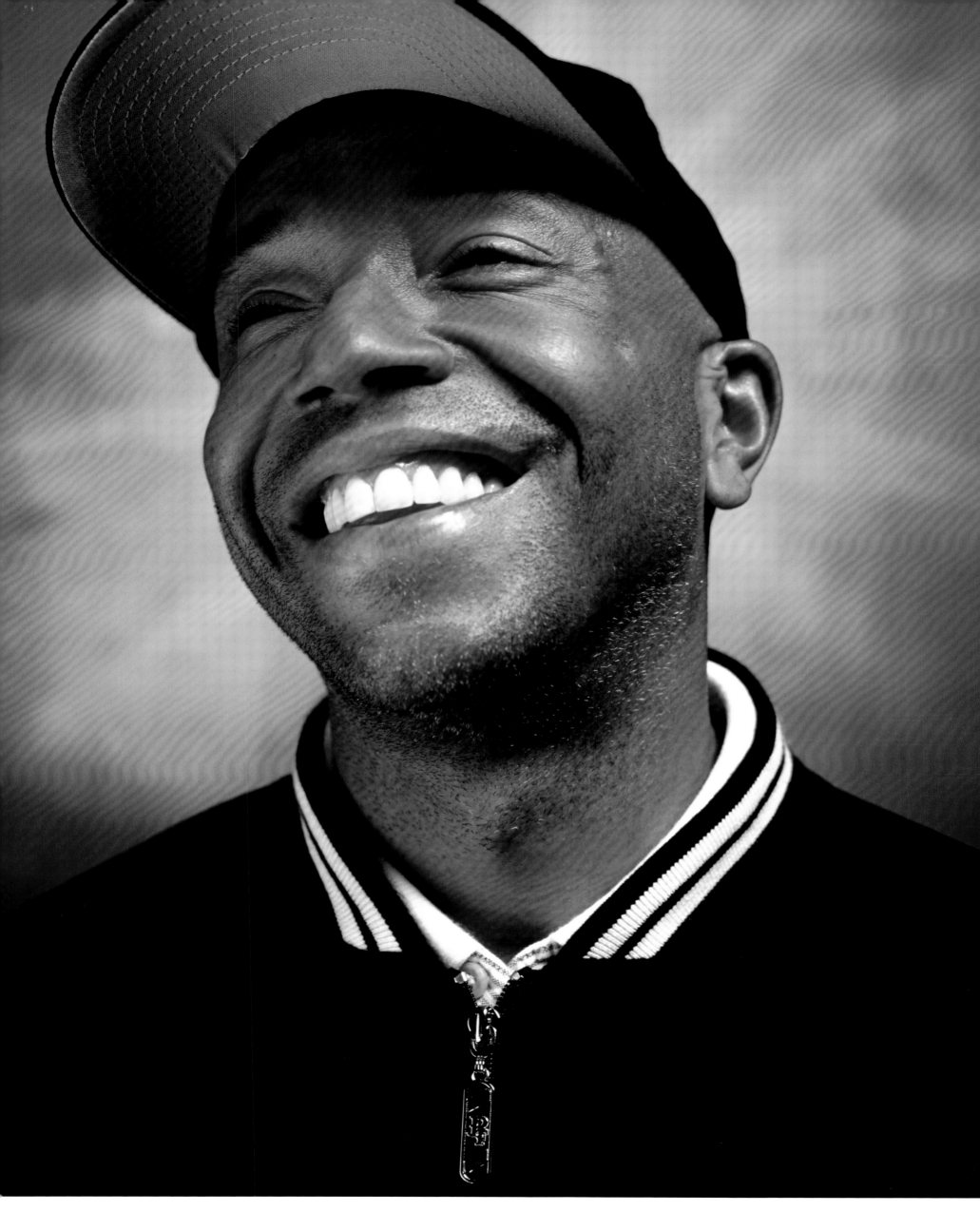

Russell Simmons, Mogul

2003

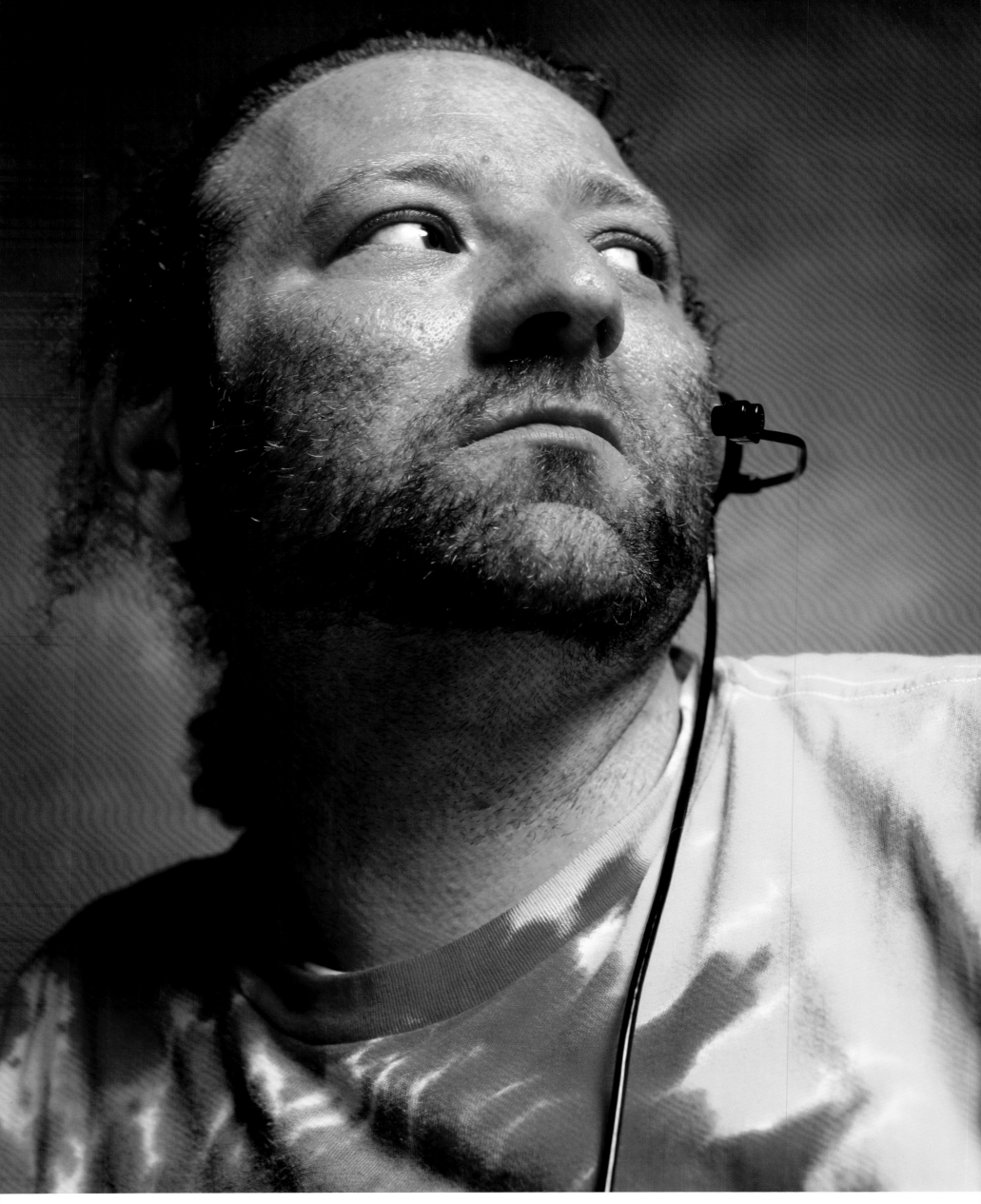

David Byrans, Telemarketer
2004

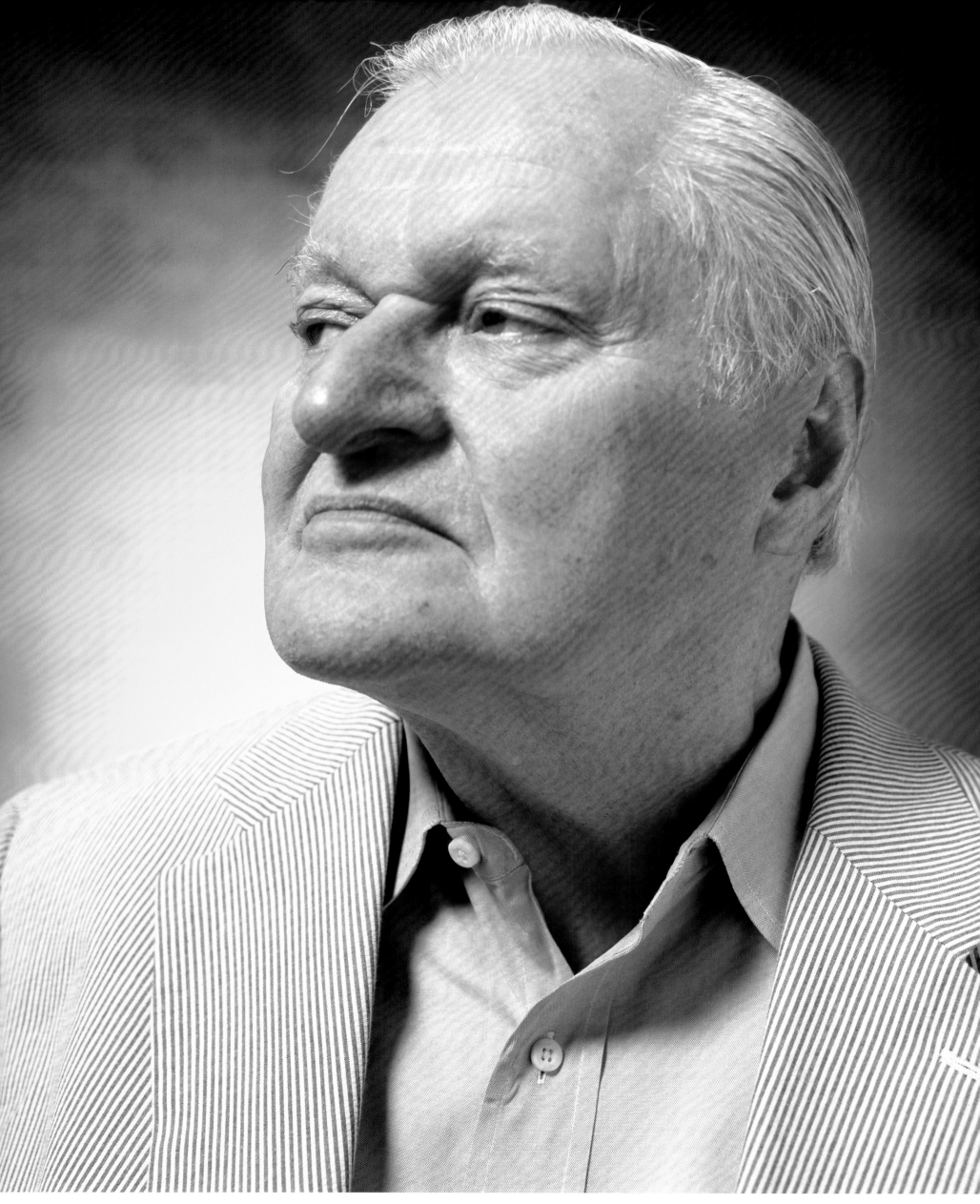

John Ashbery, Poet
2004

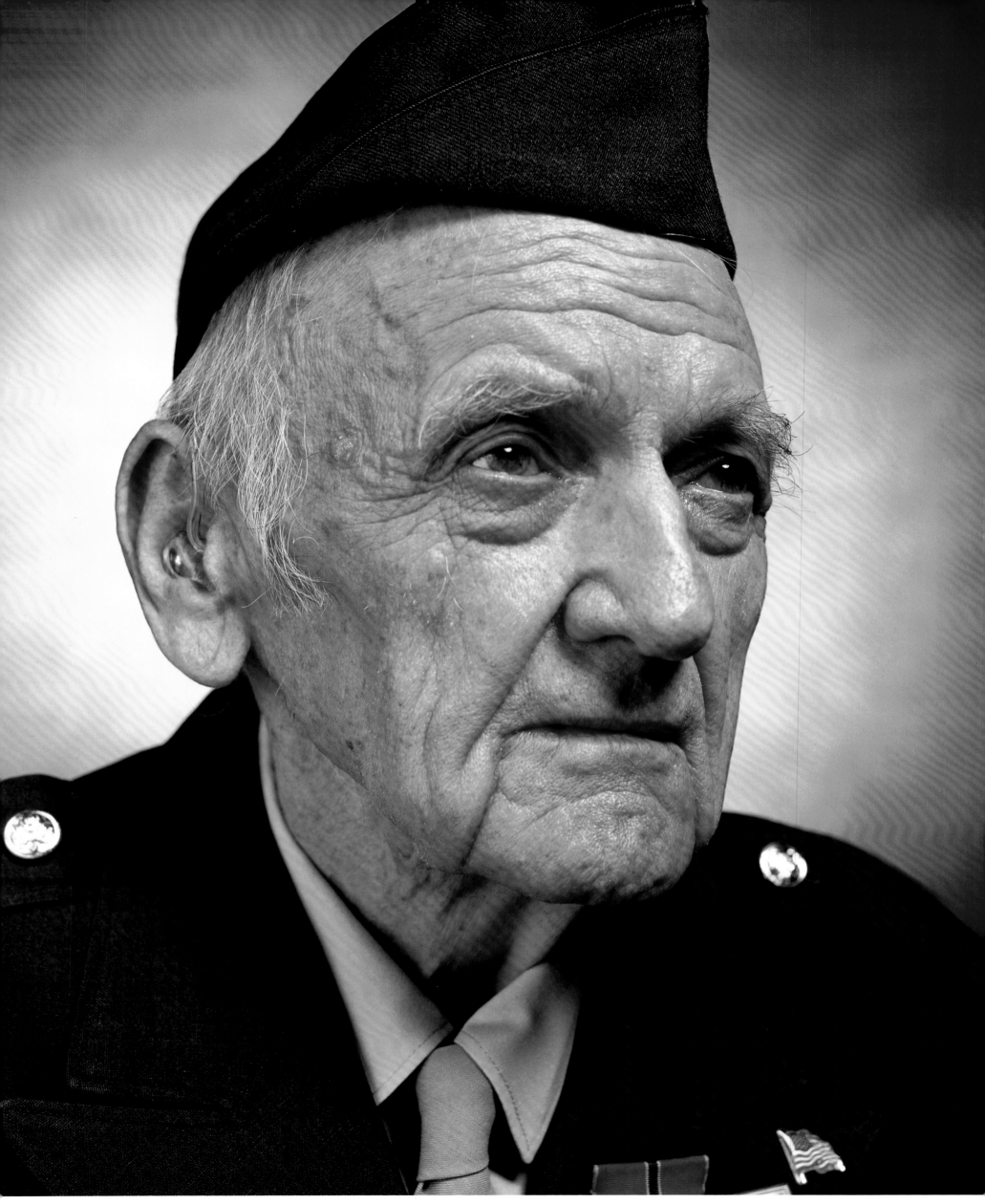

Walter Fisher, Private First Class- Battle of The Bulge 1944
2003

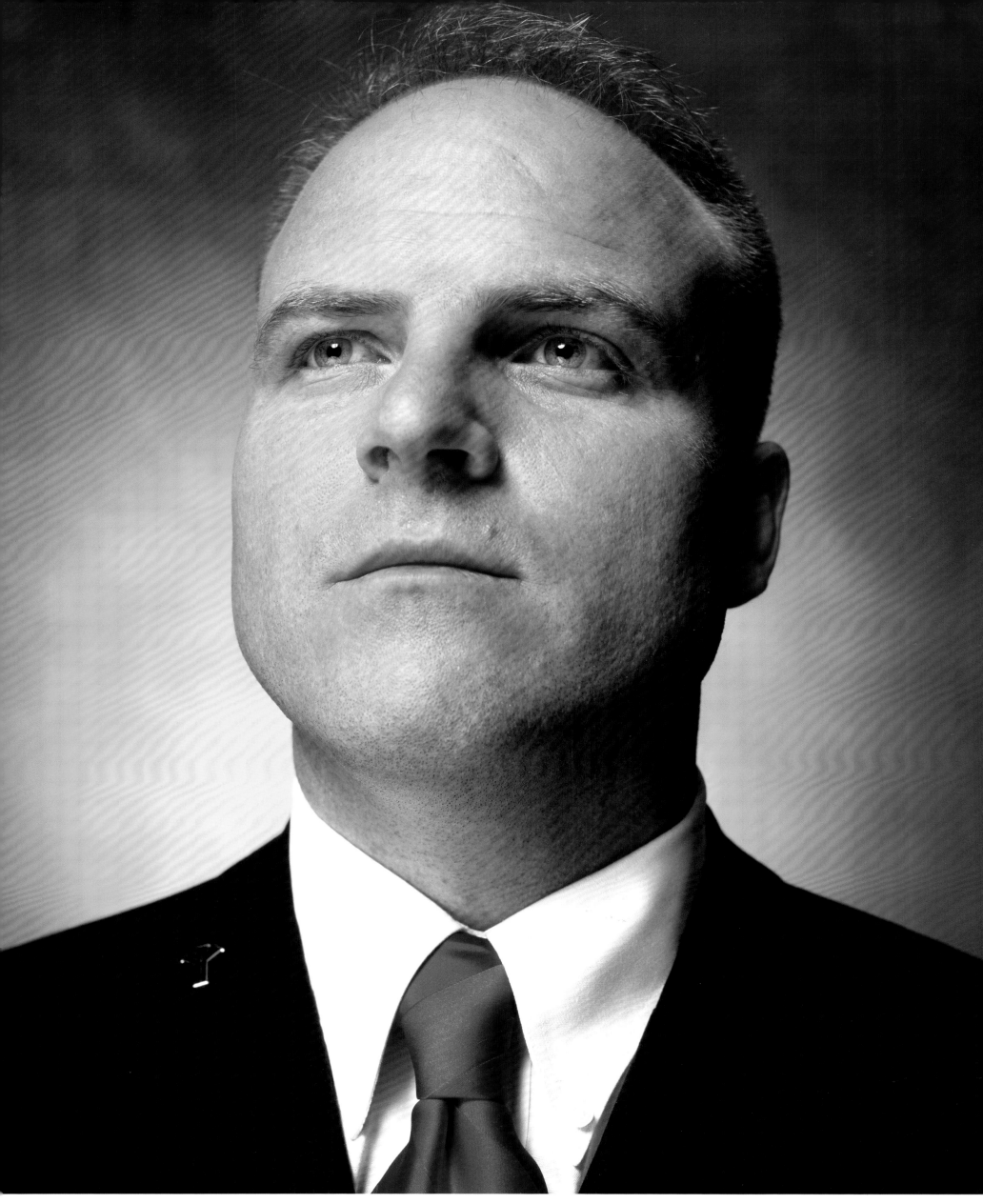

Shaun Walker, Neo-Nazi
2004

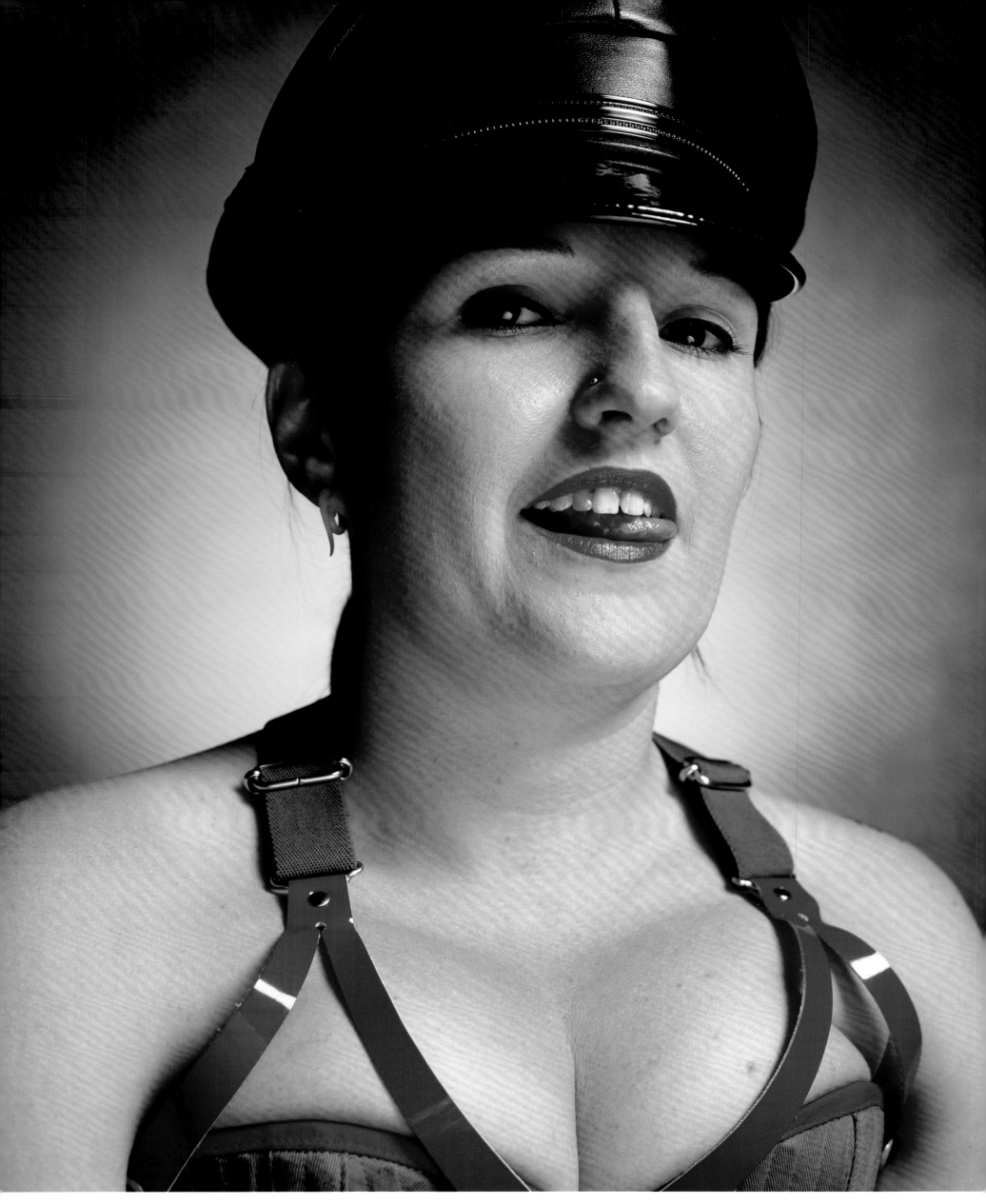

Mistress Adriana, Dominatrix

2004

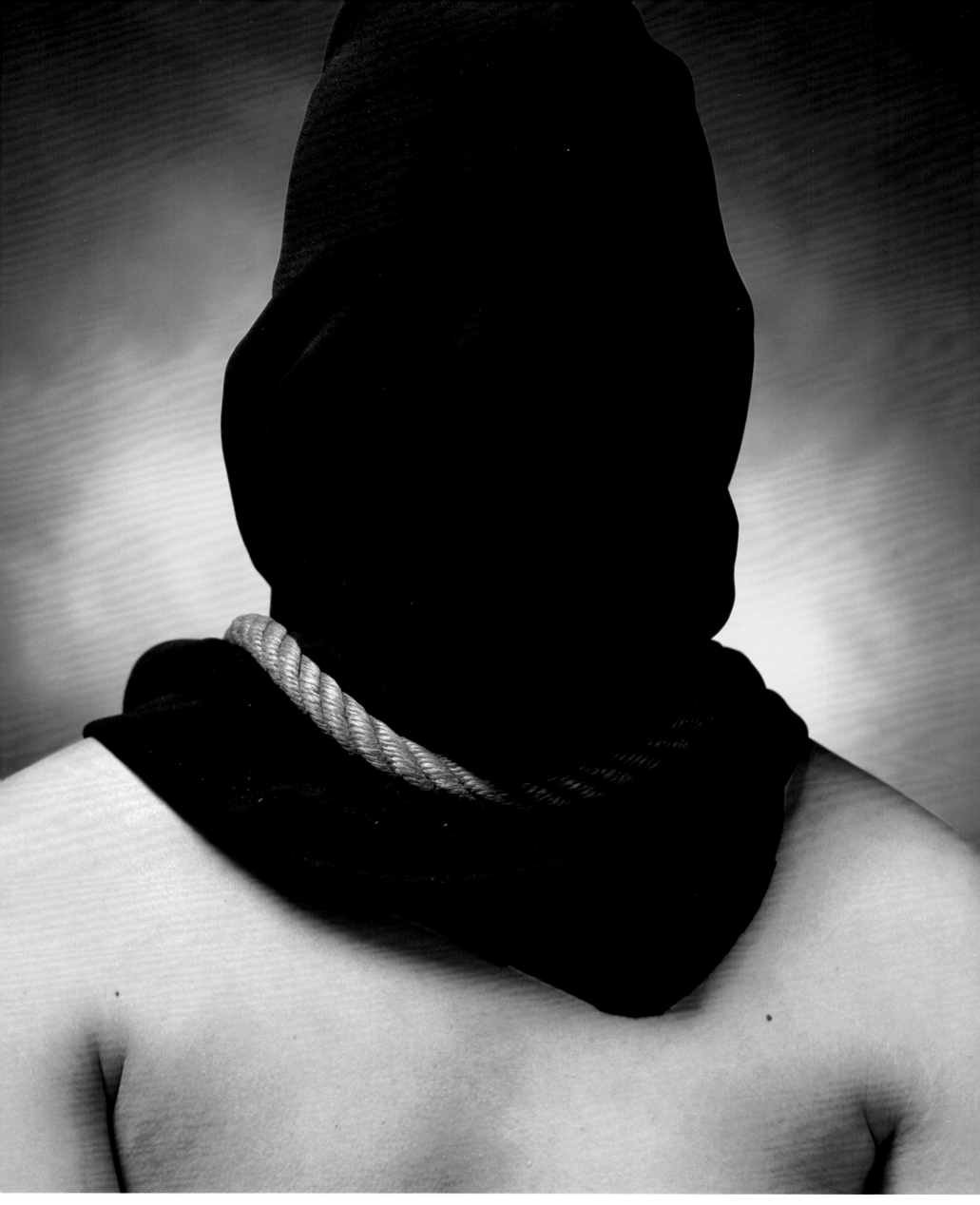

Stephen, Slave
2004

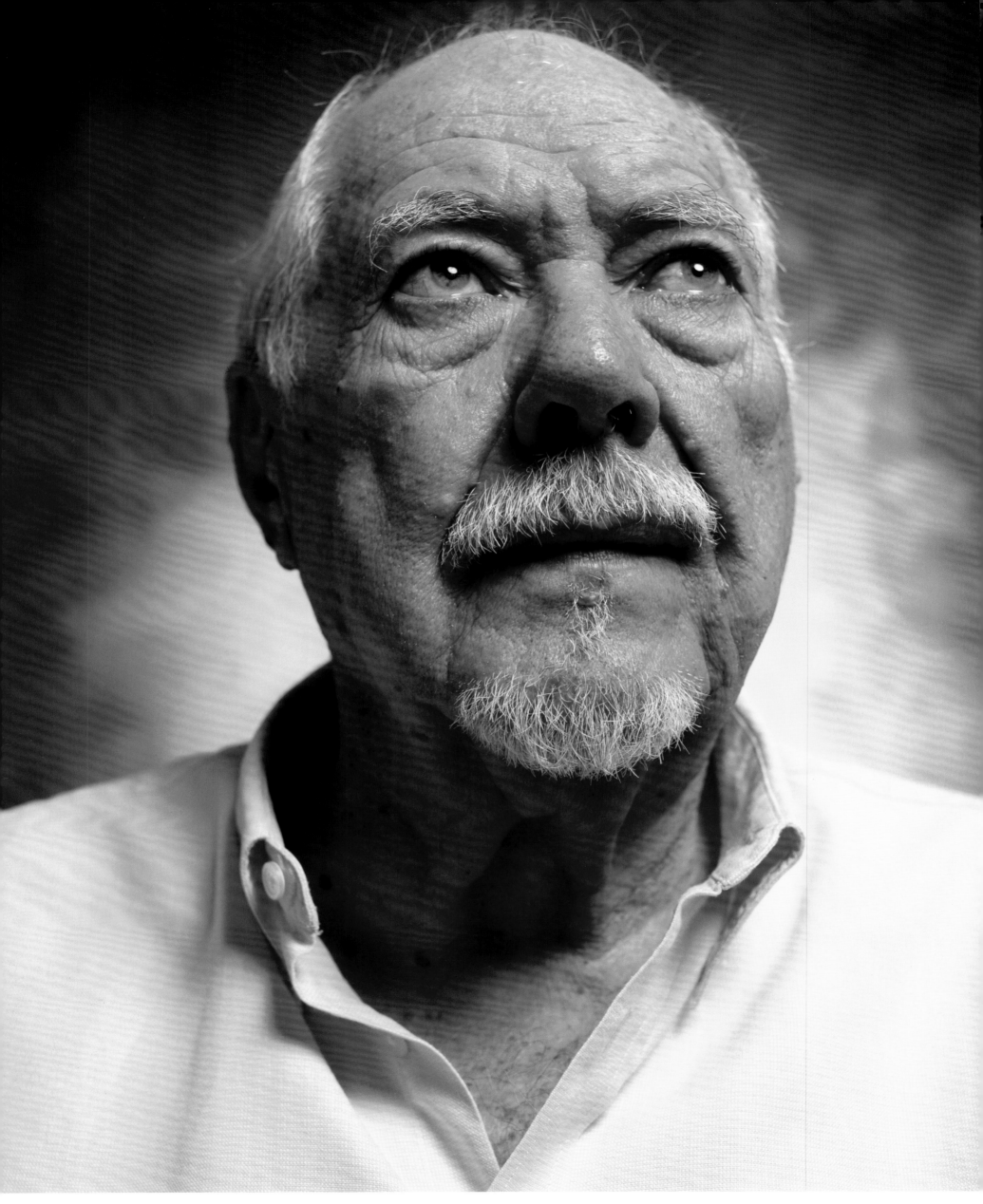

Robert Altman, Director
2004

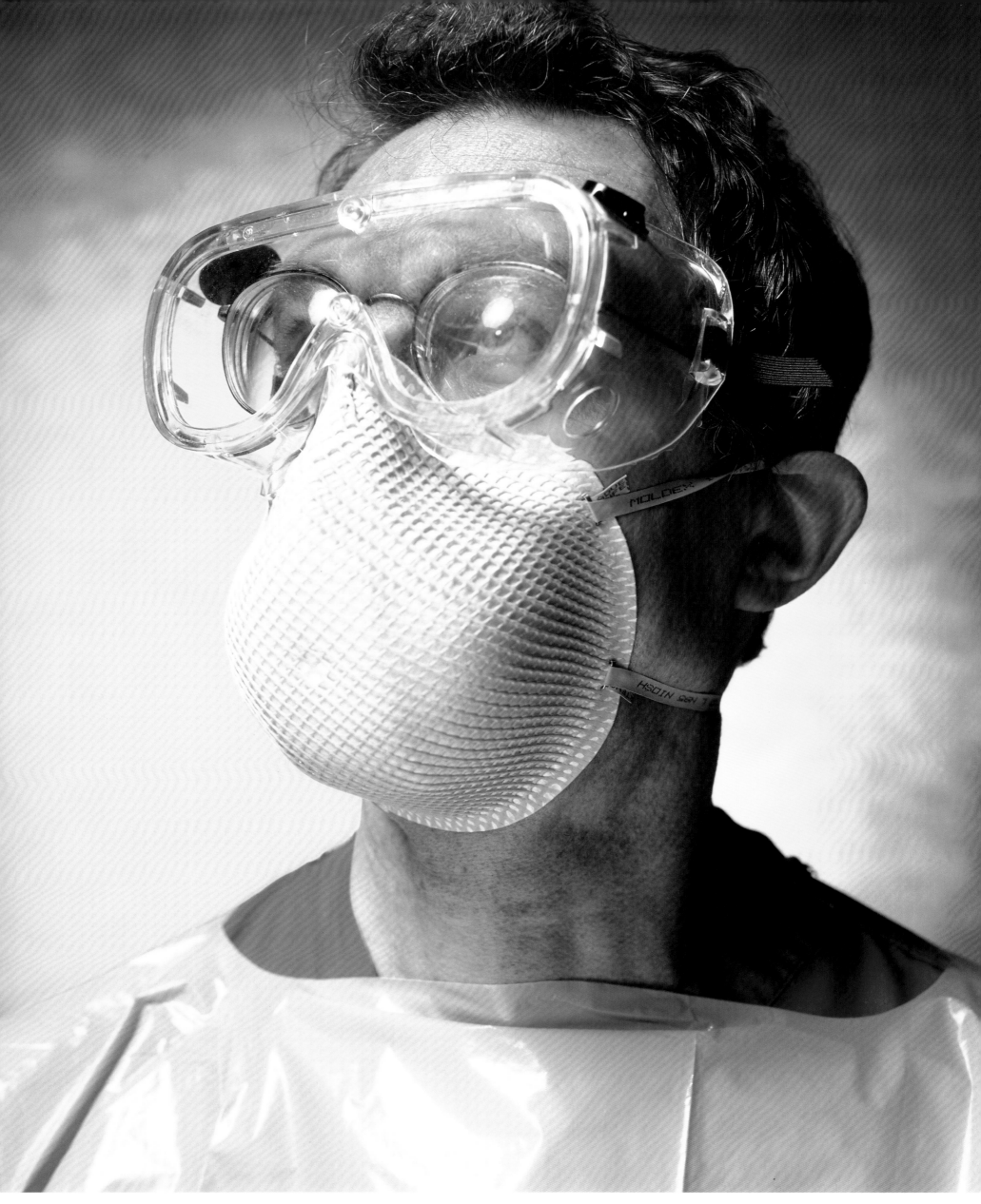

Dr. Mark Flomenbaum, Medical Examiner
2003

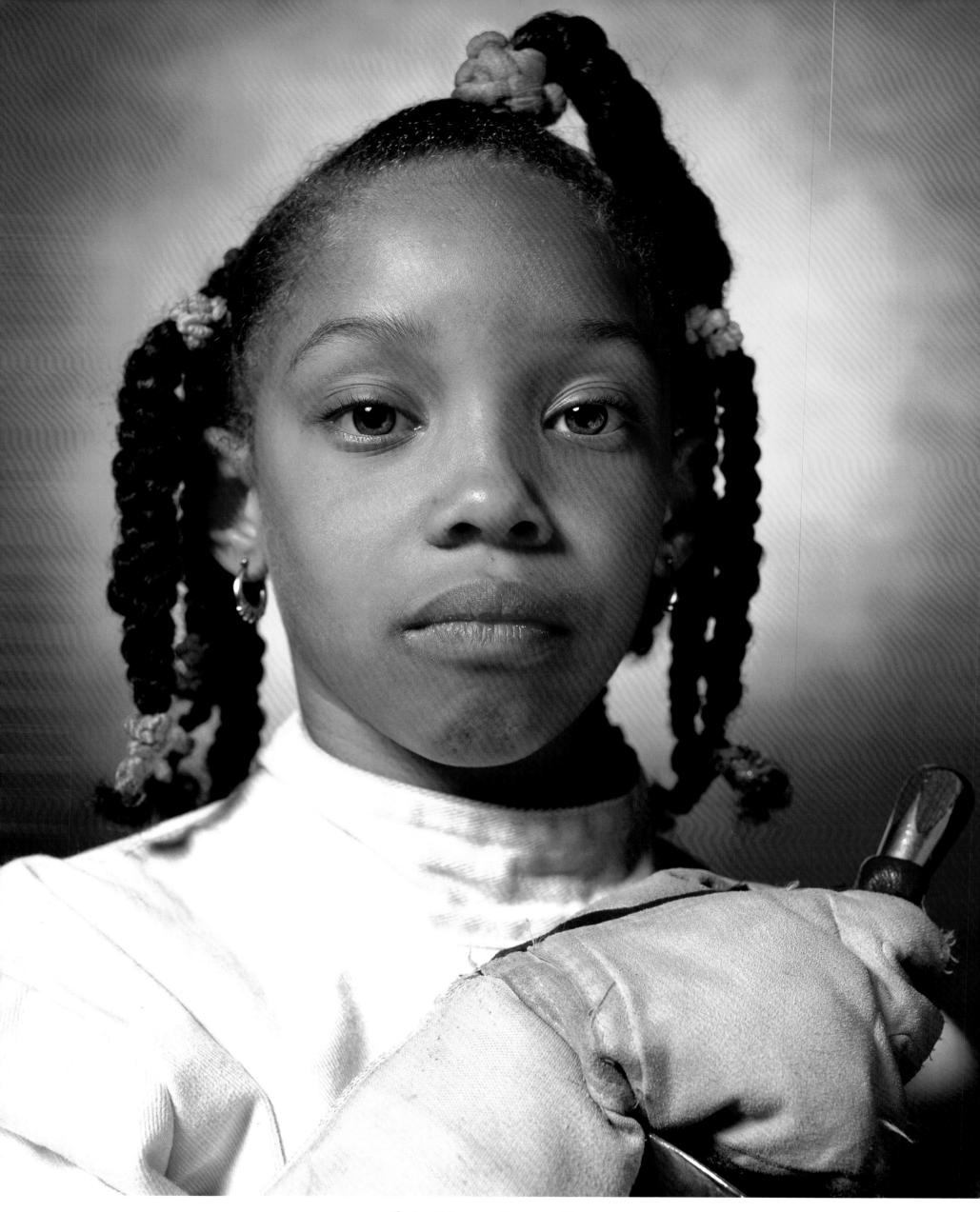

Caira Moreira Brown, Fencer
2004

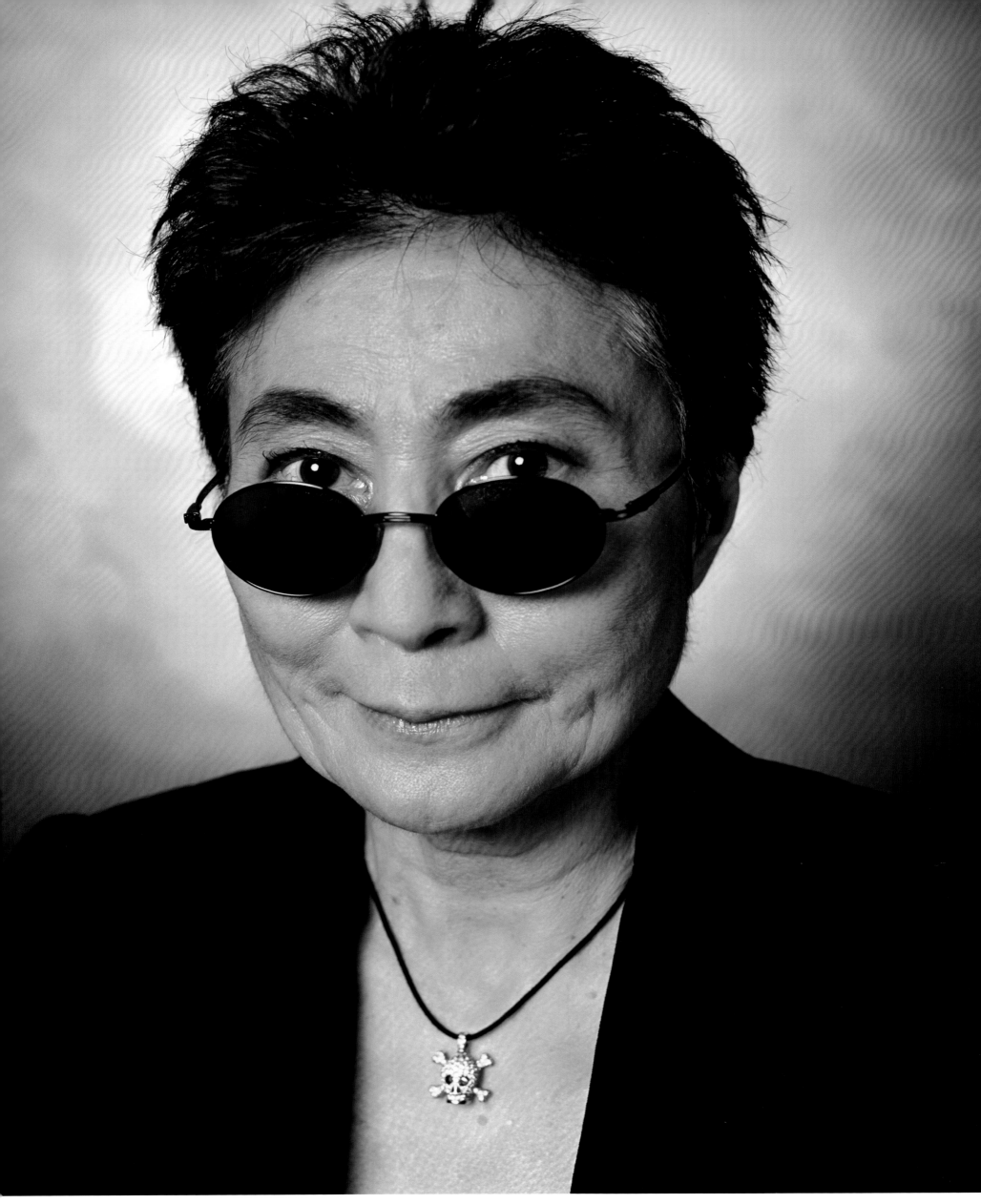

Yoko Ono

2004

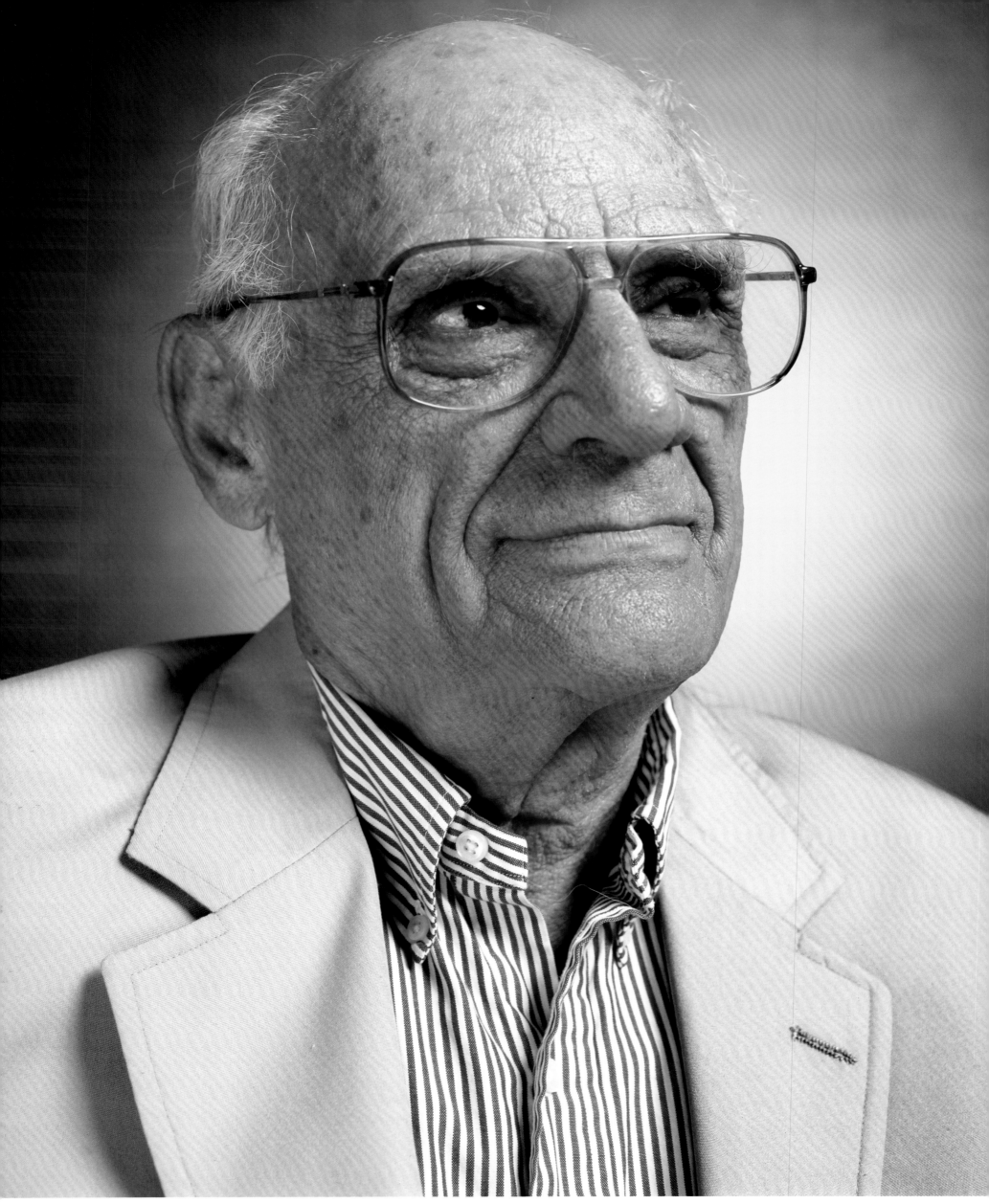

Arthur Miller
2004

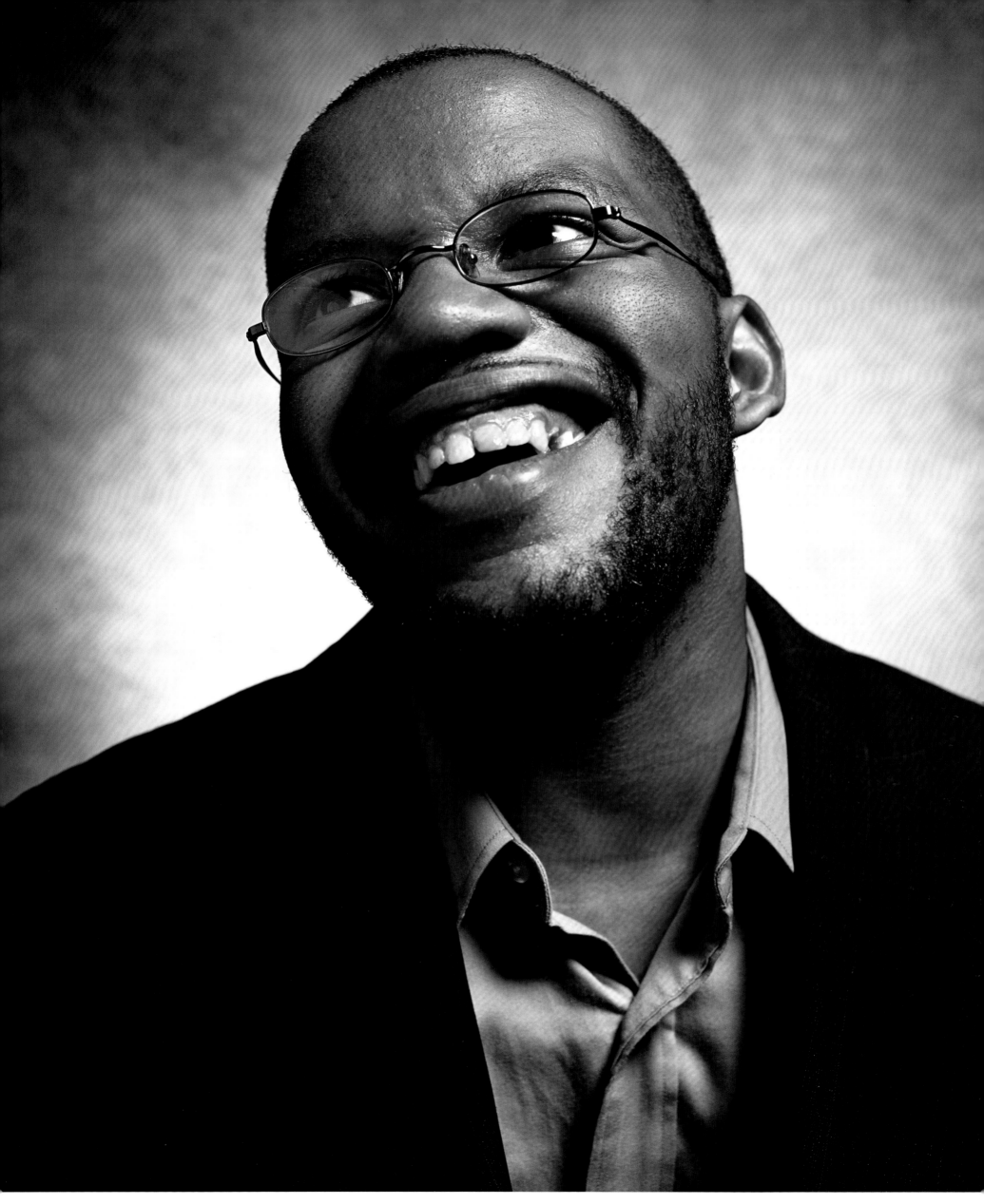

Jayson Blair, The Former New York Times Reporter
2003

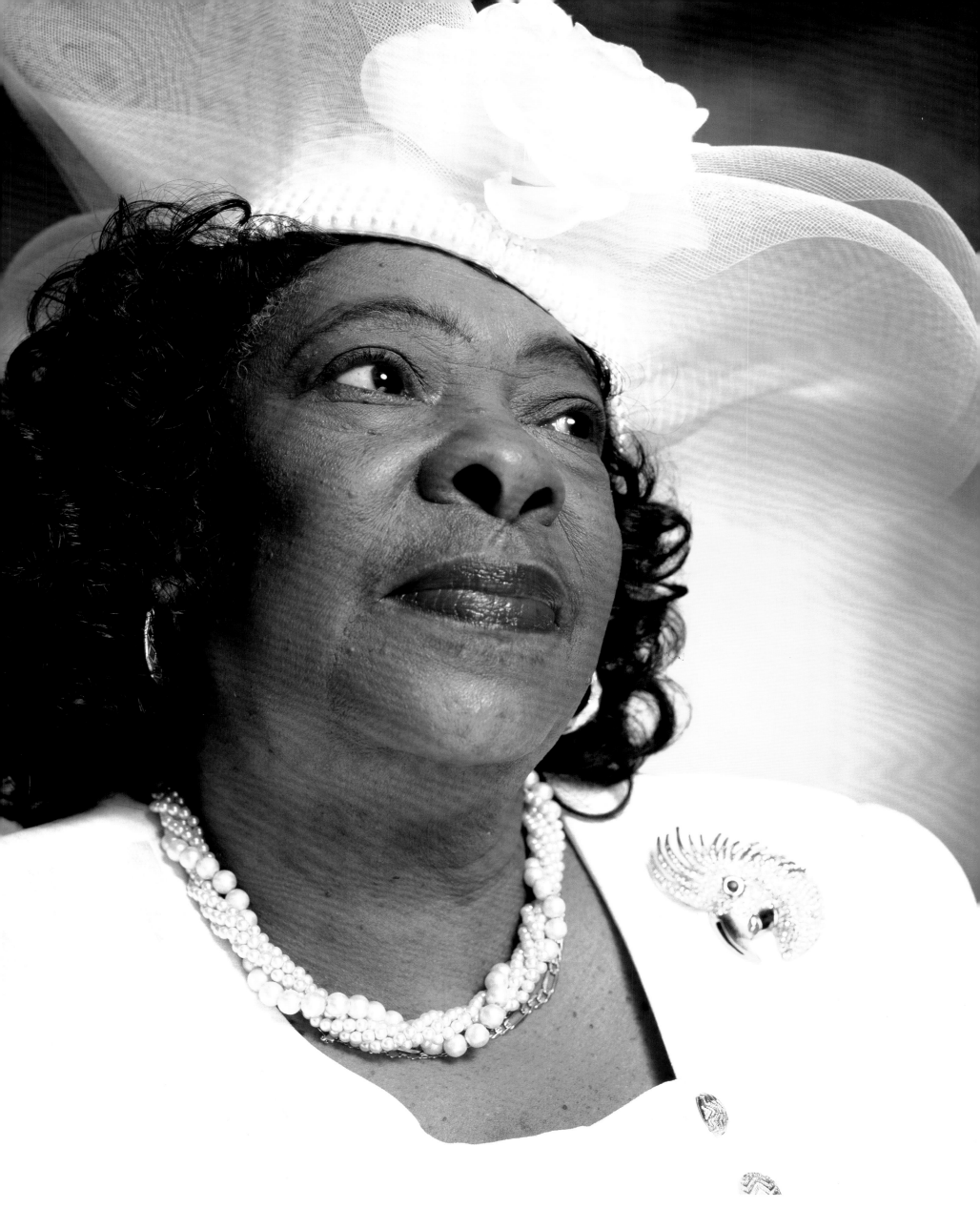

Mildred R. Pugh, Churchgoer
2004

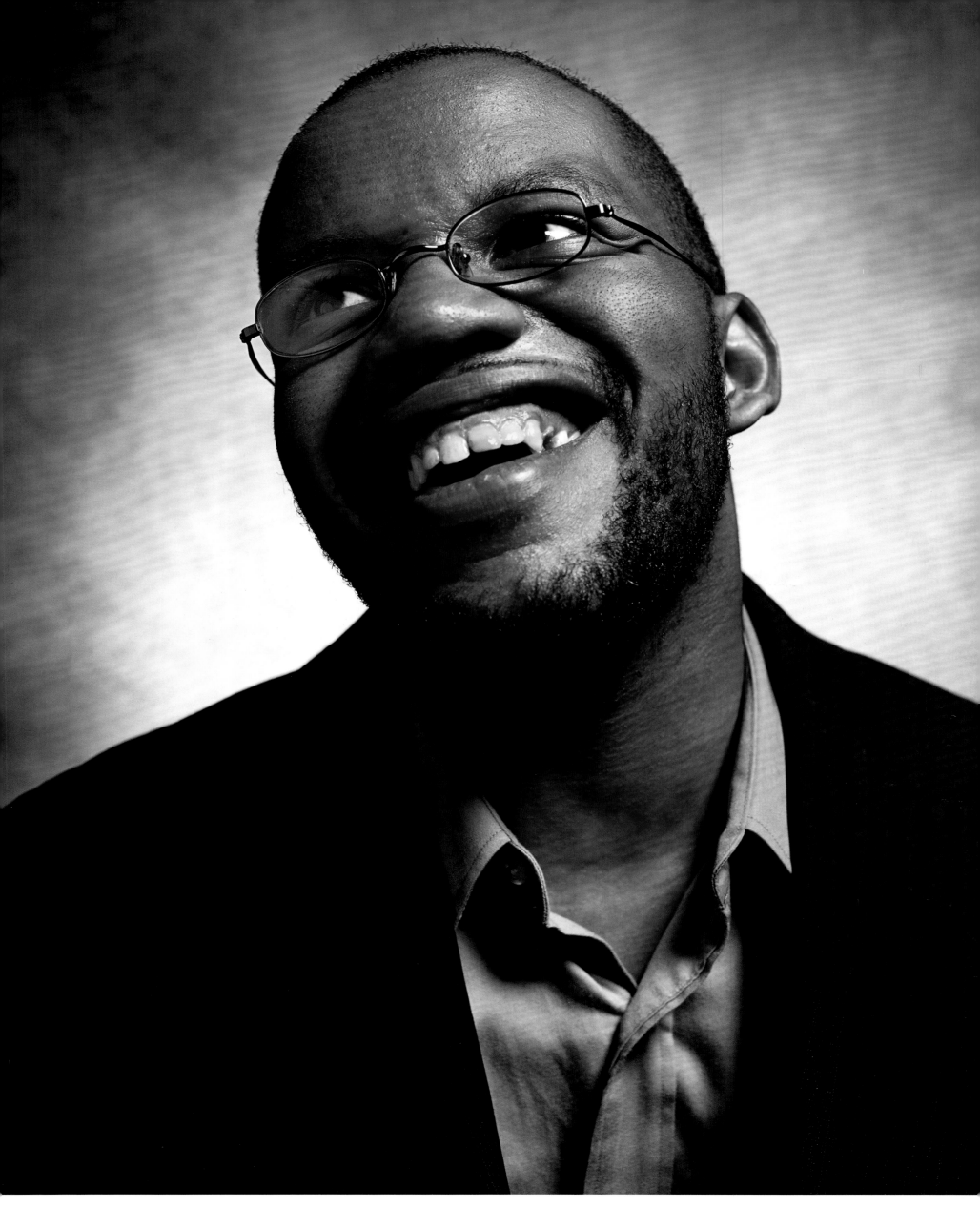

Jayson Blair, The Former New York Times Reporter
2003

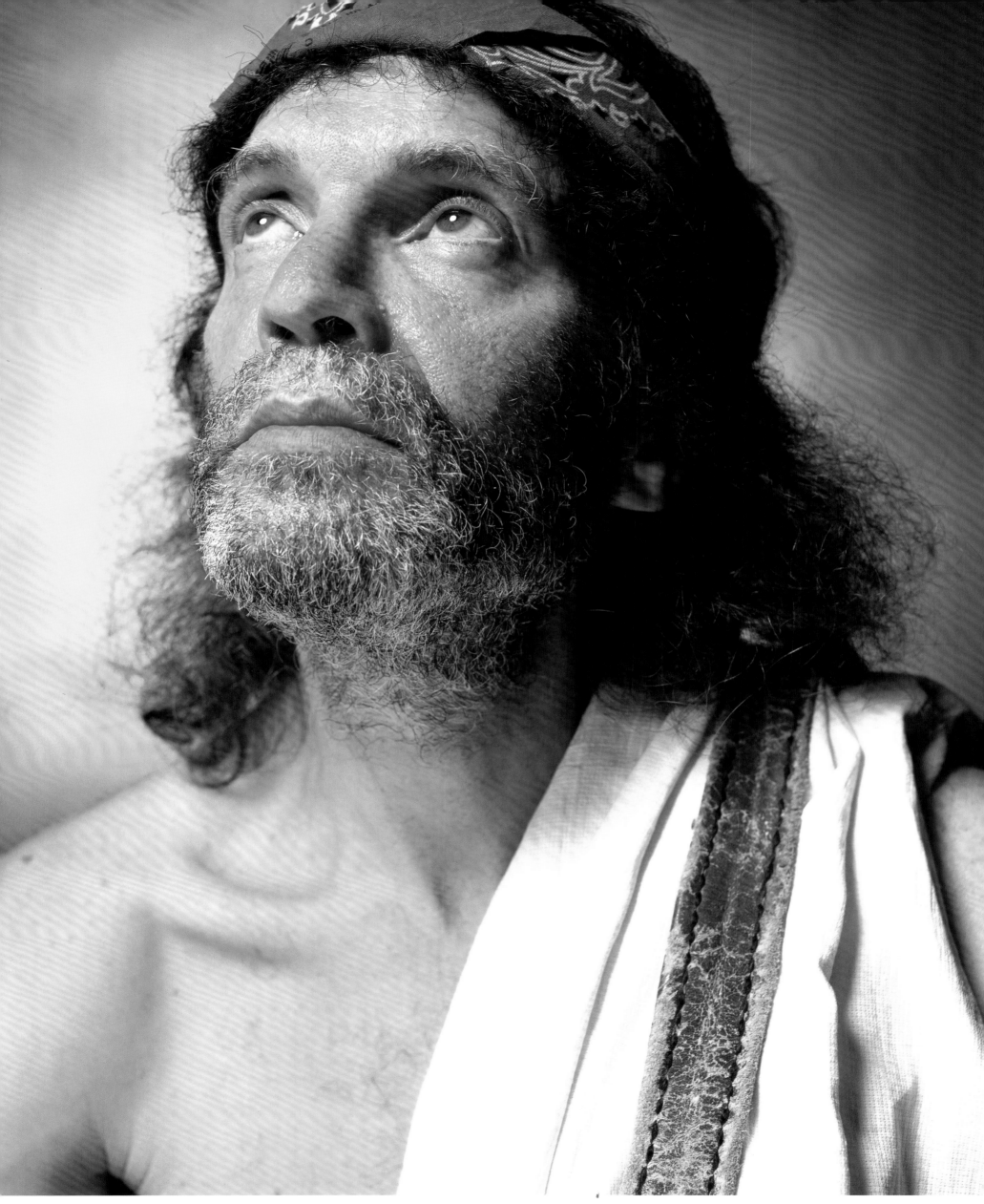

Robert Wisotsky, Unemployed
2004

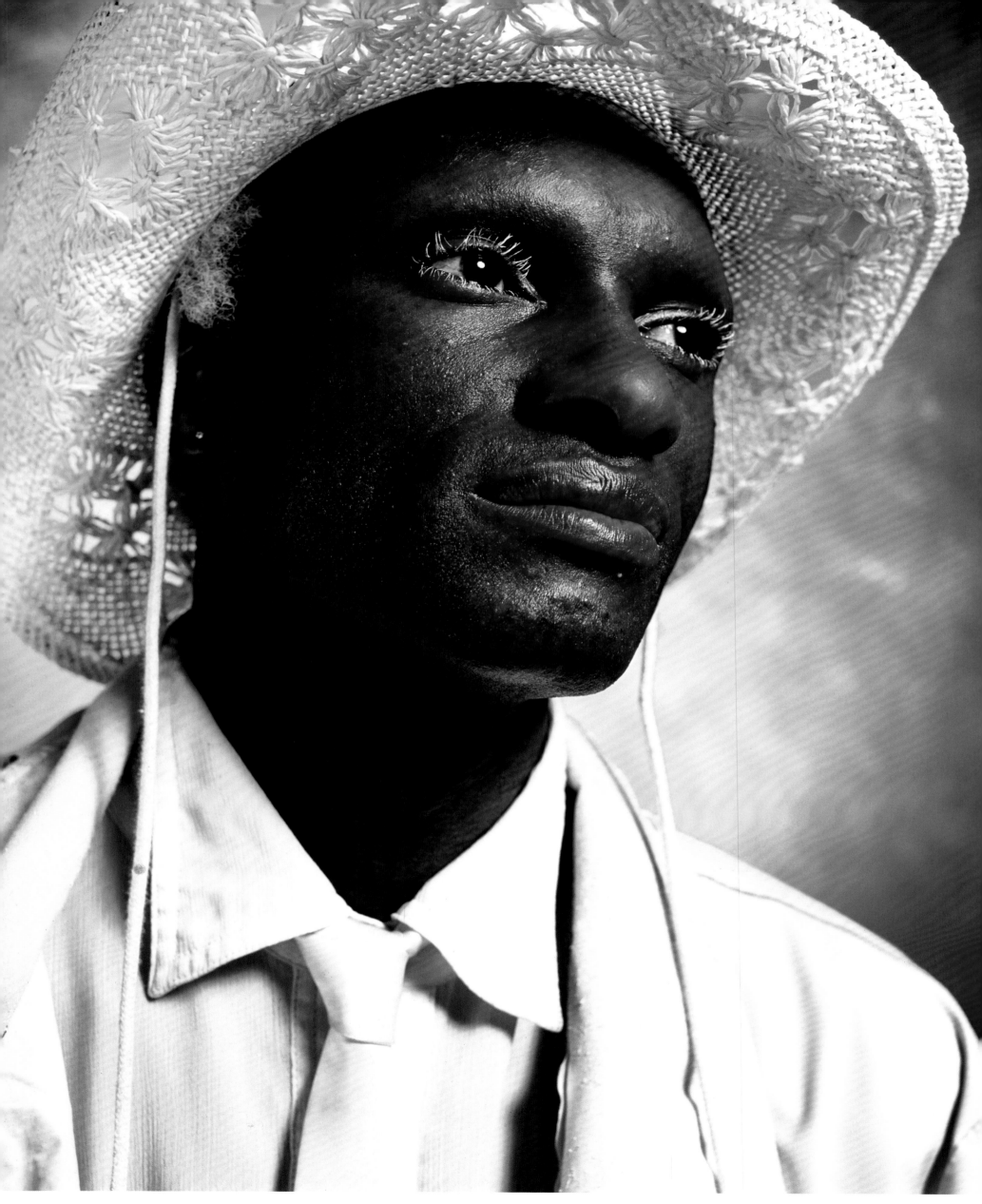

Lloyd Ruben Koulen, Panhandler
2003

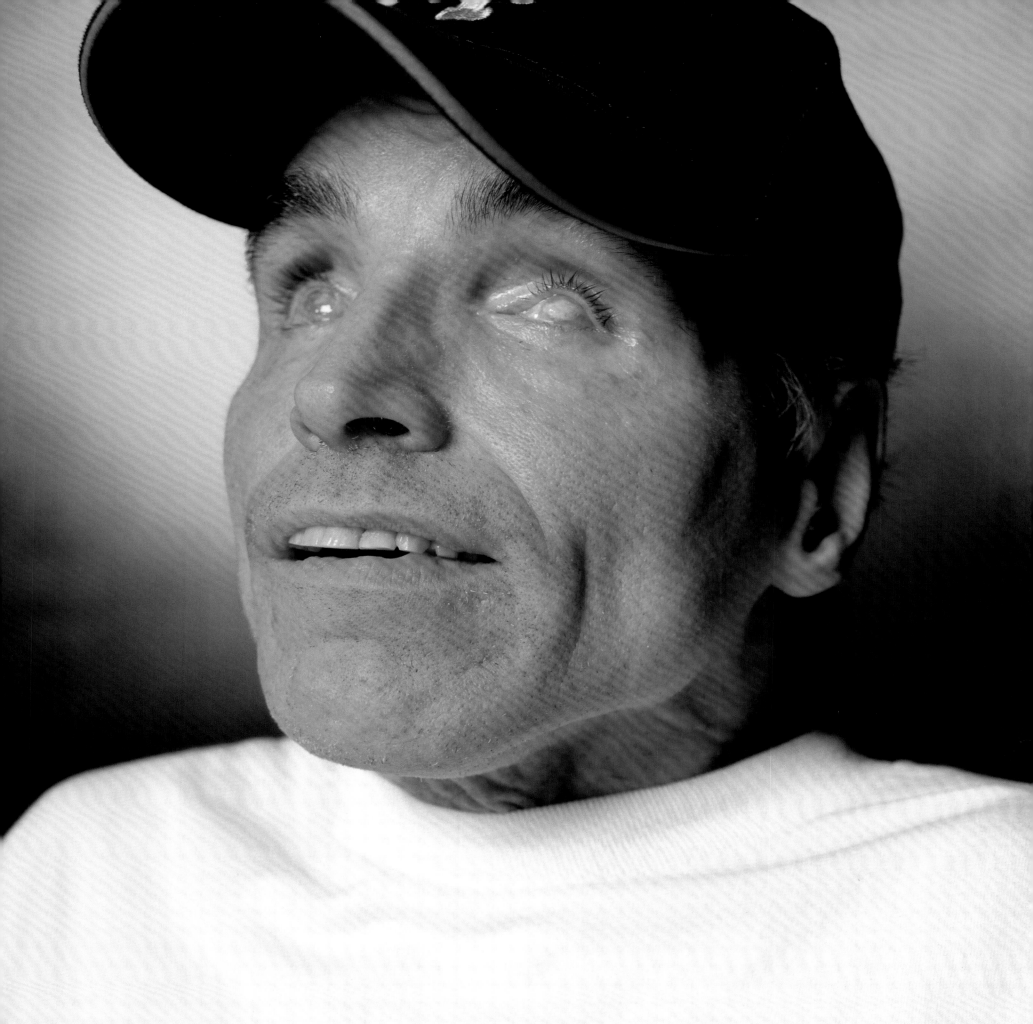

GOD BLESS AMERICA
Land that I love

Jack Callaghan, Hospital Volunteer
2004

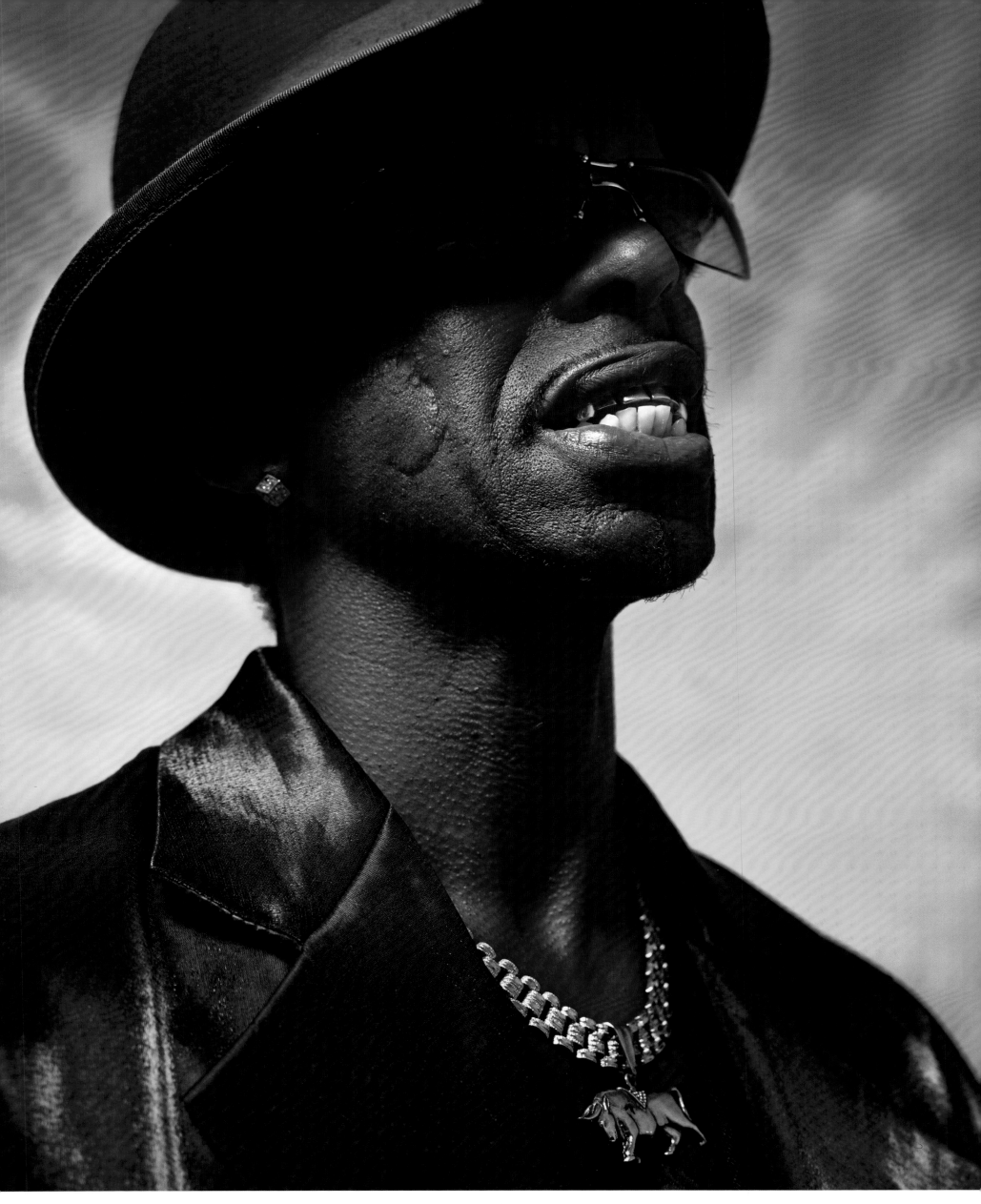

J.B., Pimp

2003

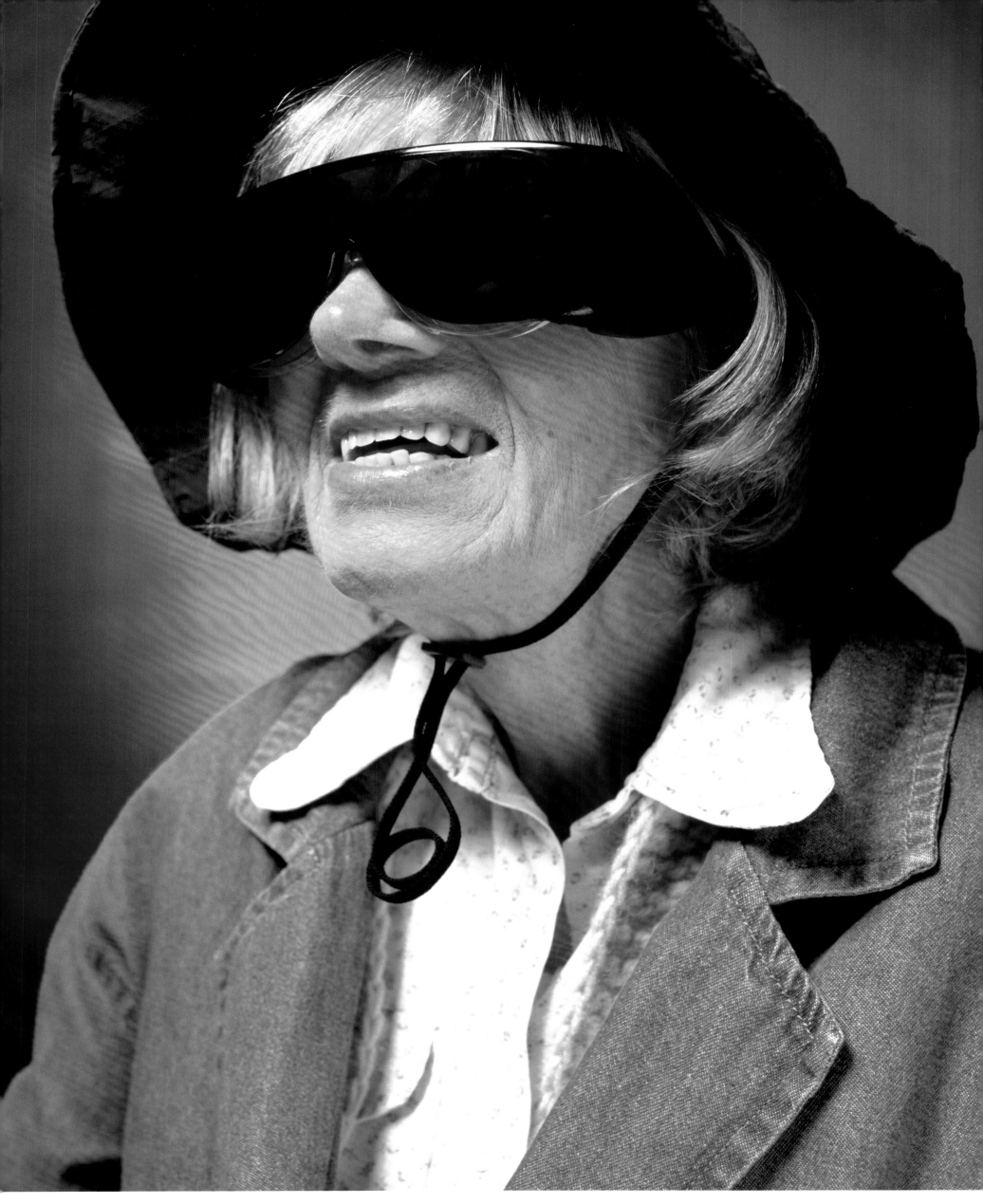

Margaret C. Walker, Jehovah's Witness
2004

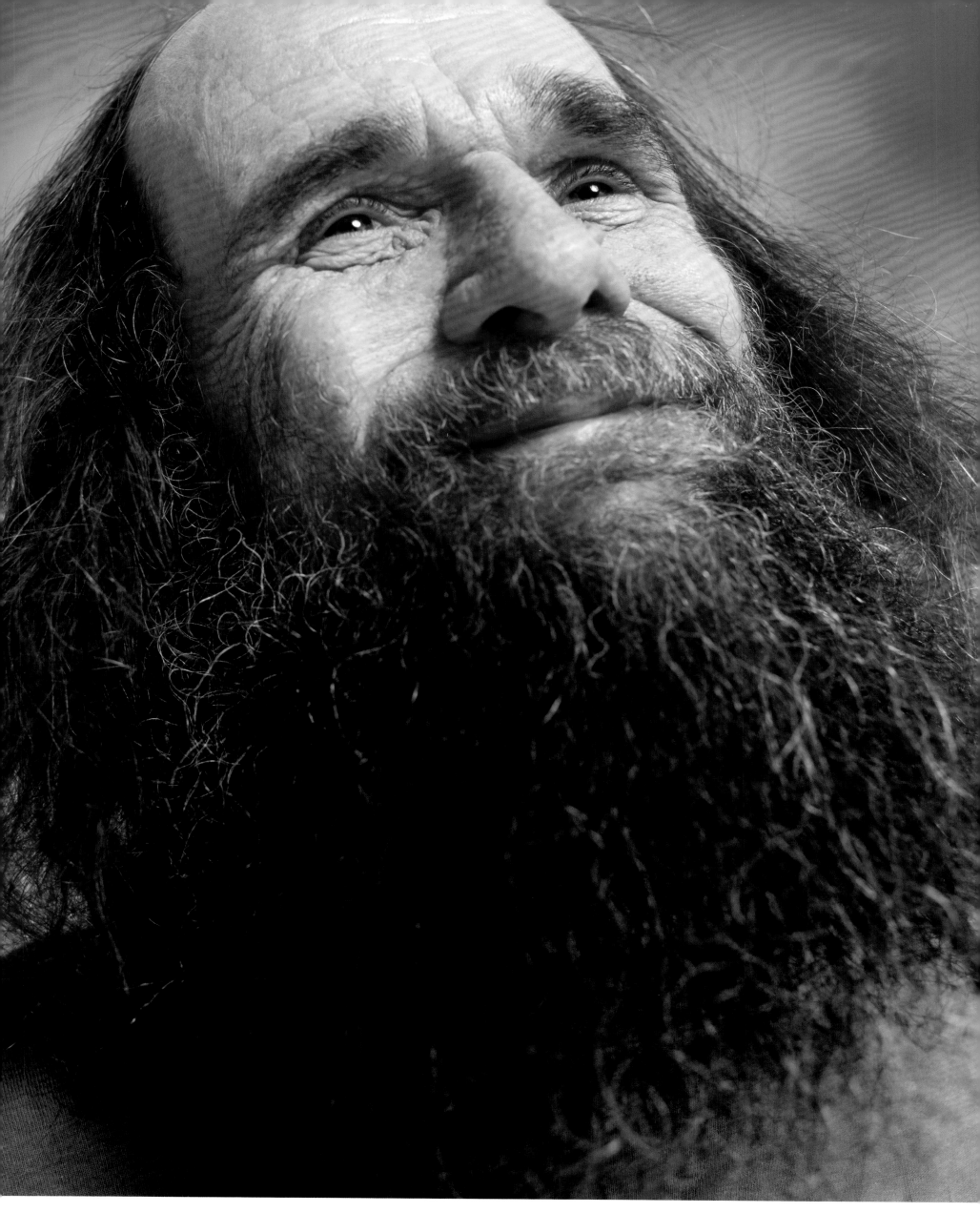

Lawrence LaDouceur
2004

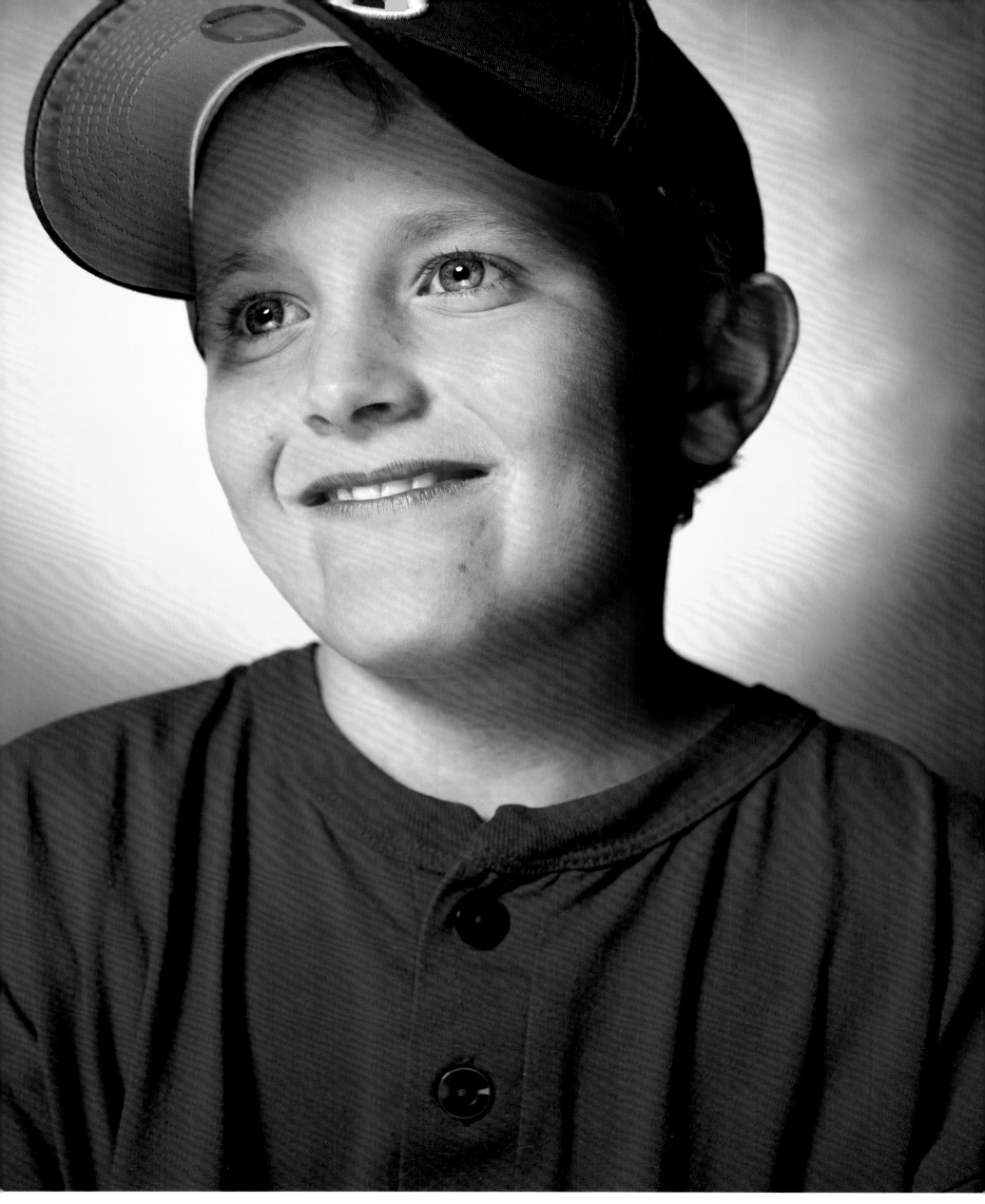

Matthew "Country" Maitland, Little Leaguer
2004

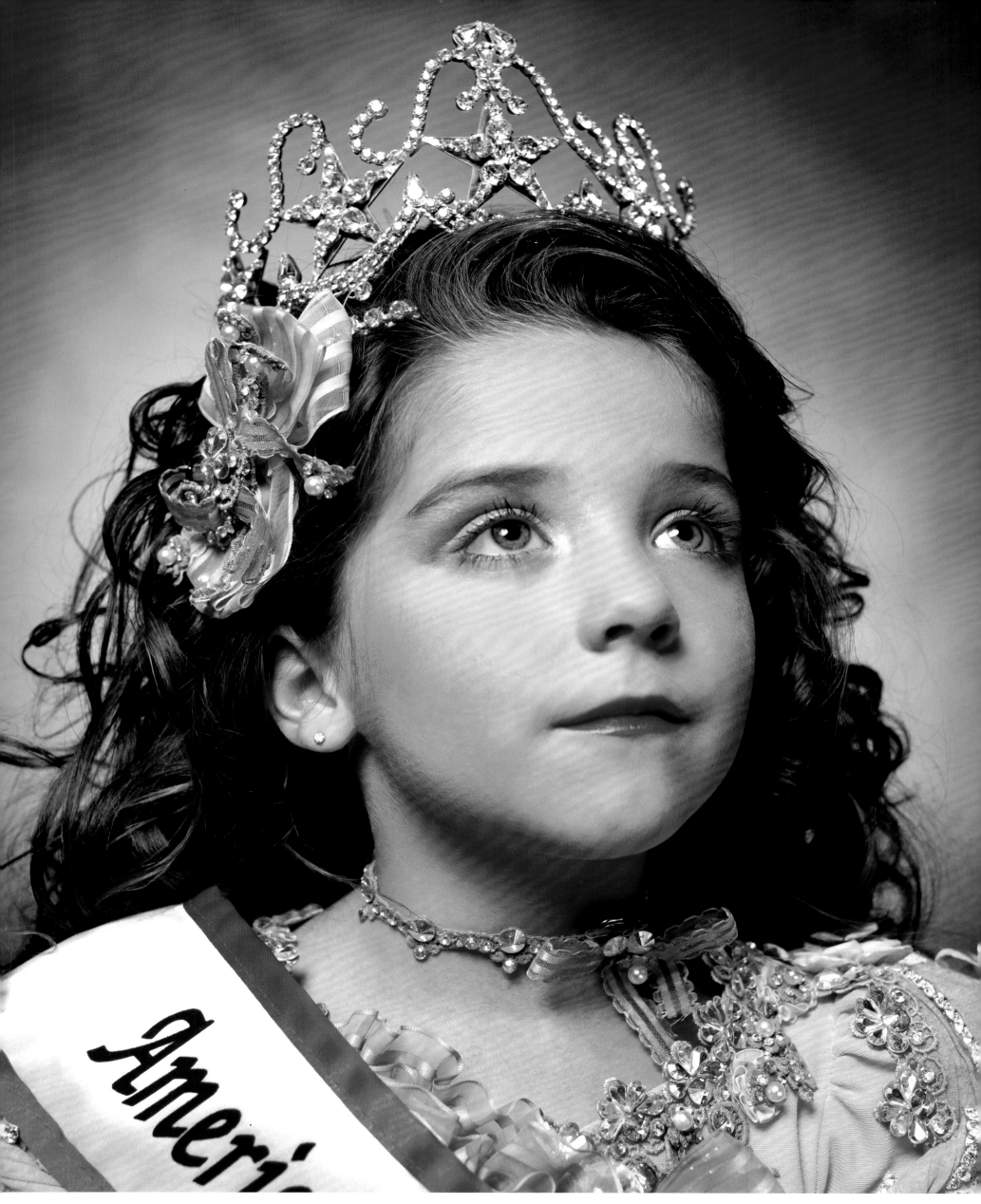

Jewel-Joy Stevens, America's Little Yankee Miss
2003

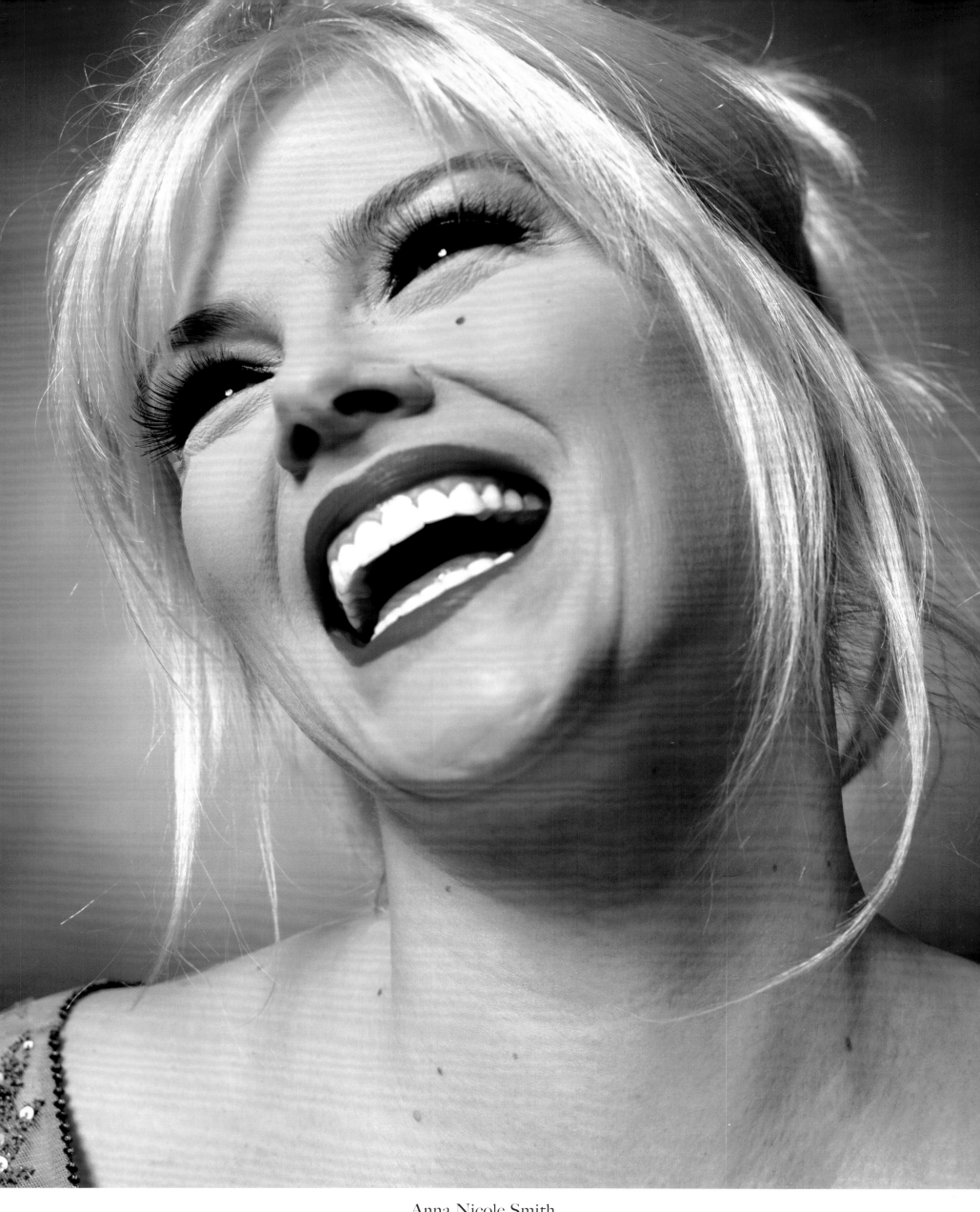

Anna Nicole Smith
2004

THE INTERPRETATION OF DREAMS

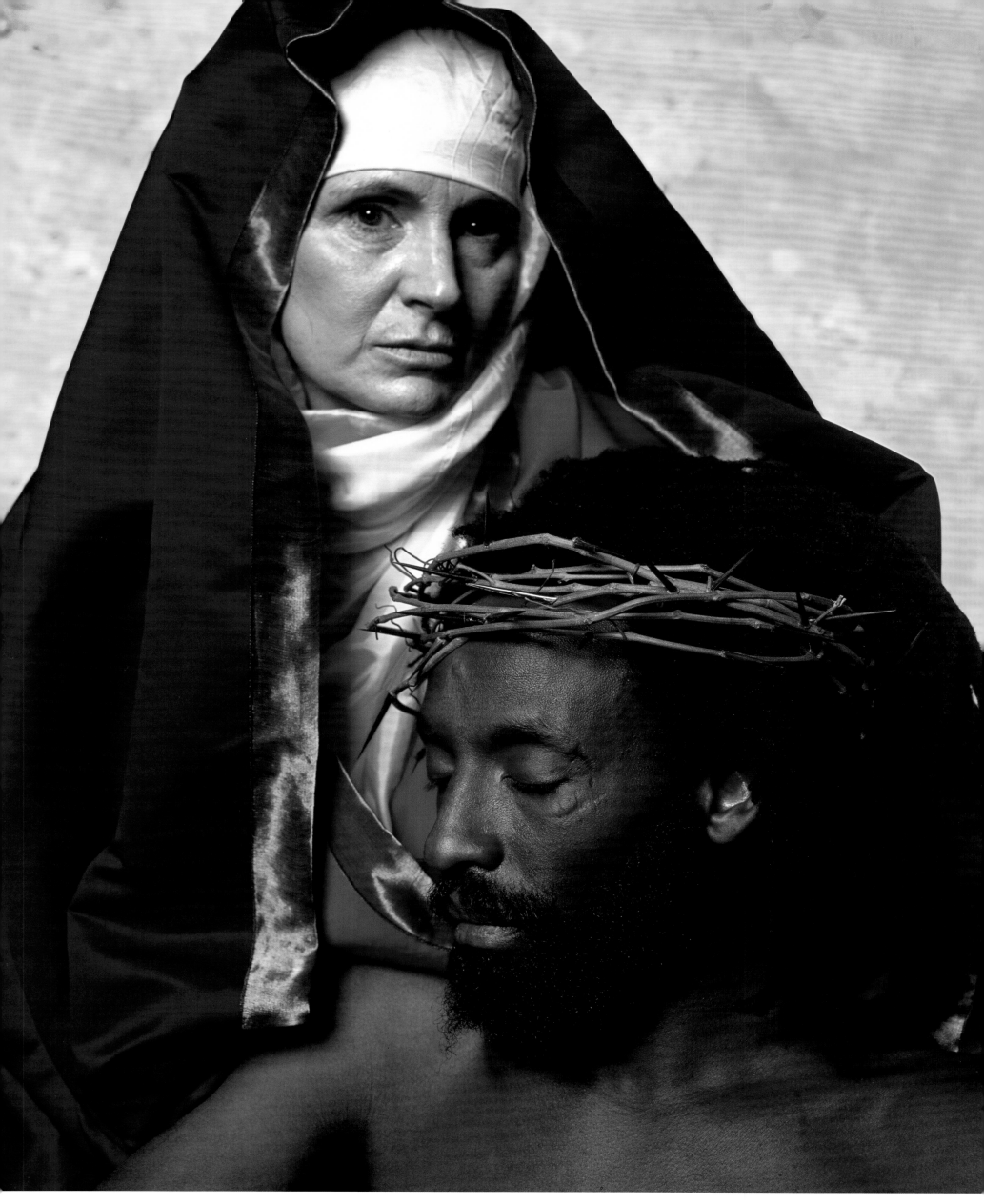

The Other Christ

2001

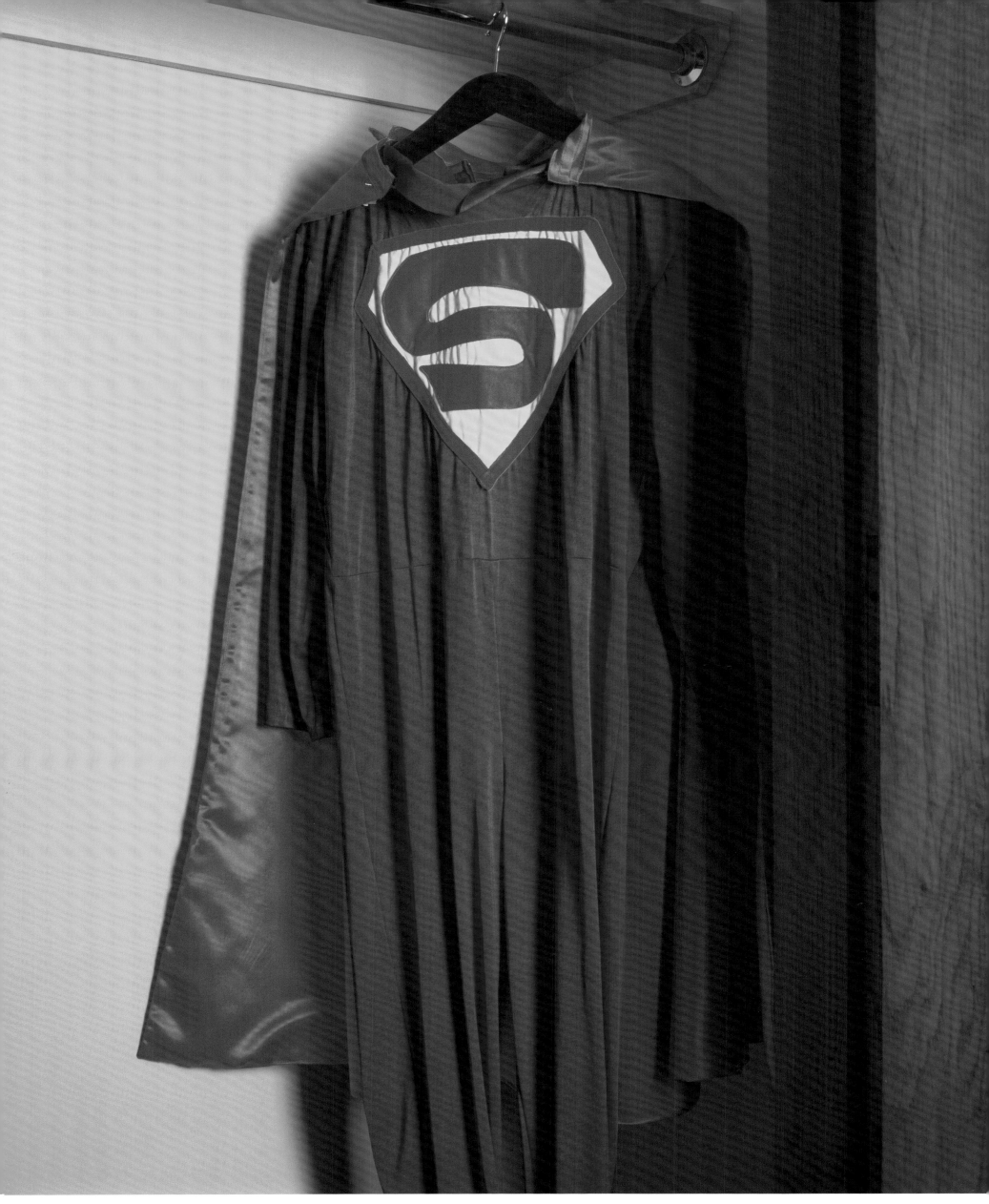

The Death of Superman
2000

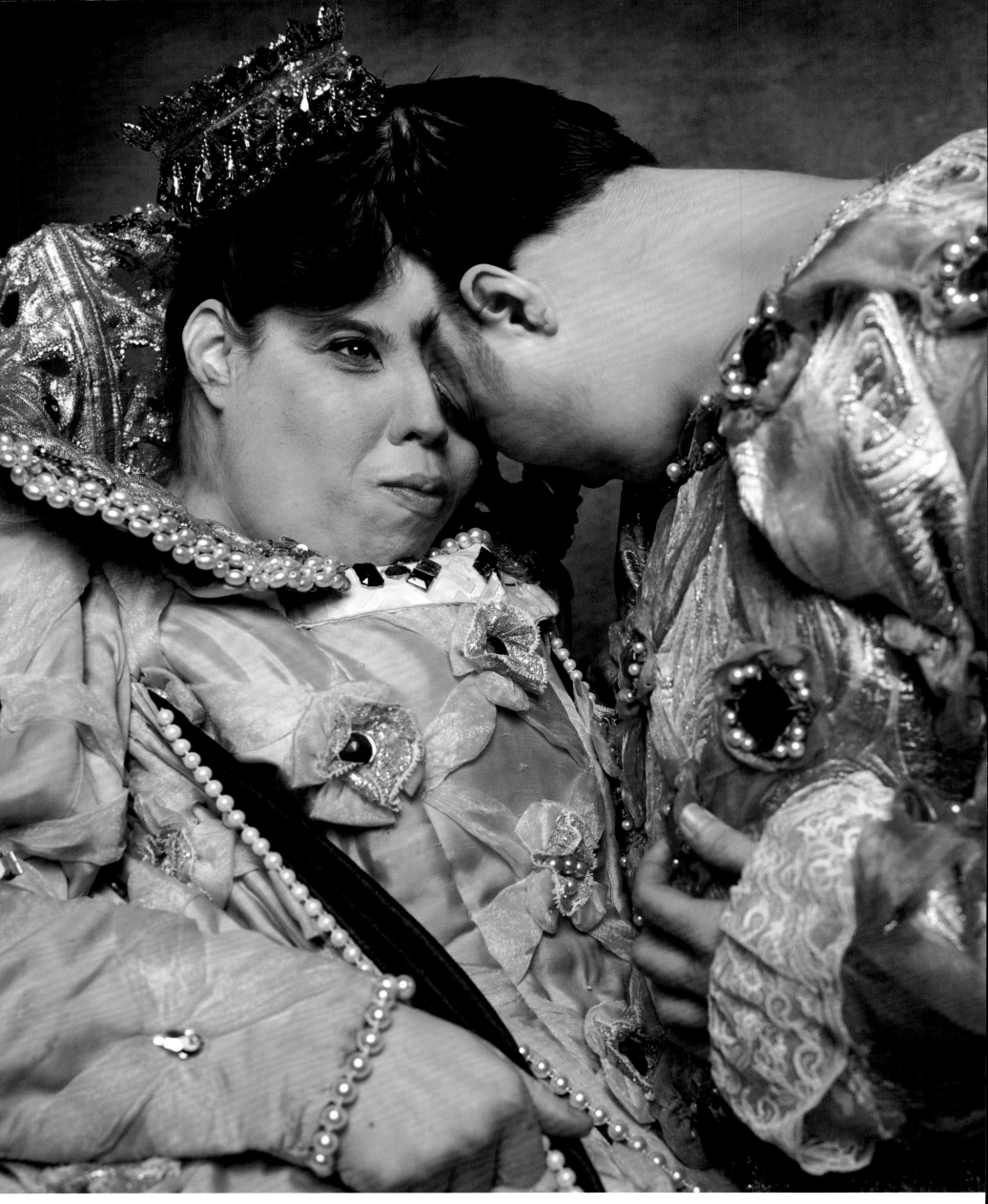

Lori and Dori
2001

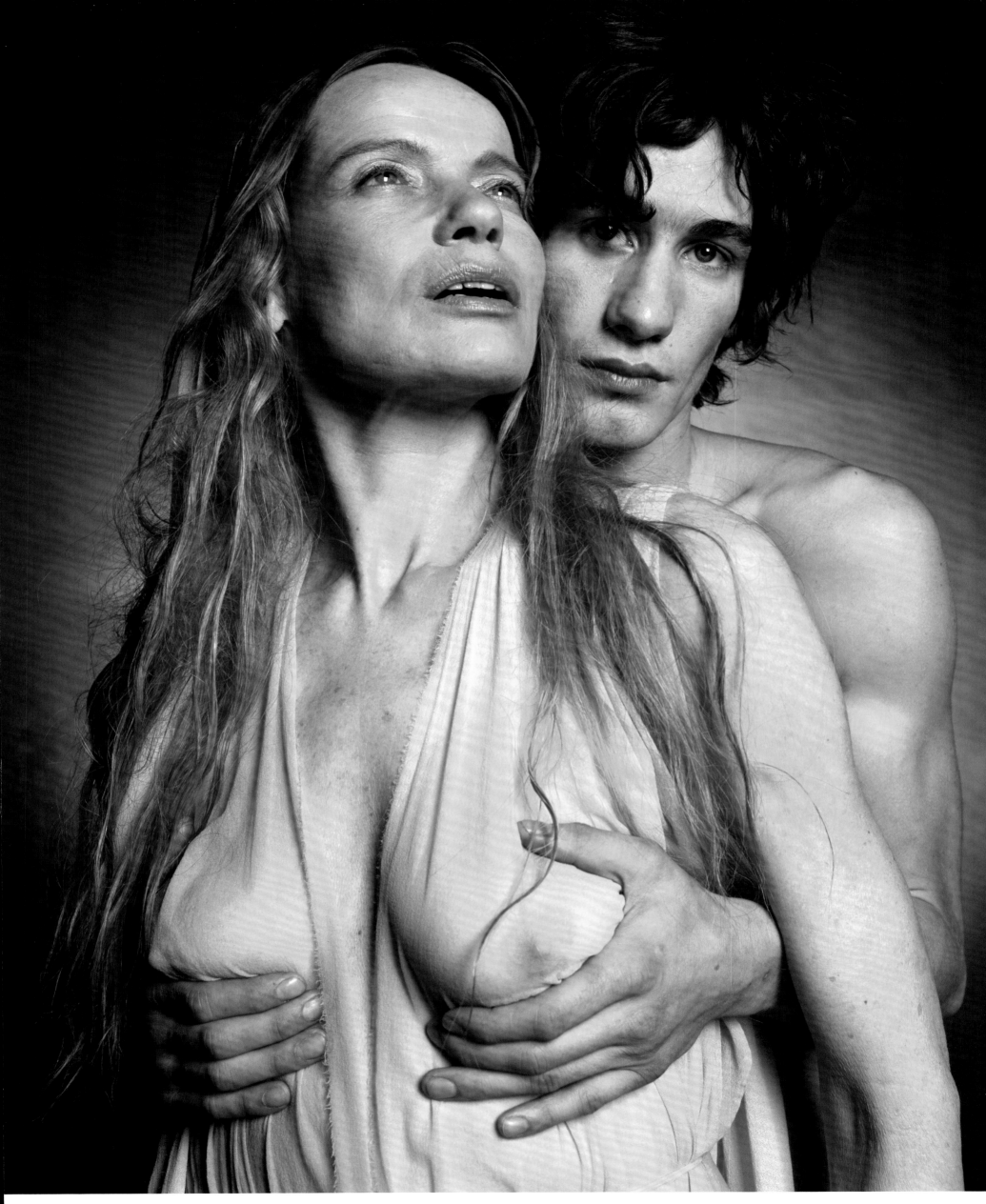

Oedipus and his Mother
2001

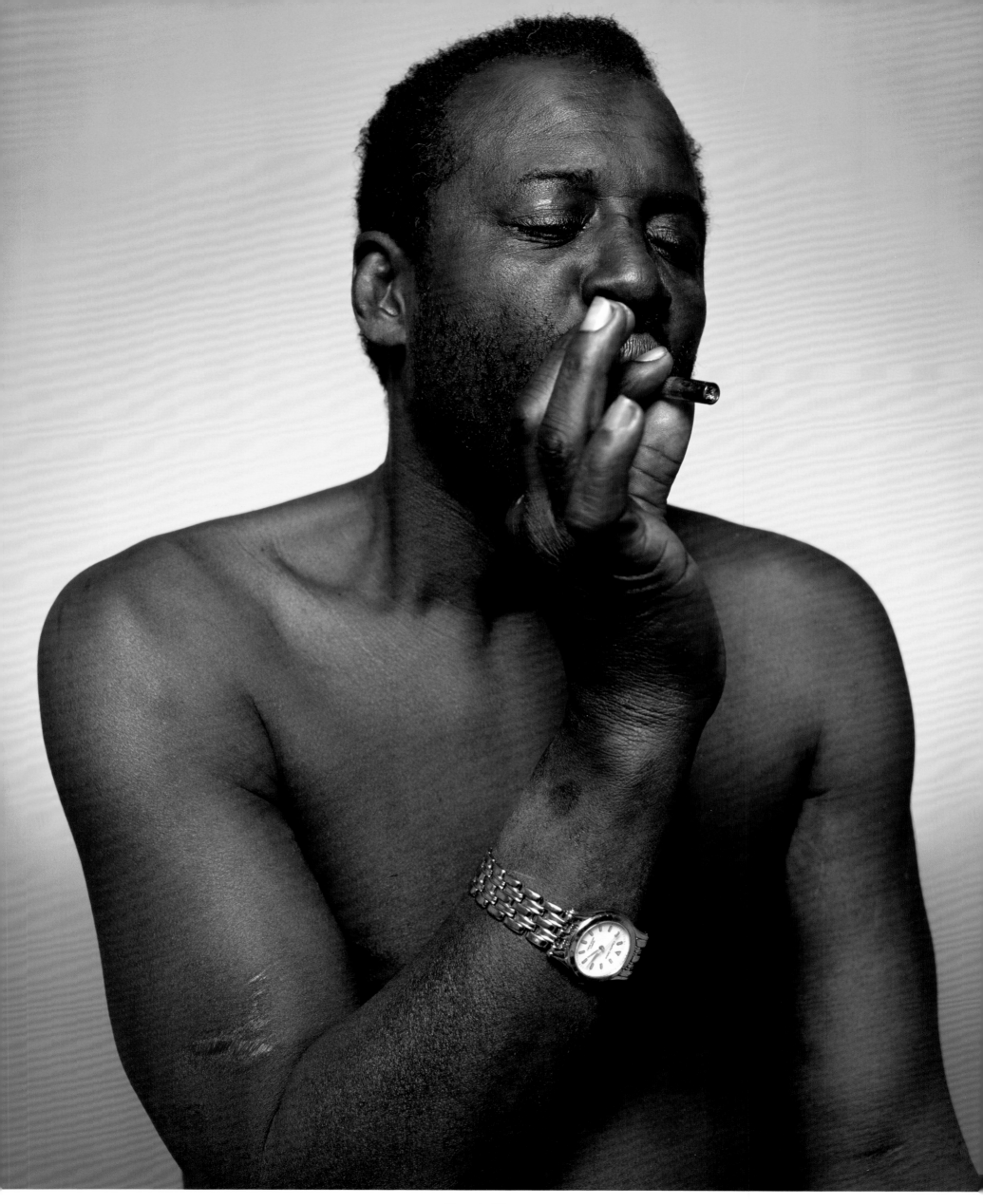

Crack Heaven

2001

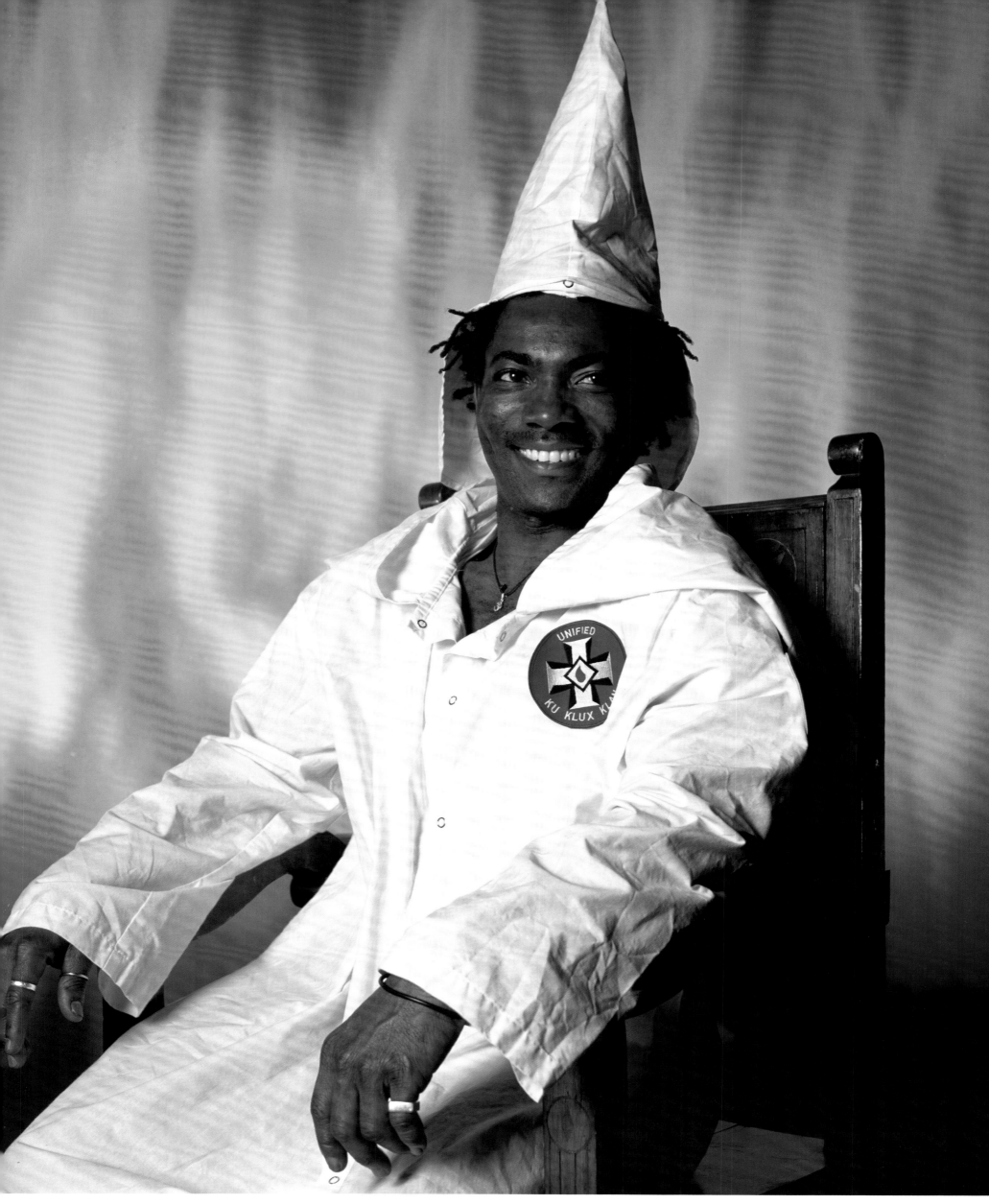

White Man's Burden
2000

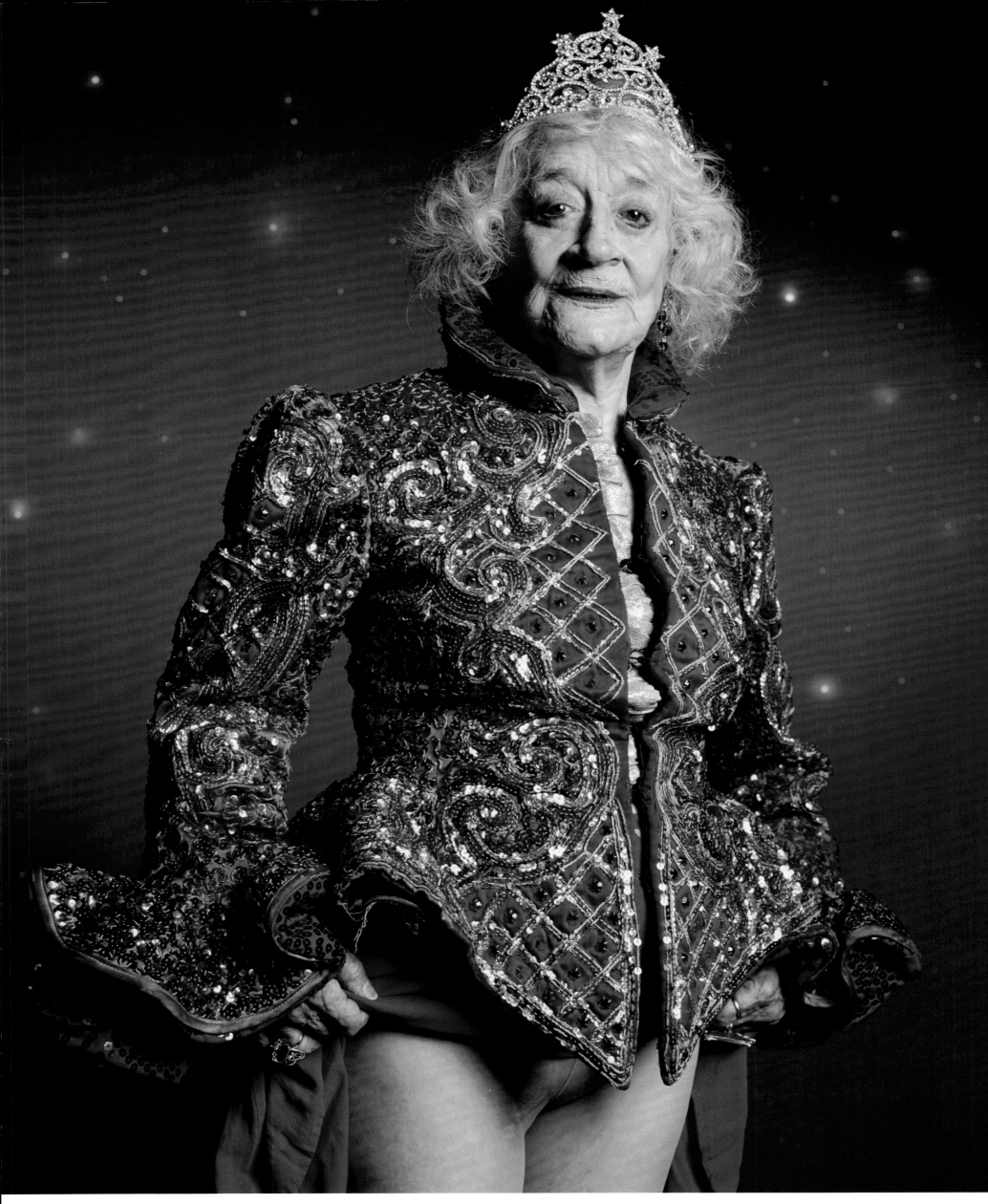

Daddy's Little Girl
2000

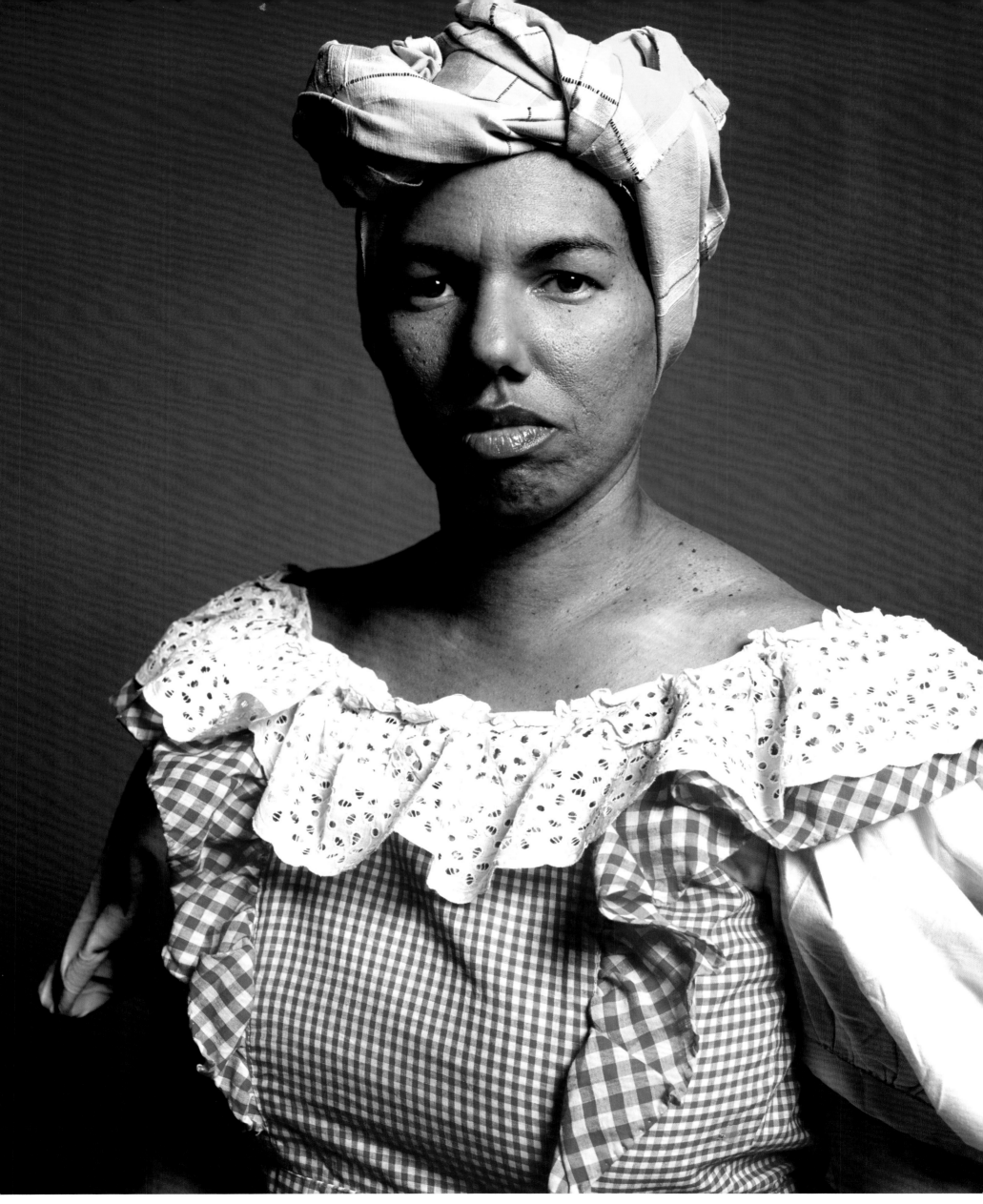

Aunt Jemima

2000

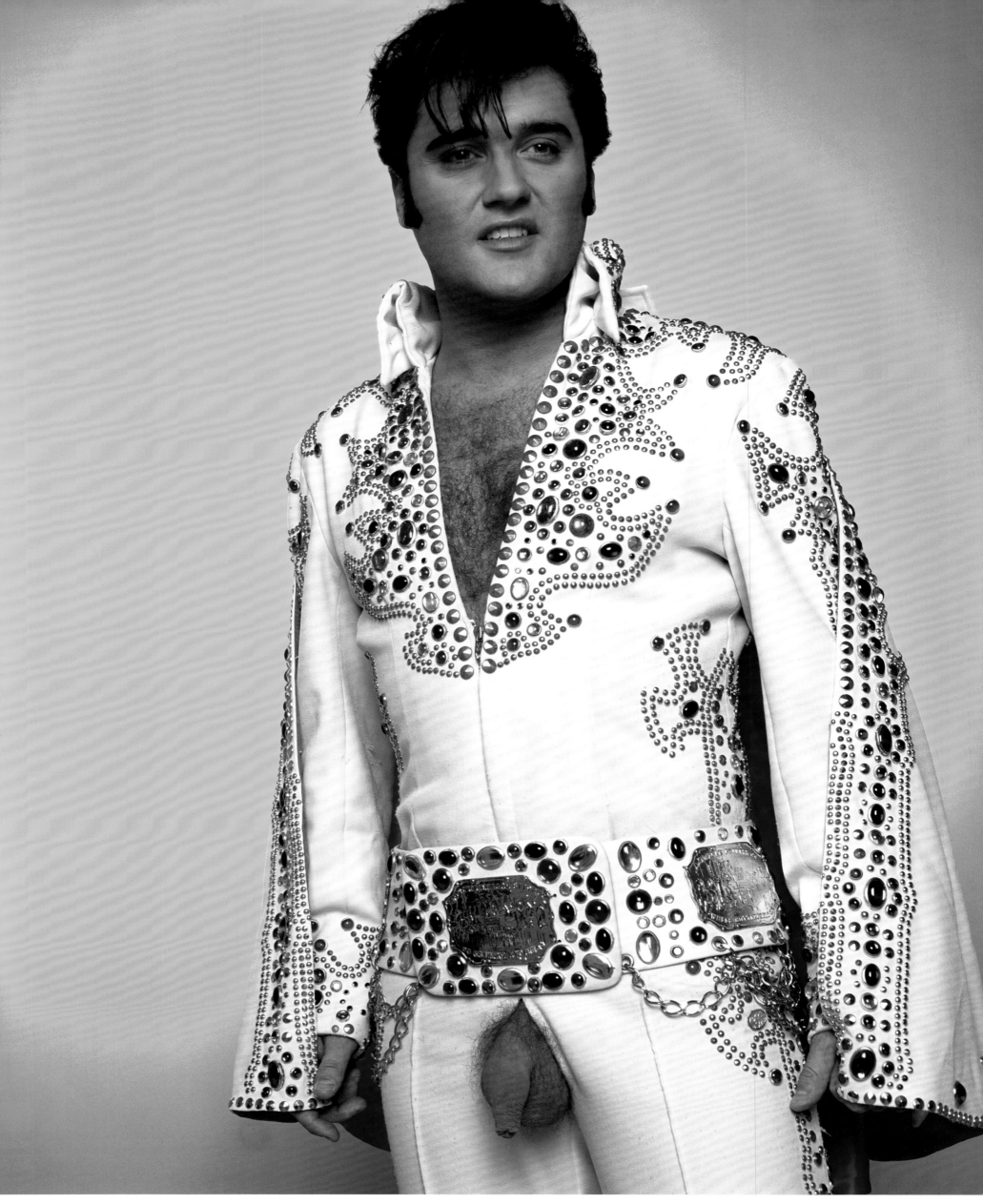

The King is Back (Long Live the King)
2001

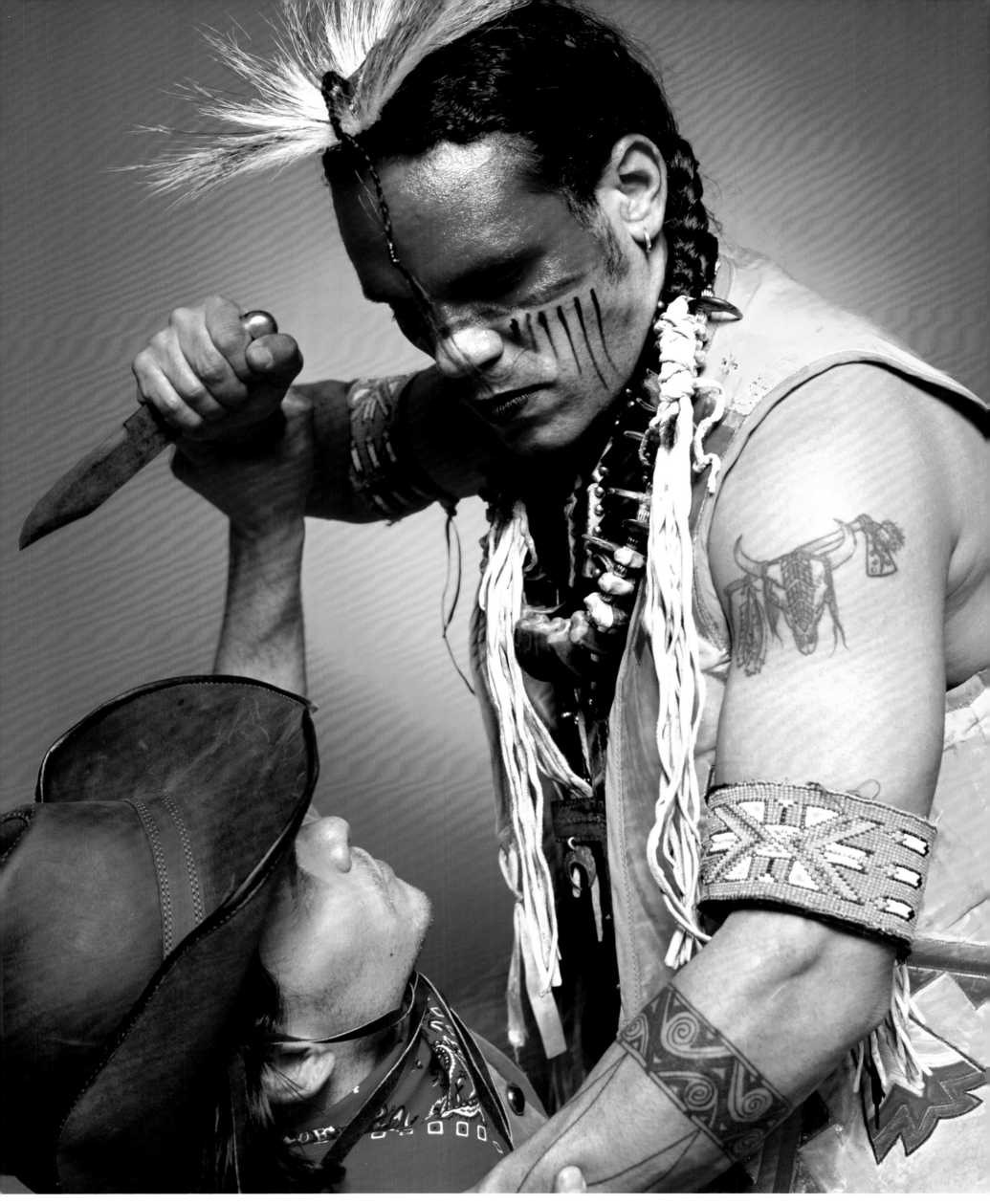

Cowboys and Indians
2001

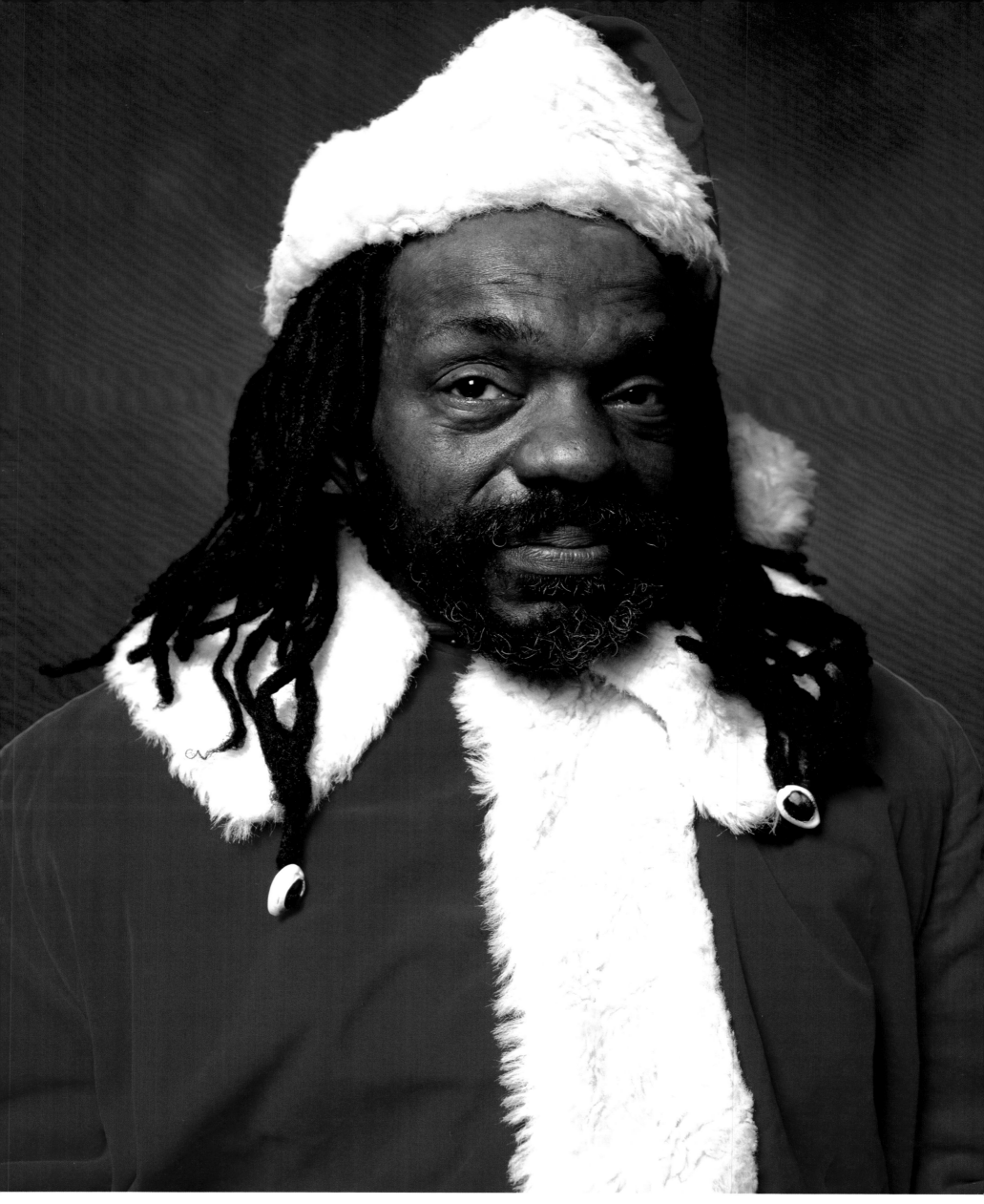

Black Santa

2001

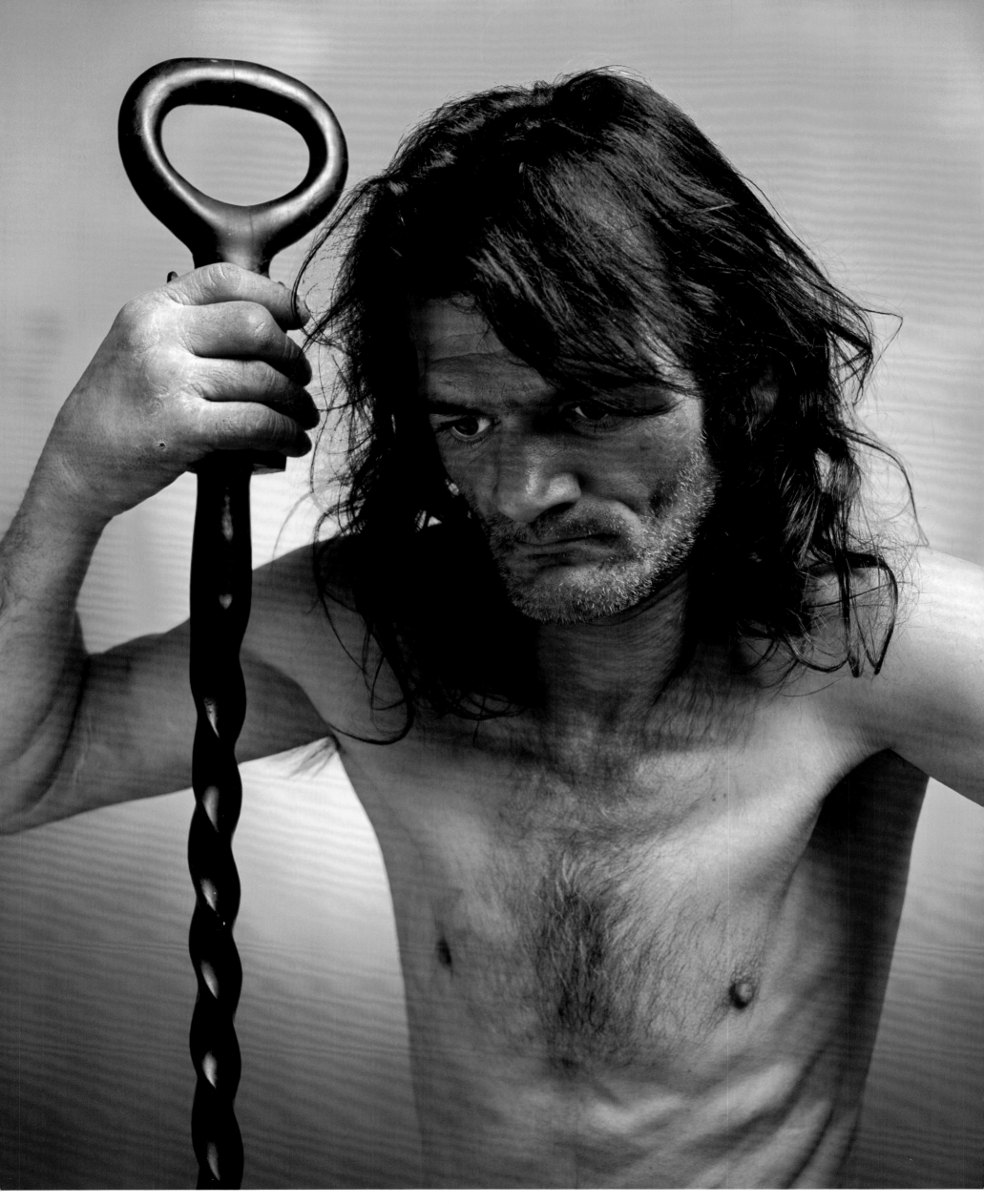

St. Lazarus

2001

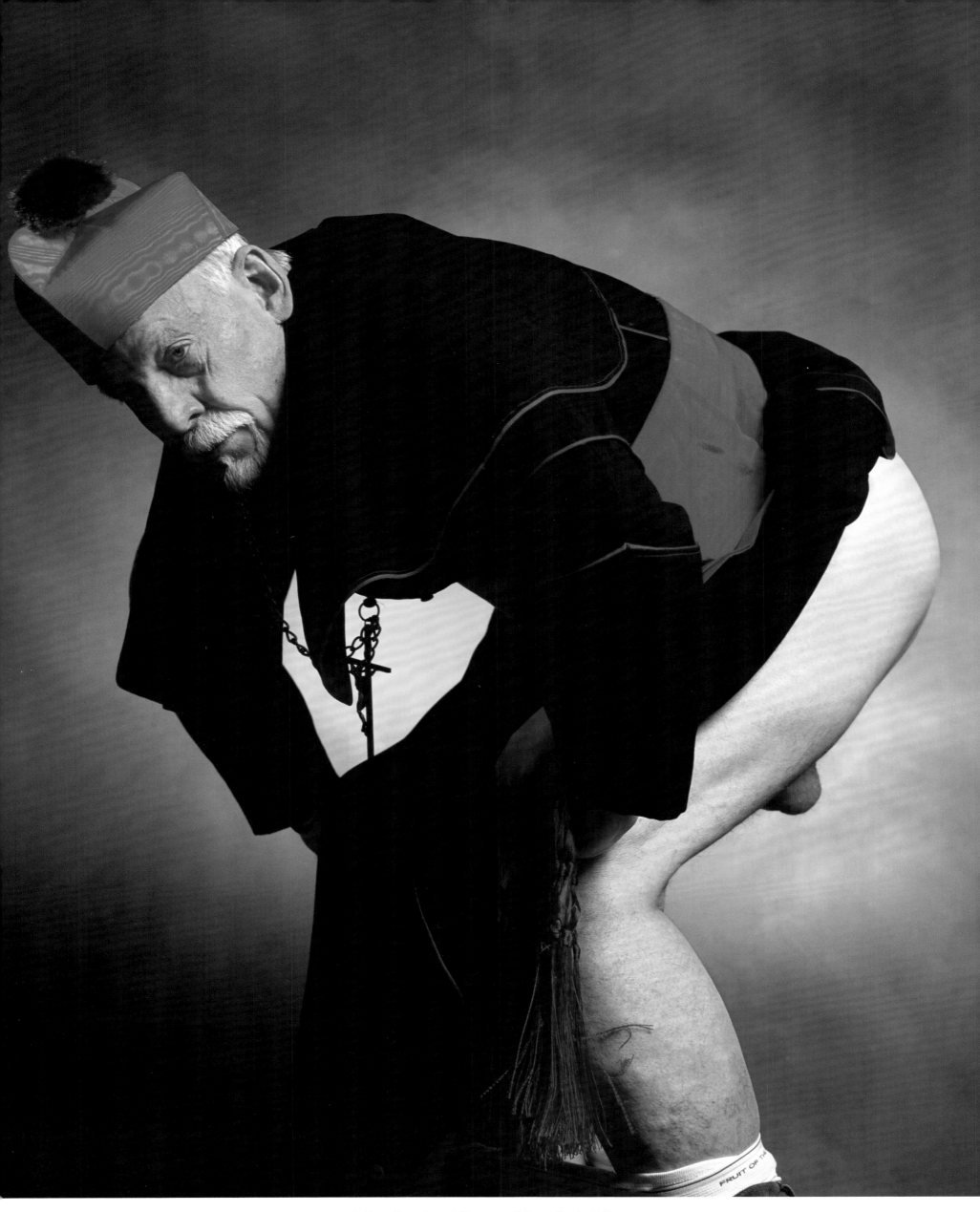

The Cardinal Proves He's Only Human

2000

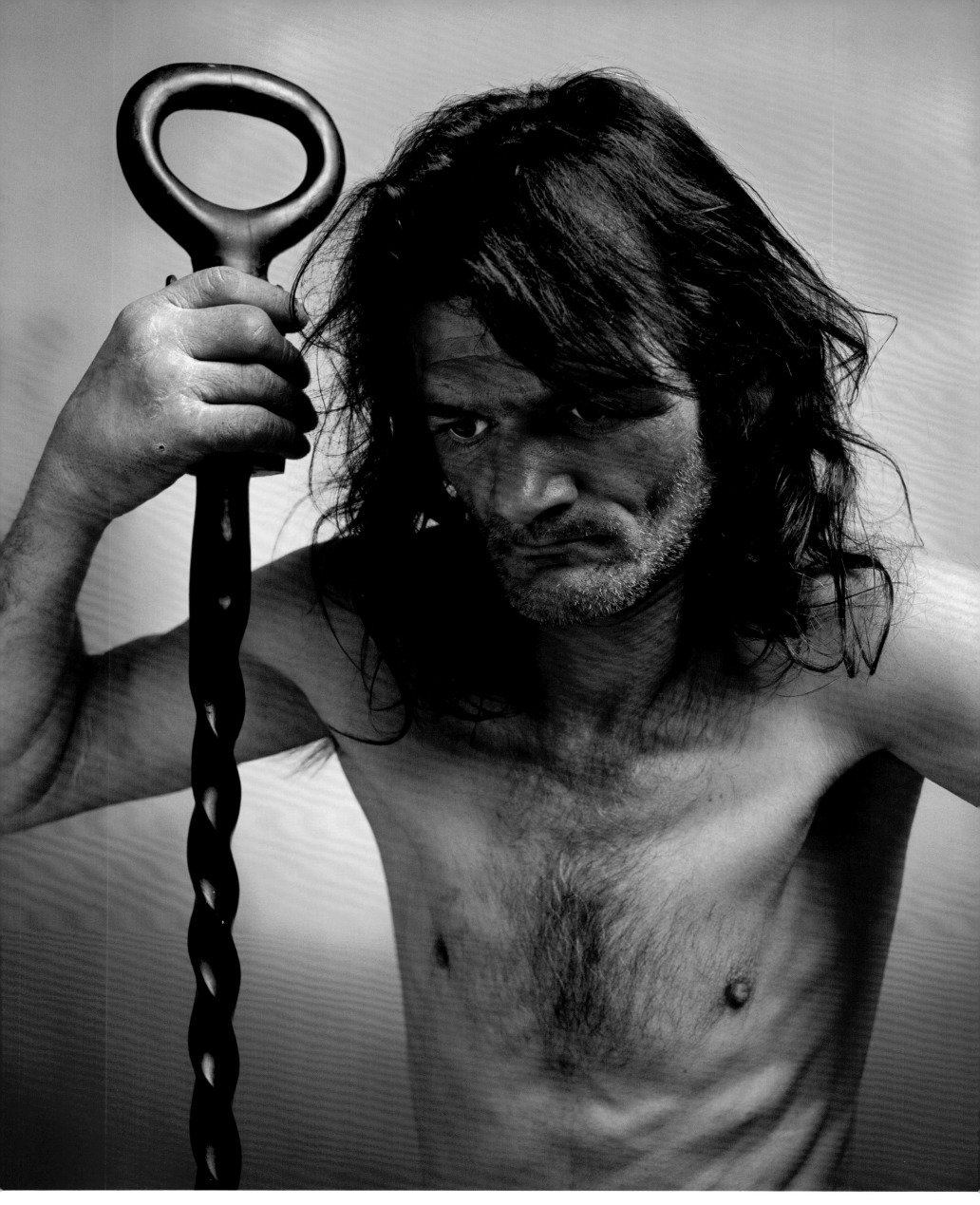

St. Lazarus

2001

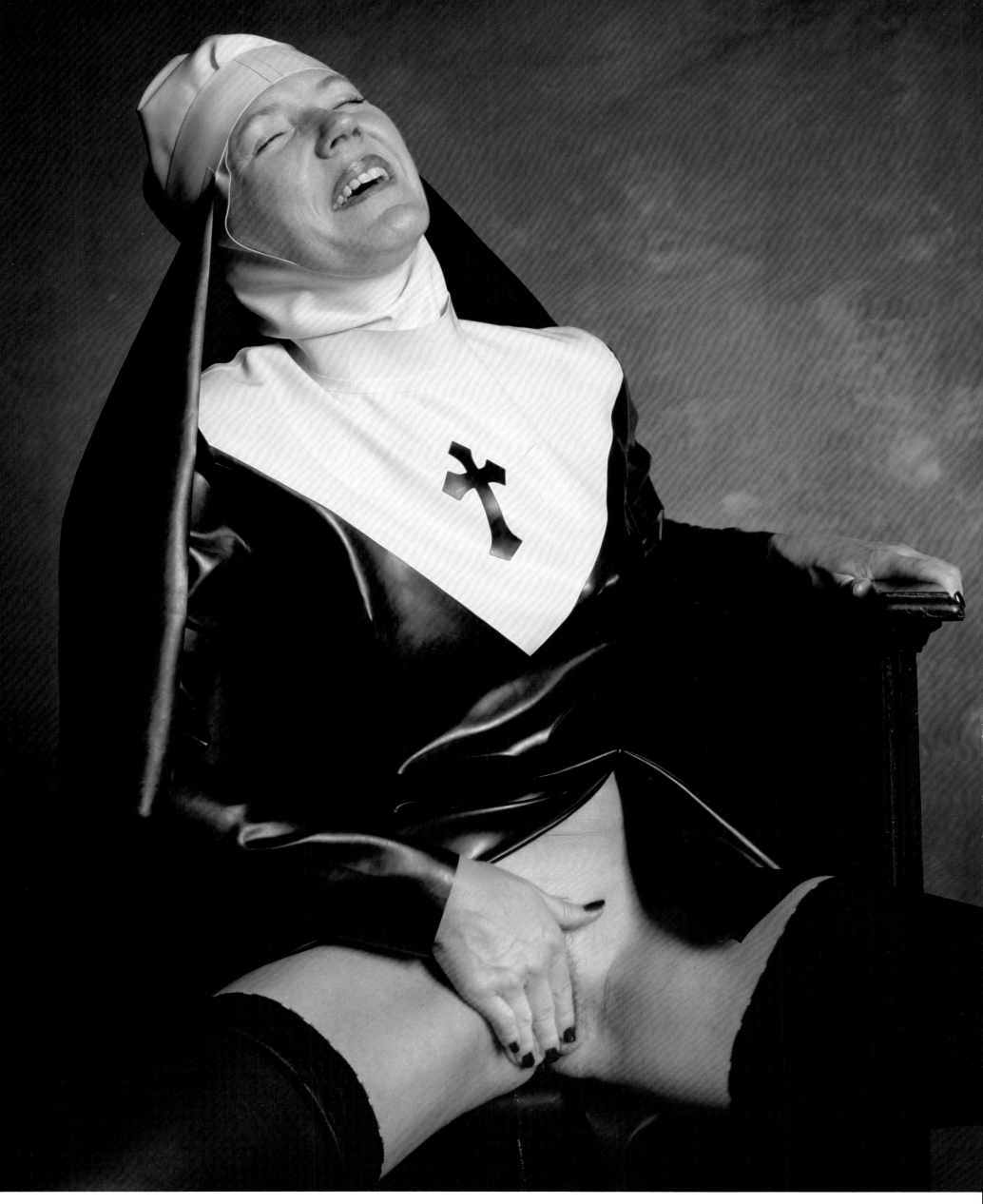

Triumph of the Flesh

2000

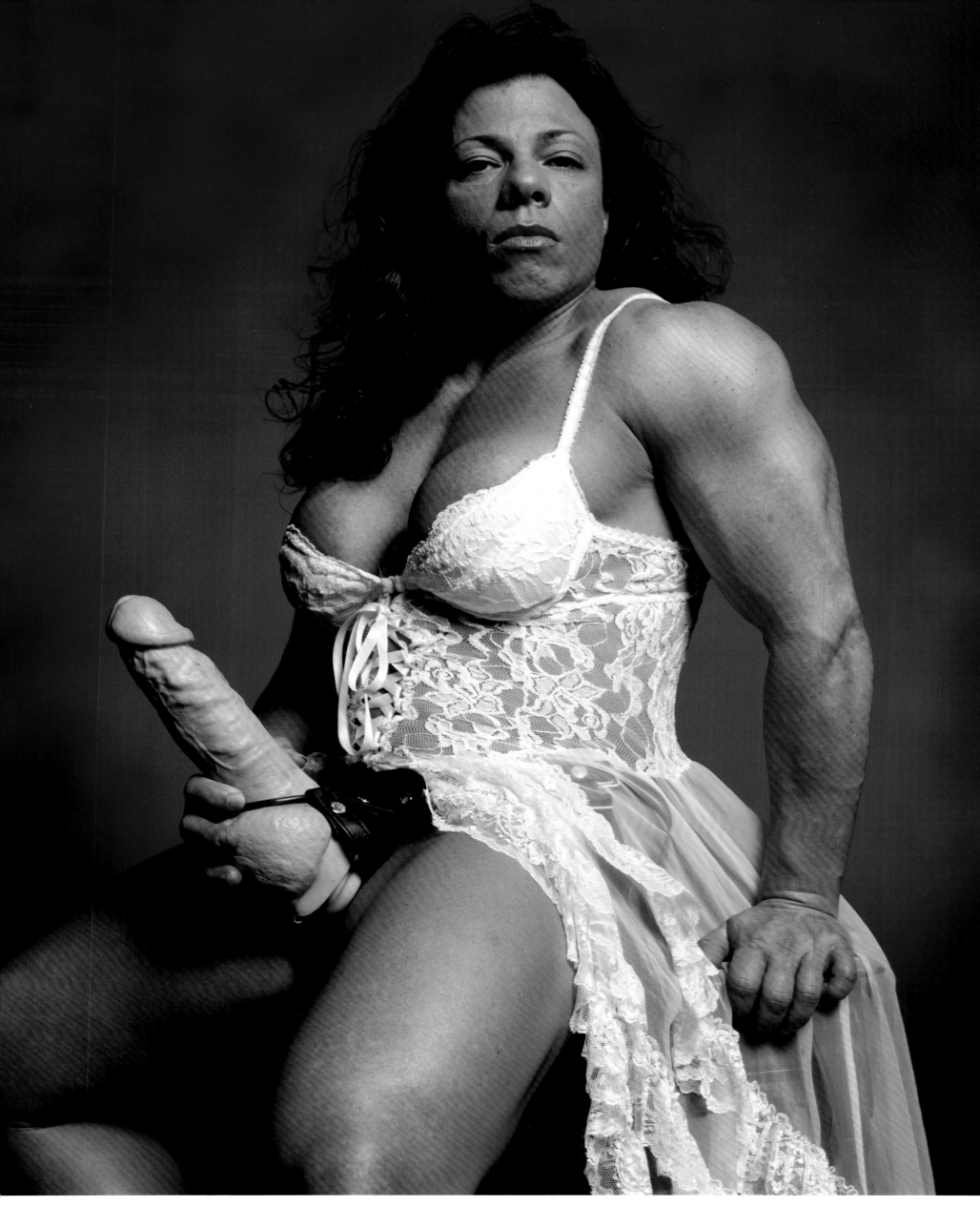

Mommie Dearest
2000

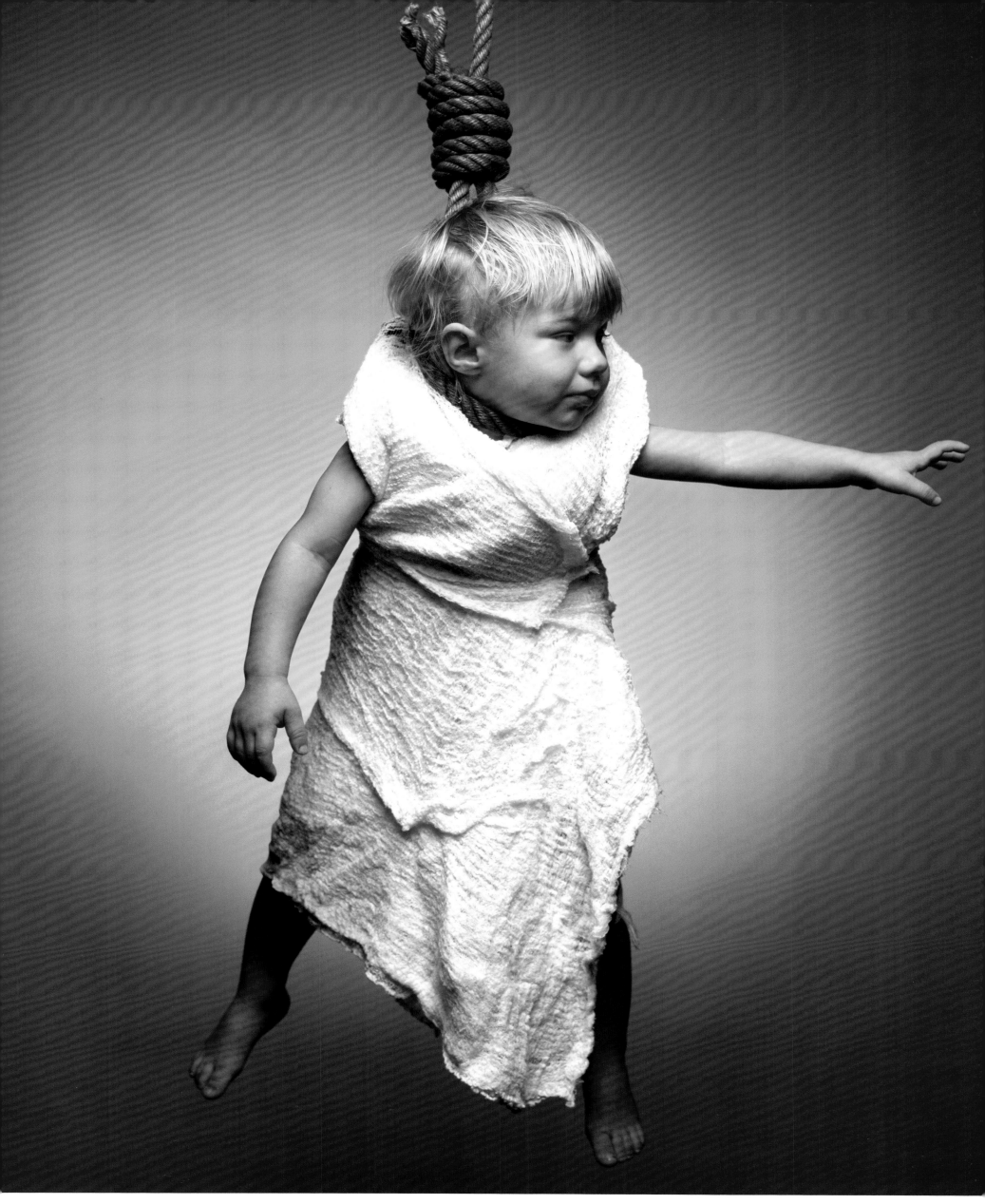

Daniel
2000

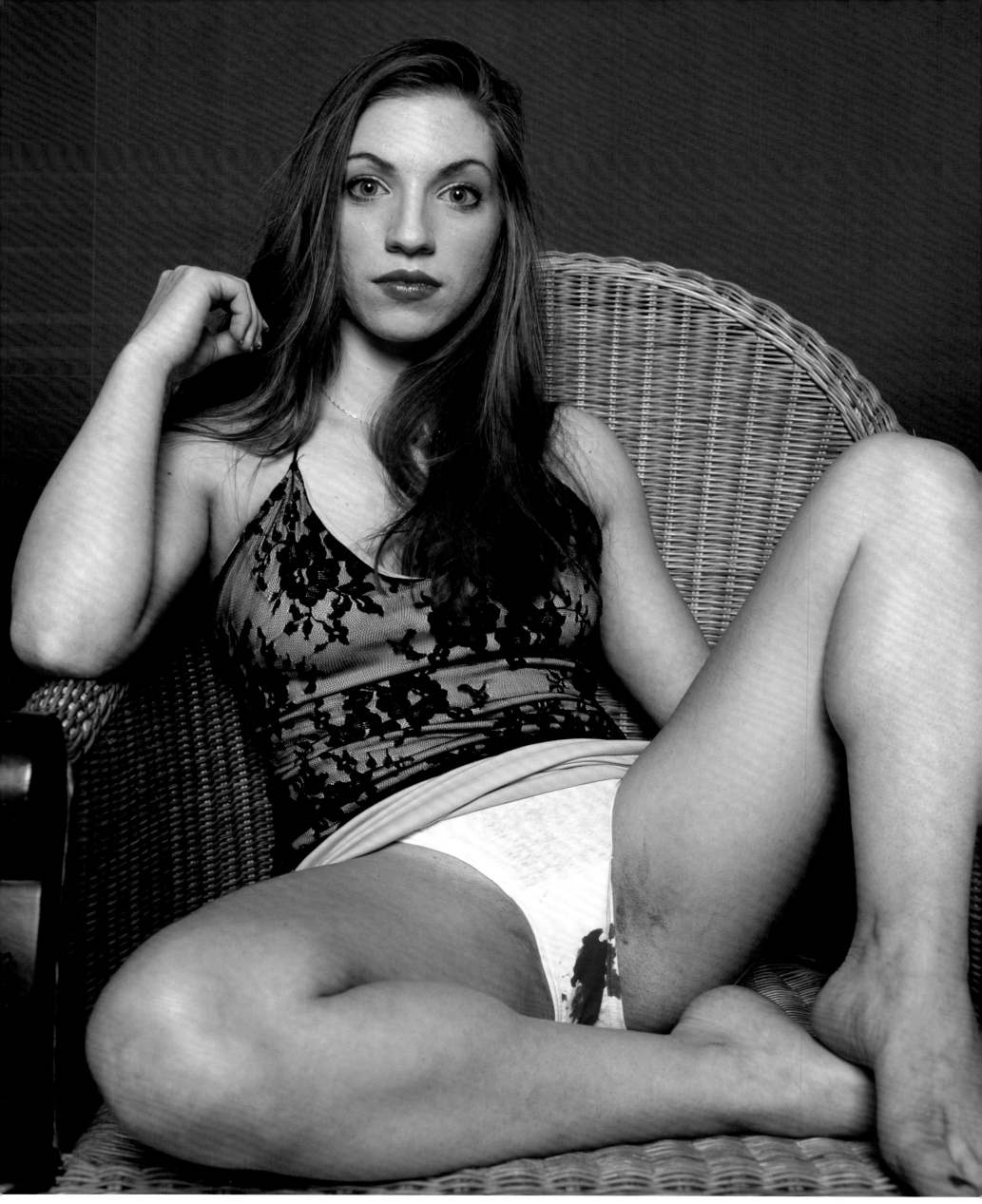

The Curse

2001

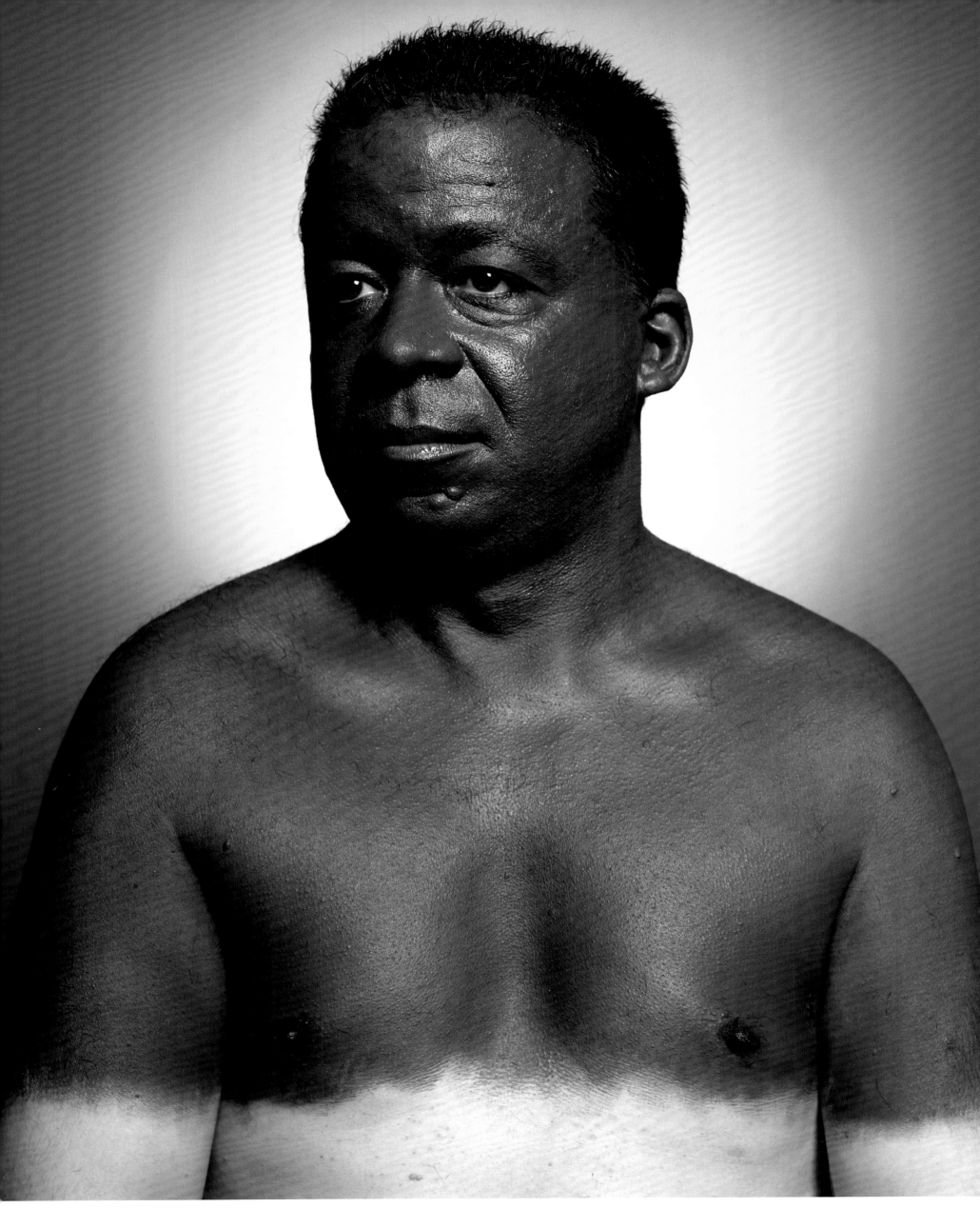

White Nigger

2001

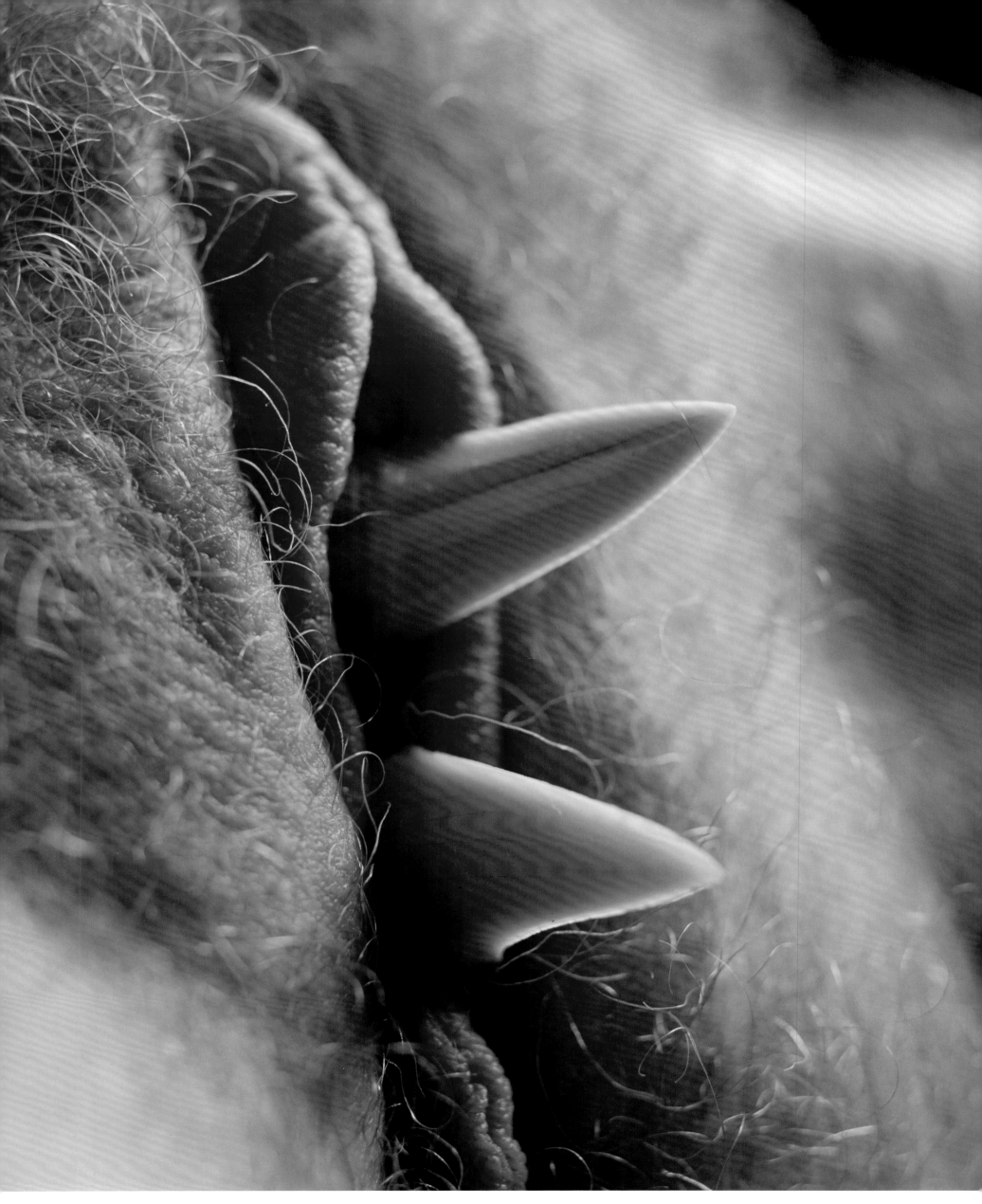

Vagina Dentata (Vagina with Teeth)

2001

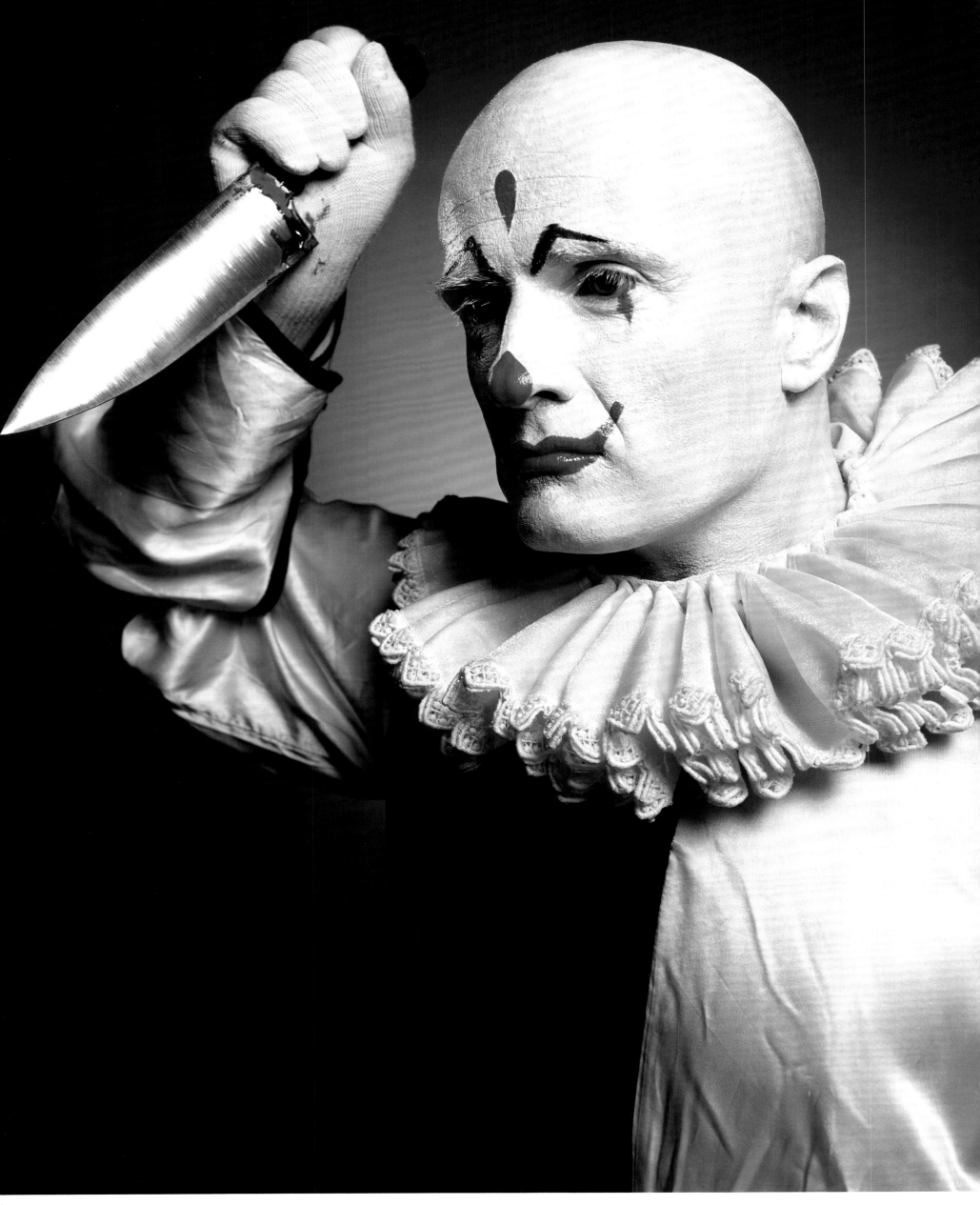

Killer Clown

2001

A HISTORY OF SEX

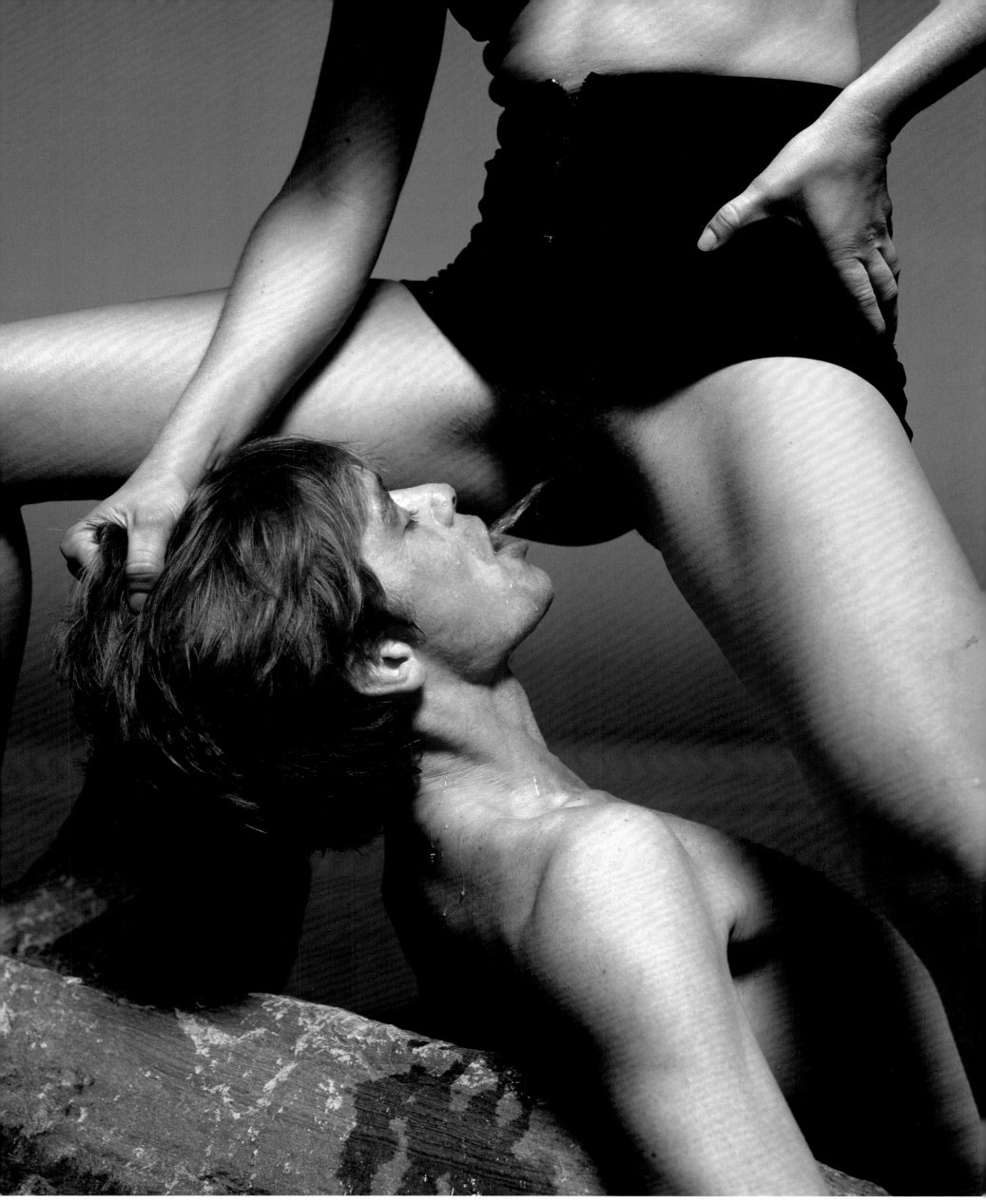

Leo's Fantasy
1996

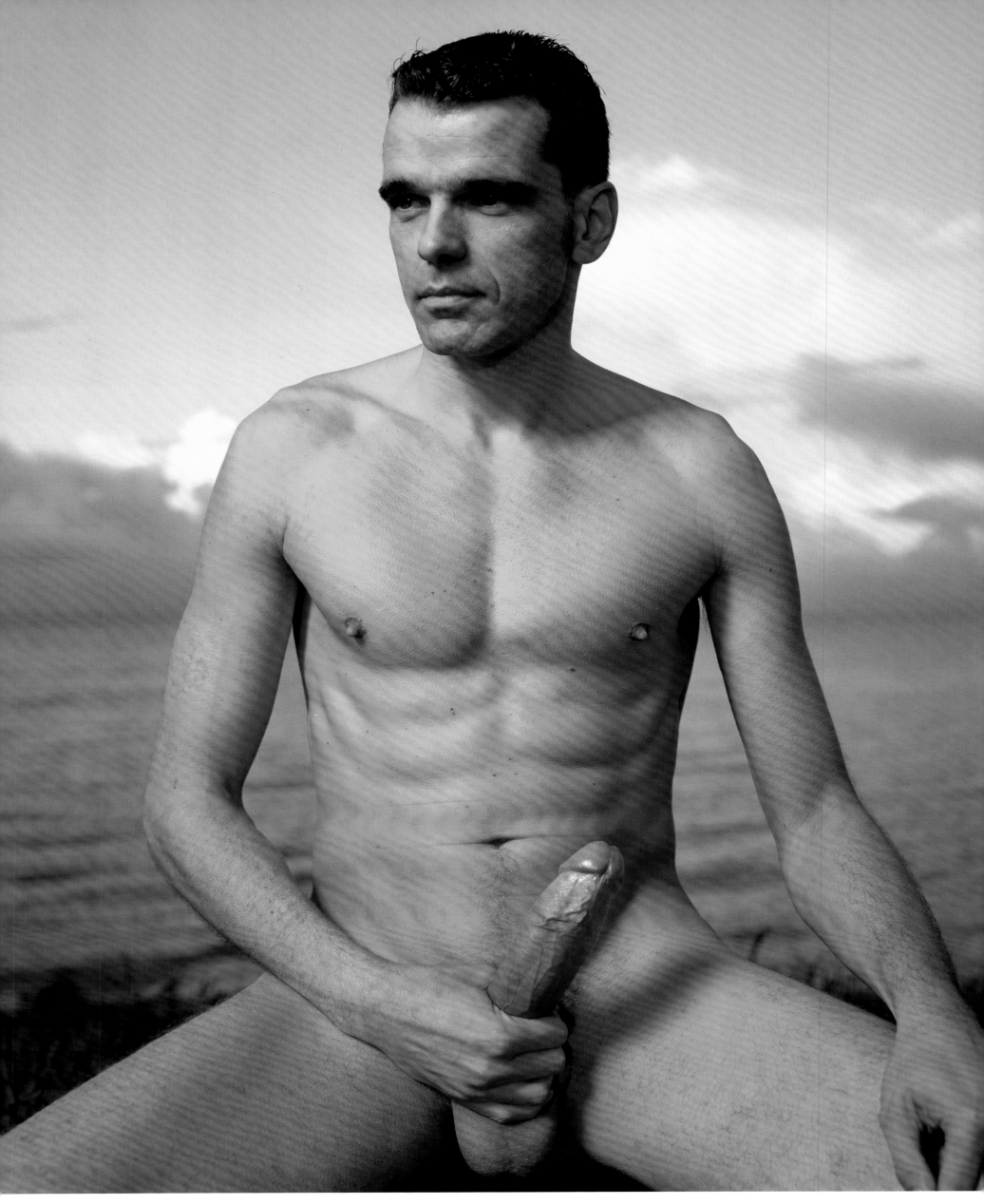

Rietveld
1996

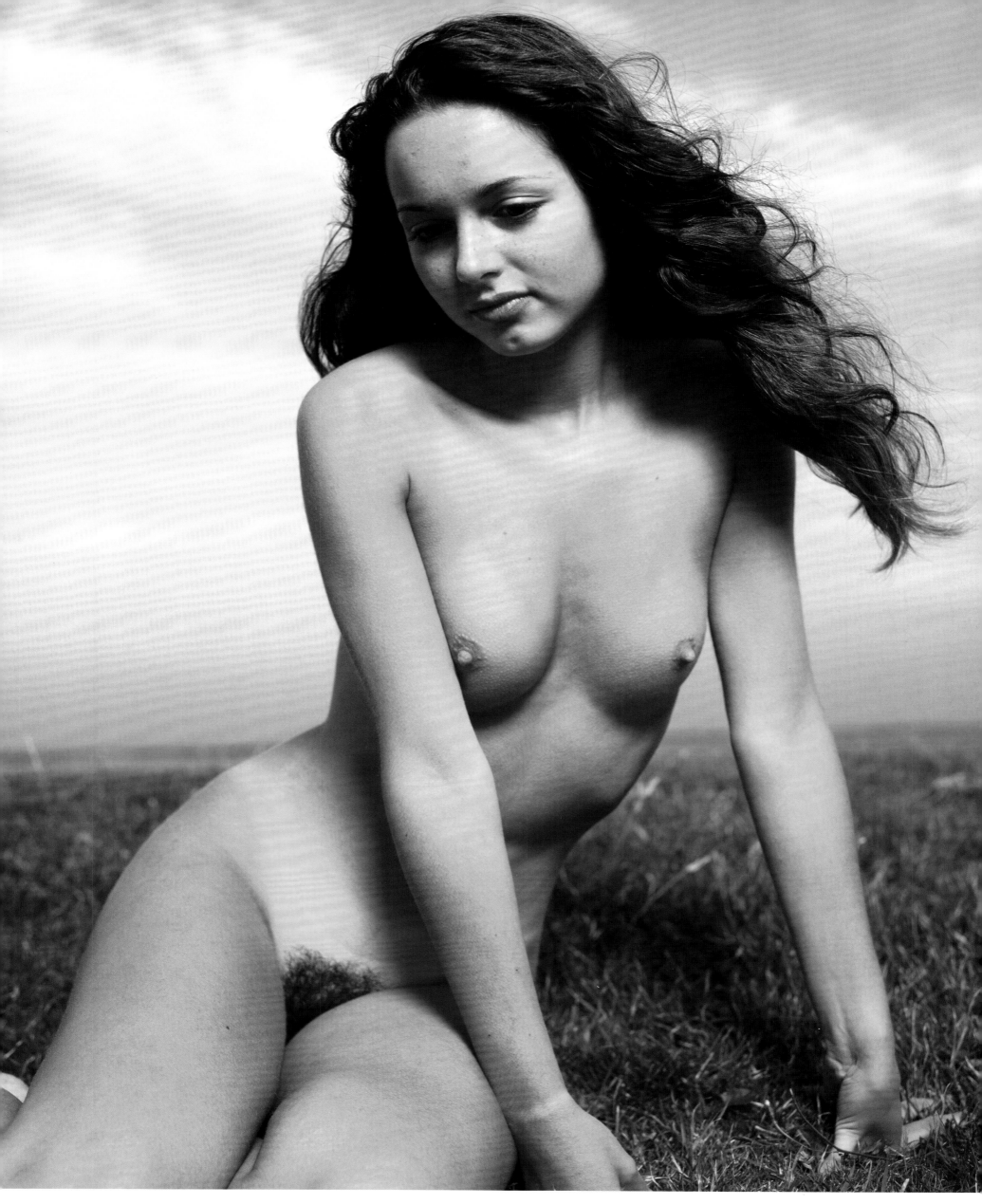

Eline
1996

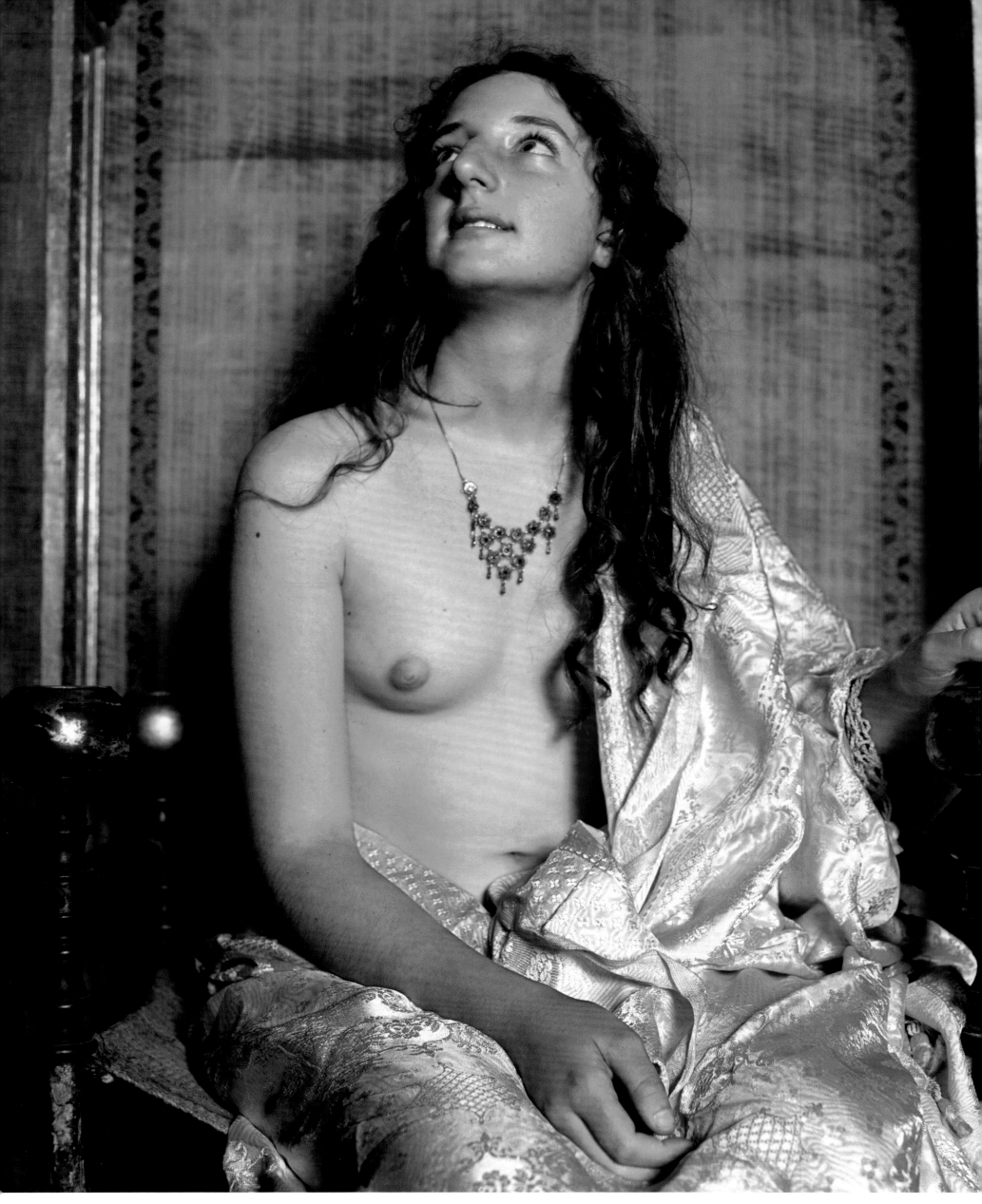

Giada
1995

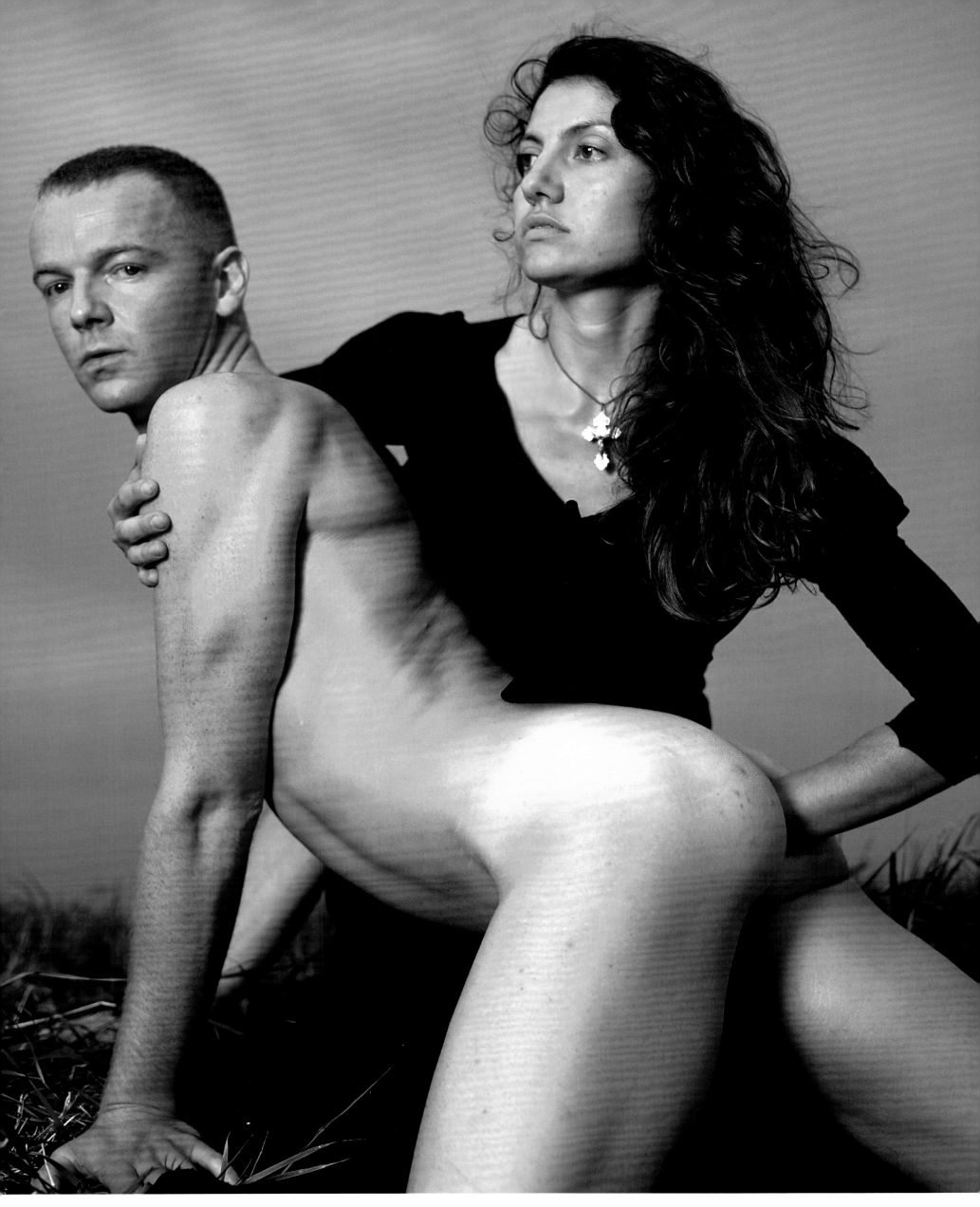

The Fisting
1996

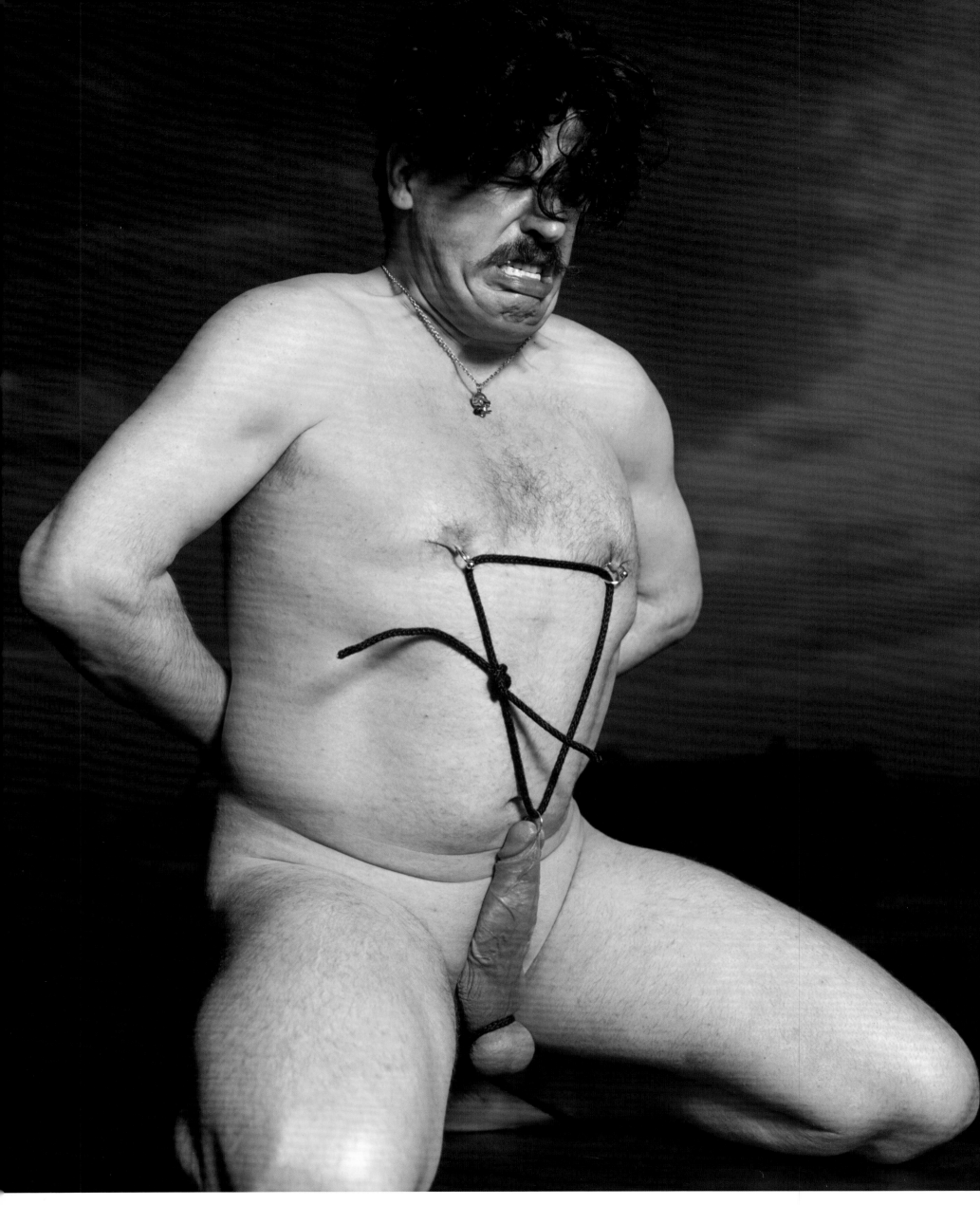

Master of Pain
1996

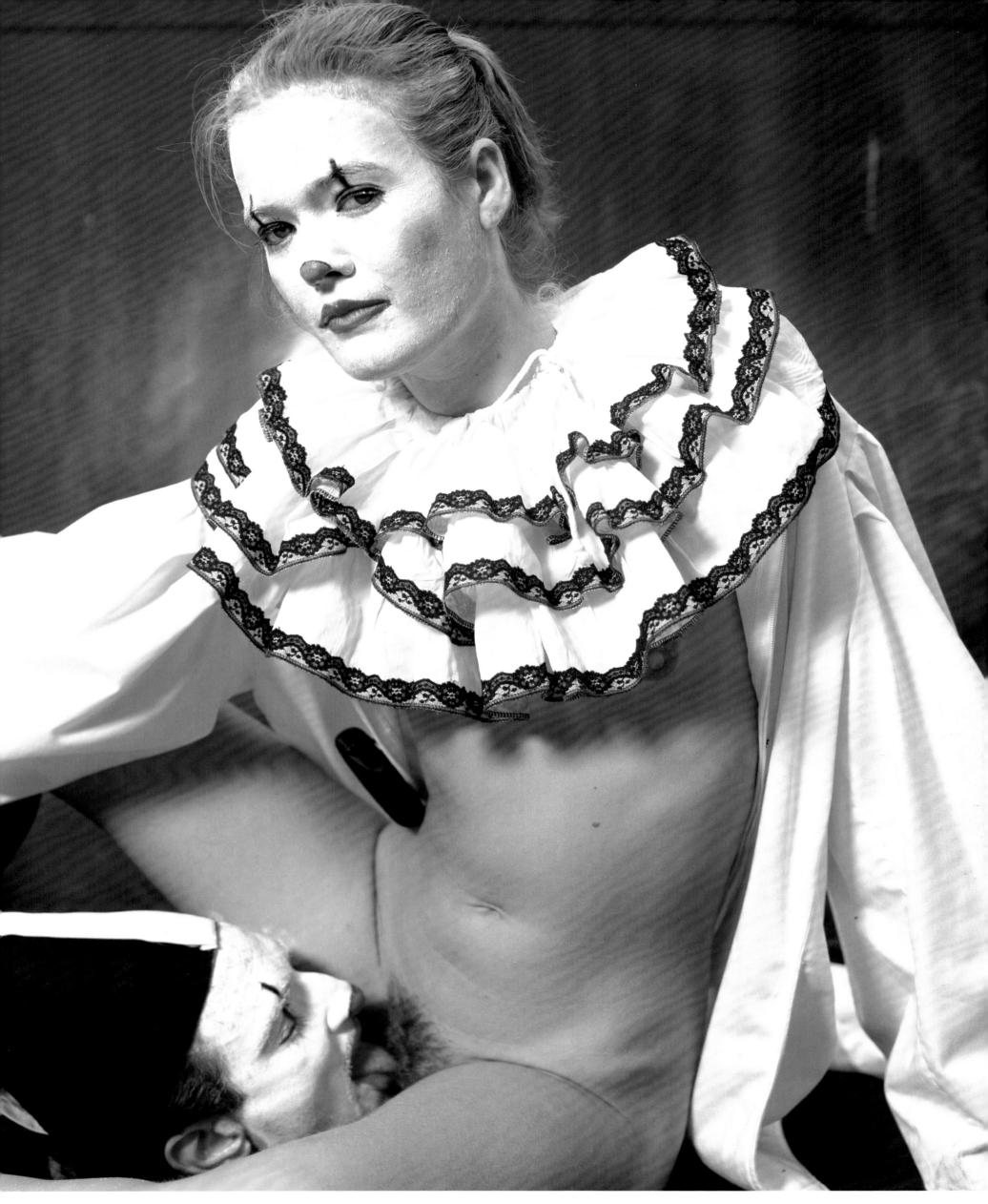

Head
1996

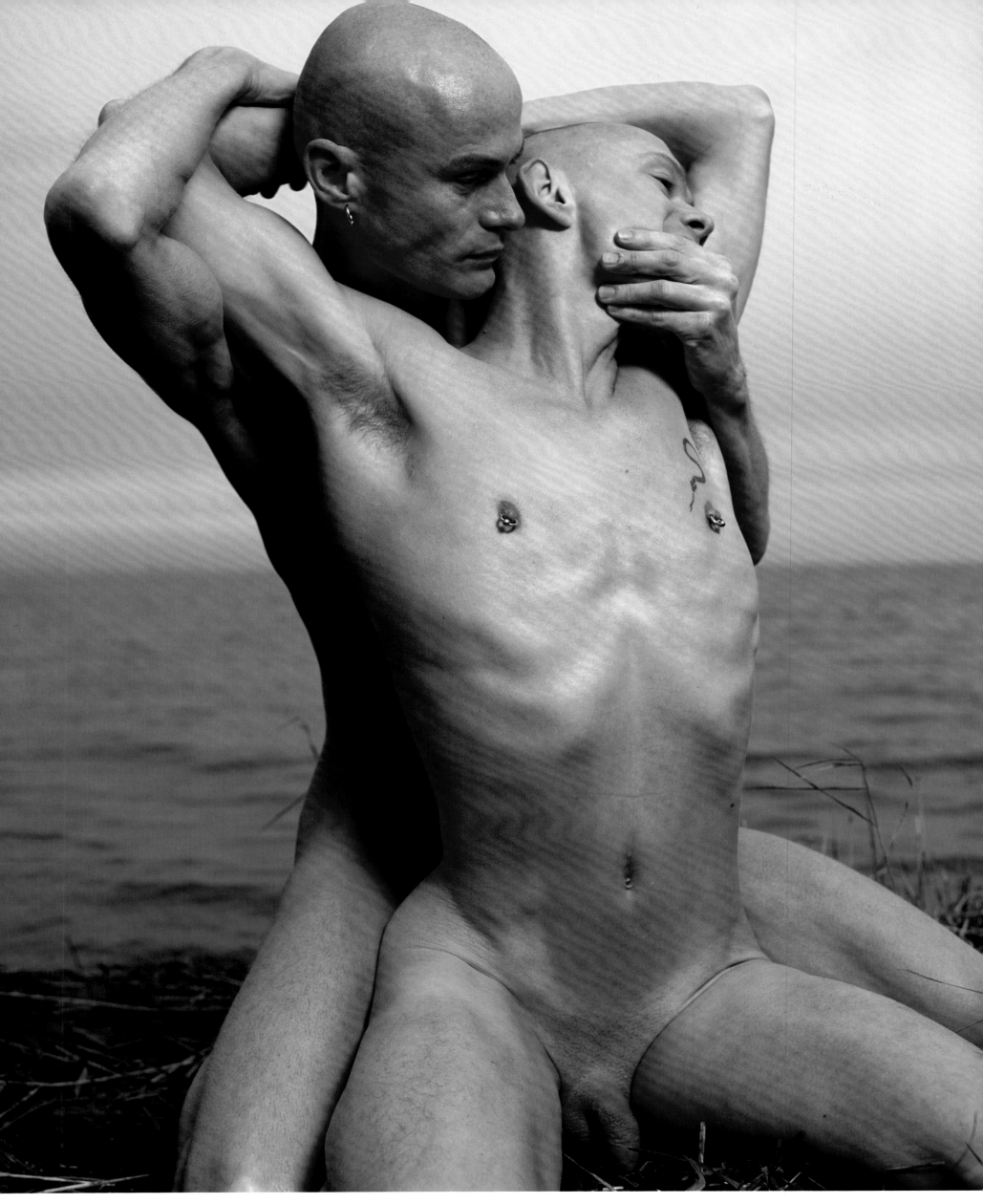

Hans and Frans
1996

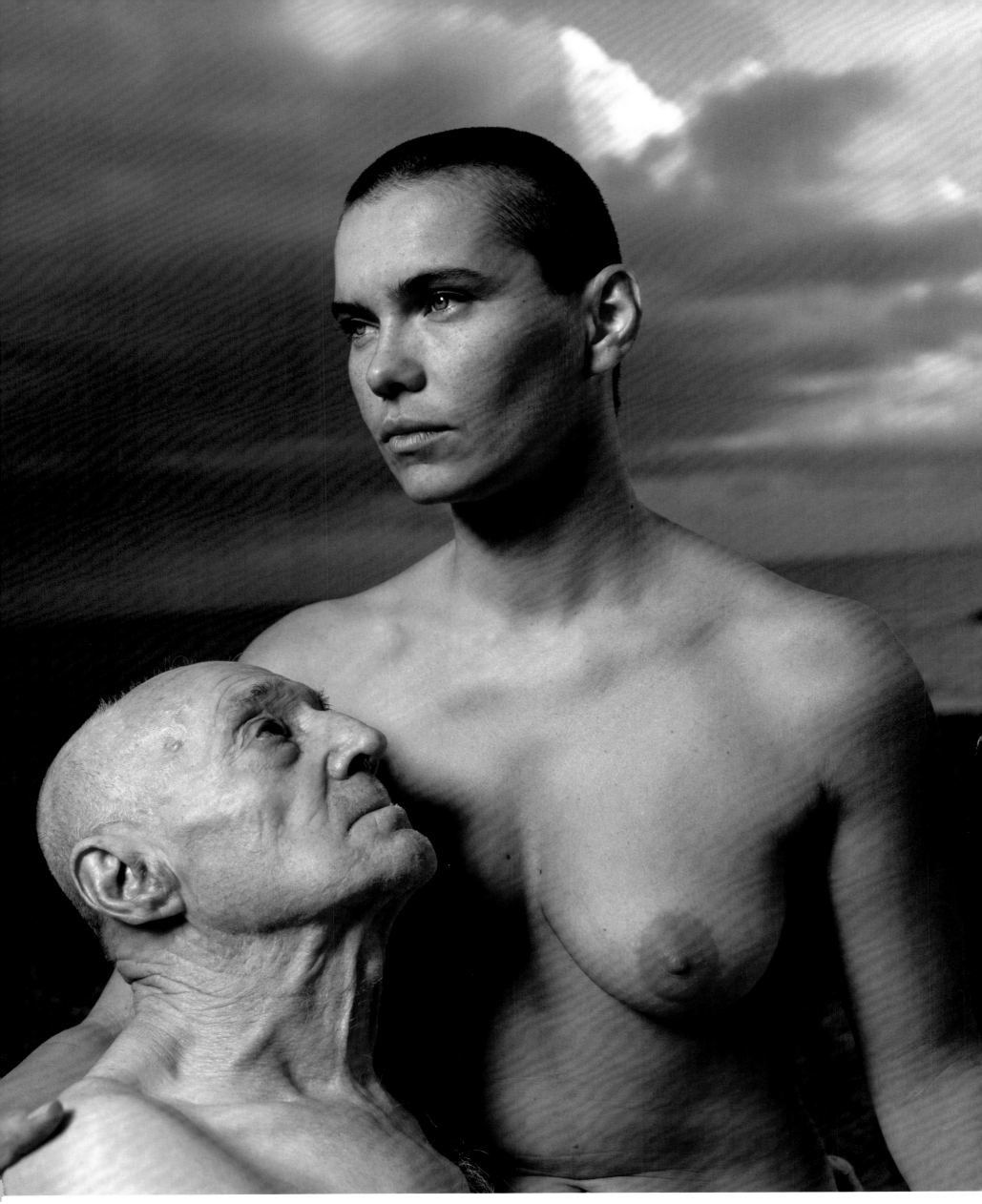

Antonio and Ulrike
1995

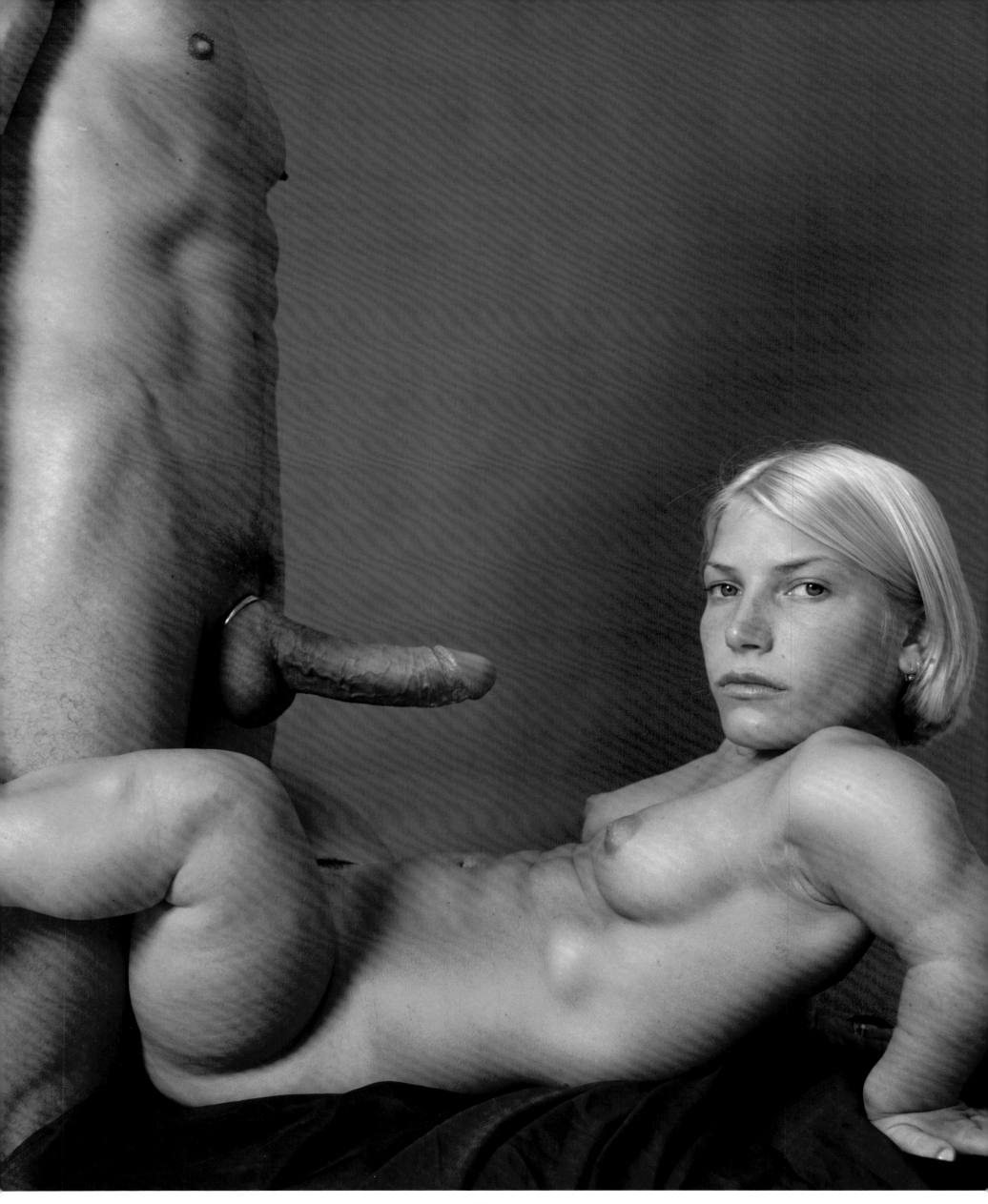

Helene
1996

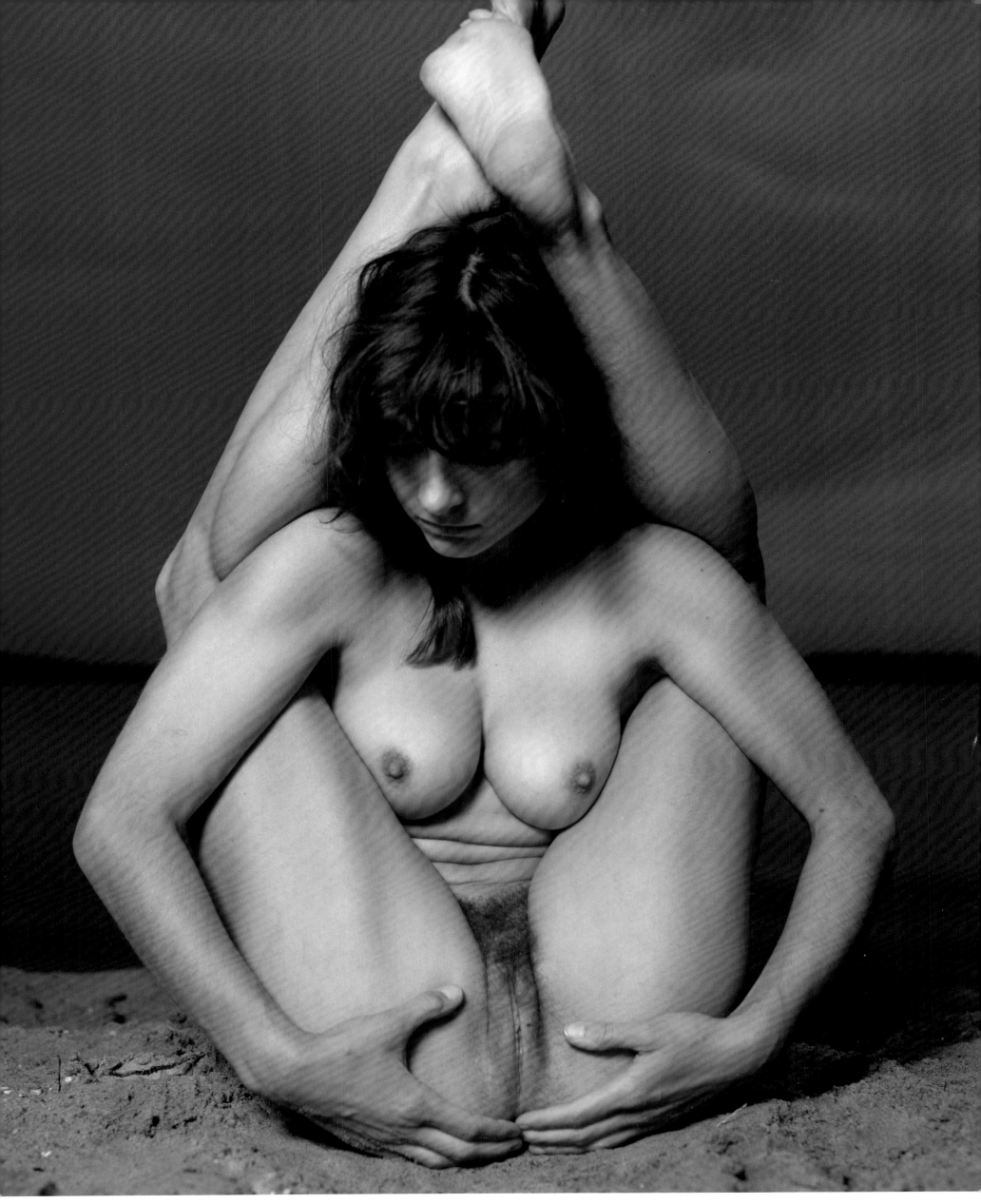

Susanne
1996

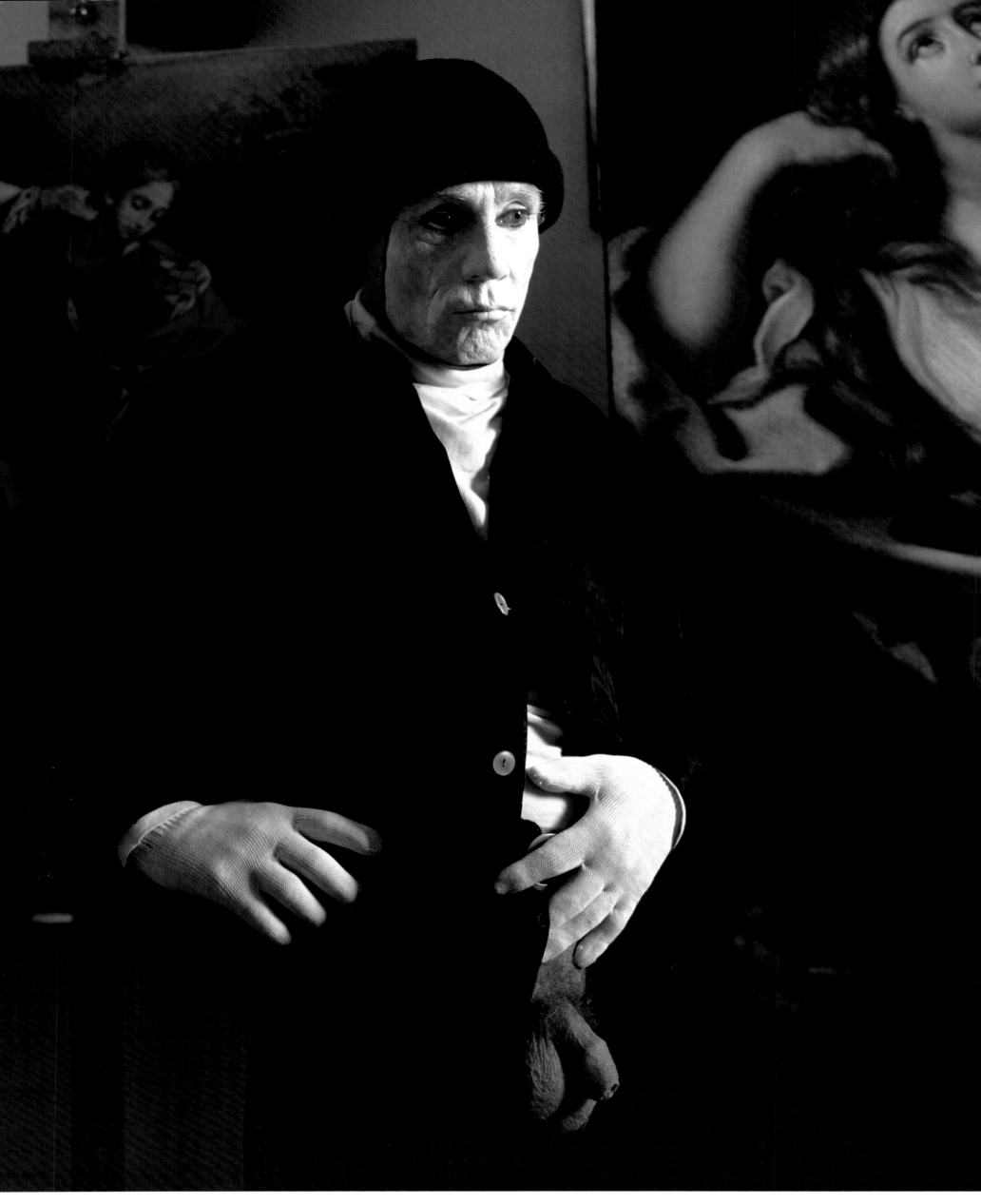

The Mime
1995

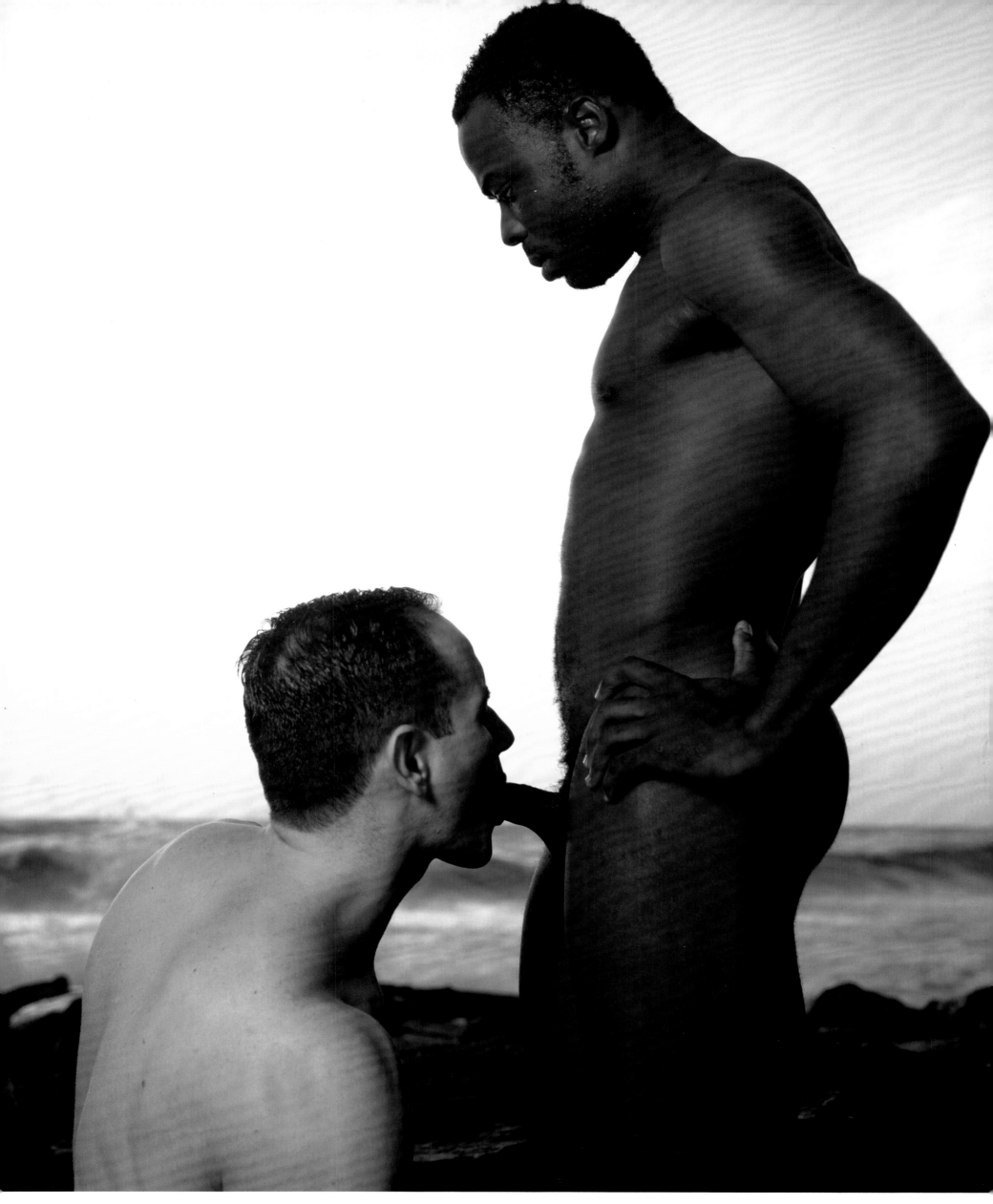

Roberts and Luca
1995

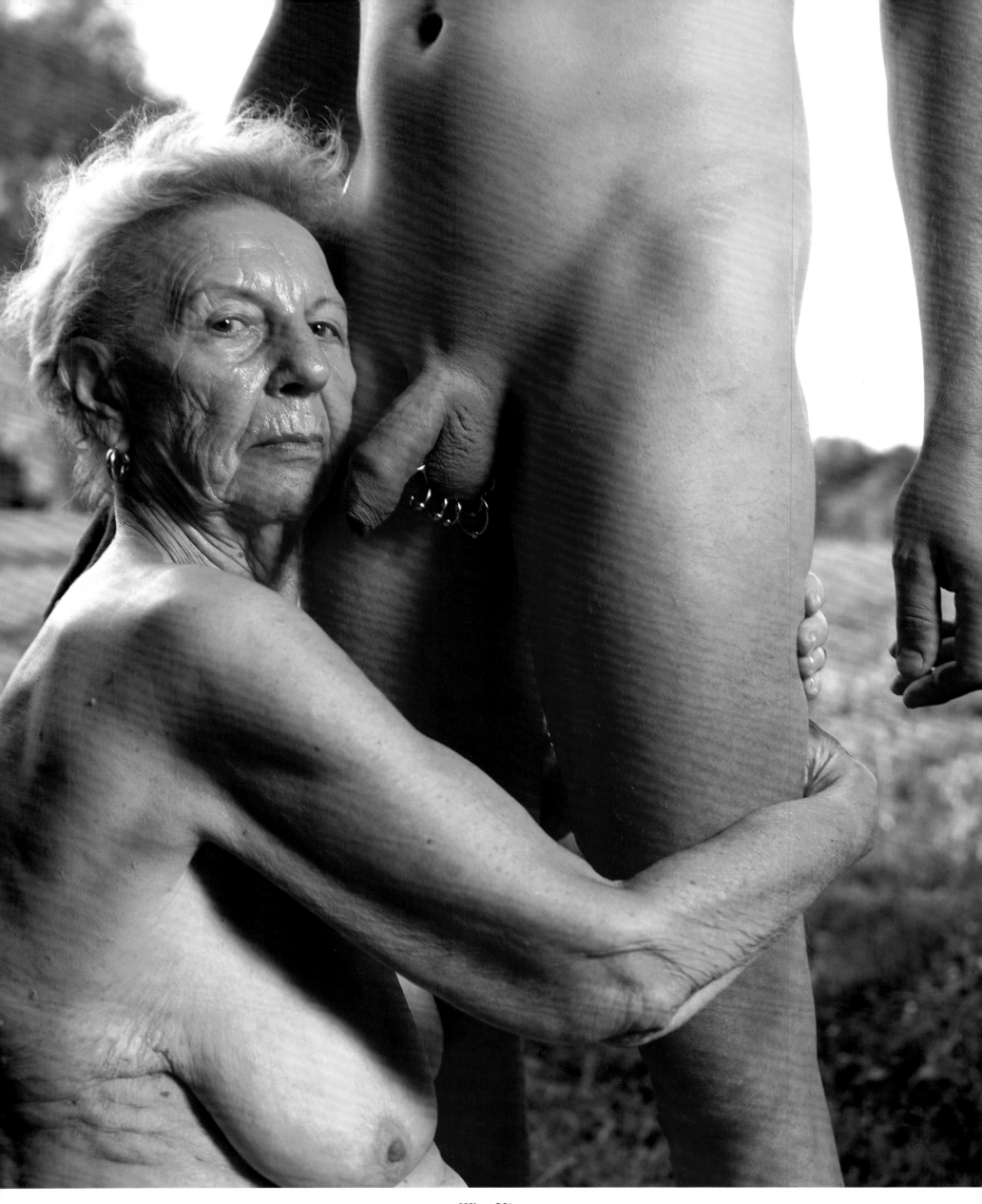

The Kiss
1996

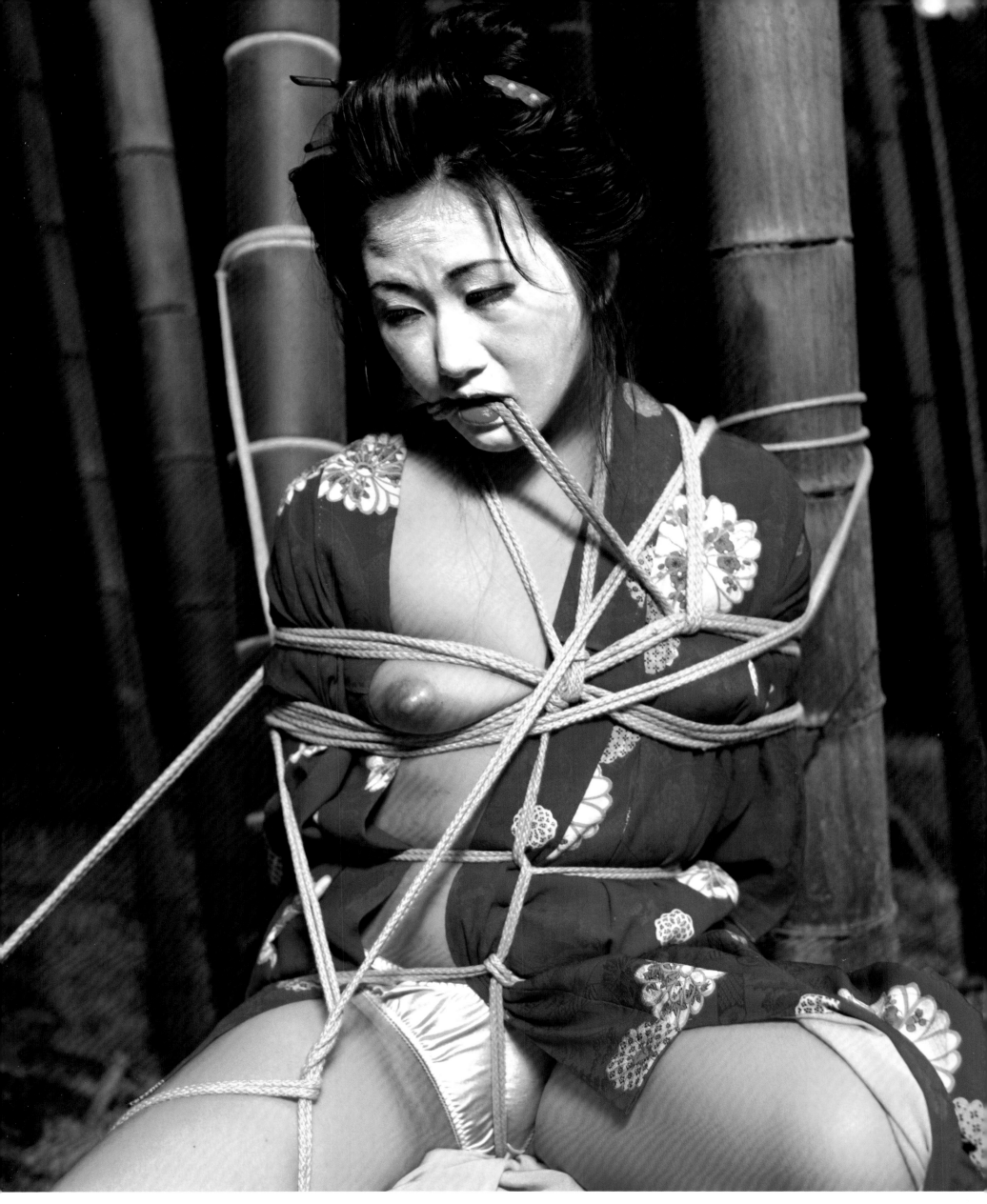

Bondage in Kyoto
1996

Christiaan and Rose
1996

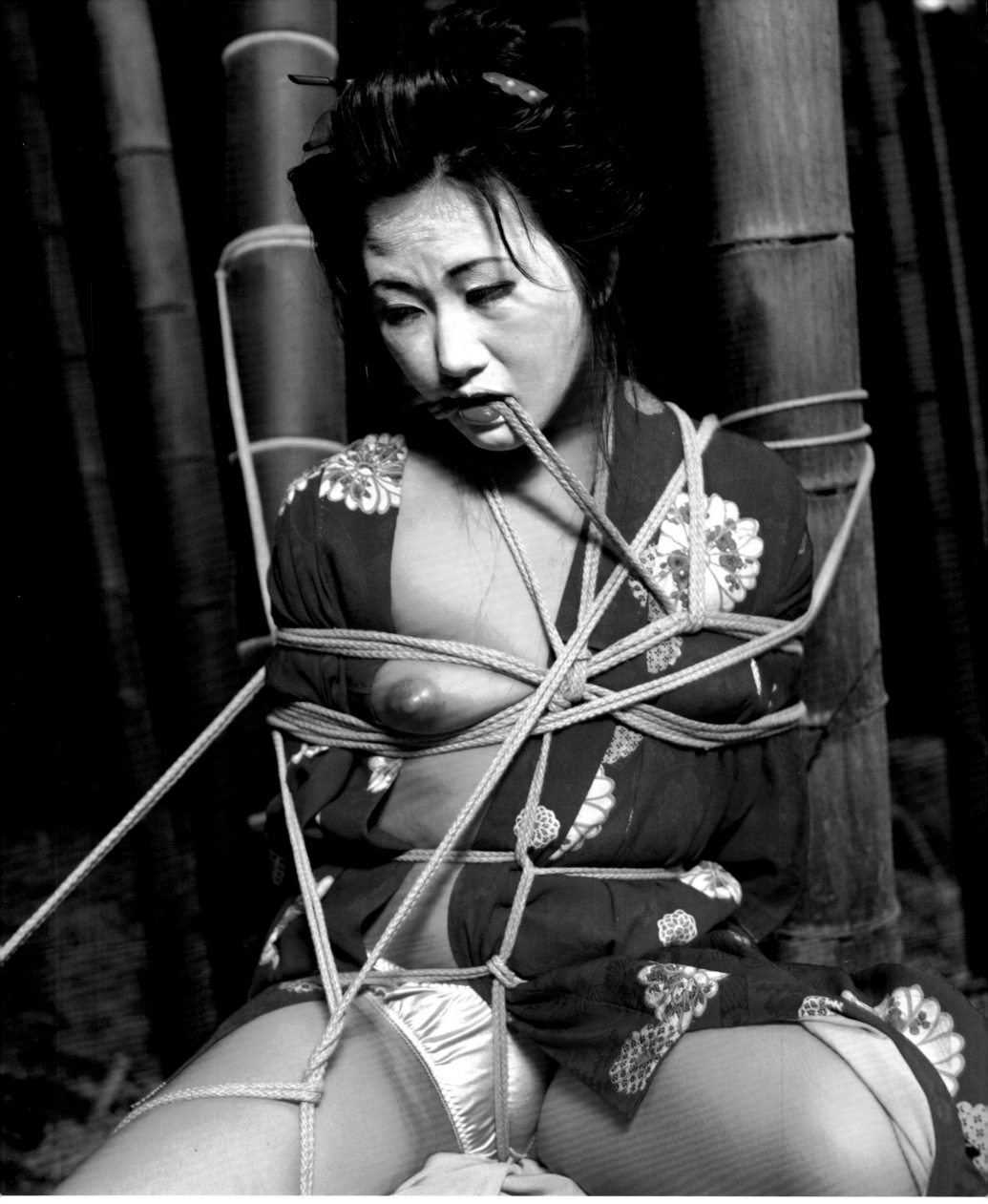

Bondage in Kyoto
1996

Martyr
1995

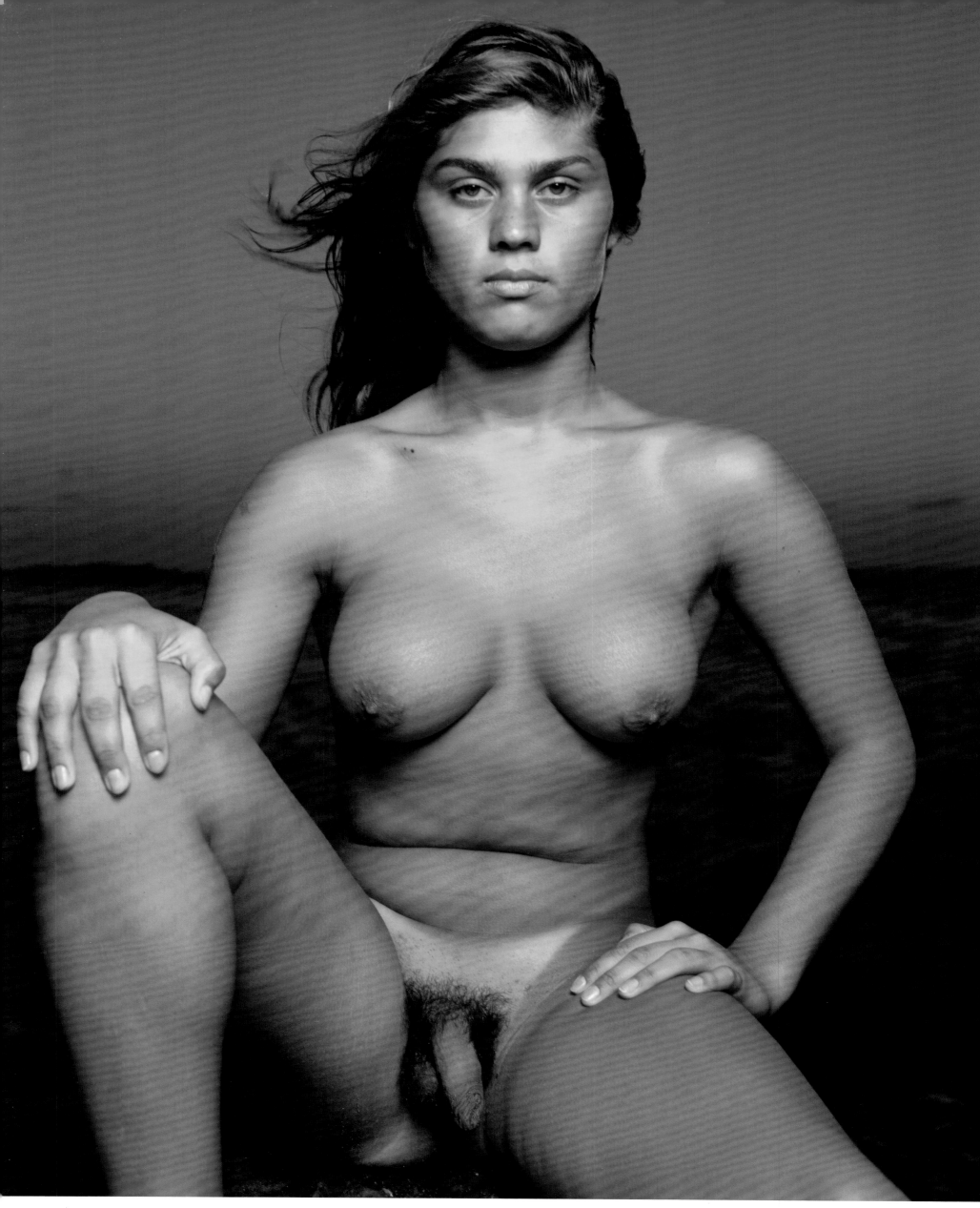

Alessandra
1995

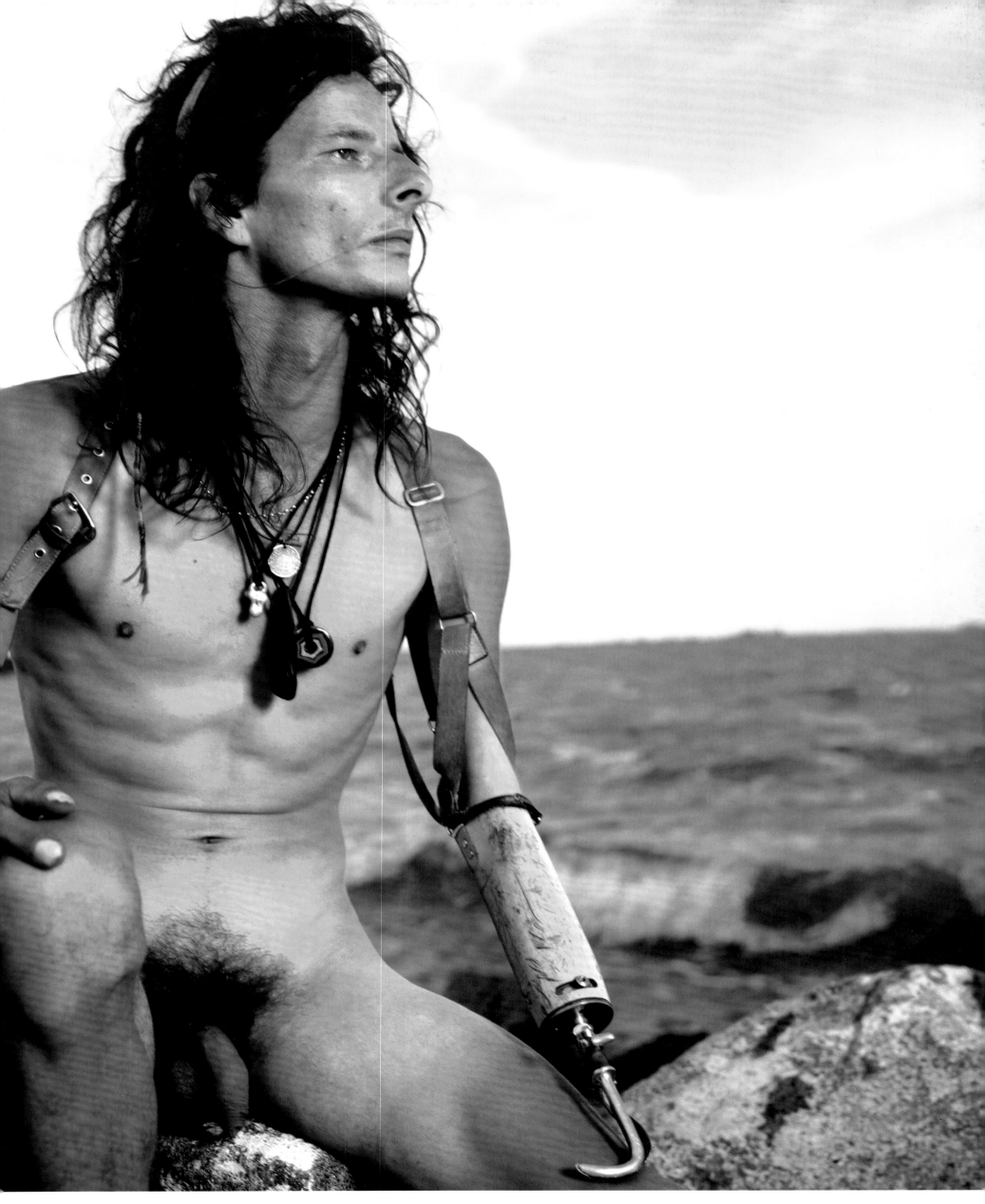

Kev
1996

THE MORGUE

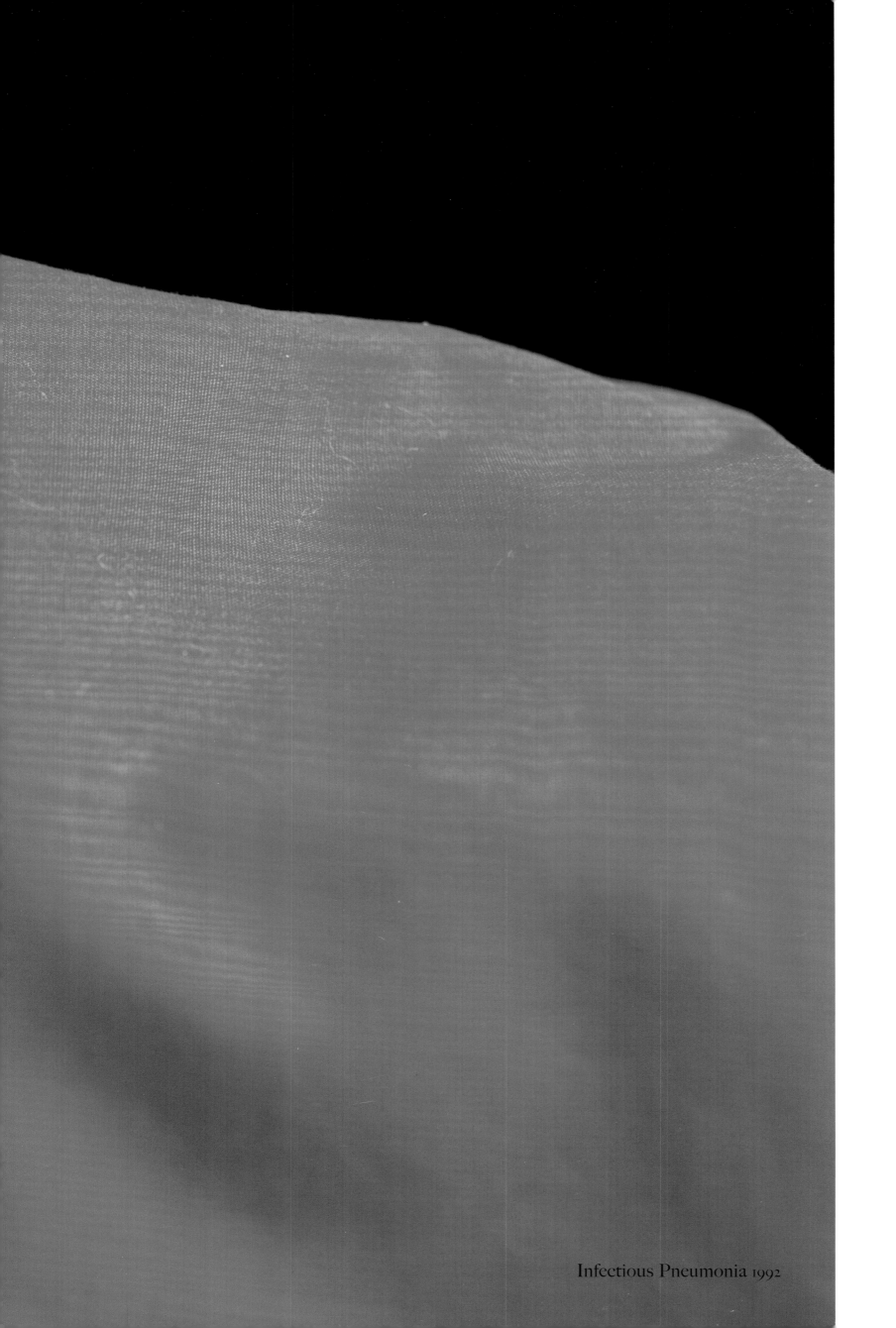

Infectious Pneumonia 1992

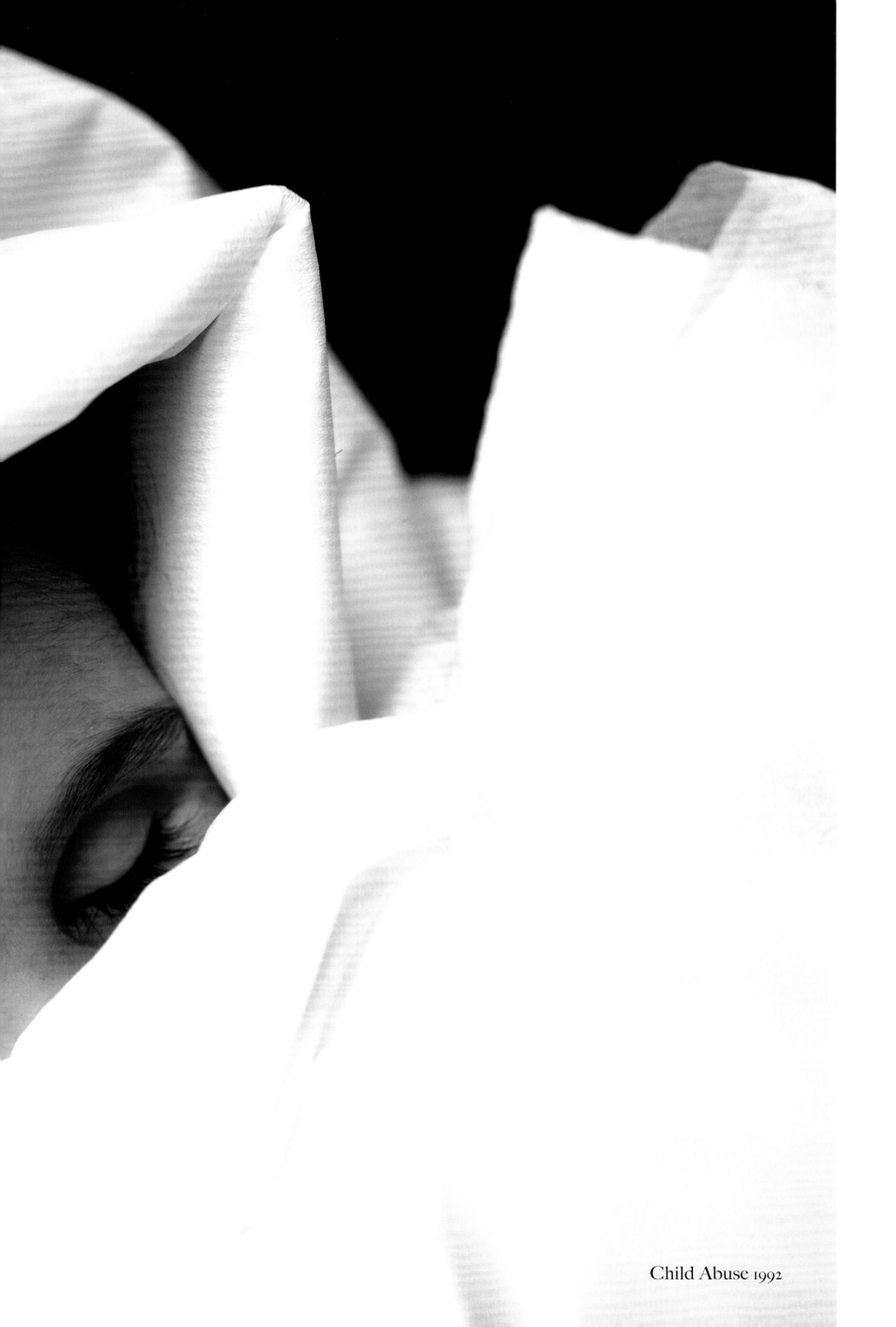

Child Abuse 1992

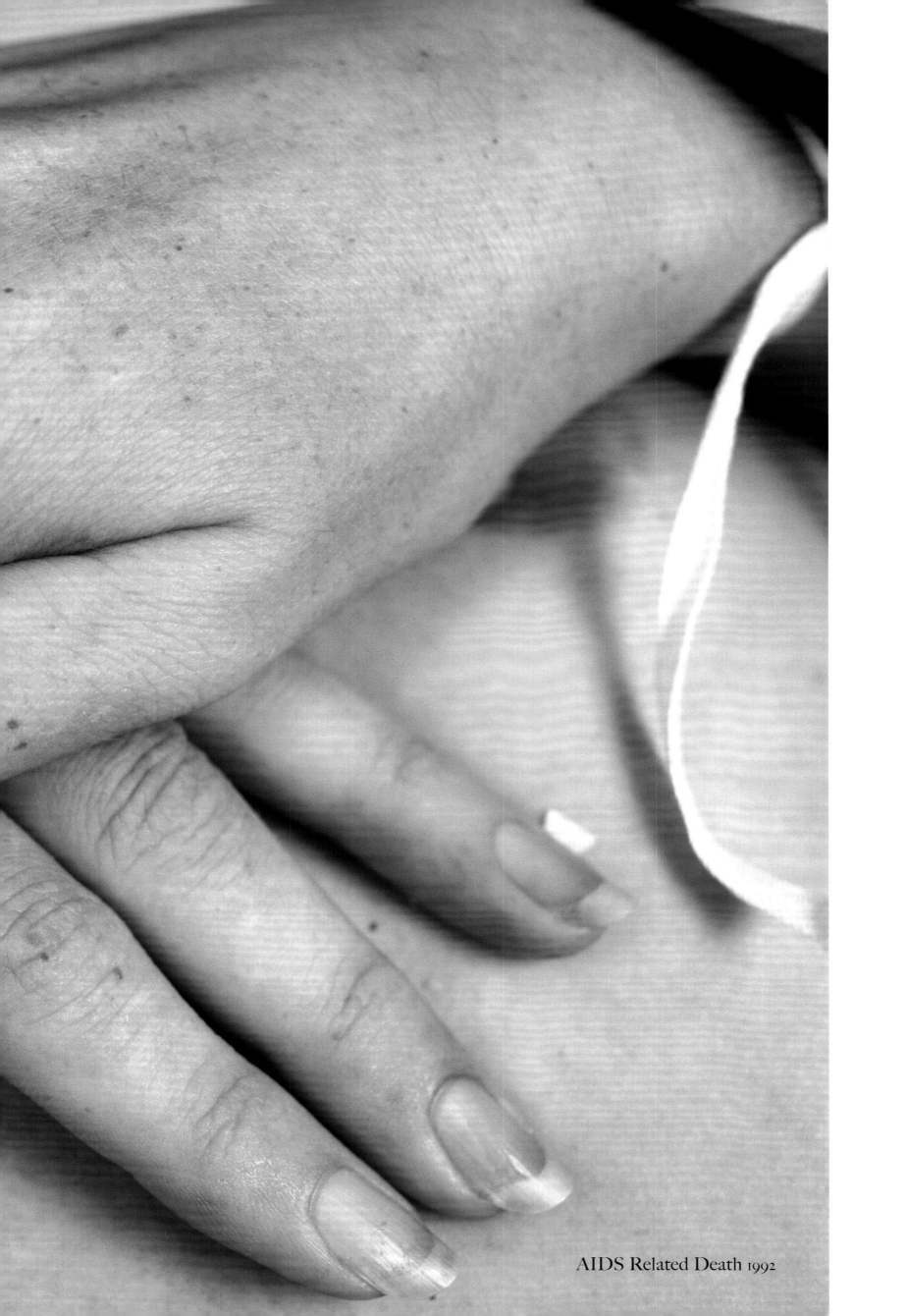

AIDS Related Death 1992

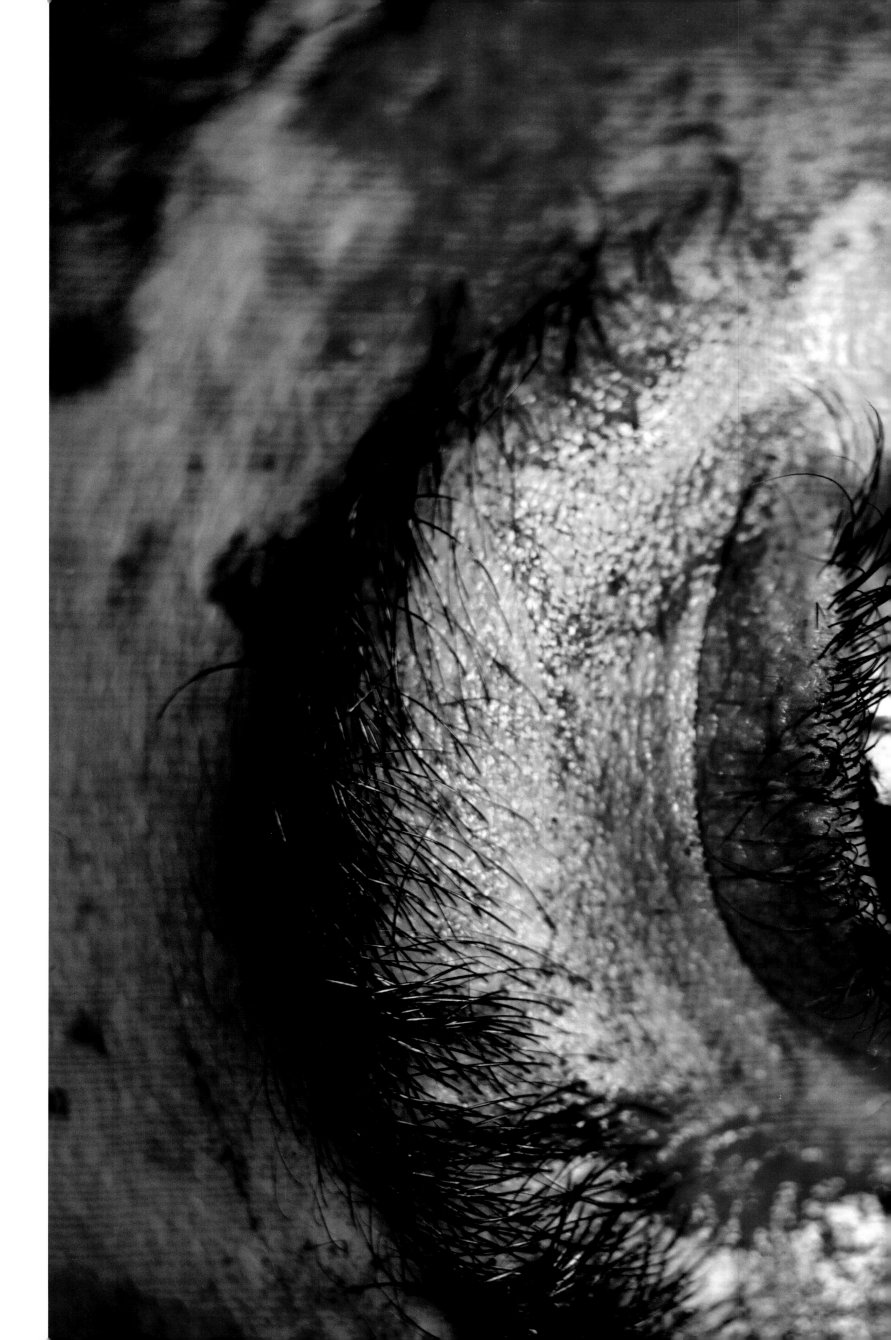

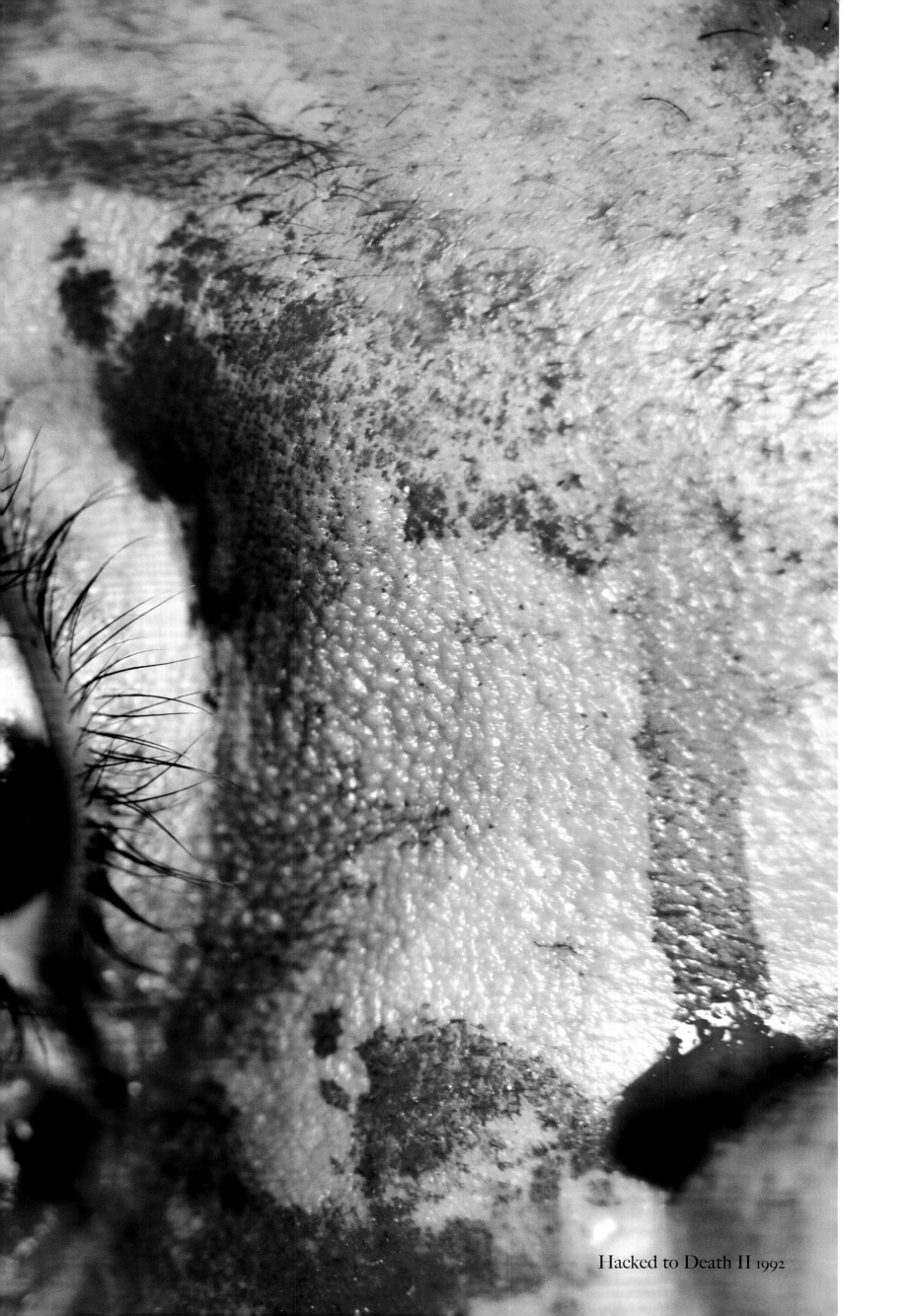

Hacked to Death II 1992

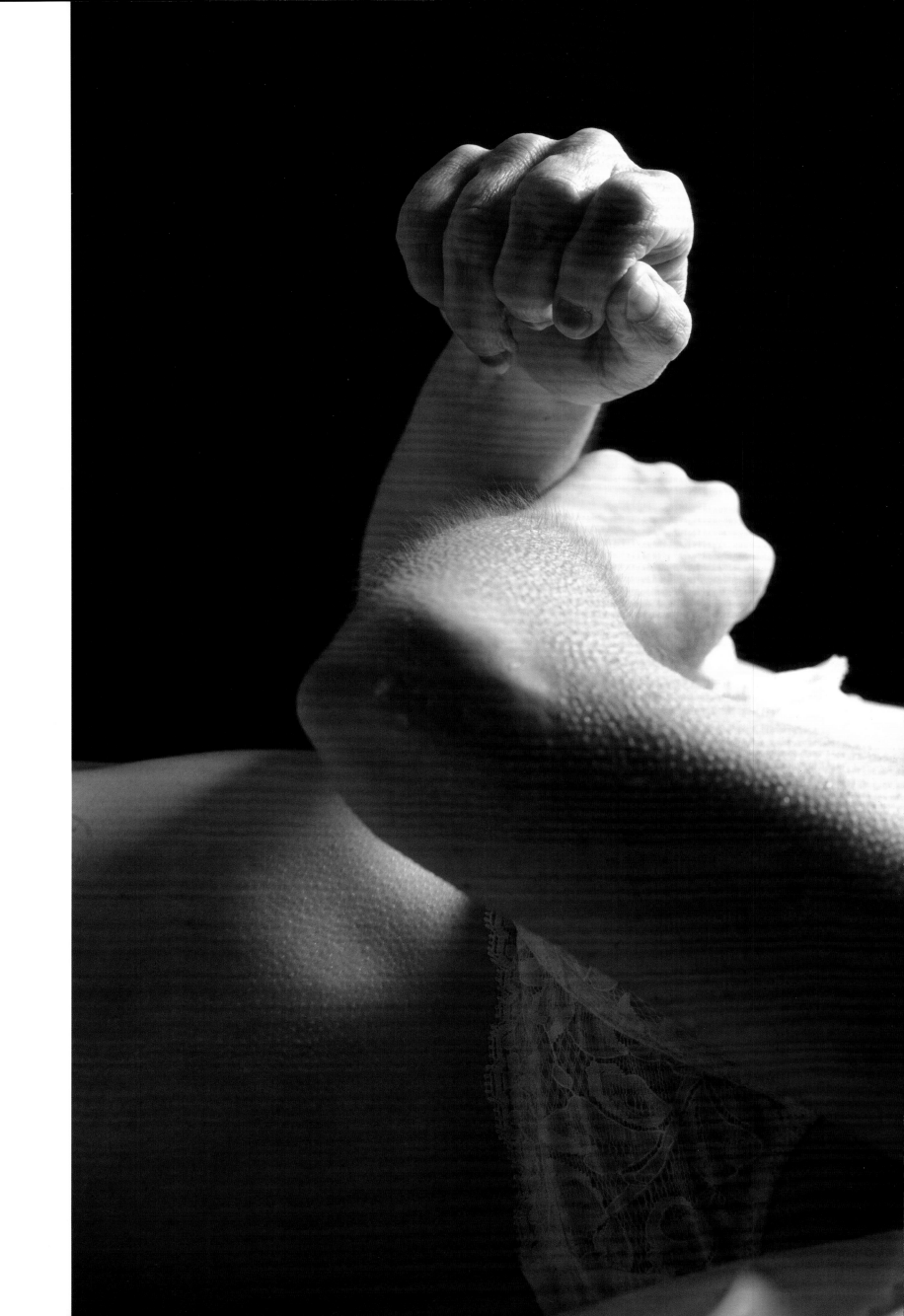

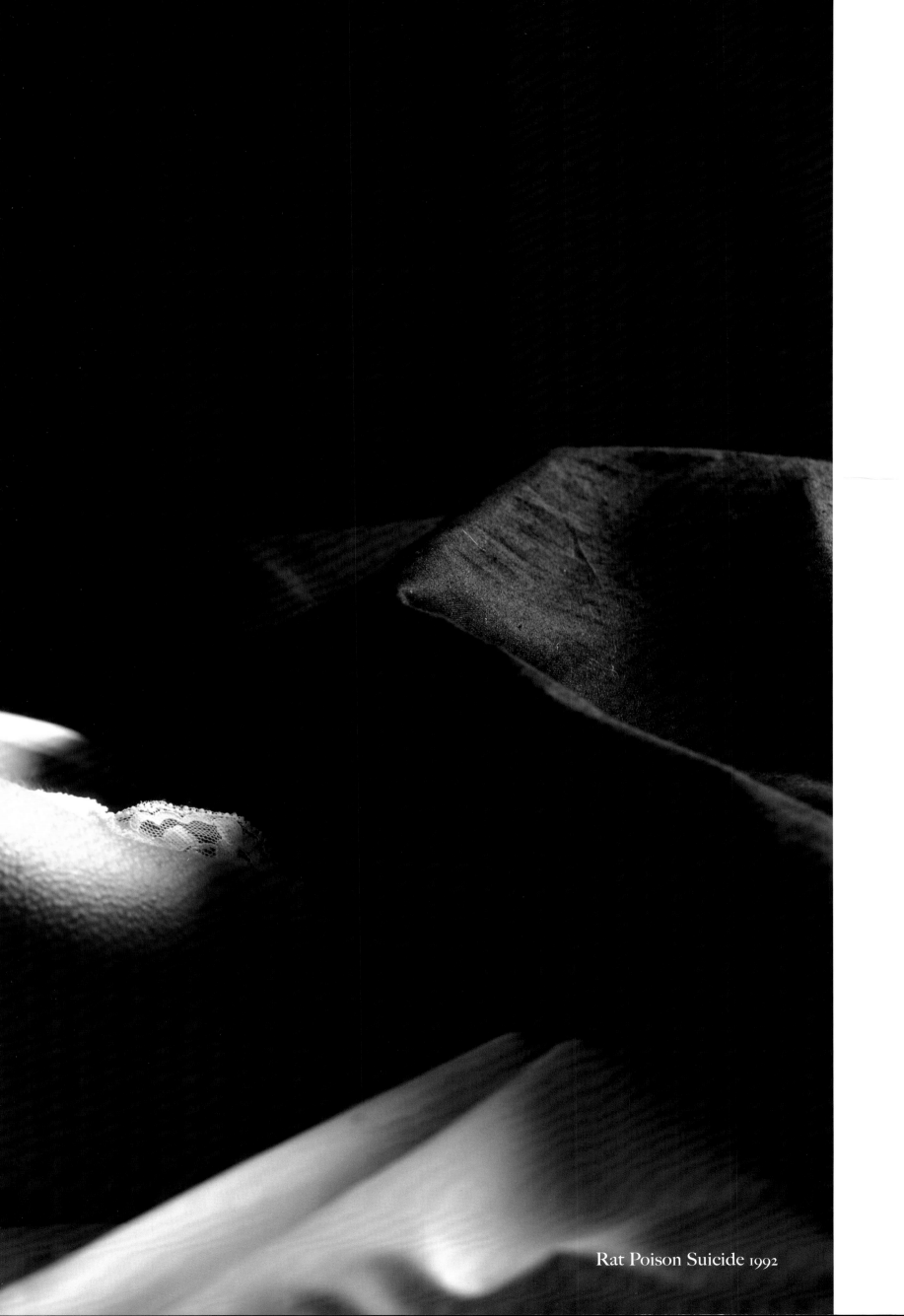

Rat Poison Suicide 1992

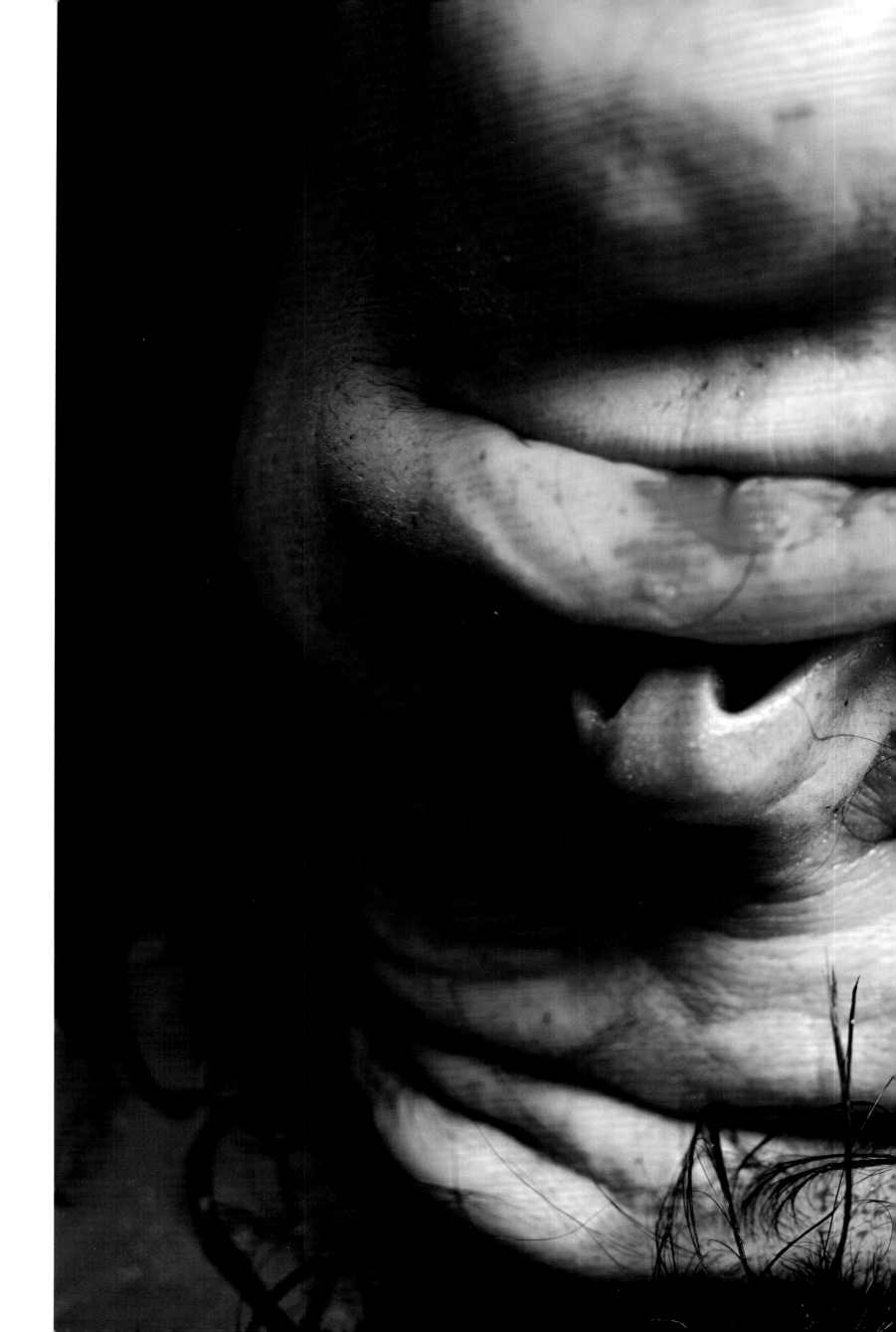

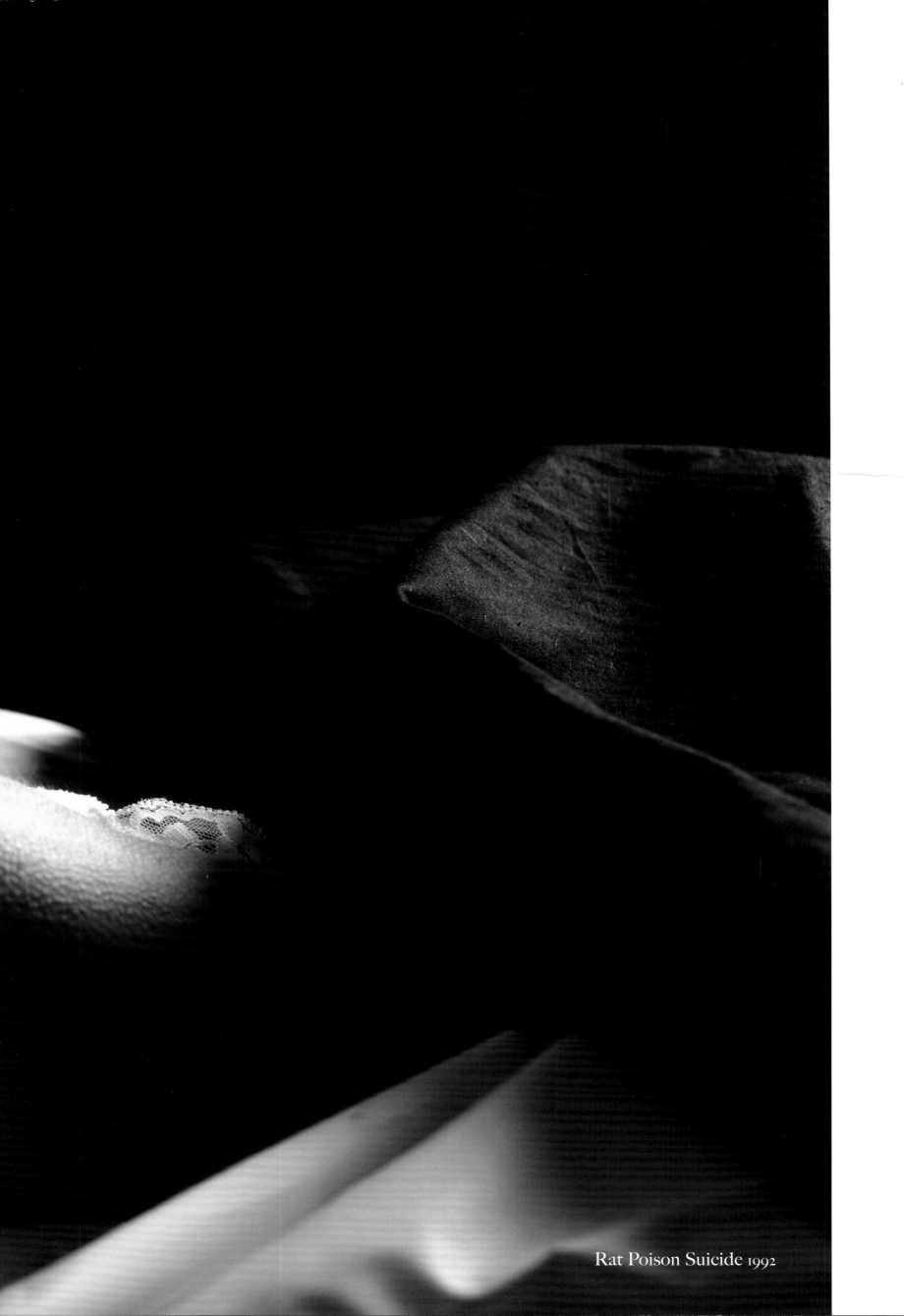
Rat Poison Suicide 1992

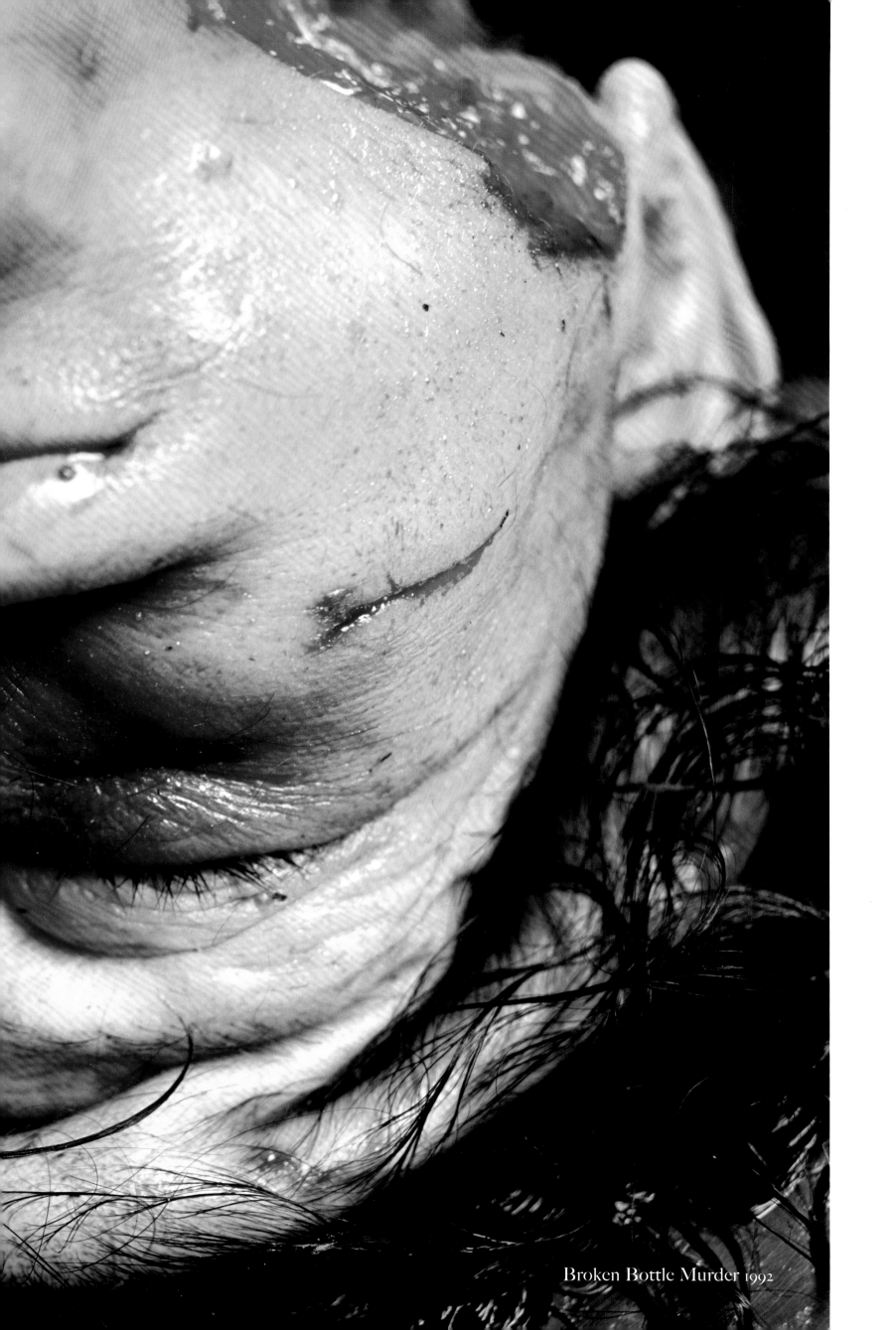

Broken Bottle Murder 1992

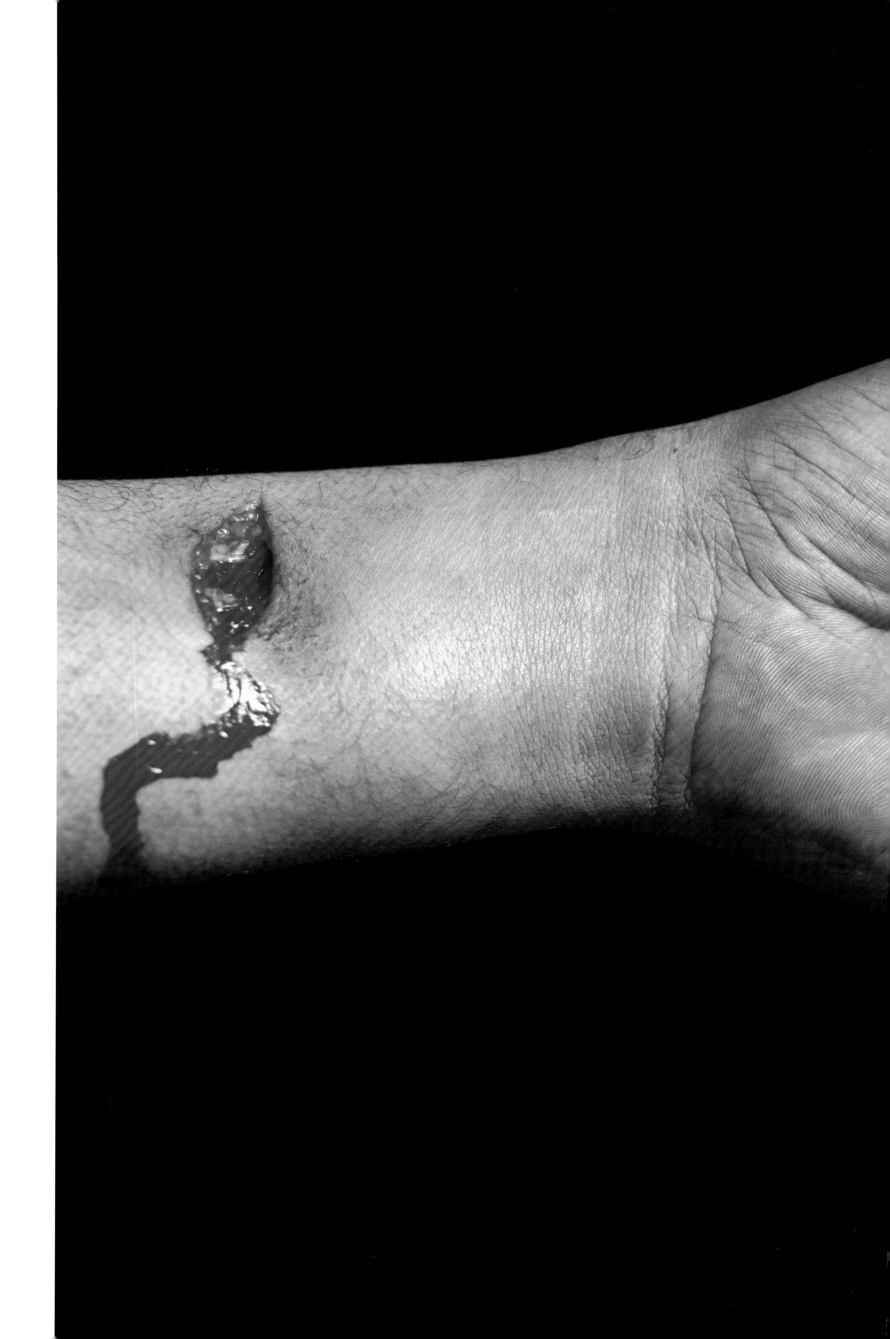

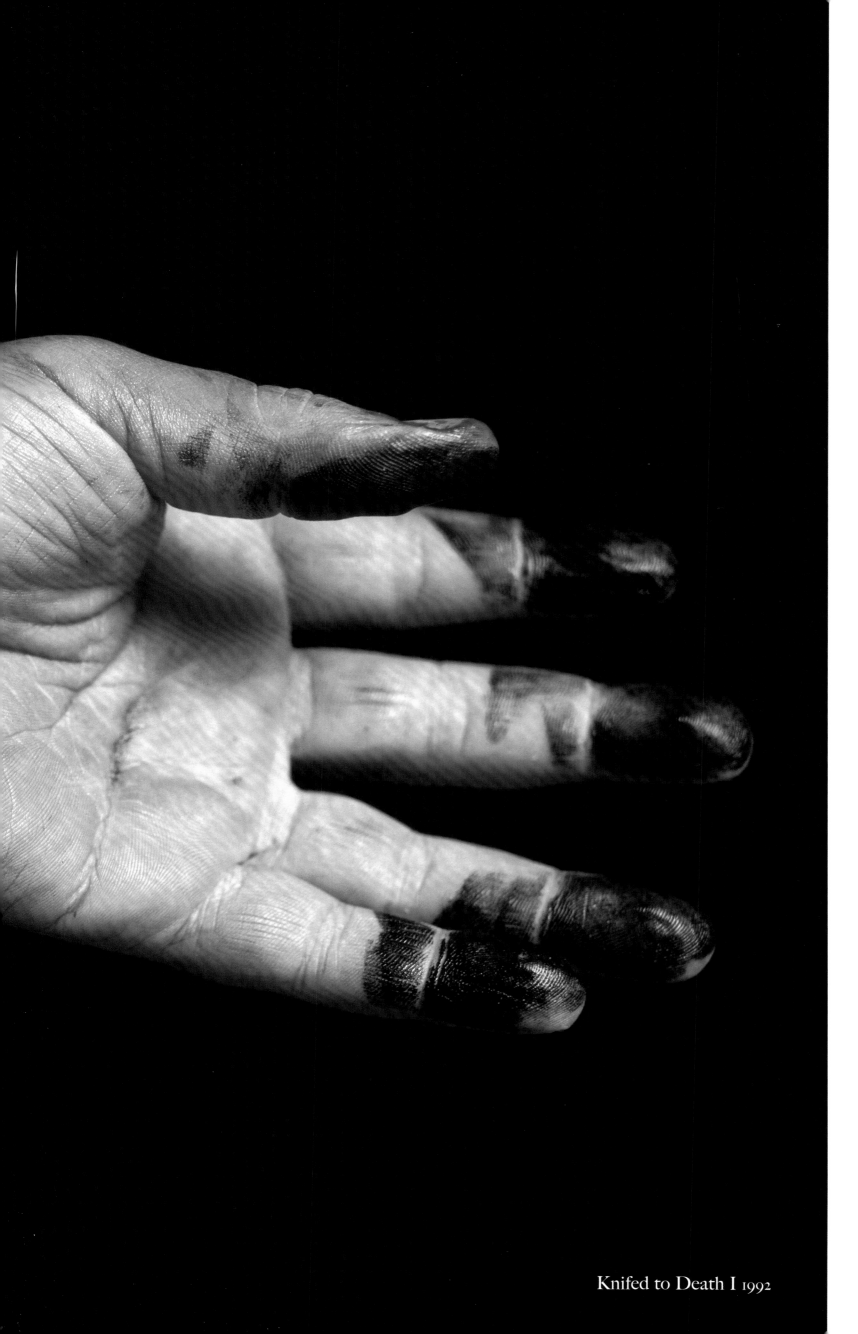

Knifed to Death I 1992

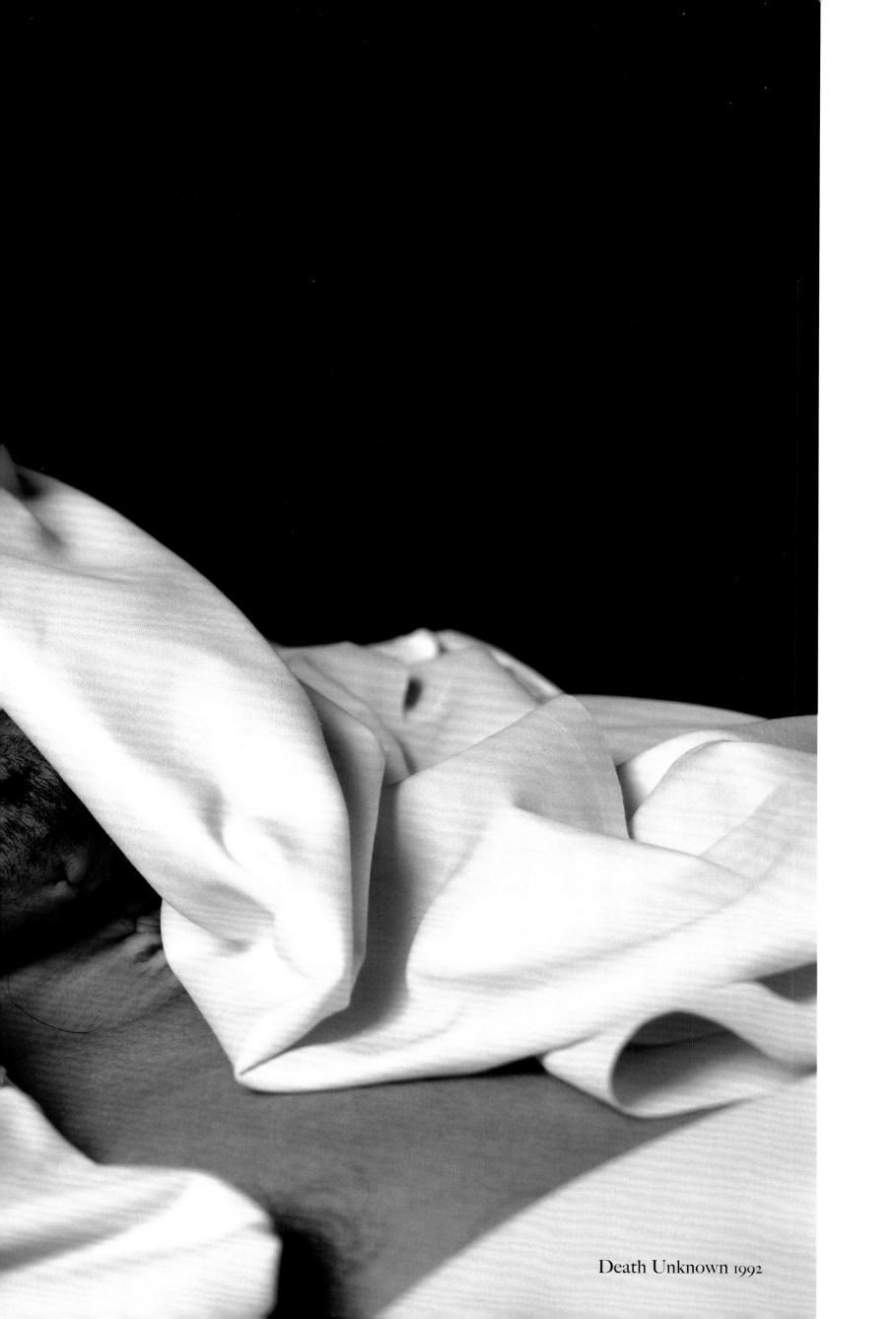

Death Unknown 1992

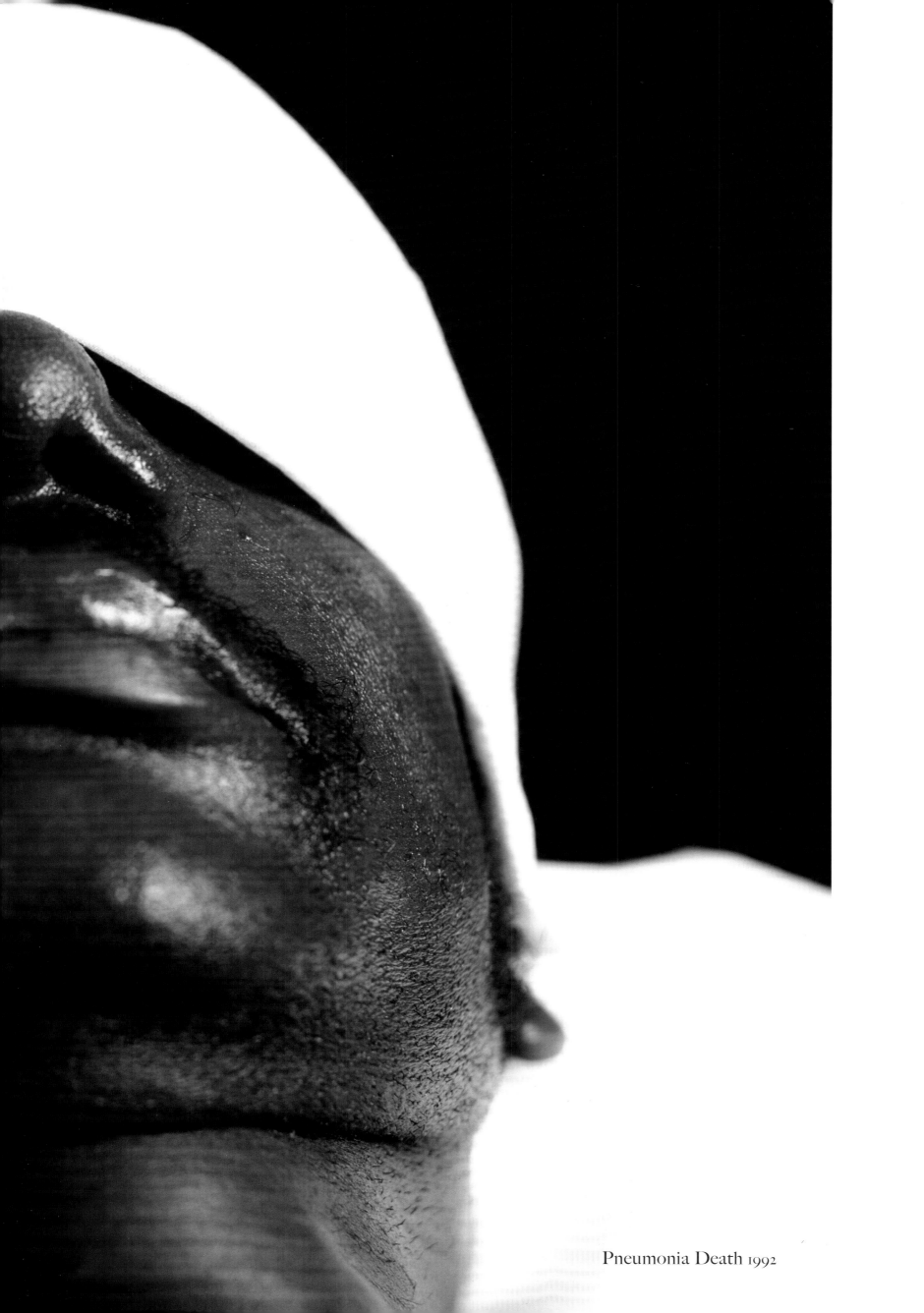

Pneumonia Death 1992

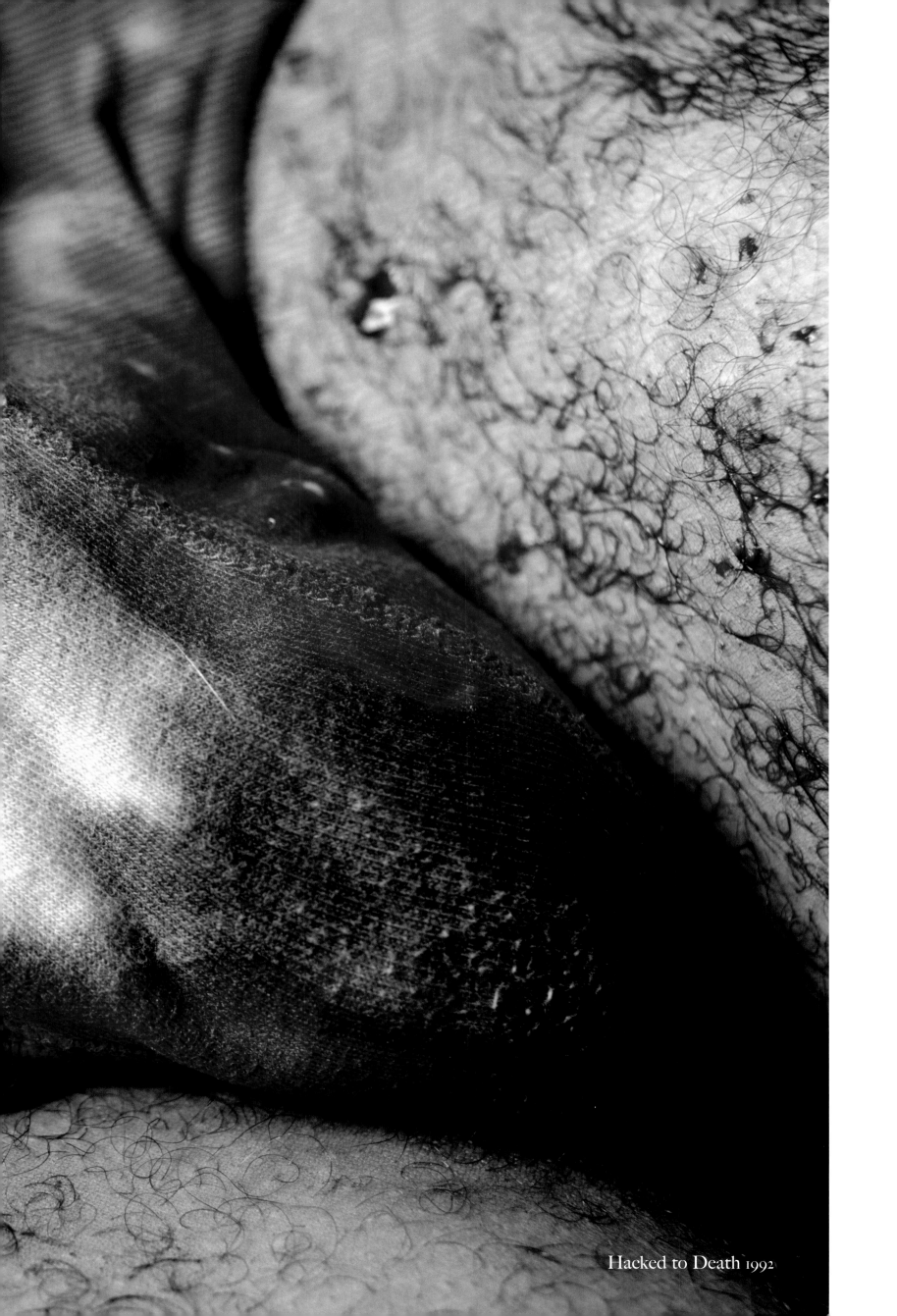

Hacked to Death 1992

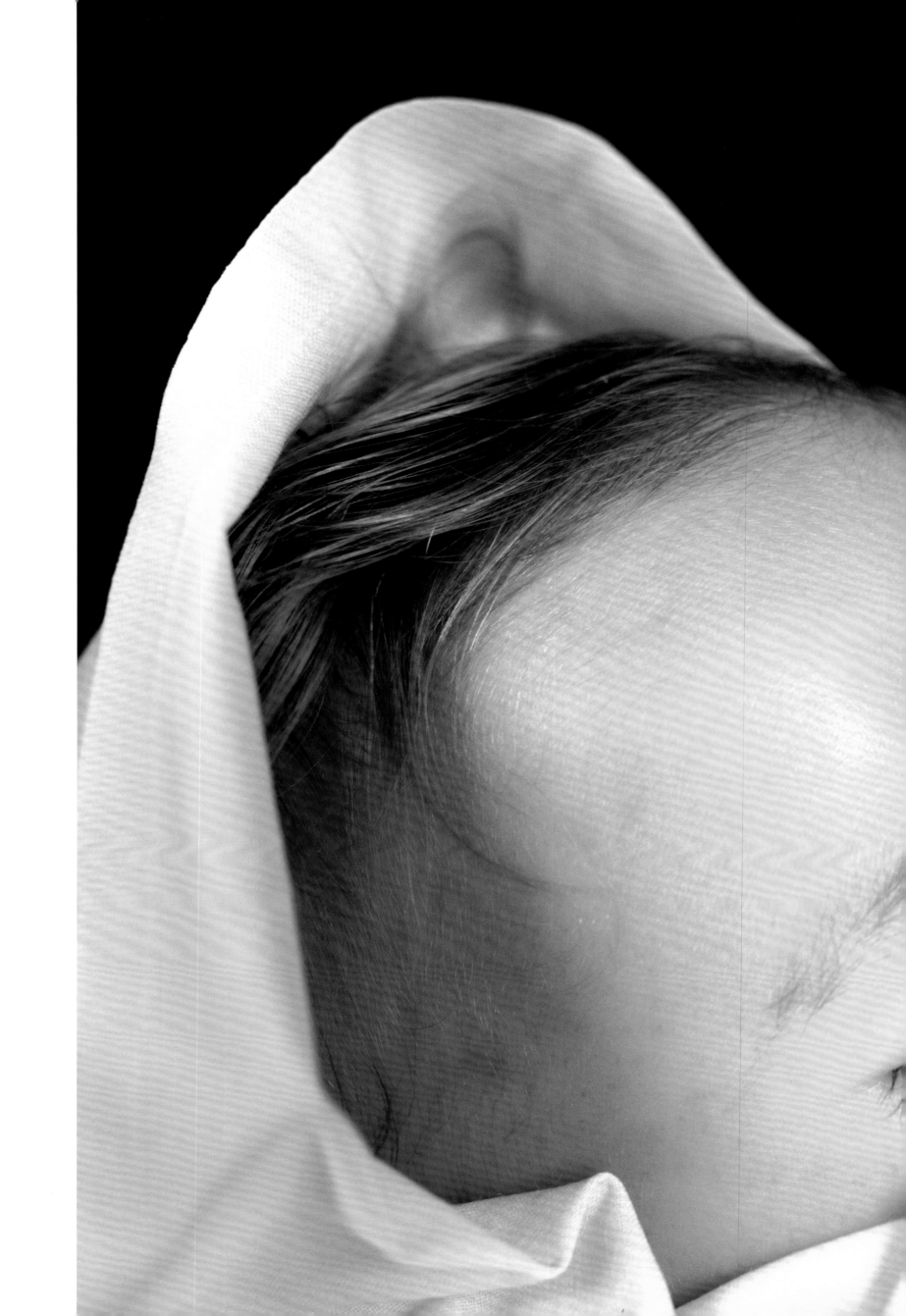

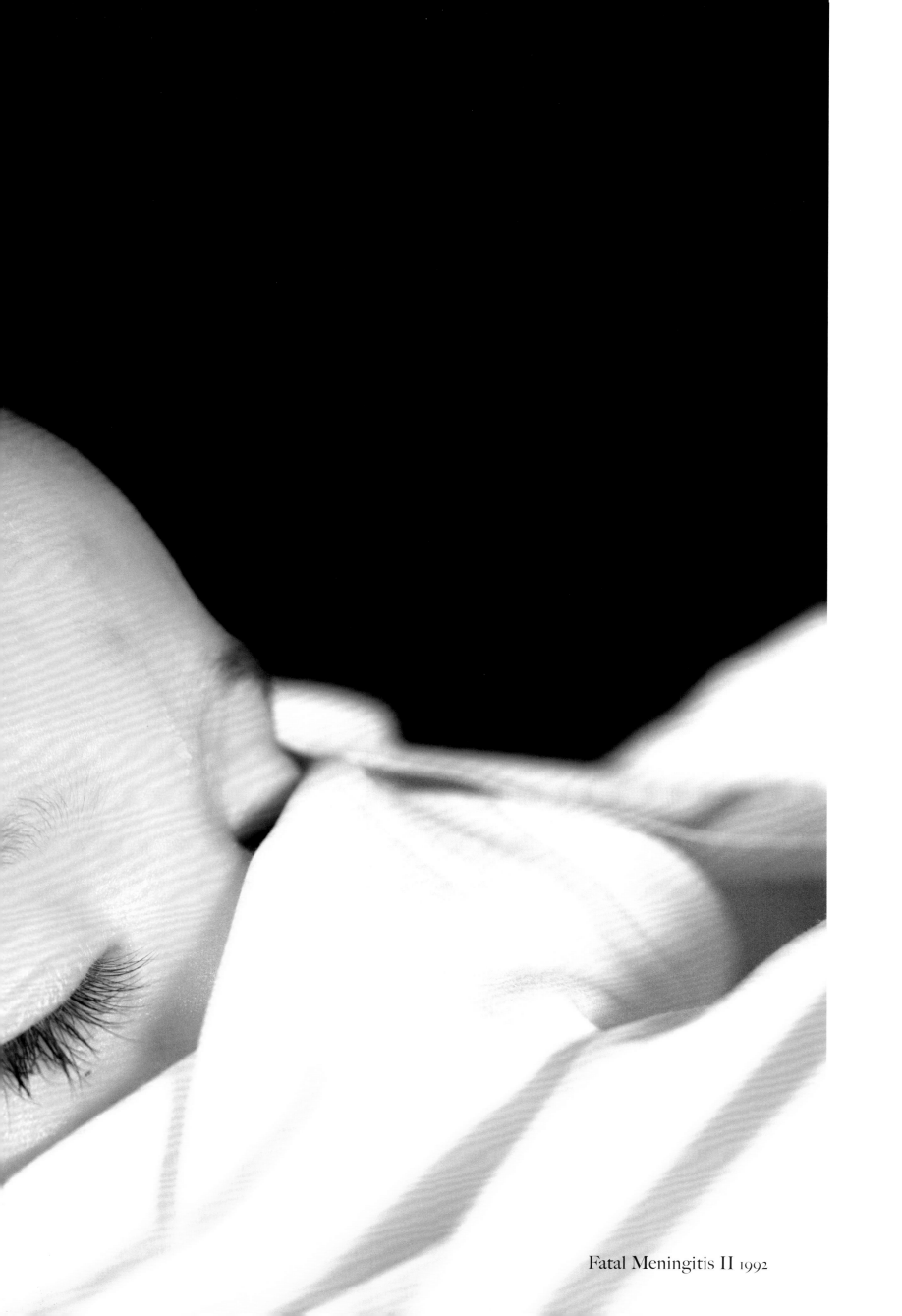

Fatal Meningitis II 1992

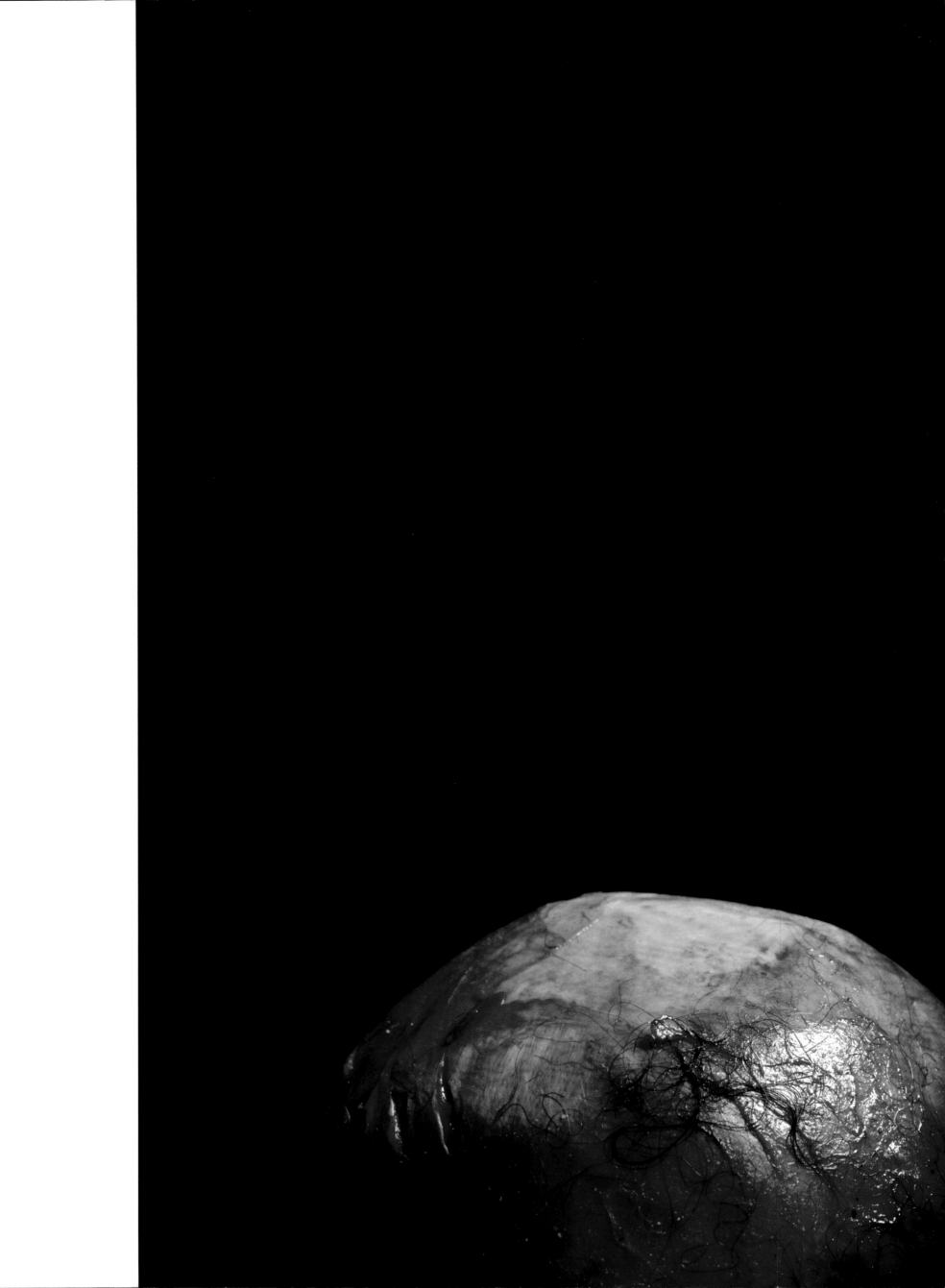

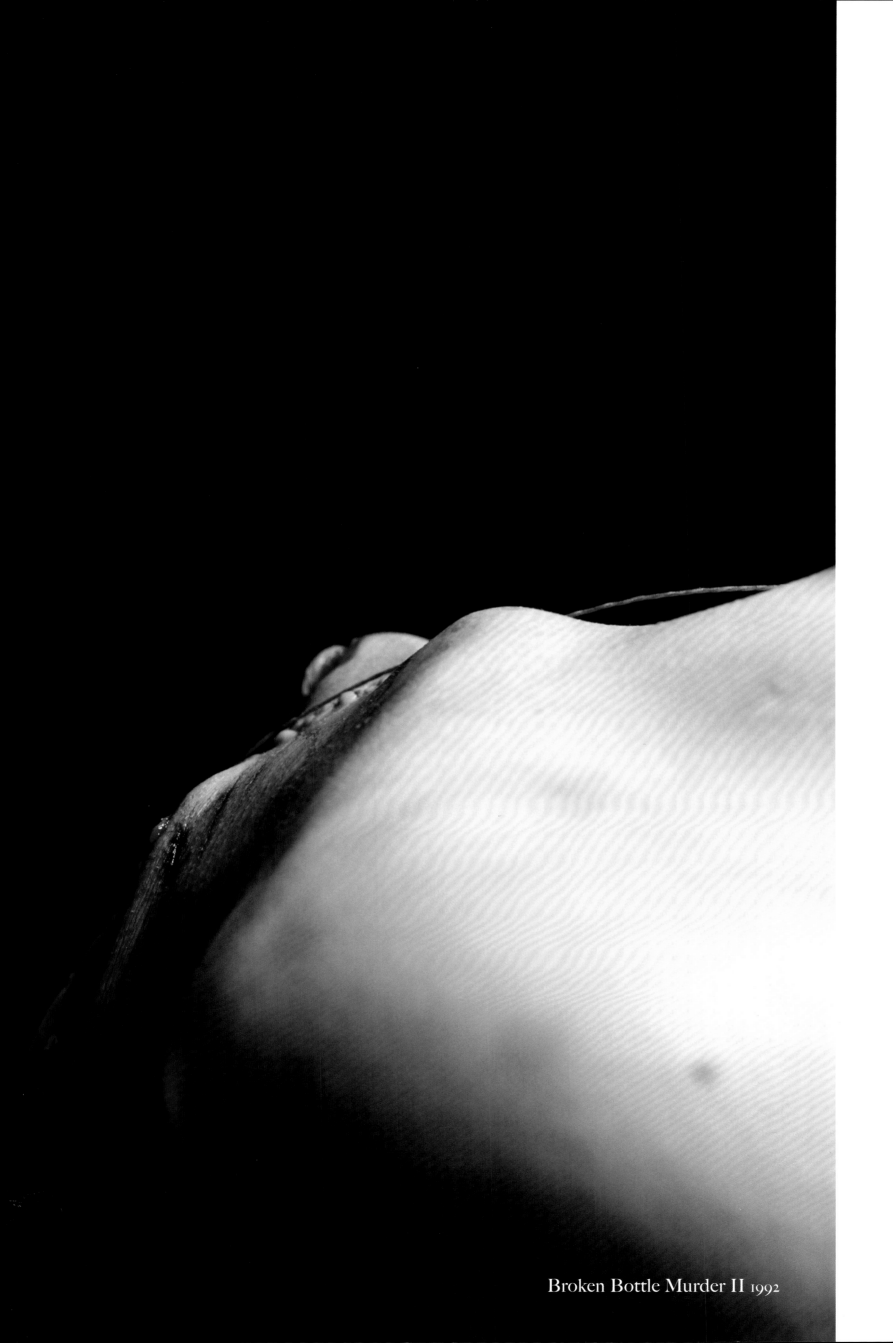

Broken Bottle Murder II 1992

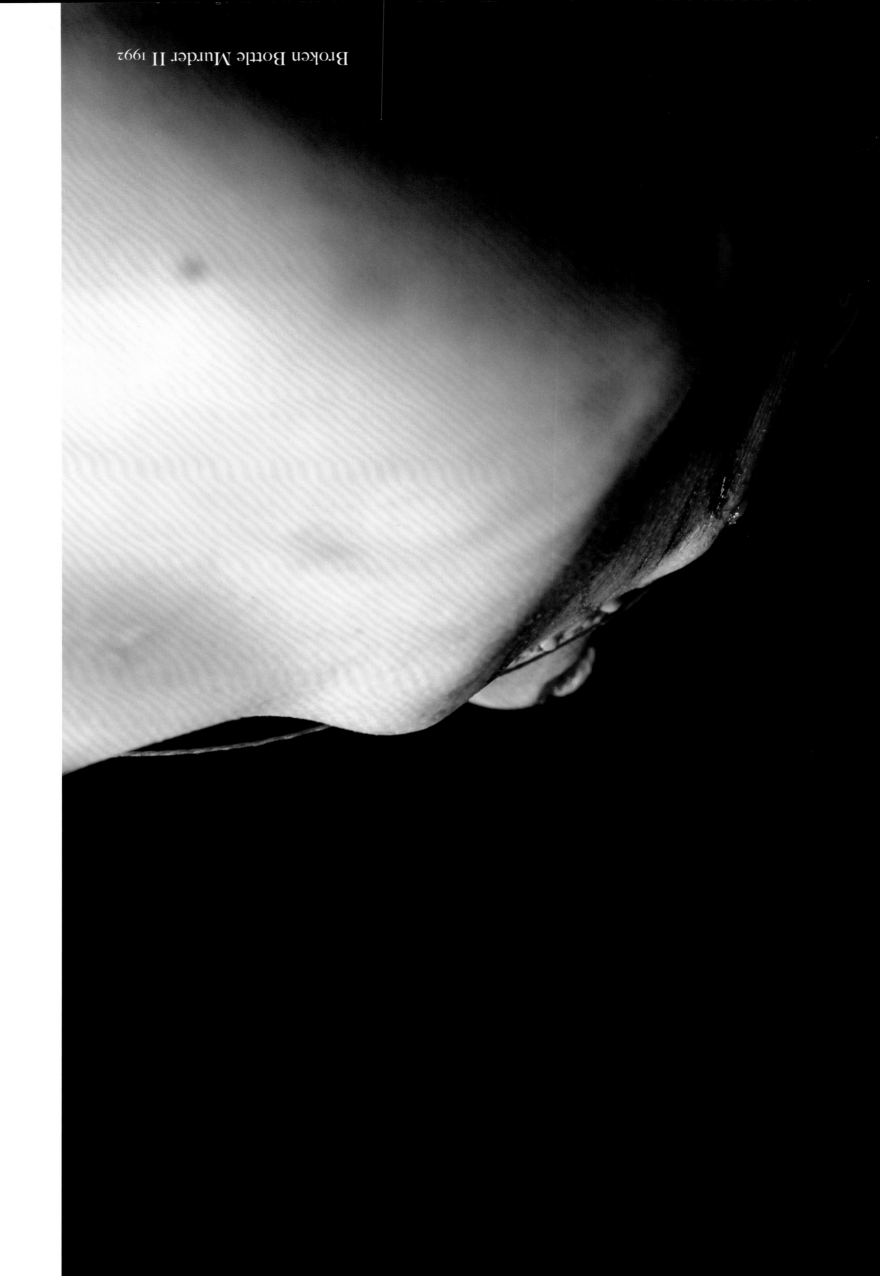

Broken Bottle Murder II 1992

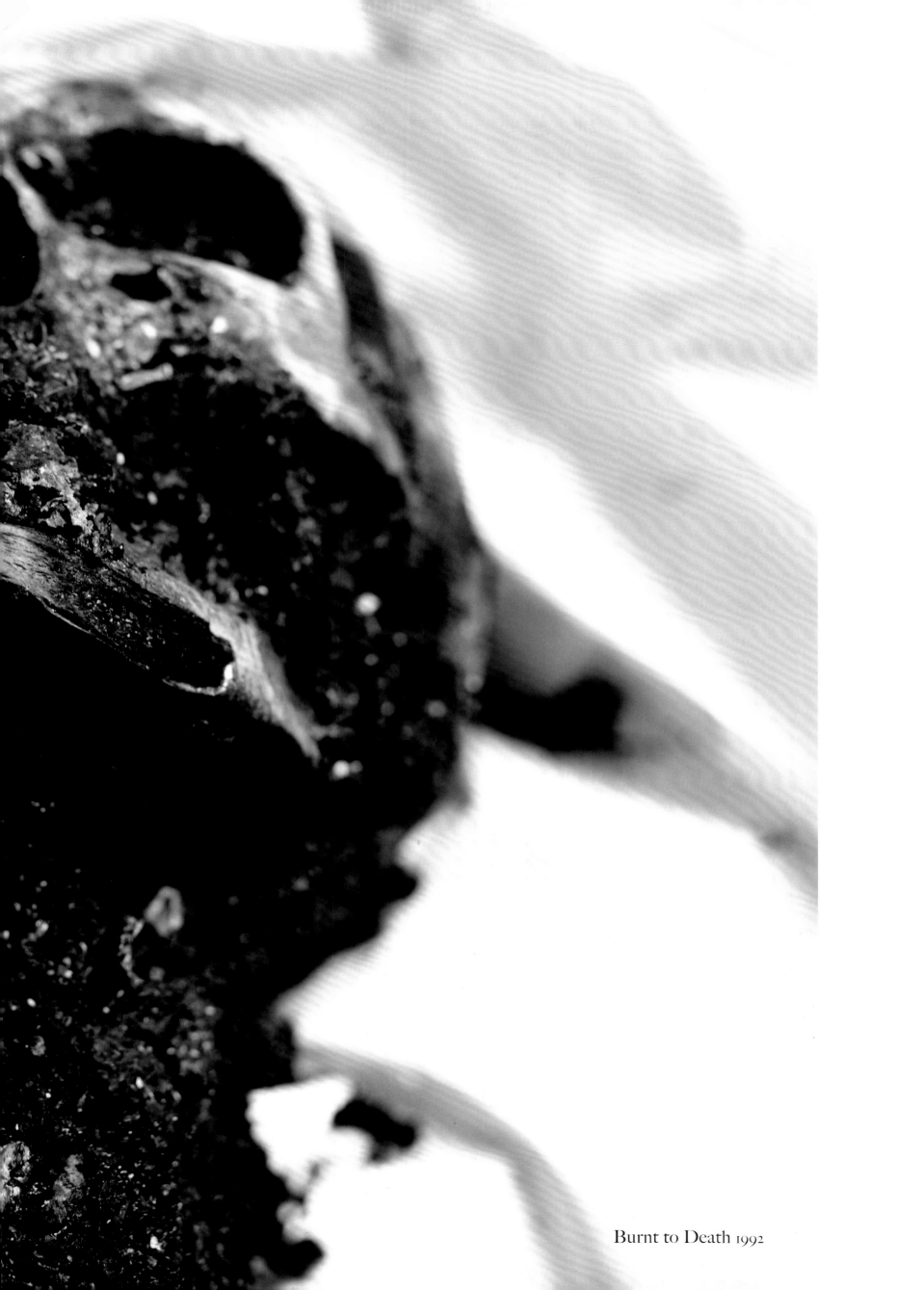

Burnt to Death 1992

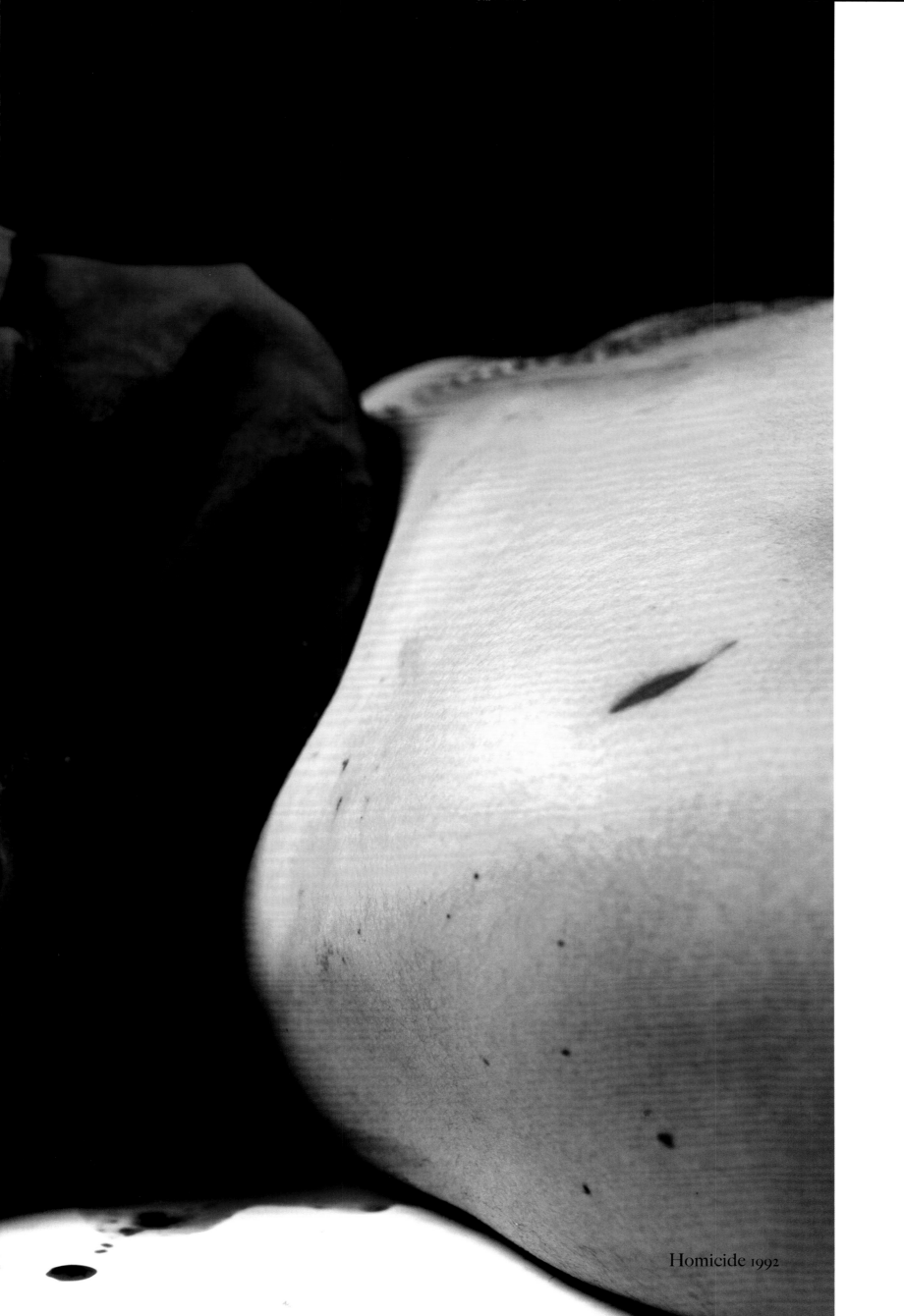

Homicide 1992

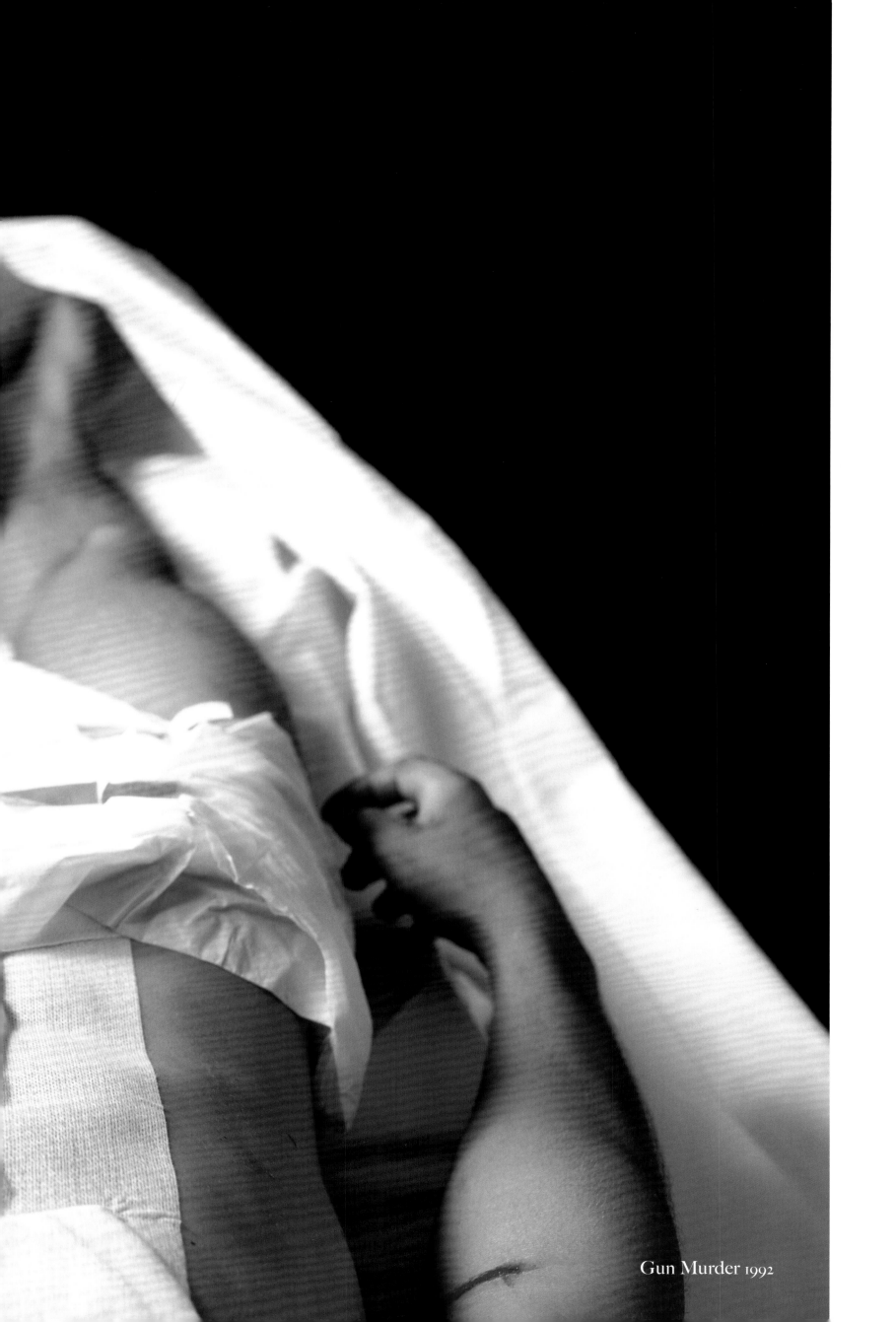

Gun Murder 1992

Burn Victim 1992

Fatal Meningitis 1992

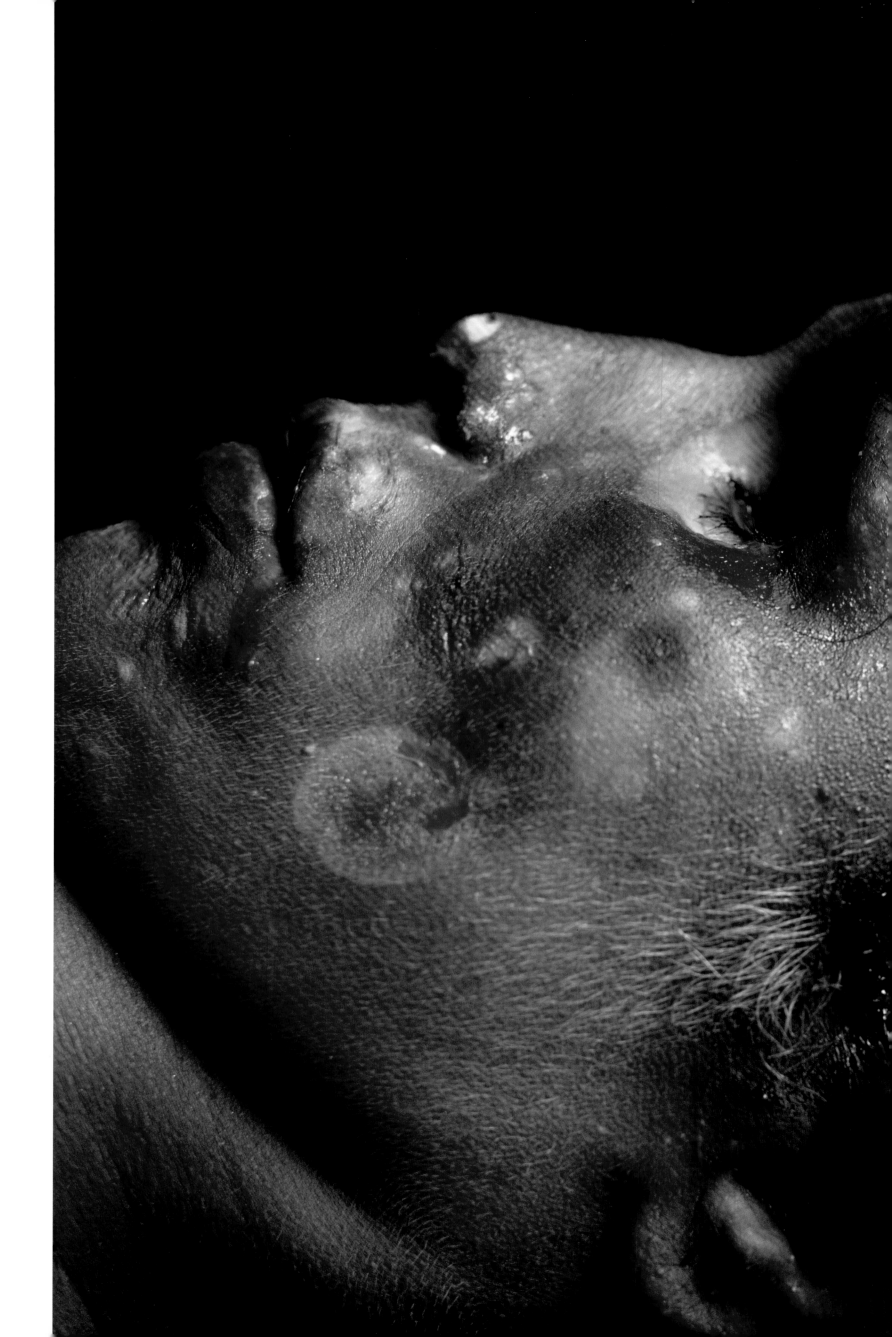

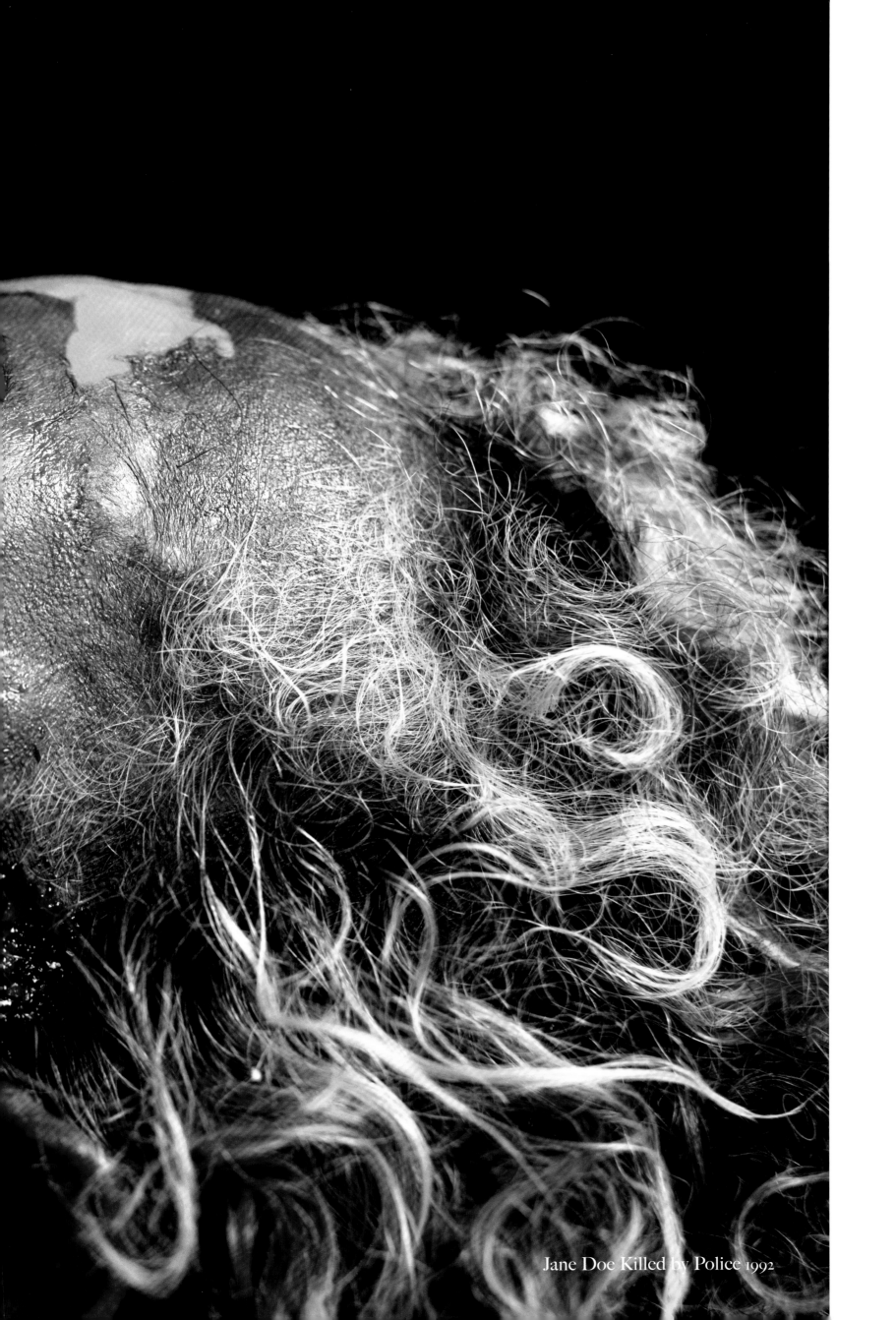

Jane Doe Killed by Police 1992

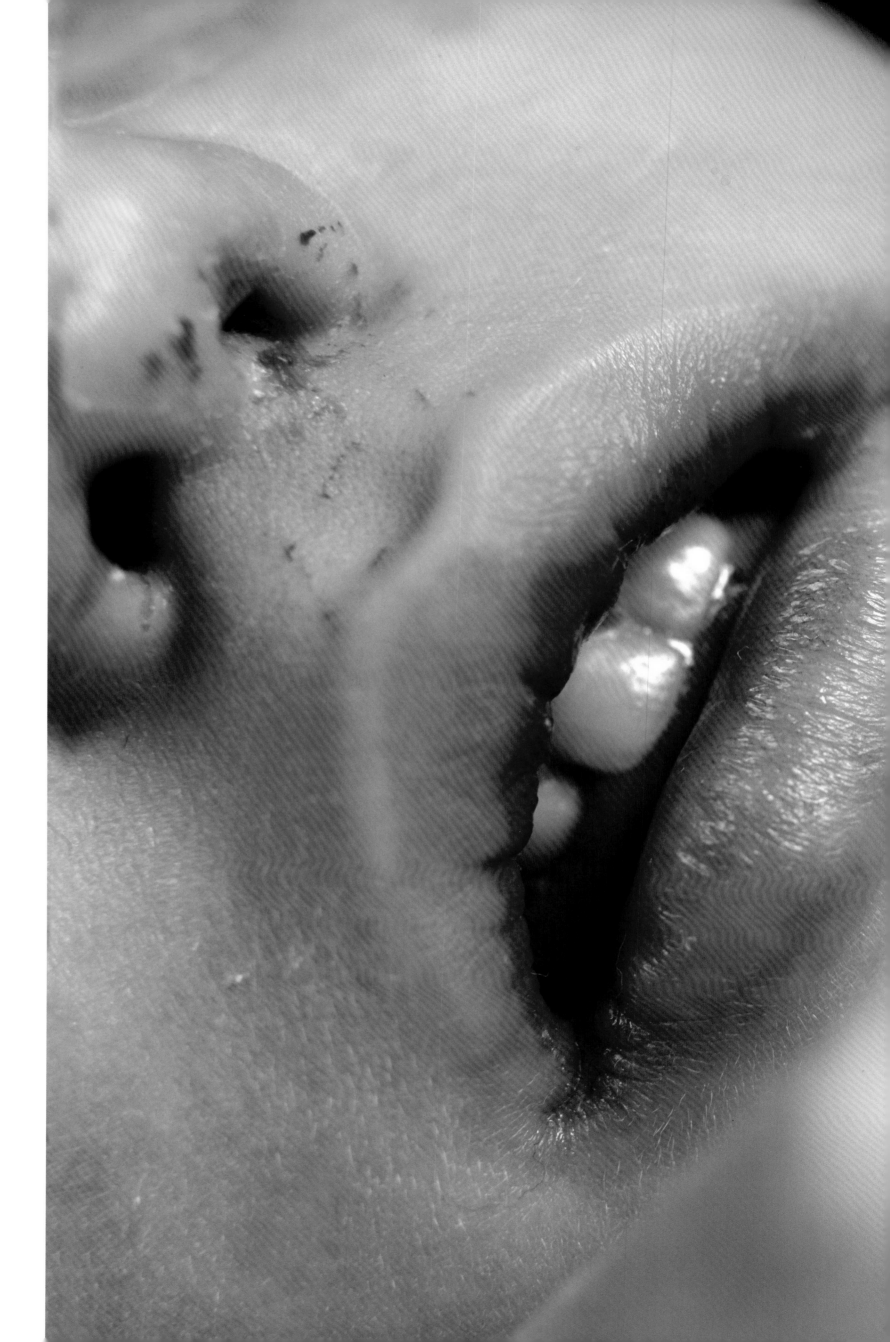

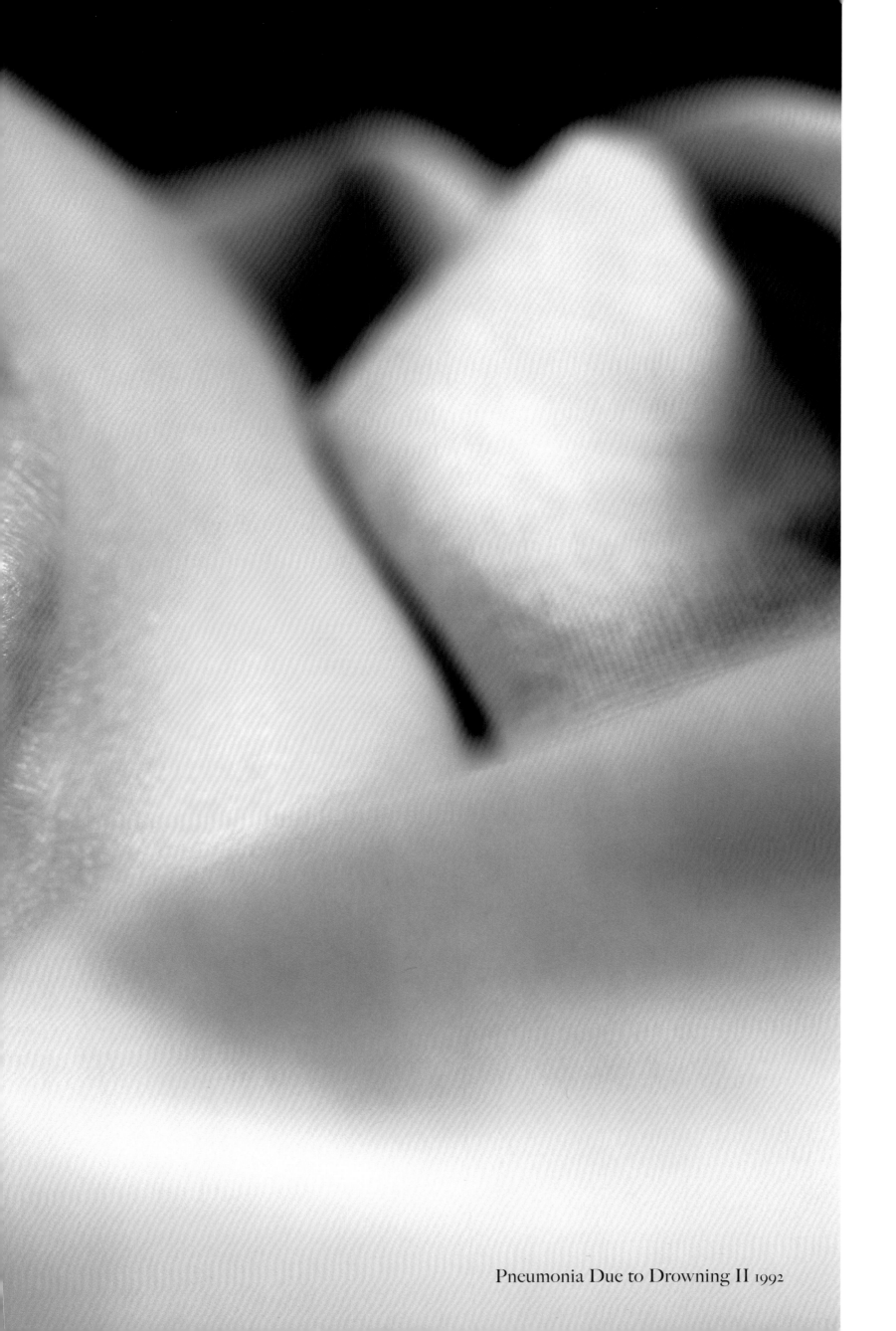

Pneumonia Due to Drowning II 1992

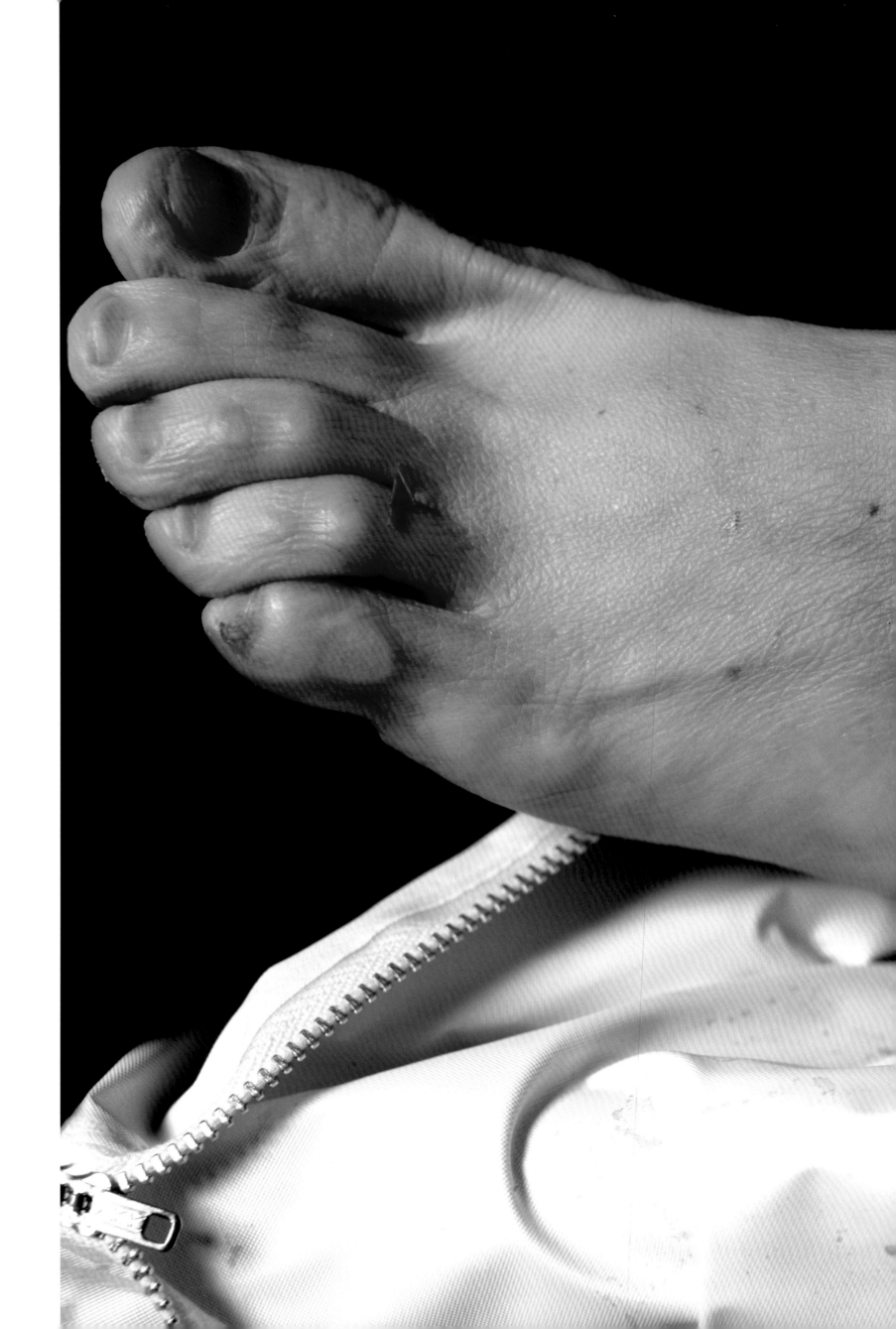

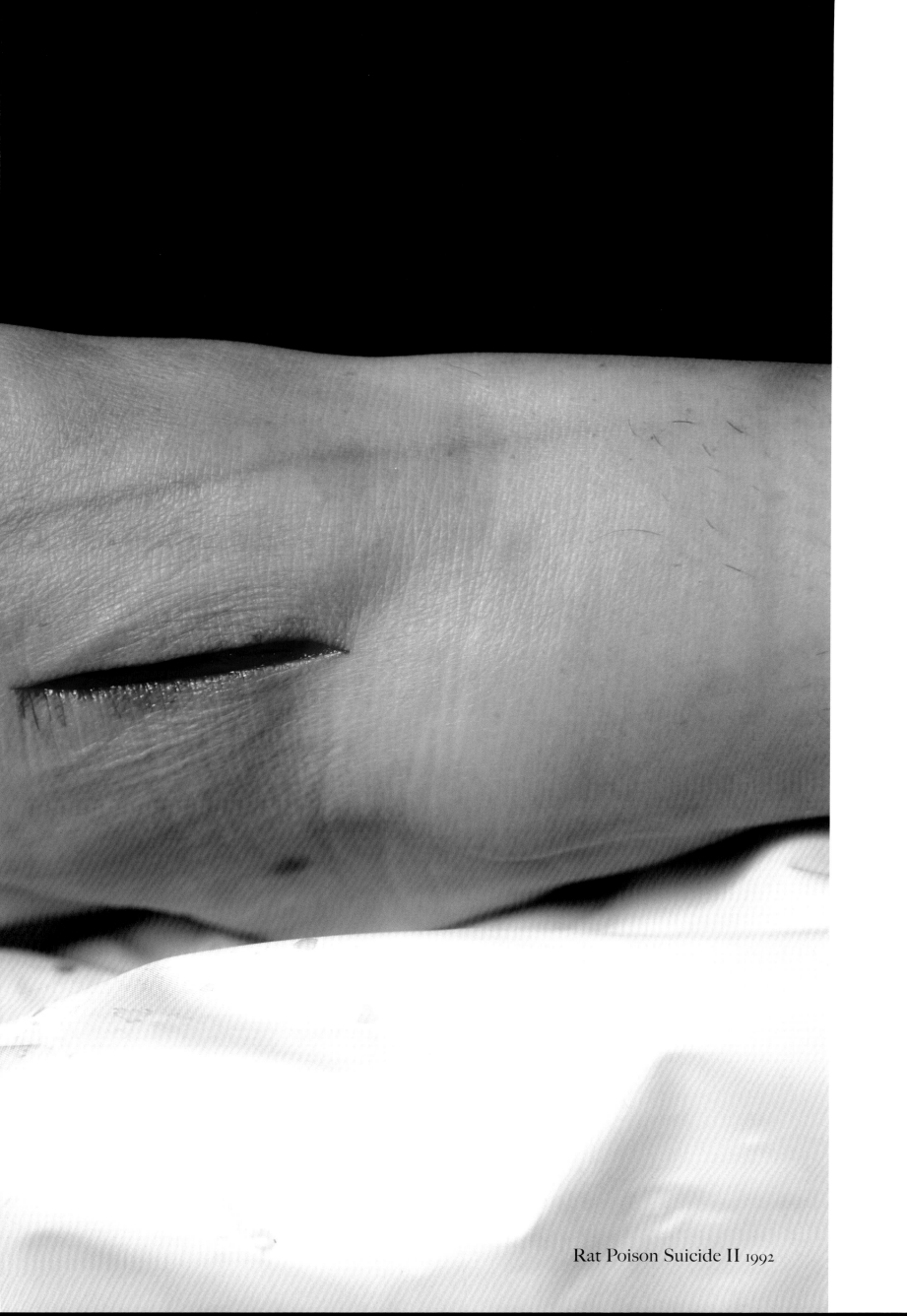

Rat Poison Suicide II 1992

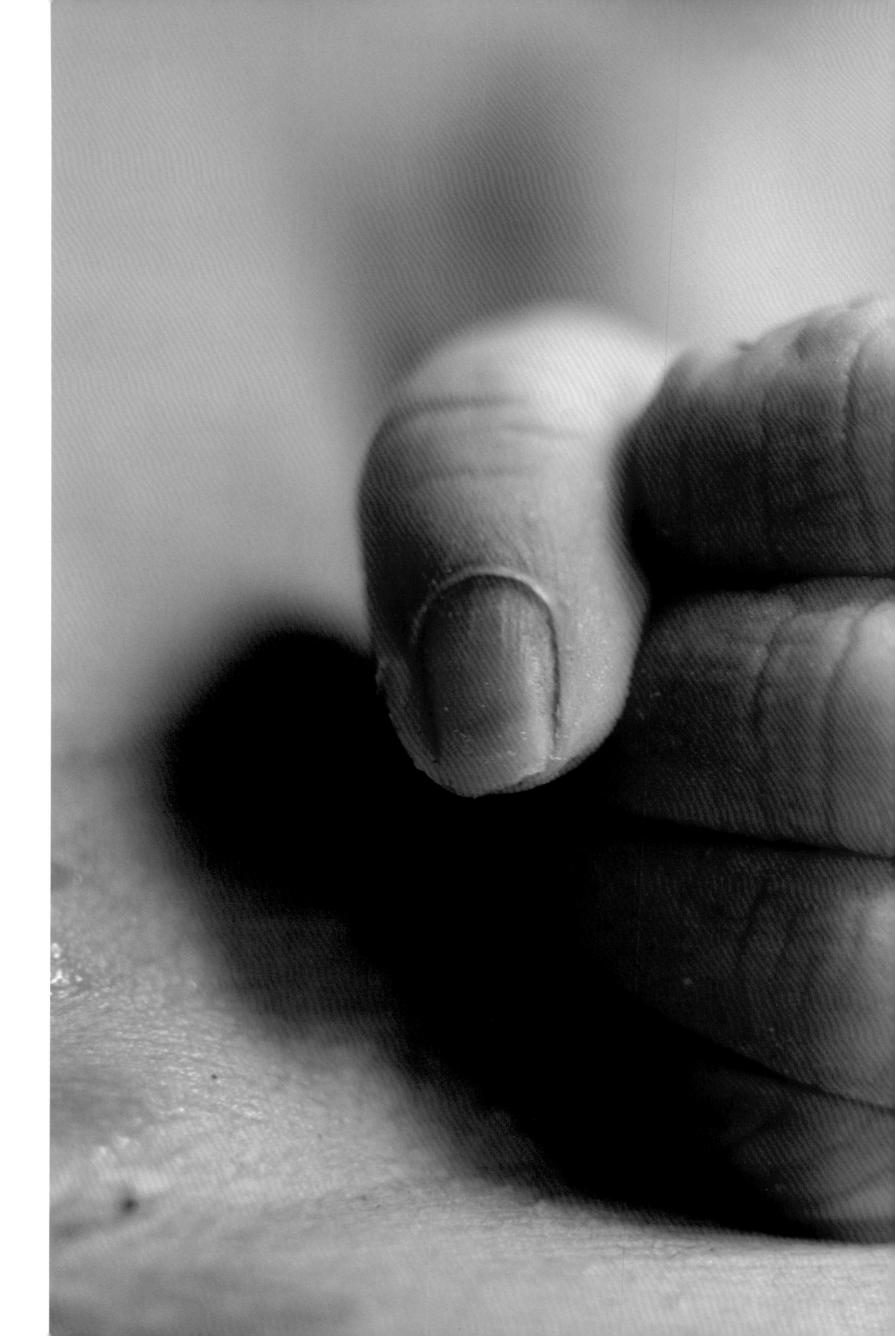

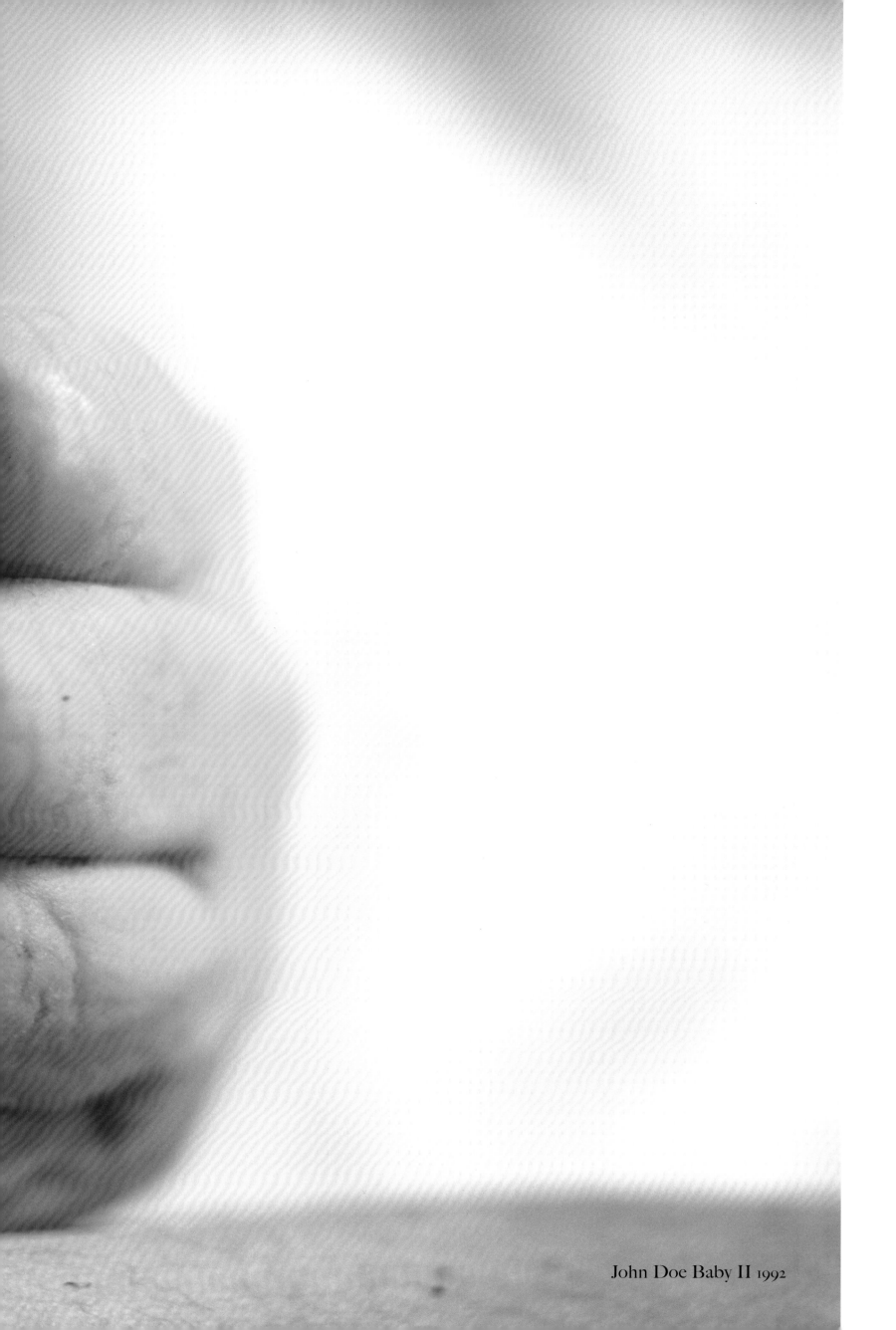

John Doe Baby II 1992

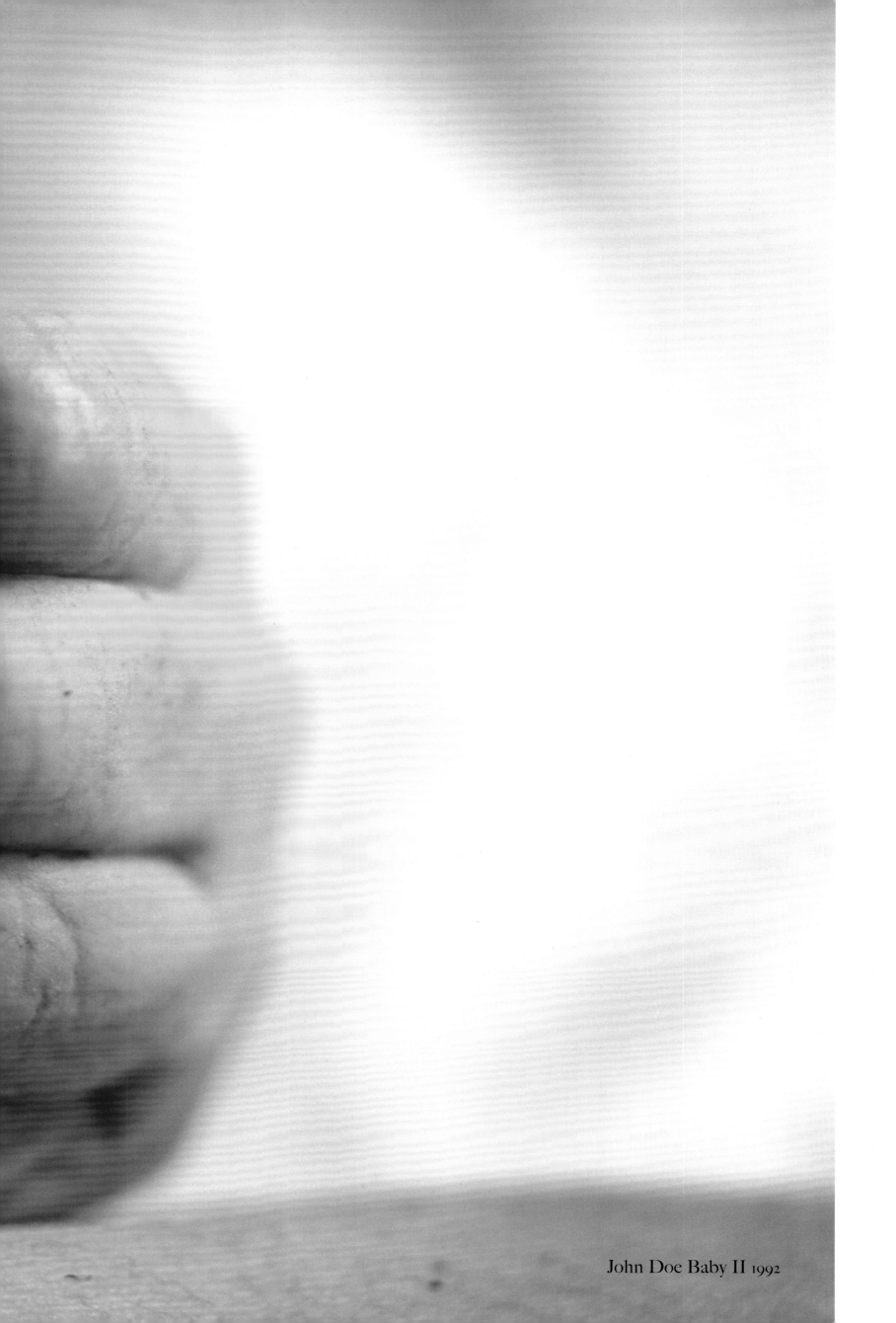

John Doe Baby II 1992

OBJECTS OF DESIRE

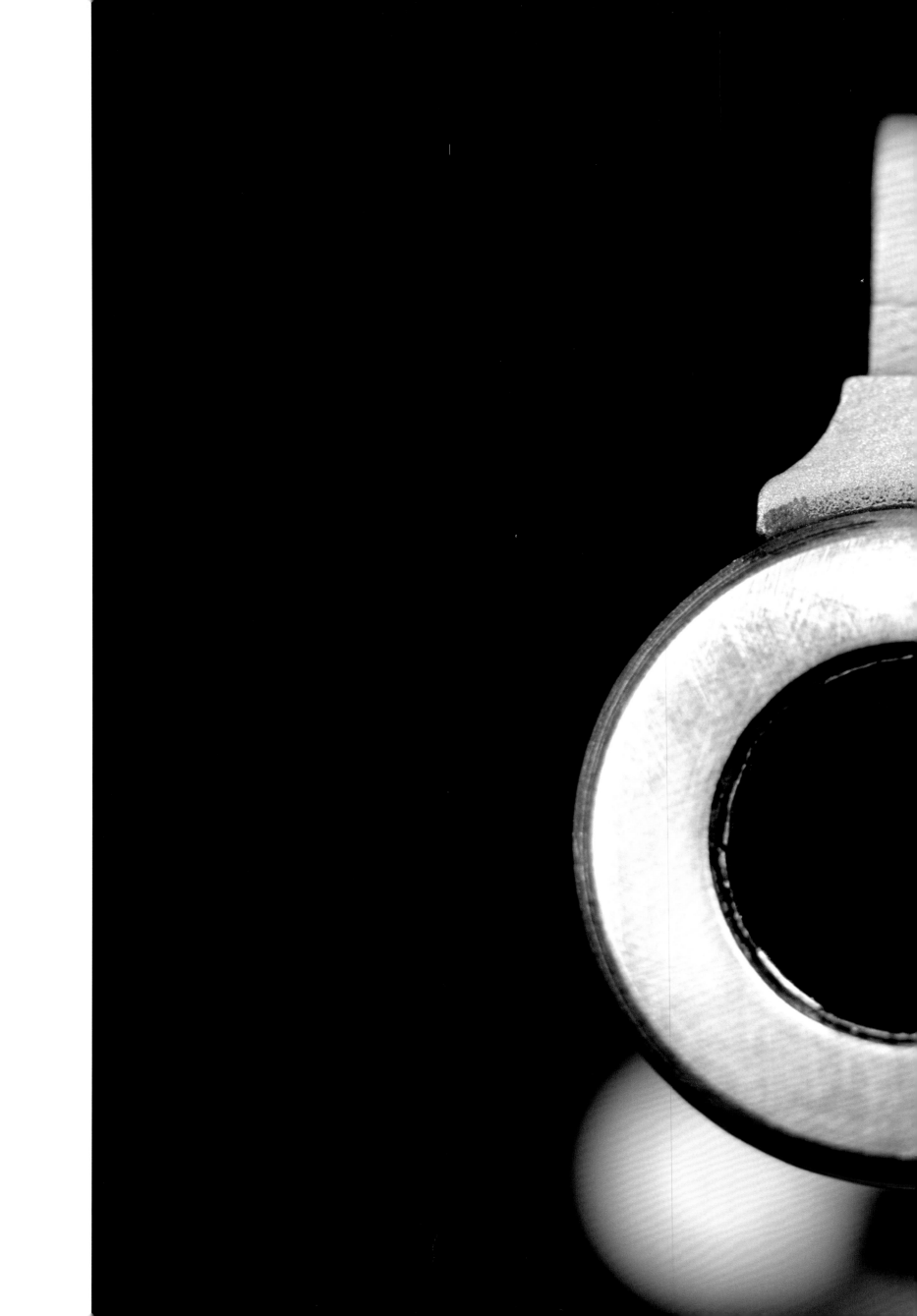

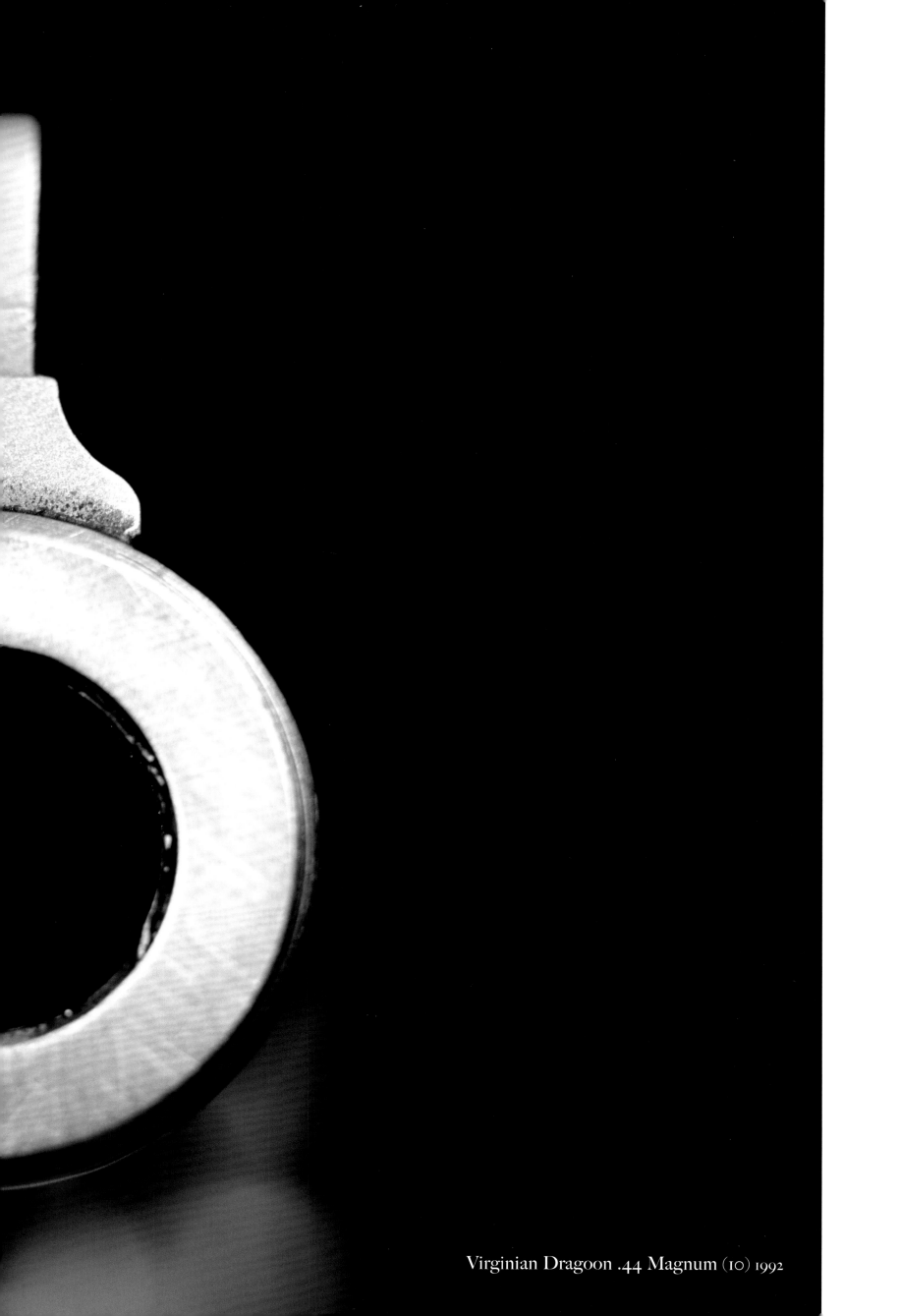

Virginian Dragoon .44 Magnum (10) 1992

IN *INSTRUCTION MANUAL*

O., INC. SOUTHPORT, CONN. U.S.A. ————

Ruger .22 Long Rifle Mark II Target (4) 1992

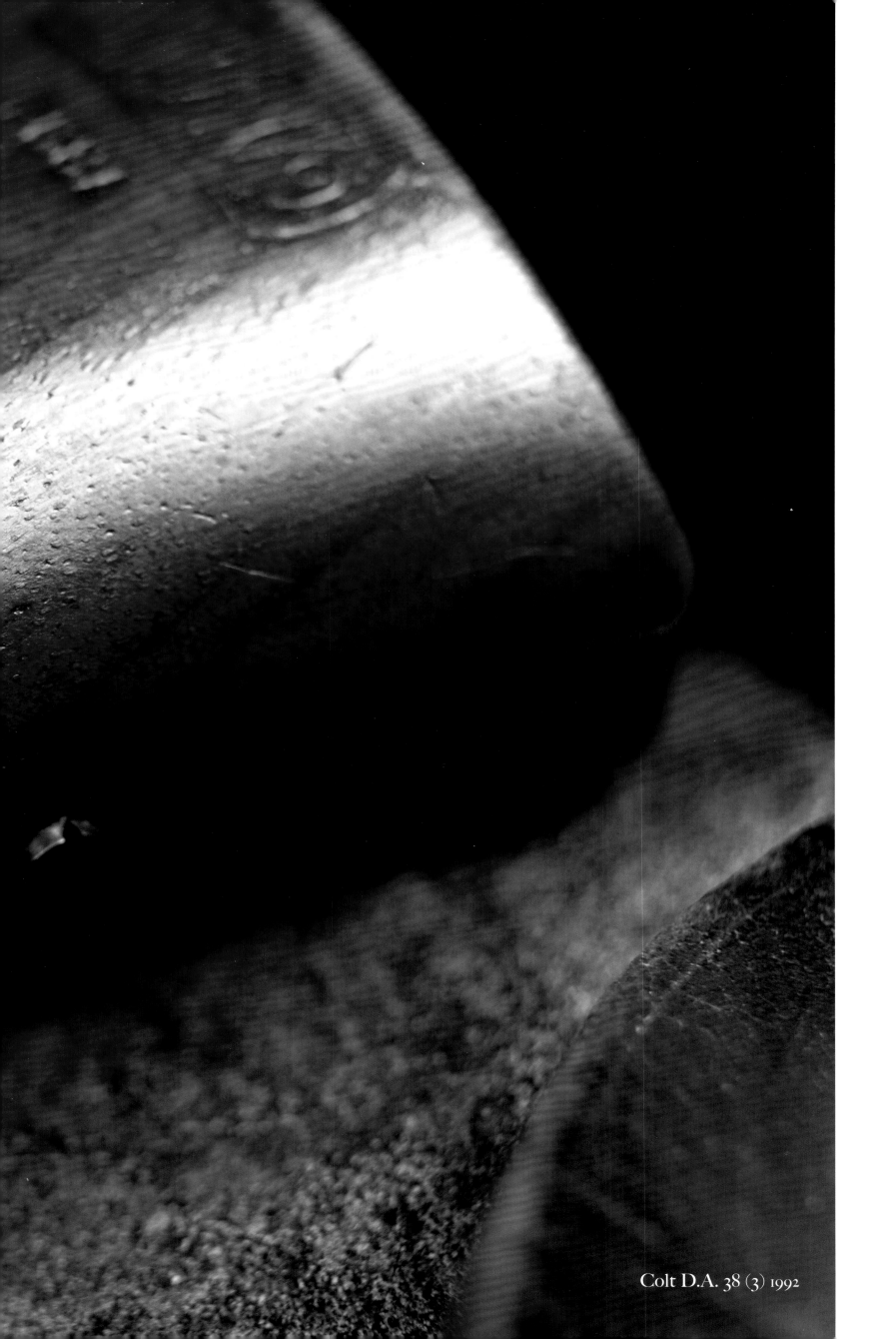

Colt D.A. 38 (3) 1992

PAT. Nº 3,803,741
DATE APR. 16, 1974

Virginian Dragoon .44 Magnum (4) 1992

Colt D.A. 45 1992

Colt D.A. 45 (3) 1992

Ruger .22 Long Rifle Mark II Target (2) 1992

NOMADS

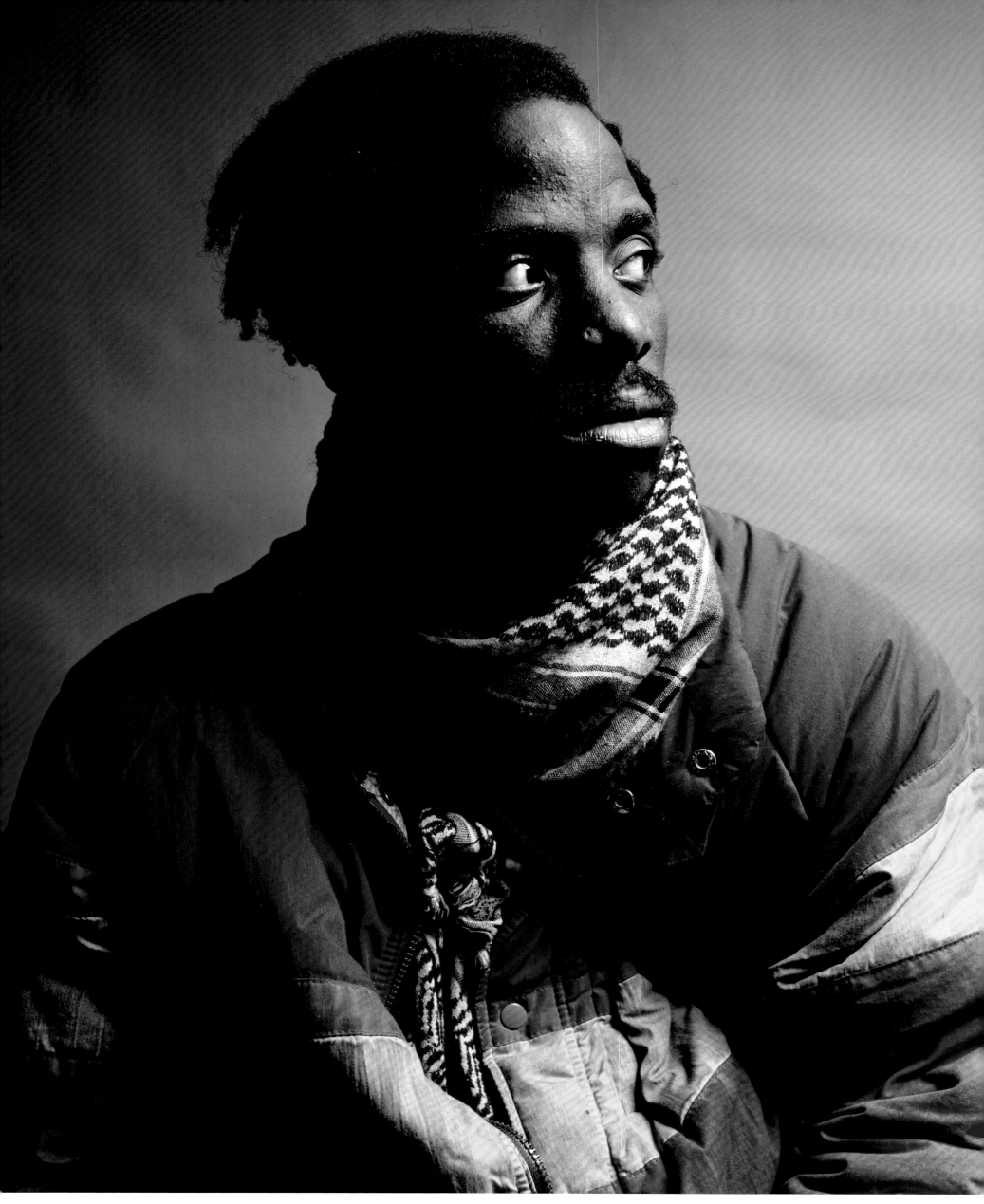

Rene
1990

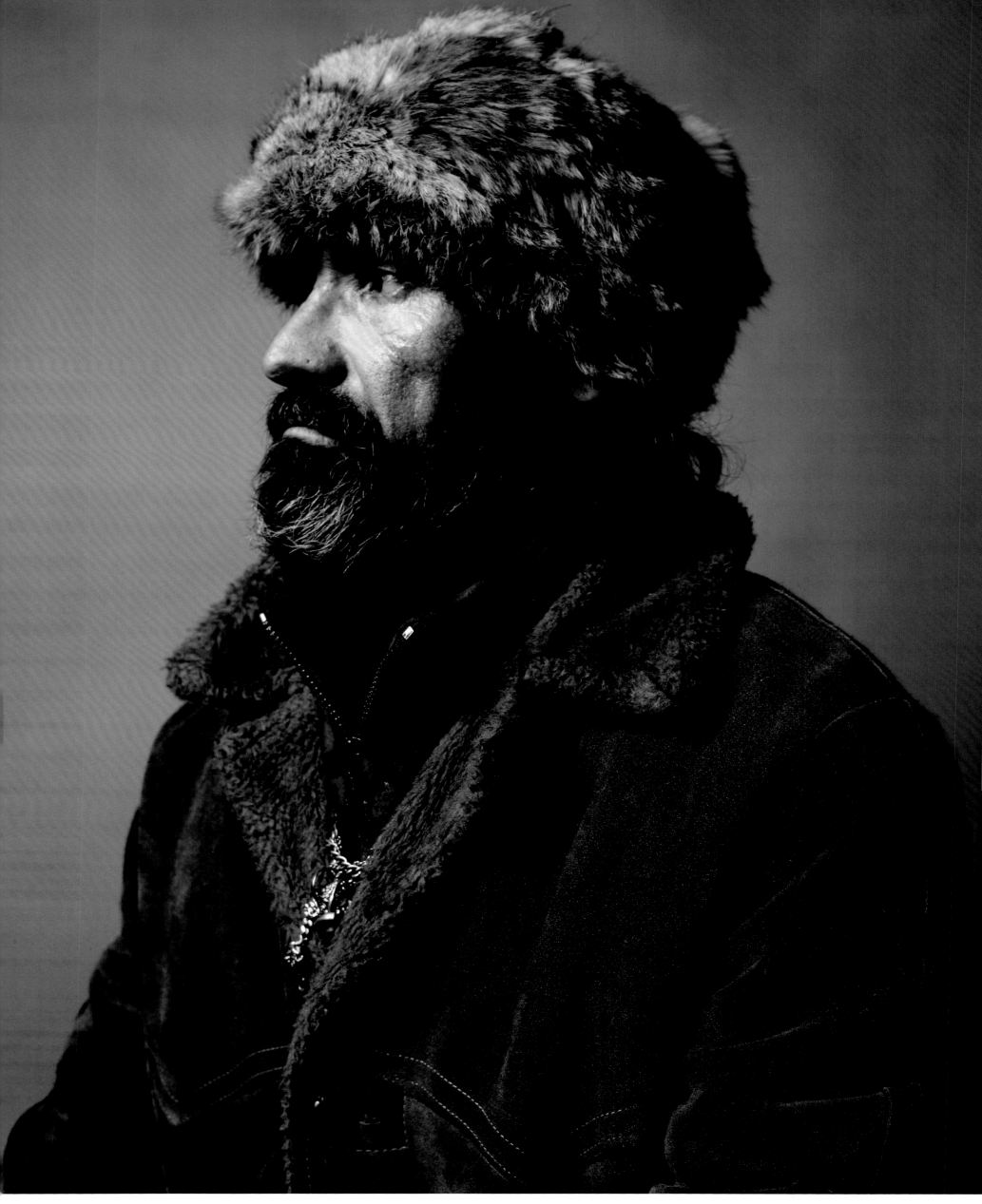

Johnny
1990

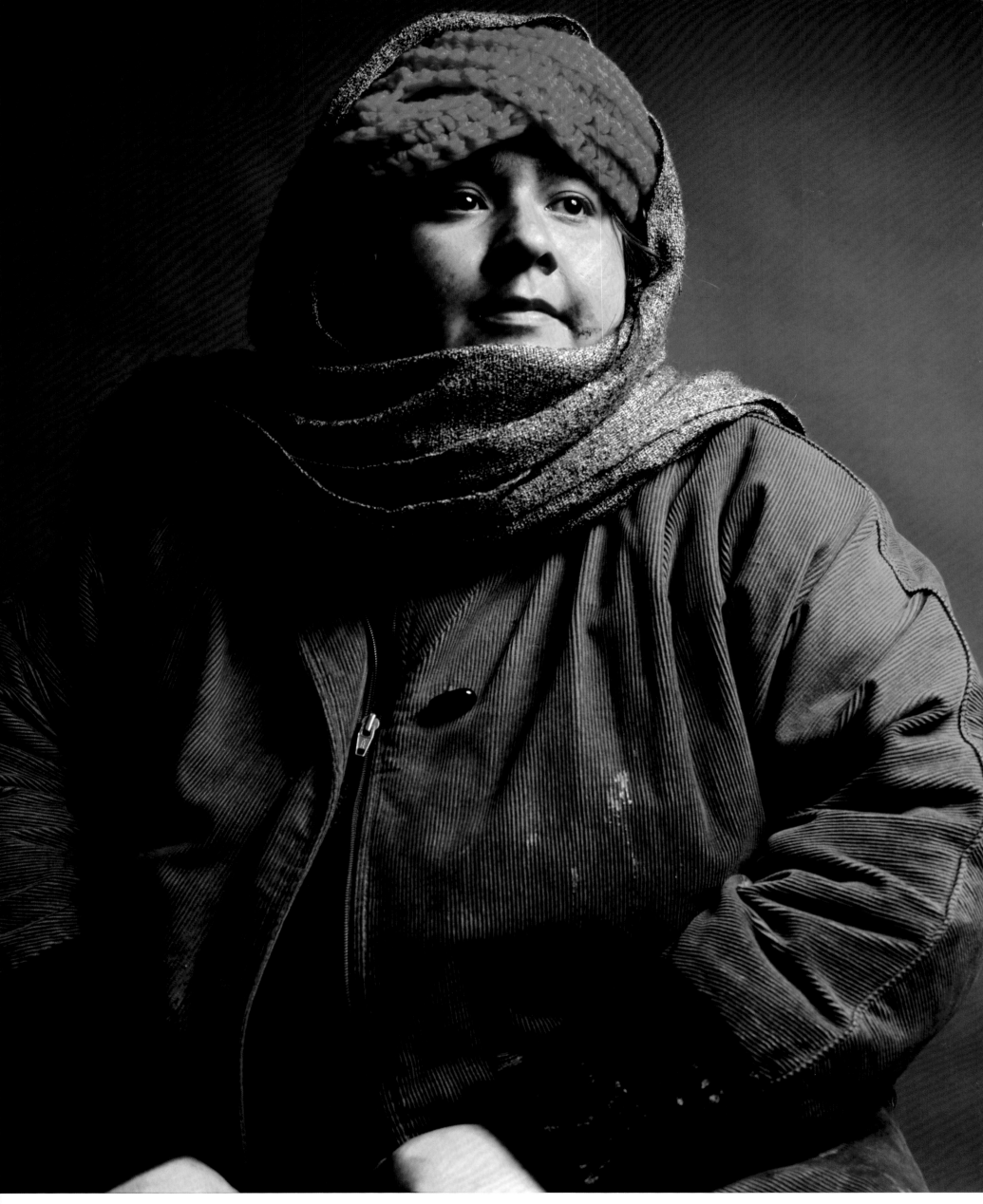

Bertha
1990

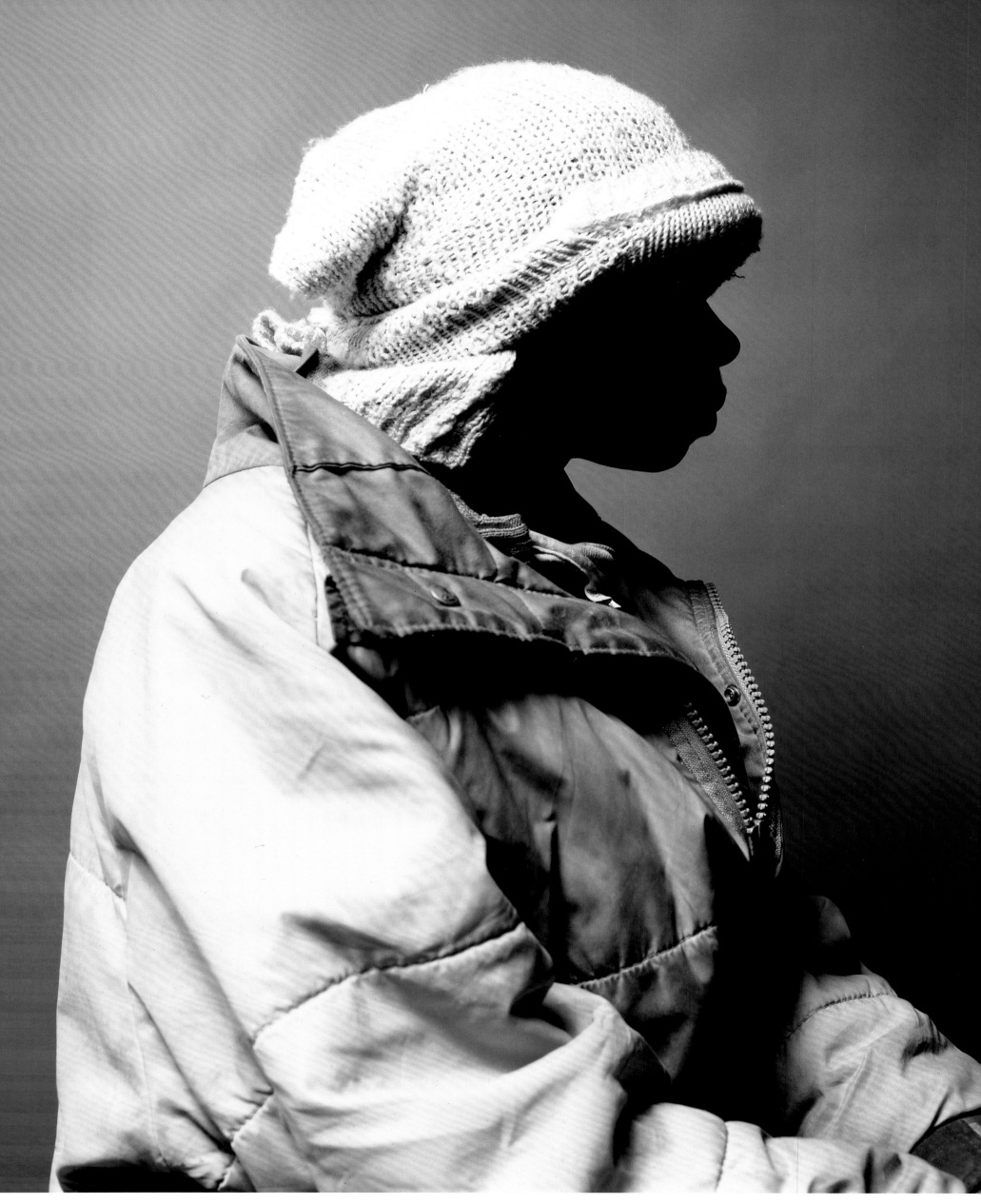

Payne
1990

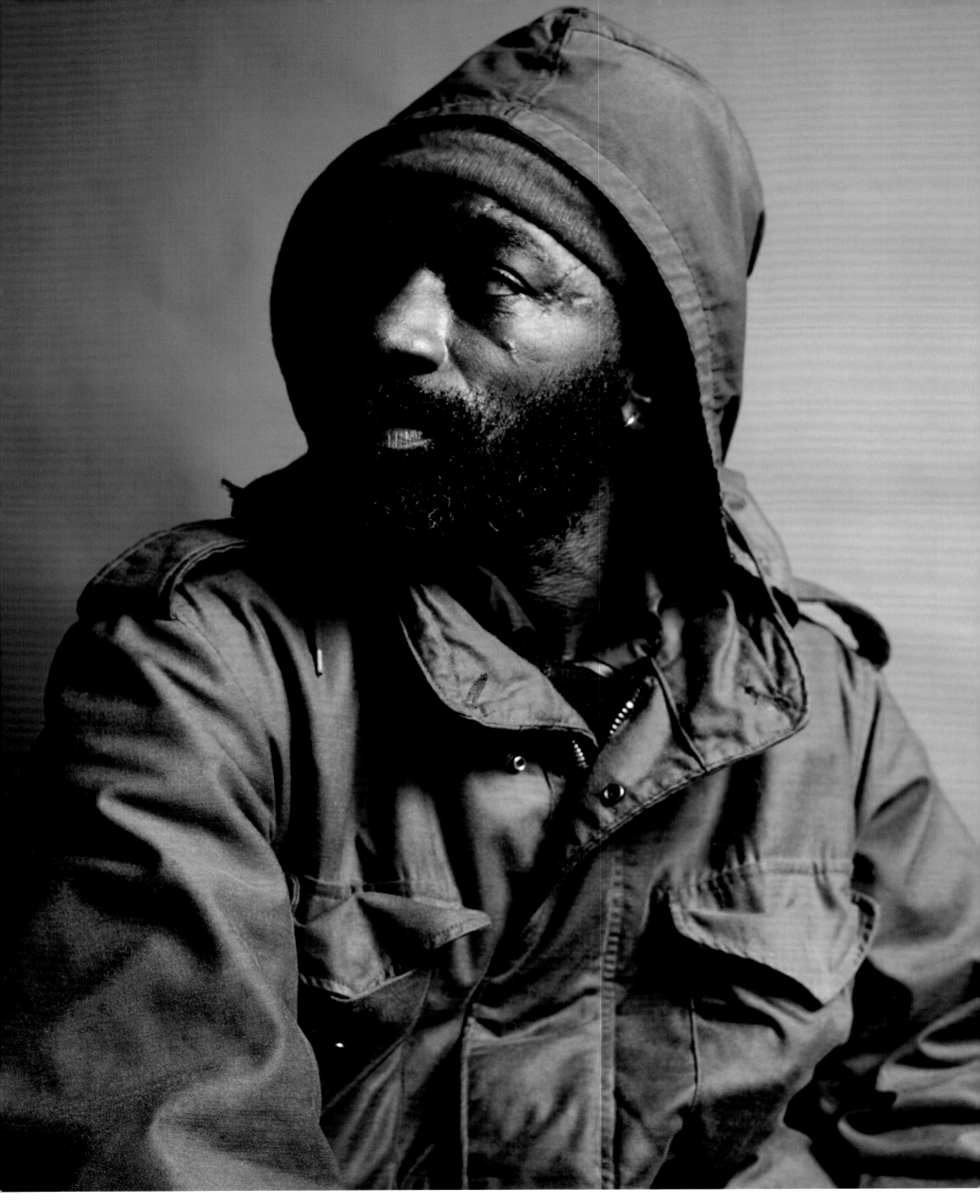

Jerome
1990

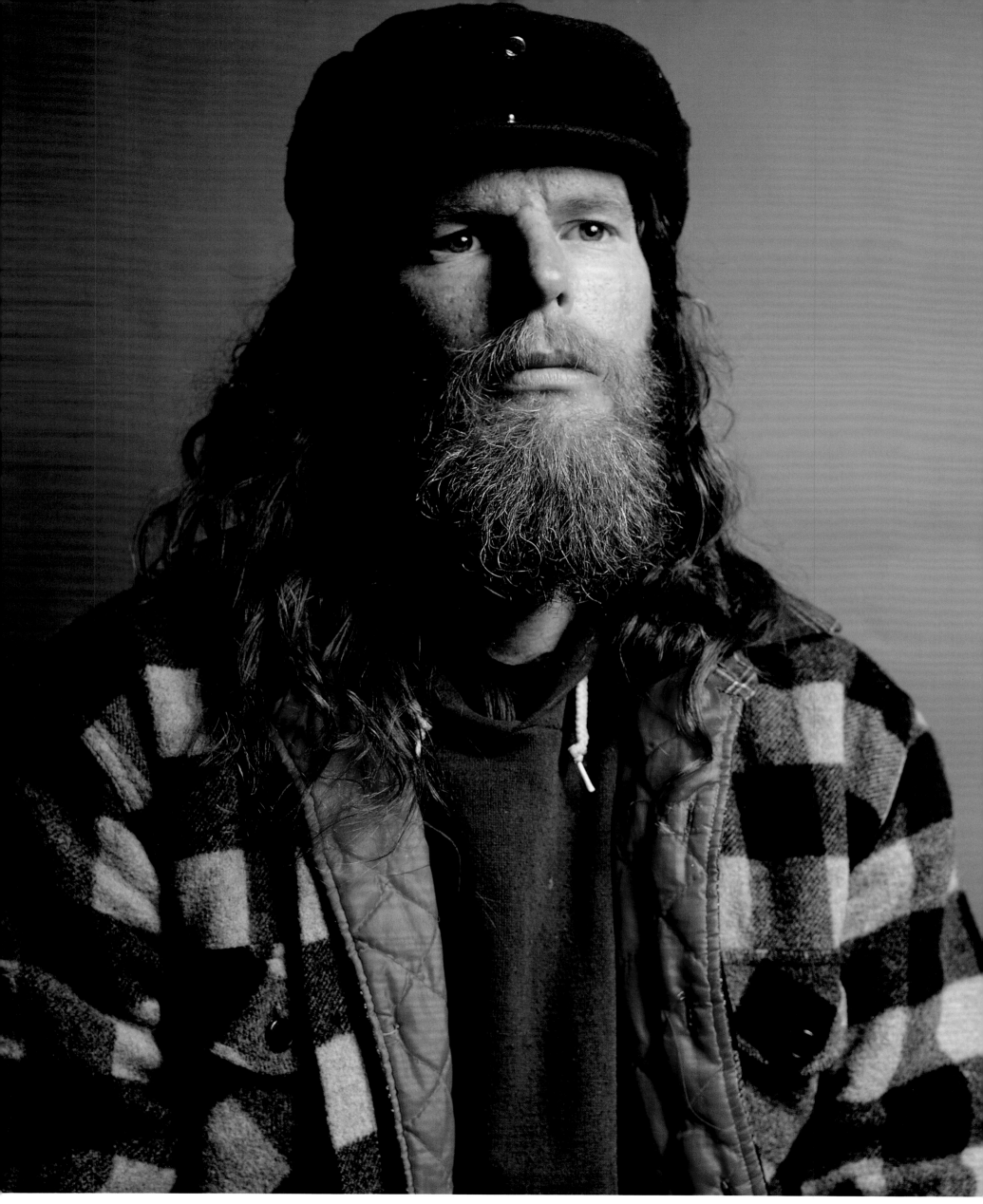

Kirk
1990

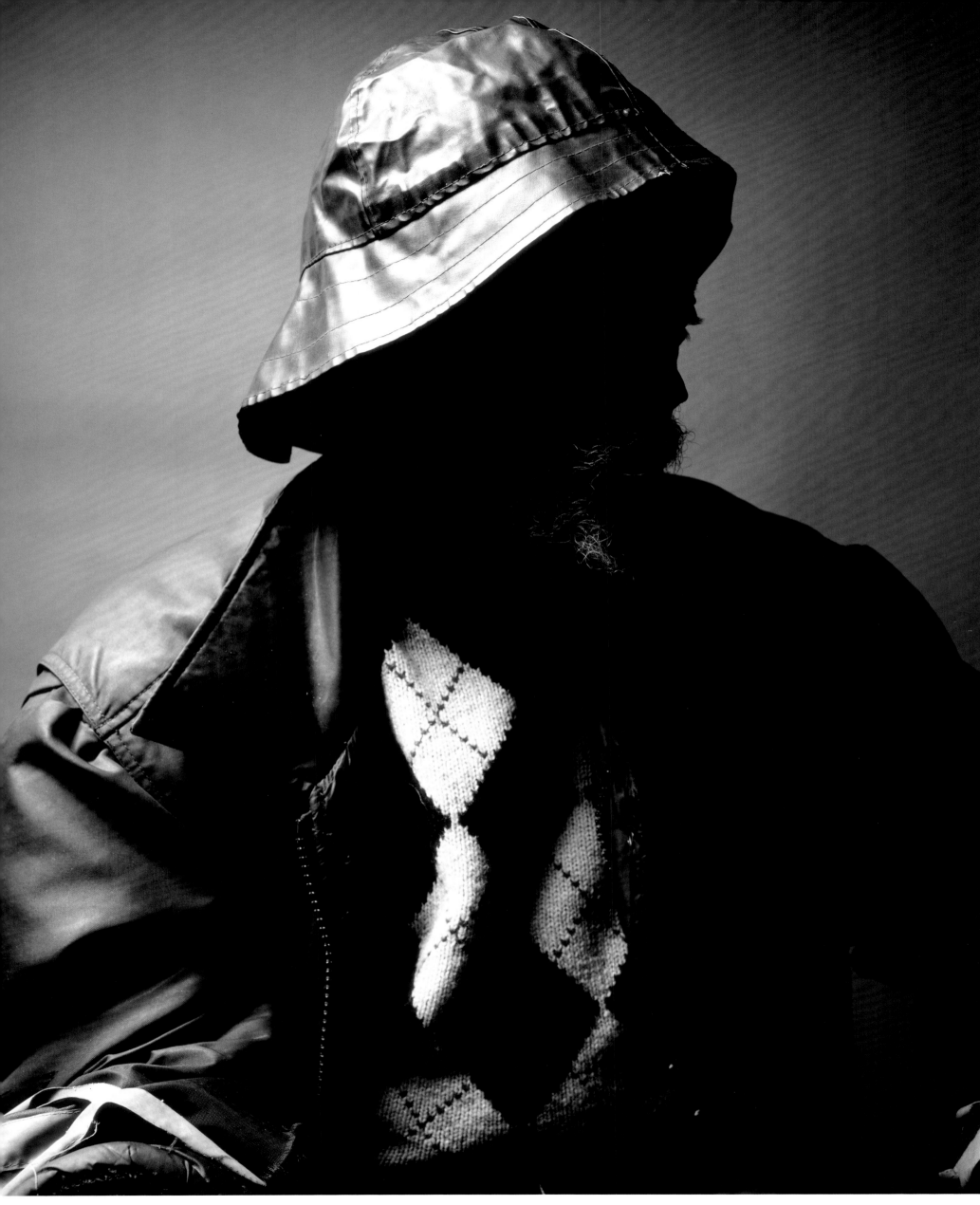

McKinley
1990

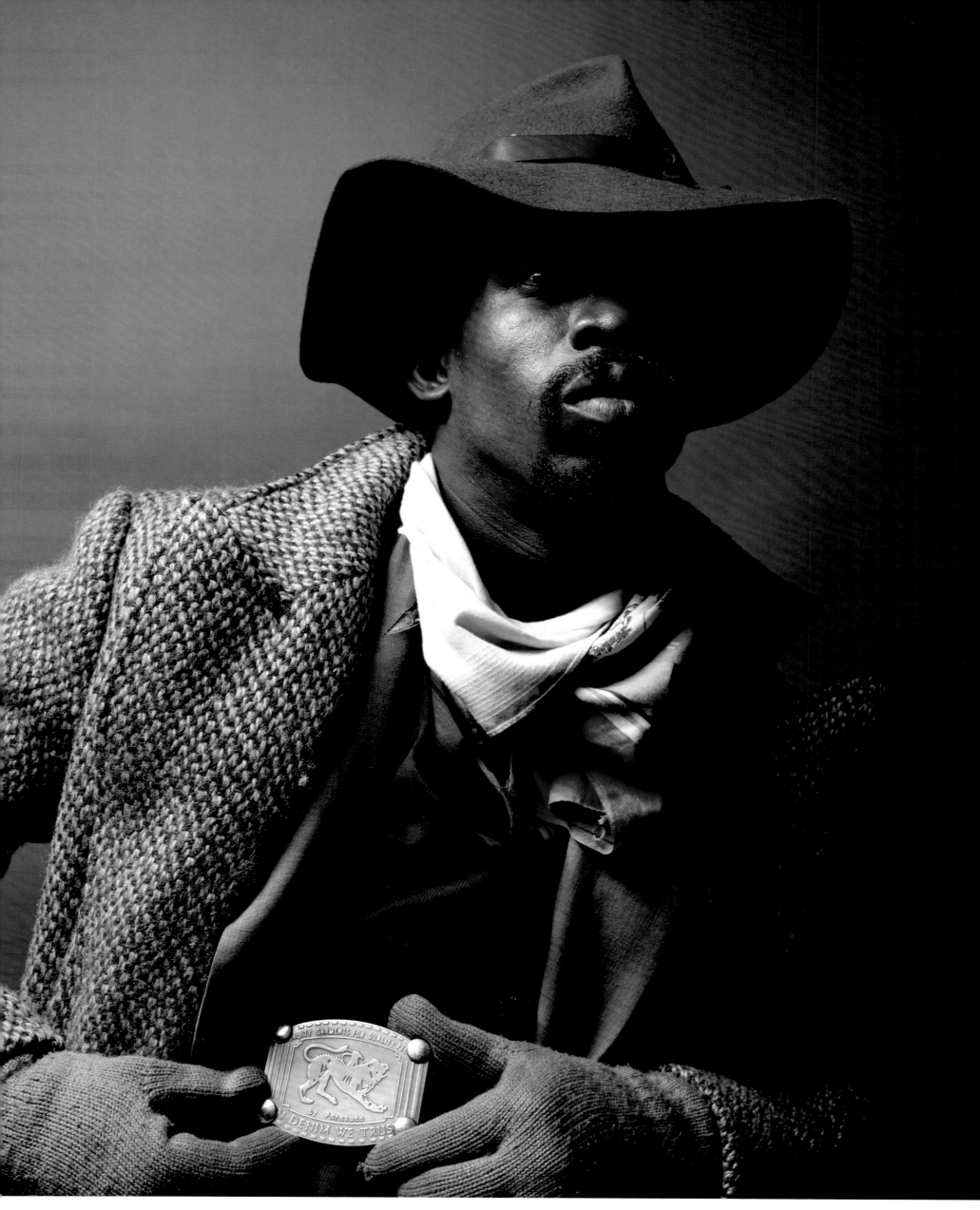

Sir Leonard
1990

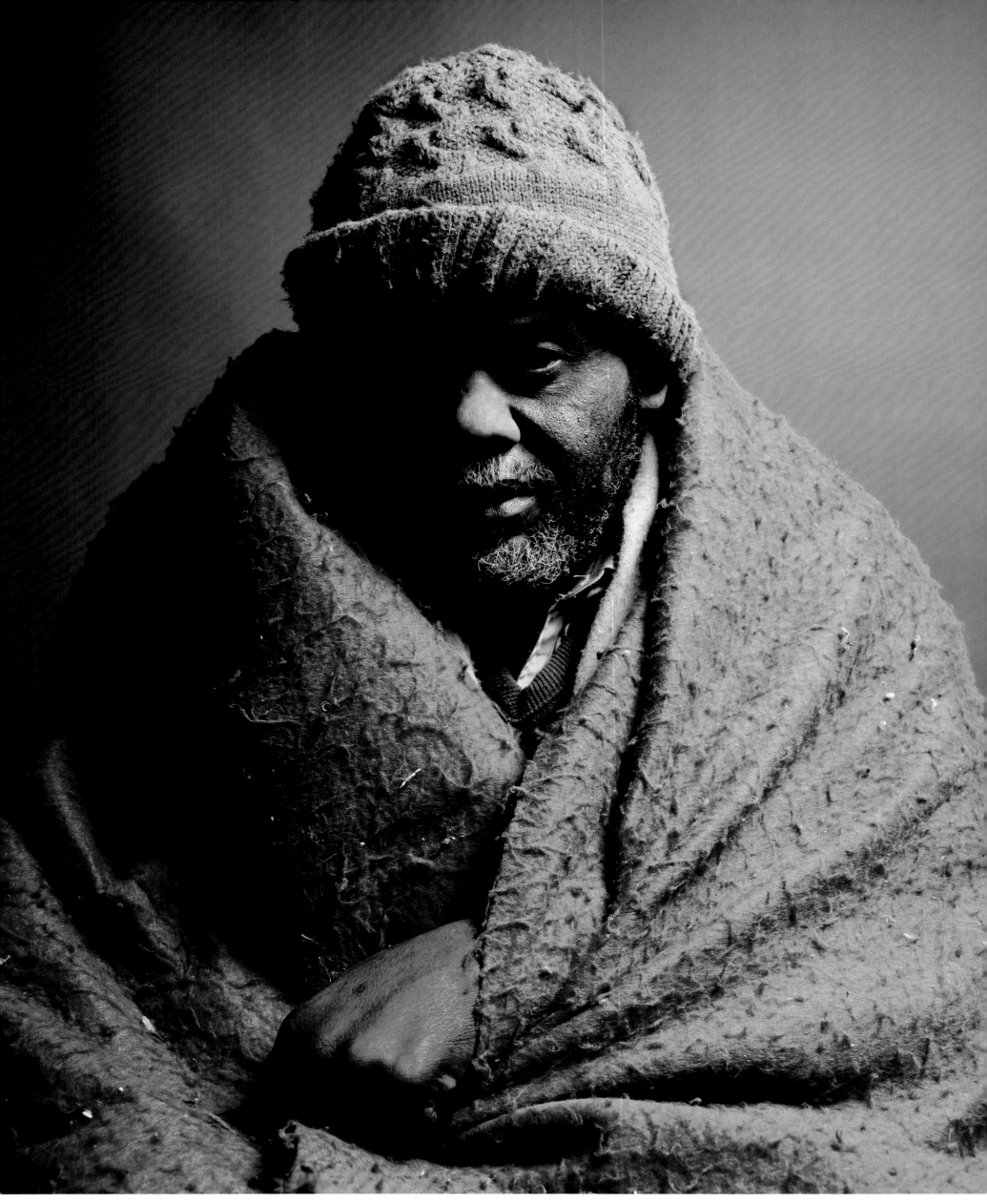

Roosevelt

1990

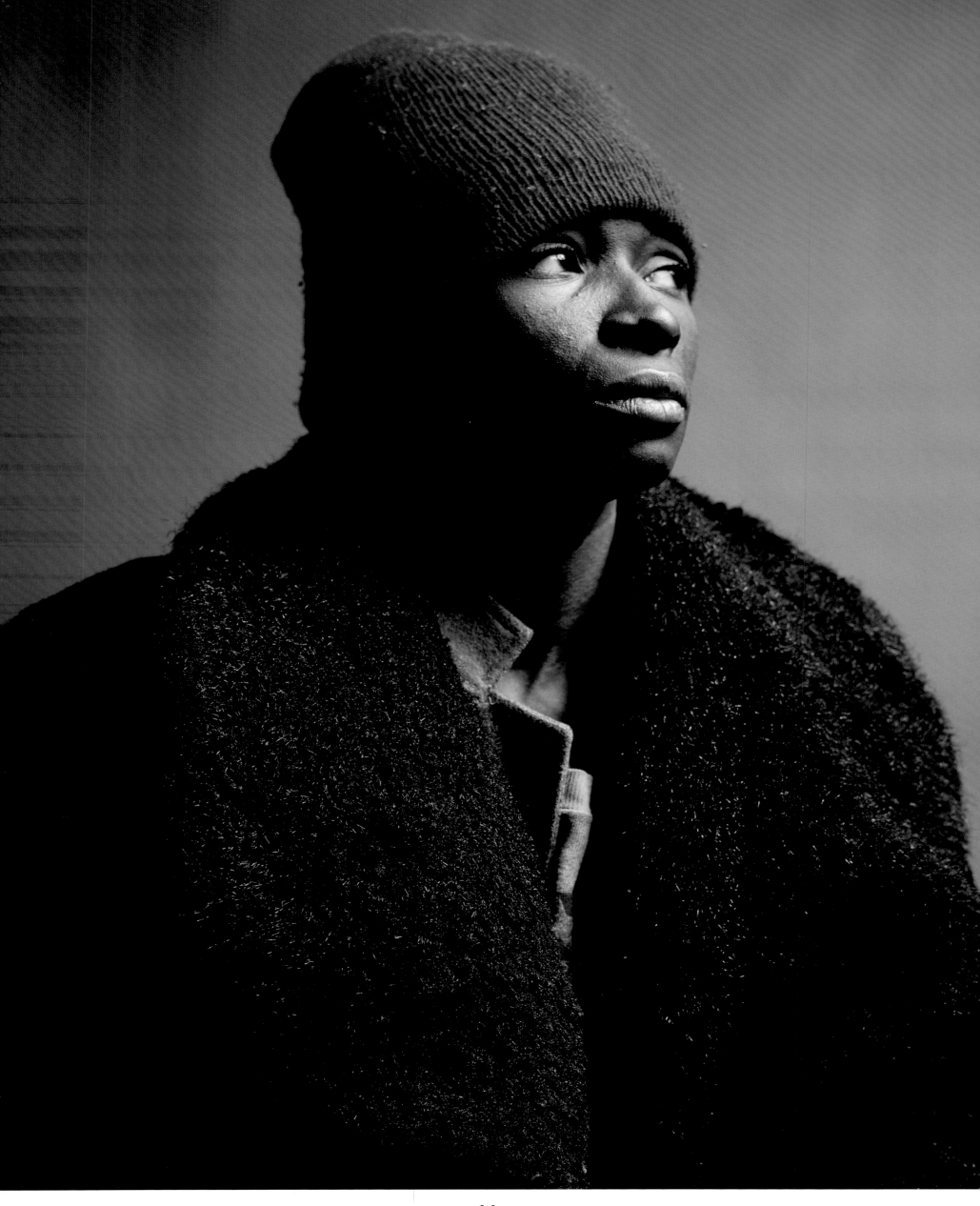

Mary
1990

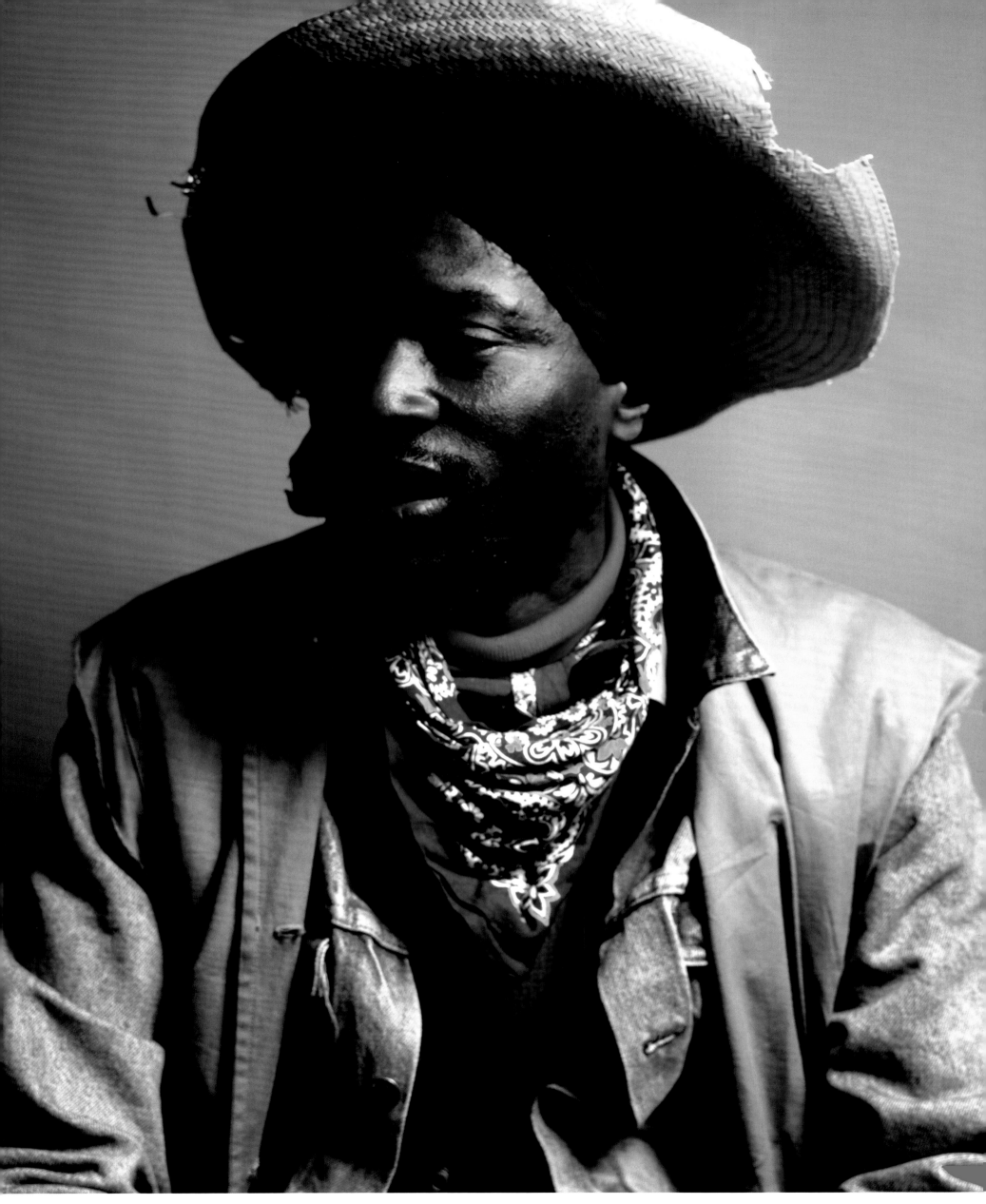

Curtis
1990

THE KLAN

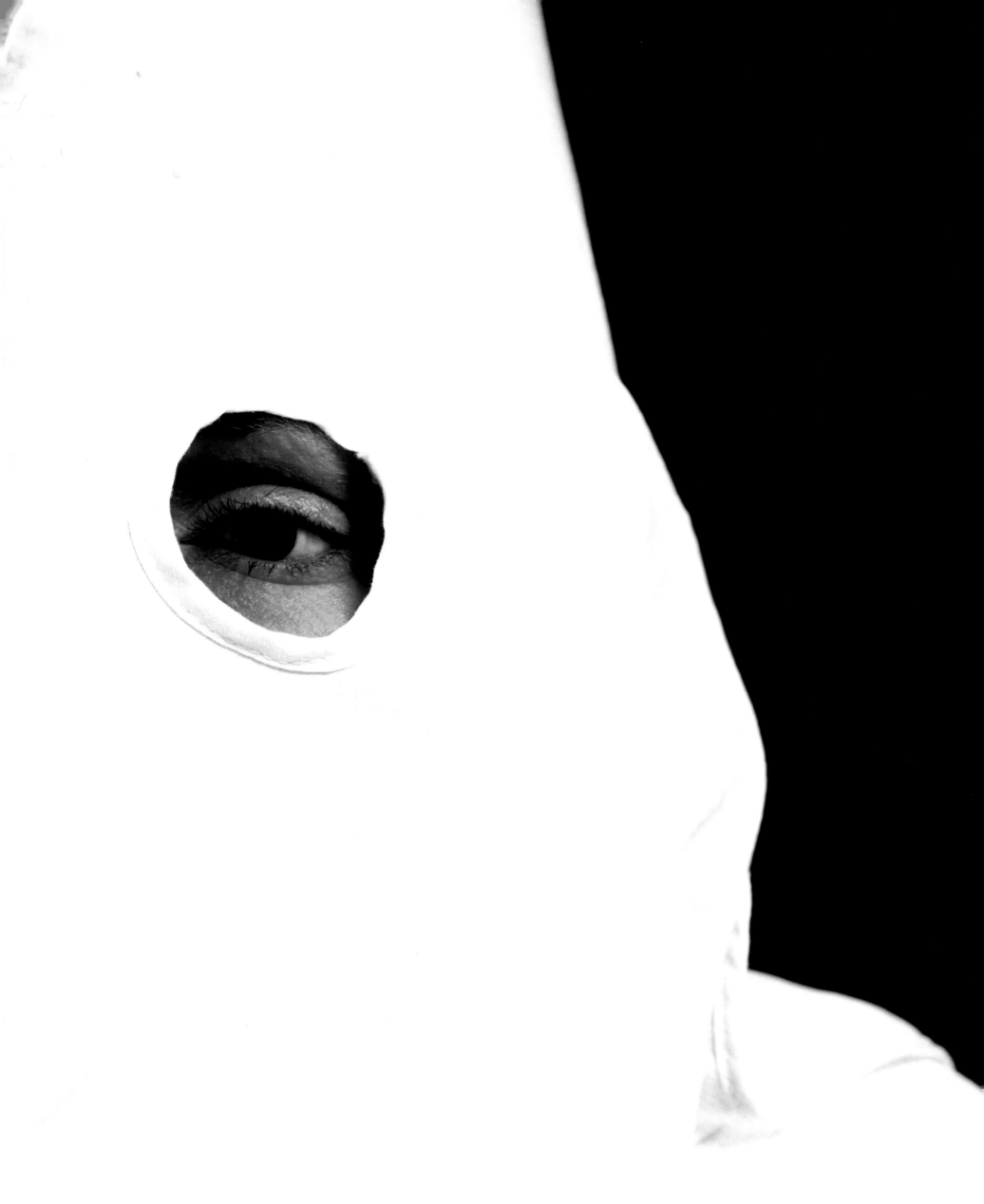

Klanswoman (Grand Klaliff II)
1990

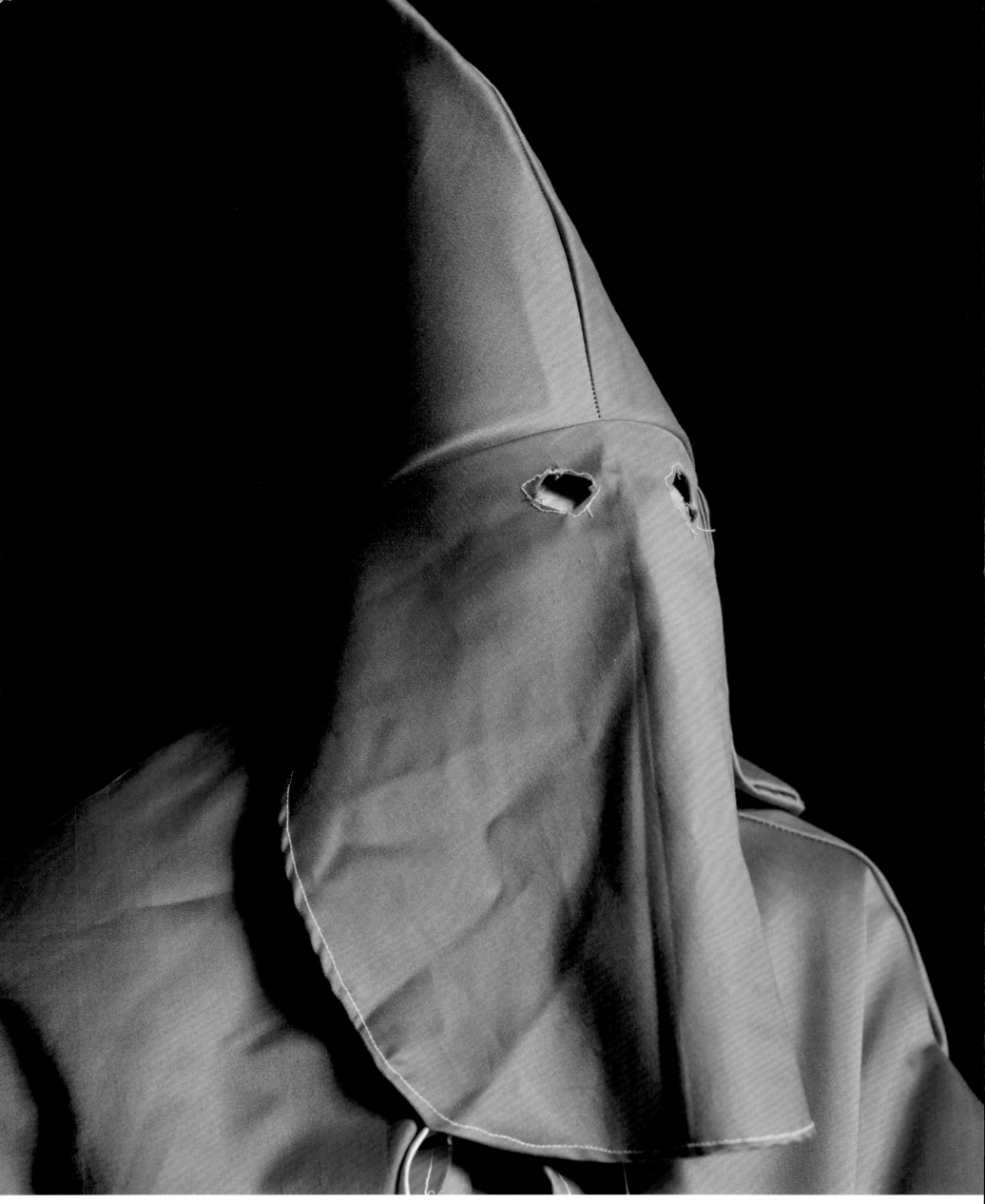

Klansman (Imperial Wizard)
1990

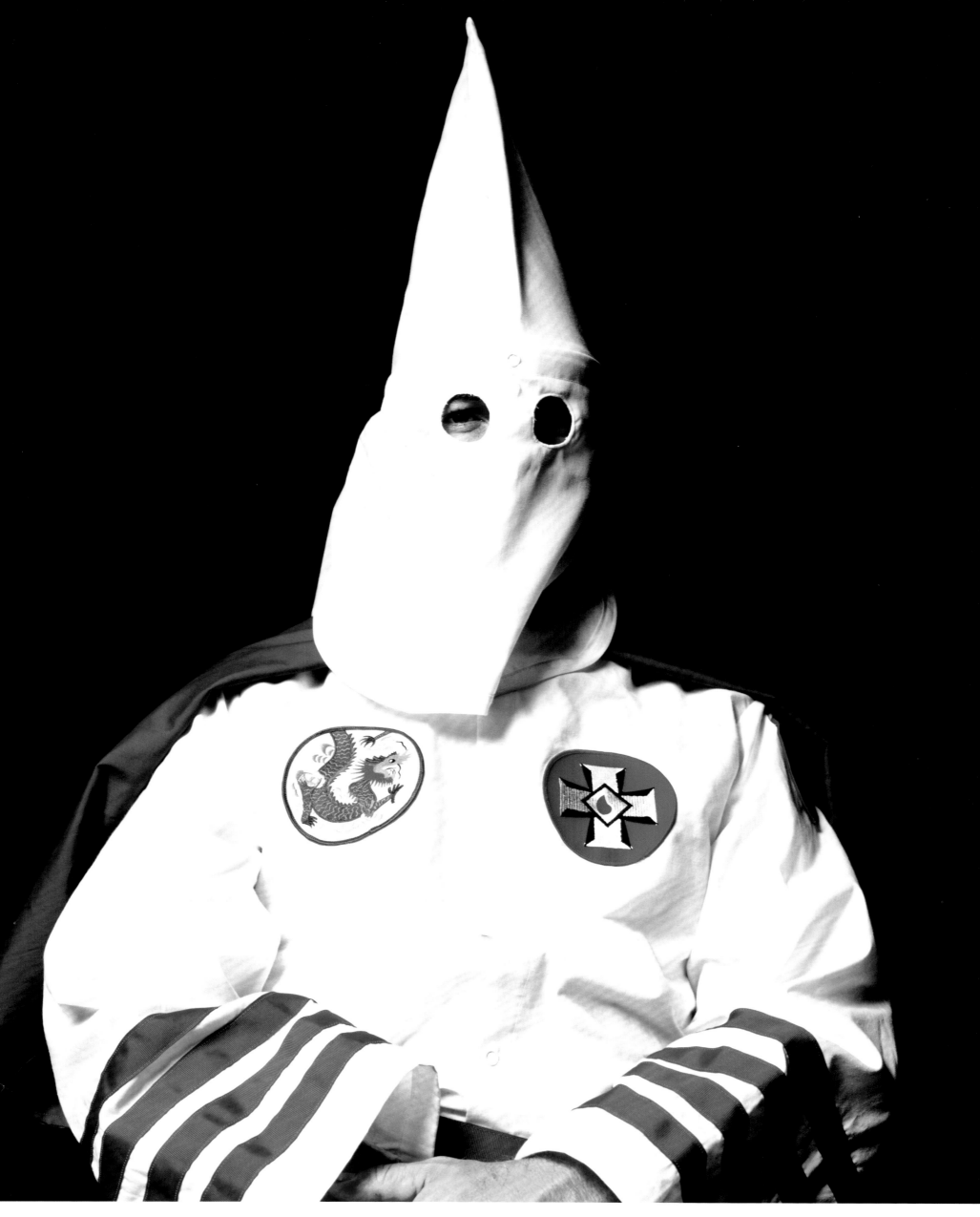

Klansman (Grand Dragon)
1990

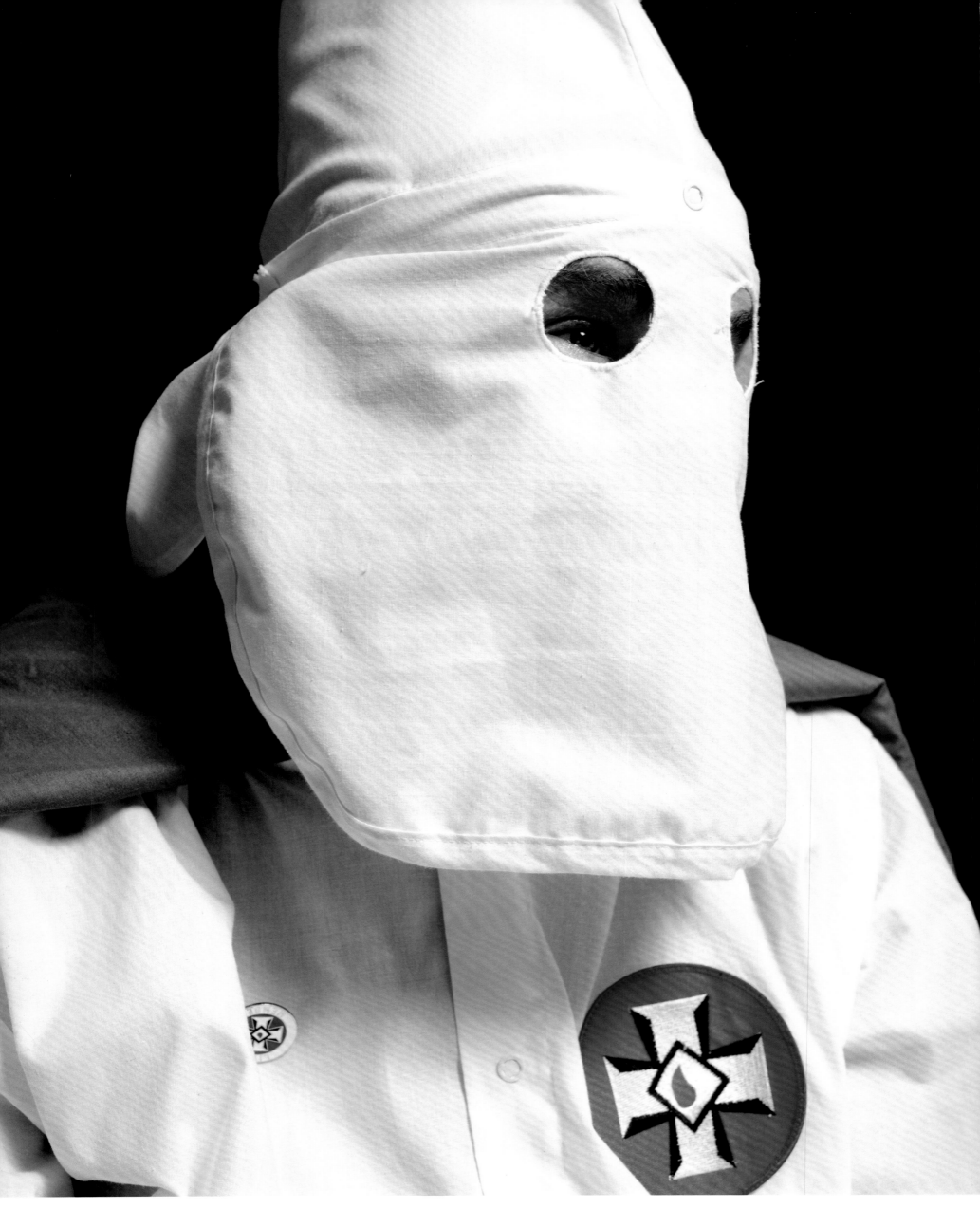

Klansman (Knight Hawk of Georgia II)
1990

Klansman (Knight Hawk of Georgia IV)
1990

Klansman (Wizard III)
1990

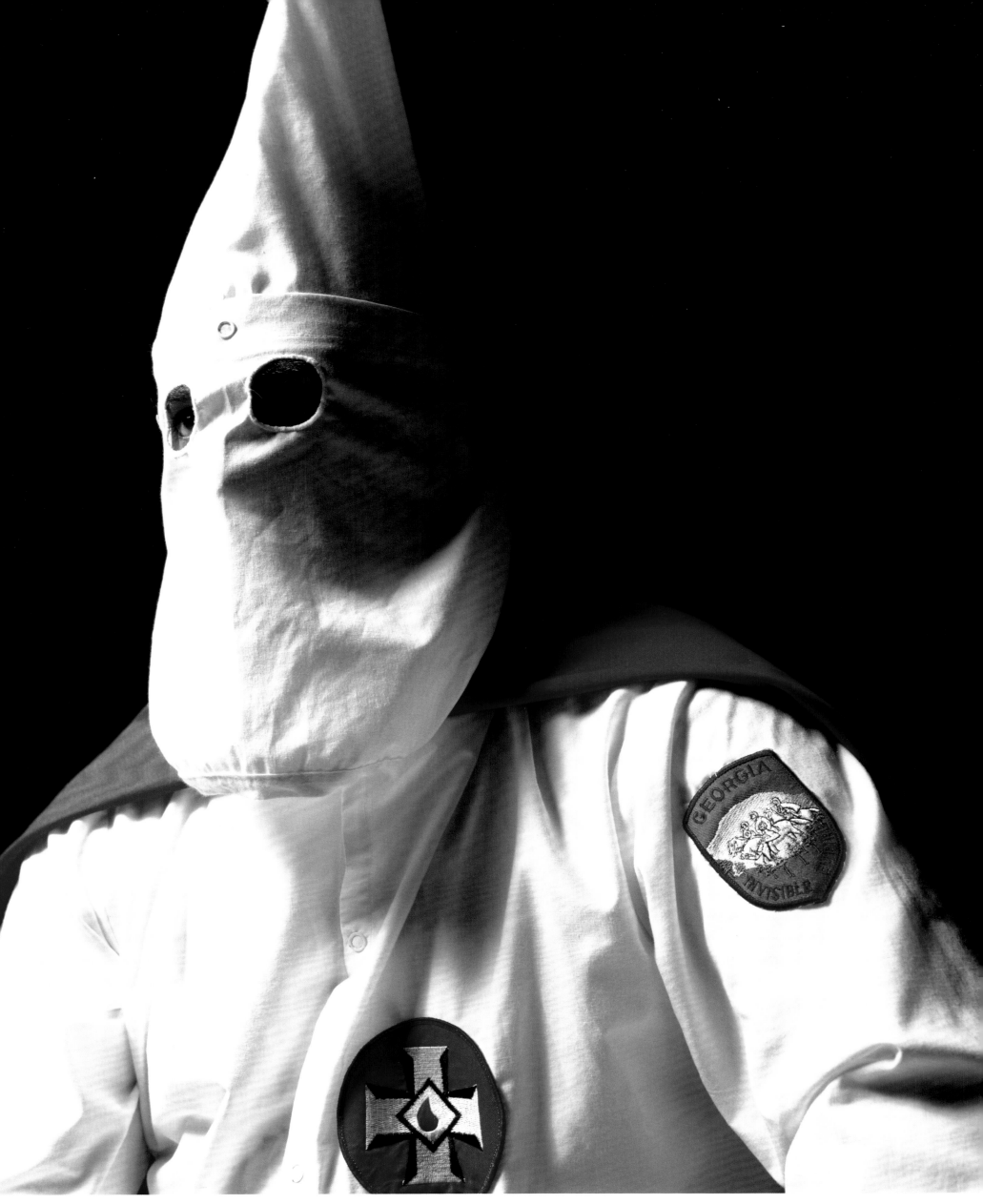

Klansman (Great Titan of the Invisible Empire III)
1990

Klansman (Knight Hawk of Georgia III)
1990

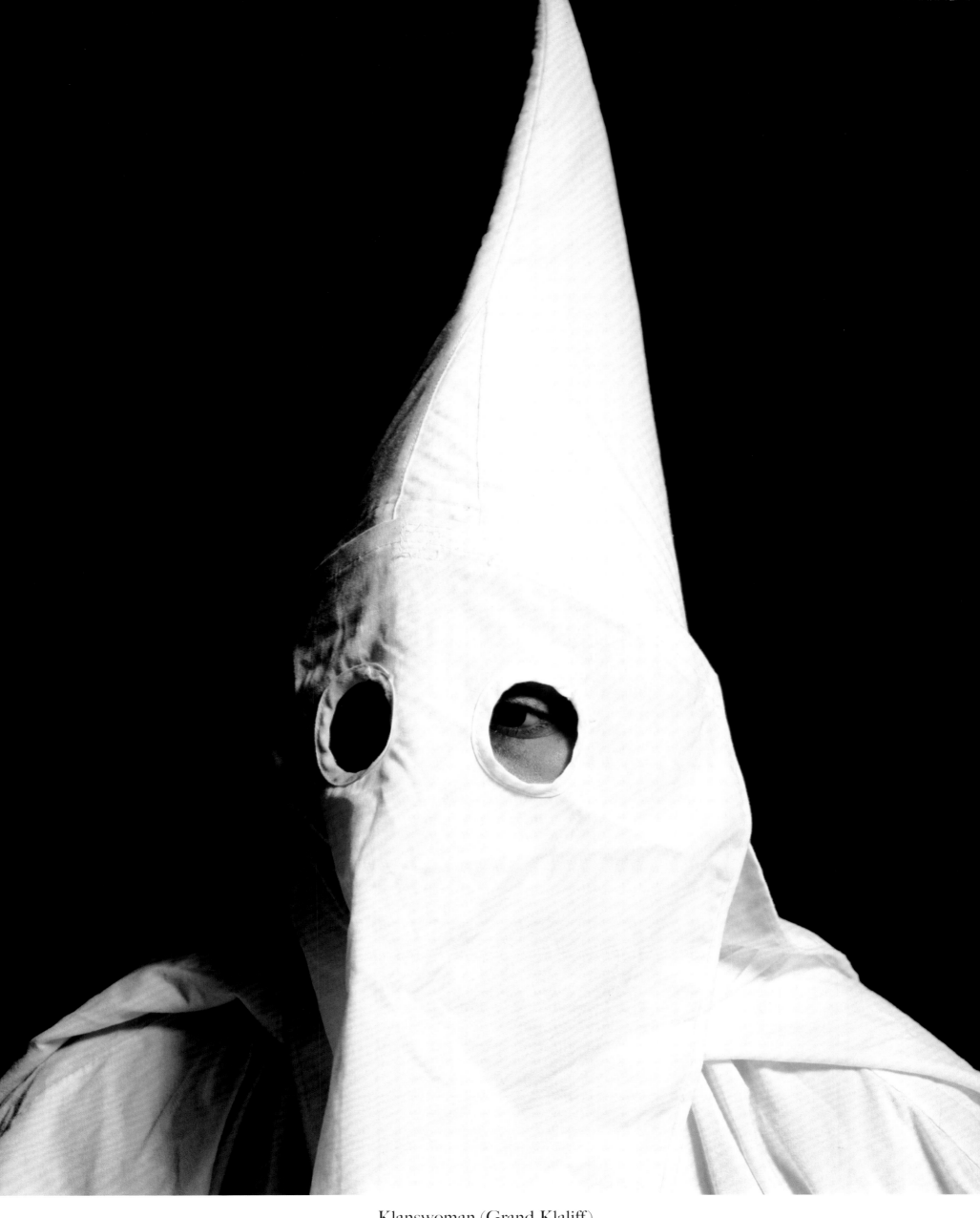

Klanswoman (Grand Klaliff)
1990

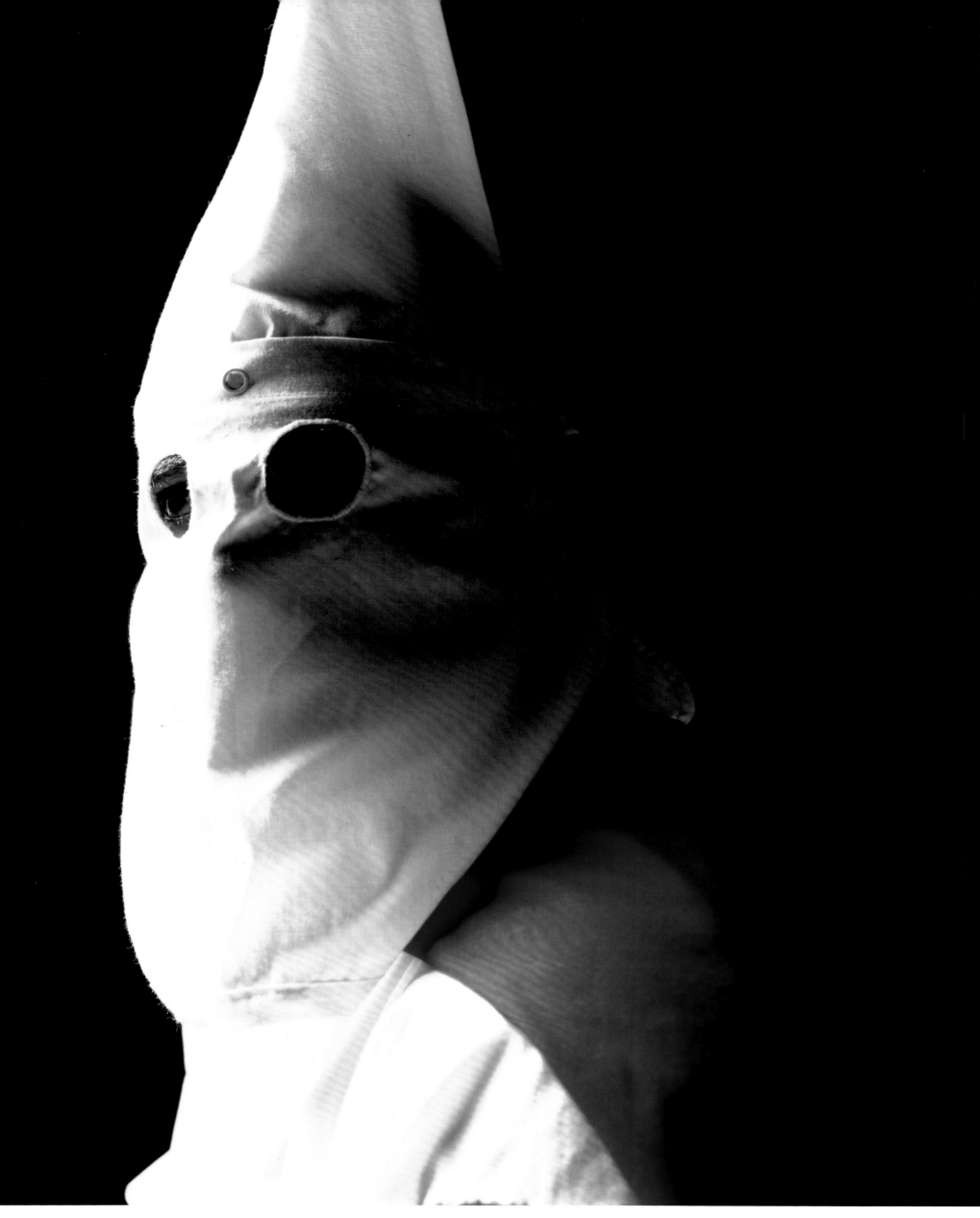

Klansman (Great Titan of the Invisible Empire IV)
1990

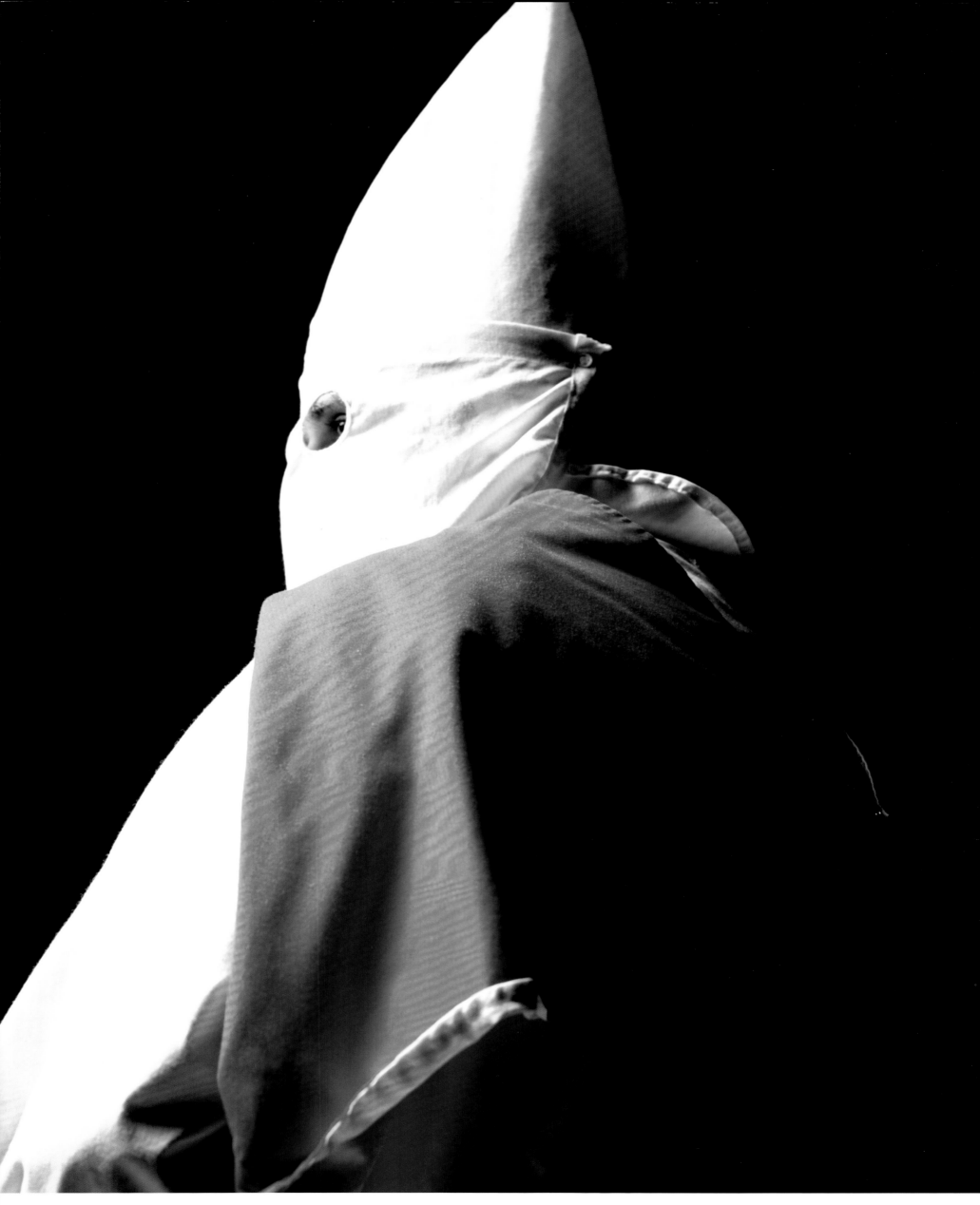

Klansman (Great Titan of the Invisible Empire)
1990

THE CHURCH

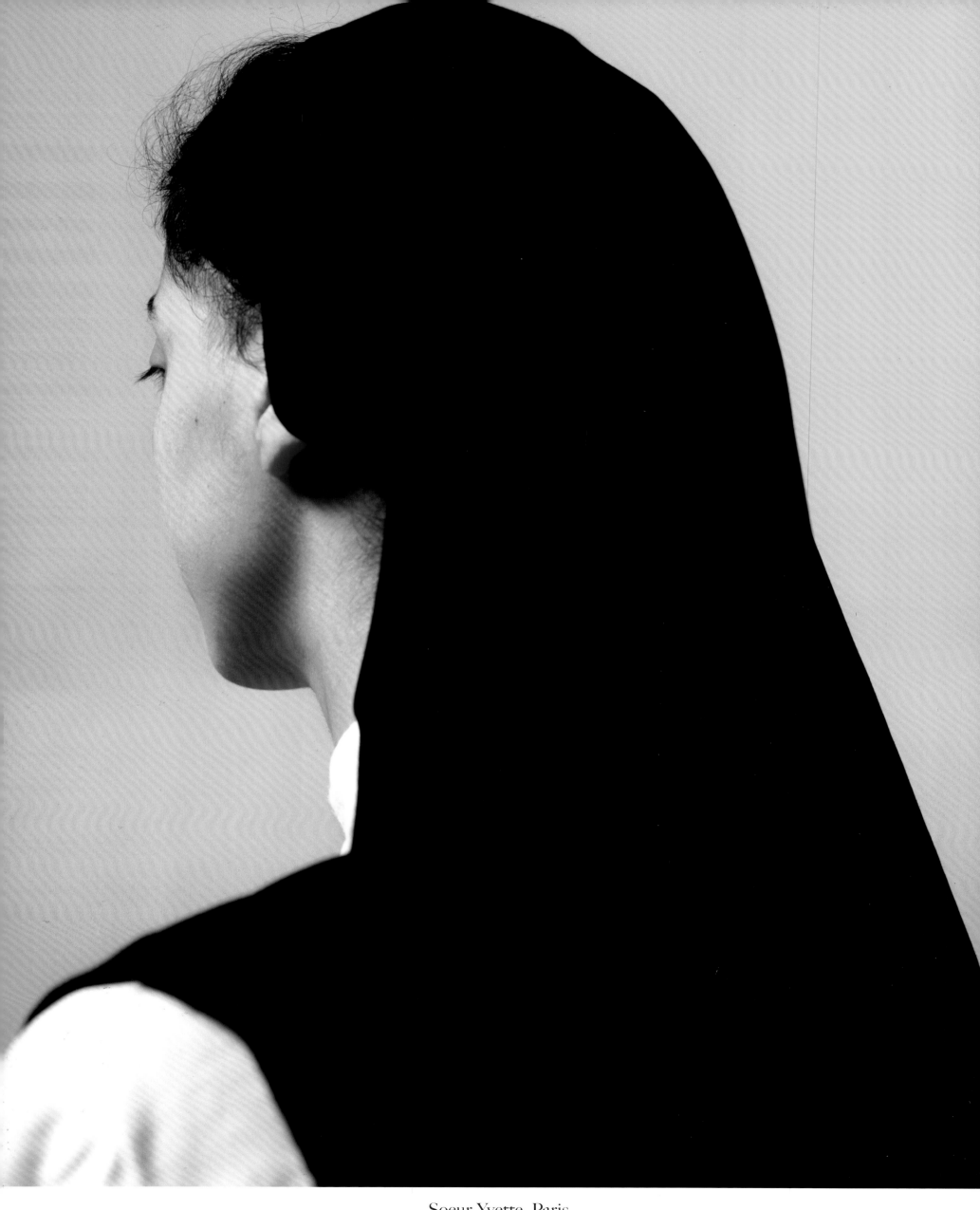

Soeur Yvette, Paris
1991

St. Clotilde II, Paris
1991

Saint Sulpice V, Paris
1991

St. Clotilde, Paris
1991

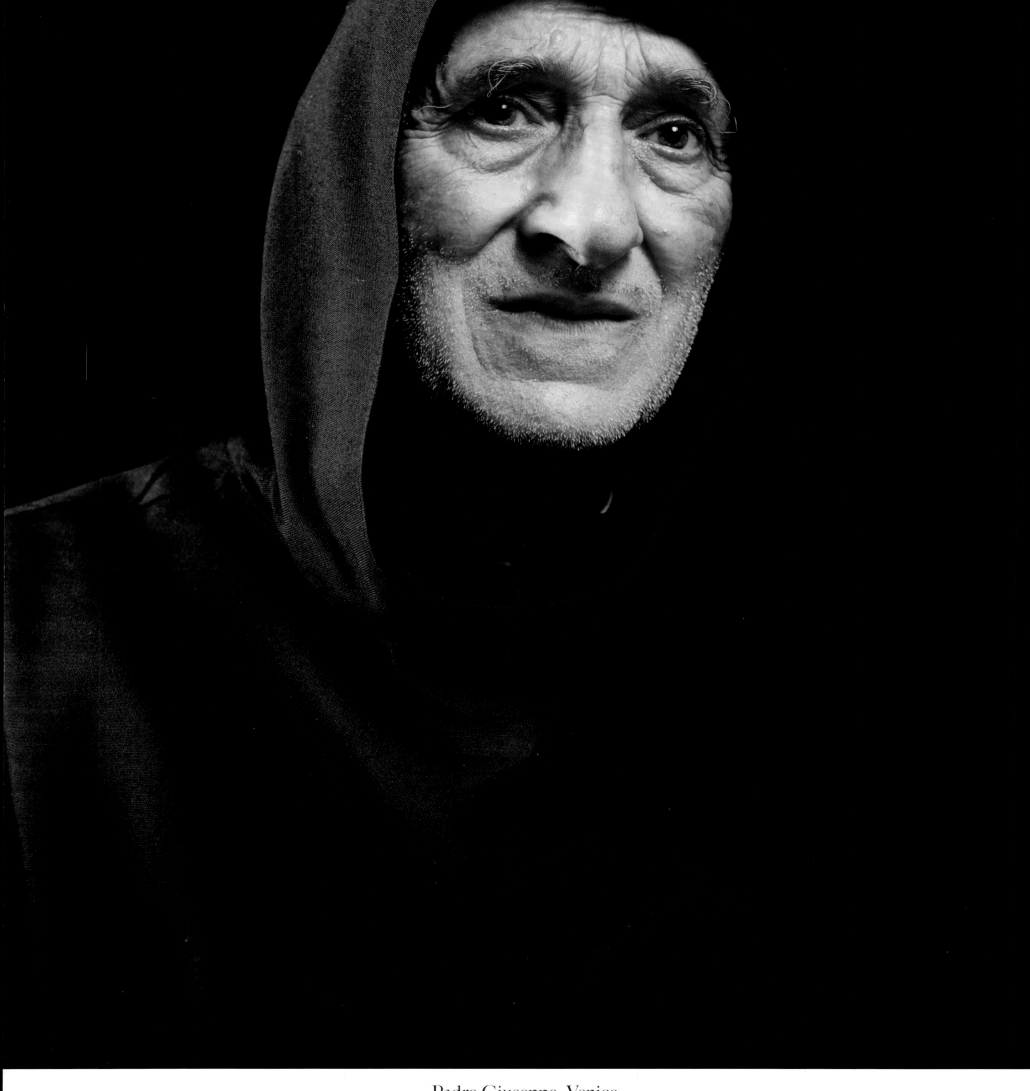

Padre Giuseppe, Venice
1991

Saint Eustache II, Paris
1991

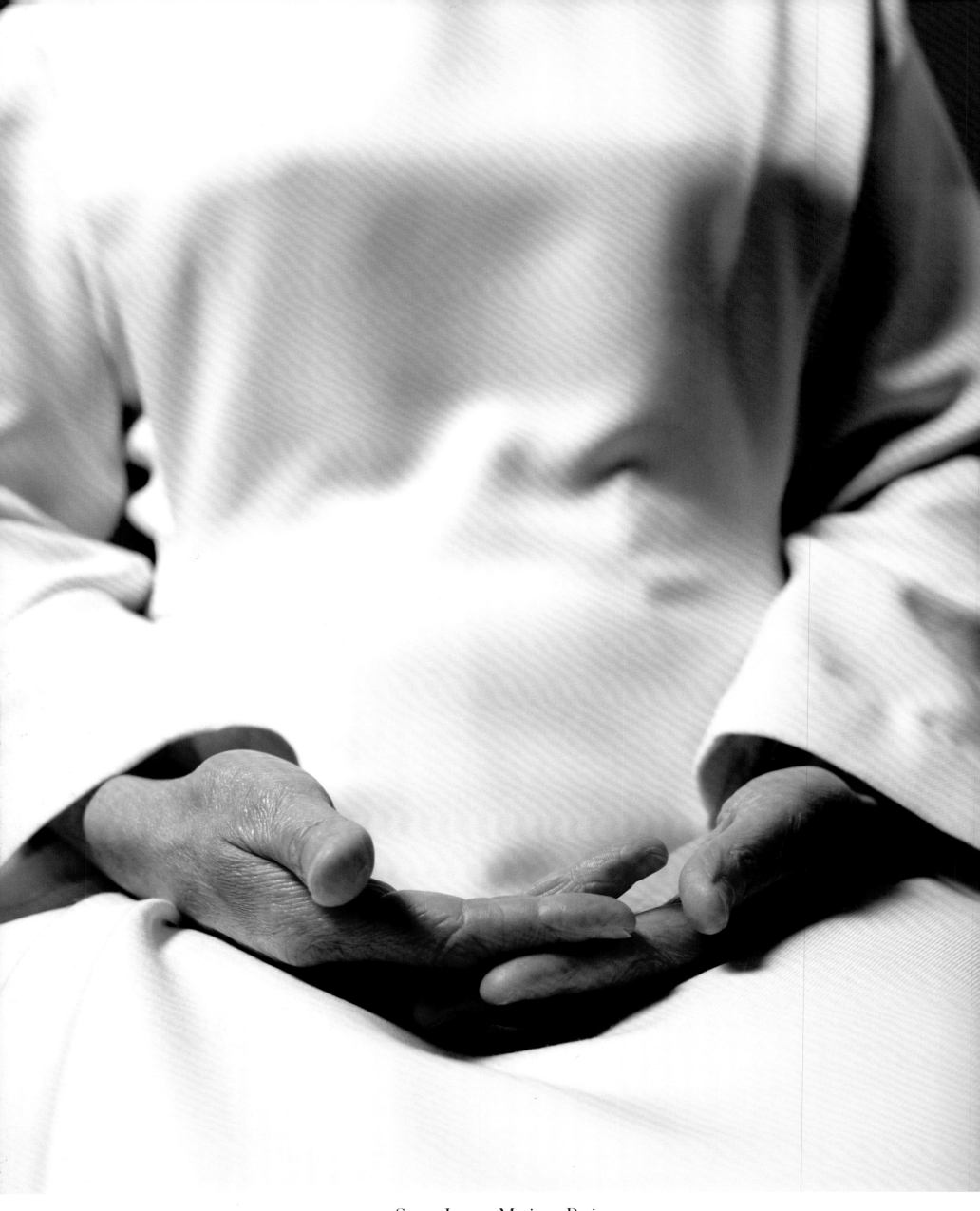

Soeur Jeanne Myriam, Paris
1991

Saint-Paul-Saint-Louis, Paris
1991

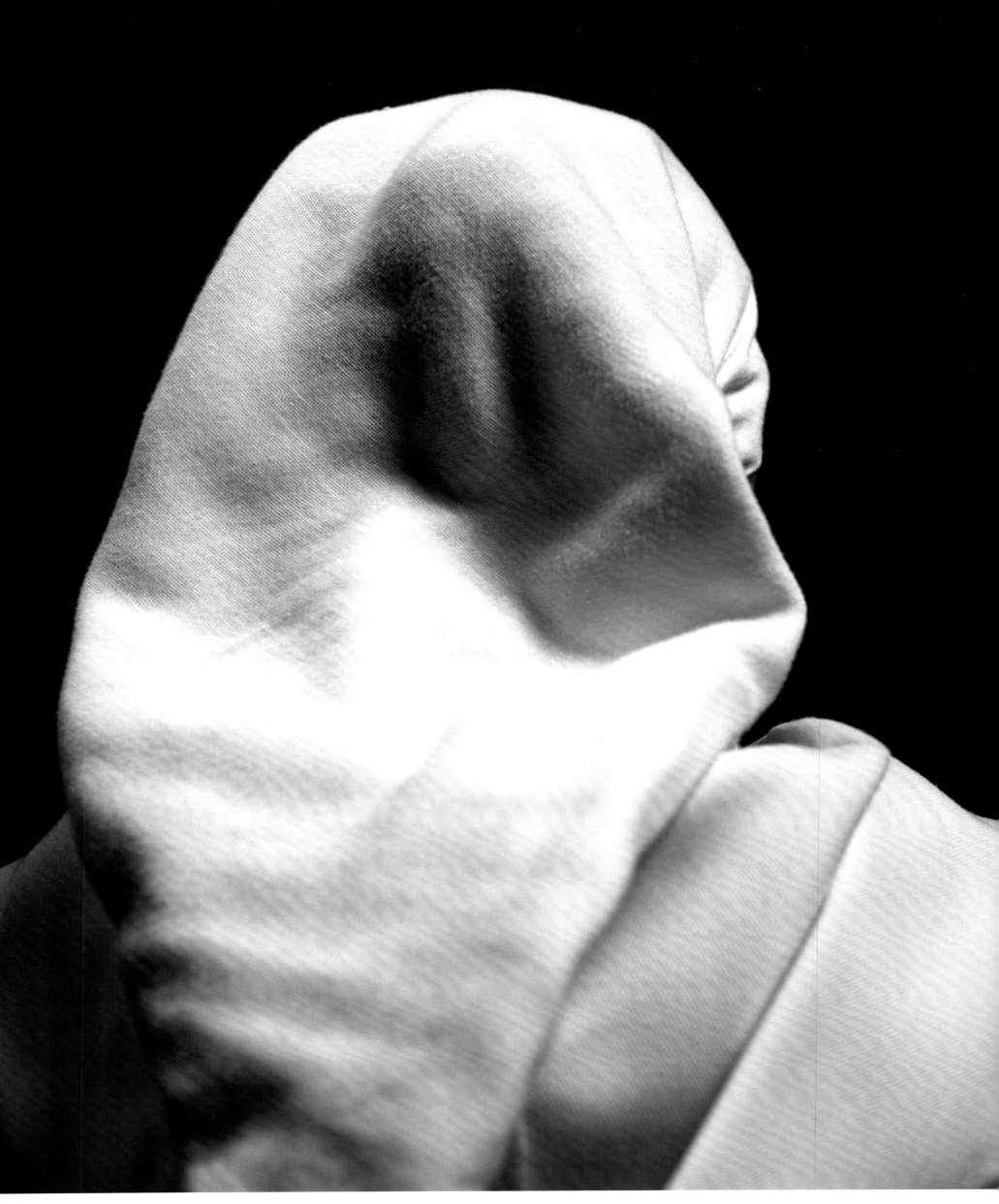

Soeur Rosalba, Paris
1991

Santa Maria del Rosario Gesuatti, Venice
1991

Monseigneur Jacques, Bishop of Chartres
1991

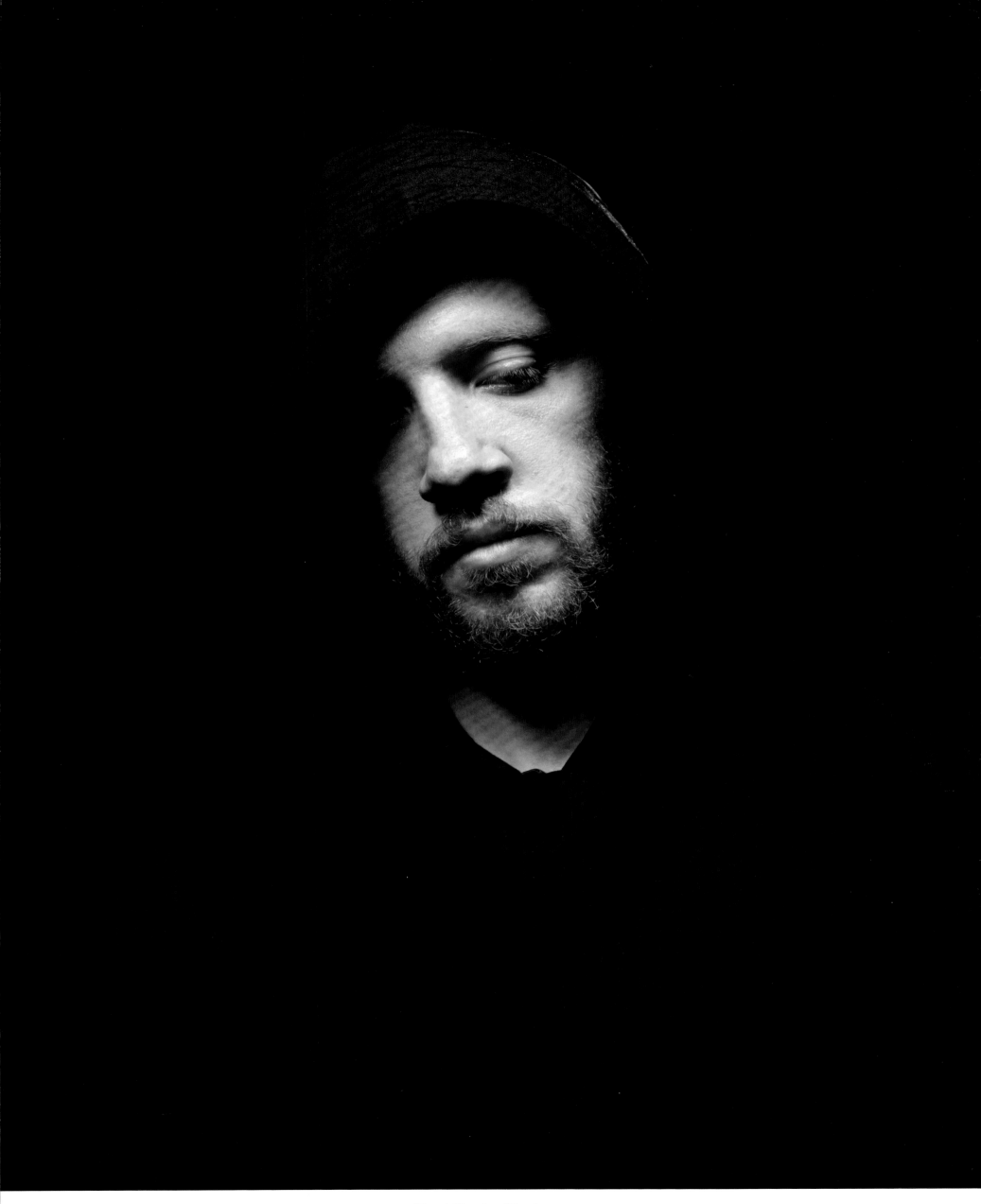

Frari Paolo, Venice
1991

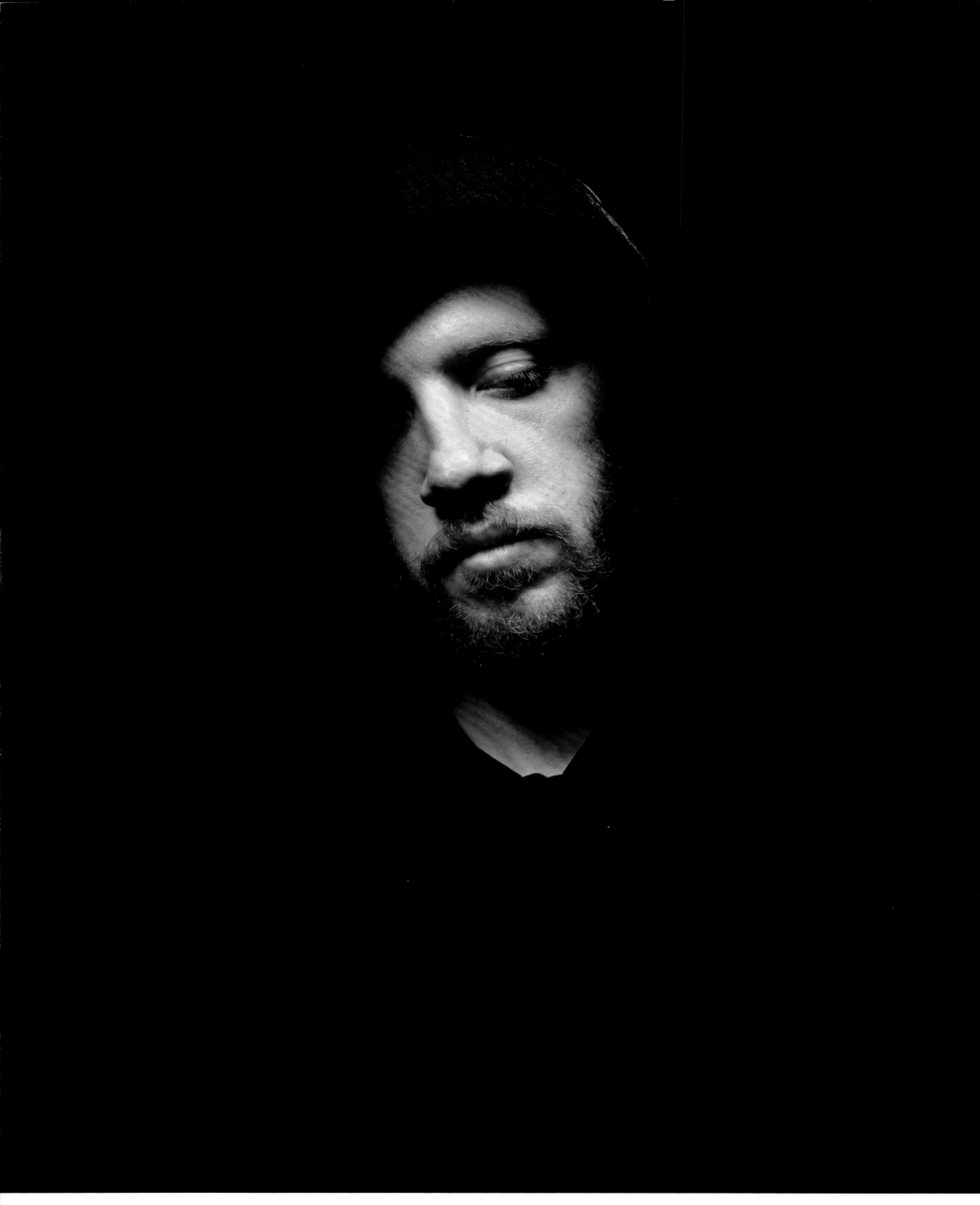

Frari Paolo, Venice

1991

BUDAPEST

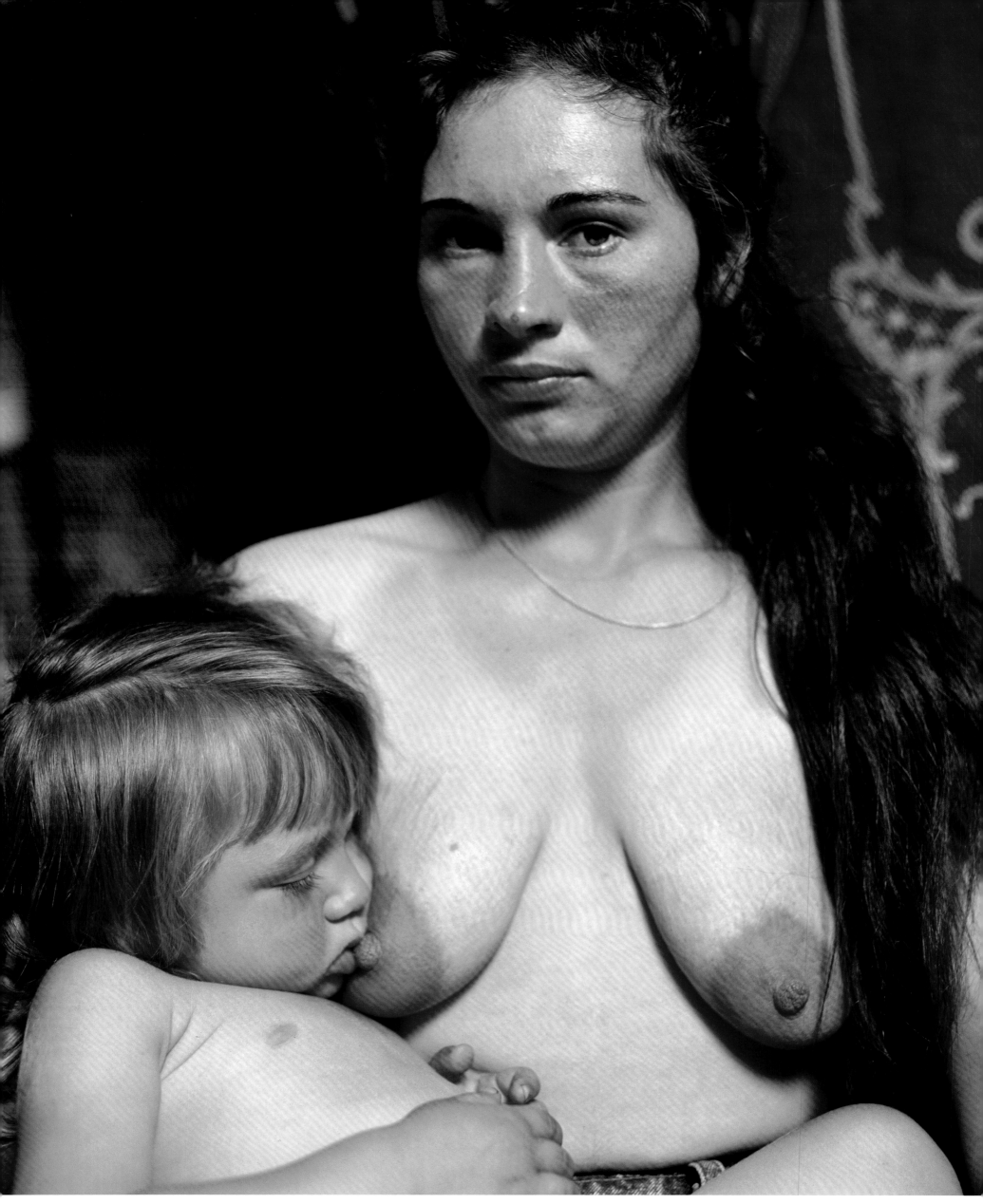

Mother and Child
1994

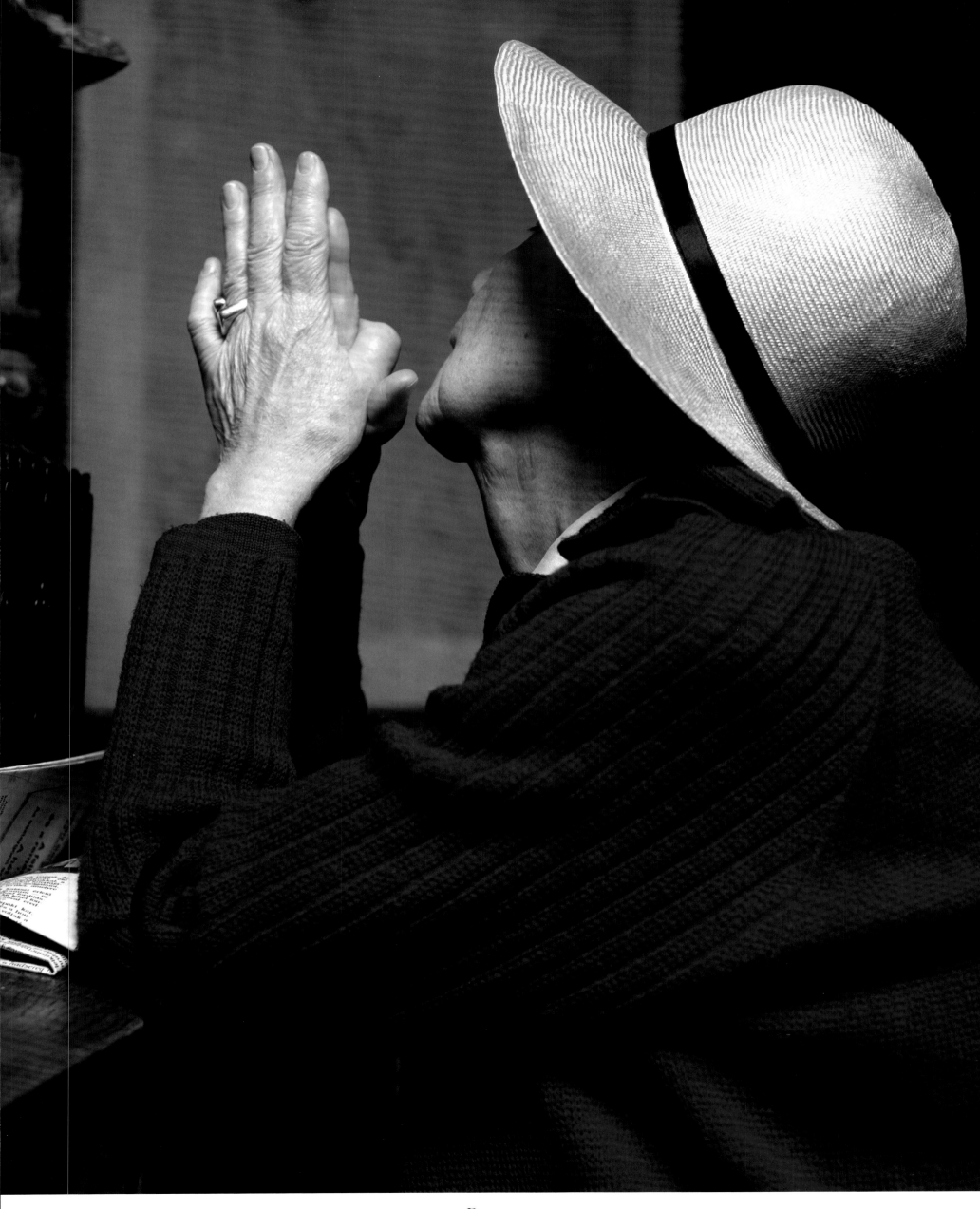

Prayer
1994

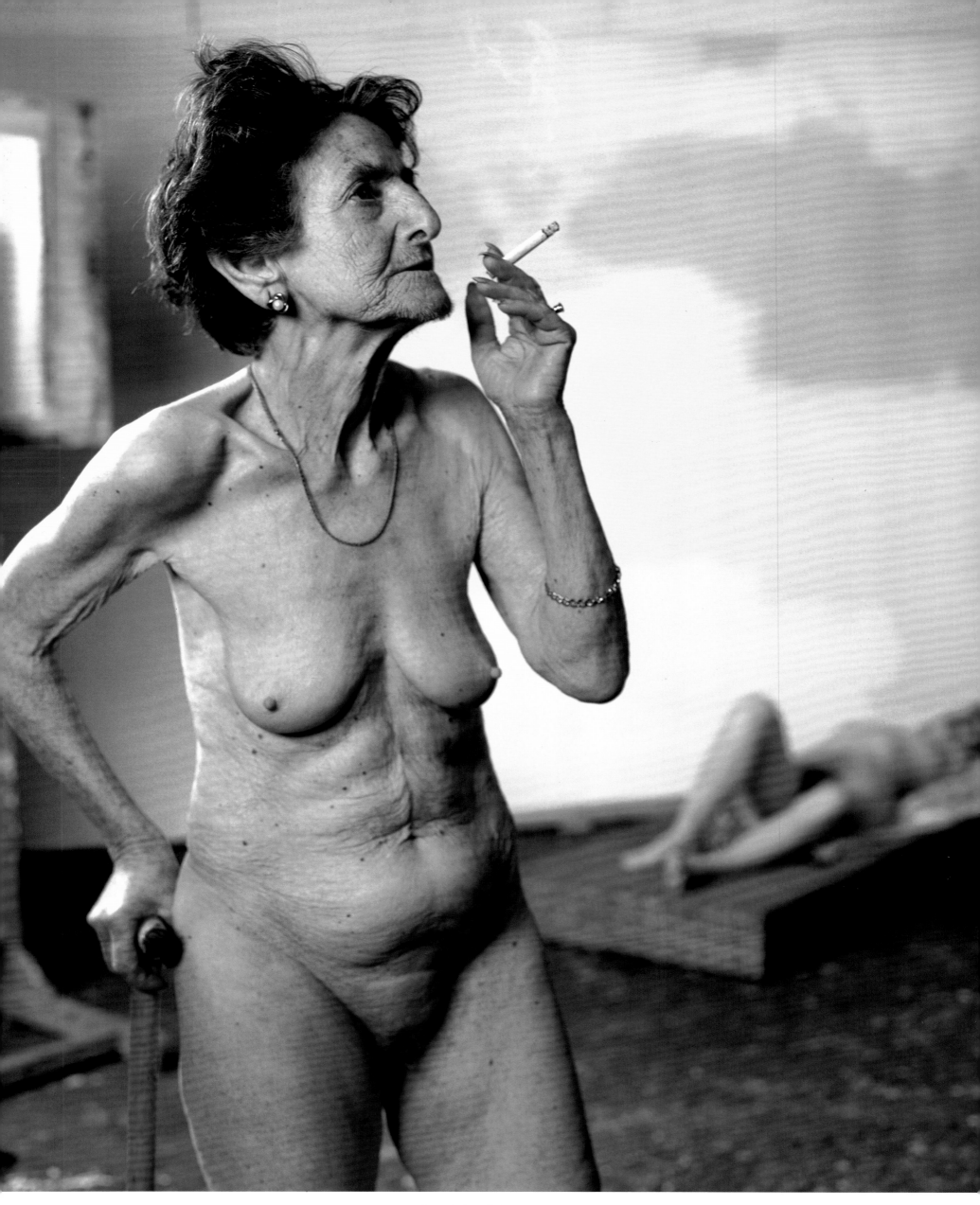

The Model
1994

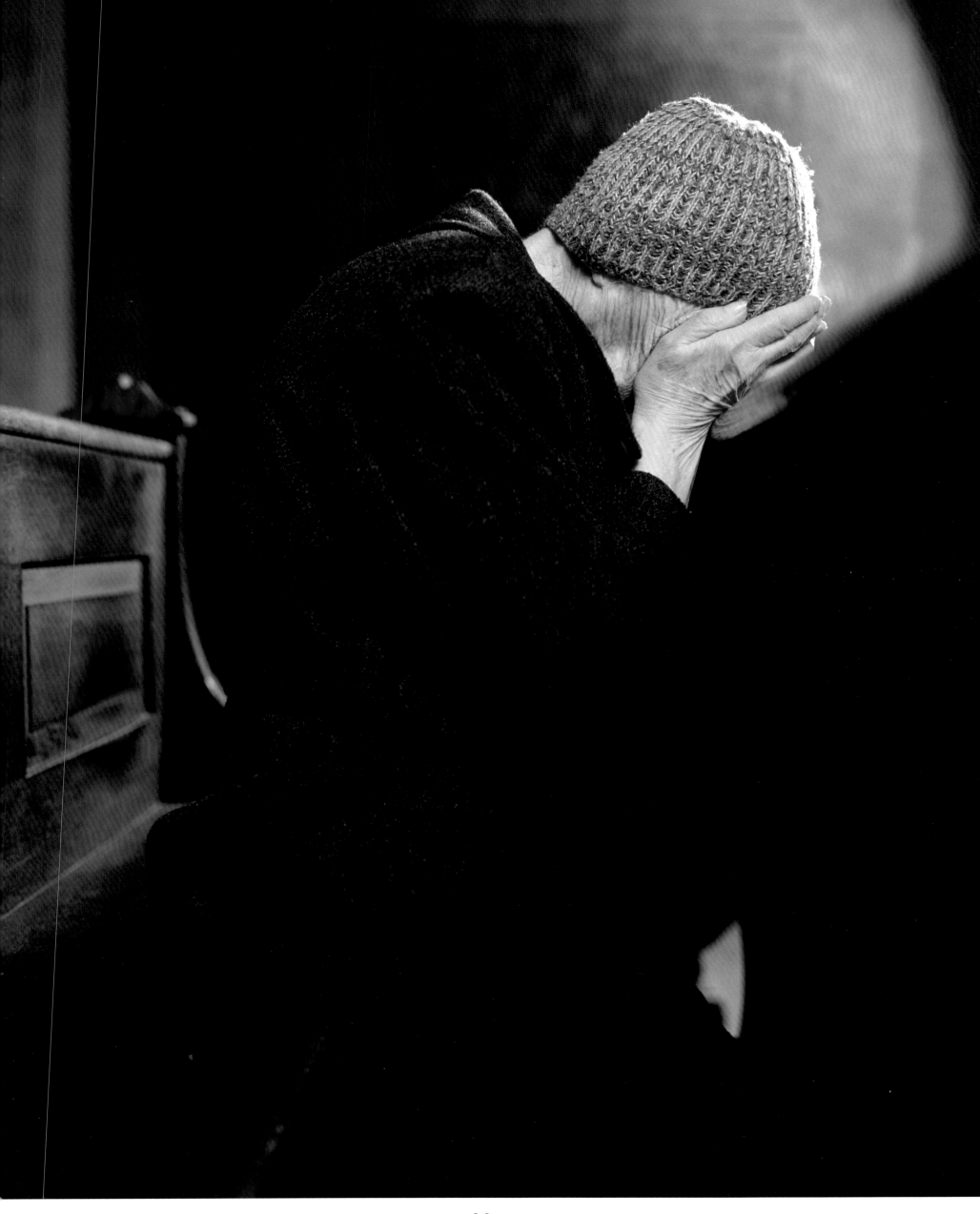

Mass
1994

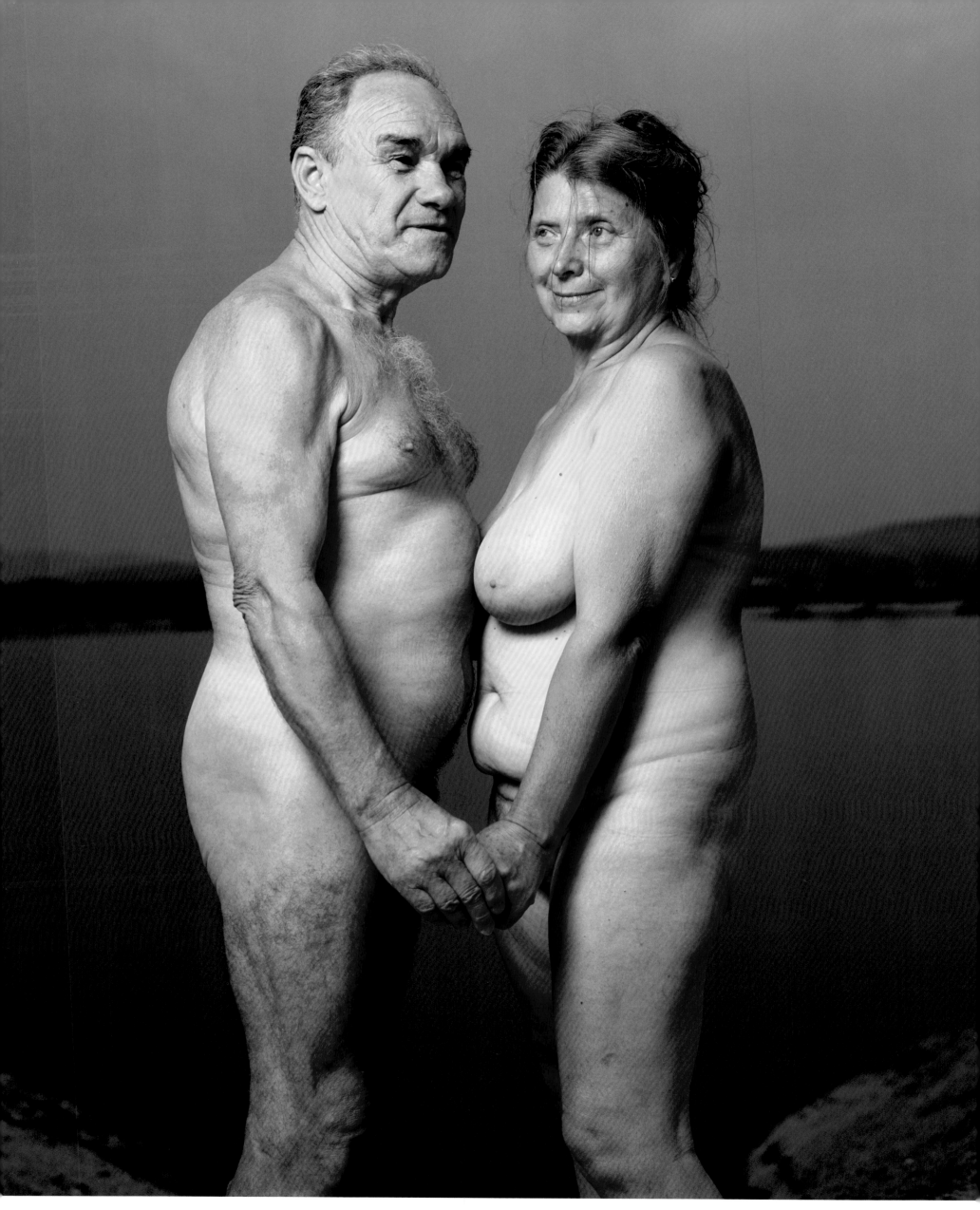

The Lake
1994

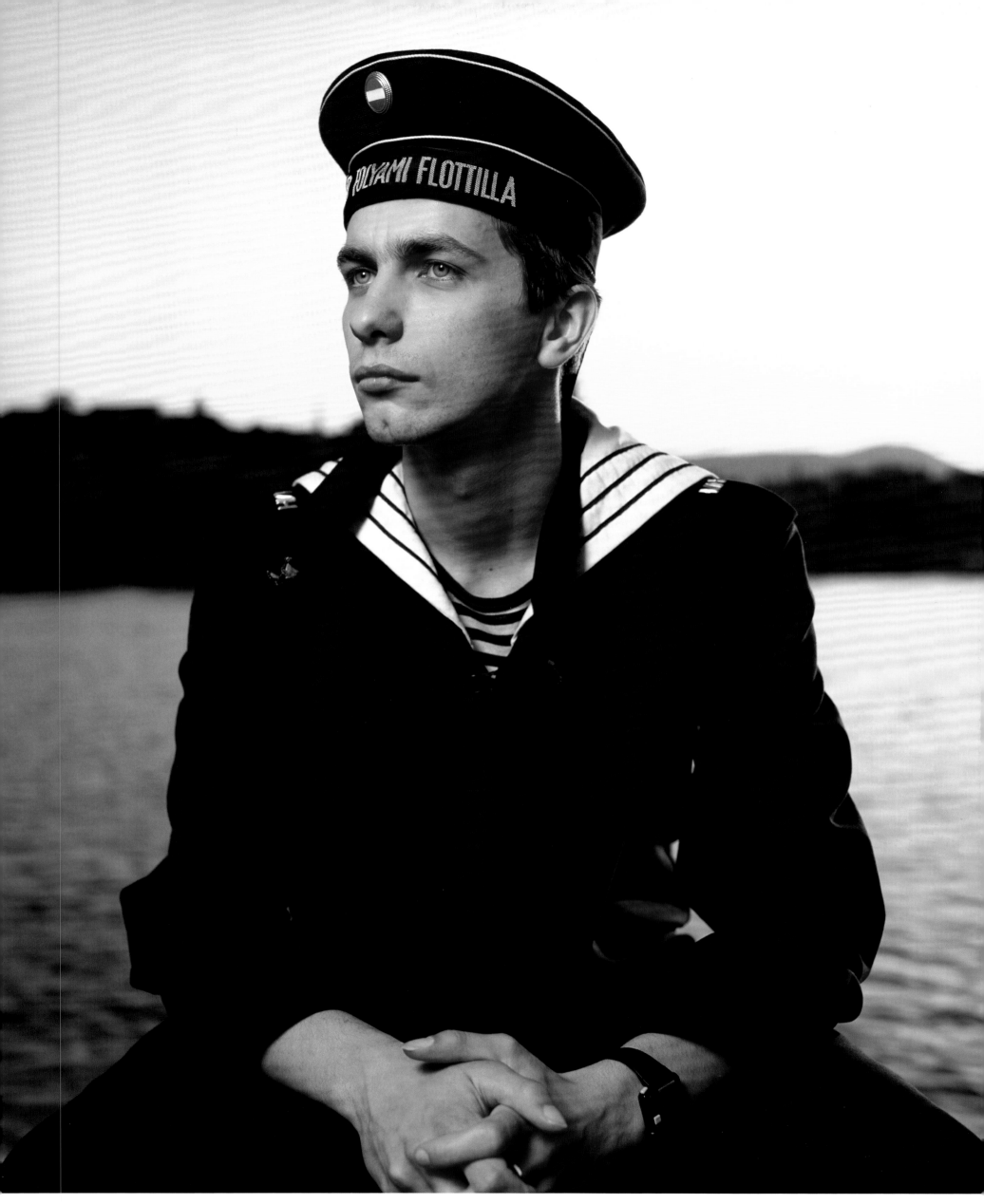

The Sailor
1994

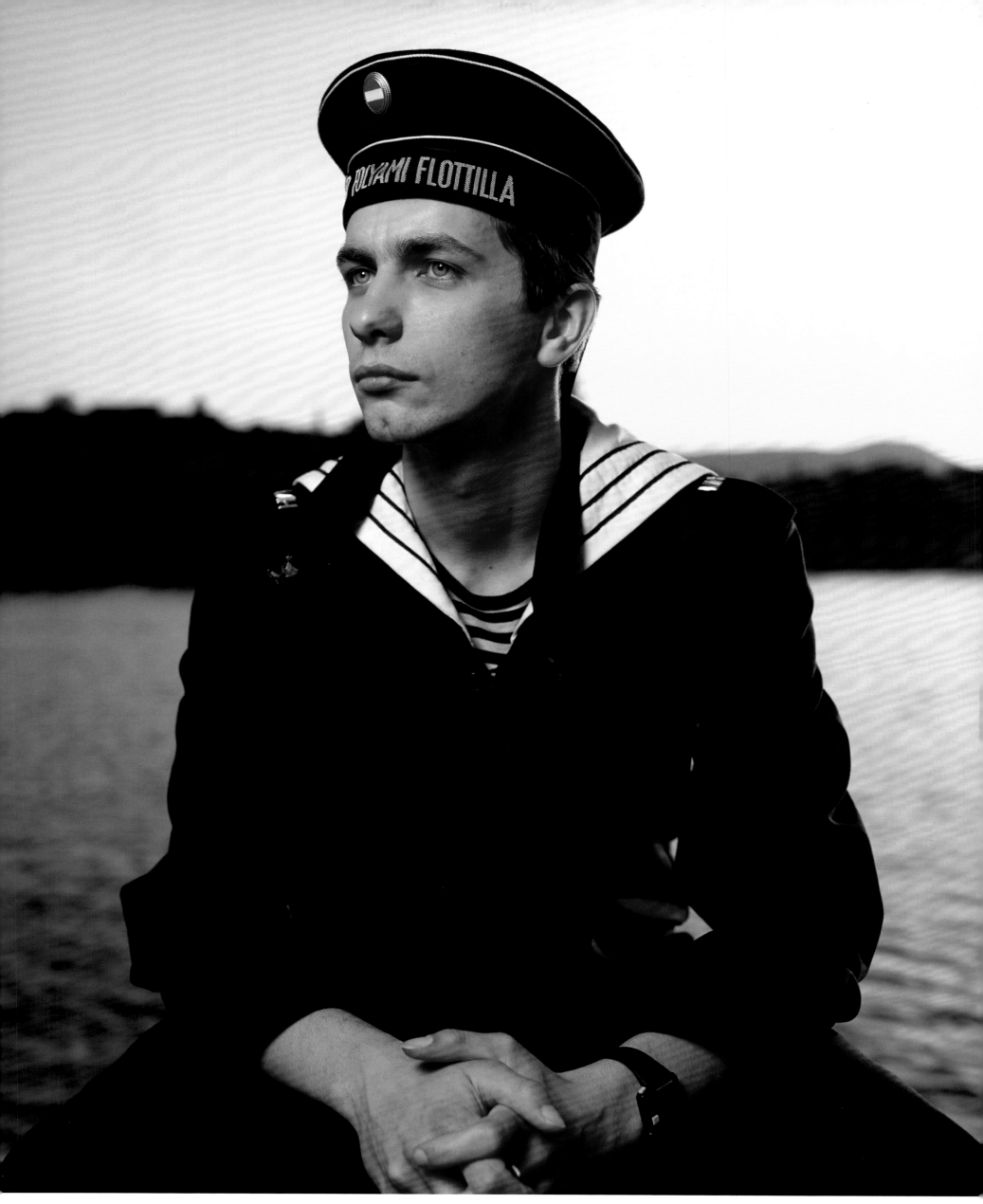

The Sailor
1994

ISTANBUL

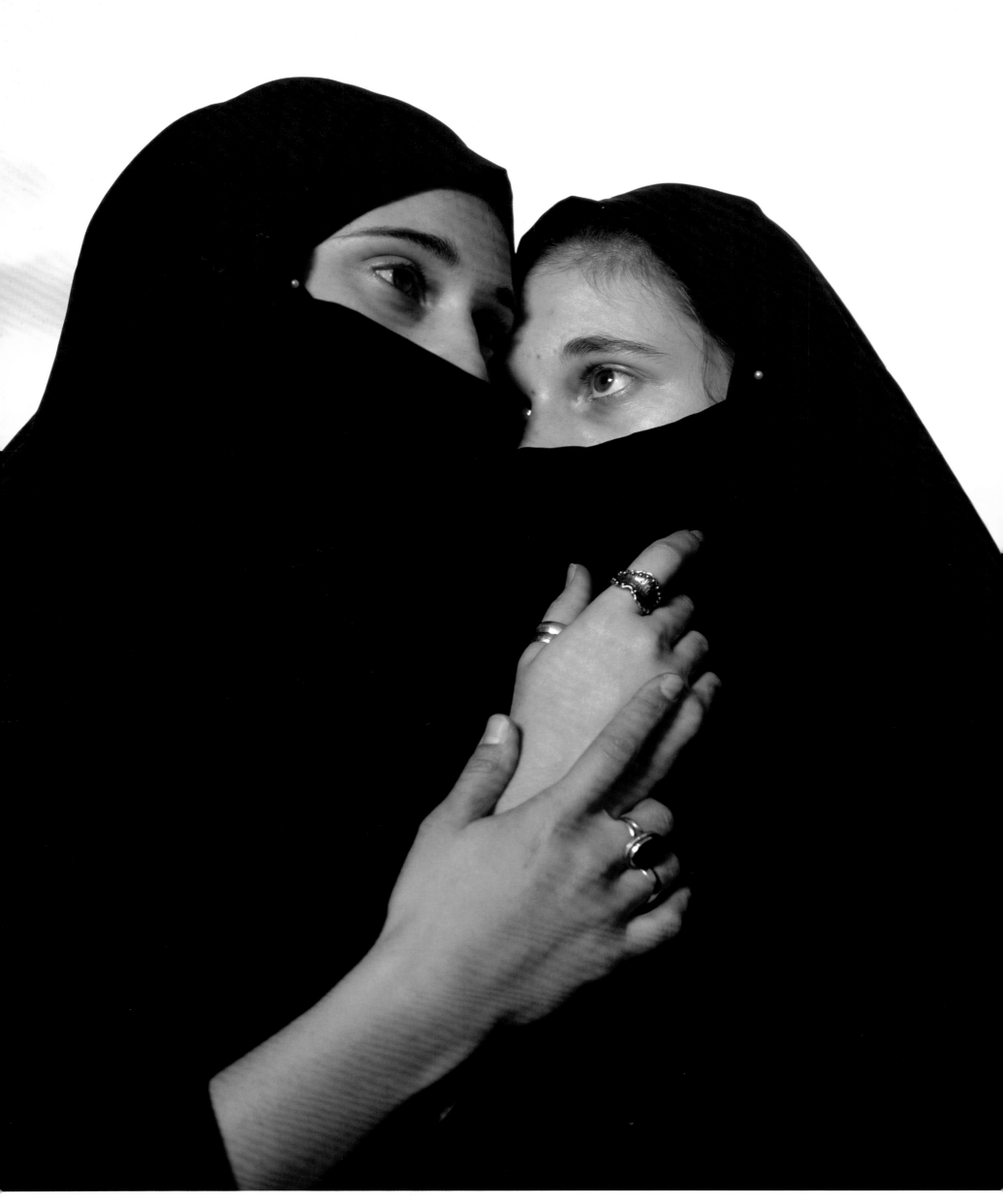

Sisters
1995

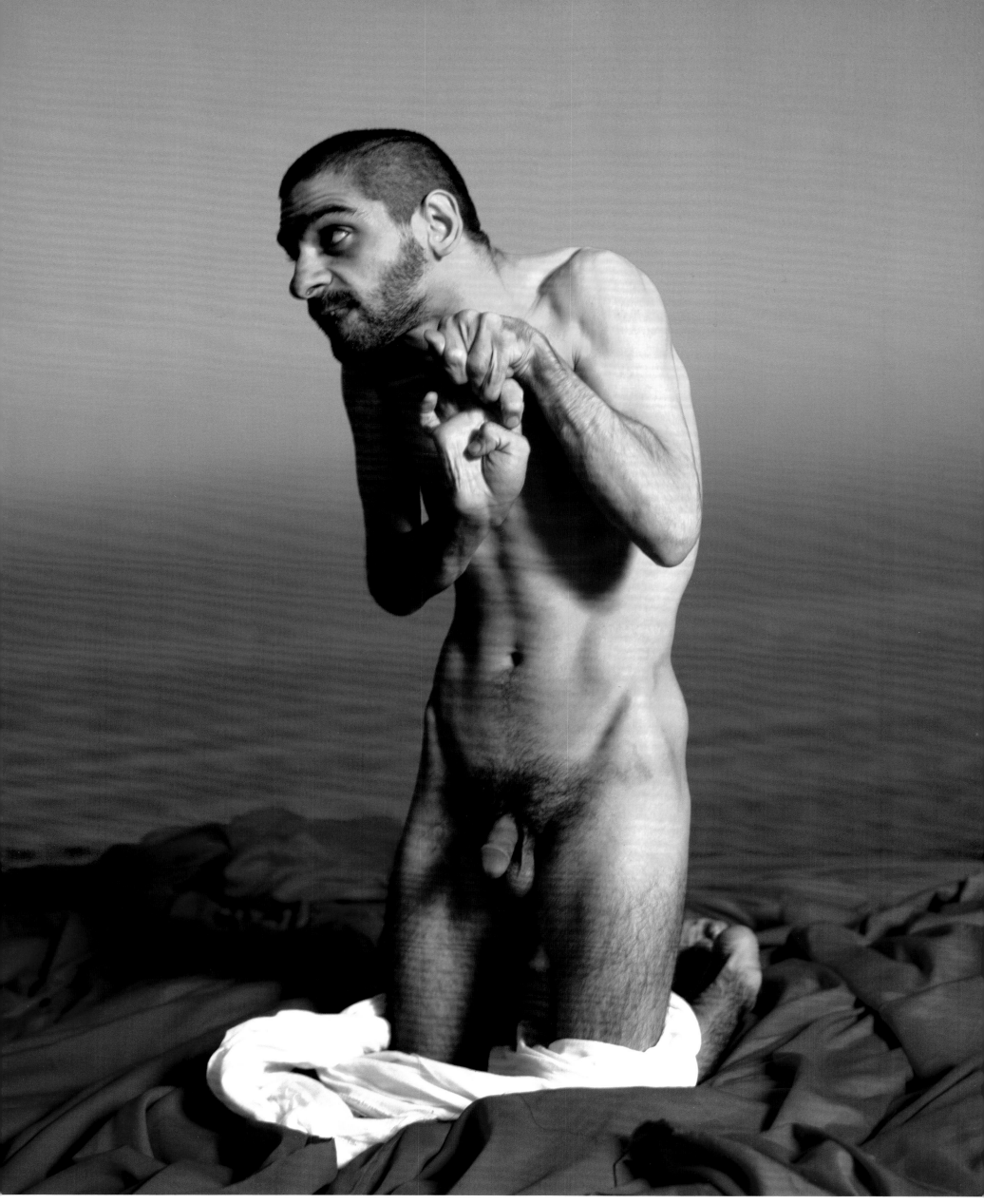

Edip
1995

BODILY FLUIDS

Milk, Blood 1986

Blut und Boden (Blood and Soil) 198-

Blood 1987

Milk 1987

Milk 1987

Piss 1987

Circle of Blood 1987

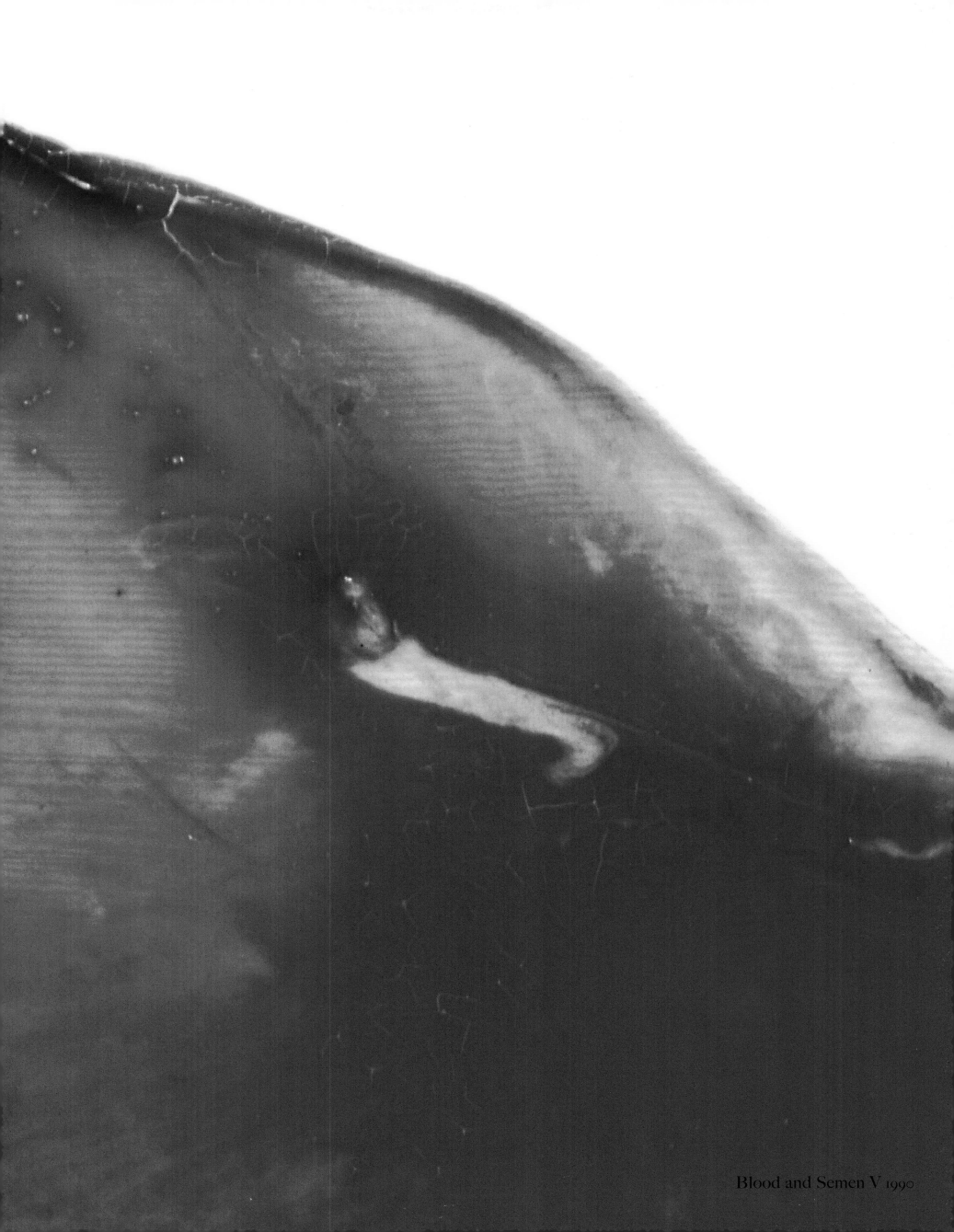

Blood and Semen V 1990

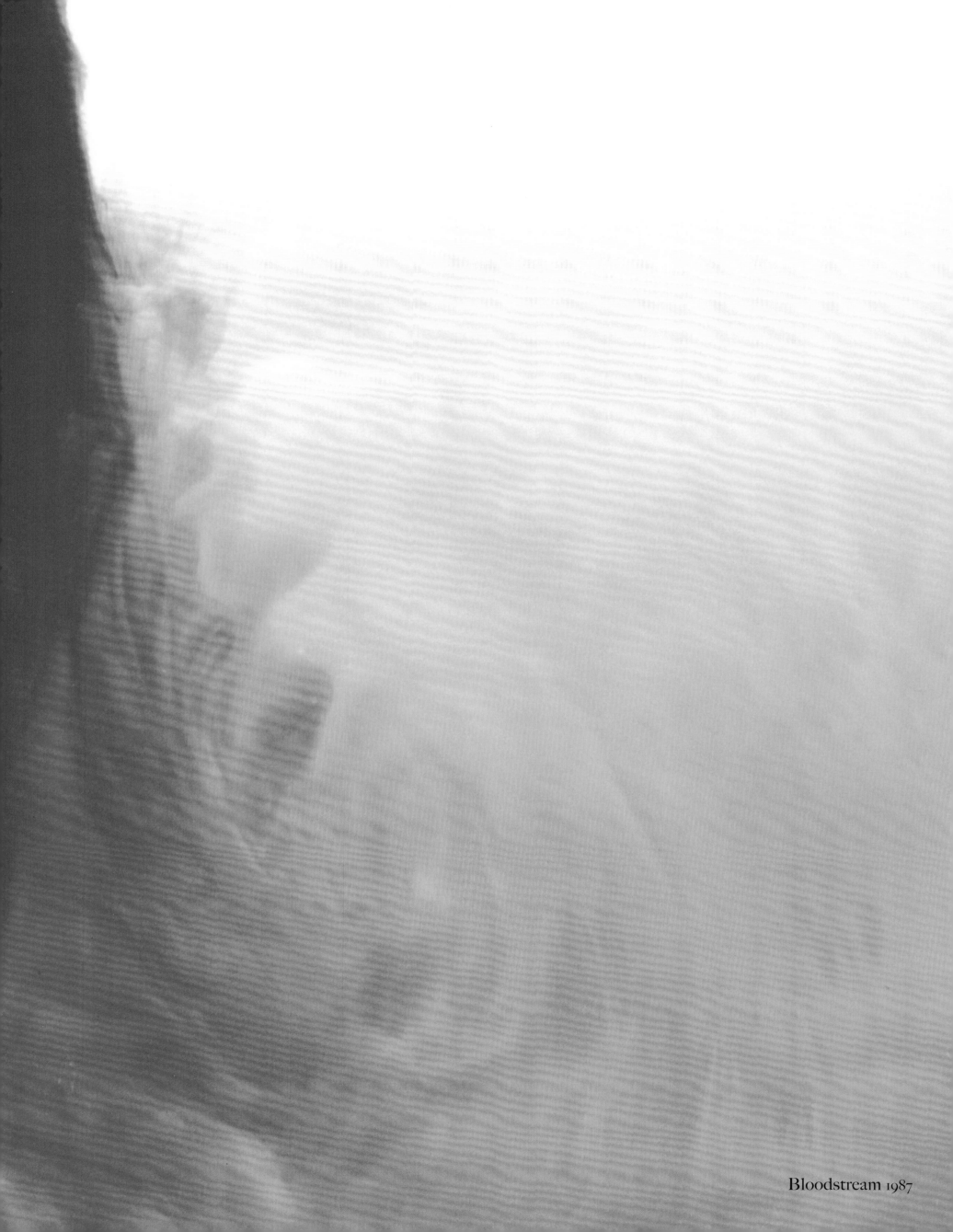

Bloodstream 1987

Bloodscape 1987

Bloodscape 1987

Piss and Blood VIII 1987

Untitled III (Ejaculate in Trajectory) 1988

Untitled (Ejaculate in Trajectory VIII) 1989

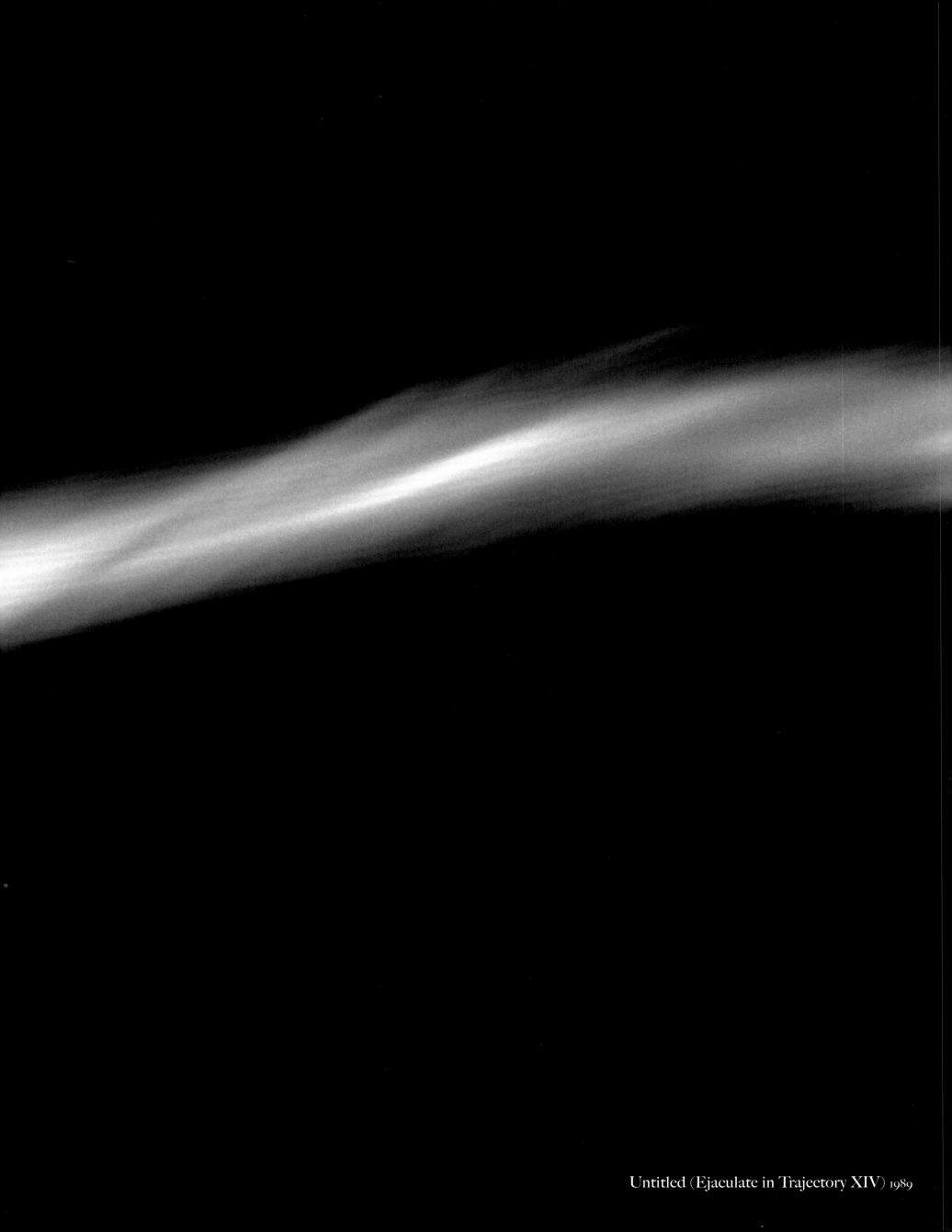

Untitled (Ejaculate in Trajectory XIV) 1989

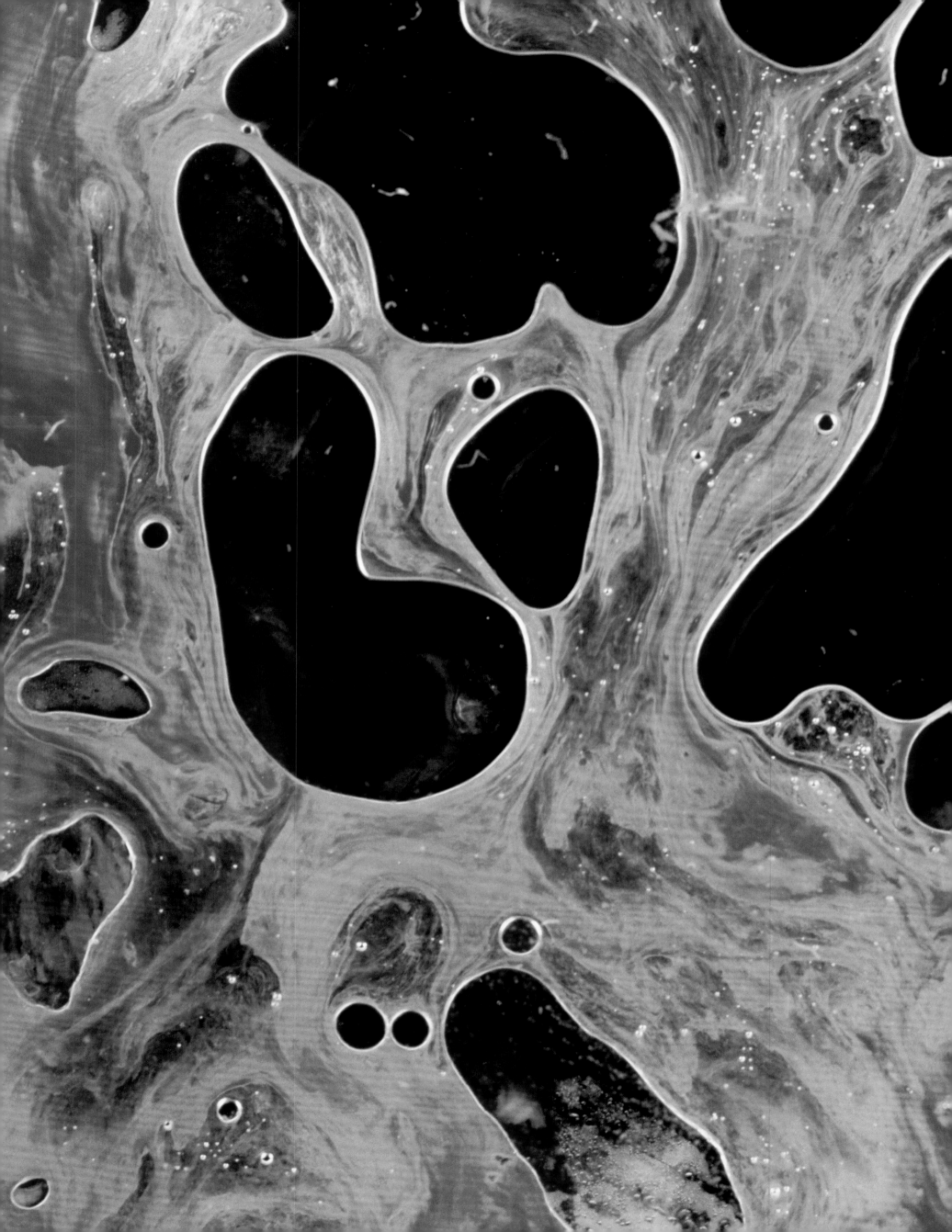

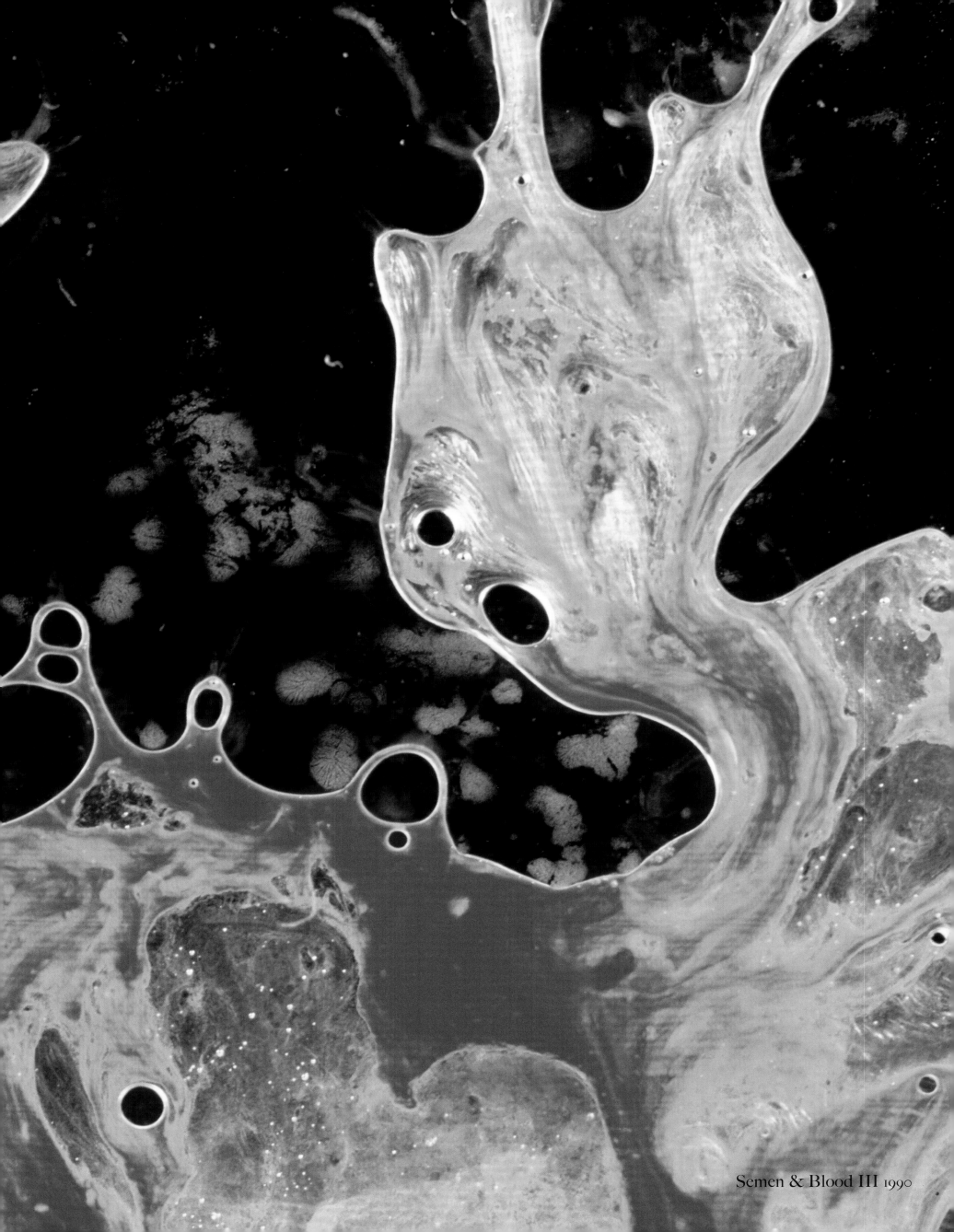

Semen & Blood III 1990

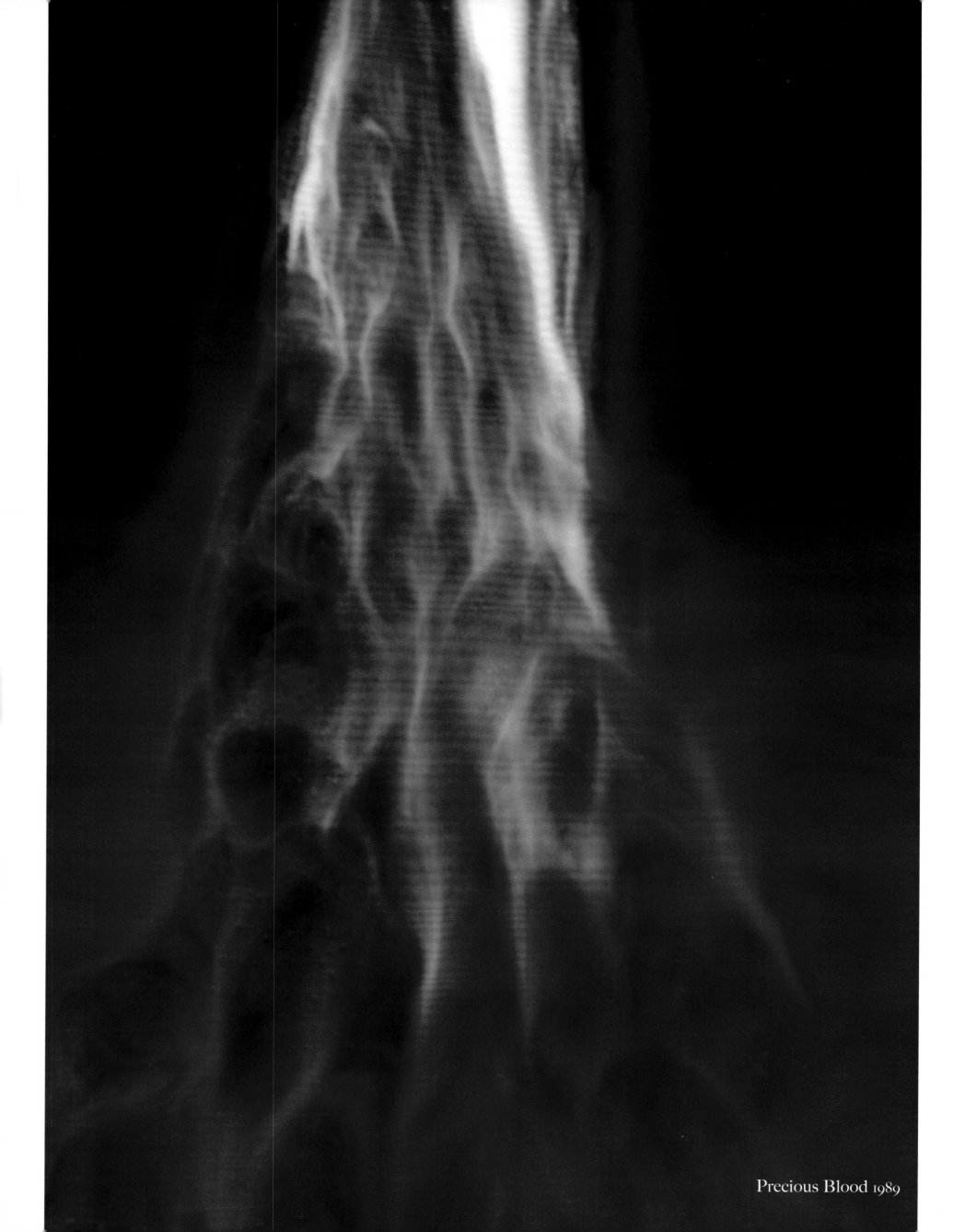

Precious Blood 1989

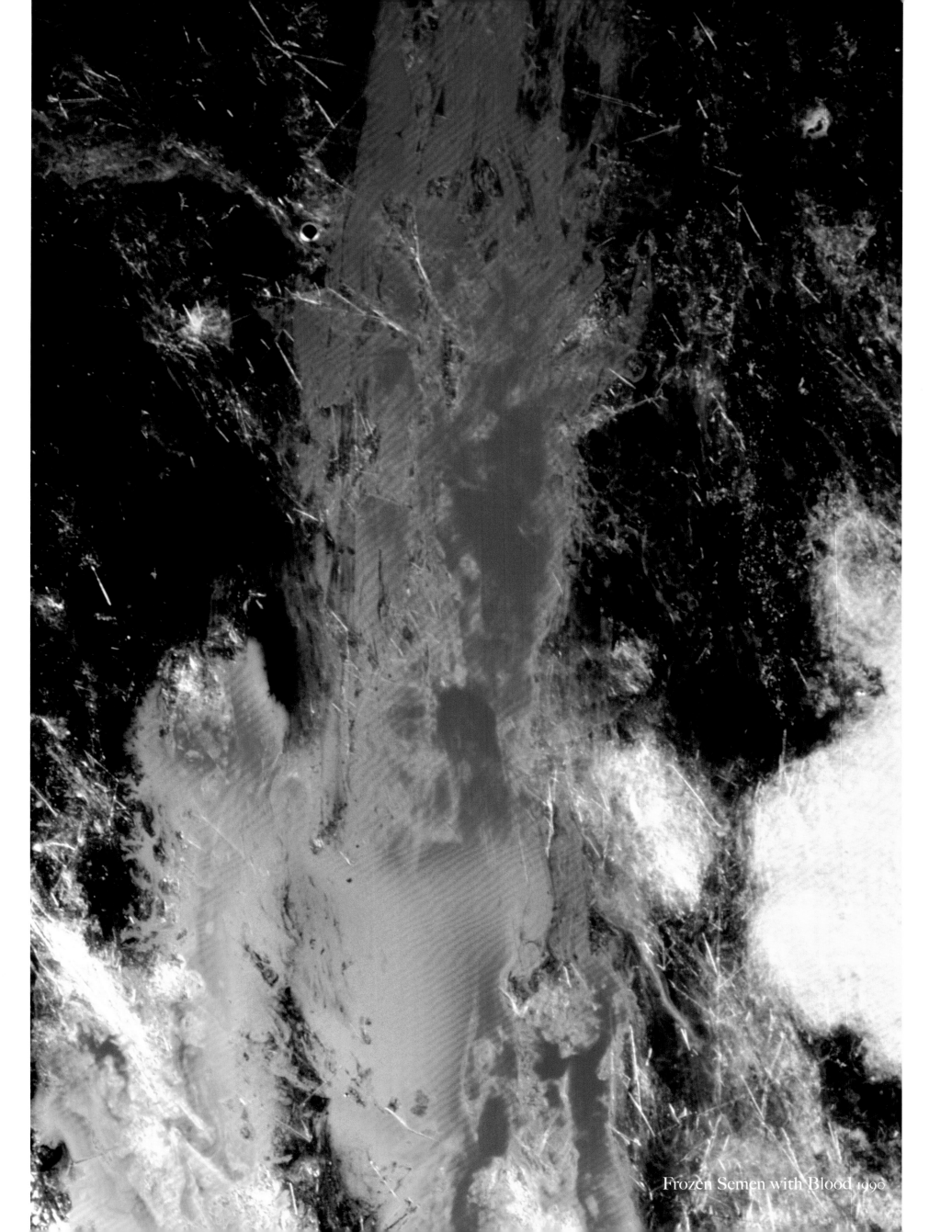

Frozen Semen with Blood 1990

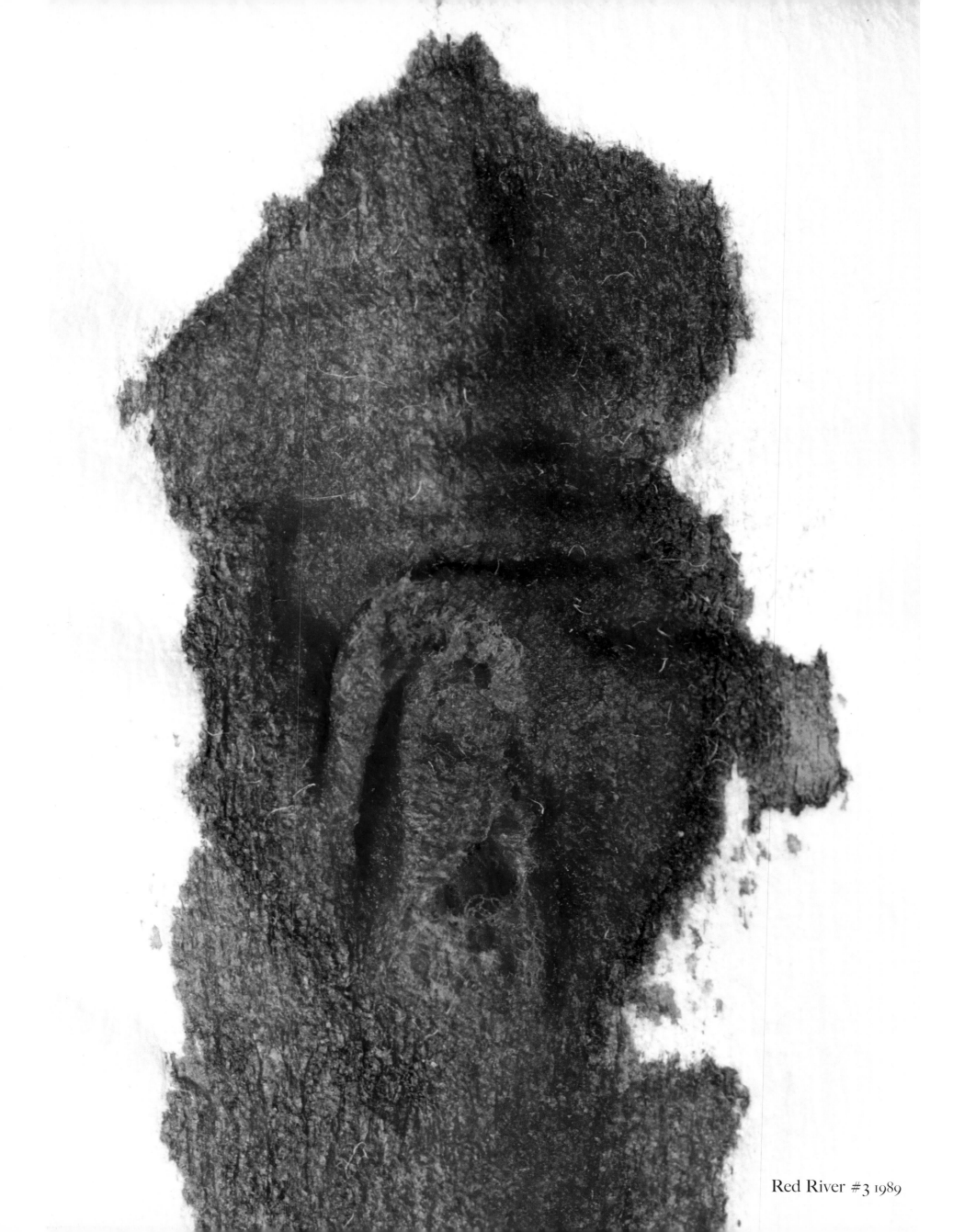

Red River #3 1989

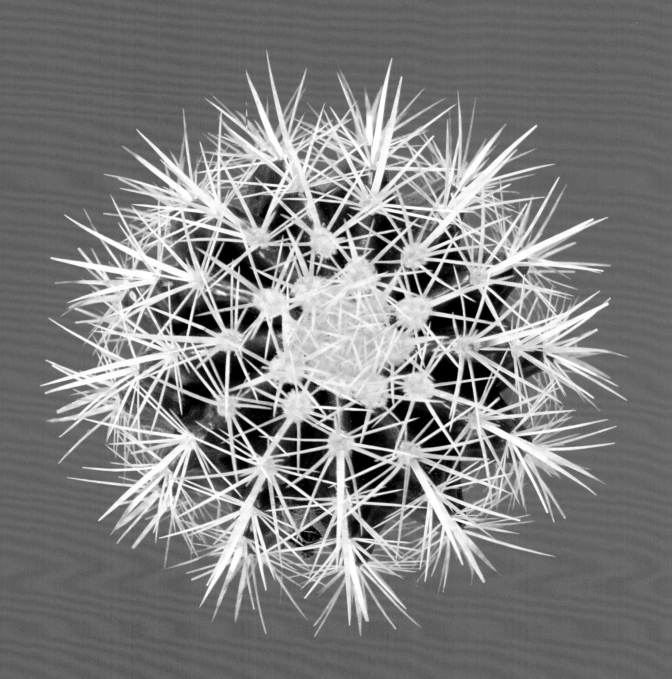

Cactus Blood 1987

IMMERSIONS

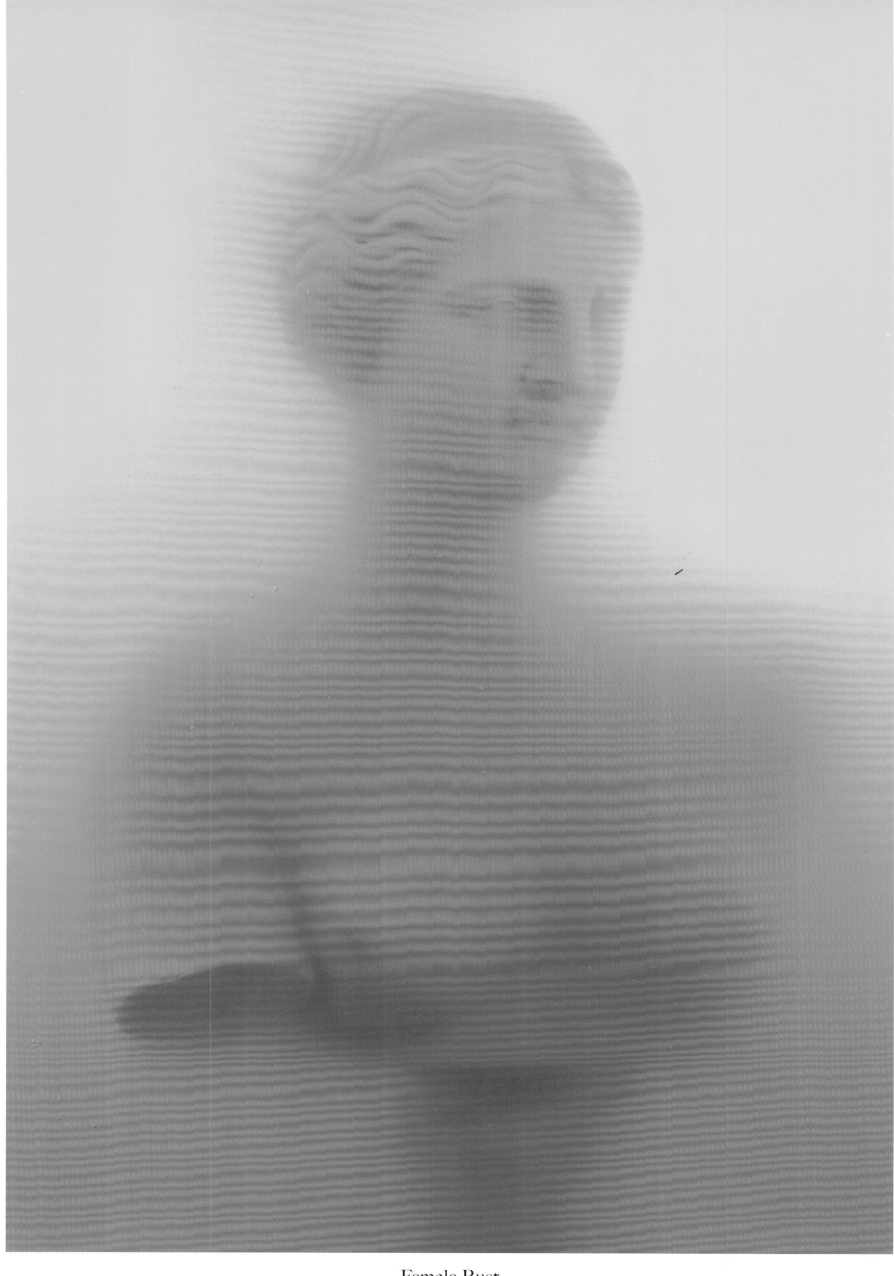

Female Bust
1988

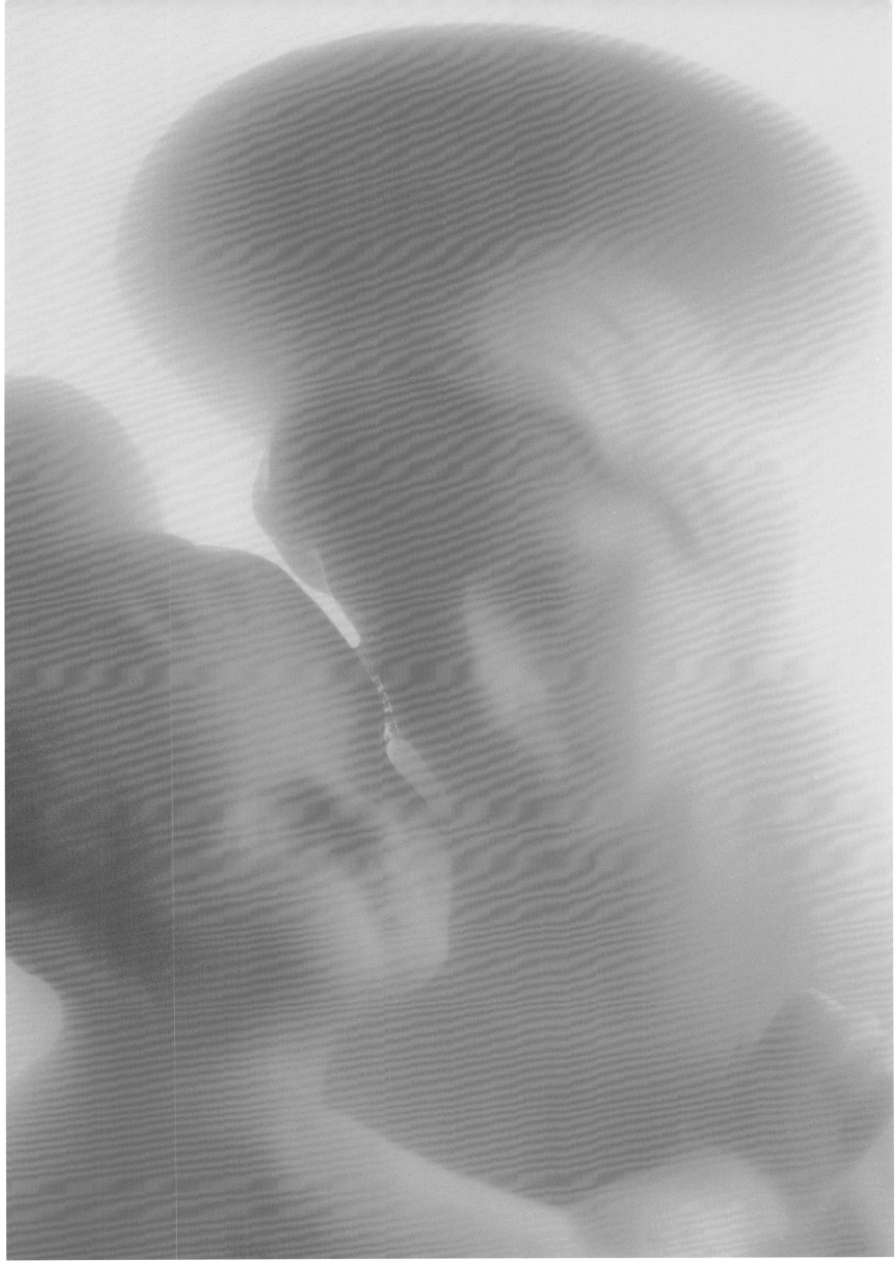

Madonna and Child II
1989

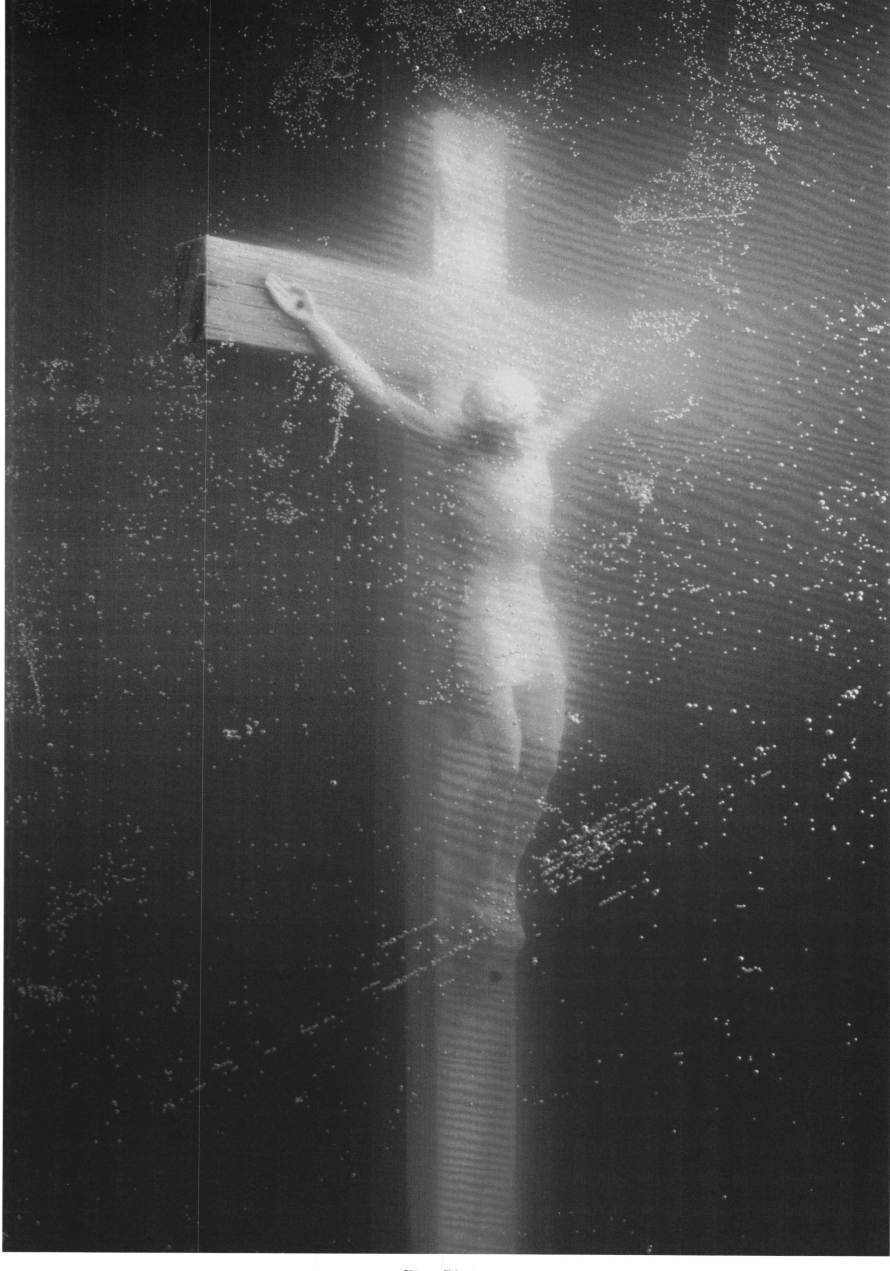

Piss Christ
1987

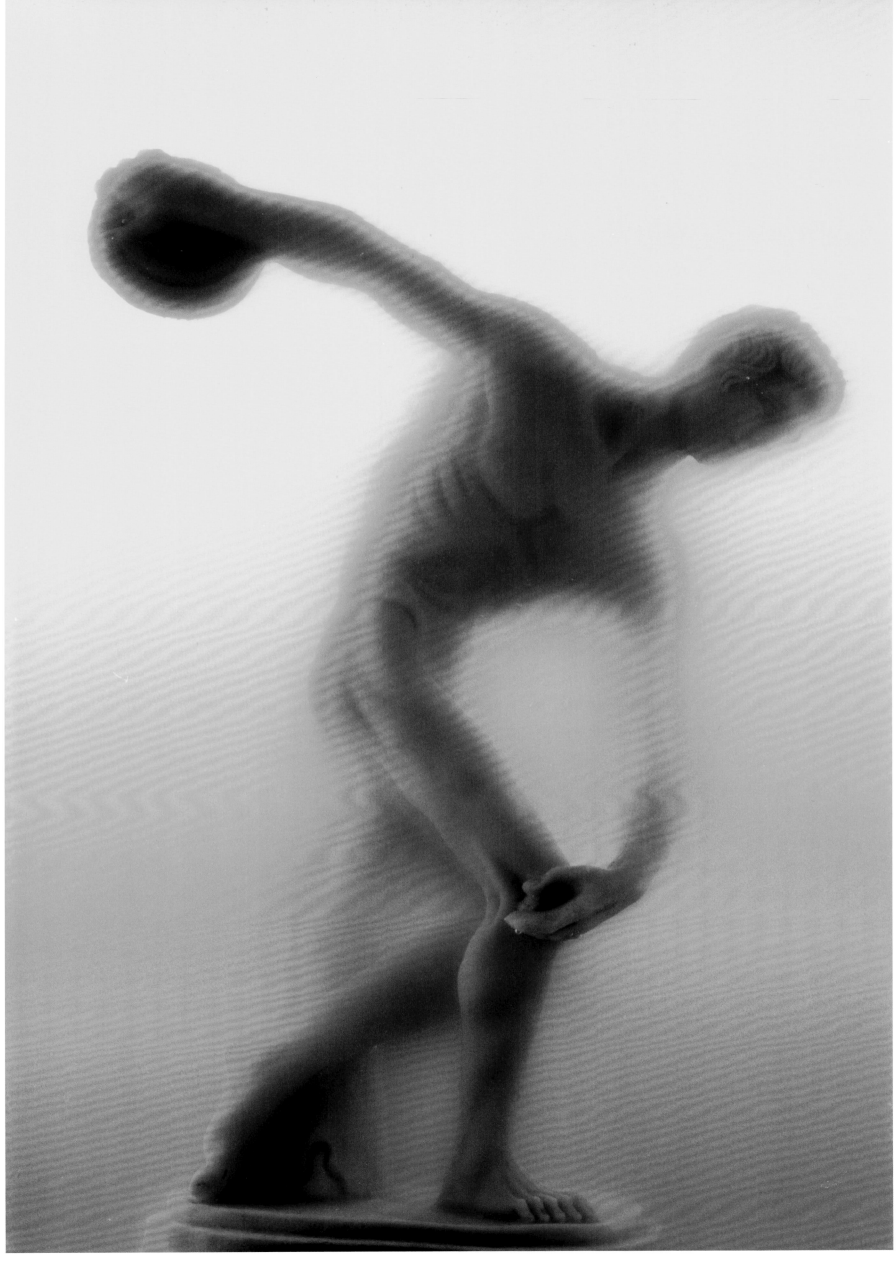

Piss Discus
1988

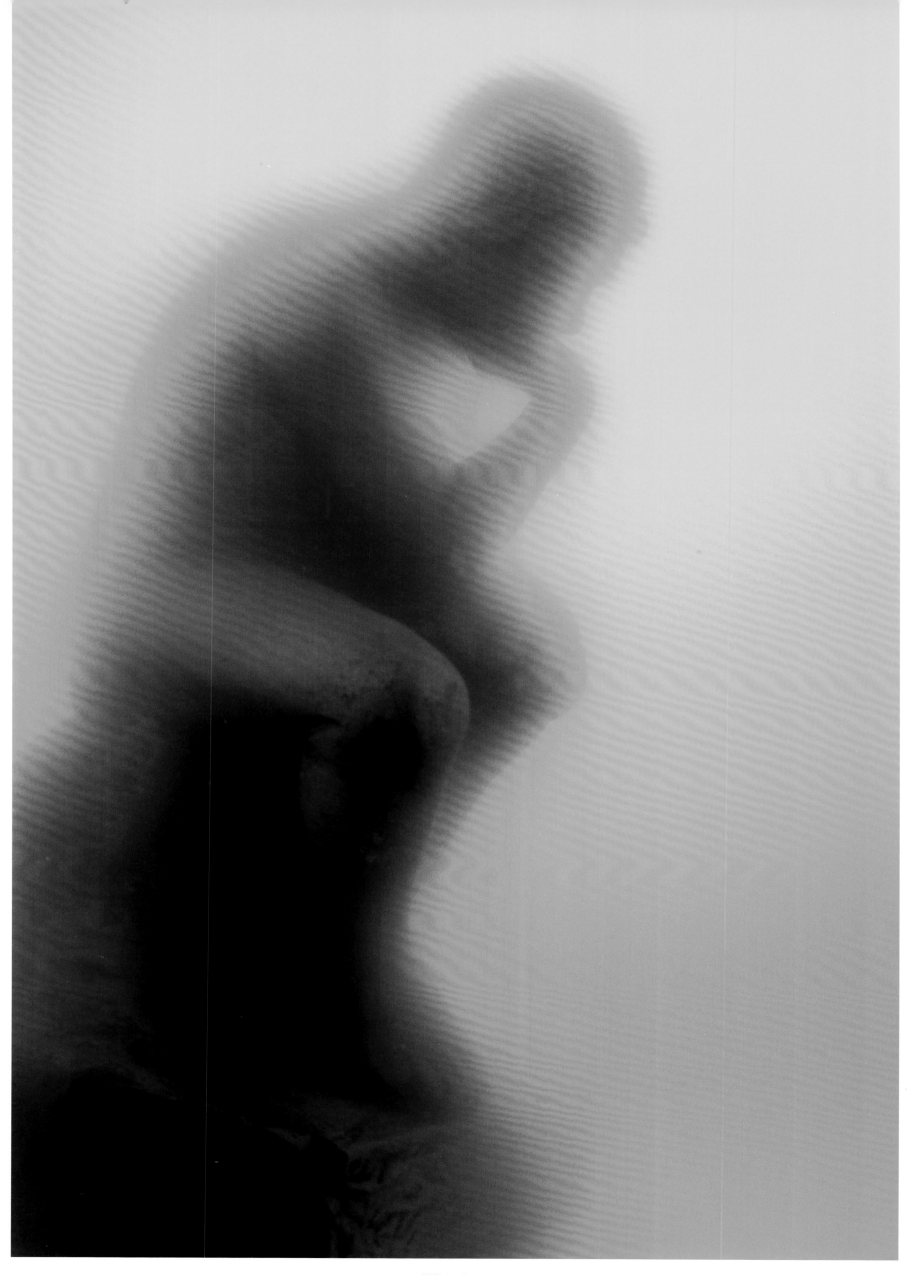

Thinker
1988

Piss Elegance
1987

Piss Satan
1988

Piss Elegance
1987

Winged Victory
1987

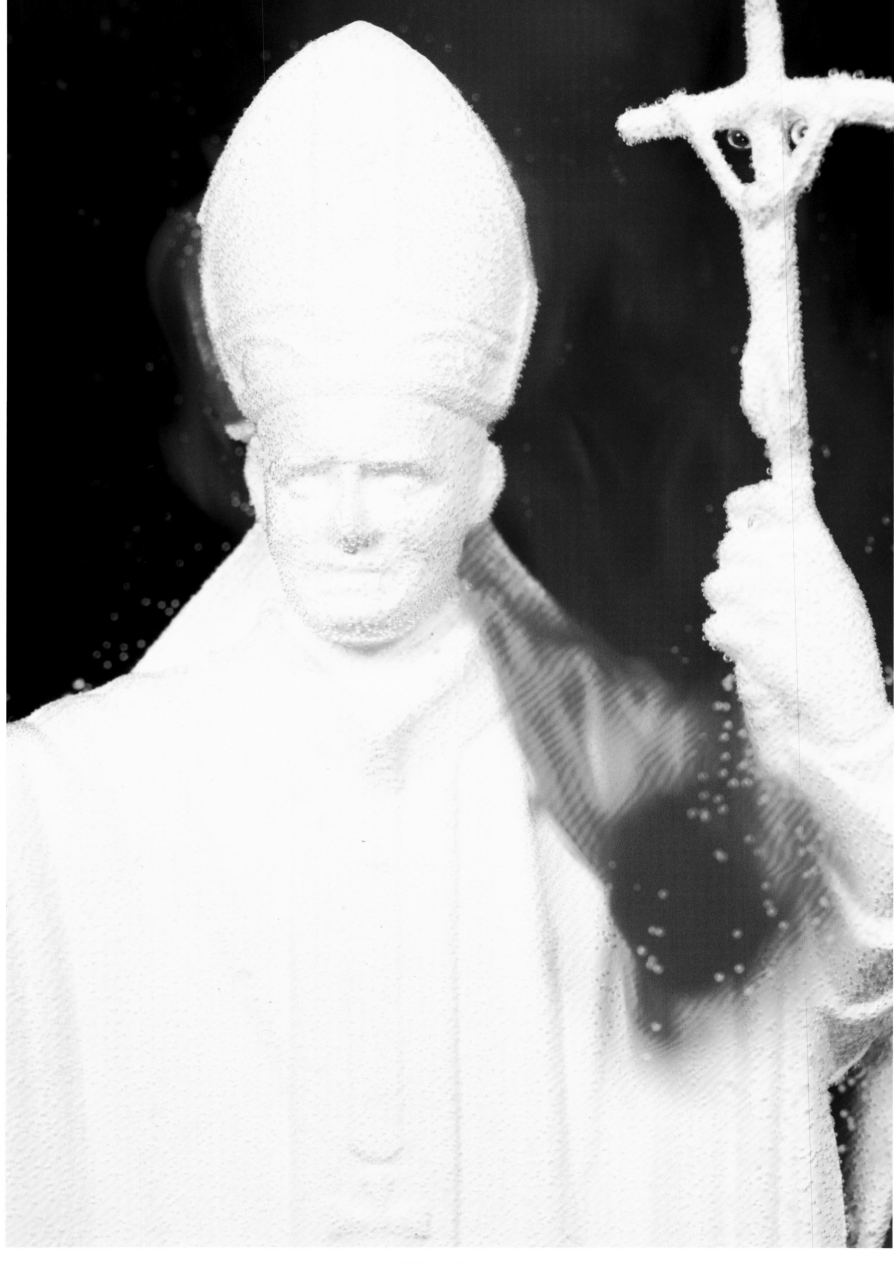

White Pope
1990

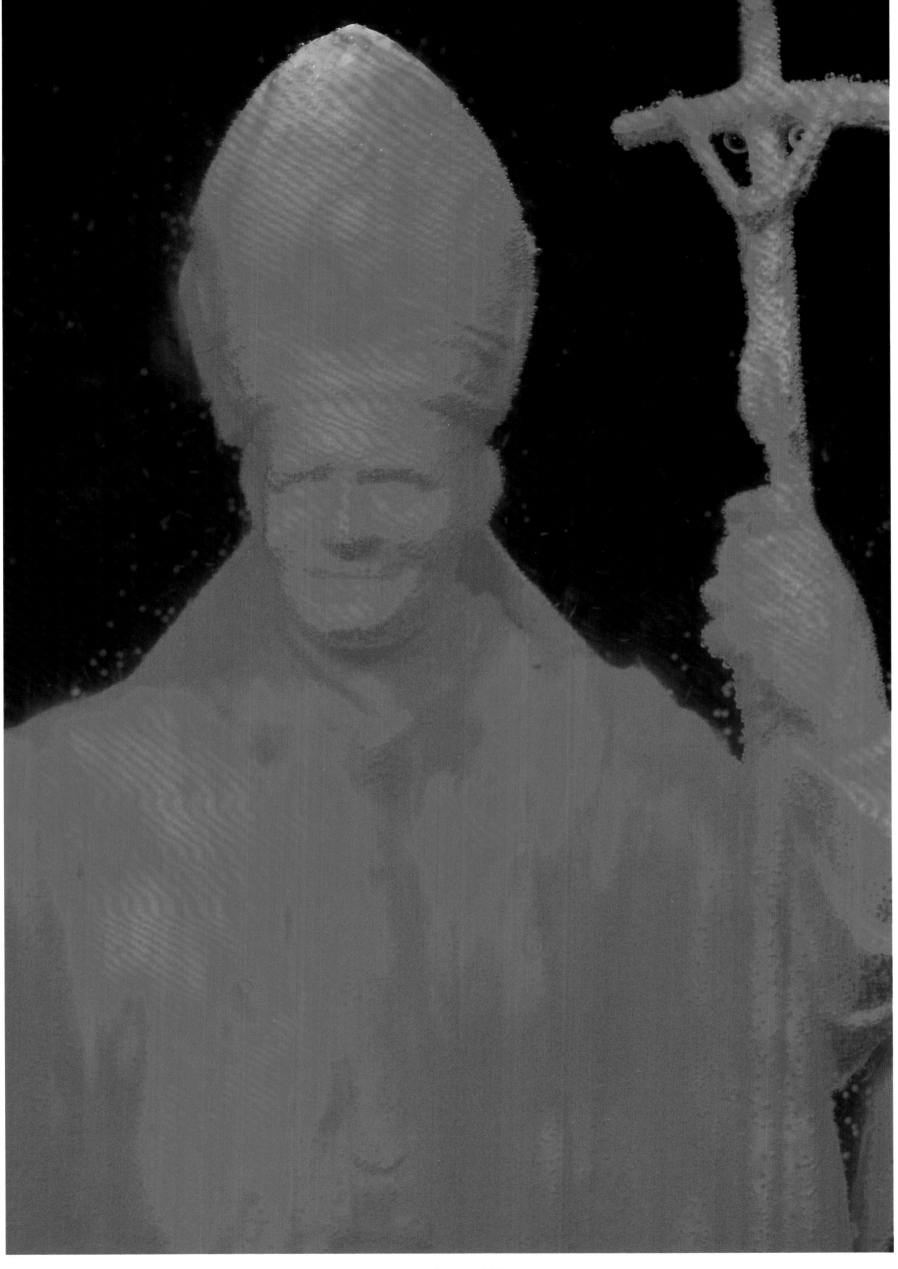

Red Pope III

1990

Hercules Punishing Diomedes Part I
1990

Hercules Punishing Diomedes Part II
1990

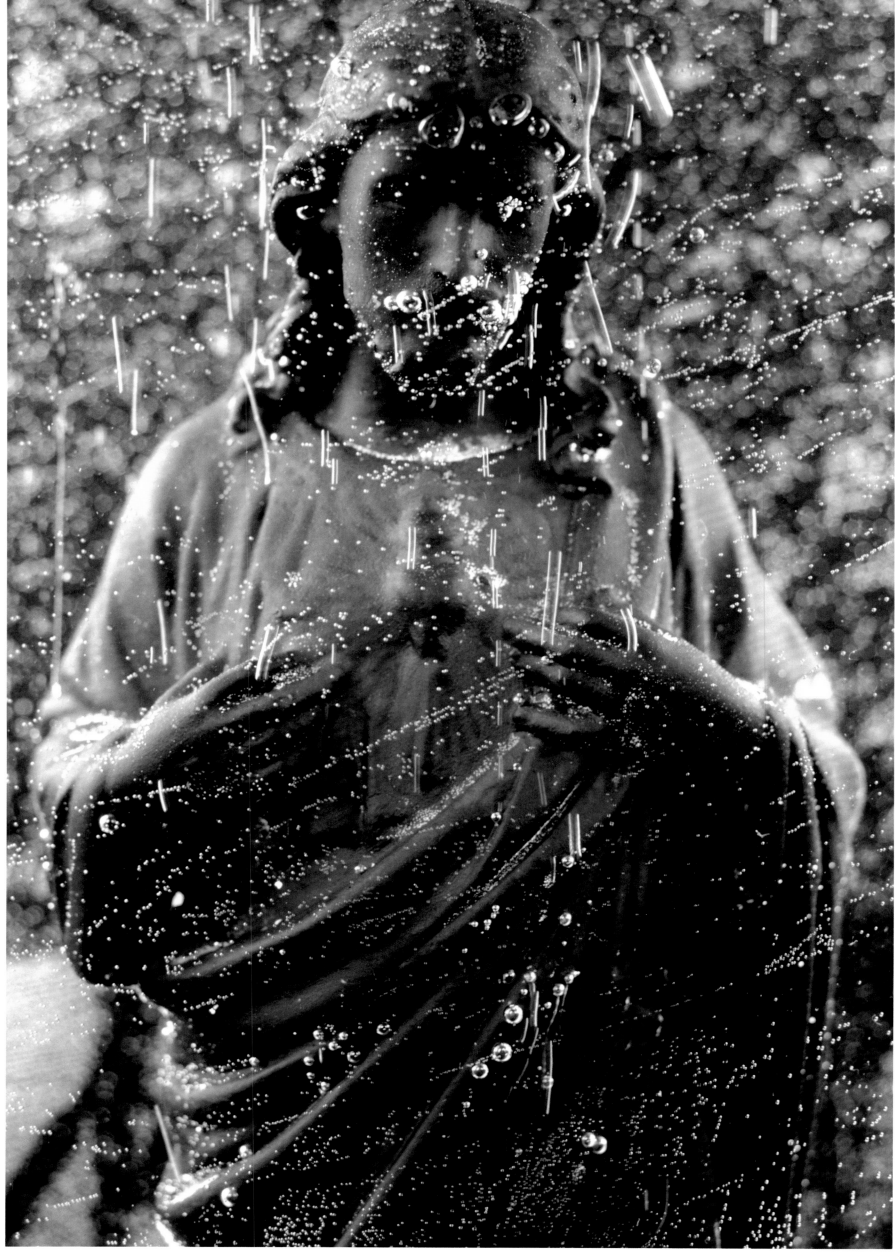

Black Jesus
1990

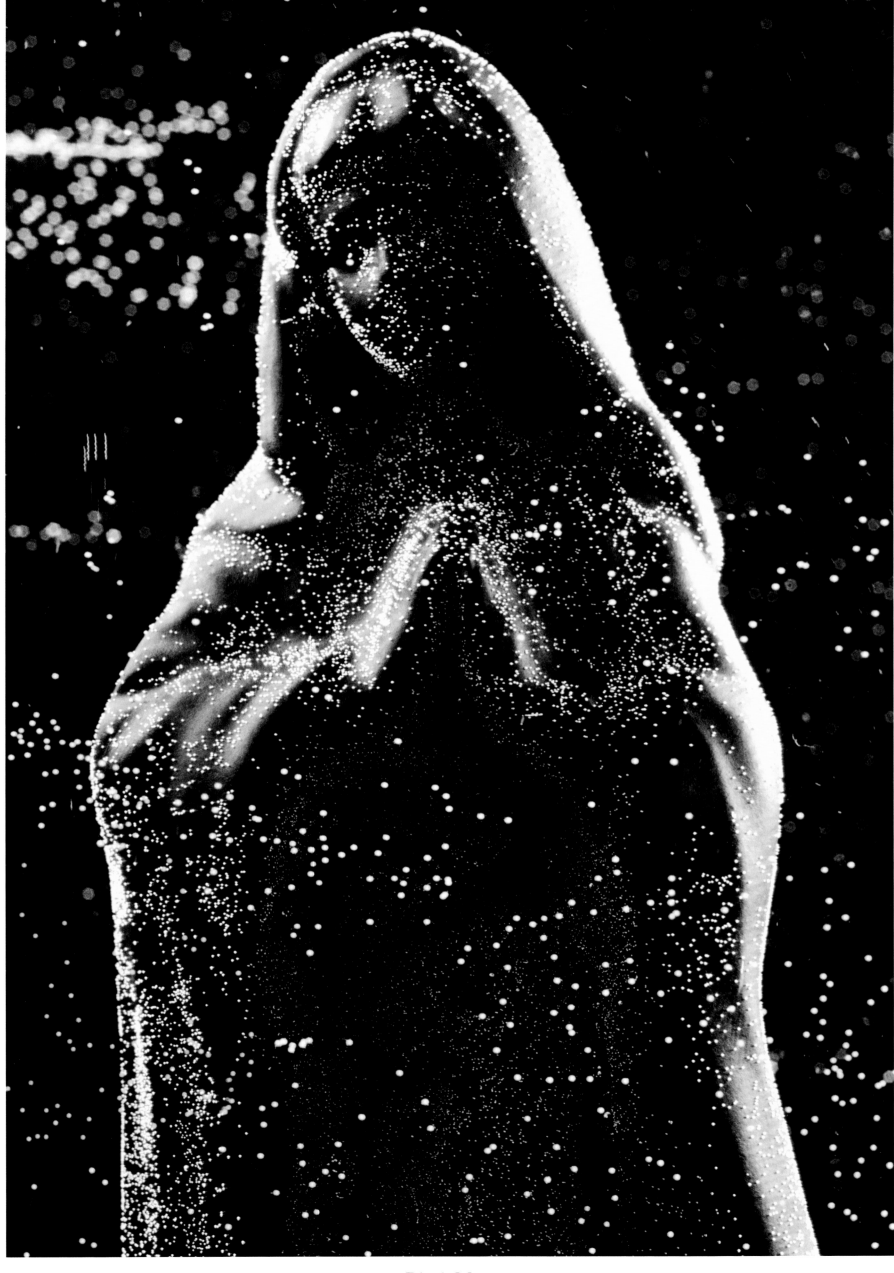

Black Mary
1990

EARLY WORKS

The Scream
1986

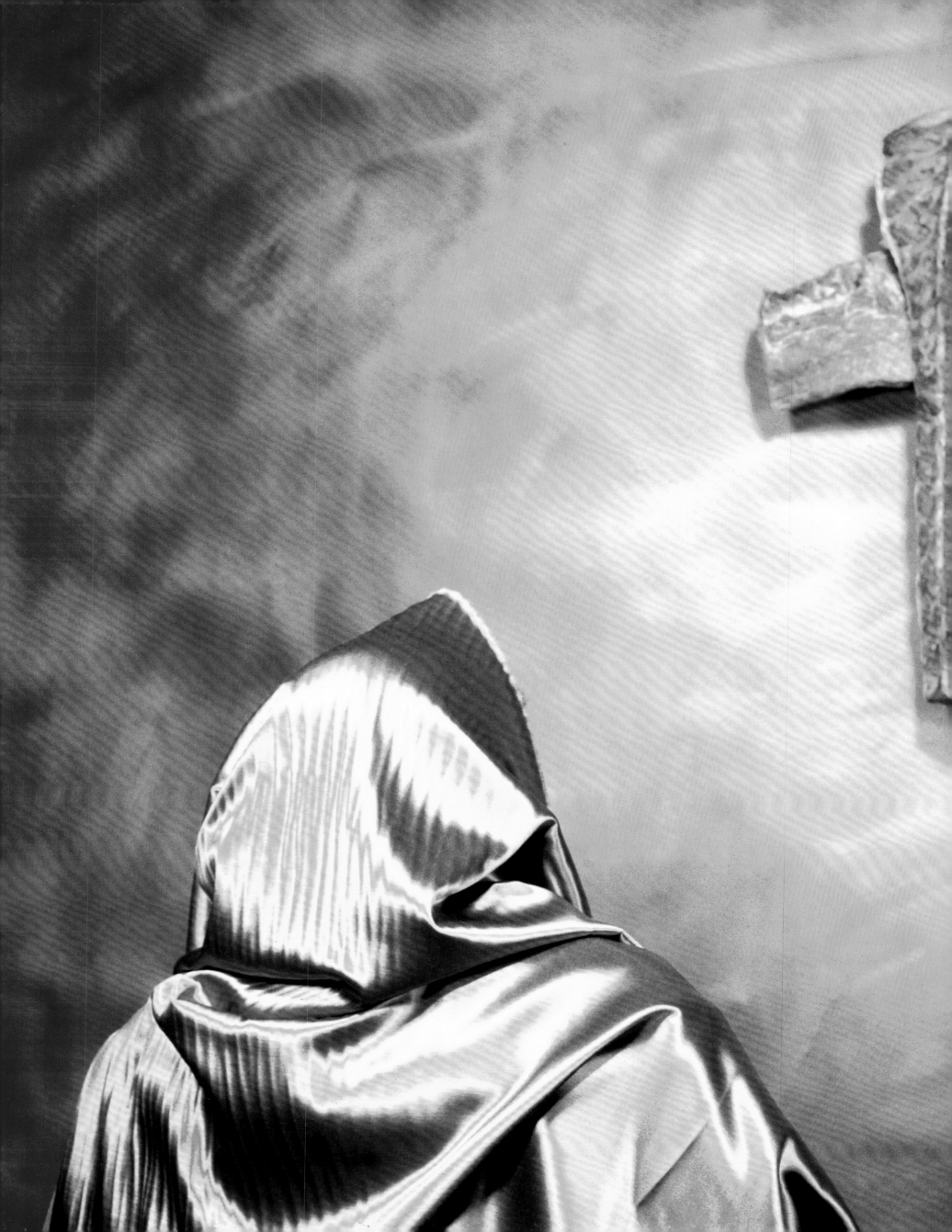

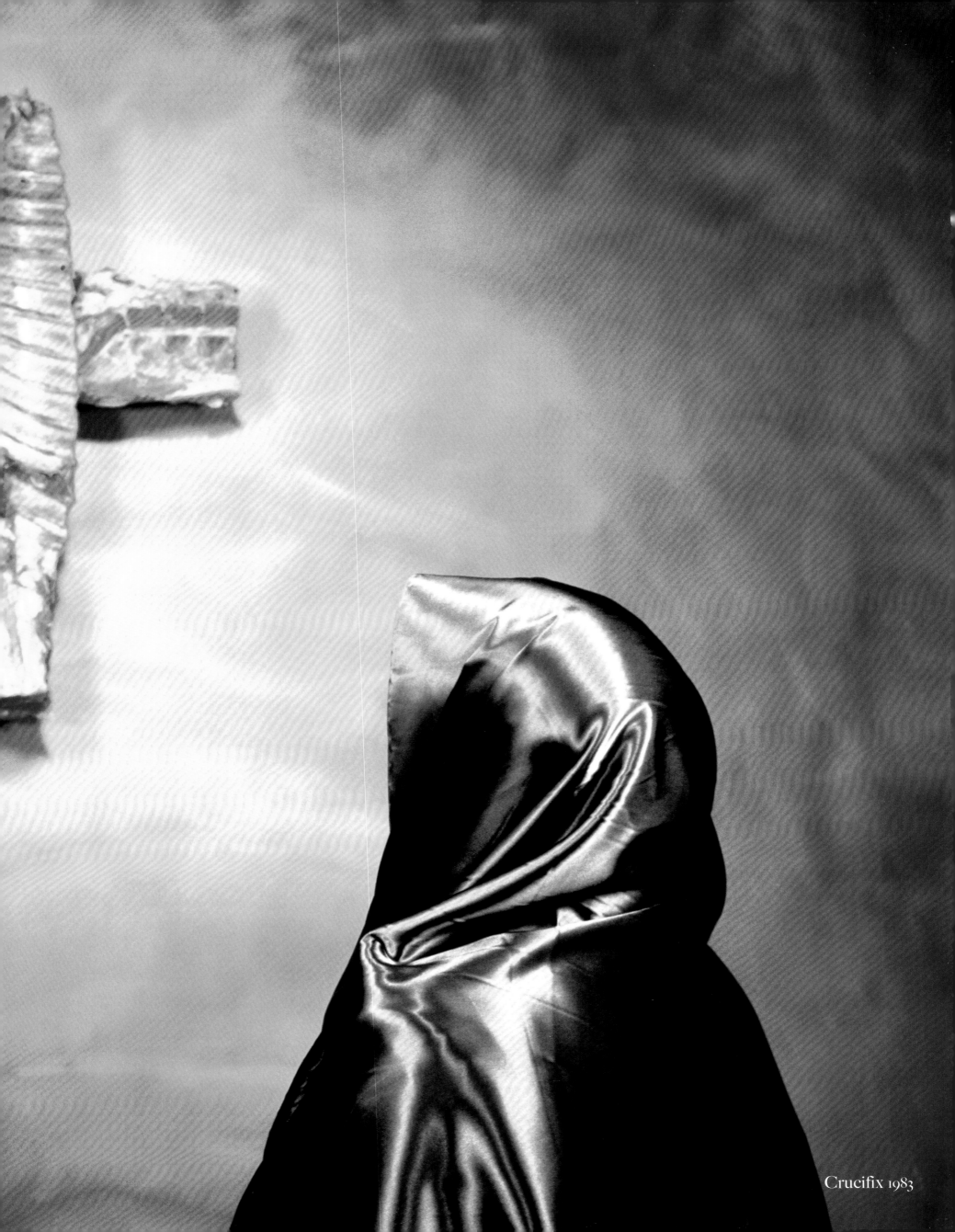

Crucifix 1983

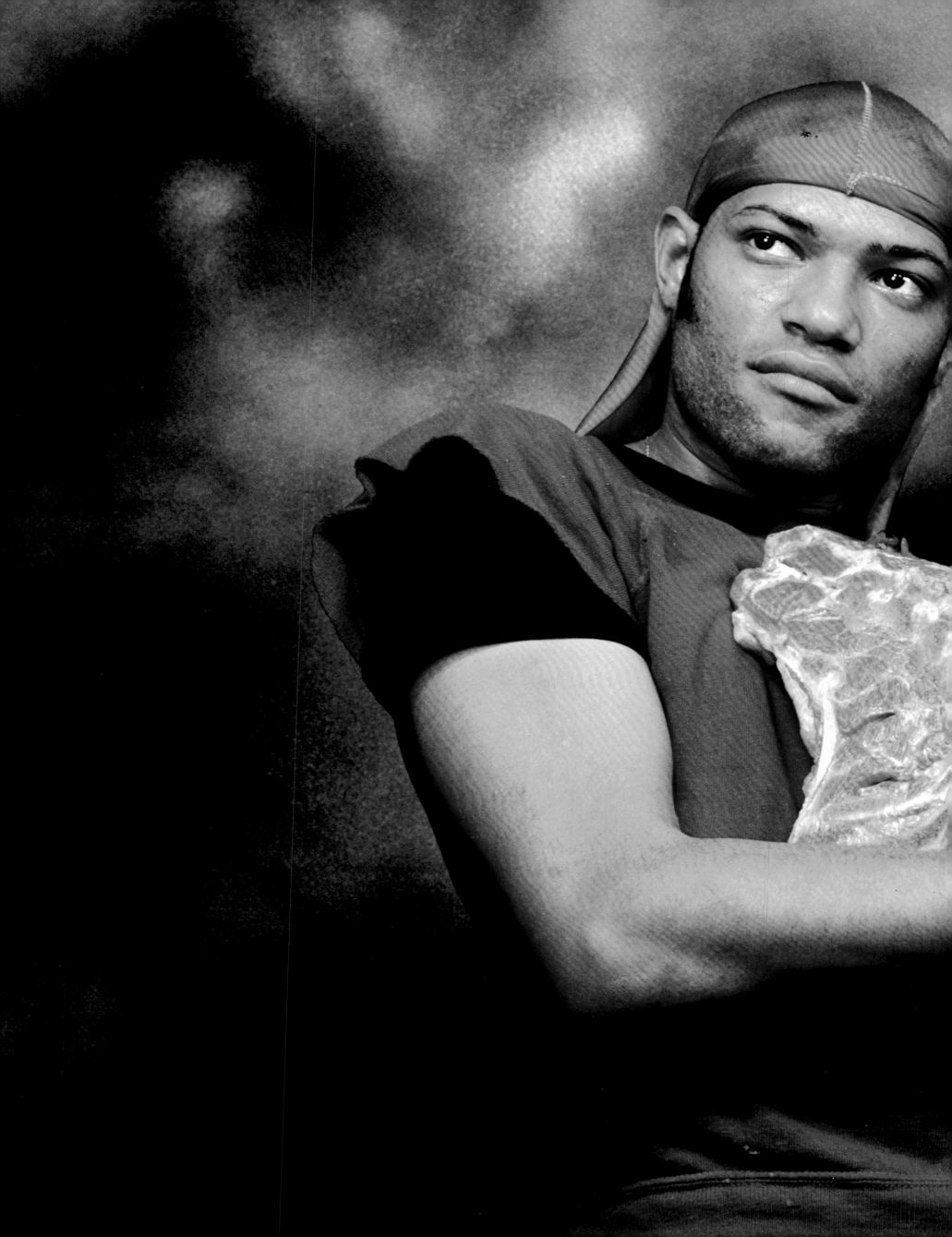

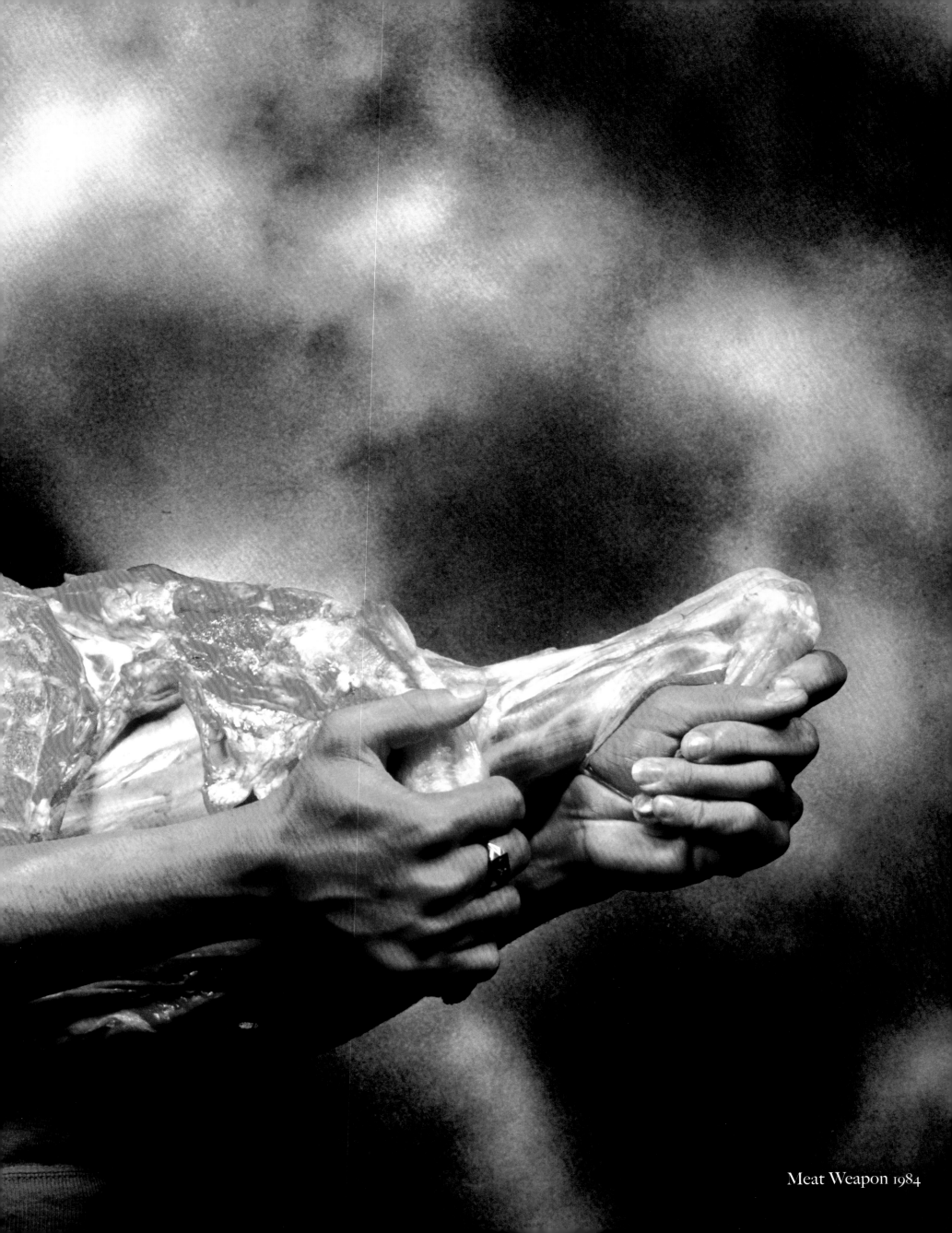

Meat Weapon 1984

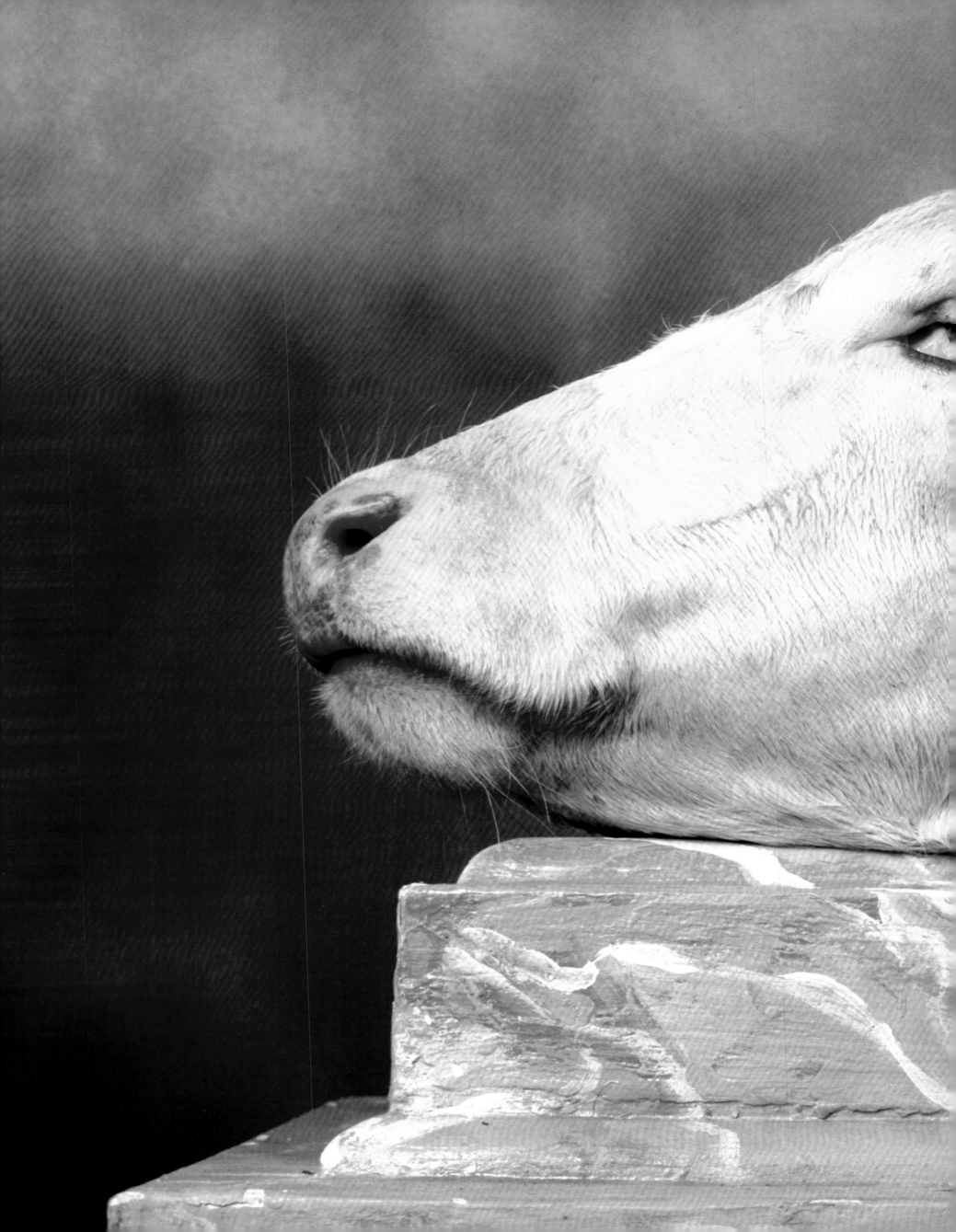

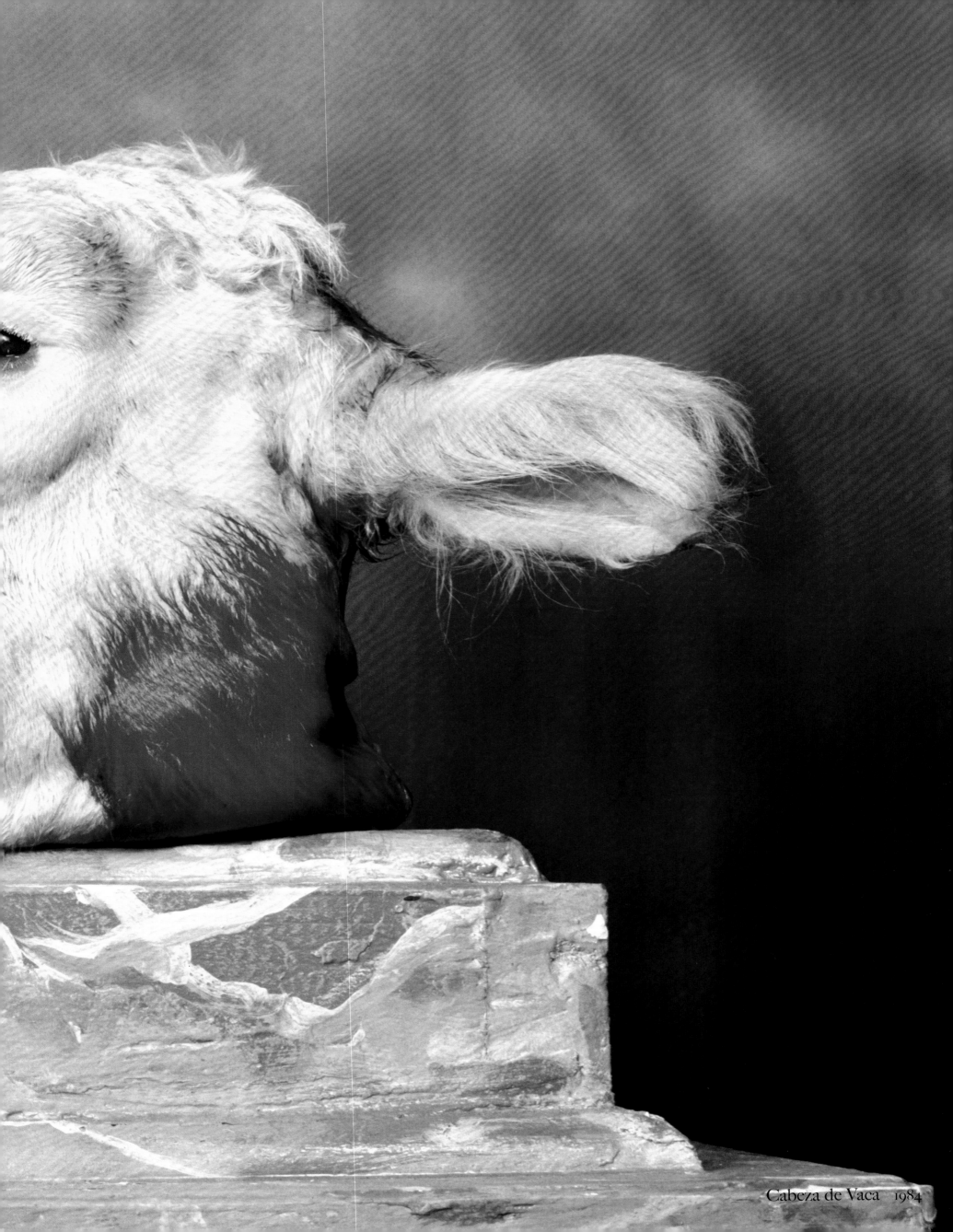

Cabeza de Vaca 1984

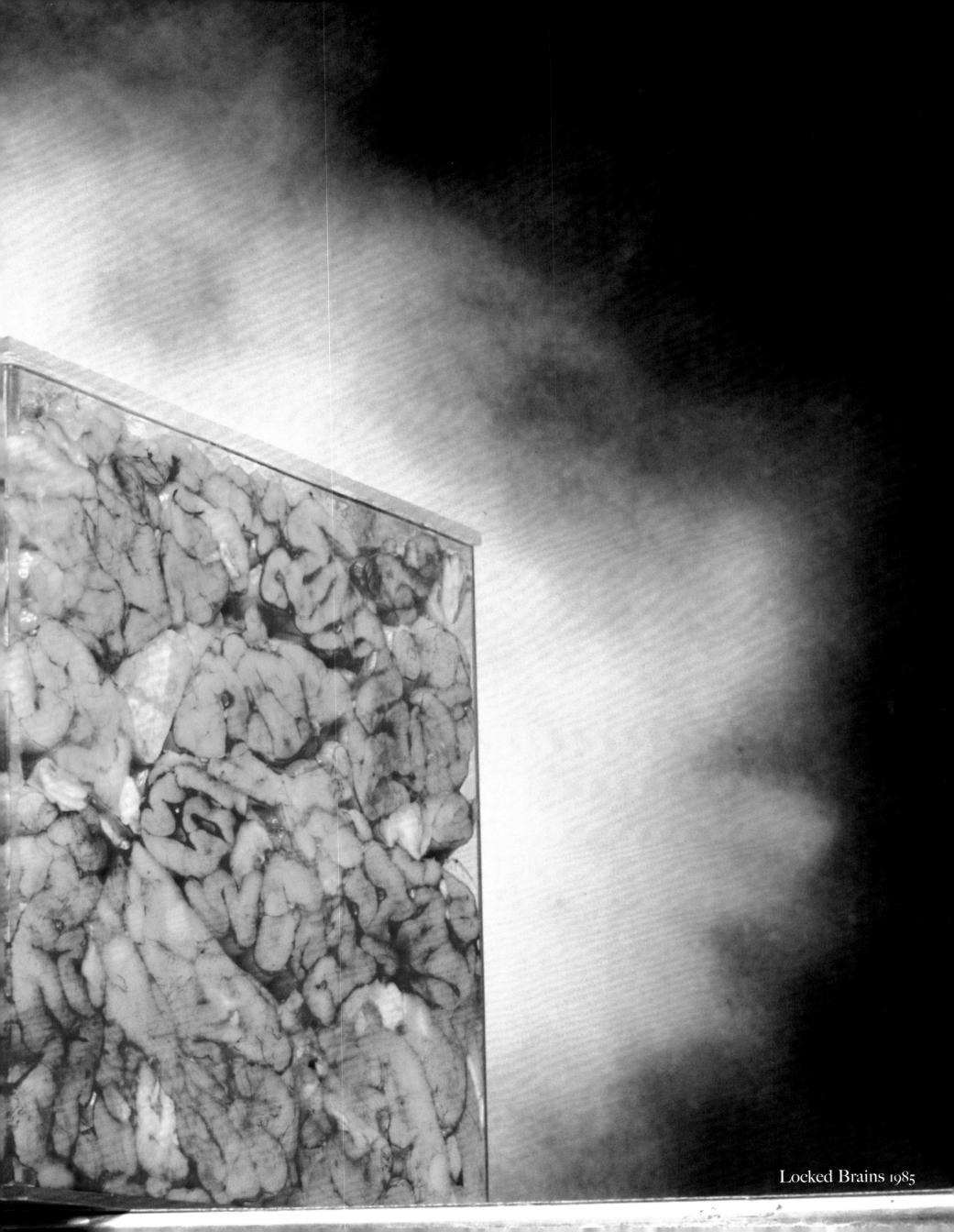

Locked Brains 1985

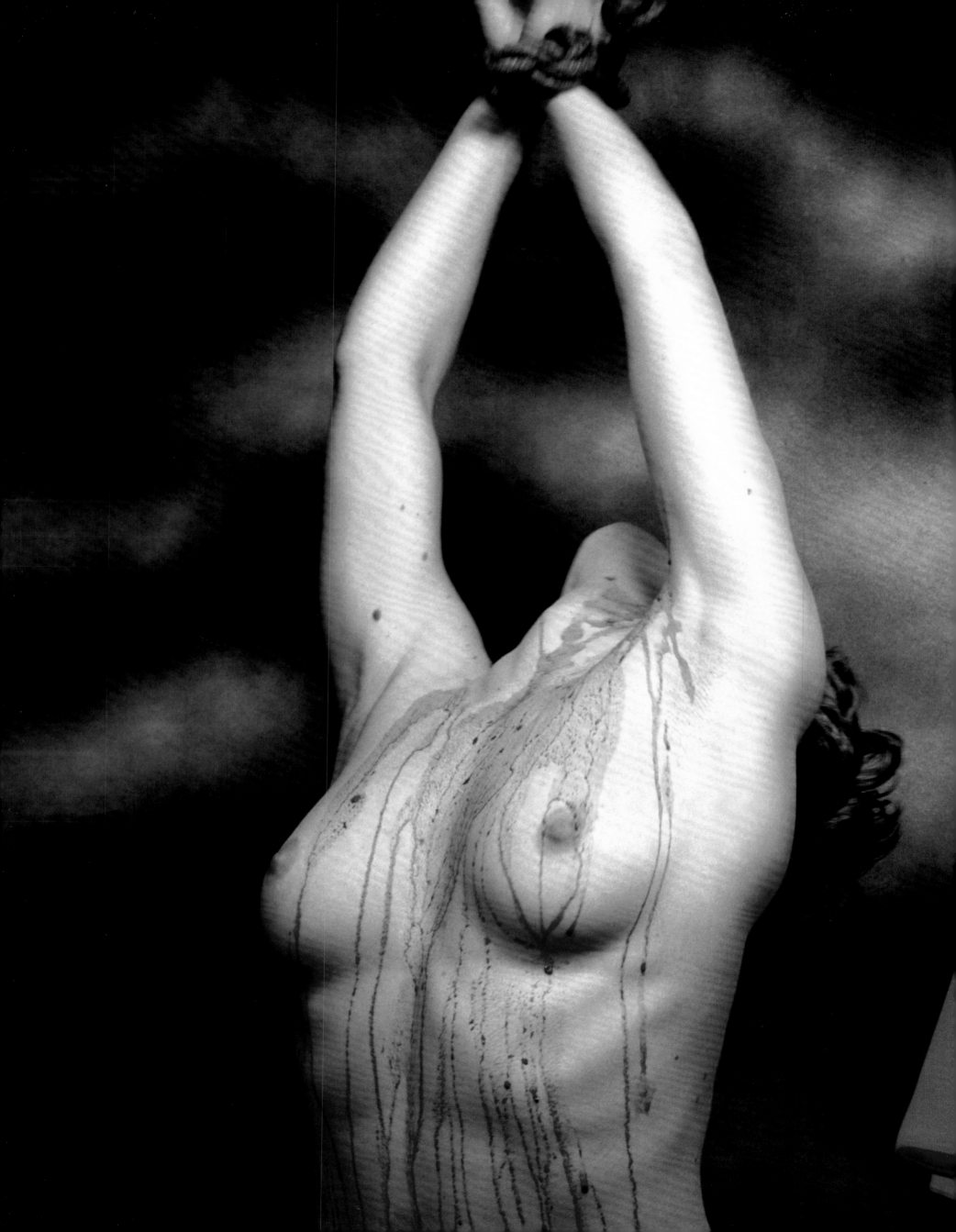

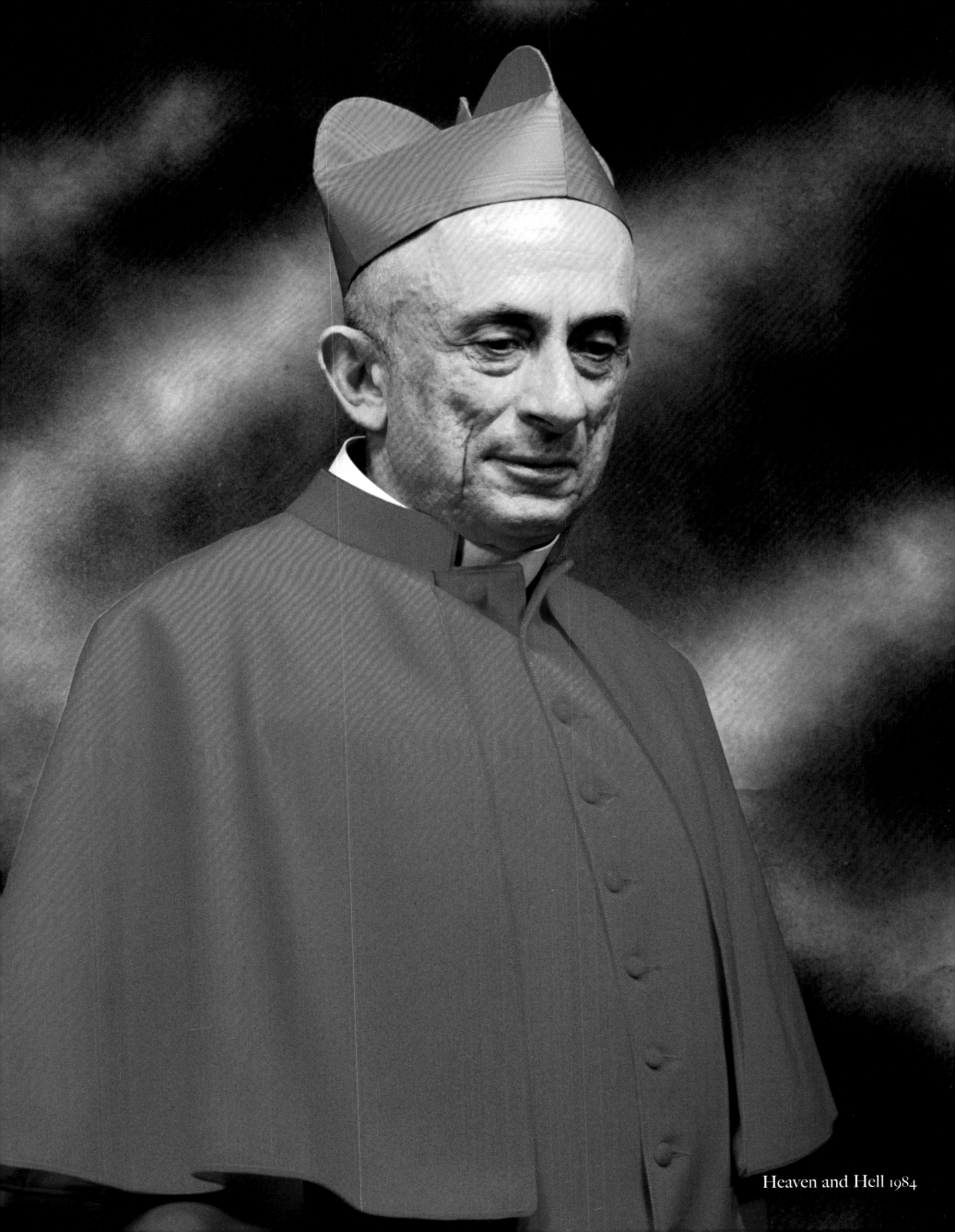

Heaven and Hell 1984

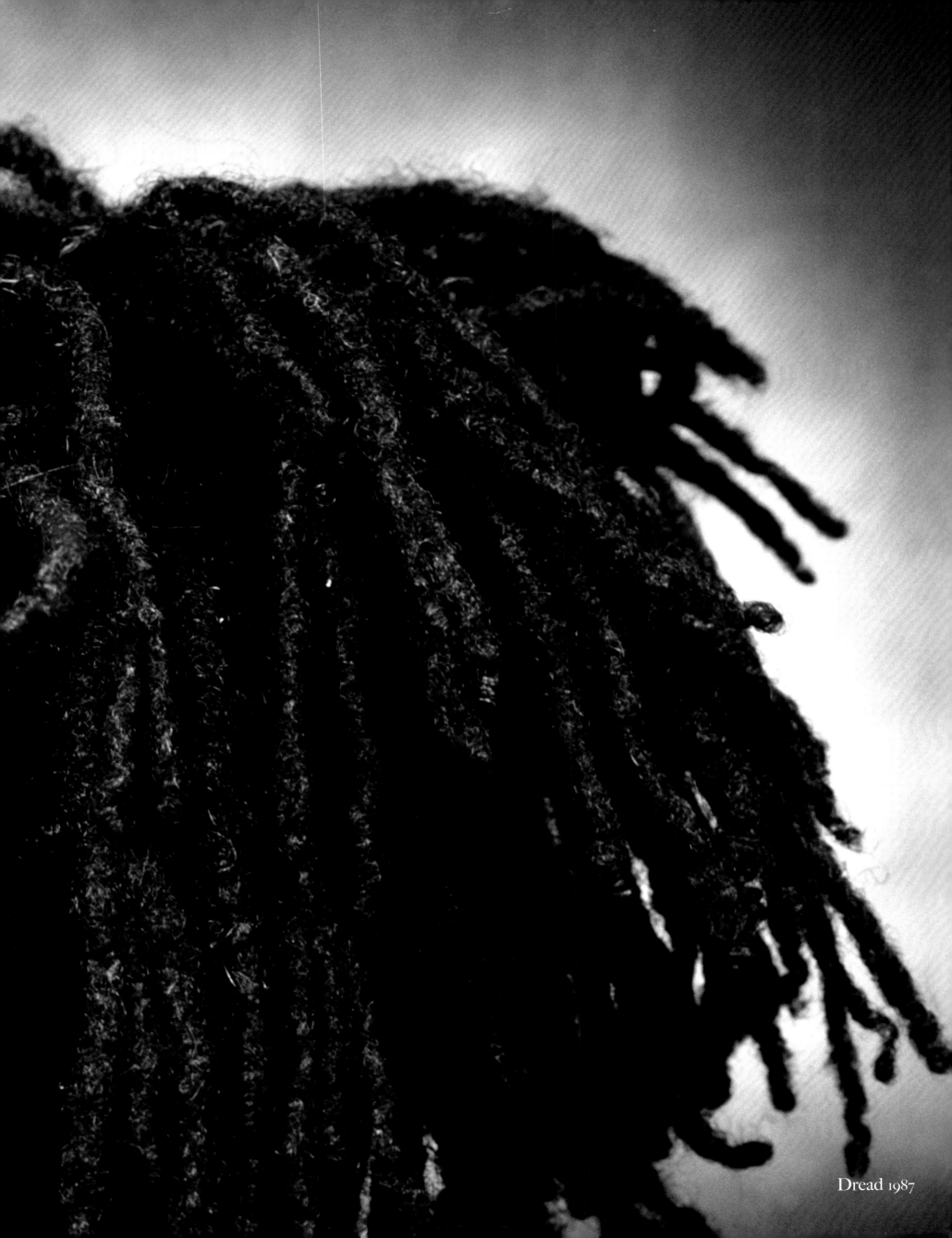

Dread 1987

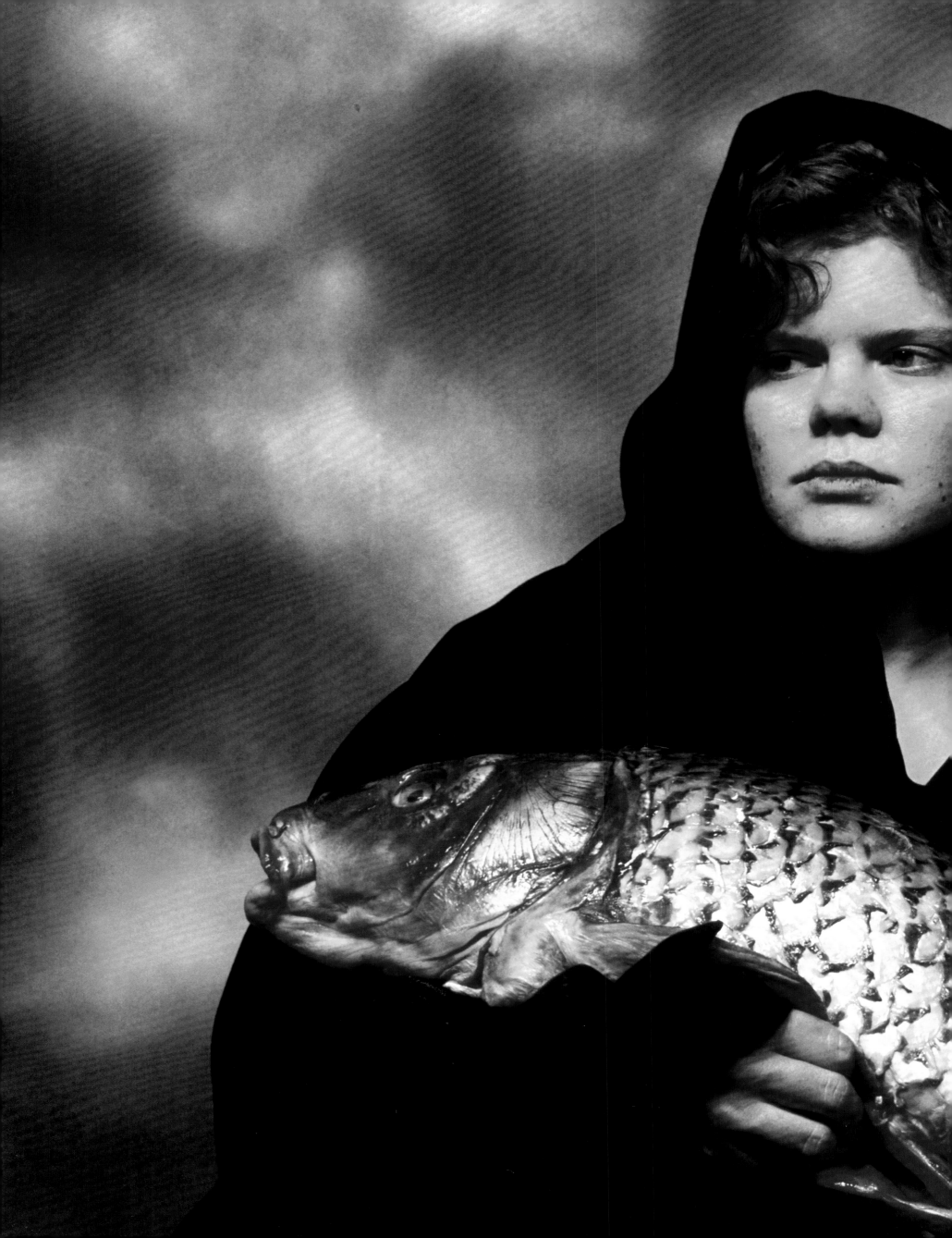

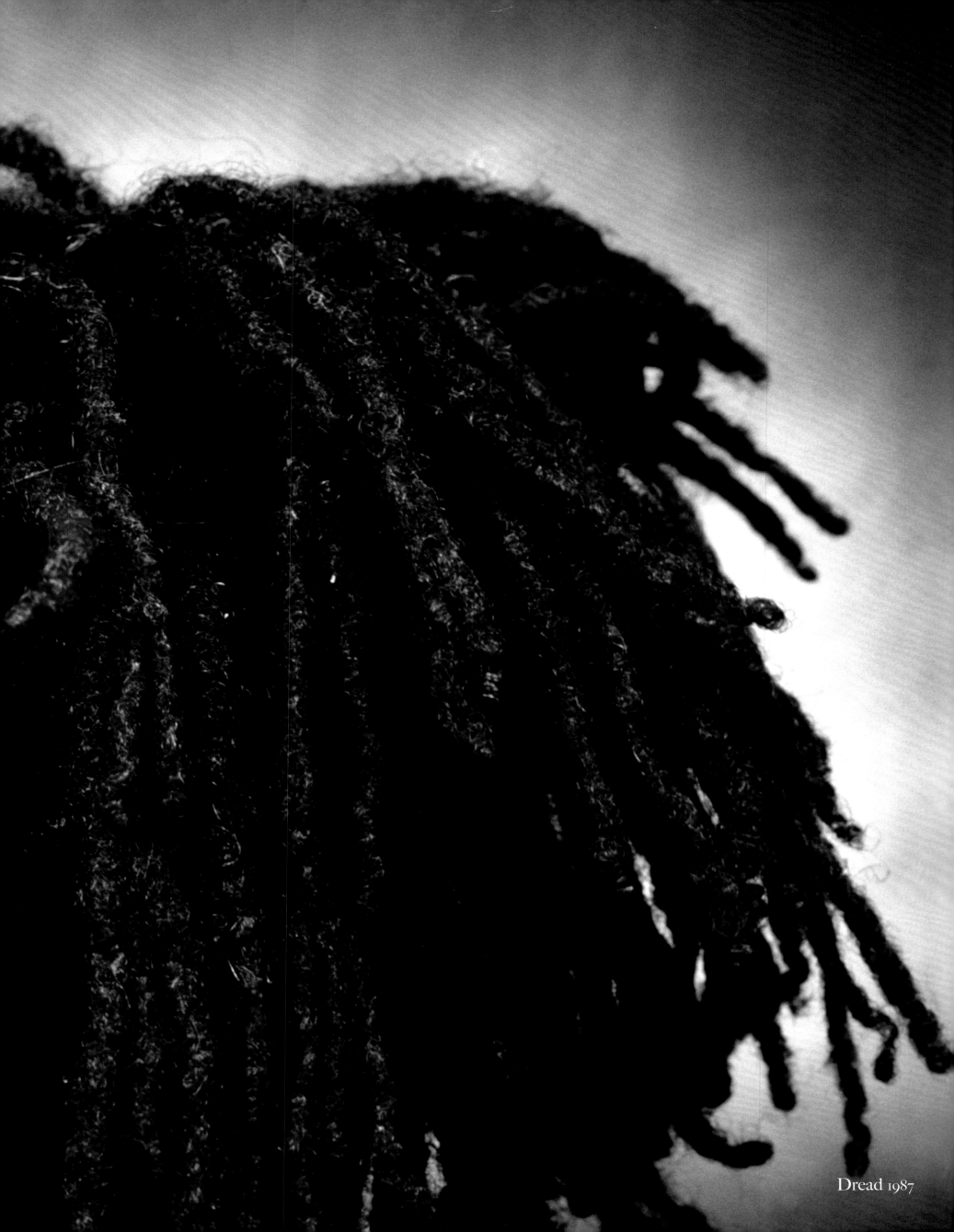

Dread 1987

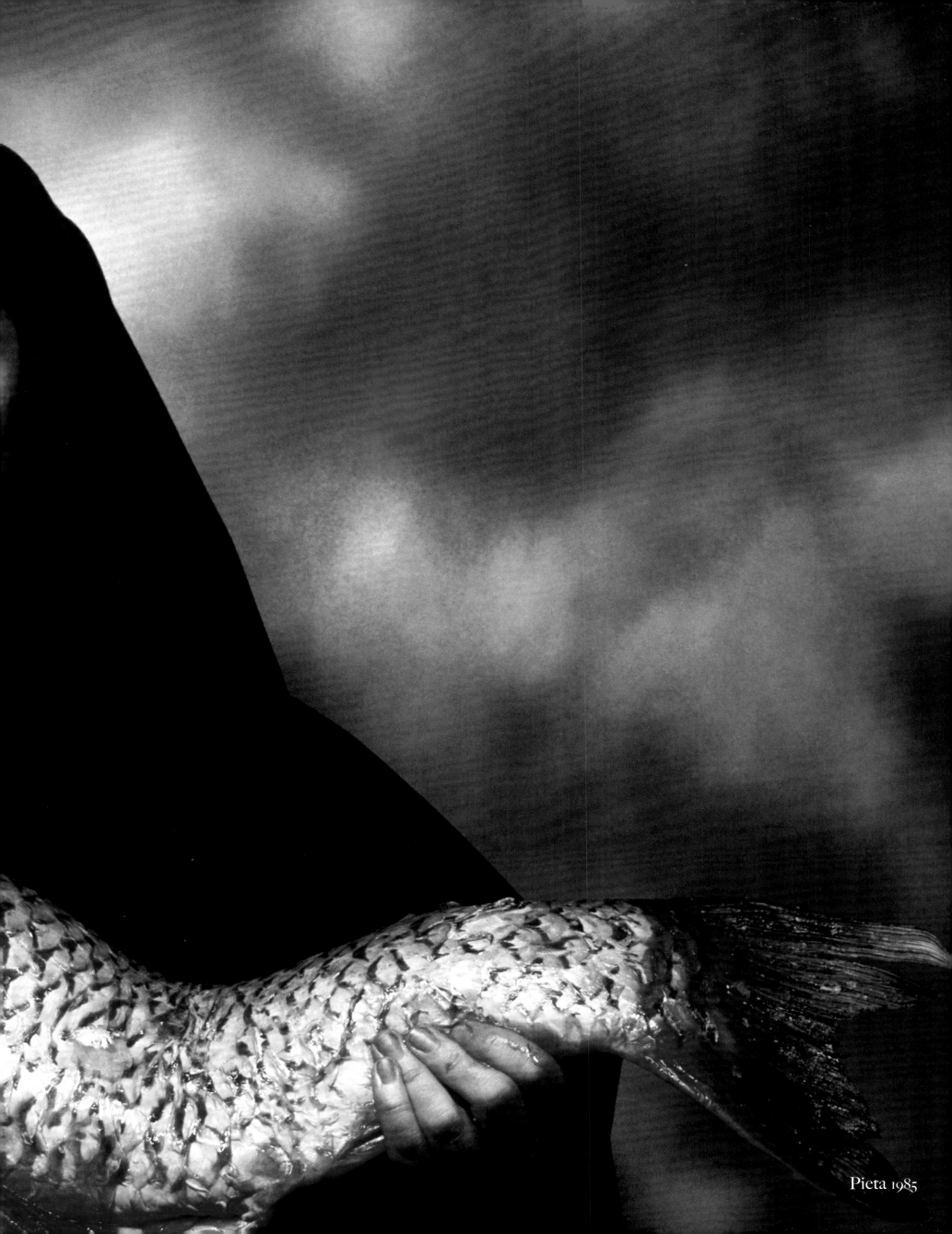

Pieta 1985

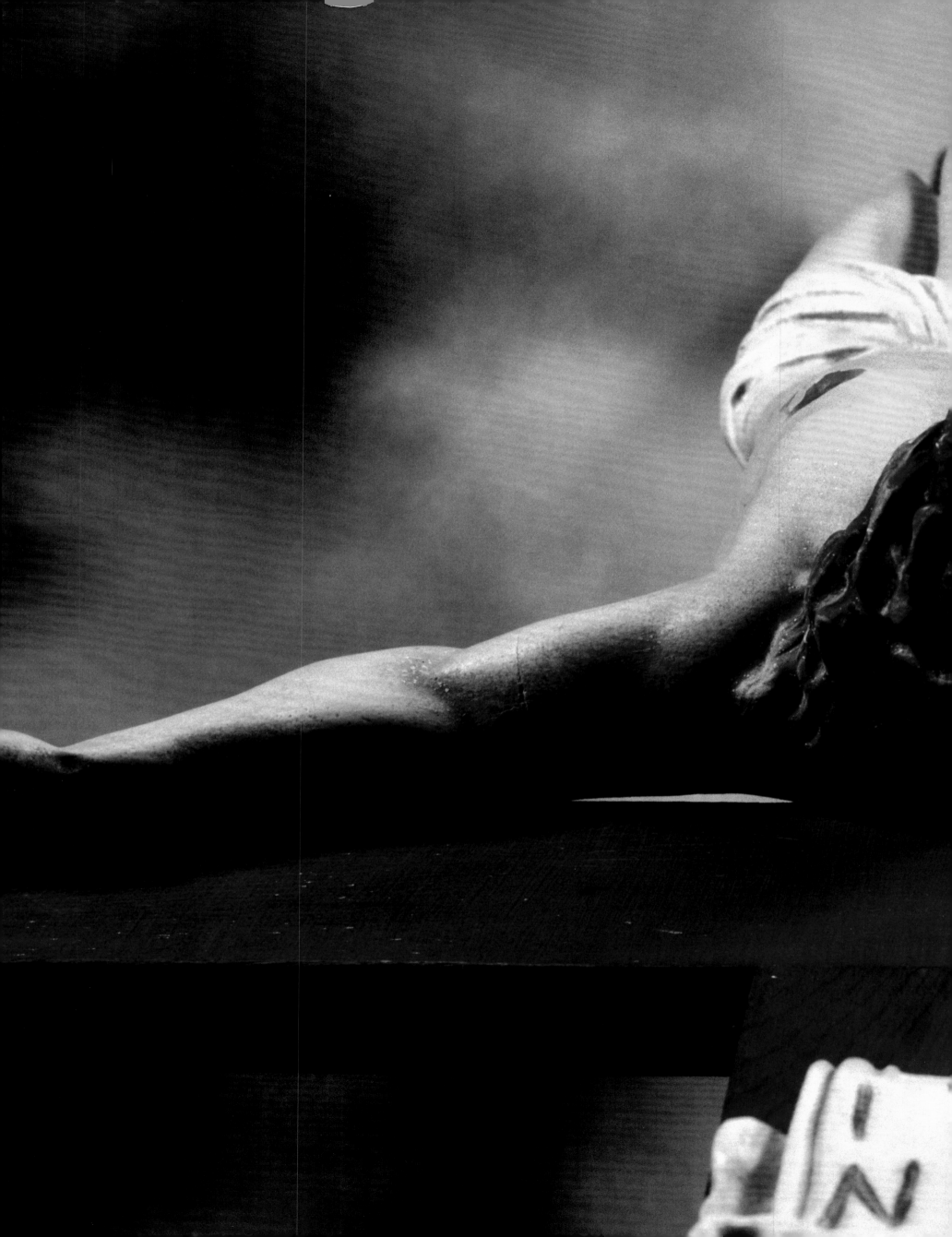

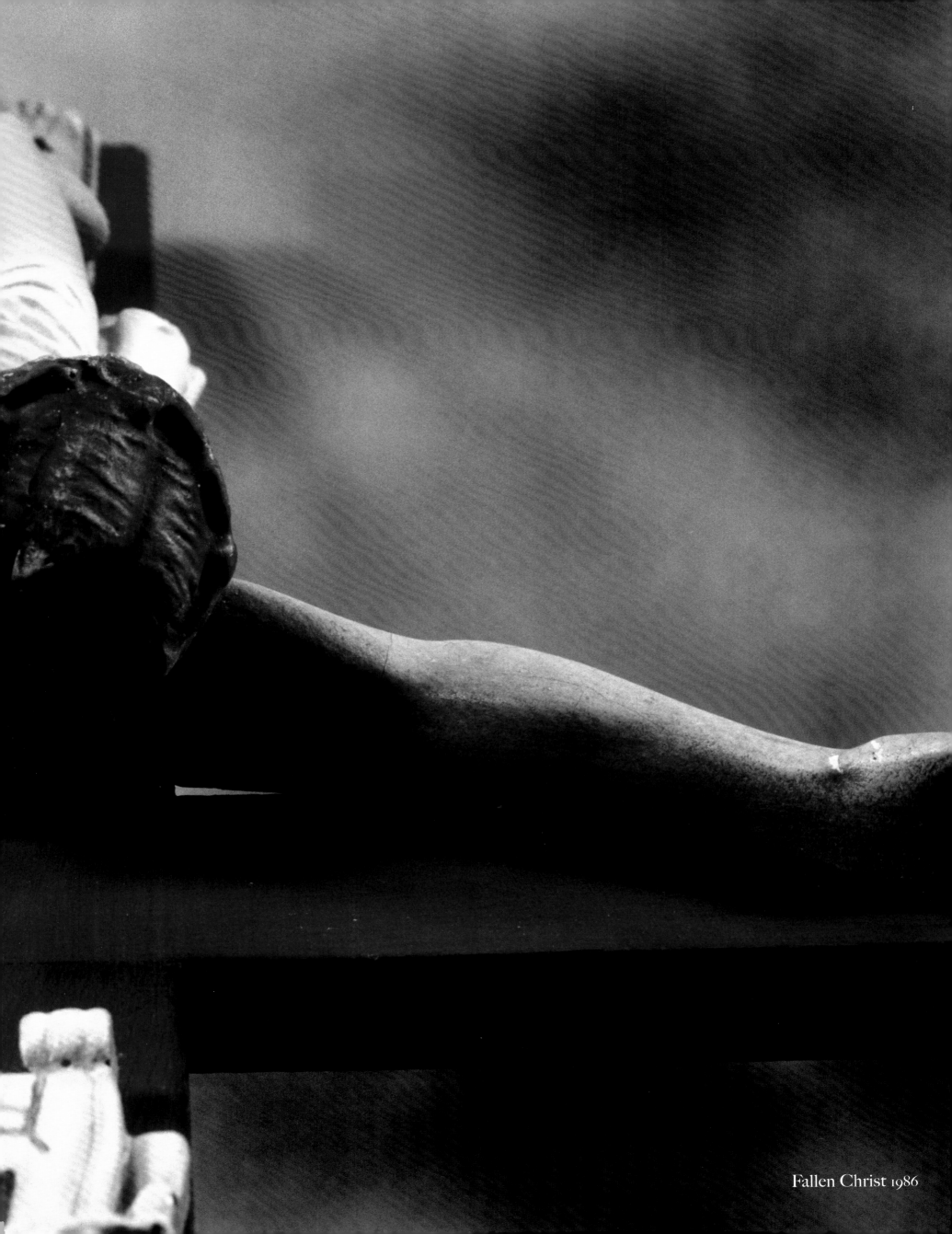

Fallen Christ 1986

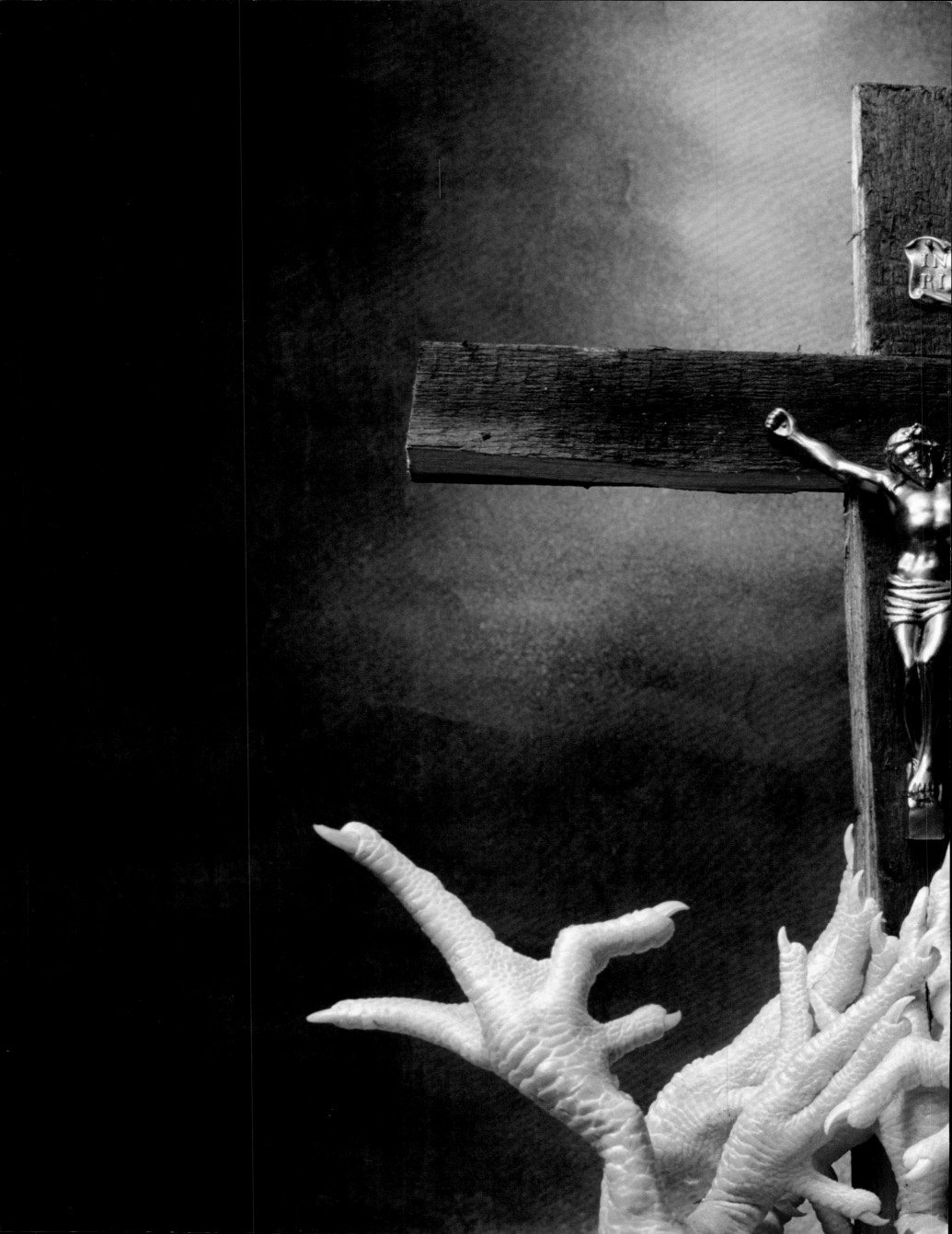

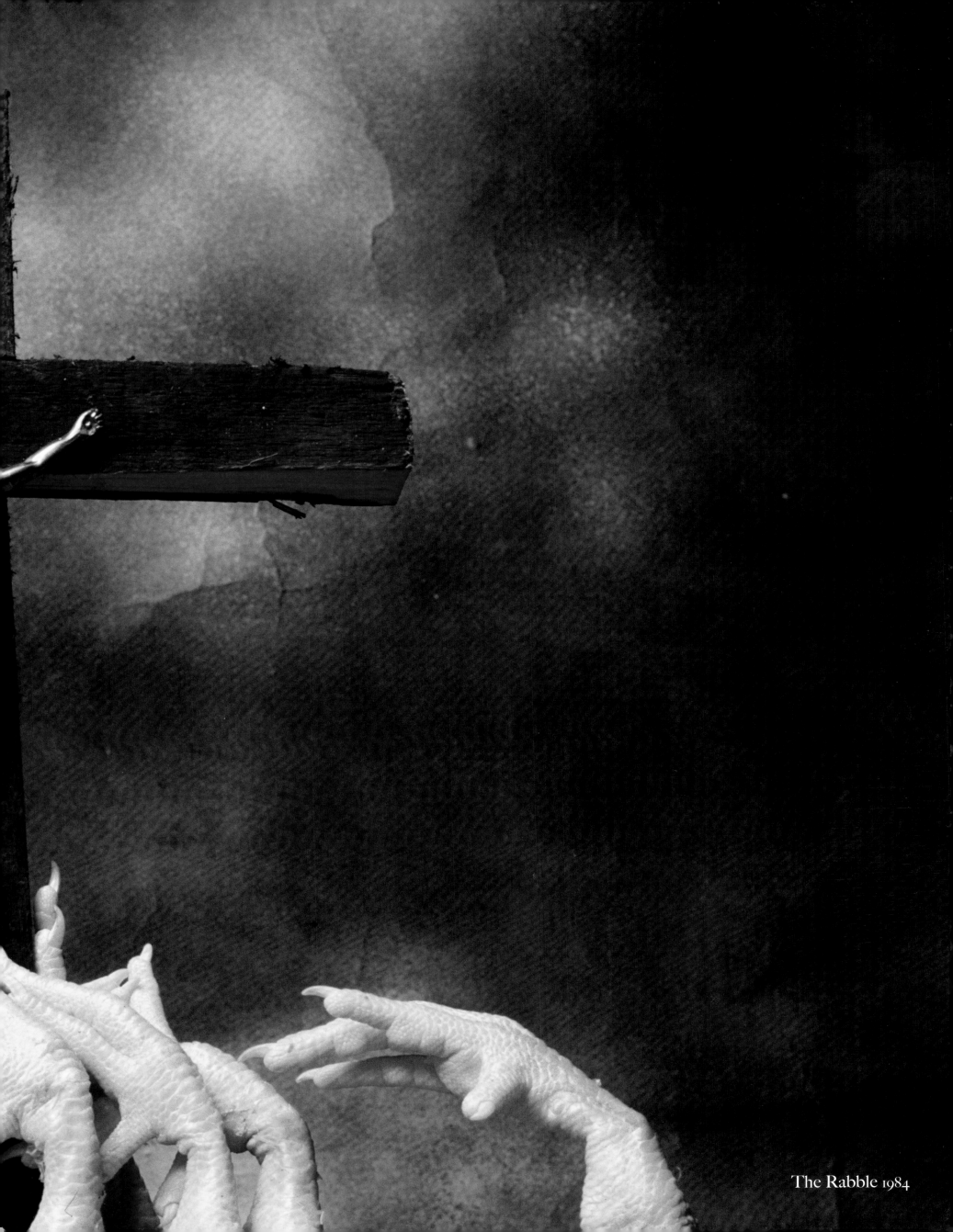

The Rabble 1984

9.11.01

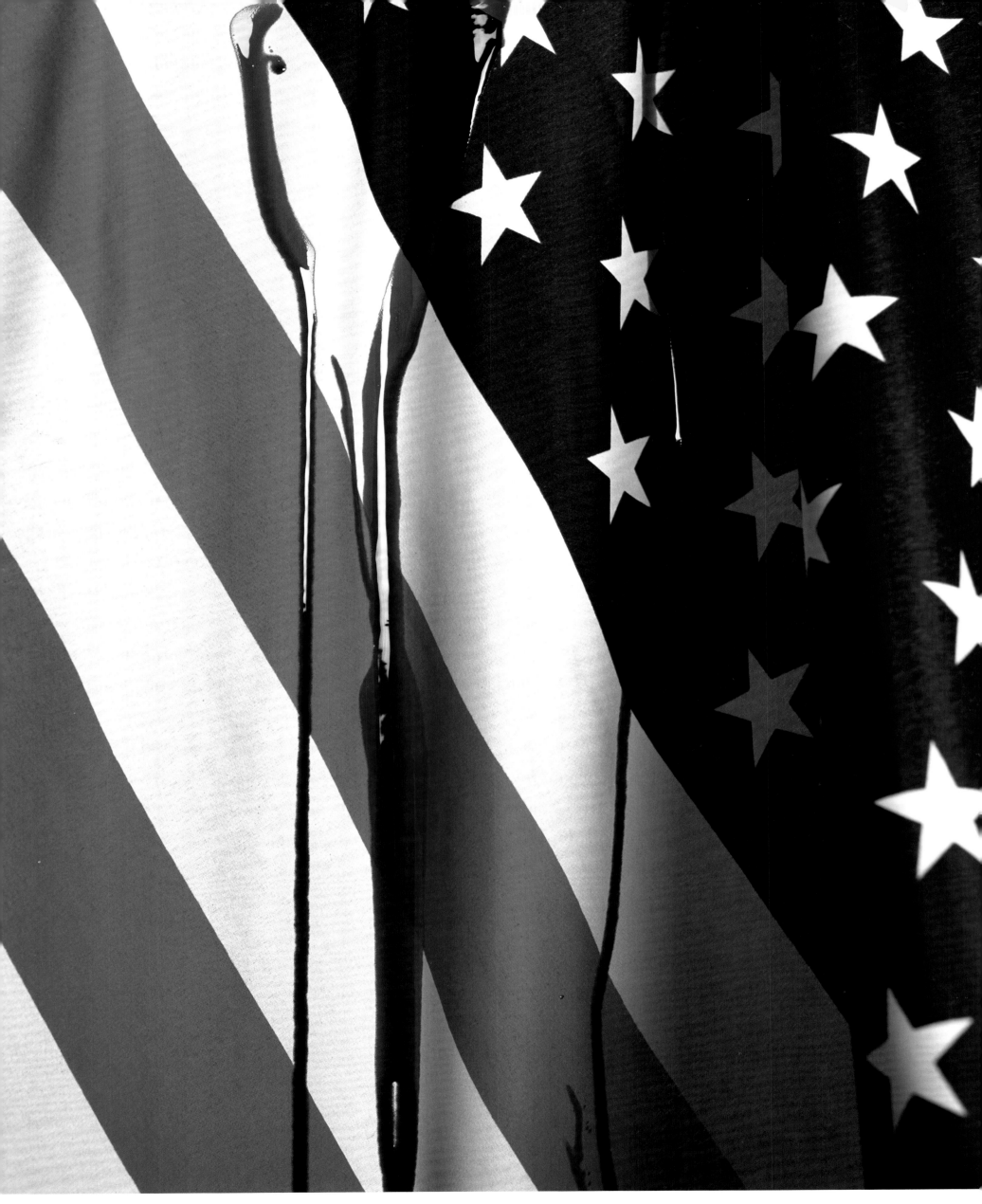

Blood on The Flag

2001

BIOGRAPHY
By Dian Hanson

Andres Serrano was born in 1950 in New York City. At age seven, the family moved to Williamsburg, Brooklyn, where he was to spend his formative years. Serrano was introduced to art at the New York Metropolitan Museum of Art, going alone at age twelve to admire the religious paintings and digest the Renaissance concepts of heaven and hell, sin and retribution. Hieronymus Bosch was one of his early favorites. "My family was Catholic, but not devoutly Catholic," he says. "It was more the aesthetics of religion — the art — and not the dogma of The Church I found intriguing." At twelve, Serrano decided to devote his life to art. At age thirteen, shortly after his Confirmation, he quit the Catholic Church completely. "There's a basic conflict between what the church tells you and what your body tells you at that age. And if you're smart, you'll listen to your body," he told interviewer Ken Paulson in 2000.

Through his teens Serrano continued pulling away from the conventional life of his Brooklyn neighborhood. At fifteen he dropped out of high school and from 1967 to 1969 studied at the Brooklyn Museum of Art School with a focus on painting and sculpture. It was while experimenting with a girlfriend's camera after leaving art school that he discovered photography as his medium and began exploring Catholic ideology and its relation to the rough reality of life in Brooklyn.

Serrano has never considered himself a photographer, but an artist who uses camera and film as a painter uses brush and pigment. He does not try to document reality, but to create carefully constructed, often cinematic tableau in vividly saturated colors. His prints are reproduced at wall-filling size to approximate the impact of those religious paintings viewed in his youth.

In 1989 Serrano was enjoying modest success when a single work suddenly thrust him into public consciousness, making him the poster-boy for controversial art.

The facts of the *Piss Christ* scandal are these: In the winter of 1988 the photograph was included in a traveling group exhibition of ten artists' work arranged by the Southeastern Center for Contemporary Art. Called "Awards In The Visual Arts 7," the show hung at the Los Angeles County Museum of Art, the Carnegie-Mellon University Art Gallery in Pittsburgh, Pennsylvania, and finished its run at the Virginia Museum of Fine Arts in Richmond, Virginia during January of 1989. To assist with the cost of shipping the art between venues the show had received a $15,000 grant from the National Endowment for the Arts.

Two days after the show closed in Virginia, a short letter to the editor appeared in the local Richmond paper from a man who'd seen the exhibition and wished to express his outrage over *Piss Christ*. This newspaper came into the hands of Donald Wildmon, a leader of the politically conservative, Christian-activist American Family Association. Wildmon drafted a letter denouncing the work, sent 178,000 copies of it to his constituents and various churches and urged all recipients to write their Congressmen to complain about the work receiving National Endowment for the Arts funding. Thousands obeyed, creating a political uproar that shook the American art establishment from top to bottom. Conservative, vote-conscious members of the US Senate joined Wildmon in painting Serrano as the enemy of all God-fearing Americans, most of whom believed that *Piss Christ* consisted of a jar containing urine and a crucifix sitting, perhaps on a pedestal, in a gallery. Few saw or would recognize the actual work, created in 1987 when Serrano was working on his *Immer-*

Andres Serrano wurde 1950 in New York City geboren. Als er sieben Jahre alt war, zog die Familie nach Williamsburg in Brooklyn, wo er aufwuchs. Serrano lernte das New York Metropolitan Museum of Art kennen, als er es bereits mit zwölf Jahren allein besuchte, um die religiösen Gemälde zu bewundern und die Vorstellungen der Renaissance von Himmel und Hölle, Schuld und Sühne zu verarbeiten. Hieronymus Bosch war schon früh einer seiner Lieblingskünstler. Mit zwölf entschloss sich Serrano, sein Leben der Kunst zu widmen. Mit dreizehn trat er aus der katholischen Kirche aus. „Es gibt da einen grundsätzlichen Widerspruch zwischen dem, was die Kirche dir sagt, und dem, was dir dein Körper in diesem Alter sagt. Und wenn du schlau bist, dann hörst du auf deinen Körper", erzählte er Ken Paulson 2000 in einem Interview.

Als Teenager entfernte sich Serrano zunehmend vom bürgerlichen Leben seiner Wohngegend in Brooklyn. Mit fünfzehn gab er die High School auf und studierte von 1967 bis 1969 an der Brooklyn Museum of Art School mit Schwerpunkt Malerei und Bildhauerei. Erst nachdem er die Schule verlassen hatte und mit der Kamera einer Freundin herumexperimentierte, entdeckte er die Fotografie für sich als Medium und begann, sich mit der katholischen Lehre und ihrem Bezug zur rauen Wirklichkeit des Lebens in Brooklyn zu beschäftigen.

Serrano betrachtete sich selbst nie als Fotograf, sondern als Künstler, der Kamera und Film so benutzt wie ein Maler Pinsel und Farbe. Er versucht nicht, die Wirklichkeit abzubilden, sondern schafft sorgfältig konstruierte, oft filmische Bilder in lebendigen, satten Farben. Seine Bilder lässt er wandfüllend vergrößern, damit sie eine ähnliche Wirkung erzielen können wie die religiösen Gemälde, die er in seiner Jugend sah.

Im Jahre 1989 war Serrano mäßig erfolgreich, als ihn ein einziges Werk plötzlich in das Bewusstsein der Öffentlichkeit rückte und ihn zum Aushängeschild kontroverser Kunst machte.

Die Tatsachen hinter dem Skandal um *Piss Christ* sind folgende: Im Winter 1988 war das Foto Teil einer Wanderausstellung mit den Werken von zehn Künstlern, die das Southeastern Center for Contemporary Art arrangiert hatte. Unter der Bezeichnung "Awards in the Visual Arts 7" war die Ausstellung im Los Angeles County Museum of Art und in der Carnegie-Mellon-University Art Gallery in Pittsburgh (Pennsylvania) zu sehen und beendete ihre Reise schließlich im Virginia Museum of Fine Arts in Richmond (Virginia) im Januar 1989. Als Beihilfe zu den Kosten, die der Transport der Kunstwerke zwischen den einzelnen Ausstellungsorten verursachte, wurde die Ausstellung mit einem Zuschuss in Höhe von $15.000 aus der Nationalen Kunststiftung (National Endowment for the Arts) bedacht.

Zwei Tage nach dem Ende der Ausstellung erschien in einer Lokalzeitung in Richmond ein kurzer Leserbrief eines Mannes, der die Ausstellung gesehen hatte und seiner Empörung über *Piss Christ* Luft machen wollte. Diese Zeitung fiel Donald Wildmon in die Hände, einem der Anführer der politisch konservativen, christlich-aktivistischen American Family Association. Wildmon setzte einen Brief auf, in dem er das Werk anprangerte, schickte 178.000 Exemplare davon an seine Anhänger sowie verschiedene Kirchen und forderte alle Empfänger auf, an ihre jeweiligen Kongressabgeordneten zu schreiben und sich darüber zu beschweren, dass das Werk Zuschüsse aus der Nationalen Kunststiftung erhalten habe. Tausende

Andres Serrano est né en 1950 à New York. A sept ans, sa famille déménagea à Williamsburg, Brooklyn, où il passa la plus grande partie de sa jeunesse. Serrano eut son premier contact avec l'art au New York Metropolitan Museum of Art, où il allait seul, à douze ans, admirer les peintures religieuses et s'imprégner des idées de la Renaissance sur le paradis et l'enfer, le péché et le châtiment. L'un de ses premiers favoris fut Hieronymus Bosch. A douze ans, Serrano décida de consacrer sa vie à l'Art. A treize, il cessa complètement de fréquenter l'Eglise. « Il y a une contradiction fondamentale entre ce que l'Eglise enseigne et ce que le corps exige à cet âge-là. Et si vous avez un peu de bon sens, vous écoutez votre corps » confia-t-il à Ken Paulson lors d'une interview en 2000.

Tout au long de son adolescence Serrano s'est distancié de la vie banale de son quartier à Brooklyn. A quinze ans, il laissa tomber l'école et de 1967 à 1969 étudia à la Brooklyn Museum of Art School plus particulièrement la peinture et la sculpture. C'est en jouant avec l'appareil d'une amie, après l'école d'art, qu'il découvrit que la photographie était son moyen d'expression et se mit à explorer les rapports entre la doctrine catholique et la dure réalité de la vie de Brooklyn.

Serrano ne s'est jamais considéré comme un photographe, mais comme un artiste qui se sert de son appareil comme un peintre se sert de sa brosse et de ses couleurs. Il n'essaie pas de photographier la réalité mais de créer un tableau soigneusement composé de couleurs vives saturées d'une qualité souvent cinématique. Ses images sont agrandies de façon à recouvrir un mur pour reproduire l'impact maximum des peintures religieuses de son enfance.

En 1989 Serrano connaissait un succès modeste, lorsqu'une de ses œuvres le révéla instantanément à la conscience du public, faisant de lui l'homme des affiches de l'art provocateur.

Voici les faits tels qu'ils se sont passés lors du scandale de *Piss Christ* : au cours de l'hiver 1988, cette photographie faisait partie d'une exposition ambulante rassemblant les œuvres de dix artistes, organisée par le Southeastern Center for Contemporary Art. Nommée pour The Visual Art 7, l'exposition fut présentée au Los Angeles County Museum of Art et à la Carnegie-Mellon University Art Gallery in Pittsburgh, Pennsylvanie, et termina sa tournée au Virginia Museum of Fine Arts à Richmond en janvier 1989. Pour couvrir une partie des frais de transport entre les différentes locations, l'exposition avait bénéficié d'une subvention de $15 000 du National Endowment for the Arts.

Deux jours après la fin de l'exposition, une courte lettre publiée dans le journal local de Richmond, envoyée par un visiteur de l'exposition exprimant son indignation à propos de *Piss Christ*. Le journal tomba entre les mains de Donald Wildmon, l'un des dirigeants de l'American Family Association, une association militante chrétienne et conservatrice. Wildmon rédigea une lettre dénonçant la photographie et en envoya 178 000 copies à tous les membres de l'association et à diverses églises, en leur demandant d'écrire à leurs représentants au Congrès pour se plaindre que l'œuvre avait été subventionnée par le National Endowment for the Arts. Des milliers de gens s'exécutèrent, créant un scandale politique sans pareil dans le monde de l'art américain. La partie conservatrice du Sénat des Etats-Unis, soucieuse des votes de ses électeurs, se joignit à Wildmon pour déclarer que Serrano était l'ennemi de tous les Américains dévots, dont la plupart croyait que *Piss Christ* était composé d'un bocal d'urine et d'un

sions and *Bodily Fluids* series, challenging the taboos surrounding blood, semen and urine in works utilizing the fluids' colors and luminosity. It had long been Serrano's habit to name his works by simply stating their elements. Thus, a photograph from *The Morgue* series is titled *Gun Murder* and a photo from *A History of Sex* is titled *The Fisting*, and a cheap plastic crucifix photographed through the gorgeous golden haze of urine is titled *Piss Christ*. No matter that *Piss Satan* hung right next to *Piss Christ*; conservative Americans were outraged, especially imagining that some fraction of a penny of their taxes had subsidized the heresy.

The battle to end NEA funding of controversial art was waged in the US Senate and in news media across the country through 1989 and into 1990. Senator Jesse Helms famously said of Serrano, "… he is not an artist. He is a jerk. And he is taunting the American people … in terms of Christianity." Serrano was stung by the controversy, especially the misunderstanding of his intentions with the work, but it was a tremendous boost to his career. The series that followed: *Nomads*, *The Klan*, *The Morgue*, *A History of Sex*, *The Interpretation of Dreams* and now *America* have been enthusiastically received worldwide, if burdened with occasional censorship. When A History of Sex was to premier in Holland in 1997 the Groningen Museum selected a photo featuring a woman urinating in a man's mouth for the promotional poster. Three weeks before the show a lawyer representing several schools and churches in the city moved to get an injunction against its display. Just before the show opened the museum solved the dilemma with a stark black and white poster reading simply, Groningen Museum: You Decide. The furor brought 90,000 people to the show and turned the forbidden poster into an instant collectable.

A few months later, when the same retrospective traveled to The National Gallery in Victoria, Australia, it again hit a nerve. This time the Archbishop of Melbourne sought an injunction against *Piss Christ*. Failing to get a favorable decision in court, the show opened. Two days later someone attacked the picture with a hammer and the show came down. After two weeks of daily news accounts Jeff Kennett, the conservative Premier and Arts Minister of Victoria, lamented to the press that it was time for Mr. Serrano "to go home." In the end, more people heard about the work than would ever have seen it at The National Gallery.

To date, Serrano has had over one hundred solo exhibitions in galleries and museums from Iceland to Australia. Individual works have appeared in hundreds more group exhibitions. His photographs are in the permanent collections of museums in eight countries, including the Whitney Museum of American Art in New York City; The National Gallery of Australia, Canberra, Australia; the Museo Nacional Centro de Arte Reina Sofia, Madrid, Spain; the Institute of Contemporary Art, Amsterdam, Holland; and the Museum of Contemporary Art, Zagreb, Croatia. He is an occasional contributor to *The New York Times Magazine*, provided photographs for two Metallica album covers ("Load" and "ReLoad"), and — so much for taunting Christianity — supplied an image from *The Morgue* series for the cover of a revised version of the New Testament.

Andres Serrano currently lives in Manhattan with his Dalmatian, Luther, and collects 16th and 17th-century religious art.

kamen der Aufforderung nach und zettelten damit einen politischen Aufstand an, der das amerikanische Kunstestablishment in seinen Grundfesten erschütterte. Konservative US-Senatoren auf der Jagd nach Wählerstimmen schlossen sich Wildmon an und stellten Serrano als Feind aller gottesfürchtigen Amerikaner dar, von denen die meisten dachten, *Piss Christ* bestehe aus einem Glas mit Urin und einem Kruzifix, das, vielleicht auf einem Sockel, in einer Galerie stand. Die wenigsten sahen oder erkannten das eigentliche Werk, das 1987 entstanden war, als Serrano an seinen Reihen Immersions und Bodily Fluids arbeitete, mit denen er die Tabus in Frage stellen wollte, die Blut, Sperma und Urin umgeben, indem er in den Werken die Farbe und Leuchtkraft der Körperflüssigkeiten nutzte. Auch wenn *Piss Satan* gleich neben *Piss Christ* hing: Konservative Amerikaner waren empört, besonders bei dem Gedanken, dass auch ein Bruchteil ihrer Steuern diese Ketzerei gefördert hatte.

Die Schlacht um die Beendigung der Förderung umstrittener Kunst durch die NEA wurde 1989 und bis ins Jahr 1990 hinein im US-Senat und in den Medien ausgetragen. Senator Jesse Helms charakterisierte Serrano mit dem berühmten Ausspruch: „… er ist kein Künstler. Er ist ein Trottel. Und er verspottet das amerikanische Volk … in Sachen Christentum." Serrano fühlte sich durch die Kontroverse verletzt, insbesondere davon, wie seine Absichten missverstanden wurden, doch sie gab seiner Karriere enormen Auftrieb. Die Fotoreihen, die darauf folgten – *Nomads*, *The Klan*, *The Morgue*, *A History of Sex*, *The Interpretation of Dreams* und nun *America* wurden weltweit begeistert aufgenommen, auch wenn sie hin und wieder mit der Zensur zu kämpfen hatten. Als *A History of Sex* 1997 zum ersten Mal in den Niederlanden gezeigt wurde, wählte das Groningen Museum ein Foto mit einer Frau, die in den Mund eines Mannes uriniert, für das Werbeplakat der Ausstellung. Drei Wochen vor Beginn der Ausstellung erwirkte jedoch ein Rechtsanwalt, der im Auftrag mehrerer Schulen und Kirchen auftrat, eine einstweilige Anordnung gegen das Aufhängen des Plakats. Kurz vor Beginn der Ausstellung zog sich das Museum mit einem schlichten Schwarzweißplakat aus der Affäre, auf dem nur zu lesen war: „Groningen Museum: Du entscheidest". Der Aufruhr lockte 90.000 Menschen in die Ausstellung und machte das verbotene Plakat umgehend zum begehrten Sammlerobjekt.

Bis heute kann Serrano auf über hundert Einzelausstellungen in Galerien und Museen von Island bis Australien zurückblicken. Einzelne seiner Werke waren in vielen Gruppenausstellungen zu sehen. Seine Fotografien hängen in den ständigen Sammlungen von Museen in acht Ländern, darunter das Whitney Museum of American Art in New York City, die National Gallery of Australia, Canberra, das Museo Nacional Centro de Arte Reina Sofia, Madrid, das Institut für zeitgenössische Kunst (ICA), Amsterdam, und das Museum für zeitgenössische Kunst in Zagreb. Er schreibt gelegentlich für *The New York Times Magazine*, steuerte Coverfotos zu zwei Alben von Metallica bei (Load und ReLoad) und – so viel zur Verspottung des Christentums – stellte ein Bild aus der Reihe *The Morgue* zur Verfügung für den Umschlag einer überarbeiteten Fassung des Neuen Testaments.

Andres Serrano lebt gegenwärtig in Manhattan mit seinem Dalmatiner Luther und sammelt religiöse Kunst aus dem 16. und 17. Jahrhundert.

crucifix posé, peut-être sur un piédestal, dans une galerie. Peu d'entre eux avaient vu ou reconnu l'œuvre, créée en 1987, quand Serrano travaillait sur ses séries Immersions et Bodily Fluids, défiant les tabous sur le sang, le sperme et l'urine dans des travaux utilisant les couleurs et la luminosité des fluides. Les conservateurs américains étaient scandalisés, surtout en imaginant qu'une infime fraction de leurs impôts avait servie à subventionner l'hérésie.

La bataille pour mettre fin aux subventions de la NEA à l'art contestataire a fait rage au Congrès américain et dans les média à travers le pays pendant toute l'année 1989 et une partie de 1990. Le sénateur Jesse Helms est connu pour avoir dit de Serrano « …ce n'est pas un artiste. C'est un pauvre type. Et il ridiculise le peuple américain… sur la Chrétienté. » Serrano fut blessé par la polémique, surtout par l'incompréhension de ses intentions, mais ce fut un formidable coup de publicité pour sa carrière. Les séries qui suivirent : *Nomads*, *The Klan*, *The Morgue*, *A History of Sex*, *The Interpretation of Dreams* et actuellement *America* ont été acclamées dans le monde entier, surtout si elles avaient été interdites par la censure. Lors de la première exposition aux Pays-Bas de *A History of Sex*, le musée de Groningen avait choisi, pour son affiche, la photo d'une femme urinant dans la bouche d'un homme. Trois semaines avant l'ouverture, un avocat représentant plusieurs écoles et églises de la ville déposa une plainte pour en empêcher l'affichage. Juste avant l'ouverture, le musée résolut le problème en présentant une affiche en noir et blanc sur laquelle on pouvait lire Le musée de Groningen : à vous de juger! L'engouement précipita 90 000 personnes à l'exposition et l'affiche censurée devint instantanément un objet de collection.

Quelques mois plus tard, lorsque la même rétrospective fut exposée à The National Gallery de Victoria, Australie, elle toucha un point sensible. Cette fois-ci, l'archevêque de Melbourne sollicita une injonction judiciaire contre *Piss Christ*. La Cour ayant refusé de donner suite à sa requête, l'exposition ouvrit ses portes. Deux jours après, quelqu'un attaquait la photo à coups de marteau ce qui provoqua la fermeture de l'exposition. Après deux semaines d'articles quotidiens dans les journaux, le Premier Ministre conservateur et Ministre de la Culture, M. Jeff Kennett, exprimait ses regrets à la presse en déclarant que le temps était venu pour M. Serrano de « plier bagage ». A la fin, plus de gens avaient entendu parler de l'œuvre qu'il n'aurait pu y avoir de visiteurs à l'exposition.

Jusqu'à aujourd'hui, Serrano a déjà eu une centaine d'expositions personnelles dans les galeries et les musées de l'Islande à l'Australie. Ses travaux ont été exposés dans des centaines d'expositions de groupes. Ses photographies font partie de la collection permanente de plusieurs musées dans huit pays, y compris le Whitney Museum of American Art de New York ; la National Gallery of Australia de Canberra; le Museo Nacional Centro de Arte Reina Sofia de Madrid, Espagne ; the Institute of Contemporary Art d'Amsterdam, Pays-Bas et le Museum of Contemporary Art de Zagreb, Croatie. Il travaille occasionellement pour *The New York Times Magazine*, et a fait les photographies des deux pochettes d'albums de Metallica (Load et ReLoad), et – autant pour ridiculiser la Chrétienté – il a fourni une photo de la série *The Morgue* pour la couverture d'une nouvelle édition du Nouveau Testament.

Andres Serrano habite à Manhattan avec son dalmatien Luther et collectionne les objets d'art religieux des XVI^e et XVII^e siècles.

SELECTED BIBLIOGRAPHY

ONE PERSON EXHIBITIONS

2004
America, Galleria Photology, Milano, Italy, January 31st to April 3rd

2003
America, Paula Cooper Gallery, New York, NY, December 10th to January 17th '04
Orizzonti – Belvedere dell'Arte, Firenze Mostre, Florence, Italy, July 7th to October 26th
Works 1985-2002, Andre Simoens Gallery, Belgium, April 20th to April 27th
Ekthesi Photographias, Kalfayan Gallery, Thessaloniki, Greece
A History of Sex, 5th Thessaloniki Documentary Festival-Images of the 21st Century, Greece, March
America, Chac Mool Gallery, Los Angeles, CA, January 17th to February 1st

2002
Body and Soul, Traveling Exhibition, MEO, Budapest, Hungary February 9th to March 10th
Andres Serrano, Reali Arte Contemporarea, Brescia, Italy, February
Andres Serrano's Via Crucis, Ex Church S. Marta, Rome, October 3rd to October 10th
America, Gimpel Fils, London, England, October 25th to November 30th

2001
World Without End, The Cathedral of Saint John The Divine, New York, NY, February 28th to April 15th
The Beauty of Evil (De Schoonheid van het Kwaad), De Zonnehof, Center for Modern Art, Amersfoort, Netherlands, October 14th to April 14th '02
Objects of Desire, Andre Simoens Gallery, Knokke-Zoute, Belgium, April 13th to May 21st
The Interpretation of Dreams, Paula Cooper Gallery, New York, NY, May 12th to June 8th
The Interpretation of Dreams, Photology, Milano, Italy, September 20th to November 17th
The Interpretation of Dreams, Galleri Charlotte Lund, Stockholm, Sweden, October 25th to December 8th
Body and Soul, The Barbican (The Curve), London, England, October 4th to December 23rd
Andres Serrano: La Interpretación de los Sueños, Juana de Aizpuru Gallery, Madrid, Spain, November

2000
Body and Soul, Traveling Exhibition, Bergen Art Society, Bergen, Norway, February 24th to March 19th; Rogaland Kunst Museum, Stavanger, Norway, April 26th to May 21st; Tromsø Art Society, Tromsø, Norway, June 8th to August 13th; Stenersenmusett, Olso, Norway, August 21st to October 15th; Helsinki City Art Museum, Helsinki, Finland, November 1st to December 31st; Ciurlionis National Museum of Art, Kaunas, Lithuania, January 1st '01 to February 1st '01; Ludwig Foundation, Aachen, Germany, March 1st to April 1st; Barbican Art Center, London, England, October 1st to December 1st
Andres Serrano, Galerie Edition Kunsthandel, Essen, Germany, September 9th to November 18th

1999
Andres Serrano, David Perez-MacCallum Arte Contemporaneo, Guayaquil, Ecuador, January 20th to February 12th, '99

Andres Serrano: Immersions & Fluid Abstractions, Andre Simoens Gallery, Knokke-Heist, Belgium, August 6th to September 6th

1998
Andres Serrano: A Survey, Ron Judish Fine Arts, Denver, Colorado, October 24th to December 12th
Andres Serrano: A History of Sex, Photology, Milan, Italy, September 15th to November 10th
Andres Serrano, Photology, London, England, May 28th to July 17th
Andres Serrano: 'Red', Baumgartner Galleries Inc, Washington, DC, June 18th to July 15th
A History of Andres Serrano, Horsens Museum of Modern Art, in cooperation with the Groninger Museum, The Netherlands, March 14th to May 24th
Andres Serrano: Fluids, Galerie Yvon Lambert, Paris, France, April 25th to May 30th
Andres Serrano: Selected Photographs 1987-1996, Greg Kucera Gallery, Seattle, WA, January 8th to February 1st
Andres Serrano: Early Works, Fay Gold Gallery, Atlanta, GA, February 6th to March 4th
Andres Serrano, Galeria 1991-Joao Graca, Lisbon, Portugal, January 17th to February 28th

1997
Andres Serrano: A History of Sex, Ugo Ferranti, Rome, Italy, October 15th to November 29th
Andres Serrano, National Gallery of Victoria, Melbourne, Australia, October 10th to October 12th
Andres Serrano, Kirkcaldy Galleries, Melbourne, Australia, October 10th to November 30th
Andres Serrano, Quintana Gallery, Coral Gables, FL, September 5th to October 7th
Andres Serrano: Natives + A History of Sex, Artcore Gallery, Toronto, Canada, September 6th to September 30th
Andres Serrano, PROA, Buenos Aires, Argentina, July 12th to August 30th
Andres Serrano: A History of Sex, Paula Cooper Gallery, New York, NY, March 1st to April 12th
Andres Serrano: A History of Sex, Galleri Charlotte Lund, Stockholm, Sweden, May 7th to June 19th
Andres Serrano: Fluids, The Klan, Lydmar Hotel, Stregatan, Sweden, May 7th to June 19th
Andres Serrano: A History of Sex, Yvon Lambert Gallery, Paris, France, January 11th to February 18th
Andres Serrano, Galeria Juana des Aizpuru, Madrid, Spain, January 29th to February 29th; Seville, Spain, May 15th to June 20th
A History of Andres Serrano: A History of Sex, Groninger Museum, Groninger, Holland, February 21st to May 21st

1996
Andres Serrano, Museum of Contemporary Art, Zagreb, Croatia, October 17th to November 10th
Andres Serrano, Galerie Dante, Umag, Croatia, August 12th to September 15th
Andres Serrano: Large Scale Photographs, Jan Weiner Gallery, Kansas City, MO, September 6th to October 31st
Andres Serrano, Mokka, Reykjavik, Iceland, June 3rd to July 3rd
Andre Serrano, Sala Mendoza, Caracas, Venezula, March 10th to April 28th
Andres Serrano, Port de Barcelona, Barcelona, Spain, April 26th to June 31st
Andres Serrano: From A Southern Perspective, UCA Baum Gallery of Fine Art, Conway, AR, April 21st to May 10th

1995
Thomas Rehbein Galerie, Köln, Germany, November 12th to January 12th '96
Andres Serrano: Budapest, Alfonso Artiaco, Napoli, Italy, November
Andres Serrano: The Morgue, Ugo Ferranti, Rome, Italy, March
Portfolio, Edinburgh, Scotland, August 12th to September 23rd
David Floria Gallery, Woody Creek, CO, March 3rd to March 30th
Andres Serrano: Works 1983-93, traveling exhibition: The New Museum of Contemporary Art, New York, NY, January 27th to April 9th; Center for the Fine Arts, Miami, FL, May 6th to July 30th; Contemporary Arts Museum, Houston, TX, September 30th to November 26th; Museum of Contemporary Art, Chicago, IL, December 9th to February 4th; Malmö Konsthall, Sweden, March 30th to May 19th

1994
Andres Serrano: Works 1983-93, traveling exhibition: Institute for Contemporary Art, University of Pennsylvania, Philadelphia, November 10th to January 15th '95
The Morgue, Museum of Contemporary Art, Montreal, Canada, October 20th to January 8th '95
Budapest, Paula Cooper Gallery, New York, NY, October 1st to October 26th
Budapest, Galerie Yvon Lambert, Paris, France, September 17th to October 29th
The Morgue, Galleri Charlotte Lund, Stockholm, Sweden, September 1st to October 8th
Galerija Dante Marino Cettina, Umag, Croatia, July 16th to August 25th
Alfonzo Artiaco, Naples, Italy, January and February
The Church Series, Paula Cooper Gallery, New York, NY, February 8th to February 19th
Centre for Contemporary Art, traveling exhibition: Ujazdowski Castle, Warsaw, Poland, January 17th to February 23rd; Moderna Galerija Ljubliana, Slovenia, March 1st to March 31st; Magazin 4, Bregenz, Austria, May 17th to June 19th
Grand-Hornu, Hornu, Belgium, February 11th to March 27th

1993
Selected Works: 1986-1992, Feigen Inc., Chicago, IL, November 19th to January 9th '94
The Morgue, Paula Cooper Gallery, New York, NY, January 23rd to February 20th

1992
The Morgue, traveling exhibition: Yvon Lambert Gallery, Paris, France, October 17th to November 18th; La Tete d'Obsidienne, Fort Napoleon, la Seyne-sur-Mer, France, March 20th to April '93; Palais du Tau, Reims, France, May 5th to May 30th; Grand Hornu, Mons, Belgium, January '94 to Febuary '94
Institute of Contemporary Art, Amsterdam, Holland
Zone Gallery, Newcastle-Upon-Tyne, England

1991
Saatchi Museum, London, England
Gallery Via 8, Tokyo, Japan
Nomads, Denver Museum of Art, Denver, CO
KKK Portraits, University of Colorado at Boulder, CO
Thomas Segal Gallery, Boston, MA
Galleri Susanne Ottesen, Copenhagen, Denmark
Galleri Riis, Oslo, Norway

Seibu, Tokyo and Kyoto, Japan
Yvon Lambert, Paris, France

1990
Stux Gallery, New York, NY
Gallery Cellar, Nagoya, Japan
Fay Gold Gallery, Atlanta, GA
BlumHelman Gallery, Santa Monica, CA
Gallery Hibbel, Tokyo, Japan
The Seibu Museum of Art, Tokyo, Japan

1989
Stux Gallery, New York, NY

1988
Stux Gallery, New York, NY
Greenberg/Wilson Gallery, New York, NY

1987
Galerie Hufkens-Noirhomme, Brussels, Belgium

1986
The Unknown Christ, Museum of Contemporary Hispanic Art, New York, NY

1985
Leonard Perlson Gallery, New York

GROUP EXHIBITIONS

2001
Because Sex Sells: Part II, Nikolai Fine Art, New York, NY
Give & Take, Serpentine Gallery, Victoria and Albert Museum, London, England
Full Frontal, Photographic Portraits, Jan Weiner Gallery, Kansas City, MO
Best of the Season, The Aldrich Museum of Contemporary Art, Ridgefield, CT

2000
Faith: The Impact of Judeo-Christian Religion on Art at the Millennium, The Aldrich Museum of Contemporary Art, Ridgefield, CT
Picturing the Modern Amazon, New Museum of Contemporary Art, New York, NY

1999
Pure Essence and Presumed Innocence, Marella Arte Contemporanea, Sarnico, Italy
1997
In Visible Light: Photography and Classification in Art, Science and the Everyday. Traveling Exhibition
The Museum of Modern Art, Oxford, England
Harris Museum and Art Gallery, Preston, England
Inverleith House, Royal Botanic Garden, Edinburgh, Scotland
Moderna Museet, Stockholm, Sweden
Finnish Museum of Photography, Helsinki, Finland

1996
Radical Images, 2nd Austrian Triennial on Photography, Neue Galerie am Landesmuseum Joanneum and Kunstlerhaus, Graz, Austria

1995
Art as Witness, 1st Kwangju International Biennale, Seoul, Korea
Critiques of Pure Abstraction, Organized by ICI, New York, NY and Blaffer Gallery, University of Houston, Texas. Traveling Exhibition
Illingworth Kerr Gallery, Alberta College of Art, Calgary, Alberta

Sheldon Memorial Art Gallery, University of Nebraska, Lincoln, NE

UCLA at Armand Hammer Museum of Art and Cultural Center, Los Angeles, CA

Crocker Art Museum, Sacramento, CA

Museum of South Texas, Corpus Cristi, TX

The Lowe Art Museum, Coral Gables, FL

Frederick R. Weisman Museum, University of Minnesota, Minneapolis, MN

ARS 95 Helsinki, Museum of Contemporary Art/Finnish National Gallery, Helsinki, Finland

1994

Black Male: Representations of Masculinity in Contemporary American Art, Whitney Museum of American Art, New York, NY

Black Male: Representations of Masculinity in Contemporary American Art, UCLA at the Armand Hammer Museum of Art and Cultural Center Los Angeles, CA

Pictures of the Real World (In Real Time), curated by Robert Nickas, Paula Cooper Gallery, New York, NY. Traveling Exhibition

Le Consortium, Dijon, France

Le Capitou, Centre d'Art Contemporain, Frejus, France

EXHIBITION CATALOGUES

2003

Andres Serrano: Works 1985-2002, essay by Gerard A. Goodrow, Andre Simoens Gallery, Belgium

Belvedere dell'Arte / Orizzonti, exhibition catalogue, Skira, Italy, p. 52–53 and 212–224, illus.

Only Skin Deep: Changing Vision of the America Self, Authors: Coco Fusco and Brian Wallis, New York, December

Pandemic: Facing AIDS, exhibition catalogue for «Pandemic: Imaging AIDS,» Umbrage Editions and Moxie Firecracked Films, New York, p. 195, illus.

Subjective Realities; Works from The Refco Collection of Contemporary Photography, The Refco Group, Ltd., New York and Chicago, p. 216–217, illus.

2002

Andres Serrano: The Normal in the Strange, 40 pages illus. art works by Andres Serrano, 1988–2001, with bio & exhibition list, German, published by Artmosphere, June

El Bello Genero, exhibition catalogue, Sala de Exposiciones Plaza de Espana, Madrid, p. 34–37, April–June

Exploring Art. Author: Laurie Schneider Adams, Lawrence King Publishing, London, England, p. 150 and 167–168, illus.

Le Livre du FRAC-Collection Aquitaine: Panorama de l'Art d'Aujourd'hui, Le Festin, p. 640–641, illus.

Life Death Love Hate Pleasure Pain: Selected works from the Museum of Contemporary Art Chicago Collection, Authors: A.T. Smith and Alison Elizabeth Pearlman, Editor: Julie Rodrigues Widholm, MCA, Chicago, IL, p. 246–247

Still Lives of the Living: An Attempt at a Poetic Dialogue with Photographer Andres Serrano. Author: Mariusz Rosiak, Poznan: Galerian

The Great American Nude, exhibition catalogue, Bruce Museum of Arts and Sciences, Greenwich, CT, p. 54, illus.

Votive: Sacred & Ecstatic Bodies, exhibition catalogue, Adam Art Gallery, Victoria University of Wellington, Dunedin Public Art Gallery and the Curators, February, p. 10–11, illus.

2001

A Disarming Beauty: The Venus de Milo in 20th Century Art, curated by Suzanne Ramljak, Salvador Dali Museum, St. Petersburg, FL, p. 39, illus.

Give & Take, exhibition catalogue, Serpentine Gallery, Victoria and Albert Museum, London, England, January 30–April 1, p. 34–35, illus.

Martwe Natury Zywych (Still Lives of the Living), Author: Mariusz Rosiak, Poland

2000

American Perspectives: Photographs from the Polaroid Collection, exhibition catalogue from the Tokyo Metropolitan Museum of Photography, Tokyo, Japan, illus.

Appearance, exhibition catalogue, Galleria d'Arte Moderna Bologna, Edizione Charta, Milan, Italy, p. 27 and 130–147, illus.

Bordes Inasibles: Diálogos Acerca del Cuerpo, CajAstur, Asturias, Spain, p. 51–53, illus.

Dormir / Sleep, Coromandel Press, Paris, France, illus.

Faith: The Impact of Judeo-Christian Religion on Art at the Millennium, The Aldrich Museum of Contemporary Art, Ridgefield, Connecticut, illus.

Information Design #6, Kadokawa Shoten Publishing Co., Japan, p. 88–89, illus.

Kinder des 20. Jahrhunderts (Children of the 20th Century), Galerie der Stadt Aschaffenburg, Mittelrhein-Museum, Koblenz, Germany, p. 171, illus.

MAN-Body in Art from 1950-2000, exhibition catalogue, ARKEN Museum of Modern Art, Skovvej, Denmark, illus.

Seizing the Light: A History of Photography. Author: Robert Hirsch, McGraw Hill, p. 463, illus.

The Modern Amazon, exhibition catalogue, Authors: Joanna Frueh and Laurie Fierstein and Judith Stein, New Museum, Rizzoli Publishing, New York, p. 13 and 114, illus.

1999

Art Matters: How the Culture Wars Changed America, Editors: Brian Wallis, Marianne Weems and Philip Yenawine. New York University Press, New York, NY, illus.

Inderlighetens Spill: Images of Religious Contemplation, exhibition catalogue, Lillehammer Kunstmuseum, Lillehammer, Norway, p. 38–42, illus.

Quoting Caravaggio: Contemporary Art, Preposterous History. Author: Mieke Bal, The University of Chicago Press, Chicago, IL and London, England, illus.

Späte Freiheiten: Geschichten vom Altern, Neue Lebensformen im Alter, exhibition catalogue, Historisches Museum Bielefeld and Schweizerisches Lnadesmuseum Zürich, Prestel Verlag, Münich, Germany, p. 54, illus.

The American Century: Art & Culture 1950–2000, exhibition catalogue, The Whitney Museum of American Art, New York, NY, illus.

The Nude in Contemporary Art, exhibition catalogue, Aldrich Museum of Contemporary Art, Ridgefield, Connecticut, illus.

This Other Being, Author: Judith Baum, Triton Verlag, Vienna, Austria, p. 58–59, illus.

1998

5000 Artists Return to Artists Space: 25 Years. Editors: Claudia Gould and Valerie Smith, Artists Space, New York, NY

Autumn Exhibition, exhibition catalogue, Galerie K, Oslo, Norway, illus.

Pure Essence and Presumed Innocence, exhibition catalogue, Marella Arte Contemporanea, Bergamo, Italy, illus.

Vile Bodies: Photography and the Crisis of Looking, exhibition catalogue, Channel Four Television, published by Prestel-Verlag, illus.

1997

A History of Sex: A History of Andres Serrano, exhibition catalogue, Groninger Museum, The Netherlands

Absolute Landscape Between Illusion and Reality, exhibition catalogue, Yokohama Museum of Art, Yokohama, Japan, p. 78–82, illus.

Allegory, exhibition catalogue, Joseph Helman Gallery, New York, NY

Andres Serrano, exhibition catalogue / hand-out, Fundacion Proa, illus.

Andres Serrano: A History of Sex, exhibition catalogue, Yvon Lambert Gallery, illus.

Angel: Angel, exhibition catalogue, Kunsthalle, Vienna, Austria, illus.

Bang! The Gun As Image, exhibition catalogue, Museum of Fine Arts, Florida State University, Florida, illus.

Breaking Barriers, exhibition catalogue, Museum of Art, Fort Lauderdale, FL, illus.

Finders Keepers, exhibition catalogue, Contemporary Arts Museum, Houston, TX, p. 148–149, illus.

In Visible Light, exhibition catalogue, Museum of Modern Art, Oxford, England, illus.

Searching for the Spiritual, Depree Art Center and Gallery, Hope College, Holland, Michigan, illus.

Sum, exhibition catalogue, Arhus Kunstbygning, Denmark, illus.

Views from Abroad: European Perspectives on American Art 3, exhibition catalogue, Essays: Nicholas Serota and Sandy Nairne and Adam Weinberg, Whitney Museum of American Art, New York, NY, and the Tate Gallery, London, England, illus.

1996

Andres Serrano, exhibition catalogue, Essays: Nada Beros and Tihomir Milovac, Muzej Suvremene Umjetnosti, Zagreb, Croatia, illus.

Andres Serrano, exhibition catalogue, Essay: Robert Hobbs, published by Malmö Konsthall, Sweden

Andres Serrano: The Morgue, exhibition catalogue, Essays: Stephan Bann and Daniel Arasse, Tel Aviv Museum of Art, illus.

Exposure, exhibition catalogue, Caldic Collection, Rotterdam, The Netherlands, illus.

Fractured Fairy Tales: Art in the Age of Categorical Disintegration, exhibition catalogue, published by Duke University Museum of Art, Durham, North Carolina, illus.

Radical Images, exhibition catalogue, 2nd Austrian Triennial on Photography, Neue Galerie am Landesmuseum Joanneum and Kunstlerhaus, Graz, Austria, illus. p.152–153

Urban Evidence: Contemporary Artists Reveal Cleveland, exhibition catalogue, Cleveland Center for Contemporary Art, The Cleveland Museum and SPACES, Cleveland, OH, illus.

Urban Structures, exhibition catalogue, Kulturreferat München, Germany, illus.

1995

Art as Witness, The Spirit of Kwangju Resistance in May, exhibition catalogue, The First Kwangju Biennale, Korea

Critiques of Pure Abstraction, exhibition catalogue, Author: Mark Rosenthal, organized by Independent Curators Inc., New York, illus.

Cuba: La Isla Posible, exhibition catalogue, Centre de Cultura Contemporania de Barcelona, Spain

Going For Baroque, exhibition catalogue, Curated by Lisa G. Corrin, The Contemporary and The Walters

The Body Photographic, exhibition catalogue, Curated by Lew Thomas, Contemporary Arts Center, New Orleans, LA

Vested Power: Icons of Domination and Transcendence, CD Rom produced in conjunction with the exhibition with the Main Art Gallery, California

1994

After Art: Rethinking 150 Years of Photography, exhibition catalogue, Essays: Chris Bruce and Andy Grundberg, Henry Art Gallery, University of Washington, Seattle, WA, p. 61 illus.

Andres Serrano, exhibition catalogue, Galerija Dante Marino Cettina, Umag, Croatia

Andres Serrano: Works 1983–1993, exhibition catalogue, Curated by Patrick T. Murphy, Essays: Robert Hobbs, Wendy Steiner and Marcia Tucker, Institute of Contemporary Art, University of Pennsylvania, Philadelphia, PA

Black Male: Representations of Masculinity in Contemporary American Art, exhibition catalogue, Curated by Thelma Golden, Whitney Museum of American Art, New York, NY, p. 59, illus.

Chasing Angels, exhibition catalogue, Essay: G. Roger Denson, Cristinerose Gallery, New York, NY, p. 31, illus.

Don't Leave Me This Way: Art in the Age of AIDS, exhibition catalogue, Text compiled by Ted Gott, National Gallery of Australia, p. 73

Face-Off: The Portrait in Recent Art, exhibition catalogue, Essays: Melissa E. Feldman and Benjamin H.D., Buchloh Institute of Contemporary Art, University of Pennsylvania, Philadelphia, PA, p. 29 and 72, illus.

Gewalt / Geschafte, exhibition catalogue, Neue Gesellschaft fur Bildende Kunst, Germany, p. 17–24

Los Gèneros de la Pintura, exhibition catalogue, Centro Atlàntico De Arte Moderno, Las Palmas, Gran Canaria, Spain, p. 55–58, 101, 103, 198

Pictures of the Real World (In Real Time), exhibition catalogue, Curated by Robert Nickas, Travelling exhibition

1993

25 Years: A Retrospective, exhibition catalogue, Cleveland Center for Contemporary Art, p. 16

American Art in the 20th Century: Painting and Sculpture, 1913–1993, exhibition catalogue, Editors: C. M. Joachimides and N. Rosenthal, Martin Gropius Bau, Berlin and Royal Academy of Fine Arts, Published by Prestel-Verlag, London, England, p. 145

Hair, exhibition catalogue, John Michael Kohler Arts Center, Sheboygan, Wisconsin

Labyrinth of the Spirit, exhibition catalogue, Author: Robert Stearns, Hammond Galleries, Lancaster, Ohio

Photography by Cintas Fellows, exhibition catalogue, Curated by Dahlia Morgan, Author: Manual E. Gonzalez, The Art Museum, Florida International University, Florida

The Naming of Colors, exhibition catalogue, Essays: Kirby Gookin and Bill Arning, White Columns

Vivid: Intense Images by American Photographers, exhibition catalogue, Raab Galerie, Berlin, Germany, Raab Boukamel Galleries Ltd., London, England and Gian Ferrari Arte Contemporanea, Milan, Italy, p. 50–51

1992

Ethik und Ästhetik im Zeitalter von AIDS, exhibition catalogue, Kunstverein, Hamburg, Germany and Kunstmuseum, Luzern, Switzerland

Perils et Colères, exhibition catalogue, Capc Musée d'art Contemporain de Bordeaux, September

1989

Abstraction in Question, exhibition catalogue, Authors: Bruce Ferguson, Joan Simon, and Roberta Smith, The Ringling Museum of Art, Sarasota, FL

Science Projects, exhibition catalogue, Author: Janet Borden, March

1988

Acts of Faith, exhibition catalogue, Author: Lucy Lippard, January

Awards in the Visual Arts #7, exhibition catalogue

Fake, exhibition catalogue, Author: William Olander, May

Foco Madrid, exhibition catalogue, Author: Alejandro Castellote, Summer

1986

Liberty and Justice, exhibition catalogue, February

New Traditions, exhibition catalogue, Author: Phelan, Robert, December

Seeing is Believing, exhibition catalogue, Author: Allen Ludwig, December

BOOKS

2003

Creative Spirituality: The Way of the Artist, Author: Robert Wuthnow, p. 18

In the Making: Creative Options for Contemporary Art, Author: Linda Weintraub, Excerpt from Back Matter

Navigating the Music Industry: Current Issues and Business Models, Authors: Dick and Leonard Weissman, Hal Frank Jermance, p. 45

The Abuse of Beauty: Aesthetics and the Concept of Art (Paul Carus Lectures), Author: Arthur Coleman Danto, p. 52

The Feminism and Visual Culture Reader, Author: Jones, Amelia. p. 240

Transgressions: The Offences of Art, Author: Anthony Julius

2002

Art a Mort: Photographies de Gerard Rancinan, Author: Virginie Luc, Editions Leo Scheer, Paris, France, p. 128–133, illus.

Bizarrism: Strange Lives, Cults, Celebrated Lunacy, Author: Chris Mikul, Excerpt from Back Matter

Frommer's South Florida including Miami and the Keys, Author: Lesley Abravanel, p. 172

Graphic Design for the 21st Century: 100 of the World's Best Graphic Designers, Authors: Peter and Charlotte Fiell, p. 227

Insight Guide Museums and Galleries of New York City, Insight Guides Museums and Galleries Series, Author: Brian Bell, p. 38

Photography: A Cultural History, Author: Mary Warner Marien, Laurence King Publishing, London, England, p. 436–437, illus.

Photography Past Forward: Aperture at 50, Aperture Foundation, Inc., New York, NY, p. 160, illus.

Revbensstaderna, Author: Eva Strom, Albert Bonniers Forlag, cover illus.

Snoecks 2003, Snoecks N.V., Belgium, p. 254–269, illus.

Twentieth-Century American Art, Author: Erika Lee Doss, p. 185

Visions from America: Photographs from the Whitney Museum of American Art, 1940–2001

2001

Brushes with History: Art of the Nation: 1865–2001, Authors: Peter G. Meyer and Arthur C. Danto, p. 453

But is it Art? Author: Cynthia Freeland, Oxford University Press, New York, NY, illus.

Open City #12: Equivocal Landscape, Author: Thomas Beller, Excerpt from Front Matter

Pollock and After: The Critical Debate, Author: Francis Frascina, p. 342

Quoting Caravaggio: Contemporary Art, Preposterous History, Author: Mieke Bal

Smile ID: Fashion and Style: the Best from 20 Years of ID, Author: Terry and Tricia Jones, p. 592

The Mission of Art In America, Author: Alex Grey, p. 48

The Visual Culture of American Religions, Author: David Morgan, Editor: Sally M. Promey, p. 28

Who's Who in Contemporary Gay and Lesbian History: From World War II to the Present Day, Authors: Robert Aldrich and Garry Witherspoon, p. 478

2000

Andres Serrano: Big Women, Editor: Marco Noire, Turin, Italy, illus.

Command Performance: An Actress in the Theater of Politics, Author: Jane Alexander, p. 36

Photography: A Critical Introduction, Author: Liz Wells, p. 220

What Painting Is, Author: James Elkins, p. 70

1999

Essays on Art, Culture and Technology, Author: Darren Tofts, Parallax

Levende Billeder, Author: Øystein Hjort, Christian Ejlers' Forlag, Copenhagen, illus.

Te Perderá la Carne, Author: Cristóbal Zapata, La (b)onda de David, Ecuador, cover illus.

The American Art Book, Phaidon Press, London, England, p. 401

The Ejaculation Motif: A Discussion of its Iconology in the Light of Works by Andres Serrano, Authors: Rune Gade and Mette Sandbye, Editor: Lars Kiel Bertelsen, Aarhus University Press, Aarhus, Denmark

The Photography Encyclopedia, Authors: Gloria S. McDarrah, Fred W. McDarrah and Timothy S. McDarrah, Schirmer Books, New York, NY, p. 444–445, illus.

1998

Beauty is Nowhere: Ethical Issues in Art and Design (Critical Voices in Art, Theory, and Culture), Author: Richard Roth, p. 9

Closet Devotions, Author: Richard Rambuss, Duke University Press, Durham, North Carolina, p. 6, 21, 25–26, 32, fig. 4, 8, illus.

«Le Pouvoir de La Morgue,» in *Art à Contre-Corps*, Author: Stéphane Napoli, Montpellier: Quasimodo-Numéro Cinq, p. 169–178, illus.

Nudes 2, Graphis Inc., New York, NY, illus.

The Citizen Artist: An Anthology from High Performance Magazine, 1978–1998, Volume 1, Critical Press, Gardiner, New York, p. 159–171

Vile Bodies: Photography and the Crisis of Looking, Author: Chris Townsend, Prestel-Verlag, Germany, illus.

Wounds of Passion, Author: Bell Hooks, The Women's Press, cover illus.

1997

ART: L'Age Contemporain: Une Histoire des Arts Plastiques á la Fin du XXe Siècle, Author: Paul Ardenne, published by Editions Du Regard, Paris, France, illus.

Art Since 1960, Author: Michael Archer, Thames and Hudson Ltd., London, England, illus.

Leonardo Lives, Essays: Trevor Fairbrother and Chiyo Ishikawa. Seattle Art Museum in association with University of Washington Press, Seattle, WA and London, England, illus.

Lier en Boog: Series of Philosophy of Art and Art Therapy, Volume 12, Authors: Annette Balkema, Henk Slager, Rodopi B.V., Amsterdam, The Netherlands. Transcription of lecture given March 1996 at Groninger Museum, p. 106–109, illus.

Surface: Contemporary Photographic Practice, Author: Michael Mack, Booth-Clibborn Editions, illus.

1996

Andres Serrano—The Morgue, Tel Aviv Museum of Art, Tel Aviv, Israel

Andres Serrano / Morgue Series, Eitt Sinn Skal hver Deyja: Dauinn i Islenskum Veruleika, Samstarfsverkefni Mokka og Myndadeildar?, Mokka-Kaffi, Jo Minjasafns Islands, Ur likhusi, Sjonarholl, June, p. 3–30

Art on the Edge and Over, Author: Linda Weintraub, Art Insight, Inc., Connecticut, p.159–164, illus.

Catalogue of Photography, Author: Tom Hinson, Forward: Evan H. Turner, The Cleveland Museum of Art, p. 317 and 467, illus.

Exploration of Nude Photography, Author: Kuraishi Nikado Amano, Yokohama Museum of Art, Japan, illus. p. 95

Fine Art: Photography, Author: Robert Delpire, Graphis Publishing Company, Zürich, Switzerland, illus. p. 52–55

Petit Dictionnaire: Des Artistes Contemporains, Author: Pascale Le Thorel-Daviot, Bordas, Paris, France, p. 235–236, illus.

The Now Art Book, Korinsha Press and Co., Japan, p. 122–129, illus.

Theories and Documents of Contemporary Art: A Sourcebook of Artists' Writings, Editors: Kristine Stiles and Peter Selz, The University of California Press

Visual Arts in the Twentieth Century, Author: Edward Lucie-Smith, Laurence King Publishing, London, England, p. 381, illus.

1995

Andres Serrano: Body and Soul, Essays: Bell Hooks, Bruce Ferguson and Amelia Arenas, Editor: Brian Wallis, Takarajima Books, New York, NY

Anima E Corpo, Author: Massimo Mazzone, Rome, Italy

Aperture—On Location With: Henri Cartire-Bresson, Graciela Iturbide, Barbara Kruger, Sally Mann, Andres Serrano, Clarissa Sligh, Aperture

Art Since 1940: Strategies of Being, Author: Jonathan Fineberg, Laurence King Publishing, London, p. 466 and 468

L'Impunité de l'Art: La Couleur des Idées, Author: Jacques Soulillou, Editions du Seuil, Paris, France, p. 17, 78–79, 121, illus.

Passion Privées: Collections Particulieres d'Art Moderne et Contemporain en France, Paris-Musées, illus.

The Body and The Lens: Photography 1839 to the Present, Author: John Pultz and Harry N. Abrams, New York, NY, p. 159, illus.

The Scandal of Pleasure, Author: Wendy Steiner, University of Chicago Press

(Visual Artist) & Bourdieu, Author: Hans Haacke, Pierre Free Exchange

1994

Actes Sud, Andres Serrano Le Sommeil de la Surface, French Texts: Daniel Arasse, Jean Louis Schefer, Jean-Michel Rey, Philippe Blon and Stephen Bann, 96 pages, illus.

Endzeitstimmung: Düstere Bilder in Goldener Zeit, Author: Gergory Fuller, Dumont Buchverlag, Köln

«Urination and Civilization: Practicing Pissed Criticism,» Anti-Apocalypse: Exercises in Genealogical Criticism, Author: Lee Quinby, University of Minnesota Press, p. 115–134

1993

Pollock and After: The Critical Debate, Author: Francis Frascina, p. 342

Vivid: Intense Images by American Photographers, Editor: Federico Motta

1992

Arresting Images, Author: Steven Dubin, Routledge, New York, NY

Perils et Coleres, Exposition du 22 Mai au Six Septembre, Author: Asta Groting, Clegg and Guttmann, cap Musee d'Art Contemporain de Bordeaux, France